Art of Renaissance
VENICE

The publisher gratefully acknowledges the generous support of the Sonia H. Evers Renaissance Studies Endowment Fund of the University of California Press Foundation and the Art Endowment Fund of the University of California Press Foundation, which was established by a major gift from the Ahmanson Foundation.

Art of Renaissance
VENICE
1400–1600

LOREN PARTRIDGE

UNIVERSITY OF CALIFORNIA PRESS

University of California Press, one of the most distinguished university presses in the United States, enriches lives around the world by advancing scholarship in the humanities, social sciences, and natural sciences. Its activities are supported by the UC Press Foundation and by philanthropic contributions from individuals and institutions. For more information, visit www.ucpress.edu.

University of California Press
Oakland, California

Library of Congress Cataloging-in-Publication Data

Partridge, Loren W., author.
 Art of Renaissance Venice 1400–1600 / Loren Partridge.
 pages cm
 Includes bibliographical references and index.
 ISBN 978-0-520-28179-0 (cloth : alk. paper)
 ISBN 978-0-520-28180-6 (pbk. : alk. paper)
 1. Art, Renaissance—Italy—Venice. 2. Architecture, Renaissance—Italy—Venice.
3. Art, Italian—Italy—Venice. I. Title.
 N6921.V5P28 2015
 709.45'31109024—dc23
 2014014670

Manufactured in China

24 23 22 21 20 19 18 17 16 15
10 9 8 7 6 5 4 3 2 1

The paper used in this publication meets the minimum requirements of ANSI/NISO Z39.48–1992 (R 2002) (*Permanence of Paper*).

For Leslie, Wendy, Amy, Shirley, and Paco

CONTENTS

PREFACE AND ACKNOWLEDGMENTS

PROLOGUE. This book opens with an evocative, scene-setting description of Venice excerpted from the journal of Arnold von Harff (1471–1505), written during his pilgrimage to the Holy Land in 1497. This observant and well-connected German nobleman provides a vivid firsthand account of Venetian commerce, government, industry, and public ceremonies. The near contemporary bird's-eye woodcut *View of Venice* by Jacopo de' Barbari (c. 1460–1516), dated 1500 (figs. 1–4), serves to visually illuminate von Harff's lengthy text. The journal and image together introduce the reader to many of this book's themes and issues.

INTRODUCTION. The introduction briefly recounts the history of Venice to 1500, including its founding, territorial expansion, social structure, government, and economy. It also outlines the so-called Myth of Venice, which was fabricated and refined in the Middle Ages. Although this history of the city's founding, mission, destiny, and acquisition of ducal regalia was largely a fiction, it was passionately believed to be true by the Venetians and, therefore, was referenced and supported by innumerable works of Venetian Renaissance art. As von Harff's description of the city makes clear, even foreign visitors were fully indoctrinated into the major elements of the myth.

Using as guides von Harff's travelogue, de' Barbari's woodcut, and a 1496 painting by Gentile Bellini (1429–1507), *Procession in the Piazza San Marco* (fig. 9), the introduction also analyzes in detail the pre-Renaissance urban development of the Rialto, the Piazza and Piazzetta S. Marco, and the Arsenal—the major commercial, governmental, and industrial centers of Venice.

PARTS I AND II. The book's twenty-six chapters are divided into two major parts. The first treats fifteenth-century Venetian architecture and art as they evolved from Byzantine and Gothic styles and forms—influenced by the art of Venice's trading partners in the eastern Mediterranean and northern Europe—to early classicizing styles and forms, resulting largely from the impact of an influx of early Renaissance Florentine artists into Venice and the Veneto.

The second part opens with an introduction outlining the history of Venice to 1600, including its politics, wars, economy, religion, and society. It then discusses the sixteenth-century developments of Venetian art and architecture from the High Renaissance to the Late Renaissance, styles that drew substantial inspiration from both ancient and High Renaissance Roman art. Knowledge of Roman art was transmitted largely by the art and writings of sixteenth-century central Italian artists who came to live in Venice or visited the city, such as Jacopo Sansovino and Giorgio Vasari, or by Venetian artists who visited Rome and Florence, most notably Titian.

CHAPTERS. The chapters are organized to lead readers systematically through the major artistic developments in the three principal categories of art—governmental, ecclesiastic, and domestic—first in the fifteenth century and then in the sixteenth century. Within each category architecture is discussed first, followed by analyses of the sculpture and painting decorating the exteriors and interiors of Venice's built environment. More specifically, the chapters in each of the parts are arranged sequentially as follows: civic architec-

ture and urbanism, churches, church decoration (ducal tombs and altarpieces), refectories and refectory decoration (part 2 only), confraternities (architecture and decoration), palaces, palace decoration (devotional works, secular painting, portraits, and [part 2 only] halls of state), and finally, villas (part 2 only). A discussion of freestanding public sculpture in the first part follows that of ducal tombs, while in the second part it follows civic architecture and urbanism.

METHODOLOGY: GENRES. Each chapter focuses on the chronological developments of a single genre of art in the course of either the fifteenth or the sixteenth century. The discussion of architecture and art according to genres has been chosen as the most effective way to examine in detail the interrelationship between an artwork's formal and iconographical characteristics and its function, patronage, and institutional setting, while the chronological analysis of stylistic developments within each genre highlights how art responds over time to changes in artistic and cultural contexts.

PATRONAGE. When known, the patrons of every artwork (mostly men, but occasionally women) are given special attention. These patrons—largely nobles who were wealthy merchants, often occupying high governmental positions, but also a substantial number of clerics and nonnoble citizens who served on the governing boards of their guilds and confraternities—were closely connected to the major political, economic, intellectual, and religious institutions of Venice. The art they commissioned, therefore, reveals much about the ideology, claims to status and power, aspirations, and anxieties of the city's elite and the institutions they served.

RELIGION. Religion is the underlying common denominator of most genres of art, for Renaissance Venetians—independent of class, occupation, education, or politics—were particularly concerned with leading moral lives for the salvation of their souls. Christian theology, liturgy, and devotion, consequently, are important themes of this book. Within this context the impact on art of the ideals of the sixteenth-century Catholic Reformation, which had some of its greatest champions in Venice, has been especially highlighted.

ICONOGRAPHY. An equally significant topic is the symbolic language, or iconography, of art, for a vast body of signs and symbols drawn largely from theology, philosophy, mythology, and classical poetry was routinely employed in Renaissance Venice. Since all symbols have multiple, even contradictory meanings, which can lead to under-, over-, or misinterpretation, a work's content and context have been used as the decisive factors in guiding interpretations.

GENDER. Female figures of piety and virtue (e.g., the Virgin Mary, Justice, the Cardinal and Theological Virtues, and Venus) consistently personified Venice and its government in art. Paintings of beautiful classicizing nude or seminude women often decorated the bedrooms of noble palaces as exempla of marital love and fecundity. And portraits of women ran the gamut, with subjects from erotic courtesans to faithful noble wives, from depictions that were unflatteringly realistic to ones that were highly idealized, even mythologized. Thus, the book analyzes in detail the conflicted perceptions of women in Venetian society—ranging from virtuous and nurturing goddesses to lustful and deceitful whores—and the impact of these perceptions on art.

CLASSICAL TRADITION. It was commonplace in the Renaissance for every major Italian city to glorify its ancient Roman and early Christian roots and idealize itself as a new Rome and a new Jerusalem. The ancient Romans, however, neither founded nor settled Venice, and the Venetians overcompensated for this lack by inventing and then believing with delusional insistence a false history that allowed them to perceive their municipality as not only a new Jerusalem but also a new Rome and a new Constantinople. As much of the city's art and architecture both mirrored and constructed these perceptions, the book particularly emphasizes the ancient visual and literary sources that inspired and substantially influenced the art created to support the Myth of Venice.

POLITICS AND ECONOMY. Venice was famous in the Renaissance for its prosperity and its social and governmental stability and longevity. But Venetian political and economic history throughout the Renaissance was especially turbulent. The key episodes of this history are summarized throughout the book to illustrate their profound impact on Venetian art.

ARTISTS AND ART THEORY. The text also strongly emphasizes artists' social status, rivalries, innovations, and art theories as important keys to visual understanding. Likewise, techniques, media, and workshop practices of art production are discussed when they play a substantive role in a work's interpretation.

MODE OF INTERPRETATION. The illustrations represent but a small percentage of the exceptionally rich artistic outpouring of Renaissance Venice. Restricting the number of works allows more in-depth discussions and supports a mode of art-historical interpretation that deploys a multitude of perspectives and proceeds from the work of art out to the cultural context and back again to the object. This approach addresses the unique materiality, content, and aesthetic properties of an individual artwork, as well as the aims, ambiguities, and conflicts of the circumstances of its making. The book, in short, presents a series of paradigmatic multilevel and nuanced interpretations that demonstrate how the culture formally registers in the work of art and how the work of art interactively informs and often shapes the culture.

BACK MATERIAL. To supplement the book's text, a timeline, glossary, bibliography, and annotated index have been included.

AUDIENCE. With the global phenomenon of climate change, it would appear that Venice is ultimately doomed to be partially submerged by the sea from which it rose about a millennium and a half ago. Therefore, it seems an optimal moment to attempt a synthetic account of the glories of Venetian Renaissance art and architecture for students, travelers, and the general public while the city is still inhabitable and visitable.

N.B. Unless otherwise noted, all biblical references are from the Douay Rheims version. English translations of foreign-language titles and quotations are my own, except from works translated in modern critical editions, such as the writings of Leon Battista Alberti, Andrea Palladio, Vasari, and Vitruvius, or cited in modern scholarly studies—all listed in the bibliography.

I offer my sincerest thanks and deepest gratitude to the following individuals: Meryl Bailey, Leslie Martin, Patricia Reilly, Randolph Starn, and Andrew Stewart for reading and commenting on a draft of the text; Andrew Stewart for help with several Latin translations; John Ceballos, Trina Lopez, and Kathryn Wayne for library assistance; Lynn Cunningham, Linda Fitzgerald, Jason Hosford, John McChesney-Young, Julie Wolf, and Samantha Zhu for help with computers and digital imagery; Sonia Evers for sharing her knowledge of the Villa Barbaro at Maser; Susan Bolsom for collecting the book's illustrations; Richard Depolo for creating the maps, plans, diagrams, ground plans, and sections; especially Juliana Froggatt for her superb copyediting, which substantially improved the text; Victoria Baker for creating the index; Claudia Smelser for her excellent book design; and finally, Kari Dahlgren, Chalon Emmons, Aimée Goggins, Karen Levine, Caterina Polland, and Jack Young for shepherding the manuscript through the editorial and publication process.

PROLOGUE

Arnold von Harff, a German nobleman from Cologne, made a four-year pilgrimage to the Holy Land and back between 1496 and 1499. The following edited and abridged excerpt, derived from Malcolm Letts's 1946 translation of von Harff's travel journal, offers a remarkably vivid and detailed account of his visit to Venice in 1497. It describes the city's setting on islands of a lagoon; its strategic location between the East and the West, fostering trade and pilgrimages; its singular governmental structure; its exceptional prosperity and cosmopolitanism; and its powerful navy, which all struck visitors as marvels of the early modern world. These and other wonders were captured visually by Jacopo de' Barbari's unique and spectacular woodcut *View of Venice* (figs. 1–4), begun in about the same year that von Harff visited the city and used here to illustrate his account.

City

Venice is a very beautiful city with many inhabitants [fig. 1]. It lies in the middle of the salt sea, without walls, and with many tidal canals flowing from the sea, so that in almost every street or house there is water flowing behind or in front, so that it is necessary to have little boats, called gondolas, in order to go from one house, from one street, or from one church to another, and I was told as a fact that the gondolas at Venice number more than fifty thousand.

Commercial Center

FONDACO DEI TEDESCHI. *I was taken by the merchants to the German trading house, called the Fondaco dei Tedeschi [fig. 2, no. 1], and into the counting house of Anthony Paffendorp, who received me honorably and showed me much friendship and conducted me everywhere to see the city.*

First to describe this trading house. As I stayed there for some time, I was able to see daily much traffic in spices, silks, and other merchandise packed and dispatched to all the trading towns, since each merchant has his own counting house there—from Cologne, Strasbourg, Nuremberg, Augsburg, Lübeck, and other German cities of the [Holy Roman] Empire. The merchants told me that the counting houses paid daily to the lords of Venice a tax of a hundred ducats in addition to all the merchandise which was bought there and dearly paid for.

RIALTO. *From this German House one goes over a long wooden bridge [fig. 2, no. 2]. Then one reaches a small square called the Rialto [fig. 2, no. 3]. Here the merchants assemble daily about nine or ten o'clock for their business. Close by the square sit the money changers who have charge of the merchants' cash. When a merchant buys from another he refers him to the bankers, so that little money passes between the merchants. Leading from the Rialto are long streets where the merchants have their shops, such as goldsmiths and jewelers selling pearls and precious stones. One street contains tailors, cobblers, rope sellers, linen and cloth dealers, and others. Above the shops is a place like a monastery dormitory, so that each merchant in Venice has his own warehouse full of merchandise, spices, rare cloths,*

VENETIE
M·D·

1. Jacopo de' Barbari, *View of Venice* (looking north), dated 1500, woodcut, 4 ft. 5 in. × 9 ft. 3 in. (135 × 282 cm), British Museum. Inscribed in Latin: (top) "I, Mercury, shine favorably on this above all other emporia"; (bottom) "I, Neptune, reside here smoothing the water of this port."

2. ▶ Rialto, detail of fig. 1: **1** Fondaco dei Tedeschi, **2** Rialto Bridge, **3** Piazza Rialto, **4** S. Giacometto, **5** Merchants' Portico, **6** Palazzo dei Camerlenghi, **7** Palazzo dei Dieci Savi, **8** Fabbriche Vecchie, **9** Fondamenta del Vin, **10** Palace of the Patriarch of Grado, **11** S. Bartolomeo, **12** S. Salvador, **13** Palazzo Dolfin, **14** S. Lucia, **15** S. Aponal, **16** S. Cassiano, **17** S. Sofia, **18** SS. Apostoli, **19** S. Giovanni Crisostomo, **20** Ca' da Mosto.

3. Piazza and Piazzetta S. Marco, detail of fig. 1: **1** Merceria; **2** Church of S. Marco; **3** Doge's Palace; **4** Sala del Maggior Consiglio; **5** Piazza S. Marco; **6** Clock Tower; **7** Procuratie Vecchie; **8** S. Germiniano, replaced in the eighteenth century by Napoleon's ballroom; **9** Campanile; **10** Piazzetta S. Marco; **11** Column of St. Mark; **12** Column of St. Theodore; **13** five inns and stalls for bakers and butchers, replaced by Jacopo Sansovino's Library (1537); **14** communal granaries; **15** three shops on the Ponte della Pescaria, replaced by Sansovino's five Doric shops (1531); **16** old Mint, with cheese vendors' stalls in front, replaced by Sansovino's new Mint (1536); **17** back of the procurators' residences; **18** back of the procurators' offices; **19** Hospice of the Orseolo.

silk draperies, and many other goods, so that it can be said that the wealth of Venice lies in this square.

MERCERIA. *From here we went to the chief church of S. Marco through many narrow streets* [including the Merceria, linking the Rialto and Piazza S. Marco; fig. 3, no. 1], *in some of which were apothecaries, in some bookbinders, in others all kinds of merchants driving a thriving trade.*

Civic Center

CHURCH OF S. MARCO. *S. Marco is a very beautiful but low church with many domes covered with lead* [fig. 3, no. 2]. *This church is covered with marble and gold mosaics. Inside on the right is the vaulted treasury, with twelve crowns and twelve pectorals made of gold, pearls, sapphires, balas rubies, and emeralds; six rare golden crosses with precious stones; the doge's crown, which is treasured as a thing of inestimable value; two great golden candlesticks, upon which are ten great balas rubies; a large and long unicorn's horn, most highly polished; and many costly jewels.*

Over the church doors stand four gilded metal horses. I asked one of the gentlemen why the horses were put up there. He informed me that the lords of Venice had caused the horses to be set up there as an everlasting memorial. [When the emperor Frederick Barbarossa (r. 1155–90) laid siege to Rome, Pope Alexander III (r. 1159–81)] *secretly fled by night dressed in a monk's habit to a monastery in Venice, where he became a brother working as a cook. Later, after more than a year, a pilgrim from Rome came unnoticed to Venice to that monastery and recognized the cook as the pope. He at once gave notice to the Venetians that they had the pope in the city. Thereupon the Venetians prepared a great procession and fetched the pope out of the monastery with great reverence. When the emperor heard that the pope was in Venice, he wrote to the Venetians demanding that they should forthwith deliver up the pope to him, but they refused. Thereupon the emperor was angry and became their enemy, and swore by his red beard that he would destroy Venice and turn S. Marco into a stable for horses. He then gathered together a great army, taking with him his son Otto* [1167/71–1200] *and besieged Venice. But leaving his son there, he withdrew to the German lands to bring more men. But in the meantime the Venetians marched out secretly and smote the army and captured the emperor's son Otto. When the emperor heard this, he was full of mistrust. But he was forced to make terms with them and to give them what they demanded. The terms were that the emperor should come to Venice and kneel down in S. Marco before the pope, and suffer the pope to put his foot on his neck. They would then deliver his son to him again. This happened. So*

4. Arsenal, detail of fig. 1.

the pact was carried out, but on account of the great oath which the emperor had sworn by his red beard, that he would make S. Marco into a stable for horses, the Venetians, out of respect for him, caused to be set up four gilded metal horses in front of S. Marco.

DOGE'S PALACE. *Close by S. Marco, southward, stands the Doge's Palace* [fig. 3, no. 3; fig. 5], *which is very fine and is daily being made more beautiful by Doge Agostino Barbarigo* [r. 1486–1501], *who is now having the palace covered with marble and gilt. He was also building a whole marble staircase with beautiful carving* [fig. 13], *which at this time was not half complete, the half having cost ten thousand ducats.*

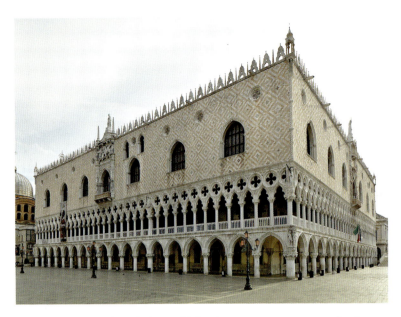

5. Doge's Palace: south, Molo (quayside) façade, 1341–65; west, piazzetta façade, 1424–38.

SALA DEL MAGGIOR CONSIGLIO. *As one first enters* [the Doge's Palace], *on the right hand one climbs a staircase to a very large hall, which is the council chamber* [the Sala del Maggior Consiglio; fig. 3, no. 4; figs. 230 and 231] *of the lords of Venice. In the council chamber there is, finely pictured, the story of Emperor Frederick Barbarossa and portraits of all who have been doges of Venice. The seven hundred, who went daily* [actually weekly] *to council were nobles, all fine men usually with gray beards, handsomely dressed in long gowns to the feet, their heads all shaved, and on the head a small cap. The sleeves of this gown hang down about an ell wide, like a sack. From the seven hundred gentlemen they choose twelve chief lords, and from the twelve they choose a doge. He must live in the palace and cannot leave the city or the palace without the permission of the other eleven chief lords.*

MARITIME AND TERRAFERMA EMPIRES. *This doge with the government has very many towns, countries, and kingdoms under him, since Venetian dominion extends from Milan to Jaffa, a port of the Holy Land. Included are many beautiful towns and castles in Lombardy, the Veneto, Apulia, Calabria,* Dalmatia, Croatia, Albania, and Greece, and innumerable islands, including Crete and Cyprus. All of which they govern with wisdom, sending every year new governors from among the gentlemen of Venice.

PIAZZA S. MARCO. *Opposite S. Marco westward across the square* [fig. 3, no. 5] *is the bell tower of S. Marco* [fig. 3, no. 9], *which is foursquare and very high. Inside it a staircase goes to the top, which one can ascend on horseback. From this tower one can overlook the whole of Venice.*

PIAZZETTA S. MARCO. *At the end of the Piazza S. Marco eastward* [in the Piazzetta S. Marco (fig. 3, no. 10)] *are two large and high monolithic columns made of stone each the height of two spears and twelve feet thick* [fig. 3, nos. 11 and 12]. *On the one stands a sculpture of* [the lion of] *St. Mark and on the other St. Theodore. Beneath these columns and between them is the fish market. If anyone is to be executed, a gallows is placed between these two columns, and here all justice is carried out.*

The Arsenal

Venice has inside the city a great house of weapons called the arsenal [fig. 4]. *I was taken in with the help of two gentlemen and by means of certain presents. At the entrance, traveling with the sun, we ascended some stairs to a great hall thirty feet wide and quite a hundred long which is full of arms hanging on both sides in three rows, one above the other, very orderly disposed, with everything that belongs to a soldier, such as a coat of mail, a sword, a dagger, a spear, a helmet, and a shield. In addition, as part of the arrangement of this hall, there are stored more than three or four thousand swords, daggers, and innumerable numbers of long pikes, with many more accoutrements for war, and above the roof are crossbows hanging side by side touching each other, six rows deep. From here we went out and came to a large high building which has thirty arches under one roof, each arched space being one hundred and fifty paces long and ten broad, beneath which they build the great ships. Also close by stands another building with arches, in which they also build ships. Between the two runs deep water, and when the ships are ready they are rolled on round wooden wheels into the water. We went further into another building in which were very fine cannons. Close by were also many other large cannon, culverins, half-culverins, mortars, and chamber-guns, which are all used on the ships.*

We went further through a door into a great square, called the New Arsenal. We came to a building where they make gunpowder. Here are twelve powder mills turned by horses. We came next to another large building, full of saltpeter. We continued to another building, where a hundred women are employed daily heck-

6. Schematic map of Venice locating selected churches, palaces, and squares.

Piazza and Piazzetta S. Marco (see also fig. 3): **1** S. Marco, **2** Doge's Palace (see figs. 11 and 97 for the Porta della Carta, Porticato Foscari, Arco Foscari, and Scala dei Giganti), **3** Clock Tower, **4** Campanile and Loggetta, **5** Procuratie Vecchie, **6** Library.

Rialto (see also fig. 2): **7** Rialto Bridge, **8** Fondaco dei Tedeschi, **9** Palazzo dei Camerlenghi, **10** Palazzo dei Dieci Savi, **11** Fabbriche Vecchie, **12** Fabbriche Nuove.

Arsenal (see also fig. 4): **13** Arsenal.

Churches: **14** Il Redentore; **15** S. Francesco della Vigna, S. Germiniano (fig. 3), S. Giacometto (fig. 2); **16** S. Giorgio Maggiore; **17** S. Giovanni Crisostomo; **18** S. Maria Assunta dei Gesuiti; **19** S. Maria dei Miracoli; **20** S. Maria Formosa; **21** S. Maria Gloriosa dei Frari; **22** S. Michele in Isola; **23** S. Pantaleone; **24** S. Rocco; **25** S. Salvador; **26** S. Sebastiano; **27** S. Zaccaria; **28** SS. Apostoli; **29** SS. Bernardino e Giobbe; **30** SS. Giovanni e Paolo.

Confraternities: **31** St. Mary of Charity (now Gallerie dell'Accademia), **32** St. Mary of Mercy, **33** St. George, **34** St. John the Evangelist, **35** St. Mark, **36** St. Roch, **37** St. Ursula.

Palaces: **38** Ca' da Mosto, **39** Ca' Dario, **40** Ca' d'Oro, **41** Ca' Foscari, **42** Palazzo Cornaro della Ca' Grande, **43** Palazzo Dolfin, **44** Palazzo Loredan, **45** site of the Palace of the Patriarch of Grado, **46** Palazzo Talenti d'Anna.

Barbary Coast, two to Constantinople, two to Jaffa, in which the pilgrims are accustomed to travel every year to Jerusalem, two to England, and two to Flanders.

When I heard that two ships were going to Alexandria, my earnest wish being to go to Mt. Sinai, I at once prepared myself with the help of the German merchants with needful things. I was taken to a gentleman of Venice who traded in all countries overseas, who gave bills of exchange in the cities of Alexandria, Damietta, Damascus, Beirut, Antioch, Constantinople, and other towns, for which the other merchants of the counting house of Anthony Paffendorp of Cologne were my sureties, that they would make good what I spent in other countries.

When we learned that the ships were about to leave, we went with the assistance of the merchants before the doge of Venice, who gave us an order to the patron of the largest armed ship which was to accompany the other ship, in which he ordered him to give us good company. We then left at once in a boat to the great ship and presented our letter to the patron, who received us honorably, gave us our own cabin, and arranged for us to eat at his table with the other merchants, where we were well served for four ducats a month.

Canal Grande

Canale della Giudecca

ling and spinning, making ropes used in ships. We proceeded to another great building, which was full of oars, more than one hundred thousand, used for rowing the ships. We came next to a large building in which were twelve forges, each with a master smith and three assistants, and all the materials for the smiths who forge cannons every day, as well as all kinds of fittings for ships. We came next to a hall full of ropes for ships. Through this hall we went to another, where about fifty women were making sails for ships, those lying there complete numbering more than ten thousand.

Churches

In Venice there are seventy-two parish churches, not counting monasteries and other chapels.

SS. GIOVANNI E PAULO. *The fine monastery of the preaching friars* [the Dominican church of SS. Giovanni e Paulo (fig. 6, no. 30; figs. 17 and 18)] *is where many of the doges are buried, their tombs covered with marble and gilded* [figs. 35, 37, 38, and 40]. *One is said to have cost ten or twelve thousand ducats.*

FRARI. *The monastery of minor brothers* [Franciscans] *is a very fine and large church* [S. Maria Gloriosa dei Frari (fig. 6, no. 21)]. *In the choir lie two doges* [Francesco Foscari (r. 1423–57) and Niccolò Tron (r. 1471–73)] *very splendidly interred high up in the walls in marble tombs* [figs. 36 and 39], *one of which cost as much as two thousand ducats.*

S. ROCCO. *Behind this monastery is the church of S. Rocco* [fig. 6, no. 24], *where the body of the saint lies in the choir above the altar in a tomb of marble and stone.*

S. MARIA DEI MIRACOLI. *Behind the German house is a fine small church called S. Maria dei Miracoli* [fig. 6, no. 19; figs. 28–30]. *At this time it was being rebuilt inside and out and covered with marble and stones. There was every evening a great crowd here on account of pardons and indulgences.*

S. ZACCARIA. *In S. Zaccaria* [fig. 6, no. 27; figs. 23–27] *lies the body of the name saint, St. Zachary, the father of John the Baptist. Beside him lie two holy bodies.*

S. GIORGIO MAGGIORE. *Opposite the entrance to S. Marco southward is a fine monastery on an island called after St. George* [fig. 6, no. 16], *where we were shown many relics: The head of St. George and his left arm with the flesh. The heads of SS. Cosmas and Damian enclosed in a gilt bowl. The left arm of St. Lucy, the virgin. The head of St. James Minor, which I saw also later at Compostela in Spain. These muddles of the priests I leave to God's judgment.*

Ducal Ceremonies

PROCESSION OF THE DOGE WITH HIS REGALIA, OR *TRIONFI*, TO S. MARCO. *The doge at this time was Agostino Barbarigo, an old man of more than seventy years. I saw him going in state to S. Marco in this manner. First they carried before him eight golden banners, of which four were white and four brown. Then came a picture which was borne on a golden standard. Next was carried a golden chair with a* [foot] *cushion which was made of golden stuff. Next they carried his* [jewel-encrusted coronation] *crown, with which he is made a doge, which is valued at one hundred thousand ducats. Then came the doge, most gorgeously dressed. He had a long gray beard and had on his head a curious red silk hat shaped like a horn behind. Before the doge was carried also a white lighted candle in a silver candlestick. There preceded him also fourteen minstrels, eight with silver herald trumpets, from which hung golden banners with the arms of St. Mark, and six pipers with cornets, also with rich hangings. Behind the doge was carried a sword with a golden sheath. There followed him the eleven chief lords with the other gentlemen richly attired, fine stately persons.*

ASCENSION DAY (OR SENSA). *On Ascension Day* [May 4 in 1497] *the doge celebrates a festival each year before the entrance* [into the lagoon] *from the high sea. He throws a gold ring into the wild sea, as a sign that he takes the sea to wife, as one who intends to be lord over the whole sea. The ship in which he celebrates is a small stately galley* [the Bucintoro], *very splendidly fitted out. On the prow of this ship is a gilt maiden* [a figurehead of Justice]: *in one hand she holds a naked sword and in the other golden scales. The sword in the right hand signifies that she will do justice: for the same reason the maiden holds the scales in the left hand.* [Also, Justice as the embodiment of Venice] *is a sign that just as she is still a maid, so the government is still virgin, never having been taken by force.*

Departure

In the evening [probably on the eve of the Feast of Corpus Christi, May 25, 1497] *all the mariners or seamen who intended that year to go overseas went to S. Marco, and we pilgrims who intended to travel with them went also. They began to sing praises to our Lady with many antiphons and psalms and blessed and consecrated a wooden cross, in the same way as with the Easter candles. We, who were about to cross the sea, then received by names our blessing from the priest, and each one departed to his inn.*

After this day, each shipman prepared for the voyage. At this time the government of Venice sends each year fourteen galleys to all countries to carry goods and to return with others: two to Alexandria, two to Beirut, two to Tripoli and the

FIFTEENTH-CENTURY VENICE

INTRODUCTION

Founding and Territorial Expansion

Venice was settled relatively late compared to other major Italian cities. Refugees from the mainland established villages on the islands of the saltwater lagoon in the sixth and seventh centuries as they fled from the Lombard invasion of northern Italy. In the seventh and early eight centuries, while still under the administrative control of the Byzantine exarch (governor) of Ravenna, these settlers united to develop an independent military force and establish a duchy under the leadership of a doge in the Rialto area of present-day Venice. In 751 the Lombard king Aistulf (d. 756) conquered Ravenna and ended Byzantine rule in northern Italy, leaving Venice isolated and a more or less independent outpost.

To survive in their isolated position in the Venetian lagoon, it was essential that the Venetians embrace a seafaring economy trading with the mainland, especially Byzantium. Thus, during the first four centuries of the duchy, Venice was most strongly influenced politically, economically, and culturally by Constantinople, the capital of the Byzantine Empire.

By the twelfth century, Venice had evolved into a prosperous and autonomous city-state. It achieved its full independence from Byzantium by diverting the Fourth Crusade (1202–4) from its original purpose of recapturing the Holy Land from the Turks, instead directing the crusaders first to capture the rebellious Venetian port of Zara in Dalmatia and then to sack the Christian city of Constantinople. During the frenzy of the pillage there, Venetians dismantled some of Constantinople's most important monuments and shipped the spoils to Venice as trophies of victory to embellish the city. These included many of the marble columns and reliefs decorating the exterior of the church of S. Marco and the four bronze horses over its entrance (now replaced by copies), which transformed the three-arched façade into a type of triumphal arch. When the crusading nations partitioned the territory of the defeated Byzantine Empire, Venice received three-eighths as its share, including the islands of Negroponte and Candia (Crete) and the outposts of Modon and Coron at the tip of the Morea, or Peloponnese (fig. 7). These acquisitions helped to support Venice's self-designation as a new Constantinople.

Over the next three centuries, Venice consolidated its control over the Istrian Peninsula (incorporated in 1267) and established or strengthened a series of outposts along the shores and on the islands of the Adriatic, Ionian, Aegean, and eastern Mediterranean Seas to support its lucrative trade with Byzantine and Muslim countries. The most important of these fortresses were along the coasts of Dalmatia, Albania, and the Morea and on the islands of Crete (acquired in 1212), Negroponte (annexed in 1390), Corfu (a protectorate in 1386, annexed in 1401), and Cyprus (acquired in 1489).

The growth of its Mediterranean trade soon brought Venice into conflict with the republic of Genoa, a competing maritime power on the western side of the Italian peninsula. Allied with nearby Padua and the kingdom of Hungary to the northeast, Genoa almost defeated Venice in a series of land and naval battles known as the War of Chioggia (1378–81). The Venetians eked out a victory with great sacrifice and skill, however, and emerged as the dominant naval and commercial power in the Mediterranean. Facilitated by formidable naval

Towns and islands under Venetian dominion
for some or all of the period 1380-1580

Non-Venetian towns and islands

Trade routes of the state galleys

Milan
See fig. 8
VENICE
Fiume
Véglia
Cherso
Genoa
Pago
Marseilles
Pisa
Zara
Florence
Sebenico
Ancona
Spalato
Trau
Brazza
Lesina
Rome
Curzola
To Provence,
Catalonia
(15th cent.)
Ragusa
Cattaro
Antivari
Scutari
Naples
Dulcigno
Alessio
Trani
Durazzo
Monopoli
Brindisi
Valona
Otranto
Butrinto
Corfu
EPIRUS
To Portugal,
Flanders,
England
Paxo
Arta
Prevesa
Leucas
Ithaca
IONIAN
SEA
Messina
Cephalonia
Lepanto
Patra
Corinth
Zante
Argos
Nauplia
Tunis
Navarino
MOREA
Coron
Modon
Monemvasia
Sapienza
Cerigo
To N. Africa,
S. Spain
(from 1436)
Malta
Canea
(later 15th cent.)
Candia
CRETE
Tripoli

BLACK SEA
Tana
(till 1452)
Trebizond
Constantinople
Thessalonika
Gallipoli
Tenedos
AEGEAN
SEA
N. SPORADES
Smyrna
Chios
Athens
Tinos
Aegina
Mykonos
Naxos
Rhodes
Carpathos
CYPRUS
Nicosia
Laiazzo
Antioch
Aleppo
Famagusta
Beirut
Damascus
Tyre
Acre
Jaffa
Jerusalem
Damietta
Alexandria
Nile
Red Sea

MEDITERRANEAN SEA

ADRIATIC SEA

Danube

Negroponte

N
W E
S

0 300 Mls
0 500 Kms

7. Venetian maritime empire, 1380–1580.

technology and one of the most advanced banking systems in Europe, Venetian trade expanded inside and outside the Mediterranean, including in cities in North Africa, Egypt, the Levant, Portugal, Flanders, and England (fig. 7).

In the course of the fifteenth century, Venetian naval dominance once again was severely challenged, by the English and Portuguese trading fleets, the opening of a new trade route around the Cape of Good Hope, marauding pirates throughout the Mediterranean, and the rise of the Ottoman Empire, especially under the leadership of the Turkish sultan Mehmed II (r. 1444–46 and 1451–81), whose large army and navy conquered Constantinople in 1453. Between 1463 and 1479 the Venetians fought many—mostly losing—battles with the Turks along the eastern coast of the Adriatic and in the Ionian and Aegean Seas. By 1466 the Turks had conquered a substantial portion of the Morea, and in 1470 they captured the key Venetian fortress of Negroponte. The Venetians defended Scutari in Albania against a Turkish siege in 1474 and again in 1477, when they lost nearby Croia. Also in 1477, the Turks invaded Friuli on the Italian mainland just to the northeast of Venice, killing or enslaving some twelve thousand Venetian subjects. As a result of these losses, the Venetians signed the Treaty of Constantinople in 1479 with the sultan, in which they sacrificed Scutari, relinquished all but three of their other fortresses in Albania, and paid a ten-thousand-ducat tribute for continued navigation rights in the Black Sea. Even this fragile peace was broken in 1499, when Mehmed's son and successor, Bayezid II (r. 1481–1512), once again attacked Venetian fortresses all along the shores of the Adriatic, seizing both Modon and Coron in 1500.

From its very beginning Venice had depended on the Italian mainland as an important source of food, raw materials, and manpower and location for villeggiaturas (summer villa retreats) and had even annexed Treviso in 1339 and Conegliano in 1344. But in the course of the fifteenth century (especially from 1404 to 1454), the Venetians embarked on an aggressive policy of outright conquest of a large territory on the Italian mainland in response to the various mainland states that had begun to expand into areas traditionally within the Venetian sphere of influence and to the ever riskier nature of maritime commerce, due to the competition from pirates, Ottoman Turks, and other trading nations. This shift from the sea to the terraferma aimed both to secure trade routes to northern Europe and mainland Italy, the latter the source of Venice's grain supply, and to provide the city with new markets and an expanded tax and employment base. The boundaries of this terraferma empire expanded to include the foothills of the Alps on the north, and on the south, west, and east the rivers Po, Adda, and Isonzo (fig. 8). It also encompassed the important towns of Crema, Bergamo, Brescia, Verona, Vicenza, Padua, Treviso, Ceneda, Feltre, Belluno, Udine, and Cividale.

By the end of the fifteenth century, when Arnold von Harff visited the city and Jacopo de' Barbari printed his woodcut *View of Venice* (figs. 1–4), Venice had become one of Europe's largest and most prosperous cities, with a population of well over one hundred thousand, not including the inhabitants of its extensive land and maritime empires.

Social Structure

Venetian society consisted of three distinct social orders. At the top were the nobles, or patricians, who constituted less than 10 percent of the population in the fifteenth century. They were mostly merchants and investors and enjoyed exclusive control of the dominant institutions of government. Legislation passed between 1297 and 1323 (the so-called *serrata,* or closing of the Great Council) decreed that only those families with male members actively serving in the Great Council since 1293 could claim noble status. Henceforth the rolls were closed to all but about 230 families, and nobility became hereditary through the male line. However, in periods of great crises additional nonnobles could be enrolled for exceptional contributions to the state—for example, about thirty individuals were added to the rolls for outstanding service during the War of Chioggia. Also, in response to lax oversight and poor record keeping in the fourteenth century, a series of laws was enacted in the fifteenth and sixteenth centuries to tighten the rules and establish more accurate records of noble births, marriages, and deaths. These laws required that before a son could claim noble status and be admitted to the Great Council, he had to prove to the communal lawyers that he was twenty-five years of age, his father had been active in the government, his birth was legitimate, and his mother was worthy, not a slave, servant, concubine, or other "vile" type. Once families that had become extinct were removed from the rolls, these laws appear to have reduced the number of patrician families to well under two hundred.

At the next level of society were the original citizens, or *cittadini originarii,* native-born citizens whose fathers and grandfathers had lived in Venice and had never worked in any manual occupation. Nonnatives could also become naturalized citizens, if they had lived in the city for at least fifteen years and paid taxes. Citizens, who dressed and acted like nobles, constituted about

Main Alpine trade routes

● Towns under Venetian dominion for
some or all of the period 1380-1580

○ Non-Venetian towns

TYROL

CARINTHIA

to the
Brenner
Pass

Cadore

Venzone

A L P S

FRIULI

Cividale

Belluno

Udine

VAL CAMONICA

Feltre

Trent

Ceneda

Pordenone

Gorizia

Sacile

Rovereto

Aquileia

Lecco

Maser

Conegliano

Como

Thiene

Asolo

Grado

Trieste

Bergamo

Fanzolo

Treviso

Castelfranco

Capo d' Istria

Milan

Vicenza

Villa Trissino

Roncade

Pirano

Villa Rotonda

Brescia

Torcello

Mestre

ISTRIA

Agnadello

Peschiera

Verona

Venice

Fiume

Crema

Padua

Lodi

Montagnana

Parenzo

Pavia

Oglio

Minicio

Chioggia

Adda

Adige

Pontecasale

Po

Cremona

Pola

Mantua

Po

Ferrara

ADRIATIC SEA

Bologna

N

Ravenna

Faenza

Lamone

W E

Cervia

Forli

ROMAGNA

Cesena

S

Rimini

Pesaro

50 Mls

0

Fano

80 Kms

Florence

8. Venetian terraferma empire, 1380–1580.

5 percent of the population in the fifteenth century and for the most part were educated professionals, merchants, military officers, and civil servants in the chancellery—communal lawyers, secretaries, and notaries. By law the *cittadini* also had exclusive rights to the office of grand chancellor, which presided over the Great Council, and to the administrative offices in the large confraternities.

At the bottom were the native and foreign *popolani,* or commoners, who made up the rest of the population. They included wealthy merchants, shopkeepers, tradesmen, artisans, laborers, and the poor and destitute.

While the definitions of who belonged to which order became ever more rigid and fraught with the potential for social conflict in the course of the sixteenth century, in practice there was a certain amount of permeability between them. In the functioning of the marketplace, the government, the confraternities, and the parish churches, the three groups interacted freely and frequently, and more often than not with a measure of equality and harmony.

Government

Venice was Europe's most politically stable and longest-lived republic, owing to its unique constitution, which established a mixed monarchic and oligarchic state. As it had evolved by the fifteenth century, the government featured a six-hundred- to sixteen-hundred-member Great Council (Maggior Consiglio)—drawn from an eligible pool of up to three thousand adult males—which approved all legislation during its weekly Sunday meetings. From the membership of the Great Council were also elected the following: the ten-member Signoria, headed by the doge (or duke), and the sixteen-member Consulta, which together constituted the Collegio, or executive branch of government; the forty-member judicial branch (Quarantia Criminal), charged with the administration of justice; the powerful Council of Ten (Consiglio dei Dieci), responsible for state security (i.e., dealing with any foreign or domestic threats to the state, whether political, religious, moral, financial, or criminal); and the 120-member Senate, which was the principal legislative and deliberative body.

The doge, the supreme head of state (but with strictly limited power and authority), served for life and lived in the Doge's Palace, while the other members of the government were elected for fixed terms ranging from several months to more typically a year or two. The citizens who staffed the governmental bureaucracy mostly held permanent positions, and their efficiency and experience contributed greatly to the government's stability and longevity.

Economy

The Venetians prospered primarily by acting as middlemen—importing a wide variety of goods from the Black Sea, the Levant, and Africa and exporting them to the rest of Europe—and by taxing the flow of goods through the city's ports. As a direct result of this international trade, shipbuilding in the Arsenal became one of Venice's major industries, which in turn promoted the rise of a large class of naval officers and seamen. The enormous wealth that maritime commerce generated also fostered the manufacture of luxury goods, especially textiles (silk, linen, and lace), metalwork (bronze, gold, and silver), glassware, and leatherwork. It also supported a thriving community of artists, sculptors, and architects. Finally, by the end of the fifteenth century, Venice had become one of the leading European centers of printing, bookmaking, and scholarship, publishing about 150 new titles a year.

THE MYTH OF VENICE

Venice was the only major Italian city that lacked the prestige of having been founded by the ancient Romans. In compensation, the Venetians evolved in the course of the Middle Ages what is now called the Myth of Venice, an apocryphal account that Renaissance Venetians considered historical fact. According to the tale, St. Peter sent his disciple Mark on a mission to Aquileia at the north end of the Adriatic (fig. 8) to convert northeastern Italy to Christianity. During his return to Rome, a storm forced Mark to seek refuge on an island in the Venetian lagoon. At night an angel appeared to him prophesying that a great city would be built in the lagoon and that the apostle himself would be buried there. The first half of the prophecy was fulfilled at noon on March 25 (the Feast of the Annunciation) in 421 AD, when Venice was supposedly founded. The second half of the *praedestinatio* (angel's prophecy)—PAX TIBE, MARCE, EVANGELISTA MEVS, HIC REQVIESCAT CORPVS TVVM (Peace be to you, Mark, my Evangelist, here your body will lie), inscribed in whole or part on a host of Venetian works of art—was fulfilled by the *translatio,* or theft of Mark's body from Alexandria in 828 by Venetian merchants and its transport in 829 to Venice for reburial in S. Marco.

To create a parallel with the founding of ancient Rome by Aeneas—the Trojan prince whose escape with his followers to Italy after the Greeks destroyed Troy is narrated in the *Aeneid* by Virgil (70–19 BC)—the Venetians claimed that Venice was founded by Christian descendants of Trojan refugees led by

Antenor, who in turn descended from Dardanus, the first king of Troy. The Venetians even claimed precedence over Rome by boasting that Antenor and his followers had settled in Aquileia and Padua before Aeneas and his companions had landed in Italy. By imagining Venice's foundation in 421 AD on the Feast of the Annunciation, nearly a century after the founding of Constantinople in 330 AD, the Venetians also insisted that Venice had never been sullied by pagan worship. They proclaimed that it was the first republic of the Christian era, a pure and holy new Jerusalem favored by God and uniquely bonded to the Virgin and the redemptive promise of Christ's Incarnation. They also believed that they had a pious, God-given mission to assist the process of salvation by establishing peace and justice in Venice and its maritime and terraferma empires—a convenient justification for their often exploitative colonialism. Venice's sacred destiny was sanctioned and protected by Mark, buried in S. Marco, just as Peter, interred in St. Peter's in Rome, legitimized and guarded the Roman Church's mission to Christianize the entire world in preparation for the Last Judgment. Mythically a new Jerusalem, a new Rome, and a new Constantinople, Venice was second to none.

It was also important that the head of the Venetian state, the doge, be perceived as equally powerful and august as any pope or emperor. In the early fourteenth century, therefore, the Venetians conceived the myth of Pope Alexander III, an elaborate and self-serving narrative spun from very few historical facts.

Facts: Emperor Frederick Barbarossa refused to recognize the legitimacy and supremacy of Pope Alexander III. But after the Lombard League (in which Venice did not participate) defeated the emperor in 1176, he was forced to reconcile with the pope and sign the Peace of Venice in 1177, during the reign of Doge Sebastiano Ziani (r. 1172–78).

Legend: In his conflict with the emperor, the pope sought refuge in Venice, and the Venetians, as pious Christians, honored and protected him. They sent ambassadors who tried but failed to persuade the emperor to submit to the pope. The Venetians were thus forced to fight the emperor in a naval battle, led by Doge Ziani, in which they defeated the imperial fleet and captured the emperor's son Otto. To obtain his release Otto persuaded his father to reconcile with the pope and sign the Peace of Venice. The doge, the pope, and the emperor then traveled by way of Ancona to Rome to celebrate a concluding triumphal entry into the Eternal City. In the course of these events Pope Alexander III rewarded Doge Ziani with a number of *trionfi,* or regalia, hence-

forth mostly carried in ducal processions, as witnessed by von Harff and as illustrated in Gentile Bellini's *Procession in the Piazza S. Marco on the Feast of St. Mark* (fig. 9).

The *trionfi* included lead seals for state documents, indicating Venetian independence; a white candle, signaling Venetian faith and piety; a drawn sword, symbolizing Venetian strength and justice; a gold ring, for annually marrying the sea as a sign of Venetian maritime dominion and prosperity during the springtime Feast of the Ascension; a gilt faldstool (imperial field throne) with a golden foot cushion, suggesting Venetian temporal sovereignty; a papal umbrella, indicating Venetian spiritual sovereignty; eight silver trumpets, proclaiming ducal majesty; and eight banners, semaphoring, according to the color that led the ducal procession, whether Venice was at war (red), at peace (white), joined in a league (blue), or partnered in a truce (purple). Clearly, the *trionfi* declared the doge equal in authority and magnificence to all European sovereigns.

PRE-RENAISSANCE URBANISM
Rialto

By the end of the fourteenth century, Venice prided itself on three major urban centers. The densely populated Rialto (fig. 2) constituted its commercial and financial district, with governmental offices, international banks, shipping insurance offices, money exchanges, trading houses, shops, markets, and state-owned bordellos, as von Harff witnessed. A wooden drawbridge spanned the Grand Canal, joining the Rialto's right and left banks (fig. 2, no 2). Rent from small shops that lined both its sides financed the bridge's maintenance.

A mid-fifteenth-century columned merchants' portico at the northwest end of the Rialto Bridge (fig. 2, no. 5) served as a place for nobles and merchants to congregate, converse, and often display their wares. The cornerstone of the small church of S. Giacometto (fig. 2, no. 4) was believed to have been laid on March 25, 421—the day the city was claimed to have been founded.

Piazza and Piazzetta S. Marco

At the end of the Grand Canal opened the large, L-shaped governmental and ceremonial center of Venice, the Piazza and Piazzetta S. Marco. As shown in both de' Barbari's woodcut (fig. 3) and Bellini's *Procession in the Piazza S. Marco* (fig. 9), the five-domed S. Marco (fig. 3, no. 2; begun circa 829, rebuilt

9. Gentile Bellini, *Procession in the Piazza S. Marco on the Feast of St. Mark (April 25)*, signed and dated with the Latin inscription: "1496, Work of Gentile Bellini, Knight, Burning with Love for the Cross," oil on canvas, 12 ft. × 24 ft. 51/4¼ in. (366 × 745 cm), Gallerie dell'Accademia. Originally on the west wall of the *albergo* (executive meeting room) of the Confraternity of St. John the Evangelist. Toward the extreme left, just behind the singers and instrumentalists, three figures dressed in red depict Giovanni Dario, the grand guardian (*guardian grande,* or head) of the confraternity (1492–93), and the flanking Gentile Bellini and his younger brother, Giovanni Bellini, both members. A ducal procession exiting from the Porta della Carta of the Doge's Palace on the right shows government officials and musicians carrying the doge's *trionfi,* including drawn sword, umbrella, faldstool, foot cushion, candle, and herald trumpets. The four bronze horses from Constantinople above the central entrance to S. Marco are trophies from the Fourth Crusade. To the right are the twelfth-century offices and residences of the procurators and to the left the twelfth-century Procuratie Vecchie. From the upper windows of the Procuratie Vecchie, festooned with carpets, at least thirty women observe the festivities. The brick and stone paving of the Piazza S. Marco dates to the thirteenth century.

in the tenth and again in the eleventh century, and continuously embellished thereafter) bounded the larger Piazza S. Marco on the east. The north and part of the west sides were defined by the long façade of the twelfth-century Procuratie Vecchie, with its stilted, Byzantine-style arched portico and windows (fig. 3, no. 7). This state-owned building featured rental shops and apartments, which helped to finance the upkeep of the Piazza and Piazzetta S. Marco. On the west stood the thirteenth-century church of S. Germiniano (fig. 3, no. 8; rebuilt in the sixteenth century and destroyed in the nineteenth). To the south were grouped the Romanesque Campanile of S. Marco (fig. 3, no. 9) and—behind a portico composed of piers carrying stilted Byzantine arches—the twelfth-century Hospice of the Orseolo (fig. 3, no. 19), for pilgrims to the Holy Land, and the thirteenth-century residences for the noble procurators (fig. 3, nos. 17 and 18; fig. 9, right side). Appointed for life, the procurators (three by 1259, nine by 1442) ranked just below the doge and formed the principal pool of candidates for the dogeship. They oversaw the acquisition, building, and maintenance of state property in Venice and acted as the executors of citizens' wills.

The smaller Piazzetta S. Marco (fig. 3, no. 10) was defined on the east by the fourteenth- and fifteenth-century Gothic Doge's Palace (fig. 3, no. 3; fig. 5), on the north by the narthex of S. Marco (fig. 3, no. 2), and on the west by the Campanile (fig. 3, no. 9) and a complex of medieval buildings containing inns and shops (fig. 3, no. 13). To the south, framing a view of the lagoon, two massive granite victory columns—spoils from Byzantium erected in Venice in 1172—were topped with statues representing Venice's saintly protectors, the lion of St. Mark (a bronze Assyrian chimera), first documented in 1293 (fig. 3, no. 11), and a figure of St. Theodore, placed in 1329 (fig. 3, no. 12).

By 1400 the piazza and piazzetta complex—fully paved in brick and stone by the later fourteenth century, surrounded almost entirely by porticoes, and punctuated by two victory columns—was the largest, most coherent, and best maintained civic space in all of medieval Italy. It also imitated in most particulars the major civic spaces of Constantinople, visually confirming that the city was the capital of a new Byzantium.

In the fifteenth and sixteenth centuries, however, a series of strong-willed doges and procurators eager to aggrandize ducal and Venetian authority commissioned a series of modifications to the piazza and piazzetta, which were initially Gothic in style but soon drew ever more explicitly from Roman architecture, both ancient and modern. By 1600 these doges and procurators had overseen the transformation of the civic center of Venice into a compelling expression of a new Rome.

Arsenal

The state-owned-and-operated Arsenal, or shipyard, to the east (fig. 4) constituted the principal source of Venetian power. Most likely founded in the early twelfth century and greatly expanded in the fourteenth century and beyond, this walled and fortified site of about eighty acres employed many hundreds of highly skilled workers (both men and women), who constructed ships, caulked hulls, carved oars, sewed sails, spun rope, forged cannon, milled gunpowder, and manufactured arms and armor. It became not only the largest industrial complex in Europe but also the most streamlined and efficient. In an early form of assembly-line mass production, ships under construction were floated along a canal to a series of warehouses—each filled with different standardized parts—where specialized yet integrated teams of workers would build, rig, and provision a galley in a remarkably short time, as little as one day.

De' Barbari's *View of Venice* (fig. 1) depicts at anchor in the basin of S. Marco a portion of Venice's fleet, which at that date consisted of about fifty galleys—smaller oar-and-sail-propelled trading and war ships—and about thirty cogs, larger, all-weather, all-season sailing ships with large cargo holds, superior steering, advanced navigational devices, and some protective armaments.

CIVIC ARCHITECTURE AND URBANISM

BARTOLOMEO BON'S PORTA DELLA CARTA

Between 1422 and 1438, during the reign of Francesco Foscari—the doge who oversaw the expansion of the terraferma empire through the annexation of Bergamo, Brescia, Crema, and Ravenna—the much deteriorated and unstable twelfth-century western (piazzetta) wing of the Doge's Palace, which housed the judicial branch of government, was rebuilt in the Gothic style of the south (Molo) wing (fig. 3, no. 3; fig. 5). After its completion in 1438, the master stone carver Bartolomeo Bon (c. 1400/10–c. 1464/67), probably assisted by his aging father, Giovanni (c. 1360–1443), was commissioned to design the Porta della Carta, a monumental ceremonial entranceway into the ducal palace that closed the gap between the new wing of the Doge's Palace and the church of S. Marco (figs. 10 and 11). As Francesco Sansovino (1521–86) wrote in his 1581 *Venetia città nobilissima et singolare* (The most noble and singular city of Venice), the Doge's Palace and S. Marco were joined by the Porta della Carta so that symbolically "justice should embrace peace and religion."

The Porta della Carta's two-towered form suggested a triumphal arch appropriate for the entering and exiting of ducal processions carrying the *trionfi*. But influenced by the prevailing Gothic architectural style of Venice's trading partners in northern Europe and responding to the style of the Doge's Palace, the sculptor also created a design employing a flamboyant Gothic vocabulary of pointed arches, tracery, leafy entablatures, pinnacles, spiral colonnettes, and flamelike acanthus—a style especially associated with ecclesiastical architecture. Triumphal arch and small church were thus apt references for the connecting function of the Porta della Carta. In addition, the multicol-ored marbles, the numerous sculpted figures, the gilding originally highlighting many details, and the ultramarine once coloring the niches all imparted a visual and intellectual splendor that allowed the Porta della Carta to easily hold its own against the much larger flanking structures.

The figural decoration was both secular and sacred, like the Venetian government itself. On the highest pinnacle, Justice—embodiment of the principal virtue of good government and personification of Venice—sits on Solomon's lion throne of justice (from 3 Kings 10:18–19) holding a sword and scales (symbols of retributive and distributive justice) and wearing a mural crown (emblem of the city of Venice). Justice and three of the four allegories in the lower tabernacles—Temperance (lower left, pouring water into wine), Fortitude (lower right, holding a shield and a now lost sword), and Prudence (above Fortitude, probably originally holding a mirror)—embody Doge Foscari's Cardinal Virtues of ideal secular rule, as defined in Plato's *Republic* (4.427–45). The fourth allegory, closest to the image of the doge, represents Charity, the chief Theological Virtue according to St. Paul (1 Corinthians 13:13). Her attributes of a cornucopia and a flame symbolize the two aspects of Charity claimed by the doge: *amor proximi* (love of neighbor) and *amor dei* (love of God).

The original representation of Doge Foscari kneeling before the lion of St. Mark was destroyed in 1797 after the conquest of Venice by Napoleon (1769–1821) and replaced by a copy in 1885. A generic image of a doge kneeling to receive a banner from a standing figure of St. Mark was standard on the reverse of nearly all Venetian coinage. It made reference to that part of the coronation ceremony in the church of S. Marco when the doge was invested with the

10. Bartolomeo Bon, Porta della Carta, signed, 1438–43, Istrian limestone and Carrara, Verona, and *verde antico* marbles, Piazzetta S. Marco. See also fig. 41.

11. Ground plan, Porta della Carta, Porticato Foscari, Arco Foscari, and Scala dei Giganti.

banner of St. Mark as a sign that his authority to rule descended from God by way of St. Mark, much like papal power was believed to descend from Christ via St. Peter. But the public display of a monumental sculpted image of the doge kneeling before a winged lion, the symbol of St. Mark as an Evangelist derived from Apocalypse 4:7, was a radical new concept that first appeared on the south, Molo façade of the Doge's Palace during the reign of Michele Steno (r. 1400–1413), the doge who began Venice's fifteenth-century expansion on to the terraferma with the annexation of Padua in 1405. The lion with an open book inscribed with the *praedestinatio* much more forcefully conflated the doge with the divinely ordained founding of Venice and its sacred destiny than the ducal image on earlier coinage. In addition, the doge holds—rather

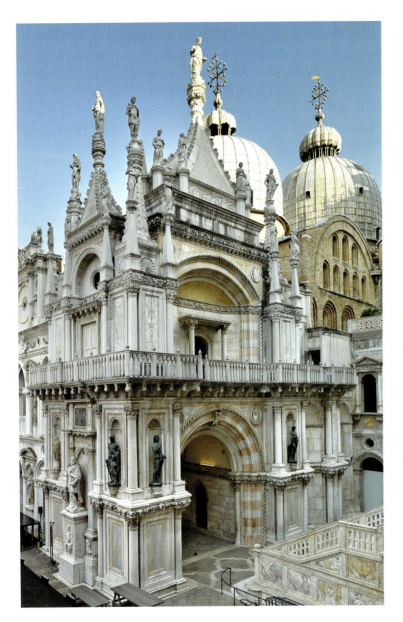

than receives—the banner, and the lion is of equal height rather than standing above the kneeling doge. The image, therefore, underplays the idea of the investiture of a subordinate by a superior and emphasizes that the doge was St. Mark's earthly vicar, just as the pope was Christ's terrestrial representative. The winged lion with the inscribed open book was also the quintessential emblem of Venetian imperialism, appearing as a sign of domination in every city and fortress under Venice's control. The motif of the doge kneeling before the winged lion thus powerfully conveyed as never before the doge's embodiment of the sacred authority of Venice and his position as the sovereign ruler of a vast dominion. Finally, references to a specific doge—here Foscari's coat of arms, conspicuously displayed by the two pairs of infant angels near the top of the piers—express his individuality and princely rank.

Between the images of Doge Foscari and Justice, three flying angels hold aloft a shell tondo with—for the first time in Venetian art—a divine epiphany of St. Mark represented as a hieratic bust-length figure blessing the doge and the city as he clutches his gospel. Along the Porta della Carta's central axis, then, the allegory of Venice's mission (Justice) is exalted above the embodiment of the state (Doge Foscari), but the sacred authority of St. Mark mediates between them, legitimating and empowering both.

PORTICATO AND ARCO FOSCARI

The Porticato Foscari—completed just before or perhaps even during the construction of the Porta della Carta—consists of a tunnel-like passageway covered with six Gothic ribbed-vaulted bays leading to the entrance of the Doge's Palace (fig. 11). It terminates in the Arco Foscari, a massive multistory structure, derived from an ancient Roman four-faced triumphal arch, commissioned by Doge Foscari in 1439 (fig. 12). Bartolomeo Bon, who began the project, designed the Arco Foscari with solid corner piers articulated with shell-topped niches and stout, vaguely Corinthian, superimposed columns inspired by the façade of S. Marco. He combined, however, the basic classical form with Gothic ornament, evident in the variety of surface colors and textures and in the multiple parts—including acanthus entablatures, spiral moldings, balcony

12. Arco Foscari, 1439–98, courtyard, Doge's Palace. Architecture by Bartolomeo Bon, 1439–64, and Niccolò di Giovanni Fiorentino, 1464–67; sculpture by Niccolò di Giovanni Fiorentino, 1465–67, and Antonio Rizzo, 1468–98. See also figs. 42 and 43.

colonnettes connected by tiny trilobed arches, and pinnacles punctuating the sky. He thus created a stylistic hybrid that marks the moment of transition from Gothic to a classicizing Renaissance style.

The eight sculptures on the pinnacles at the lowest level personify the liberal arts, the intellectual foundation of Venetian civilization. At the next level three warriors in pseudo-Roman costume embody Venetian might and dominion. Together these eleven sculptures express the overarching Renaissance virtues of Arms and Letters, the two virtues of ideal secular rule touted in many political treatises derived from sources in classical antiquity, such as the *Commentaries* by Julius Caesar (100–44 BC) and the code of civil law by Justinian (482–565 AD). The sculptures on the two highest pinnacles symbolized Venice's special piety and sanctity. On one, Charity, holding a flame symbolic of *amor dei* (love of God), the essential motivating virtue of the government and its citizens, appropriately looks south across the inner courtyard of the Doge's Palace toward the Sala del Maggior Consiglio. On the highest pinnacle, St. Mark towers above the entire ensemble, guarding the ducal treasury housed in the second-story room beneath. Six angels at the pinnacle's base and four at the saint's feet signify Mark's sanctity, as he looks east toward the Sala del Collegio, where the Collegio administered his sacred authority under the leadership of his standard-bearer, the doge.

RIZZO'S SCALA DEI GIGANTI

In 1483, as the Arco Foscari was nearing completion, a fire swept through the eastern wing of the Doge's Palace, containing the ducal apartment and various governmental council chambers. As part of the rebuilding campaign, Doge Marco Barbarigo (r. 1485–86) began and his brother Doge Agostino Barbarigo oversaw the completion of a new monumental stairway in the courtyard of the Doge's Palace (figs. 11 and 13) by Antonio Rizzo (c. 1440–c. 1499). The stairway was aligned with the Porticato and the Arco Foscari to complete the architectural definition of the east-west ducal processional route, or *via triumphalis* (triumphal way), to and from the Doge's Palace. It also provided a northern focal point for the longitudinal north-south axis of the palace's courtyard (see fig. 97). Symbolically the stairway supported ducal claims to imperial sovereignty, since it derived, at least in part, from the monumental exterior entrances to the audience halls, or *Pfalzen,* of German emperors. The four classicizing triumphal arches with winged Victories in their spandrels supporting the stairs,

and the three roundheaded openings at the top of the stairs, which created another triumphal arch as a backdrop for the upper landing, together evoked an ever-victorious Venice.

The stairway was considered the doge's dais or land throne, for welcoming and taking leave of high-ranking dignitaries. It was also designed to accommodate the 1485 decree establishing a new ritual of ducal coronation that publicly enhanced the majesty of the doge, a decree first fulfilled in 1501 with the coronation of Doge Leonardo Loredan (r. 1501–21; fig. 91). After receiving

13. Antonio Rizzo, Scala dei Giganti, c. 1486–97, Istrian limestone and gray, pink, and white Brescian and Carrara marbles, originally partially gilt, courtyard, Doge's Palace. At the top stand Jacopo Sansovino's *Mars* and *Neptune* (fig. 112), 1554–67; his *Lion of St. Mark,* 1554–56, looks out over them.

14. Mauro Codussi, Clock Tower, 1496–99, Piazza S. Marco. See fig. 3, no. 6, for the Clock Tower without the flanking wings added by Pietro Lombardo in 1501–6. Giorgio Massari (1687–1766) added the two setback stories on top of the wings in 1755–66.

St. Mark's banner at the high altar of S. Marco and being presented to the assembled citizens from its pulpit, the doge was paraded through the Piazza S. Marco on a litter carried by Arsenal workers, the doge's personal guard, who embodied the strength of the Venetian navy. From the litter the doge tossed coins to the populace to express Venice's prosperity. This ritual imitated the well-known distribution of largesse by ancient Roman emperors during their triumphal entries into Rome and by popes during their postcoronation triumphal procession from St. Peter's to S. Giovanni in Laterano to suggest that the doge's authority was equal to that of emperor or pope. The doge then climbed to the top of the Scala dei Giganti, treading over a prison cell below the stairs to dramatize the state's power to pacify rebellious citizens or disgruntled subjects with its divine justice. Finally, on the upper landing the doge would take the oath of fealty to the Venetian state and—as witnessed by the Collegio, the Senate, and other governmental officials—be crowned with the jewel-studded ducal *corno*.

The stairway's exquisitely inlaid marble risers and exceptionally fine relief carving, originally gilt, conveyed Venice's wealth. The profusion of such classical motifs as grotesques, vases, baskets of fruit, cornucopias, candelabra, torches, musical instruments, trophies, putti, and winged Victories spoke to Venice's abundance, harmony, military might, and imperial sovereignty. Coats of arms, portraits, and inscriptions also referenced the princely rank and victorious leadership of the Barbarigo doges. Agostino Barbarigo's claims to ancient Roman imperial–like authority were echoed by the diarist and historian Marin Sanudo (1466–1536), who called him "the new [Emperor] Augustus" in his 1495 *De Bello Gallico* (On the Gallic war), and by the poet Ventura da Malgrate, who termed him "prince of my new Rome" in his 1490s *Visione Barbariga* (Barbarigo vision).

The Scala dei Giganti's classicizing visual rhetoric of sovereignty, dominion, and triumph reflected the fifteenth-century expansion and consolidation of Venice's terraferma empire, but it also masked the defeats and failures resulting from the constant Turkish military pressure on Venetian bases and shipping in the Mediterranean, which gradually undercut Venice's maritime power.

CODUSSI'S CLOCK TOWER

The Clock Tower (fig. 3, no. 6; fig. 14) by Mauro Codussi (1440–1504) was commissioned during the regime of Doge Agostino Barbarigo for the north

side of the Piazza S. Marco, to provide a triumphal entrance to the Merceria—the street of the mercers, or textile dealers—leading to the Rialto (fig. 3, no. 1) and to articulate the junction between the Venetian governmental and commercial centers. The Clock Tower also visually unified the Piazzetta S. Marco, by creating a northern focal point counterbalancing the two victory columns of SS. Mark and Theodore at the south (fig. 3, nos. 11 and 12). This north-south axis marked the processional route of the doge embarking on the Bucintoro—his ornamental galley and symbolic sea throne—to marry the sea at the entrance to the lagoon each year during the spring Sensa, the Feast of Christ's Ascension. It was also the route of any Venetian commander embarking on or returning from a successful naval engagement (figs. 234 and 240).

Inlaid colored marble tondi, blue and gold mosaic backgrounds, and multiple layers produced a rich surface reminiscent of the Arco Foscari's Gothic ornamentation (fig. 12). The Clock Tower, however, constitutes an early manifestation in Venetian secular architecture of the employment of a classical trabeated (post and beam) system of columns, piers, and pilasters supporting entablatures. The progressively shorter Corinthian piers at the two upper levels created a sense of greater height by optical foreshortening.

The Clock Tower was inspired by secular towers on seignorial palaces and town halls in the civic centers of most major Italian cities (at least one—the tower on the Palazzo della Signoria in Padua—even had a large clock) and like them symbolized sovereignty, strength, and unity. The Venetian tower, however, was unique in its arched gateway and triumphalist sculptural program. The renowned clock, built between 1493 and 1499 (signed and dated 1499) by Giampaolo Rainieri from Reggio Emilia and his son Giancarlo, symbolically correlated the order of the Venetian state with the natural rhythms of the universe, measured by the progression of zodiacal signs, lunar phases, and hours and minutes of the day. Above the clock the bronze image of the Virgin and Child enthroned, within a classicizing tabernacle, was the site of an annual drama during the weeklong celebration of the Sensa. On this occasion the doors flanking the tabernacle opened hourly to allow four automated figures to move in front of the Virgin on a circular track. First Gabriel, then the three Magi saluted and genuflected before the Virgin, enacting the Annunciation and the Adoration of the Magi. Gabriel recalled Venice's sacred founding in 421 AD, while the Magi evoked the Epiphany, or the Feast of the Magi (January 6), which commemorates Christ's first appearance to the Gentiles.

Above the Virgin and Child a marble image of Doge Agostino Barbarigo originally knelt before the lion of St. Mark (destroyed in 1797, replaced by a copy of the lion only) boldly trumpeting his leadership of the sacred city as the vicar of St. Mark.

At the tower's top, two bronze, originally gilt wild men with long hair and beards and animal-skin clothing signified Venice's less civilized enemies, who challenged its sovereignty and justice; here, though, they have been pacified and forced eternally to sound the hours and the harmony of the Venetian state.

CHURCHES

S. MARCO

Church architecture in Venice before the Renaissance generally followed one of two stylistic paradigms, Byzantine or Gothic. The church of S. Marco (begun c. 829, rebuilt from 1063 to 1094) constituted the most influential example of a Venetian Byzantine style (fig. 3, no. 2; figs. 15 and 16). Constructed to honor the body of the Apostle Mark, it appropriately derived from the sixth-century Justinian Church of the Holy Apostles in Constantinople (destroyed by the Turks in 1461). The overall plan of S. Marco is a Greek cross (a cross with four equal arms), symbolizing Christ on the cross. But the five domed units creating the nave, crossing, chancel, and transepts also constitute five interlocking quincunxes.

An architectural quincunx, one of the most characteristic features of Byzantine church design, is defined as a Greek cross plan within a square, forming nine bays. A high hemispherical masonry vault or dome surmounts its largest, central square bay, while lower domical (or groin) vaults cap the four smaller square corner bays. The vault over the central bay is carried on pendentives (sections of a cone), which in turn are supported by massive square piers. The masonry dome is buttressed by high barrel vaults over the rectangular bays on the four sides of the central bay, as well as by the four compact corner bays.

The quincunx defining S. Marco's east end, however, has been modified to provide an elevated chancel terminating in a large semicircular apse flanked by two smaller apsidal chapels. The large apse serves to focus the longitudinal space of the nave on the high altar, while the flanking apsidal chapels provide visual closure for the side aisles. The central dome of the crossing, lit by sixteen

15. Ground plan, S. Marco.

16. ▶ Interior, S. Marco.

windows, provided a majestic canopy over the doge, who originally attended Mass enthroned in the large northeast pulpit. Similarly, the chancel's dome exalts the high altar, while the gold mosaics throughout—largely derived from examples of Islamic mosque decoration—transform the interior into a resplendent image of heaven.

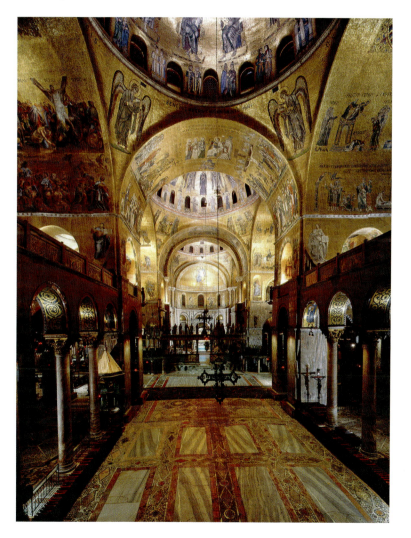

SS. GIOVANNI E PAOLO

S. Marco's Byzantine style was not Venice's principal one, however. Owing to the city's strong commercial ties with northern Europe in the thirteenth century, its prevailing pre-Renaissance architecture style was Gothic, a paradigm already encountered in the Doge's Palace (fig. 3, no. 3; fig. 5) and the Porta della Carta (fig. 10). In ecclesiastical architecture, the Dominican church of SS. Giovanni e Paolo represents a preeminent example (figs. 17 and 18). The plan is a Latin cross (a cross whose bottom arm is longer than the other three). The nave (the long arm), lighted by pointed-arch clerestory windows and the rose (round) window of the façade, is composed of five rectangular bays defined by massive, tall columns with octagonal bases and capitals that support tie-beam-strengthened, pointed arches carrying rib vaults. Five lower rib-vaulted rectangular bays flanking each side of the nave create the side aisles, lighted by rose and lancet (long, narrow, and pointed-top) windows. The high nave bays are repeated to form the crossing, transepts, and chancel. The chancel terminates in an apse flanked on each side by two smaller square apsidal chapels, which open on to the transepts. The tall lancet windows of the chancel emphasize the high altar by flooding it with light. As early as the thirteenth century and continuing through the Renaissance, SS. Giovanni e Paolo served as a major pantheon for ducal tombs.

CODUSSI'S S. MICHELE IN ISOLA

By the mid-fifteenth century, however, patrons and architects of Venetian churches were rejecting the Gothic style as a northern European import and returning to a "native" Byzantine style to celebrate Venice's self-proclaimed status as a new Constantinople—especially important when the city was starting to lose its maritime supremacy to the Turks. In addition, Venice's conquest and consolidation of its terraferma empire in the first half of the fifteenth century, the rise of Venetian classical studies following the diffusion of humanist ideals from central Italy, and a new interest in Roman ruins found in Venetian territories alerted architects and patrons alike to the classicizing Renaissance style of central Italian architecture. In Venice, Mauro Codussi first negotiated this transition from a Gothic to a Romano-Byzantine classical style, in his church of S. Michele in Isola, commissioned by the Tuscan Camaldolese Order of Benedictine hermits—not surprisingly, a major center of classical learning in Venice, with a large library of Greek and Latin manuscripts and an active scriptorium.

17. Ground plan, SS. Giovanni e Paolo, begun 1246, consecrated 1430; dome over the crossing, late fifteenth century: 1 Tomb of Doge Tommaso Mocenigo (fig. 35), 2 Tomb of Doge Pasquale Malipiero (fig. 37), 3 Tomb of Doge Pietro Mocenigo (fig. 38), 4 Tomb of Andrea Vendramin (fig. 40), 5 Confraternity of St. Ursula (figs. 58–61).

18. Interior, SS. Giovanni e Paolo.

19. ▶ Plan and section, S. Michele in Isola (Mauro Codussi, architect), 1468–80s.

20. ▶ Nave and chancel, S. Michele in Isola.

S. Michele in Isola's five-bay nave with flanking side aisles (fig. 19) constitutes a typical Gothic plan, probably following that of the earlier church it replaced. Codussi, however, articulated the interior with such classical details as wooden coffered ceilings, columns with classical entasis (a slight convexity of the shaft), capitals with fluted necks, and round arches (fig. 20). But most notably, the *barco* (rood screen and singing loft, accessed from the cloister by the monks) built across the nave's second bay consists of five vaulted bays faced with an engaged arcuated (arched) and trabeated Corinthian system recalling a classical triumphal arch (fig. 21). Inspired by S. Marco, Codussi terminated the east end of S. Michele with an elevated cubic apsidal chancel with a domical vault carried on pendentives and Corinthian piers over the high altar. Also

25. Chancel, S. Zaccaria.

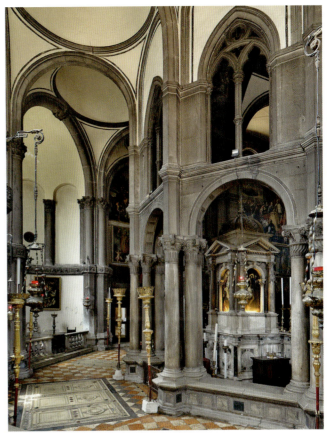

26. Ambulatory, S. Zaccaria.

orated with Romanizing eagles and garlands, imitated those honoring Leo V's early imperial patronage in the nave of the original ninth-century church but here expressed Venetian claims to imperial dominion. Indeed, in 1462 the city began to designate itself a *dominio* (dominion) rather than a *comune* (commune).

The apsidal half-decagonal chancel was juxtaposed to rather than integrated with the nave (fig. 25). Its windowlike openings allowed the doge's retinue and pilgrims to view the high altar from the ambulatory. The lower level of the chancel was articulated by clusters of four columns (their shafts from a former monastery on the island of Torcello) with fluted necks and Corinthian capitals that carried stilted Byzantine arches. On the upper level, pointed Gothic arches infilled with two smaller trilobed arches and a quatrefoil tondo deliberately recalled the articulation of the upper portico of the Doge's Palace (fig. 5) to further mark S. Zaccaria as a state church. The piers framing the entrance to the chancel and carrying a classicizing entablature unified the entire eclectic ensemble.

and his retinue processed annually to S. Zaccaria to venerate its relics and to celebrate Mass during Easter Sunday vespers, a ritual designed to cement the bond between the Venetian state and the promise of salvation offered by the Resurrection. The procession was also a ducal rite of thanksgiving for the Benedictine nuns' ninth-century gift of the jeweled ducal crown, which the retinue carried under a baldachin from S. Marco, and the twelfth-century donation of an orchard that made possible the westward enlargement of the Piazza S. Marco. So important was S. Zaccaria to the state and so well-connected and influential were its mostly noble nuns that in 1462 the Senate authorized a subvention of one thousand ducats to aid in the church's rebuilding.

It appears that Gambello laid out and partially executed the almost purely Gothic plan, while Codussi added a series of Romano-Byzantine articulating elements and vaults appropriate for the annual ducal procession and the ideo-logical perception of Venice as a new Constantinople. The chapel of S. Tarasio, remodeled c. 1442–44, served originally as the chancel of the twelfth-century Gothic church that the present S. Zaccaria replaced (fig. 23). This earlier church's left (north) aisle became the site of the Renaissance church's right (south) aisle, which is composed of three tall, narrow, groin-vaulted rectangular bays separated by pointed Gothic arches. The new nave had three exceptionally high square bays with classicizing round arches united by an entablature carried on corbels (fig. 24). The first two nave bays were groin vaulted, while a Byzantine domical vault on pendentives covered the third to provide an imperial-like canopy before the high altar for the doge, as at S. Marco. The nave columns, with entasis, appear to be late antique spoils, but because they were too short for the seventy-eight-foot-tall bays, they were raised on tall Gothicizing octagonal piers with imaginative classicizing plinths. The capitals, dec-

23. Plan and section, S. Zaccaria (Antonio Gambello and Mauro Codussi, architects), 1458–90s, consecrated 1543 (the church was founded in the ninth century, enlarged in the tenth century, and rebuilt again in the twelfth century): **1** right aisle, **2** left aisle, **3** nave, **4** crossing, **5** chancel, **6** ambulatory, **7** S. Atanasio Chapel (nave and left aisle of the twelfth-century church), 8 S. Tarasio Chapel (chancel of the twelfth-century church, remodeled c. 1442–44), 9 altar (fig. 45).

24. Nave, S. Zaccaria.

also likely that Codussi had seen Alberti's Tempio Malatestiano (1447–60) in nearby Ravenna and perhaps the Palazzo Rucellai (c. 1455–70) in Florence.

The patron, Pietro Donà (abbot, 1468–79), no doubt saw the new style as a visible symbol of his zeal to reform his order. Donà's close associate and eventual successor, Pietro Dolfin, certainly understood the novelty of Codussi's façade when he wrote in 1477 to his abbot, then in Ravenna, that the façade is "something great and rare, which adds adornment and decorum not only to our order but also to the whole city. . . . It is resplendent with such beauty that it attracts the gaze of every passerby and traveler by boat. Everyone is amazed that it could have been built . . . with such artistic merit, a building of such greatness that it not only emulates antiquity but even evokes the finest works of the ancients" (Meneghin, 308–9).

GAMBELLO AND CODUSSI'S S. ZACCARIA

The success of S. Michele led Lucia Donà—the Benedictine prioress at S. Zaccaria and a close relative of Abbot Pietro Donà—to commission Codussi to complete the rebuilding of her convent church (figs. 23–27) in 1483, two years after the death of Antonio Gambello (active 1448, d. 1481), who had begun the project in 1458 under a previous abbess, Marina Donato. Among its numerous significant relics, S. Zaccaria contained the remains of St. Zachary, the father of John the Baptist, donated in the ninth century by the Byzantine emperor Leo V (r. 813–20). Capitals carved with spread eagles in the nave of the ninth-century Byzantinizing church honored Leo's patronage. S. Zaccaria served as an important burial site for early ninth- and tenth-century doges (seven are buried in the crypt) and played a major role in state ritual. The doge

21. Choir loft (*barco*), S. Michele in Isola.

22. Façade, S. Michele in Isola; Emiliani Chapel to the left by Guglielmo Grigi il Bergamasco, c. 1526–30. The inscribed frieze over the door proclaims the church's dedication: "Temple of the divine Archangel Michael." The inscription in the top frieze, from the Bible—"My house is a house of prayer [but you have made it a den of thieves]" (Isaiah 56:7; Matthew 21:13; Mark 11:17; Luke 19:46)—conjures up the need to reform the earthly church by purging it of sin. The inscription in the lower frieze, from an early Christian hymn used at church dedications ("Urbs Beata Hierusalem")—"In this temple, almighty God, enter in response to our prayers and support our offerings in your benign goodness"—indicates the means to salvation through God's grace: prayers and Masses.

as in S. Marco, two smaller elevated apsidal chapels with domical vaults flank the S. Michele chancel.

The church's high visibility on the island of S. Michele prompted Codussi and his patrons to construct the distinctive, slightly curved façade from white limestone and colored marble (fig. 22). This was the first all-stone church façade in Venice after S. Marco's, and the first to employ the vocabulary and syntax of classical antiquity. The crowning corona (curved pediment) flanked by quadrant coronas (quarter segments of a round pediment) characterized several Venetian Gothic churches, but no previous Venetian façade included classical trabeation—Ionic pilasters carrying full entablatures of architrave, frieze, and cornice—or such a rich variety of classical details: flutes, shells, dentils, egg-

and-dart molding, volutes, rosettes, rustication, and Roman block lettering of the most advanced type. The overly attenuated lower pilasters and the lancet-like windows still reflect a Gothic sensibility, but the door framed by Corinthian pilasters and a triangular pediment is more classically proportioned and, like the entire façade, precisely carved with elegant classicizing motifs.

The church's new classicism was likely inspired by the design of the Venice-trained Giorgio da Sebenico (c. 1410–75) for the Dalmatian cathedral of Šibenik and by a manuscript of the 1452 architectural treatise *De re aedificatoria* (translated as *On the Art of Building in Ten Books*) by Leon Battista Alberti (1404–72), known to the humanist-trained monks of S. Michele. It is

The ambulatory surrounding the chancel—rare in Italy and unique in Venice—was designed to facilitate the processions of the doge's retinue and pilgrims through the church (fig. 26). Gambello appears to have envisioned an ambulatory with Gothic rib vaults and rib-vaulted radiating side chapels—all inspired by French royal Gothic churches, such as S. Denis on the outskirts of Paris. Codussi, however, completed the ambulatory with slightly ovoid domical vaults carried by stilted arches and Corinthian columns with tall octagonal plinths, and constructed the radiating chapels with more classicizing semicircular apses, each punctuated by four niches framed by engaged Corinthian columns supporting stilted arches. This unique and inventive spatial configuration produced a Byzantine-style triumphal way highly appropriate for ducal processions.

The imposing six-layer façade, buttressed by four piers, gives a measure of the great height of the interior (fig. 27). The first level reflects a Gothic mentality in its subdivision into multiple parts by cornices, twisted colonnettes, and multicolored marble panels that undercut the supportive function of the piers. The second level employs a classical vocabulary—an arcade carried on fluted Corinthian pilasters flanking windows and shell niches—but each of its twenty units has been equally stressed, without regard to the different functions of pier, wall, and window.

Above the first two levels rises a more rational, architectonic, and rhythmic design marking a transition to Codussi's more Renaissance approach. The corona, quadrant coronas, and colored marble insets derive from Gothic façades, but their articulating details are classical. Pairs of freestanding Corinthian columns or piers superimposed in vertical continuity express the structural function of the four buttresses. The bays between the buttresses with open and blind arched windows framed by Corinthian pilasters are arranged horizontally in syncopated rhythms of ABA-ABBBA-ABA (third level) or A-BB-A (fourth and fifth levels). Finally, the crowning sculptures of the resurrected Christ and the four flanking angels with instruments of the Passion allude directly to the annual ducal procession to the church on Easter Sunday.

PIETRO LOMBARDO'S S. MARIA DEI MIRACOLI

In about 1430 the Amadi family, silk merchants originally from Lucca, commissioned for an external wall of their house a panel painting of the Virgin and Child, now attributed to Zanino di Pietro (1389–1448). When the painting began to work miracles in 1480, a neighborhood committee, with the approval

27. Façade, S. Zaccaria.

28. Exterior, S. Maria dei Miracoli (Pietro Lombardo, architect), 1480–89. Façade sculptures: *Christ the Salvator Mundi* flanked by *Angels* (top and sides of corona), *Annunciation* (corner spandrels), *Four Prophets* (spandrels in between), and *Virgin and Child* (over the entrance), signed by Giovanni Giorgio Lascaris, called Pyrgoteles (active 1465–1531).

of governmental and ecclesiastical authorities, voted to build a votive shrine dedicated to the Immaculate Conception to house the popular image and to construct a new convent next door for Franciscan Poor Clares to service the shrine. Popular subscription raised such vast sums that no expense was spared to create the most sumptuous church in Venice save for S. Marco. It was faced inside and out with colored marbles and, unique for Venice, was completely freestanding, like a giant reliquary (fig. 28).

Also for the first time in Venice, the architect, Pietro Lombardo (1435–1515), articulated the entire church exterior with two classical orders, Corinthian pilasters with a horizontal entablature below and Ionic pilasters with arches above. This design appears to have been inspired largely by the Romanesque (but at the time believed to be classical) Florentine Baptistery, perhaps in reference to the Tuscan origins of the Amadi family. Like the designer of the Baptistery, Lombardo handled the marble cladding between the orders with exquisite sensitivity to color and design, making each bay bilaterally symmetrical and vertically continuous with the bay above or below. He also used a modular system new to Venice, in which the width-to-height proportions of the pilasters and the relationships between them roughly followed classical precedents. The placement of the Ionic over the Corinthian order, however, reversed what was considered the correct sequence, based primarily on the example of the Colosseum in Rome. Other noncanonical elements evident on the upper level of the façade include an arch overly flattened above the wide central bay, arches tapering to nonstructural points where two come together over a single pilaster, a crowning entablature that lacks either columnar or arched support beneath it, and a semicircular pediment framing the rose windows that lacks any structural relationship with the arcade below. The architect nevertheless succeeded in combining Roman classicism with the Venetian predilection for colored and textured surfaces to create a luxurious chapel for the Virgin expressive of the city's piety and wealth.

An intricately carved wooden barrel-vaulted ceiling covers the main interior space (fig. 29)—another Venetian first, perhaps inspired by Alberti's plans for the ceiling of his Tempio Malatestiano in Rimini. In each of the ceiling's fifty coffers are painted panels with busts of prophets, patriarchs, and saints, apparently by a variety of early sixteenth-century artists. The multicolored polished marble walls and floor gleam in the abundant light from the tall windows. The chancel, elevated over a sacristy, is approached by a flight of fifteen

29. Interior, S. Maria dei Miracoli.

steps, an allusion to the Virgin's first consecration, when, according to the popular thirteenth-century *Golden Legend* by Jacopo da Voragine (c. 1230–98), she was presented at age three at the Temple of Jerusalem and ascended its steps unassisted. These steps commemorated the fifteen psalms of degrees (Psalms 120–34), describing the stages by which one ascended through virtue and perfection to salvation. Above the well-lighted chancel with its delicately carved marble furnishings, a Byzantine-inspired hemispherical dome, carried on pendentives and a drum, creates a magnificent baldachin over the miracle-working altarpiece.

The exterior profile of the double-shell dome with a cupola, elevated for greater visibility, recalls the domes of S. Marco, thus connecting the popular piety expressed by S. Maria dei Miracoli with the sacred destiny of Venice (fig. 30). The octagonal stair and bell tower provide additional visual charm to the ensemble.

30. Chancel exterior, S. Maria dei Miracoli.

CODUSSI'S S. MARIA FORMOSA

A substantial bequest in 1487 by the merchant Antonio Bragadin provided the opportunity for Codussi to construct his masterpiece, S. Maria Formosa. Like S. Zaccaria, S. Maria Formosa was one of the seven oldest churches in Venice, founded in the seventh century by Bishop Magnus, who had been shown the site in a vision by the beautiful (*formosa*) Virgin. Also like S. Zaccaria, the church played an important role in state ritual. Every February 1 the doge and his retinue processed to the church to celebrate the vigil Mass of the Purification of the Virgin (Luke 2:21–39) and by extension the purity and piety of Venice, bonded to the Virgin and Christ by its founding on the Feast of the Annunciation in 421 AD. The awarding of dowries to poor girls on this day also enacted Venetian charity.

The plan is roughly a Greek cross within a square, with the east end terminating in three apses (fig. 31), like S. Marco (fig. 15). Codussi distinguished the nave, chancel, and transepts with differing lengths. But he unified them with uniformly crowned groin vaults—three over the nave, two over each transept, and one over the square chancel—and a wide entablature surrounding the entire cruciform space (figs. 32 and 33). Illumination from round clerestory windows highlights the nave and transepts, while the three tall windows backlighting the altar draw the eye to the darker chancel. Codussi vaulted the crossing with a hemispherical dome carried on pendentives and piers to provide, as at S. Marco, an imperial-like canopy for the doge before the high altar.

The nave's side aisles are defined by square bays covered with domical vaults on pendentives and by arches springing from square channeled piers (fig. 34). The aisles are aligned with the two apsidal chapels flanking the chancel, each covered with a lower barrel and a higher groin vault and connected to the chancel by an arched opening behind the altar (fig. 31). Like the ambulatory at S. Zaccaria (fig. 23, no. 6; fig. 26), the aisles and flanking chancel chapels form a Byzantine-styled triumphal way, designed to allow the ducal procession to circulate around the church and behind the high altar. Finally, the four deep barrel-vaulted side chapels entered from the side aisles have double-arched openings in their walls to allow the circulation of light and air between the chapels and the transepts.

S. Maria Formosa is one of the most imaginative churches of the early Venetian Renaissance. It stands out with its hierarchical but integrated plan, its crisp articulation of gray stone against white plaster, and especially its vari-

31. Plan, S. Maria Formosa (Mauro Codussi, architect), 1491–1505.

32. ▶ Sections, S. Maria Formosa: A transverse through the crossing and transepts; B longitudinal through the nave, crossing, and chancel; C transverse through the nave, side aisles, and side chapels; D longitudinal through a side aisle, transept, and chapel flanking the chancel.

33. ▶ Nave, S. Maria Formosa.

34. ▶ Right side aisle and side chapels, S. Maria Formosa.

ety of vaulted spaces. The elevated dome on pendentives over the crossing; the semicircular groin vaults over the nave, chancel, and transepts; the barrel and domical vault combination over the chapels flanking the chancel; the domical vaults over the side aisles; and the barrel vaults over the side chapels—all are arranged in a descending sequence directly related to the form and function of the spaces they cover.

A

B

C

D

3

DUCAL TOMBS

As the vicar of St. Mark, the doge embodied the sacred authority of the Venetian state. However, the *promissione ducale* (the statement of duties and restrictions that he swore to obey at his coronation) circumscribed his power, and he shared his rule with various members of the Collegio and the Senate. As a result, the doge served much more as a ceremonial figurehead and first among equals than as an autonomous autocratic sovereign like a duke elsewhere in Italy. He was also prohibited from displaying signs of his noble rank and family status on public monuments outside the Doge's Palace or on state coinage. When powerful and ambitious doges did exhibit publically their coats of arms and portraits—as did Francesco Foscari and Agostino Barbarigo on the Porta della Carta, the Scala dei Giganti, and the Clock Tower (figs. 10–14)—prohibitions were usually strengthened after their deaths by revising the articles of the *promissione*. Ducal tombs, however, were left to the discretion of the doge, his heirs, and church authorities and became objects of competitive rivalry among patrician families. They thus evolved into costly and innovative monuments that expressed ever more forcefully the virtues, deeds, and magnificence of each doge. They also served as prime visual sites of ducal ideology, providing perspectives on how doges were perceived in life.

PIETRO LAMBERTI AND GIOVANNI DI MARTINO'S TOMB OF TOMMASO MOCENIGO

The 1423 wall-hung tomb of Doge Tommaso Mocenigo (r. 1414–23) by Pietro Lamberti (1393–1435) and Giovanni di Martino da Fiesole (active 1423) con-

formed to the dominant early fifteenth-century Gothic style in Venice, especially evident in its acanthus leaf decoration, pointed gables, and intermediate row of blind biforal windows (fig. 17, no. 1; fig. 35). The Florentine sculptors who executed the work, however, introduced several new classicizing features, including shell-topped niches and slender Corinthian pilasters carrying a cornice with egg-and-dart molding. From the slightly earlier tomb of John XXIII in the Florentine Baptistery by Donatello (1386–1466), the sculptors appropriately also borrowed the canopy, a symbol of sovereignty and dominion, but shaped their version to resemble a Gothic gable lined with ermine. The open canopy was a standard motif indicating a divine epiphany, but here the revelation is not of the Virgin and Child, as on the tomb of John XXIII, but of the recumbent doge dressed in ducal garb—crown, skullcap, ermine cape, mantle, slippers, and gloves. The two angels who open the canopy further suggest that the doge is, if not divine, at least invested with divine authority as the standard-bearer of St. Mark. The representation of the Annunciation in the two outermost niches of the upper zone and the paired lions of St. Mark at the tomb's base and on the canopy's pinnacle also imply that Mocenigo's sacred authority derived from both St. Mark and Venice's mission to exercise divine justice, mandated by its supposed founding on the Feast of the Annunciation in 421 AD.

The allegories on the sarcophagus personify the Theological and Cardinal Virtues (from left to right): Faith (on the left end, not visible in fig. 35), Fortitude, Prudence, Justice, Charity, Temperance, and Hope (on the right end, not visible in fig. 35). The sculptors also suggested that the doge embodied divine

35. Pietro Lamberti and Giovanni di Martino da Fiesole, Tomb of Doge Tommaso Mocenigo, signed and dated 1423, white and red marble, left aisle, SS. Giovanni e Paolo (fig. 17, no. 1). Upper niche figures: Archangel Gabriel, St. Mark (?), St. Paul (?), St. Peter, St Thomas (?), and Virgin Annunciate.

justice by placing above and below his effigy two representations of justice on the central vertical axis—one on the sarcophagus and the other freestanding on the pinnacle, inscribed IVSTITIA.

The two warriors on the corners of the sarcophagus in pseudoclassical Roman dress—the one on the left derived from Donatello's circa 1417 *St. George* for Or San Michele in Florence—are also new to ducal tomb design. They reflect a shift from Venice's relatively noninterventionist foreign policy in the fourteenth century to its early fifteenth-century aggressive military establishment of political and economic control over the terraferma to protect its commerce from the expansionist policies of the king of Hungary, the Ottoman sultan, the Holy Roman emperor, and various Italian sovereigns, including the Carraresi of Padua and the Visconti of Milan. Fifteenth-century ducal tombs, therefore, became increasingly militaristic and classicistic to express the doge's martial prowess exercised in the name of Venice and his new status as a sovereign over an extensive terraferma empire. Mocenigo had been a prominent military commander, with victories to his credit over the Genoese during the War of Chioggia. During his principate, as the tomb's inscription records, this "magnanimous, grave, and humble prince of justice, who was the glory of the Senate," "destroyed the fleet of the turbulent Turks to restore the towns of Treviso, Ceneda, and Feltre" on the mainland, "suppressed the rabid Hungarians" to subjugate "Traù, Spalato, and Cattaro" on the eastern coast of the Adriatic, and "destroyed the pirates to open up the seas that they had closed" in the Mediterranean.

NICCOLÒ DI GIOVANNI FIORENTINO'S TOMB OF FRANCESCO FOSCARI

The policy of Duke Filippo Maria Visconti (1392–1447) and his successor, Duke Francesco Sforza (1401–66), to belligerently expand the duchy of Milan eastward into the Venetian sphere of influence compelled the energetic and ambitious Doge Francesco Foscari to engage in protracted and costly warfare throughout most of his thirty-four-year reign. In spite of employing several of the most talented mercenaries available to lead the Venetian army, engaging in various defensive alliances with neighboring states, and signing numerous peace treaties, Foscari effected little change in the northern Italian balance of power. He did, however, manage to expand Venice's terraferma empire eastward from the Mincio River to the Adda River by annexing Brescia, Bergamo, and Crema and southward along the Adriatic coast of Italy by

annexing Ravenna (fig. 8). But the ever-increasing burden of taxation to support the war effort, and recurring outbreaks of the plague and bouts of famine, provoked sharp opposition to Foscari and his expansionist policies by various factions in the governing elite. This factionalism was exacerbated by the unprecedented length of Foscari's dogeship, his gradually failing health, and the alleged corruption of his son and other relatives. In addition, his expensive building campaign—the piazzetta wing of the Doge's Palace, the Porta della Carta, the Porticato Foscari, and the Arco Foscari (figs. 5 and 10–12), all designed to enhance his personal status to equal or exceed the majesty claimed by mainland sovereigns—bred resentment. As a result, shortly before his death, his enemies took the extreme and nearly unprecedented step of deposing the eighty-four-year-old doge. His heirs, therefore, intended his tomb to rehabilitate his and his family's tarnished reputation by boldly celebrating his virtues and achievements.

Compared to Tommaso Mocenigo's tomb, Doge Foscari's tomb (fig. 36), by Niccolò di Giovanni Fiorentino (1418–1506), is more militaristic, classicistic, and self-aggrandizing. In place of angels, large Roman warriors holding shields open the canopy to reveal the seemingly sacred recumbent effigy of the doge dressed in full ducal regalia. Furthermore, warriors atop tall freestanding Corinthian columns imitate classical victory monuments—such as those in Rome and Constantinople that inspired the columns of SS. Mark and Theodore in the Piazzetta S. Marco (fig. 3, nos. 11 and 12). They thereby celebrate those "great wars on land and sea . . . fought [by Doge Foscari] with greatest success for the safety and dignity" of Venice's "eternal empire" and "for the liberty and peace of Italy," as the tomb's panegyric inscription mentions.

Just as Foscari's reign decisively marked the transition in the status of the doge from a relatively obscure participant in large corporate councils to a more individualistic and majestic sovereign of a landed empire, so too his tomb marked the transition from Gothic to Renaissance and from wall hung to floor mounted. The sarcophagus, however, remains hung from the wall, and the pointed canopy and the gable edged with flame acanthus reflect a continuing Gothic sensibility.

The arrangement of the Theological Virtues on the sarcophagus (from left to right, Charity, Faith, and Hope) locates Faith on the central axis to evoke

36. Niccolò di Giovanni Fiorentino, Tomb of Doge Francesco Foscari, 1457–70s, partially gilt limestone, right wall, chancel, S. Maria Gloriosa dei Frari.

Foscari's well-known piety ("fortitude of soul," as per the inscription) and devotion to the Virgin (to whom S. Maria Gloriosa dei Frari, his resting place, was dedicated). The large scale of the figures representing the Cardinal Virtues (from left to right, Fortitude, Temperance, Justice, and Prudence) and their location within the canopy at either end of the bier also express more boldly than ever before the doge's virtues of Platonic rule, to which the inscription adds Foscari's "genius, memory, eloquence, justice, and sure purpose."

At the pinnacle of the canopy the resurrected Christ within a blazing mandorla blesses and holds the Gospels, as represented on the reverse of every Venetian ducat inscribed "To thee, Christ, is this duchy, which thou rulest, dedicated." At Christ's feet a small winged figure presumably symbolizes Foscari's resurrected soul, thereby linking Foscari's rule with the justice of Christ and the prosperity of Venice. As on Mocenigo's tomb, the Annunciation flanking the resurrected Christ locates the doge's sovereignty in Venice's sacred destiny, endowed at its founding on the Feast of the Annunciation. The figures framing the ends of the sarcophagus—Mark, the patron saint of Venice, and Francis, the doge's name saint and the patron saint of the Frari's Franciscans—further express the doge's sacred authority. Finally, the unprecedented tenfold presentation of the Foscari coat of arms powerfully commemorates the noble status of the doge and his family.

In spite of the ignoble conclusion to Foscari's career, the tomb trumpets more emphatically than previous ones had the doge's piety, leadership, sacred authority, military prowess, and family status, to demonstrate, as the inscription boasts, that through his "inexhaustible patriotism for his country" Foscari exerted himself "to rival the glory of the greatest princes."

PIETRO LOMBARDO'S TOMB OF PASQUALE MALIPIERO

Foscari's successor, Pasquale Malipiero (r. 1457–62), had played a major role in Foscari's strategy of expanding and consolidating Venetian control over the terraferma. He had been appointed multiple times as ambassador to various courts and cities in Italy and served as a governmental liaison and quartermaster general of the Venetian army to oversee the successful outcome of Foscari's foreign policy. He helped to negotiate the Peace of Lodi, signed in 1454 by Venice, Milan, and Florence, which formally recognized the River Adda as the western boundary of Venice's terraferma empire and established a peaceful balance of power among these three states that endured until near the end of the century. Malipiero's five-year reign, therefore, was relatively peaceful (he was

called the *dux pacificus,* or doge of peace), although he did support the crusade against the Turks that Pope Pius II (r. 1458–64) organized, which came to naught when the pope died at Ancona just before his fleet's departure for the Holy Land.

Malipiero's wall-hung tomb is radically different stylistically and iconographically from previous tombs, even though its sculptor, Pietro Lombardo, repeated the now traditional ermine-lined canopy, a motif of ducal sanctity and dominion, opened to reveal the recumbent effigy of the doge in full regalia on a sarcophagus (fig. 37). For the first time in Venetian tomb design, and anticipating by more than a decade his design of S. Maria dei Miracoli (figs. 28–30), the artist employed a consistent classical architectural vocabulary and grammar, which communicate a visual harmony and structural stability reflective of Malipiero's reign of peace. Corinthian piers supported on corbels carry a full entablature and a round pediment decorated with classical moldings of dentils, flutes, eggs and darts, and beads and reels. Only the rinceaux (vine motifs) decorating the base, pilasters, back-wall panels, and frieze reveal a continued taste for Gothic pictorialism, although they are classical in origin and appropriately evoke regeneration. In addition, the oak wreath (sign of victory), winged shell (emblem of immortality), and pair of griffons (eagle-headed lions, symbols of Christ's dual nature: material [the lion] and spiritual [the eagle]) derived from classical sources. Finally, the *Man of Sorrows* in the lunette, inspired by the paintings of Giovanni Bellini (c. 1433–1516), also displays the stature of a classical hero, supported by two angels based on classical winged Victories.

This unprecedented classicism suggested not only that Venice constituted a new Rome with its newly expanded terraferma empire but also that the office of doge was analogous to that of a Roman emperor. Nevertheless, in contrast to the aggrandizement of ducal authority and personal virtue that Foscari's tomb expresses, here the concern is more for the doge's salvation and the Venetian government's need to assist its citizens in achieving redemption through the exercise of justice and charity. The winged scallop shell, victory wreath, recumbent effigy, and heroic Christ on the central vertical axis communicate the doge's hope for salvation through Christ's sacrifice. The figures standing on the pediment, commanding the whole ensemble, embody the virtues of the doge and the government that promote deliverance: Justice (attributes of sword and scales lost) flanked by the two aspects of Charity, Amor Proximi (Love of neighbor, holding a cornucopia) and Amor Dei (Love of God, her attribute of a flaming bowl lost).

37. Pietro Lombardo, Tomb of Doge Pasquale Malipiero, c. 1467–70, limestone and marble, left aisle, SS. Giovanni e Paolo (fig. 17, no. 2).

PIETRO, TULLIO, AND ANTONIO LOMBARDO'S TOMB OF PIETRO MOCENIGO

The tomb of Doge Pietro Mocenigo (r. 1474–76) is the first Venetian large-scale floor-mounted tomb to employ a classicizing triumphal arch (fig. 38). The motif so perfectly expressed the triumph of Venice and the doge's hope for a victorious passage from death to renewed life that it became the norm for the design of most subsequent Venetian tombs. This first experiment with the form, however, proved architecturally awkward. The piers lack capitals, their entablature lacks an architrave or a full cornice, and the entablature's continuation behind the standing doge compromises the illusion of a passageway. The six flanking sculptural niches also appear too tightly stacked and their pilasters too thin to visually support the upper, more classically correct entablature. Finally, the attic's framing pilasters appear too short, its cornice too long, and the curve of its pediment too flat. The sculptors, in short, remained more responsive to the ornamental surfaces of Gothic decoration than to the rigors of classical structure.

Mocenigo, "honored at home as senator and abroad as naval commander," according to the tomb's inscription, was one of Venice's greatest admirals, serving as the supreme commander of Venetian forces from 1470 to 1474, the longest unbroken command in Venetian history. "Asia having been devastated by iron and fire from the Hellespont to as far as Syria," the inscription records, Mocenigo successfully "restored the Karamanian [Anatolian] kings, allies of the Venetians, whose kingdom was oppressed by the Ottoman Turks, . . . suppressed pirates everywhere, . . . rescued Cyprus from conspirators, . . . and liberated Scutari from siege"—deeds for which "he was in his absence created procurator of St. Mark, then doge by consensus of the grateful Senate." The reliefs on the sarcophagus depict (on the left) his acceptance of the keys of Scutari in Albania after his defeat of a Turkish siege in 1471 and (on the right) his presentation of the keys of Famagusta to the Venetian-born Caterina Cornaro (1454–1510) to secure her position first as the regent (1473–74) and then as the queen of Cyprus (1474–89) on the deaths of her husband King James II (r. 1464–73) in 1473 and their infant son James in 1474. The inscription within the victory wreath between the reliefs records that the monument was funded "from the enemy's booty."

For the first time on a ducal tomb, the doge's effigy stands lifelike on the sarcophagus. The figure's classical contrapposto (the body counterbalanced on either side of the rotated spinal axis, with weight carried on one leg and the

other relaxed) suggests that the doge is raising the banner of St. Mark (once in bronze, now lost), pulling his ducal cape across his armor like a Roman toga, turning toward the high altar, lifting his eyes heavenward, and preparing to step forward into battle once again to defend Venice. He is accompanied by two pages, who hold his blazoned shield, sword, and baton of supreme command (the latter two attributes mostly broken off). Nine companions, all poised for action in various states of contrapposto, are dressed in Roman armor and togas, as if the doge were the supreme commander of a new Roman Empire. The creation of this unprecedented representation of the doge as a dynamic imperial commander, from 1476 to 1481, coincided, quite ironically, with a period of ever greater losses to the Turks, beginning with the defeat of the Venetians at Negroponte in 1470 and concluding with the humiliating Treaty of Constantinople in 1479, which ended the fifteen-year Venetian-Ottoman war.

The visual parallel that the sculptors have created between the (once) banner-carrying doge and the toga-clad, blessing, and (originally) banner-carrying resurrected Christ at the top implies that the doge remains vital both in the present and in the hereafter and that his redemption is merited by his investiture with the standard of St. Mark and the baton of supreme commander and by his defense of Venice. And just as the attic relief depicts three holy women at Christ's empty tomb on Easter morning bearing witness to his resurrection, so too do the three sarcophagus bearers—appropriately representing humanity's three ages, of youth, maturity, and senescence—appear to victoriously carry their commander into the next life. The freestanding statues of SS. Mark and Theodore, the protectors of Venice, which originally stood on either side of the attic relief (now placed elsewhere on the church's inside façade), further linked the bold allusion of the doge's salvation to the larger sacred mission and ever-triumphant destiny of Venice.

Classical myths also appear here for the first time on a Venetian ducal tomb, mythologizing the doge. The reliefs on the base represent Hercules overcoming the Nemean lion and the Lernaean hydra, evoking the military might of the doge and his defense of Venice's empires on land and sea. As a mortal who achieved immortality through his self-sacrificial labors, Hercules also traditionally prefigured Christ, whose sacrifice and resurrection promised redemption for the Venetians and their doge.

38. Pietro, Tullio, and Antonio Lombardo, Tomb of Doge Pietro Mocenigo, c. 1476–81, painted and gilt limestone and marble, inside façade, right aisle, SS. Giovanni e Paolo (fig. 17, no. 3).

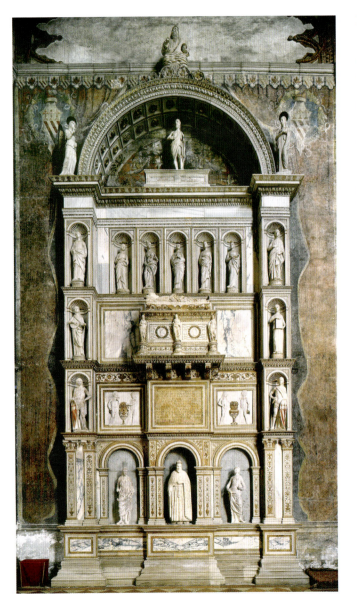

RIZZO'S TOMB OF NICCOLÒ TRON

In designing the floor-mounted tomb for Niccolò Tron (fig. 39) to rival the tomb of Francesco Foscari on the opposite wall in the Frari's chancel, Antonio Rizzo produced the largest ducal tomb, with the greatest number of free-standing figures, to date. It is also the most classicizing tomb, designed as a huge arch with flanking piers carrying a full entablature and a coffered barrel vault. Within the large arch, the first level constitutes a smaller triumphal arch with three openings. On the second level, two warriors with Tron blazons wear ancient Roman dress, and paired putti with vases of fruit imitate a Roman relief in Ravenna known as the *Throne of Ceres*. On the sarcophagus, the four wreathed heads of Roman emperors (two on the front and one on each end) and the framing standing allegories of Peace (holding a palm), Abundance (displaying a sheaf of wheat), and Security (leaning on a column) were all inspired by classical coins. Although the subdivision of the whole into unequal levels and the interruption of the supporting function of the flanking piers by the insertion of niches still reflect a Gothic sensibility, akin to that of the façade of S. Zaccaria (fig. 27), overall the tomb communicates as none before that the doge reigns as a new emperor over Venice, the new Rome.

The Tron tomb was also the first to show two effigies of the doge, standing as if alive on the first level and recumbent in death on the third. Furthermore, Rizzo arranged the effigies and their accompanying allegories in a logical progression from bottom to top. On the lowest level the serious, self-confident-seeming doge in the central niche is animated by his knit brow, outward gaze, slightly parted lips, raised left arm, and lowered right hand holding open the ducal cape. Simultaneously, Rizzo depicted the ceremonial majesty of the doge by carefully carving and gilding the details of the splendid brocaded and ermine-lined ducal robes and evoked the might and stability of Venice with the doge's massive, frontal, and symmetrical body.

Two contrasting female allegories flank the doge. One is shod, turned rightward, looking down, and (originally) offering with her right hand a fruit bowl (still extant in another context and location in Venice). The other is barefoot,

39. Antonio Rizzo, Tomb of Doge Niccolò Tron, 1476–80, gilt and painted limestone and marble, left wall, chancel, S. Maria Gloriosa dei Frari. The now damaged fresco of an open curtain embroidered with the Tron coat of arms surrounding the tomb created the illusion that the entire tomb was a divine epiphany.

turned leftward, and looking up. They embody and enact the two aspects of Charity, *amor proximi* and *amor dei*. These personifications are particularly remarkable for Rizzo's convincing imitation of classical contrapposto and the classical "wet" drapery style, which vividly reveals the underlying anatomy.

On the second level, an inscription records the doge's good works, offered for his salvation: "Niccolò Tron was an unexcelled citizen, senator, and prince of the aristocracy under whose most blessed leadership the most flourishing state of the Venetians received Cyprus into its empire and joined in alliance with the king of the Parthians [Sultan Uzun Hassan of Persia, 1423–78] against the Turks." It adds that the doge "restored the value of the debased coinage with his living image" (in imitation of Roman imperial coinage, he had his bust-length profile portrait in ducal regalia struck on a new coin called a Tron). Not mentioned, of course, is the fact that the coinage was withdrawn immediately after his death, as the striking of such an individualized portrait on coins was condemned as an autocratic act and prohibited to future doges. The flanking warriors in niches and the paired putti with vases of fruit further express the doge's stand against the Turks and his promotion of Venetian prosperity. Finally, the grapes amid the other fruit in the vases allude to the Eucharist, the sacramental rite that promised salvation for the doge and the citizens of Venice.

On the third level, in the exact center of the tomb, Rizzo presented the doge's effigy in ducal regalia recumbent over his sarcophagus on a bier with lion's paws, remarkably the only allusion on the entire tomb to St. Mark. The four heads of Roman emperors and the allegories of Peace, Abundance, and Security characterize the imperializing nature and aims of his principate, while the wheat that Abundance holds as her attribute also evokes the Eucharist. The allegories in the flanking niches, embodying Music (with a lute) and Law (with a tablet), signify the harmony and justice of the Venetian state under Doge Tron. These two figures and the two warriors in the niches just below them also together embody the two major Renaissance virtues of ideal rule—Arms and Letters.

Some of the personifications on the fourth level lack clear attributes, but they appear to represent the interweaving from left to right of the Cardinal and Theological Virtues: Fortitude, Faith, Prudence, Hope, Temperance, Charity, and Justice.

The coffered arch at the top of the tomb, a symbolic heaven, reveals a dynamic statue of Christ rising from his tomb, his drapery sweeping across his body as he displays the wound in his side and holds (originally) a bronze banner of the Church. The progression up the central axis, from the living doge to the record of his worldly deeds to Abundance holding a sheaf of wheat to the recumbent doge *in transito* (in transit from death to renewed life) to the prayerful and upward-gazing figure of Hope to, finally, the culminating drama of Christ's resurrection, poignantly expresses the cycle of the doge's life, death, and hope for renewed life as promised by the Eucharistic sacrament and as merited by his virtues and patriotic deeds for the well-being of Venice.

Standing triumphant on top of the tomb's piers but still earthbound outside the symbolic celestial zone of the coffered arch, the Archangel Gabriel, his right hand raised in greeting, and the Virgin Mary, her hands in prayer, face each other as they enact the Annunciation and recall Venice's founding on March 25. As any Renaissance viewer would have understood, the drama of the Annunciation also implied the invisible presence of the Holy Spirit, passing from Gabriel to Mary. Above Christ and outside the entire ensemble floats a representation of a cloud-borne God the Father, blessing and holding a globe symbolic of the universe. Together Christ, the Holy Spirit, and God the Father constitute the Trinity, the mystical expression of divinity's manifestation at a single moment and place in history, across all human history, and outside time and space. The Trinity and the Annunciation thus linked Tron's ducal rule to the entire sweep of Christian history to the end of time. Within this trajectory, Venice had a special, sacred destiny.

TULLIO LOMBARDO'S TOMB OF ANDREA VENDRAMIN

Tullio Lombardo's floor-mounted tomb for Doge Andrea Vendramin (r. 1476–78) is the first fully classical Renaissance ducal tomb in Venice (fig. 40). The entire ensemble, classically correct in nearly every detail, is based on a modular design. The two freestanding Corinthian columns—the lower diameter of which served as the module—and the four Corinthian pilasters, all raised on separate pedestals, are unified by a full classical entablature. This entablature supports the coffered barrel-vaulted arch and the flanking attic niches, which in turn are united by the crowning entablature. The design constitutes a harmonious and stable triumphal arch, which by its vocabulary and syntax suggests a victorious Venice and the doge's anticipated triumph over death.

Following the lead of earlier ducal tombs, a recumbent effigy of the doge dressed in ducal regalia rests *in transito* on a sarcophagus adorned with the

Cardinal and Theological Virtues, offered for his salvation. Warriors in Roman military dress, originally on the outermost pedestals (now placed in the niches), and shield-bearing pages, originally on the outermost corners of the upper entablature (now lost), embodied Vendramin's military defense of Venice, which included, according to the inscription, "the liberation of Croia [Albania] from a Turkish siege and the repulsion of an invasion of the Turks in Carnia [Friuli]," "deeds motived by his deep patriotism." The tondi with busts of Roman emperors derived from Roman coins, in the spandrels above the coffered arch; the reliefs representing classical myths in the tondi above the lower niches; and the reliefs of classical figures carved on the tomb's base reinforce the association of Venice with ancient Rome and the doge with a Roman emperor.

But the tomb is remarkable for its new emphasis on sin, death, and rebirth in a Christian context. In the lower niches were originally life-size freestanding sculptures of Adam and Eve dramatizing their disobedience to God (for Adam see fig. 44; Eve is now lost but known from a close copy), an act that doomed all humanity to sinfulness and death. The black marble lining the niches of Adam and Eve and the Virtues, the black marble disk under the bier, and the black marble frieze of the crowning entablature powerfully communicate the insistent presence of death. So too do the down-turned extinguished candelabra held by the two youths flanking the bier. But according to Church doctrine, the original sin of Adam and Eve would be redeemed by a savior who offered the hope of renewed life. Here Gabriel and Mary enact the coming of the savior at the Incarnation in the rectangular niches above Adam and Eve. This drama also recalls the founding of Venice, its special sacred bond with the Virgin and Christ, and the obligation of the doge to exercise divine justice to curb the innate sinfulness of its citizens and to promote their salvation.

The promise of regeneration for the doge, and by extension for all Venetians, is emphasized by the spread eagles and winged black disk supporting the bier (symbols of the resurrected Christ and renewal after death), the youth holding an upturned candelabra centered behind the bier (sign of divine enlight-

40. Tullio Lombardo, Tomb of Doge Andrea Vendramin, c. 1492–95, gilt limestone and colored marble, originally in S. Maria dei Servi, now in the chancel of SS. Giovanni e Paolo (fig. 17, no. 4). SS. Catherine and Mary Magdalene to the extreme left and right were not part of the original tomb.

enment), and at the top of the tomb the infant Christ as the *Salvator mundi* (Savior of the world) blessing and holding a globe within a victory wreath topped by a flaming vase (emblems of divine illumination and regeneration).

The themes of sin, death, and redemption are also allegorized by reliefs of classical myths. In the tondo above Adam, the centaur Nessus attempts to rape Hercules's wife Deianeira as he ferries her across the Evenus River, while from the riverbank Hercules shoots Nessus with a bow and arrow (see Ovid [43 BC– 17 AD], *Metamorphoses* 9.101–33). As he was dying, Nessus misled Deianeira into saving some of his poisoned blood by claiming it would act as a love potion, but it ultimately resulted in Hercules's death. The centaur's lust for Deianeira prefigured Adam's desire for Eve, and Hercules's self-sacrifice to save his wife and his subsequent death foretold Christ's martyrdom on the cross to save humankind.

The tondo above Eve represents Perseus beheading Medusa (see Ovid, *Metamorphoses* 4.765–86). Medusa, the evil and seductive snake-haired Gorgon who turned people to stone with her gaze, foreshadowed the fatal seductiveness of Eve, but her beheading by Perseus, the son of Zeus, anticipated the coming of Christ, the second Adam and the son of God, who triumphed over sin. The images of Minerva and Judith with the head of Holofernes on the ped-estals of the columns symbolize the wisdom and chastity of the Virgin Mary, the second Eve.

While the virtues on the sarcophagus are traditional, they have been arranged for the first time so that the Theological Virtues are in the center, framed by the Cardinal Virtues, with Hope appearing on the central axis: from left to right, Fortitude (left end), Temperance, Charity, Hope, Faith, Prudence, and Justice (right end). In addition, the inscription records that the doge was "brimming with good fortune, an even temperament, and virtue."

The salvation that Vendramin hoped for, based on the merits of his personal virtues, is fulfilled visually in the lunette relief, where he is depicted kneeling in heaven with his son (one of the "distinguished offspring by which he was blessed," mentioned in the inscription) while being presented to the enthroned Virgin and the blessing Christ child by SS. Mark and Theodore, protectors of Venice and saints for whom the doge served as earthly vicar.

Also new with this tomb are sea creatures, here a Capricorn (a goat with a fish tail) and a sea horse sculpted in relief on the tomb's base and the freestanding winged mermaids at the top supporting the victory wreath with the *Salvator mundi*. Together they evoke the sacrament of baptism, which cleanses the soul of Adam and Eve's original sin.

4

FREESTANDING PUBLIC SCULPTURE

BARTOLOMEO BON'S *FORTITUDE*

From her niche at the lower right of the Porta della Carta, a wavy-haired personification of Fortitude looks down toward those entering the Doge's Palace (figs. 10 and 41). She holds her attributes of sword (lost) and shield and wears a pseudoantique Roman cuirass, scale shoulder guard, vambrace (arm guard), *couter* (elbow guard), and toga. The immediate and overwhelming impression of the figure's stance, reinforced by the drapery, is that of the so-called Gothic sway, a body arranged to create a lyrical *S*-curve from head to toe. Nevertheless, the allegory also exhibits an incipient classicism, in her costume of Roman armor and toga. In addition, the leftward rotation of her shoulders counterbalances the rightward turn of her head, and her engaged left leg planted firmly at the center of the octagonal base contrasts with her relaxed right leg and foot thrust emphatically to the side. By thus employing a degree of classical contrapposto, the sculptor has created a work that stylistically marks the transition from Gothic to early Renaissance.

RIZZO'S *ADAM AND EVE*

In the niches on the east face of the Arco Foscari (fig. 12) once stood the first freestanding over-life-size classicizing marble nudes in Venetian sculpture—Antonio Rizzo's masterpieces *Adam* and *Eve* (figs. 42 and 43), now displayed inside the Doge's Palace and replaced by bronze copies outside. These representations of Adam and Eve, who disobeyed God's commandment not to taste the forbidden fruit on the tree of knowledge—the original sin that Christ re-

deemed on the cross—reminded the doge and his councilors of their sacred duty to assist Venetians toward salvation by curbing their sinfulness through the laws and justice of good government.

Rizzo carved *Eve* as a passive, frontal, and closed figure with a discreetly classicizing contrapposto but followed a Gothic canon of form—long neck, narrow shoulders, small hemispherical breasts, high waist, and broad hips—even though he derived her gestures from the classical "modest Venus" type. The Fall was generally blamed on Eve's seductive sensuality, which Rizzo suggested with her curvaceous silhouette, her left hand pressing a fig leaf against her genitals, and her right hand (restored) fondling the forbidden fruit, reminiscent of her breasts. Yet even as she enacts her fall from grace, her downward, introspective gaze, which indicates an awareness of her transgression and nakedness, also suggests the beginning of her repentance, which holds out the promise of redemption.

Rizzo's *Adam,* by contrast, is a remarkable classicizing tour de force of focused energy and coordinated movement. The figure's contrapposto, angular silhouette, cascading Christlike hair, tensed muscles, and stretched tendons all animate his display of the fruit and gestures of repentance and supplication as he looks upward in an anguished appeal for God's forgiveness.

TULLIO LOMBARDO'S *ADAM*

Tullio Lombardo's remarkable *Adam,* originally in a niche on the tomb of Andrea Vendramin (fig. 40), is the first heroic male nude in Venetian sculpture in-

spired by the classical *Doryphorus* (Spear-bearer) type (fig. 44). Unlike the taut muscles of Antonio Rizzo's wiry and impulsive *Adam* from the Arco Foscari (fig. 42), which express the strain of his guilt and remorse, the smooth skin and curly hair of Tullio's *Adam* suggest a sensuality and vanity that confirm Adam's guilt, while his introspective expression communicates his dawning realization of the terrible price he will pay for the exercise of his free will in the service of knowledge. Yet Adam's heroic stature imparts a dignity and grace that reflect his Creator and foreshadow the Second Adam, who will redeem the Fall. The grape vine encircling the stabilizing stump and the bird about to take flight from the vine also symbolize Christ's sacrifice and its promise of salvation through the Eucharistic wine.

41. Bartolomeo Bon, *Fortitude,* 1438–43, marble, c. life size, detail of fig. 10.

42. Antonio Rizzo, *Adam,* 1470s or early 1480s, marble, 7 ft. 1 in. (216 cm), originally on the east face of the Arco Foscari, now inside the Doge's Palace.

43. Antonio Rizzo, *Eve,* signed, 1470s or early 1480s, marble, 7 ft. ¼ in. (214 cm), originally on the east face of the Arco Foscari, now inside the Doge's Palace.

44. Tullio Lombardo, *Adam,* signed, c. 1492–95, marble, 6 ft. 4 in. (193 cm), Metropolitan Museum of Art, New York. Originally in the lower left niche of the Tomb of Doge Andrea Vendramin (fig. 40).

5

ALTARPIECES

FUNCTION

Renaissance altarpieces were designed to visually enhance the liturgy of the Mass. When, accompanied by the ringing of bells, the priest consecrated the Eucharistic elements of bread and wine, he effected a mystical transubstantiation—the transformation of the bread and wine into the Real Presence, the actual sacrificial body and blood of Christ. Transubstantiation, therefore, was understood as the mystical reenactment of both the beginning and the end of Christ's life: his Incarnation, when the divine Word was made flesh, and his crucifixion, by which he shed his blood to redeem humanity from original sin.

Immediately following the consecration, the priest elevated the Host (bread) and the chalice with the wine toward heaven as a sign of Christ's resurrection and as a thanksgiving offering to God (*Eucharist,* from Greek, means "thanksgiving"). The elevated bread and wine were in turn adored by the faithful as a manifestation of their belief. Altarpieces—which generally depicted Christ, the Virgin Mary, various saints, and/or narratives from their lives—served primarily as a backdrop for the consecration and elevation and were thus intended to provide a visual analogue to the mystery of transubstantiation and to Christ's birth, death, and resurrection, celebrated in the liturgy.

At the moment of the elevation, it was also believed, a divine presence mystically flooded the altar to conjoin the terrestrial liturgy with the celestial Mass celebrated perpetually in heaven by angels and saints in praise of the Trinity (Father, Son, and Holy Spirit), a conjunction that promised salvation for the faithful. An altarpiece, therefore, also represented the liturgy's uniting of heaven and earth, most often with the depiction of some manifestation of divinity, such as angels, divine light, or one or more persons of the Trinity.

Altarpieces were commissioned and paid for by patrons, who could be lay or ecclesiastical individuals, families, or institutions. A legal contract obligated the patron to decorate and maintain the altar and to establish a large endowment for its upkeep. In return, the patron was granted numerous rights. These usually included burial near the altar in a floor or wall tomb; regular celebration of Masses for the soul or souls of the patron by the church's priests, who were paid from the endowment; display of the individual, family, or corporate coat of arms; and choice of the altarpiece's artist, subject matter, and sometimes even its dedication—all subject to the approval of the church authorities. In the case of high altars, patronage rights were normally reserved for the church authorities themselves.

Altarpieces usually made explicit reference to the patron, and often to the artist, by the inclusion of a name saint, portrait, signature, or inscription, for a public display of piety and devotion was believed to aid the process of salvation. The church authorities also generally insisted on some allusion to their interests, such as the depiction of St. Francis if Franciscan friars serviced the church. Finally, altarpieces always indicated in some way the altar's dedication, which, in the case of high altars, was normally the same as the church's dedication.

ANTONIO VIVARINI AND GIOVANNI D'ALEMAGNA'S
S. TARASIO CHAPEL POLYPTYCH

As the rebuilding of the Gothic chancel of the old S. Zaccaria was being completed in 1443 (fig. 23, no. 8), the convent's Benedictine abbess from 1437 to 1455, Elena Foscari, the sister of then doge Francesco Foscari, and her prioress Marina Donato commissioned a Gothic altarpiece from Antonio Vivarini (c. 1415–c. 1484) and his brother-in-law Giovanni d'Alemagna (d. c. 1450).

The altarpiece represented the liturgy's reenactment of the birth, death, and resurrection of Christ (fig. 23, no. 9; fig. 45). The sculpted figure of Gabriel on top of the left pinnacle announces the Incarnation to the Virgin standing on the opposite pinnacle. In the central panel the newly born Christ child sits on his enthroned mother's lap and holds an apple signifying humanity's fall from grace, which his sacrifice redeemed. Originally in the space above the Virgin and Child there appears to have been a painted panel representing the dead Christ as the Man of Sorrows with a Holy Innocent (moved to the back of the altarpiece in the nineteenth century), while a sculpted image of the resurrected Christ crowns the highest, central pinnacle. In addition, Old Testament prophets in the carved vegetation on the margins of the frame and atop the four intermediate pinnacles foretell the coming of a savior. Scattered throughout the polyptych, a host of painted and sculpted saints intercede for the faithful and evoke the Church's mission to save humanity throughout history.

The mystery of transubstantiation at the consecration and the conjunction of heaven and earth at the elevation were given visual form when the priest's raised Host was juxtaposed to Jesus, the incarnate Word, and to the Virgin crowned as the queen of heaven, seated on a regal throne and surrounded by angels and an aura of divine light. Furthermore, the altarpiece represents heavenly glory with its upward-aspiring arches, gables, and pinnacles and in the dematerialization of matter expressed by the multiplicity of its parts and its resplendent gold-leaf surfaces.

45. Antonio Vivarini and Giovanni d'Alemagna, *S. Tarasio Chapel Polyptych,* signed and dated 1443, tempera panels with gilt wood sculptures, S. Tarasio Chapel, S. Zaccaria. The central panel, *Virgin and Child with Two Angels,* and the two flanking panels, *St. Blaise* and *St. Martin,* were inserted in the nineteenth century from a 1385 altarpiece by Stefano Veneziano (active 1369–85), but the original panels were probably similar.

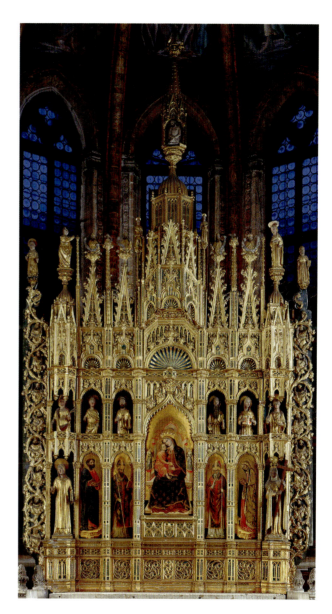

The patrons, whose names are inscribed on the frame carved by Lodovico da Forlì (active 1425–76), are indicated by the prominent, full-length gilt wooden images of their name saints, Helena and Marina, standing in the niches to the extreme lower right and left. Further allusions to the interests of the Benedictine nuns are made by the numerous saints depicted on the front and back of the altarpiece, which reference the multitude of relics, among the most treasured in Venice, deposited in S. Zaccaria.

The altar, originally the high altar of the earlier twelfth-century church, was most likely dedicated to St. Zachary, the father of John the Baptist, which suggests that the sculpted bearded figure holding a censer above and to the right of the Virgin and Child represents the dedicatee.

FLORENTINE INFLUENCE

Between about 1421 and 1425 the Venetian painter Jacopo Bellini (c. 1400–70/71) accompanied his teacher Gentile da Fabriano (c. 1385–1427) on a trip to Florence, where, before returning to Venice, he became familiar with artists of the early Florentine Renaissance, including Filippo Brunelleschi (1377–1446), Masaccio (1401–28), and Fra Angelico (c. 1400–55). Then, between the late 1420s and the early 1450s, a number of other Florentine artists worked in Venice and nearby Padua, including Paolo Uccello (c. 1397–1475), Filippo Lippi (c. 1406–69), Andrea del Castagno (c. 1421–57), and Donatello, further spreading Florentine Renaissance ideas into Venice. The two most important Florentine ideas that profoundly influenced Venetian painting were the invention of one-point linear perspective and the revival of ancient classical forms, both architectural and figural.

Brunelleschi invented one-point linear perspective before 1425. The two painted panels on which he demonstrated his invention have been lost, but his ideas were codified and publicized by Alberti in his 1435 treatise *De pictura* (On painting).

Alberti recommended that artists conceive of paintings as scenes viewed through a square or rectangular window with a modular grid, as Albrecht Dürer (1471–1528) represented in a circa 1527 woodcut (fig. 46). This new perception of the world had enormous implications for painting, for it determined that pictorial fields increasingly consisted of single unified square or rectangular surfaces rather than multipaneled surfaces with pointed Gothic arches and pinnacles, such as the *S. Tarasio Chapel Polyptych* (fig. 45).

46. Albrecht Dürer, *Artist Drawing a Nude,* c. 1527, woodcut, 3 × 8½ in. (7.5 × 21.6 cm), British Museum, London.

With his eye fixed by an obelisk, the artist in Dürer's woodcut records his view of the reclining nude through an Albertian window on to a sheet of paper of the same size and squared with the same modular grid. This procedure guaranteed proper foreshortening of the forms and the correct relationship of each part to all other parts, and it was based on Alberti's understanding of vision as rays of light emanating from objects in nature to focus conelike at a single point in the eye. Lines in a painting—a rectangular or square section of this visual cone mirroring in reverse what the eye saw—necessarily also focused at a single point: hence the name one-point perspective.

To construct a painting in one-point perspective, Alberti instructed the artist to divide the bottom edge of his painting surface into an even number of modular units (fig. 47). This was shorthand for the modular grid understood to cover the entire pictorial surface. From each of the modular divisions the artist then drew diagonal lines, called orthogonals, to a single point, the focal point, ideally placed at the same height as the viewer's eye and usually at the center of the painting. Next the artist drew a horizontal line, the horizon line, through the focal point and extended it to a point, the distance point, at or beyond the edge of the painting. A distance point farther from the edge of the painting created a shallower space; a point closer to the edge, a deeper space. The artist then drew a line from the distance point to the far end of the base line. Where this diagonal intersected the orthogonals, the artist drew horizontal lines, called transversals. Together the orthogonals and transversals created a geometrical, boxlike space, characterized by the receding tiled floor or coffered ceiling common to many Renaissance paintings.

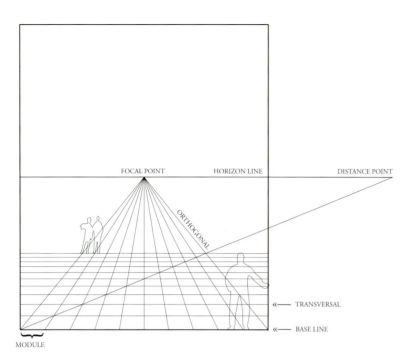

47. Diagram of Albertian perspective.

The squares in the floor—Alberti recommended three—determined the common height of each figure, measured from the square on which the figure was standing. This procedure guaranteed that figures properly diminished in space and that one figure related to another in terms of a mathematical ratio.

One-point perspective, in sum, produced a lucid geometrical space in which each element related to every other according to mathematical ratios. Perspectival space was also strongly illusionistic, with forms diminishing systematically from foreground to background as in natural vision. Finally, it created a spatial continuum with the viewer much like the flow of space between inside and outside when one looks through an open window.

It was precisely these characteristics that fostered perspective's reception and rapid development in Renaissance art, in the context of the humanist ideal of reviving classical literature and philosophy that championed the autonomy and perfectibility of each individual. On the one hand, perspective's link to a single viewer supported the idea of the importance of each individual, and its spatial illusionism created a world where individuals could move freely and act autonomously. On the other hand, the geometrical perfection of perspectival space and the mathematical relationships among its forms expressed the perfection of God and his creation and the potential for the godlike perfectibility of human beings.

ANTONIO VIVARINI AND GIOVANNI D'ALEMAGNA'S *VIRGIN AND CHILD AND FOUR LATIN DOCTORS*

The large triptych painted by Antonio Vivarini and Giovanni d'Alemagna for the altar in the *albergo* of the Confraternity of Charity represents one of the earliest responses in a Venetian altarpiece to Florentine Renaissance art (fig. 48). In contrast to the *S. Tarasio Chapel Polyptych* (fig. 45), created only three years earlier, this painting uses perspective to create a boxlike space coordinating the three canvases. The orthogonals defining the walls of the closed garden, an emblem of the Virgin's fruitful virginity, aptly focus on the Virgin's womb. They also draw attention both to the Scriptures, marked by the Virgin's index finger, alluding to her foreknowledge of Christ's destiny, and to the foot of Jesus—who holds a pomegranate, a traditional symbol of the Church—as he steps into the world to accept his fate. Much like the *S. Tarasio Chapel Polyptych,* however, this altarpiece, with its richly ornamented Gothic architecture, gilt surfaces, and sumptuous fabrics, remains primarily a Gothic evocation of heaven, with the crowned Virgin presiding over her celestial court while attended by the four Latin Doctors of the Church and enthroned under a baldachin carried by four angels.

GIOVANNI BELLINI'S *PESARO ALTARPIECE*

The *Pesaro Altarpiece* represents the first fully articulated Venetian response in altarpiece design to Florentine models, through Giovanni Bellini's employment of classicizing architectural forms and a rigorous one-point linear perspective construction (fig. 49). The central rectangular panel, a *Coronation,* surrounded by an inner wooden frame carved with classicizing rinceaux, rests on a substantial predella (the base of an altarpiece with narrative scenes related to the main panel above). It is framed by two classically proportioned

48. Antonio Vivarini and Giovanni d'Alemagna, *Virgin and Child and Four Latin Doctors (SS. Jerome, Gregory, Ambrose, and Augustine),* signed and dated 1446, tempera on canvas, central painting 11 ft. 3⅜ in. × 6 ft. 7⅞ in. (344 × 203 cm), side paintings 11 ft. 3⅜ in. × 4 ft. 5⅞ in. (344 × 137 cm), for the altar of the *albergo* of the Confraternity of St. Mary of Charity, now in the Gallerie dell'Accademia.

49. Giovanni Bellini, *Pesaro Altarpiece,* c. 1473–76, oil on panel, originally on the high altar of S. Francesco in Pesaro, now in the Museo Civico, Pesaro. Central panel, 8 ft. 7¼ in. × 7 ft. 10½ in. (262 × 240 cm): *Coronation of the Virgin with SS. Paul, Peter, Jerome, and Francis, Dove of the Holy Spirit, and Red Seraphs and Blue Cherubs.* Left pier: *St. Catherine of Alexandria, St. Lawrence, St. Anthony of Padua,* and *John the Baptist.* Right pier: *Blessed Michelina, St. Bernardino of Siena, St. Louis of Toulouse,* and *St. Andrew.* Predella panels: *St. George Slays a Dragon, Conversion of St. Paul, Crucifixion of St. Peter, Nativity, St. Jerome in the Desert, Stigmatization of St. Francis,* and *St. Terence.* Pinnacle, 3 ft. 6⅛ in. × 2 ft. 9 in. (107 × 84 cm), now in the Pinacoteca, Vatican: *Joseph of Arimathea, Nicodemus, and St. Mary Magdalene Prepare the Body of Christ for Burial.*

Corinthian piers, which carry a full entablature of architrave, frieze, and cornice decorated with standard classical moldings of cables, beads and reels, eggs and darts, dentils, and flutes. This frame provides a rectangular Albertian window, through which the central drama is viewed. In previous Venetian representations of this subject, the drama took place in some radiant, infinite-seeming golden ether, usually with a vast heavenly court of saints and angels, some joyously playing music. But here Bellini reduced the heavenly host to four saints, as in a standard *sacra conversazione* (an altarpiece depicting holy figures of various historical periods gathered together in a heavenly court and engaged in "sacred conversation"). He also grounded the narrative in a solid, measured, open-air architectural structure that appears to be an extension of the real world before the altar. He heightened the illusion by using orthogonals that begin at the base line of the central panel and come to a focus between the knees of Mary and Christ at approximately the beholder's eye level, as Alberti recommended.

Thus, the viewer's eye is drawn in close to the drama of the coronation, slightly above the shallow inlaid marble floor in the foreground. The illusion of spatial continuity between the real and painted worlds is enhanced by the Corinthian architecture of Christ's throne, with its window opening on to a landscape, which echoes the painting's Corinthian wooden frame, which in turn opens a window on to the coronation. In addition, Bellini uses throughout the altarpiece a consistent and naturalistic light, which appears to flow into the painting from an outside source high at the upper left.

For the first time in a Venetian altarpiece, Bellini also employs an oil rather than a tempera medium, a technique he learned from northern European artists such as Jan van Eyck (c. 1390–1441), Petrus Christus (c. 1410/20–1475/76), Dieric Bouts (c. 1415–75), and Hans Memling (c. 1430–94), whose works were in Venetian collections, and perfected through direct contact with Antonello da Messina (c. 1430–79), who worked in Venice in 1474–76. Oil allows a much subtler modulation of light, shade, and color and the creation of more massive and sculptural figures that seem to live and breathe in a palpable and luminous atmosphere. Furthermore, all the figures strike active poses. Mary crosses her arms over her chest and leans forward as Christ places a crown on her head. Paul with his sword of martyrdom steps forward, as if to defend the Church. Francis holds a cross and a book and turns toward the viewer. And Peter and Jerome read Scripture.

Even the scene in the pinnacle—united to the main panel by an echoing frame exactly the same width as Christ's throne—has been related illusionis-tically to the viewer by the employment of *dal sotto in su* perspective (designed to be seen from below by someone looking obliquely upward), which presses the figures close to the foreground as they enact a poignant drama. The dead Christ is positioned on the edge of his tomb, echoing in reverse his posture in the coronation; Joseph of Arimathea supports him from behind and covers him with a linen shroud; Nicodemus holds a vessel with the myrrh and aloes to prepare the body for entombment; and Mary Magdalene anoints the wound on Christ's left hand (all recounted in Matthew 27:59–61; Mark 15:46–47; Luke 23:53–56; John 19:39–40).

Simultaneously Bellini depicted the Mass's conjunction of earth and heaven by transmuting the seemingly earthly drama of the two panels into a celestial vision by means of the space's geometrical perfection, the sky's radiance, the throne's multicolored marble splendor, and the divine figures' golden auras, grave solemnity, and meditative introspection. Even more explicitly, he represented the dove of the Holy Spirit, suffusing all time and space, surrounded by a halo of divine light and red seraphs and flanked by two rows of red seraphs and blue cherubs, symbols of divine love and divine wisdom, respectively. Viewed from this perspective, the landscape seen through the throne, reminiscent of the Castle of Gradara near Pesaro, is transfigured into a new Jerusalem and the window itself into a sign of salvation by allusion to one of the Virgin's many epithets: window to heaven (*fenestra caelo*). Bellini's placement of the four saints also emphasizes the conjunction of the earthly and heavenly Churches effected by the Mass, for SS. Peter and Paul (founders of the visible Church) are paired with the Virgin (embodiment of the earthly Church), and SS. Jerome and Francis (ascetics who renounced the world through self-mortification and penitence to achieve beatific enlightenment) are joined with the resurrected Christ.

Along the altarpiece's central vertical axis, Bellini made explicit reference to the liturgy of the Mass by depicting in the central predella panel Christ's birth, in the pinnacle his death, and in the main panel the resurrected Christ. In addition, the cross-armed gesture of the Virgin in the *Coronation* recalls one of her usual gestures in scenes of the Annunciation, while St. Francis with his cross and stigmata (echoing the five wounds of Christ) in the main panel and the *Crucifixion of Peter* and the *Stigmatization of St. Francis* in the predella all allude to Christ's crucifixion. Similarly, the figures' expressions of melancholy, the dark shadows falling across the Virgin and the dead Christ, the black clouds gathered at the top of the throne, and the relief of nude warriors in combat in the throne's frieze all express sacrifice and death. Finally, the in-

ternal light low on the horizon of the main panel suggests either dusk or dawn, expressive of both death and renewed life.

The high altar of the church of S. Francesco would have had the same dedicatee as the church itself, St. Francis, which further accounts for the saint's prominence both in the predella and in the *Coronation*. The four Franciscans represented on the piers of the frame (Anthony of Padua, Michelina, Bernardino of Siena, and Louis of Toulouse) also reflected the interests of its patrons. The remaining saints served as intercessors for the faithful but might also have been the name saints of donors of funds whom the Franciscans are known to have solicited to help pay for this monumental and costly altarpiece.

GIOVANNI BELLINI'S *S. GIOBBE ALTARPIECE*

The *S. Giobbe Altarpiece,* a magnificent *sacra conversazione* and Bellini's largest extant painting (fig. 50), was made for the Observant (reformed) Franciscan church of SS. Bernardino and Giobbe, which was designed in about 1450 by Antonio Gambello, completed between 1470 and 1485 by Pietro Lombardo, and consecrated in 1493. The altarpiece originally was placed in a large, classicizing gilt stone frame still in situ in the church, probably carved by the Lombardo workshop based on a design by Bellini (fig. 51).

Although undocumented, the painting was probably commissioned by the Confraternity of St. Job. The visual prominence of the seminude figures of Job, whose body was once covered with boils, and Sebastian, whose body was pierced by arrows, also suggests that the work served as a votive image of thanksgiving for the end of the terrible plague that swept through Venice in 1478, killing an estimated thirty thousand inhabitants, for the plague produced painful lesions on the bodies of those infected.

The depiction of the founder of the Dominican Order, St. Dominic (1177–1221), to the Virgin's left, is difficult to explain in a rival Franciscan church, suggesting that an individual named Domenico, perhaps the head of the confraternity, was a secondary patron who helped pay for the altarpiece, along with a certain Marco Cavallo, whose coats of arms are carved into the bottom of the stone frame.

The altar's dedication to Job, patron of both the confraternity and the church, is indicated by his prominent location closest to the Virgin's right side (the most prestigious) and by his receipt of a benediction from the right hand of the Christ child, seated on his mother's knee.

Bellini also responded to the concerns of the Franciscans by including to the extreme left St. Francis (1182–1226), the founder of the Franciscan order, and to the extreme right Louis of Toulouse (1274–97), one of the order's most famous bishops and saints.

The Latin inscriptions in the simulated mosaics of the apse—"Hail, undefiled flower of virgin modesty" and "Hail, full of grace"—call to mind Gabriel's words to Mary when announcing the Incarnation. Mary also raises her hand in a traditional gesture of greeting depicted in many scenes of the Annunciation when she acknowledges Gabriel's words. In addition, Bellini positioned John the Baptist on the left between Job and Francis, thus reminding worshipers that John prophesied and preached the coming of a savior and that as the last of the Old Testament prophets and the first of the New Testament saints, he bridged the Old Dispensation, embodied by Job, and the New Dispensation, embodied by St. Francis.

Several details recall Christ's death: the infant Jesus gesturing to his right side, the future site of one of his wounds; the cross and the classical patera (libation dish) on the back of Mary's throne; the reed cross carried by John the Baptist; and the stigmata that Francis conspicuously displays to the worshiper, wounds that led to his designation as *alter Christus* (another Christ). Christ's resurrection is evoked by the laurel branch above the canopy, a sign of victory.

Far more convincingly than in the *Pesaro Altarpiece* (fig. 49), Bellini has designed his painted architecture to precisely mirror and continue the classicizing architecture of the gilt stone frame, including such decorative details as the stylized vines on the piers, the dolphin volutes on the capitals, the denticulated cornice on the entablature, and the coffers with rosettes on the arch and barrel vault. Bellini also employed a far more rigorous and unified structure of one-point perspective here, with the multiple orthogonals of the coffered barrel vault and its supporting entablatures all focused at a vanishing point at the bottom center of the panel, the approximate eye level of the viewer. The design thus creates the illusion that the worshiper is looking upward into a barrel-vaulted chapel, constructed behind the wall plane of the church, that is materially and immediately accessible. Although anticipated by Masaccio's *Trinity* fresco in S. Maria Novella in Florence, Antonello da Messina's Venetian *S. Cassiano Altarpiece* (its three fragments now in Vienna), Piero della Francesca's *Montefeltro Altarpiece* for Pesaro (now in Milan), and Bellini's own *St. Catherine of Siena Altarpiece* for SS. Giovanni e Paolo (now destroyed), Bellini's conception represents the first time in Venetian altarpiece design that the

50. Giovanni Bellini, *S. Giobbe Altarpiece (Virgin and Child Enthroned with SS. Francis of Assisi, John the Baptist, Job, Dominic, Sebastian, and Louis of Toulouse, and Three Music-Making Angels)*, signed, c. 1478–80, oil on panel, 15 ft. 6⅝ in. × 8 ft. 6 in. (471 × 258 cm), originally on the second altar on the right in SS. Bernardino and Giobbe, now in the Gallerie dell'Accademia.

51. Reconstruction of Bellini's *S. Giobbe Altarpiece* in its original frame, SS. Bernardino and Giobbe.

Virgin and Child are depicted in a large-scale classicizing chapel that is consistent with the surrounding architecture of the church itself. Bellini made the illusion all the more convincing by coordinating the altarpiece's painted light, flowing diagonally across the work from the upper right, with the major source of the church's daylight, which enters from its western façade, at the painting's right. Bellini has also perfected his oil paint technique so that his figures appear even more convincingly to be living beings inhabiting a real chapel filled with natural light and air. Finally, the stringed instruments depicted at the base of the Virgin's throne are contemporaneous Renaissance ones: a rebec and two lutes. One of the major effects of Bellini's verisimilitude is to express powerfully that the Virgin—enthroned in a solid and stable chapel and bathed in natural light—is the very embodiment of the earthly Church.

Simultaneously, however, Bellini has depicted the Virgin as the heavenly Church. She is enthroned as the queen of heaven and surrounded by a celestial court composed of saints from various times in human history. The vision of divine presence confected by the Mass is further supported by the geometrical and mathematical perfection of the perspectival space; by the coffered barrel vault and its canopy, traditional signs of spiritual sovereignty and dominion; and by the blue cherubs in the apse mosaics, symbols of divine love. The natural light also glows with a golden divine radiance, especially in the vault, evoking the liturgy's conjunction of matter and spirit. When the officiating priest performed the elevation, the three music-making angels would have framed the Eucharistic elements, visually adding an aural note of celestial joy and harmony at the climax of the Mass and further evoking the conjunction between here and hereafter. Finally, Bellini also inserted his signature between the angels, as if he were making his own perpetual prayer at each Mass for his salvation, merited by this exceptionally creative product of his hand and mind.

The church of SS. Bernardino and Giobbe was largely financed by Doge Cristoforo Moro (r. 1462–71), who is buried in the chancel in front of the high altar, along with his wife Cristina Sanudo. For his patronage, Doge Moro was given the right to dedicate the high altar to St. Bernardino of Siena (1380–1444), a famed Franciscan Observant preacher and Church reformer who had prophesied that Moro would one day be elected doge. When the prophecy was fulfilled with Moro's election in 1462, Moro became the major patron of the church and established St. Bernardino as one of the patron saints of Venice. The church's ducal patronage was surely why Bellini's painted chapel evokes the interior of the church of S. Marco, with its barrel vault, gold apse mosaics, marble riveted walls, and doge's *trionfo* (the canopy) above the throne. The Romano-Byzantine architecture would thus suggest Venice as a new Rome and a new Constantinople, just as the several allusions to the Annunciation would recall that in 421, Venice was founded and sanctified on the Feast of the Annunciation. The grandeur and originality of Bellini's conception may also be partly explained as compensation for the displacement of the original dedicatee of the church (Job) from the high altar to a side aisle when Doge Moro insisted that the high altar be dedicated to St. Bernardino.

GIOVANNI BELLINI'S *FRARI TRIPTYCH*

In 1478 the brothers Niccolò, Marco, and Benedetto Pesaro endowed the altar in the Gothic sacristy of S. Maria Gloriosa dei Frari in memory of their recently deceased mother, Franceschina Tron, buried before the altar. In 1488 they commissioned a small *sacra conversazione* from Bellini for this altar, still in situ in its original frame (fig. 52), to honor their name saints and that of their father, Pietro Pesaro (d. 1468).

Bellini employed one-point linear perspective rigorously and consistently, and precisely coordinated the design of the painted architecture with the classicizing Corinthian wooden frame. He thereby created the illusion of a somewhat claustrophobic church with a barrel-vaulted apsidal chancel flanked by side chapels with flat ceilings carried on Corinthian piers and entablatures. The illusionism is heightened by glimpses into nature at the extreme left and right and by the natural-seeming illumination that highlights the architectural setting, backlights the figures, and sculpts them in a dense atmosphere characteristic of Venice. Bellini, in short, has created a remarkably convincing self-contained image of the earthly Church embodied by both the Virgin, to whom the altar is dedicated, and Peter, the Church's founder, who stands in the honored position to her right.

Bellini also alluded to the Church's sacraments. The Virgin's sad introspection, indicating her awareness of Christ's fate, and the octagonal dais, alluding to Christ's resurrection on the eighth day after entering Jerusalem, reminded the worshiper of the Eucharist, its commemoration of Christ's sacrifice, and its promise of salvation. On the gilt frame the winged mermaids and dolphins evoke the miraculous purifying water of baptism, which cleanses the soul of original sin, while the five classicizing candelabra suggest the five wounds of Christ and divine enlightenment.

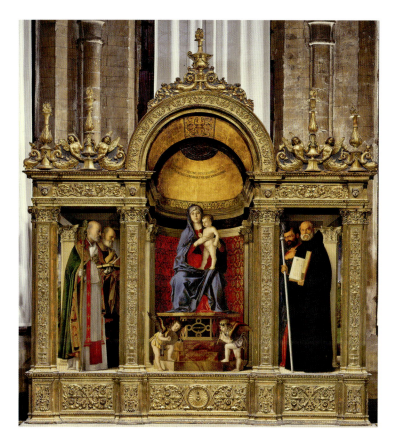

52. Giovanni Bellini, *Frari Triptych* (*Virgin and Child with SS. Nicholas, Peter, Mark, and Benedict*), signed and dated 1488, oil on panels, central panel 6 ft. ½ in. × 2 ft. 7⅛ in. (184 × 79 cm), side panels 3 ft. 9¾ in. × 1 ft. 6⅛ in. (116 × 46 cm), Sacristy Chapel, S. Maria Gloriosa dei Frari.

Although Bellini emphasized the terrestrial Church, he also offered the worshiper a vision of the celestial Church. The tripartite frame, while harkening back to a Gothic triptych, imitates a classical triumphal arch to suggest the ultimate victory of the Church over evil, sin, and death. The Virgin sits enthroned as the triumphant queen of a celestial court. The geometrically and mathematically perfected apsidal space, the cloth of honor in red brocaded silk laced with gold thread, the golden radiance of the mosaics, and the two angels playing a lute and a flute all serve to enhance the Virgin's spiritual sovereignty and transform the scene into a harmonious image of the new Jerusalem. The Latin inscription in the mosaic of the apse, addressed to the Virgin—"Sure gate of heaven, lead my mind, direct my life, may all that I do be committed to thy care"—marks her as a triumphant intercessor mediating between matter and spirit. It also evokes Franciscan devotion to the doctrine of the Immaculate Conception (the Virgin's conception free from original sin in the womb of her mother, St. Anne), for the text was taken from the service for the Feast of the Immaculate Conception established only a decade earlier by the Franciscan pope Sixtus IV (r. 1471–84). Finally, Bellini depicted Benedict (c. 480–c. 550), the founder of the Benedictine order and an early promoter of the doctrine of the Immaculate Conception, holding a Bible open to Ecclesiasticus 24, a text used in the liturgy of the Immaculate Conception.

Where the orthogonals focus, at the base of the throne, Bellini added his signature and date as if they were inlaid in marble. When a priest elevates the Host between the celebratory angels who conjoin earth and heaven, he draws attention to this record of Bellini's presence, suggesting that the artist himself, longing for eternal salvation, makes the prayer inscribed in the apse and offers the altarpiece to aid in his salvation.

6

CONFRATERNITIES

FUNCTION

Venetian confraternities, called *scuole,* were associations of laity that practiced acts of charity—both *amor dei* (love of God) and *amor proximi* (love of neighbor)—to promote the salvation of members' souls. Members performed *amor dei* through regular communal participation in Masses and prayers. They exercised *amor proximi* by helping needy Venetians, such as the poor, aged, sick, lame, orphaned, or imprisoned, and by providing material and spiritual support for their members. Material support might consist of low- or no-cost housing, medical care, or emergency loans. Spiritual support included above all a good death for each member, including a requiem Mass, procession to the grave, graveside rites, and frequent Masses celebrated for their souls.

Most confraternities were founded in the thirteenth or fourteenth century as an outgrowth of the late medieval mendicant movement—a wave of mass popular piety promoted by the mendicant (begging and preaching) orders, such as the Franciscans and the Dominicans, that swept across Europe. At least ten thousand Venetians, or about 10 percent of the population, enrolled in confraternities during the Renaissance. The members were mostly from the middle to lower classes (*cittadini* and *popolani*) but also included a number of patricians and clerics, who, however, could not hold office. Venice's large confraternities (*scuole grandi*), which grew from four to six during the Renaissance, each had up to six hundred or more flagellant (penitential self-scourging) male members. More than two hundred small confraternities (*scuole piccoli*) each enrolled anywhere from twenty to one hundred nonflagellant members, both male and female.

In the Renaissance all the large confraternities either remodeled and embellished their old medieval two-story meeting halls or built new ones in close proximity to a sponsoring church. A few of the small confraternities owned meeting halls, but more typically they met in church chapels, like the Confraternity of St. Job, which met in front of Giovanni Bellini's *S. Giobbe Altarpiece* (fig. 50).

Venetian confraternities participated regularly in civic processions on major religious feast days and on occasional secular holidays commemorating a victory, treaty, alliance, or visit of a foreign dignitary. Such public displays of piety and devotion created communal stability through ritual bonding, promoted support for governmental policies, and, above all, dramatized Venice's claim to a sacred bond with God.

Gentile Bellini's 1496 *Procession in the Piazza S. Marco on the Feast of St. Mark* presents a vivid image of one such procession, honoring Venice's patron saint (fig. 9). In the foreground, members of the large Confraternity of St. John the Evangelist, dressed in white habits, carry large burning processional candles, smaller lit tapers, a canopy decorated with emblems of the five large confraternities, and under the canopy their most precious reliquary, containing a fragment of the cross of Christ's crucifixion. Members of the other large confraternities stand in formation on the left in front of the twelfth-century Procuratie Vecchie, from whose windows, draped with carpets, women observe the festivities. Bellini also depicted a miracle in progress. Jacopo de' Salis, a Brescian merchant (dressed in red) who had just received word that his son had fractured his skull and was in danger of dying, kneels in the foreground and

prays for his son's recovery as the reliquary passes before him. On his return to Brescia, he discovered that his prayers had been answered and that his son had been miraculously cured. Bellini has subtly heightened the impact of the miracle by focusing the orthogonals of the perspective on the central entrance of S. Marco. He also depicted the light shining from high in the northeast (upper left), casting the short shadows of midday, in response to the natural light from the south wall of the *albergo* in which the work originally hung. Yet simultaneously he painted the eastern horizon as if it were aglow at the dawn of a new day—an ancient metaphor for salvation. By including the miracle, Bellini not only demonstrated the prestige of his confraternity and the charisma of its relic but also visually supported the city's claim to being a new Jerusalem.

The government chartered and supervised all Venetian confraternities, which all had an administrative structure mirroring that of the state. As Francesco Sansovino phrased it in his 1581 *Venetia città nobilissima et singolare* (The most noble and singular city of Venice), confraternities "represent a certain type of civil government, in which, as if in a republic of their own, the citizens enjoy rank and honor according to their merits and qualities" (1663 ed., p. 282).

A confraternity's head was called the grand guardian (*guardian grande*) or *gastaldo,* its vice-head the *vicario,* the processions' marshal the *guardian da matin,* and the bookkeeper the *scrivan.* These officials—always *cittadini* in the case of the large confraternities—paralleled the doge and his advisors in the Signoria and the Collegio. The grand guardian presided over an administrative council of fourteen to sixteen members called the *banca,* named after the long bench on which they sat to conduct business (Bellini's painting originally hung above the *banca* in the *albergo*). After 1521 the *banca* was often supplemented by a powerful executive committee called the *zonta,* and together the *banca* and the *zonta* mirrored the Venetian Senate. Finally, assemblies of the full membership were analogous to the Great Council. While nonnoble members of confraternities were excluded from participation in the Venetian government, they were given considerable autonomy in managing the internal affairs of the "republic[s] of their own." Indeed, the self-governance of confraternities and their provision for the spiritual, material, social, and political well-being of their members appear to have effectively alleviated much potential for resentment by disenfranchised citizens and to account in part for Venice's remarkable social and political stability over the centuries.

CONFRATERNITY OF ST. MARK

Amassing great wealth from initiation fees, dues, and bequests to support their pious works, many confraternities, especially the large ones, were encouraged by the government to spend a portion of their funds to build or rebuild sumptuous meeting halls to enhance the confraternity's prestige and beautify the city. The large confraternity of S. Mark, founded in 1261 under the sponsorship of the church of S. Croce, had become sufficiently wealthy by the fifteenth century to construct between 1437 and 1438 a new Gothic building adjacent to a more prestigious sponsor, the Dominican church of SS. Giovanni e Paolo. Unfortunately, it burned to the ground in 1485, but reconstruction in an early Renaissance style on the same site began in 1487. Between 1489 and 1490 Pietro Lombardo oversaw the workforce, followed by Mauro Codussi, who brought the building mostly to completion between 1490 and 1495.

The design of the major spaces, which became the norm for subsequent confraternities, can be read from the façade (fig. 53). The main entrance, to the left, led to the ground-floor assembly room (fig. 54A), where members would gather for processions, store processional paraphernalia, hold occasional banquets, and disburse charity. The smaller entrance, to the right, led to an administrative office.

In the assembly room (fig. 55) two rows of five Corinthian columns on high square pedestals—decorated with classicizing rinceaux and moldings of flutes and eggs and darts—carry a wooden-beam ceiling supporting the terrazzo floor (polished marble chips set in mortar) of the chapter room above. Classicizing doorways at either end of the east (right) wall opened on to a double-ramp barrel-vaulted stairway with five sail-vaulted landings that provided two processional routes to and from the chapter room (fig. 54C).

The chapter room (fig. 56)—lit by the two large tabernacle windows on the façade above the main entrance and by ten arched windows along the west wall—was used for communal Masses, prayers, singing, meetings, elections, and funerals. It featured a coffered wooden ceiling (1519–35), an elevated altar chapel (1532–34) by Jacopo Sansovino (1486–1570) at the north end, and originally paintings depicting the life of St. Mark by Jacopo Tintoretto (c. 1518–94) and his workshop.

The two smaller windows on the right side of the façade lit the *albergo,* the meeting room of the *banca* (fig. 54B, no. 4). Originally seven paintings executed between 1504 and 1534 by Gentile Bellini, Vittore Belliniano (active

1507, d. 1529), Giovanni Mansueti (active 1485–1526/27), Palma Vecchio (c. 1479/80–1528), and Paris Bordone (1500–1571) graced the walls.

Stylistically the façade represents a middle term between the richly textured colored surfaces of Pietro Lombardo's classicistic S. Maria dei Miracoli (fig. 28) and the more rigorous trabeation of Codussi and Lombardo's Clock Tower (fig. 14). Seven channeled Corinthian pilasters at the lower level and seven fluted pilasters above provide continuous lines of vertical support from bottom to top, balanced by the long horizontal entablatures they support. The six still somewhat Gothic semicircular coronas at the top—the three to the left elevated on short piers and columns—recall the transitional façades of S. Michele in Isola and S. Zaccaria (figs. 22 and 27) and lend an appropriate religious aspect to the façade.

Freestanding Corinthian columns on high pedestals defining the main arched entrance anticipate the columns in the assembly room behind. These columns carry a shallow coffered arch, echoed by the flanking illusionistic marble reliefs also with coffered barrel-vaulted niches, above the guardian lions of the confraternity's patron saint. Together these three bays create a triumphal arch motif, appropriate for the exiting and entering of confraternal processions.

On the two levels directly above, the ornate arched tabernacle windows with round pediments and the three elevated crowning coronas create a series of echoing semicircular forms, emphasizing the main body of the confraternity, with the assembly and chapter rooms.

The relief in the lunette above the main entrance, dating to 1437–38—probably

carved by Bartolomeo Bon's workshop and saved from the prefire façade—is *St. Mark Enthroned Blessing the Grand Guardian Zoffredo da Brazzo and Ten Members of the Confraternity of St. Mark.* It illustrates *amor dei,* as the members kneel adoringly before their patron saint.

On top of the coffered arch of the main entrance and silhouetted against panels of yellow Carrara marble outlined in red Verona marble, a figure of Charity holds two children, also from the prefire façade. She personifies the other major function of the confraternity: *amor proximi.* Charity is flanked by two exemplars of *amor dei* from Lombardo's workshop: St. Dominic and St. Peter Martyr (c. 1205–52)—the Dominicans' founder and one of the order's martyred saints—both standing on griffons (part lion and part eagle), symbolic of Christ's dual material and spiritual nature.

On the highest corona, Mark's winged lion (a nineteenth-century replacement of a lost original) displays on an open book the angel's prophecy of Venice's divinely ordained founding and its apostolic sanctity. A freestanding sculpture of St. Mark, holding the Gospels and flanked by two angels, reigns triumphant over the whole ensemble as the embodiment of divine justice. On top of the two flanking coronas are allegories of (from left to right) temperance (pouring liquid from one vessel to another), prudence (holding a skull), faith (with a chalice), and hope (hands in prayer). In the niches below these figures, two soldiers in classical dress not only suggest the military obligation of all able-bodied members of this and all confraternities to serve Venice in times of war but also embody the virtue of fortitude to complete the façade's roll call of the four Cardinal and three Theological Virtues.

At the extreme ends of the entablature's frieze of the highest corona are carved in relief the zodiacal signs of Sagittarius and Capricorn, the signs of December and January, marking the beginning of winter and nature's dormancy yet also the beginning of a new year, which promises renewal. The apotheosis of St. Mark and the cornucopias and vases of fruit carved in relief on this highest corona emphasize the hope for regeneration, the principal concern of all confraternities.

Since the Confraternity of St. Mark was more closely associated with the doge and the Venetian government than any other confraternity, the program of façade sculpture closely followed ducal ideology, as expressed in the sculptural programs of the Porta della Carta (fig. 10), the Arco Foscari (fig. 12), and Renaissance ducal tombs, many of which were in SS. Giovanni e Paolo (figs. 35, 37, and 38).

57. Details of fig. 53: (a) *St. Mark Heals Anianus Injured by a Cobbler's Awl* and (b) *St. Mark Baptizes Anianus,* relief sculptures by Tullio Lombardo incorporating gray, yellow, green, red, and white marbles and limestone.

But most striking and completely unique to Venetian confraternity decorations are the two pairs of large illusionistic reliefs on the façade flanking the two doors—executed by Tullio Lombardo but probably designed by Giovanni Bellini, who was a member of the confraternity, as was his older brother, Gentile. Each pair—united by rigorous linear perspective with a shared focal point at the center of the door they flank—adds exceptional visual drama to the façade with its majestic spatial settings of classicistic architecture: coffered barrel vaults carried on massive channeled piers in one pair, and flat coffered ceilings carried on arcades in the other pair.

In the left pair of reliefs, two watchful lions, emblems of St. Mark, guard the entrance. Guardian lions as emblems of Christ were traditional on church

façades and thus, like the coronas above, appropriately evoke the religious character of the confraternity.

The pair of reliefs to the right, each framed by channeled Doric pilasters carrying an architrave, depict St. Mark's first acts in Alexandria (figs. 57a and 57b). In the left relief, Mark in classicizing dress steps rightward with his hand raised in benediction and performs an act of *amor proximi* by miraculously curing the cobbler Anianus's hand, which Anianus had injured with an awl. This rhetorical drama was deliberately chosen to create a parallel with St. Peter's miraculous healing of the lame man at the Temple of Jerusalem, to emphasize Venice's apostolic sanctity. Indeed, Anianus sits in an awkward, angular posture, crumpled on the ground as if he were lame, and Mark appears to lift him up by his wounded hand. The bearded and turbaned witness in oriental dress in the background so closely resembles Anianus that he serves to thematize the cobbler's cure and rising.

In the right relief, Mark baptizes Anianus, who eventually became his successor as the second bishop of Alexandria. The eyes of the excited bystanders now focus on Mark, who demonstrates his priestly power by ritually redeeming from original sin the soul of the nude Anianus. As Anianus kneels reverently and humbly before Mark, he enacts *amor dei.* Together the two reliefs exemplify the two primary functions of the confraternity—the exercise of *amor proximi* and *amor dei*—and exult Mark as priest and miracle worker. The scene of baptism also accounts for the freestanding figure of the penitent St. John the Baptist standing at the extreme upper right of the façade.

CONFRATERNITY OF ST. URSULA

The small confraternity of St. Ursula, also sponsored by the Dominicans and attached to SS. Giovanni e Paolo (fig. 17, no. 5), was founded in 1300 with about thirty-five members, both men and women. Its small rectangular meeting hall, with an altar at the east end, was built in 1306 and dedicated to SS. Dominic, Peter Martyr, and Ursula.

In 1488 the confraternity commissioned Vittore Carpaccio to decorate the hall with an altarpiece and eight large narrative canvases illustrating the life of St. Ursula, following the thirteenth-century *Golden Legend.* The paintings (figs. 58–61), completed in about 1500, were organized to read clockwise around the room, beginning on the south wall to the right of the altar and ending with an altarpiece depicting the apotheosis of St. Ursula. All nine paintings are now displayed together in the Gallerie dell'Accademia.

According to the legend, the pagan king of England sent ambassadors to Maurus, the Christian king of Brittany, demanding Maurus's beautiful daughter, Ursula, as the bride for his son, Etherius, and threatened war if Maurus refused. Although she had planned to remain a virgin, Ursula accepted the suit to avoid war, but only on three conditions: Etherius had to convert to Christianity, she and eleven thousand virgin companions had to take a three-year pilgrimage to Rome before the wedding, and Etherius had to provide the ships and provisions for the pilgrimage. To her surprise, Etherius accepted these onerous demands. But on the pilgrims' return from Rome, the Huns massacred all eleven thousand outside Cologne.

The story contained much that appealed to Renaissance Venetians. Just as Maurus and Ursula had to compromise with the pagan king of England to avoid war, so too the Venetians were in perpetual conflict with the heathen Turks and forced to fight or, more often, make unfavorable treaties to preserve the peace and their trade routes.

Just as Ursula had to accept marriage in the best interests of her family and country, so too many a Venetian woman had to accept matrimony against her will for a profitable alliance with another family. Many other women—and they numbered in the hundreds—were forced into convents or prostitution, for their families could or would not pay the large dowries that eligible suit-

58. Vittore Carpaccio, *Arrival of the Ambassadors*, signed, c. 1496–1500, oil on canvas, 9 ft. ⅛ in. × 19 ft. 3¼ in. (275 × 589 cm), Gallerie dell'Accademia.

ors increasingly demanded. Members of the Confraternity of St. Ursula were acutely aware of this problem, since they specialized in offering dowries to poor women as their practice of *amor proximi*. In this context, Ursula provided an ideal model. She conformed to societal expectations by accepting matrimony, while remaining a pious and chaste servant of God.

Similarly, Etherius was required to postpone his marriage and submit to the trials of a new faith, just as most Venetian men were pressured to put off their nuptials until midlife so as not to diminish their family's wealth by prematurely claiming their share. Late marriages for men also fueled the demand for prostitutes, of which Venice had an abundance—11,654, according to the diaries of Marino Sanudo—severely compromising its self-image as the new Jerusalem. Etherius, however, represented the ideal bridegroom: obedient, patient, pious, and chaste.

Carpaccio's *Arrival of the Ambassadors*

The narrative cycle opens with *Arrival of the Ambassadors* (fig. 58). Given the narrative's contemporaneous significance, Carpaccio represented Brittany as if it were Venice. With its gilt starburst on the ceiling, a sign of divine radiance, and its piers decorated with relief busts of Roman emperors, Maurus's sumptuous audience hall recalls the splendid council chambers in the Doge's Palace. The dais and long bench on which the king sits with his advisers, backed by a cloth of honor, evokes the Signoria or the men of the *banca* in the *albergo* of a confraternity. Indeed, the *gastaldo* of the confraternity, dressed in the red costume of his office, stands to the extreme left, balanced on the right by an old seated woman with a cane, probably also a member; together they thematize the viewing audience. With her expression of introspection and black mourning garb, the old woman also anticipates Ursula's scene of martyrdom (fig. 61), where a similar figure appears kneeling in prayer.

While the portico preceding Maurus's hall calls to mind the porticoes of Piazza S. Marco, the paved square occupied by a flagpole, dogs, and an assortment of well-mannered people of various ages and social classes alludes to the piazza itself. The artist heightened this allusion by including buildings suggestive of Venetian landmarks in the background: S. Giorgio Maggiore (extreme left), the Gothic custom house (above the pair of kneeling ambassadors), an early-Renaissance-style Venetian palace with characteristic spark-arresting chimney pots and an *altana* (wooden deck for drying clothes and sunning), the high-profile Byzantine-style domes of S. Marco (the octagonal baptistery in the center), and the Clock Tower. The sailing ships and gondolas in a lagoon also evoke Venice's unique setting and maritime commerce. These details project an image of a harmonious, prosperous, and pious city with a stable, hierarchical political regime based on both a Roman imperial model and divine justice, just as the Venetians imagined their city. When Carpaccio painted this scene, however, Venice was experiencing an economic downturn, owing to its recent losses to the Turks, including Modon and Coron in the Morea (fig. 7) in 1499. Shipbuilding had come to a near standstill, unemployment was widespread, crime was rampant, and many poor and indigent were begging in the streets.

Colored hose identify the young men in the portico, one of whom holds a falcon, as members of one of the twenty-three Venetian Companies of the Sock (Compagnie della Calza), associations of unmarried noble youths founded about 1400 to channel their energy into religious drama during civic festivities to enhance the sacred character of the city. Their presence in the painting and Carpaccio's presentation of the narrative within a perspectival proscenium stage conjure up the processional obligations of the confraternity.

The use of one-point linear perspective underlines the sense of order and harmony. The orthogonals of the perspective that focus near the horizon draw the viewer's eyes through the open gate into Maurus's audience hall. Here the ambassadors of the English king perform in sequence the protocol used to approach the pope in the court of Rome, which was imitated in Venice to approach the semisacred doge: they genuflect at the rear of the hall, genuflect again at the center of the hall, and then kneel before Maurus to present the English king's demands. The off-center focal point, the longer orthogonals to the right, and the breeze blowing the background banner and sail rightward enhance the ambassadors' movements from left to right.

At the far right Carpaccio provided another opening into the painting's space, a flight of stairs up to a bedroom where Maurus and Ursula consider the English demands. Active and self-confident, Ursula ticks off arguments for maintaining peace on her fingers to her brooding father. The compositional diagonal formed by Ursula's drapery and the canopy of the bed visually associates the saint with the image of the Virgin and Child hanging on the wall to underline that her virginity and piety are modeled on Mary's. By silhouetting her head against a metallic mirror, next to a book, Carpaccio further evoked her wisdom and purity by allusion to Wisdom 7:26: "For she [Wisdom] is the unspotted mirror of God's majesty." Finally, pearls—traditional signs of spotlessness—are interwoven with the braids of Ursula's hair. As the embodiment of wisdom, piety, purity, and peace, Ursula serves as a stand-in for the Venetian state and Venetian justice.

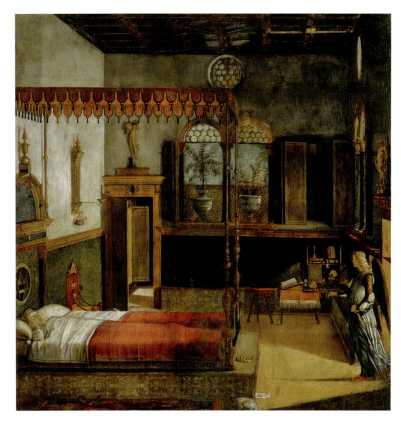

59. Vittore Carpaccio, *Ursula's Dream,* signed and dated 1495, oil on canvas, 8 ft. 9½ in. × 8 ft. 7½ in. (268 × 263 cm), Gallerie dell'Accademia.

Carpaccio's *Ursula's Dream*

After Ursula and her companions arrived in Cologne from Brittany, Ursula dreamed that an angel appeared to her announcing that after receiving the pope's blessing in Rome, she and her eleven thousand companions would be martyred in Cologne at the hands of the pagan Huns on their return to Brittany. The angel holding a palm of martyrdom, the supernatural light flooding into the room from the direction of the altar, the hourglass on the table, the snuffed candle in the bookshelf, and Ursula's sleep all suggest her coming martyrdom (fig. 59).

Carpaccio embroidered the tale in the *Golden Legend* by depicting Ursula in an ideal Venetian bridal chamber, with red carnations and the evergreen myrtle, symbols of nuptial bliss, in the windows and a small white dog at the foot of the bed—a sign of marital loyalty. Above the doors, antique statuettes of a nude Venus, the goddess of love, and a water carrier, the classical zodiacal sign of Aquarius, thematize love and fecundity. But Ursula sleeps alone in the matrimonial bed, indicating that her betrothal to Etherius will be ethereal rather than carnal. Furthermore, the angel's appearance, recalling the Annunciation, suggests that Ursula's real groom is Christ and that her princess's crown at the foot of the bed is her heavenly crown.

Carpaccio underlined Ursula's purity and piety through her orientation toward the altar, the devotional image on the wall, and the aspergillum (vessel and brush for sprinkling holy water in rites of purification) hanging below the painting.

Carpaccio's *Arrival in Rome*

The next scene shows Ursula and her companions reaching Rome, the goal of their pilgrimage, as they make their way up from the Tiber River to meet Pope Cyriacus (r. 384–99) outside the Vatican walls (fig. 60). The twelve banners, the trumpeters on the ramparts of the Castel Sant'Angelo, and the pope's umbrella all recall the doge's *trionfi* and his claim to equality with the pope in sovereignty and majesty.

As pages hold their royal crowns, Ursula and Etherius kneel to be blessed by the pope and joined in a spiritual betrothal. But the severed stump and nearly barren land in the foreground allude to their coming martyrdom, while the flowers suggest their ultimate salvation. According to the *Golden Legend,* Pope Cyriacus was so moved by Ursula's devotion that he renounced the papacy and joined the pilgrimage on its return to Brittany.

Since Ursula was a stand-in for Venice, the scene subtly expresses the Venetian sense that papal meddling in its religious affairs was a perennial threat to its sovereignty and independence, that Rome was less spiritually pure than Venice, and that the Venetians were the true defenders of the Church against the Turks. Carpaccio visually expressed these sentiments by depicting Cyriacus wearing a tiara (a crown of temporal power) rather than a miter and locating the pope and his party against the backdrop of a massive papal fortress (the Castel Sant'Angelo) rather than in front of the church of St. Peter's, as if secular power and domination were the main characteristics of the papacy. The documented portrait of Ermolao Barbaro (1453/54–93) in the foreground

60. Vittore Carpaccio, *Arrival in Rome,* signed, c. 1494–95, oil on canvas, 9 ft. ⅛ in. × 10 ft. (275 × 305 cm), Gallerie dell'Accademia.

immediately to the right of the pope, dressed in red and looking rightward, confirms this interpretation. Barbaro had been appointed the Venetian ambassador to Rome in 1490. In 1491 he accepted an appointment as the patriarch of Aquileia from Pope Innocent VIII (r. 1484–92). However, since the Venetian Senate claimed exclusive jurisdiction over this appointment, Barbaro was accused of treason, ordered by the Senate to refuse the position, stripped of his ambassadorial position, and exiled from Venice.

Carpaccio's *Ursula's Martyrdom and Burial*

Carpaccio concludes the cycle with an exceptionally violent scene of martyrdom (fig. 61). In the foreground, Ursula, kneeling stoically in prayer, is about to be killed by a blond archer in a dandyish costume as Julius, the leader of the Huns, nonchalantly draws his sword. The violets and strawberries in front of Ursula symbolize her coming salvation. Simultaneously, Ursula's companions are being slaughtered. Etherius, sharply foreshortened in the foreground, is stabbed in the torso; the pope, standing behind Ursula, is knifed in the throat; and behind him a cardinal has just had an arrow shot up his nose. Since confraternities were required to provide men in time of war for the state galleys and militia, such scenes of carnage would have been all too familiar. In fact, the Hun behind Julius holding a red and white banner, both colors marked with the triple crown of the Turkish sultan Mehmed II, indicates that this scene of martyrdom is a metaphor for the endless Venetian struggle against the Turks, in which the confraternity's members participated.

A tall flagpole marks a change in time in the right third of the canvas, which depicts the burial of St. Ursula. In sharp contrast to the massacre, this scene is of an ordered, stately funeral cortege moving rightward, in the direction of the confraternity's altar, with Ursula on a bier under a canopy, carried by four bishops up a flight of stairs, past a ruined building in the background, and into a classicizing burial chapel, whose entablature frieze is inscribed URSULA. The scene is populated by portraits of confraternity members, including a woman dressed in black kneeling in prayer with rosary beads in the foreground. She is probably Ursula di Giovanni di Pietro Pisani, the wife of Antonio Loredan (1420–82), an important military commander who throughout his life fought for Venice on both land and sea. Members of the Loredan family, whose coat of arms is represented on the base of the flagpole, were major patrons of the confraternity, and some were even buried in its chapel. In any case, the kneeling and praying woman would have reminded all members of their obligation to provide a similarly decent and dignified burial for each member and to similarly exercise *amor proximi* and *amor dei* to facilitate the salvation of their own souls.

Ursula—with whom the members were joined in a common bond of faith, hope, and charity—embodied the highest aspirations of the Venetians. But the subtext of Carpaccio's utopian image of the city was the reality of economically enforced celibacy for many men and women, large-scale prostitution, and intense anxiety about war, death, and damnation.

CONFRATERNITY OF ST. JOHN THE EVANGELIST

The confraternity was founded in 1261 in a chapel of S. Aponal but transferred in 1307 to a double chapel in S. Giovanni Evangelista. In 1340 the confrater-

61. Vittore Carpaccio, *Ursula's Martyrdom and Burial,* signed and dated 1493, oil on canvas, 8 ft. 9 in. × 18 ft. 3¾ in. (267 × 558 cm), Gallerie dell'Accademia.

nity rented a room to serve as a meeting hall in the hospice run by the Badoer family adjacent to the church. Over the next 175 years, the confraternity acquired and remodeled the entire hospice and an adjacent building to the east to create an entrance vestibule and assembly room on the ground floor and an *albergo* and chapter room on the piano nobile (fig. 62).

Bastiani's *Donation of the Relic of the True Cross*

In 1369 Philippe de Mézières (c. 1327–1405), the grand chancellor of Cyprus, gave the confraternity a fragment of the cross of Christ's crucifixion, which he had received from the patriarch of Constantinople. The relic—enshrined in a crystal, gilt, and silver fourteenth-century processional cross represented in profile under the portable canopy in fig. 9—brought great prestige to the confraternity, especially when it performed nine miracles between 1369 and 1480. The painting by Lazzaro Bastiani (active 1449, d. 1512) for the confraternity's *albergo* documents this donation (fig. 63). The orthogonals of the perspective draw the viewer's eye through the portico, open door, and nave of S. Giovanni Evangelista to the high altar. In front of the altar, Grand Guardian Andrea Vendramin receives the relic from Mézières as three kneeling priests and oth-

62. A Ground-floor plan, B piano nobile plan, C staircase section, Confraternity of St. John the Evangelist: 1 entrance vestibule, 2 assembly room, 3 chapter room, 4 *albergo,* 5 *albergo nuovo.*

ers witness the event. Four members of the confraternity, in their white habits, support an honorific baldachin on long poles over the entrance, while other members—two with tall processional candles—line up two by two under the church's portico. The top of the portico is decorated with statues of a blessing Christ in the center and the four Evangelists with their symbols at their feet: (from left to right) SS. Luke (ox), John (eagle), Mark (lion), and Matthew (angel). Elevated on stone benches in the left and right foreground, twelve por-

traitlike figures, probably the men of the *banca,* witness the event, along with a multitude of other individuals of various ages and genders dressed in contemporary garb in front of the benches, in the piazza, on top of the portico, and in an upper balconied window.

To the extreme left, Bastiani has depicted a foreshortened view of the two-story confraternity bathed in the early afternoon sunlight from the southwest. The ground-floor assembly room and the second-floor chapter room both display pointed Gothic windows. When the artist painted the picture in 1494, however, the chapter room had been renovated within the previous three years by raising the walls and the roof a little more than two meters (two yards) to accommodate the landing of a new double-ramp staircase joining the assembly and chapter rooms. At the top of the chapter room, Bastiani represented a segment of these heightened walls and two of the many round windows that were inserted into them.

In the background to the left beyond the church portico, the artist also depicted an assembly of participating members in their white habits standing with a processional banner in front of the back wall of an atrium constructed by Pietro Lombardo from 1478 to 1481. He represents in the lunette at the top of the atrium wall a relief of a spread eagle, symbol of John the Evangelist, a sculpture of a kneeling angel to the left of the lunette, and an iron-barred window with a triangular pediment in the atrium wall below the angel—all still extant. Finally, to the left between the portico and the atrium wall he offers a foreshortened glimpse of the two-story building that the confraternity acquired in 1389 and remodeled twice in the fifteenth century (1414–24 and 1453–67) for the entrance vestibule on the ground floor and the *albergo* on the piano nobile.

Bastiani's presentation of an event that occurred a century and a quarter earlier in terms of the accurate and harmonious rendering of contemporaneous ceremonial protocol and locale serves to convincingly document the provenance, authenticity, and sacred authority of the confraternity's famous relic. The contemporary figures in the foreground also act as witnesses who vouch for the veracity of what is depicted against any possible claims of skeptics. If the stage set, actors, and actions are true to contemporary experience, who could doubt the validity of the event? And since such a solemn ceremony demonstrated the great honor that the confraternity had conferred on the fragment of the True Cross, who could question the relic's spiritual charisma?

67. Vittore Carpaccio, *Miracle near the Rialto Bridge,* 1494, oil on canvas, 12 ft. 2 in. × 12 ft. 10⅜ in. (371 × 392 cm), Gallerie dell'Accademia. The painting was cut at the lower left in 1544 to allow for a new door to the *albergo nuovo*.

tablatures and pedestals. The faces of the piers are carved with ribbons, trophies, and other classicizing motifs, while the faces of the arches feature bead and egg-and-dart moldings. The biforal round-arched window carried on free-standing Corinthian columns and surmounted by an oculus—the signature invention by Codussi—constitutes a classical rationalization of a Gothic window with tracery.

The lower, intermediate, and upper landings are unified yet varied as they build to a climax at the top. The ramps are well illuminated at the bottom and middle yet culminate in a burst of light. The stonework and vaulting throughout imitate the vocabulary and syntax of classical architecture but are varied to distinguish the lower, intermediate, and upper landings from one another and the landings from the risers and vaulted ramps. The stonework has been selected with great sensitivity to harmonize color and grain and exquisitely carved to unify yet differentiate the varied spaces contained within the plain plaster surfaces of the ramps and vaults. The space swells upward, and the stone articulation culminates in a virtuoso display of structural solidity animated by freestanding forms, varied colors, rich textures, and brilliant illumination. Few architectural experiences of space, form, and light are more exhilarating than Codussi's design.

Carpaccio's *Miracle near the Rialto Bridge*

After the walls and ceiling of the *albergo* were raised in the early 1490s and half oculi were inserted into the new wall segments for improved light, seven artists executed a total of nine paintings between 1494 and 1510 for the walls of the *albergo,* where the reliquary of the True Cross was displayed on an altar. Gentile Bellini's *Procession in the Piazza S. Marco* (fig. 9) hung over the *banca* on the west wall, opposite the altar, while Bastiani's *Donation of the Relic* (fig. 63) hung on the north wall, opposite the windows. But the great masterpiece of the series was Carpaccio's *Miracle near the Rialto Bridge* (fig. 67), one of two paintings that hung over the altar on the east wall, probably to the left.

Carpaccio's canvas depicts the first miracle of the relic of the True Cross sometime between its donation to the confraternity in 1369 and the death of Francesco Querini, the patriarch of Grado, in 1372. In a feat of remarkable topographical accuracy, Carpaccio has selected a viewpoint near the right bank of the Grand Canal, representing the Palace of the Patriarch of Grado to the extreme left, with its triangular battlements and two-story loggia projecting on to the quay (fig. 2, no. 10; fig. 6, no. 45). The orthogonals of his perspective on the left side of the painting focus at about the middle of the left end of the wooden Rialto Bridge, built in 1458. They draw the viewer's eye upstream (northeast) along the Fondamenta del Vin (Quay of wine)—fronted by at least seven steeply foreshortened buildings—to the Rialto Bridge, beyond which two columns of the Merchants' Portico are just visible (fig. 2, no 5). On one of the building hangs the sign of the well-documented Inn of the Sturgeon (Locanda Storione). As a visual pun on the name of the quay, Carpaccio has depicted a man pouring wine into the Grand Canal from a cask.

The light-filled formal order of the left half of the painting contrasts strongly with the shadowed right half as the Grand Canal curves away from the viewer to reveal ten facades. Just behind the bridge to the extreme right stands the Fondaco dei Tedeschi (before it burned to the ground in 1505), with the bell tower of S. Giovanni Crisostomo behind (fig. 2, nos. 1 and 19; fig. 6, nos. 8 and 17). A little to the left of the center of the composition is the Gothic Ca' da Mosto, with the campanile of SS. Apostoli behind (fig. 2, nos. 20 and 18; fig. 6, nos. 38 and 28). Carpaccio intensified the verisimilitude of the setting by representing nearly forty spark-arresting chimneys, two workmen repairing a tile roof, and various women (probably servants, at least one black)—one peering out from a belvedere with her laundry hanging from two poles, one airing a carpet from an open window, and two on an *altana* beating a pair of throw rugs and a pair of long textile runners, used as wall hangings, woven with coats of arms and foliage.

The two halves of the composition are joined by the wooden Rialto Bridge, lined on both sides with small shops (fig. 2, no. 2). In the central drawbridge portion, Carpaccio represented nine members of the confraternity in their white habits—four carrying tall processional candles, one a processional banner, and two smaller tapers—processing from right to left across the bridge intermingled with a stream of citizens. Another contingent, of more than a dozen members, carrying a processional banner, tall candles, and tapers, has traversed the Fondamenta del Vin and arrived at the patriarch's palace, where they have begun to ascend the external stairway leading to the upper story of the patriarch's loggia. In the loggia are yet another dozen or so members—including the four top officers, dressed in red—holding candles and a processional cross. One member kneels and another prepares to kneel in awe of the miracle unfolding before them. Querini, clad in the red and white clerical garb of the patriarch of Grado, lowers the foreshortened reliquary of the True Cross over a contorted man looking upward at the relic to exorcise the demon that possesses him.

64. Mauro Codussi, ground-floor entrance to staircase, 1498–1505, Confraternity of St. John the Evangelist.

65. Staircase ramp, Confraternity of St. John the Evangelist.

66. Staircase landing, piano nobile, Confraternity of St. John the Evangelist.

Codussi's Staircase

Between 1495 and 1498 the confraternity acquired a narrow strip of land to its north for a new double-ramp staircase. In 1498 Mauro Codussi was enrolled as a member and commissioned to design a stairway (fig. 62C) that would outshine his similar example for the Confraternity of St. Mark (fig. 54). The stairway is entered from either the assembly room or the adjoining vestibule through a doorway framed with marble fluted Corinthian pilasters on pedestals supporting a full entablature with a painted palmette frieze (fig. 64). The square ground-floor landings are richly riveted in marble, lighted by two rectangular windows, and covered by domical vaults on pendentives supported by pilasters carrying an entablature.

The two barrel-vaulted ramps rise from these landings in two stages, with each intermediate landing lit by a rectangular window (fig. 65). The ramps are wider at the top than at the bottom to counteract perspective foreshortening and to create the perception of the walls as parallel. Low marble panels supporting marble handrails opulently frame the marble risers. The barrel vaults covering the stairs spring from entablatures that are supported visually by fluted pilasters in the lower landings and by corbels at the intermediate landings. Coffered stone arches with a single row of rosettes create a visual pause at the intermediate landings and anticipate the articulation of the top landing.

The stairs culminate in the sumptuously articulated and brightly lit upper landing, capped by a domical vault (fig. 66). The vault rests on a circular stone cornice decorated with dentils and palmettes. It is supported by pendentives, wide coffered stone arches with three rows of rosettes, and clusters of paired piers and paired freestanding Corinthian columns with shared marble en-

63. Lazzaro Bastiani, *Donation of the Relic of the True Cross,* 1494, oil on canvas, 10 ft. 5⅝ in. × 14 ft. 4½ in. (319 × 438), Gallerie dell'Accademia.

Carpaccio has amplified the movement of the procession from right to left, toward the altar, and from background to foreground, toward the viewer, with the jumble of bobbing gondolas (some with tapestrylike sunshades) that are mostly being propelled downstream, toward the viewer, by gondoliers dressed in the livery of various noble houses. In particular, the two boats in the foreground encapsulate the painting's processional movement: the one to the right, with the Maltese dog, floats leftward, while the one to the left, rowed by a black African, glides toward the viewer. Even the light flows across the painting from the right to the left, in response to the light in the *albergo* entering from the windows on the south wall. Since the viewer is looking northeast, the bright glow low on the horizon indicates an early morning light, an age-old metaphor for regeneration—highly appropriate for the narrative. However, to an observer not attentive to the topography, the sky might suggest the setting sun, a traditional symbol of aging and death, equally appropriate for the drama.

In the lower left, Carpaccio represented more than four dozen figures, primarily male, of various ages, ranks, occupations, and ethnicities (Venetians, Greeks, Armenians, Arabs, Turks, and three blond youths dressed in the dandyish costumes of the Companies of the Sock). The two dozen or so portrait-like figures, many gazing out at the viewer, have gathered solemnly below the patriarch's portico as respected contemporary witnesses—perhaps many once recognizable members of the confraternity—to honor and testify to the authenticity of an event that had occurred about a century and a quarter earlier. In this foreground crowd, two figures—a woman and a man—each raise an arm and look upward to establish a visual connection between the bystanders and the miracle.

The *albergo* paintings of Bastiani, Bellini, and Carpaccio all depict, with great accuracy and detail, major confraternal, governmental, and commercial locations in Venice, each animated by a solemn procession of the confraternity, whose members, along with bystanding citizens, serve to witness and verify the authenticity and charisma of the relic of the True Cross in both the past and the present, exult the prestige and dignity of the confraternity across time, and confirm the sacredness of Venice as a new Jerusalem.

While both Bellini and Bastiani employed a balanced and centralized perspectival stage for their narratives, Carpaccio created a far more dynamic pictorial world, based on contrasts. He counterbalanced the rigorous thrust into space of the orthogonals on the left with the natural flow of the Grand Canal toward the foreground on the right. He differentiated the rectilinearity and massiveness of the highlighted buildings on the left with the curvilinearity and flatness of shadowed façades on the right. He played the varied movements of the sleek but fragile gondolas on the dark water against the uniform and stable mass of citizens standing on the light-filled quay. He also offset this grave and static group in the foreground with the gondolas in the far background on the upstream side of the bridge, all moving parallel to the picture plane. Similarly, he arranged the foreground witnesses to look mostly rightward, while the diverse activities of the citizens on the Fondamenta del Vin draw the viewer's interest into depth. By contrast, the movement of the gondolas below the Rialto Bridge pulls the viewer's eye leftward and forward, toward the foreground. Carpaccio also contrasted the solemn and decorous demeanor of the contemporary witnesses with the concentrated and awe-filled reactions of the historical participants on the loggia above. Finally, while he created a compellingly true-to-life portrait of everyday life, he also positioned the observer at a surreal viewpoint, hovering above the water of the Grand Canal and looking downward. The net result is a composition that convinces with its verisimilitude but transmutes the mundane into an expression of intense spiritual drama through its visual dynamism.

CONFRATERNITY OF ST. GEORGE

The Council of Ten approved the foundation of the small confraternity for the Dalmatian Slavs (Schiavoni) in 1451 with the sponsorship of the church of S. Giovanni al Tempio, administered by the Order of St. John in Jerusalem (Knights of Rhodes)—a military order of crusaders and hospice keepers dedicated to retaking the Holy Land from the Turks. For the confraternity's chapter room, the knights provided the ground-floor room in their nearby fourteenth-century Hospice of St. Catherine.

In 1454 the council approved the statutes of the confraternity, which were dedicated to the third-century SS. George and Tryphon, patron saints of Cattaro, then part of the province of Dalmatia. Soon after, St. Jerome (342–420), born in Strido and once the bishop of Spalato in Dalmatia, was added as a third dedicatee.

The confraternity had about two hundred members in 1451, both men and women, governed by a *gastaldo* and a *banca*. Members—largely merchants, artisans, and seamen—had many obligations, including attendance at the Mass celebrated in Slavic on the second Sunday of every month and on the feast days of the confraternity's patron saints, attendance at a requiem Mass for dead members every Wednesday, recitation of fifteen Paternosters and Ave Marias

for each member who died, and making confession and taking communion on Christmas and Easter.

In 1464 the Greek cardinal Bessarion (1403–72), the papal legate to Venice, conceded an indulgence (partial remission of punishment in Purgatory) to anyone who took part in five of the confraternity's services, including the feast-day celebrations of its three patron saints.

In 1480 the Dalmatian sailors in the confraternity—fiercely loyal both to the Knights of Rhodes and to the Venetians, who had helped protect their homeland against the Turks—played a significant role in helping to defend Rhodes against a Turkish siege. In gratitude, Pope Sixtus IV granted the confraternity yet another indulgence, in 1481.

In 1502 Paolo Valaresso—the commander of the Venetian fortresses at Modon and Coron in the Morea when they fell to the Turks in 1499—donated to the confraternity the important relics of St. George, which the patriarch of Jerusalem, on his deathbed, had given him. Two months later, still another papal indulgence was given to the confraternity, by the papal legate and bishop of Tivoli Angelo Leonino.

With its prestige now significantly enhanced, the confraternity commissioned Carpaccio to paint nine narratives (1502–7) for the walls of its chapter room depicting events from the lives of Christ (two canvases) and SS. George (three), Tryphon (one), and Jerome (three). In 1518 the confraternity expanded to the upper floor of the hospice, and between 1551 and 1586 the ceilings of both floors were raised, a new façade was built, and Carpaccio's paintings were reinstalled on the ground floor, as seen today.

Carpaccio's *St. George and the Dragon*

According to the thirteenth-century *Golden Legend,* a dragon with poisoned breath living in a lake near Silena, Libya, could be prevented from killing the local inhabitants only by being supplied with a daily diet of sheep or children. After nearly all the sheep and youths had been sacrificed, the king of Silena could not avoid sacrificing his own daughter. But just before the dragon could eat her, St. George rescued her in the name of Christ (fig. 68). In thanksgiving the king and his subjects converted to Christianity and built a church dedicated to the Virgin and St. George.

A dragon was a traditional sign of Satan, who brought sin and death to humankind. All confraternities were preoccupied with overcoming the temptations of Satan to achieve salvation. By saving the princess, St. George exemplified *amor proximi,* one of the principle functions of the confraternity in its quest for redemption. Carpaccio emphasized the North African setting of the story by modeling his gate at the upper left on Cairo's eleventh-century Bab el-Futuh (Gate of conquest) and by putting turbaned spectators on the balconies of the two tallest towers. This pagan orientalism implied a parallel between the Devil's threat to Silena and the constant threat of the Turks to Dalmatia and Venice. In addition, the church in the upper right—anticipating the church that the king built after St. George's victory—is modeled on S. Ciriaco in Ancona, where in 1464 Pope Pius II launched his crusade against the Turkish infidels. Although Venice had agreed to supply some warships, the crusade came to naught when the pope died before the fleet could set sail. Nevertheless, Carpaccio's clustering of the princess, the church, and a Venetian galley and cog on the horizon suggests that the princess was understood as a type of Virgin—an embodiment of the Church—and a stand-in for Venice in its unending struggle to defend the city and the Church against the Turks. Similarly, St. George's self-sacrifice to save Silena in the name of Christ exemplifies the patriotic *amor dei* of the members of the confraternity and the Knights of Rhodes.

Carpaccio has depicted St. George in a heraldic, ornamental Gothic style typical of chivalric romance, in which a knight slays a monster for his ladylove and then devotes the rest of his life to her service. In some versions of the legend, in fact, the king and queen offered George the hand of the princess and half of their kingdom, but following the chivalric ideal of chaste love and selfless service, he refused.

On the barren ground between the dragon and St. George's horse, Carpaccio has represented a nude woman, once young and beautiful but now ravaged by the dragon. The dragon has eaten her legs and lower torso, and two lizards, a toad, and a snake frame her body, all symbols of evil, particularly lustful sex, that contrast sharply with St. George's chastity and virtue.

The nude male under the horse was also once a handsome fair-haired youth and has undergone a kind of castration, further suggesting the bestiality of Satan and the evils of carnal pleasures, heightened by the toad that gazes at his genitals and the nearby snake that devours a toad. St. George's penetration of the dragon's mouth with his lance also represents a type of perverse and violent sexual assault.

The painting, in short, exhibits a strong undercurrent of anxiety about sexuality as the root of all sin that brings barrenness and death. Not coincidentally, Eve traditionally bore the blame for the fall of humankind, due to her seductiveness. Yet the orderly row of palm trees in the background evokes Christ's entry into Jerusalem and the beginning of his Passion, which redeemed hu-

68. Vittore Carpaccio, *St. George and the Dragon,* 1502–7, oil and tempera on canvas, 4 ft. 7½ in. × 11 ft. 9¾ in. (141 × 360 cm), Confraternity of St. George.

69. Vittore Carpaccio, *St. Jerome and the Lion,* 1502–7, oil and tempera on canvas, 4 ft. 7½ in. × 6 ft. 11 in. (141 × 211 cm), Confraternity of St. George.

manity. The severed dead tree above the dragon symbolizes death, while the leafy green tree beside the princess evinces the possibility of regeneration through acts of *amor proximi* and *amor dei* as performed by St. George. The partially dead and partially alive tree between the dragon and the horse mediates visually between the two poles of death and renewal.

Carpaccio's *St. Jerome and the Lion*

According to the *Golden Legend,* a lion with a paw wounded by thorns wandered into the monastery that St. Jerome had founded in Bethlehem. All the monks fled in fear except for Jerome, who performed an act of *amor proximi* by dressing the wound and taming the lion as a pet (fig. 69). But Jerome also exercised an act of *amor dei,* for the lion was an age-old symbol of Christ, and a

wounded lion a sign of Christ's redemptive sacrifice. The lion, of course, also symbolized St. Mark, suggesting that like St. George, Jerome was an exemplar of patriotic service to Venice, the new Jerusalem. By scattering nine turbaned pagans throughout the background, Carpaccio subtly transmuted the terror of the monks fleeing the lion in the fore-, middle-, and background into fear of the infidel Turks, major enemies of the Slavs, the Knights of Rhodes, Venice, and the Church.

Carpaccio has exploited the traditional understanding of a monastery compound as an earthly paradise by creating—in the midst of a monastic life of penitence and self-sacrifice—a space teeming with symbolic plant and animal life. The tall palm tree that soars beyond the picture frame in the middle ground and the row of palm trees in the background behind the lion recall the palm fronds strewn before Christ as he entered Jerusalem to begin his Passion, and the flowers, grasses, and trees evince the resulting promise of renewed spiritual life. The stag and the doe signal the soul's yearning for salvation, based on Psalm 41—"As the hart panteth after the fountains of water; so my soul panteth after thee, O God"—while the five birds evoke resurrected souls. In particular, the peacock, here in the center of the composition, traditionally symbolized immortality.

Carpaccio also rendered the church to the right with its deep entrance porch, the monks' dormitory in the center, and the small building to the extreme left in a manner that recalls the forms and grouping of the S. Giovanni al Tempio, the dormitory of the Knights of Rhodes, and the Hospice of St. Catherine, the location of the confraternity. By thus equating confraternal life with monastic life, led by an ascetic and chaste brotherhood in pious service to God, Carpaccio offered an example of model behavior for the members and an alternative to St. George's engagement with the world of evil and sexuality.

Carpaccio's *Funeral of St. Jerome*

Carpaccio set this scene on the porch of the church in the previous scene, but viewed from the opposite direction so that the soaring palm tree is now fully visible, along with another seven turbaned Asians, two mounted on horseback (fig. 70). He made the palm tree's symbolism of Christ's Passion explicit with the tall echoing cross in the background, near the monastery's entrance, with a signboard on top, a crown of thorns around the crossbar, and flails of the Flagellation hanging from the crossbar's ends. He also framed the palm tree with an ass, the animal that carried Christ into Jerusalem to begin his Pas-

70. Vittore Carpaccio, *Funeral of St. Jerome,* signed and dated 1502, oil and tempera on canvas, 4 ft. 7½ in. × 6 ft. 11 in. (141 × 211 cm), Confraternity of St. George.

sion, and a chained mongoose, a killer of snakes, to symbolize Christ's self-sacrificial triumph over Satan, who provoked Adam and Eve's original sin in the guise of a serpent. Between the palm tree and the cross, the artist also depicted a counterbalanced pole hinged through a forked tree stump—a lever to help lift a bucket from a well. In this parched landscape, a well suggests the cooling water of refreshment or, symbolically, baptismal water, which cleanses the soul of original sin, while the long-eared Nubian goat next to the well, like goats in general, embodies the lust that provoked the Fall. Carpaccio also depicted symbols of both death and regeneration in the left extreme foreground: a dead tree with green plants at its base and adorned with a skull and a jawbone supports a holy water font with an aspergillum for sprinkling the purifying water.

As the lion roars with grief at the death of his master in the right middle ground, Jerome lies in the foreground on the red and white tiles of the church's porch with a rock for his pillow, his emaciated body a manifestation of his exemplary asceticism. His fellow monks, with tapers, Scriptures, and a processional cross, solemnly perform the proper funeral rites and prayers—a

demonstration of the ideal death, in a loving brotherhood, desired by the members of all confraternities. In the central foreground Carpaccio represented a salamander, believed to be impervious to fire and hence a symbol of the faithful, purified by divine enlightenment. The flower to the right of the salamander and the birds in the left middle ground also evoke the promise of renewed life. Finally, the paper recording the artist's signature and the date next to the salamander serves as Carpaccio's personal prayer for salvation, merited by his imagination and creativity.

Carpaccio's *St. Augustine's Vision of St. Jerome*

This painting (fig. 71) illustrates a passage from the late thirteenth-century *Hieronymus vita et transitus* (Life and death of Jerome), published in Venice in 1485, which records that while St. Augustine (354–430) was writing a treatise on "how much glory and joy the souls of the blessed have, who rejoice with Christ," the spirit of the recently deceased St. Jerome suddenly appeared in a burst of light and rebuked him:

> Augustine, Augustine, what are you seeking? Do you think that you can put the whole sea in a little vase? Enclose the world in a small fist? Make fast the heavens so that they may not keep going in their accustomed motion? Will your eye see what the eye of no man can see? Your ear hear what is received by no ear through sound? Do you think you can understand what no human heart has understood, nor even considered? What will be the end to an infinite thing? By what measure will you measure the immense? Sooner would the whole sea be shut in a very restricted vessel, sooner would a small fist hold the globe of the earth, sooner would the heavens cease from continuous motion, than you could understand a small part of the glory which the souls of the blessed possess without end, unless you have learned from experience, as I have. To speak briefly: Do not attempt to do impossible things until the course of your life is fulfilled. Do not seek them here or elsewhere, except where they can be found so quickly and happily. Here be content to perform such works that later, there, whence none who enter come out, you may completely have in eternity what you seek here to understand in some degree. (1485 ed., fol. 22r–v)

Carpaccio set the scene in a sumptuous, classicizing scholar's studio with a gilt coffered ceiling supported by a stone cornice and masonry walls with a green textile wainscoting capped with a stone entablature. The entablature

71. Vittore Carpaccio, *St. Augustine's Vision of St. Jerome,* signed, 1502–7, oil and tempera on canvas, 4 ft. 7½ in. × 6 ft. 11 in. (141 × 211 cm), Confraternity of St. George.

serves as a shelf for a few books, assorted small hand-decorated vessels, a brass candlestick, bronze statuettes of a horse and a classicizing nude Venus Felix, and, it appears, a number of flint blades or artifacts. Fanciful bronze bear-paw candle sconces project from the walls, and under the left sconce a bookshelf is angled from the wall by metal consoles.

At the end of the room, a red niche with a gold mosaic apse depicting a seraph contains an altar with a bronze statue of the Risen Christ serving as an altarpiece. The altar table and the cabinet below display all the necessary accoutrements for celebrating Mass: two candlesticks, a censer, an incense boat, cruets, an altar cloth, and liturgical books. The miter and crosier indicate St. Augustine's investiture as the bishop of Hippo.

Two doors flank the altar, and through the open one on the left is visible a green room with a high shelf with books and boxes from which hang a quadrant and three astrolabes, used for astronomical and navigational calculations. On the table covered with a red cloth rest a lectern, books, and other scholarly

implements. The angled shadows cast on the casement by the window bars indicate that the green room receives its light from a natural source high on the left.

On the left side of the main room, Carpaccio represented an upholstered armchair and prie-dieu for reading, meditating, and praying. On the opposite side the artist depicted a similarly upholstered desk and bench on a raised oval podium cluttered with books. The desk also displays a seashell, a bell, scissors, two vessels with lids, and a candle snuffer. An armillary sphere (a model of the celestial sphere) hangs from the ceiling above the desk, and under the desk a built-in bookcase displays an hourglass and additional books. The three documents with round and oval seals—one on Augustine's bench and two on the podium—may reference the three papal indulgences conferred on the confraternity in 1464, 1481, and 1502. The sheet music to the extreme lower right is open to three-part secular music, while the music book just above displays a four-part hymn.

Carpaccio has rendered the subtle drama and message of the painting largely in terms of light, color, and suspended movement. The orthogonals of the rigorous perspective system all focus just under the raised right hand of St. Augustine, seated on a red cushion and dressed in his bishop's black hooded mozzetta (short cape), black zucchetto (skullcap), and white cassock over his cardinal's red tunic. The orthogonals thus draw the viewer's eye to the instant the saint has suspended writing, lifted his pen from his book, and raised his head to center his attention on the cross-mullioned window to the extreme right. Entering through this window and the two other windows on the same wall, the light from St. Jerome's apparition floods the room on a diagonal marked by the ecliptic band of the armillary sphere and the tilted head and alert eyes of the white Maltese dog. A dog was especially appropriate to anchor this diagonal, since, beyond being a common symbol of loyalty and faith, dogs were believed to embody prophetic vision. Carpaccio underscored the supernatural quality of this light by contrasting the angle of the shadows it casts on the window casement and on the floor with the exactly opposite angle of the shadows cast by natural illumination on the casement in the small green room.

In the painting's many naturalistic details, Carpaccio implied a series of upward progressions—from secular to sacred music, from the hourglass measuring earthly time to the armillary sphere modeling the entire cosmos, from natural to divine light, and from Christ's sacrifice, commemorated at the altar, to the image of the risen Christ—to visualize the potential ascent of the soul from the terrestrial to the celestial, the celestial underlined by the geometric harmony and perfection of the space. The dominant color scheme of the painting—white, green, and red, the colors of the Theological Virtues (Faith, Hope, and Charity)—evokes the means by which one might merit salvation.

Carpaccio appears to have depicted St. Augustine in the guise of Cardinal Bessarion—very likely the only cardinal to wear a beard during his lifetime—who in 1461 had been made a Venetian noble, in 1464 had granted an indulgence to the confraternity, and in 1468 had donated his valuable library of more than a thousand manuscripts to the Venetian state. He was also closely connected to the family of Paolo Valaresso, who donated the relics of St. George to the confraternity in 1502. Finally, as an illustrious scholar who wished to reconcile classical and Christian thought, Bessarion was an appropriate stand-in for St. Augustine.

Whether or not the likeness was intended, there remains a negative undercurrent in the painting. The episode, after all, represents St. Jerome's rebuking of St. Augustine for his intellectual arrogance in attempting to understand the unknowable. Furthermore, Carpaccio has imagined an environment of unprecedented luxury, comfort, and grandeur in which the prie-dieu and the altar remain unattended, without the performance, as St. Jerome recommended, of "such works that later . . . you may completely have in eternity what you seek here [on earth] to understand." The contrast represented in the three Jerome paintings between Augustine's solitary intellectual life in self-indulgent material splendor and St. Jerome's active communal life of charity in a self-sacrificial and penitential life of poverty could not have been more starkly drawn. In the context of the aims and membership of the confraternity, most members would have desired to emulate Jerome. However, in this masterpiece that ends the Jerome cycle, Carpaccio's magisterial control and coherent integration of all the means of visual representation—light, color, space, form, drama, and symbolism—and his proud signature ("Vittore Carpaccio imagined this") suggest that the artist might have been partial to St. Augustine's life of the intellect.

7

PALACES

The fiction that all Venetians were equal mandated that only the residences of the doge, the patriarch of Grado, and the bishop of Venice be called palaces, while a private abode was termed a house, or *casa,* usually abbreviated *ca',* or *ca' grande.* In addition, the ingrained concepts of moderation and consensus that governed Venetian political and social life encouraged, according to Francesco Sansovino in his 1581 guidebook to Venice, adherence to the supposed first law of the republic, introduced by Zeno Daulo (a member of the triumvirate that supposedly laid the foundations of the Venetian government in the fifth century), which held that individual *case* "should be equal, alike, of similar size" (1663 ed., p. 382). However, given the large scale and distinctive articulation of the most innovative residences discussed below, the word *palace* will be used interchangeably with *casa.*

Venetian palaces evolved from a Veneto-Byzantine style in the thirteenth and fourteenth centuries through a Gothic style in the first seven decades of the fifteenth century to an early Renaissance style in the last three decades of the fifteenth century and to an ever more Romanizing High Renaissance style in the sixteenth century. Yet their plans and structures remained fairly constant and were quite different from those elsewhere in Italy, since Venice uniquely was built on a series of islands comprising mostly sand, gravel, and clay.

To forestall a palace's settling into the unstable soil, its foundations were by necessity always built on top of a forest of wooden piles driven into the mud. As long as the piles remained submerged, free from exposure to sunlight and air, they underwent petrifaction and endured for centuries. The piles were capped with an impermeable stone base that extended below the low waterline and above the high. On top of this base were constructed relatively lightweight brick walls. The walls supported wooden beams, generally placed parallel to the façade and covered with wooden planks that served as ceilings and floors. From the sixteenth century onward some of the grandest palaces were provided with foundations strong enough to carry the stone walls and masonry vaults characteristic of most central Italian palaces. But in the typical residence with beam-and-plank ceilings and floors, the façade supported little more than its own weight and could be designed as an ornamental showpiece penetrated with many porticoes, loggias, doors, and windows.

CA' D'ORO

The wealthy merchant Marino Contarini (1386–1441) was descended from an old Venetian noble family that boasted three doges. Most likely with the dowry of his first wife, Soradamore Zeno, whom he married in 1406, he acquired in about 1412 the large house on the Grand Canal that became the Ca' d'Oro (fig. 6, no. 40). The rebuilding and remodeling began in 1421 and took more than fifteen years to complete, at a total cost of about seven thousand ducats. The floor plans are typical of most Venetian palaces, but the Gothic façade is the city's most luxurious and the first constructed entirely of stone (figs. 72 and 73).

72. Matteo Roverti (active 1389–1433) and Giovanni and Bartolomeo Bon, Ca' d'Oro, 1421–36, limestone and colored marble façade, Grand Canal.

73. A Ground-floor plan, B first piano nobile plan, C second piano nobile plan, Ca' d'Oro: 1 *riva* (watergate), 2 *androne,* 3 courtyard, 4 wellhead, 5 loggia, 6 *portego,* 7 *albergo,* 8 loggia, 9 *portego,* 10 *albergo.*

From the Grand Canal the palace was entered through a watergate (*riva*) for embarking and disembarking people and supplies (fig. 73, no. 1). Behind the watergate followed the standard *androne,* a long paved hall running from the front to the back of the building and covered with a beamed ceiling (fig. 73, no. 2). Here the owner stored his gondola, oars, ropes, and boat canopy. Often an *androne* also held stalls for horses and mules. On either side of this *androne* were originally offices and storage rooms for merchandise, some with mezzanine rooms above, for the Ca' d'Oro, like a few other Venetian palaces, was a *casa-fondaco*—that is, it functioned as a trading center and warehouse as well as a residence. Most warehouses, however, were in the Rialto area, convenient to the shops of the commercial center.

A walled exterior courtyard (fig. 73, no. 3), which provided space for a garden and light and air for the interior, was located toward the back on the east side of the *androne,* creating an overall C-shaped plan. However, in many other Venetian palaces, depending on the site, the exterior courtyard was located in such a way that the overall plan was L-shaped or U-shaped. Centralized internal courtyards, influenced by central Italian palace design, first appeared only in the largest palaces of the sixteenth century. The land entrance to the palace was commonly, as here, through the courtyard. Underneath the sloped pavement of nearly all exterior courtyards, which numbered in the thousands, were deep cisterns, large waterproof stone-lined receptacles filled with sand, designed to capture and filter storm runoff. A well—capped by a stone wellhead, usually in the center of the courtyard—provided access to this supply of freshwater. The courtyard of the Ca' d'Oro also contained an L-shaped external stairway, which led from the land entrance to the first *piano nobile.*

On the first piano nobile, a loggia (fig. 73, no. 5) above the watergate, over-looking the Grand Canal, served as the principal source of light and air for the interior. It also afforded residents spectacular views of life on the canal and allowed boaters a glimpse of palace life when candles were lit there in the evenings. The loggia opened on to the *portego* (fig. 73, no. 6), or great hall run-ning over the *androne* from the front to the back of the piano nobile. The *por-tego,* the principal reception, entertainment, and banqueting room, was usually paved with highly polished multicolored terrazzo (marble chips set in mortar over the plank subfloor) and had either a beamed or coffered wooden ceiling, often painted and gilded. The walls were usually decorated with paintings, tex-tiles, and arrangements of arms and armor and lined with many chairs and a few tables, while colorful blown-glass chandeliers hung from the ceiling. Al-though unheated in the winter, the *portego* provided a shady retreat cooled by cross breezes in the hot and humid Venetian summers.

Off the *portego,* the palace's circulatory core, opened the main living room (*albergo grande;* fig. 73, no. 7), with two small balconies overlooking the Grand Canal, and internally connected dayrooms, bedrooms, dining room, and kitchen (although kitchens and laundry rooms were commonly on the ground floor). Typically these rooms might have either plank or terrazzo floors, painted and gilded beamed or coffered ceilings hung with glass chandeliers, and white or colored plastered brick walls, often covered with some combina-tion of wainscoting, tapestries, textiles, tooled leather, mirrors, candle sconces, and gilt-framed paintings (for examples of some of the interior furnishings mentioned here and in what follows, see figs. 58, 59, and 71). Either braziers or, more commonly, fireplaces with carved stone mantelpieces and sculpted brass or bronze andirons heated these rooms. Their windows were glazed with bot-tle glass or panes and usually curtained and shuttered. Beds in bedrooms were often built-in curtained alcoves with small mezzanine rooms above, which served as children's bedrooms, or alternatively large freestanding canopied is-lands with storage cabinets underneath.

Other furniture in the palace included, above all, abundant, often elabo-rately decorated storage chests and boxes, usually placed along the walls, but also chairs, stools, cabinets, armoires, tables, desks, bookcases, candelabra, stat-uettes, and musical instruments.

Beds, tables, and chests were commonly covered with finely woven, exqui-sitely textured, and brightly colored textiles and carpets, some locally manufac-tured, some imported from the eastern Mediterranean. As the light through the windows constantly shifted in intensity with the movement of water and clouds outside to create a medley of color within, the overall effect of most pal-ace interiors would have been one of prosperity and comfort.

The second piano nobile of the Ca' d'Oro (fig. 73C) was nearly identical to the first and was probably intended as a separate apartment for one of Conta-rini's brothers. Indeed, it was common for several families and generations to live in the same palace. The servants of the Ca' d'Oro lived in a mezzanine un-der the roof.

Turning to the decoration of the façade, we see that the watergate of the Ca' d'Oro is articulated by a wide central elliptical arch flanked by four narrower pointed arches, all supported on short, vaguely Corinthian columns without entasis. The loggias of the first and second piano nobile each display five short marble columns carrying pointed trilobed ogee (slightly S-shaped) arches that flower into either quadrilobed tondi or kite-shaped diamonds, variations on the upper portico of the Doge's Palace (fig. 5), thereby visualizing Contarini's elite status as a patrician member of the Great Council, which he entered in 1410 at age twenty-five. All the windows are articulated with pointed Gothic ogee arches, those on the first piano nobile infilled with elaborate pendant tracery. The façade is further decorated with alternating red and gray marble squares, dogtooth and rope moldings, tondi with projecting porphyry spheres, spiral colonnettes, lion-headed corbels, and the Contarini coat of arms. It is crowned with a trilobed arched cornice and fanciful cresting—also derived from the Doge's Palace—symbolic of power. For an even more sumptuous ef-fect, many details were originally highlighted with costly ultramarine (a deep blue made from crystals of crushed lapis lazuli) and gold leaf, hence its name, Ca' d'Oro (Golden House).

Most Venetian façades, as here, were designed to be experienced from gon-dolas gliding through the canals low in the water. Since the lagoon was the drainage basin for much of the terraferma, the water in Venice's largest canals flowed like rivers toward the sea. But the lagoon was also a tidal basin, so that water in all of the city's canals also constantly rose and fell in response to the flood, ebb, and slack tides of the Adriatic. In addition, the surfaces of the ca-nals reflected and refracted the ever-changing light and atmosphere and threw back on to palace façades a shimmering illumination that tended to demate-rialize their substance under many atmospheric conditions. The façade of the Ca' d'Oro was further perceived as an insubstantial screen due to the absence of a rigorous structural system of continuous vertical lines of support or hor-izontal lines of load and the many loggias and windows piercing its surface. The surface was further fractured by the multicolored marbles framed by a

variety of decorative moldings, the painted and gilt highlights, and especially the cresting, which blurred the transition from matter to air. While no other Gothic-style palace rivaled the Ca d'Oro in ornamentation, most façades were enlivened and fragmented by inset marble bas-relief plaques, gleaming white limestone doors and windows, and colored marble loggia columns, all played off against red brick or colored plaster walls. Some façades were even frescoed with illusionistic sculptural reliefs, although most have now faded or disintegrated in Venice's humidity.

To a viewer slipping by in a gondola in certain conditions of light and air, therefore, a Venetian palace façade could appear to be a glistening, kaleidoscopic, ever-shifting illusion miraculously floating on the water. Simultaneously, Venetian palaces conjoined the four fundamental elements of the universe—earth, water, air, and fire (the light of the sun).

Similarly, Jacopo de' Barbari depicted the entire city of Venice as a series of islands rooted in the rippling water of the lagoon, illuminated by the eastern sun of a bright new day, and refreshed by eight cloud-born winds (fig. 1). And just as he further represented the city as a self-contained sacred cosmos by a using a God's-eye perspective and adding the protective classical deities of Mercury and Neptune, gods of commerce and the seas, so too did Venetian palaces present themselves as both elemental and surreal microcosms. The aesthetic of Venetian palace design, in short, was yet another manifestation of the Myth of Venice, a city bonded both with the elements and with God. And just as Venice was allegorized as Venus—the sea-born goddess of love and beauty—so too were Venetian palaces housing the domestic life of its citizens designed as stunning sensory shells seemingly afloat on the water.

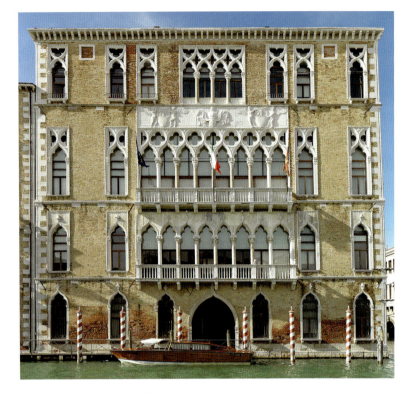

74. Ca' Foscari, c. 1453–54, Grand Canal.

CA' FOSCARI

The Ca' Foscari (figs. 74 and 75) occupies one of the most conspicuous sites in Venice—a corner lot at a bend on the right (west) bank of the Grand Canal (fig. 6, no. 41), which provides its east-facing façade with spectacular views upstream toward the Rialto Bridge and downstream toward Piazzetta S. Marco. The Ca' Foscari replaced a late twelfth- to early thirteenth-century Veneto-Byzantine residence called the Palace of Two Towers, which the Venetian government had purchased in 1428 as a gift for Gianfrancesco Gonzaga (1395–1444), a Venetian mercenary commander—and by 1433 the marquis of Mantua—for his faithful service to the city in its war against the duke of Milan, Filippo Maria Visconti. When Gonzaga changed sides, in 1438, the palace was confiscated

and given the next year to Francesco Sforza for his services as the captain general of the Venetian army in its struggle against Milan. When Sforza succeeded Visconti as the duke of Milan in 1450 and became ipso facto the enemy of Venice, the Palace of Two Towers was again confiscated. To help finance its costly war with Milan, the Venetian state put the palace up for auction in 1453 with a minimum bid of fifty-five-hundred ducats. It was bought by Francesco Foscari, a most surprising move by the then eighty-year-old doge, who was expected to live out the remaining years of his life (four, as it transpired) in the Doge's Palace. In addition, the Foscari family already had a palace in the parish of San Simeon, and Foscari's only son, Jacopo, could not expect to inherit the new palace, having been stripped of all his property and exiled permanently from

75. Second piano nobile plan, Ca' Foscari.

1464)—the de facto ruler of Florence and a longtime Venetian ally against Visconti until he too betrayed the Venetians, in 1450, by supporting the new duke of Milan, Sforza. Both the Ca' Foscari and the Medici Palace (c. 1446–57) occupy commanding corner sites at bends in major thoroughfares, dominate the neighboring palaces with their great height, use traditional Gothic vocabulary blended for the first time with classicizing elements, and feature trapezoidal walled gardens at the rear. But the Ca' Foscari is grander than the Medici Palace, by virtue of its greater height, bilaterally symmetrical façade, and nearly cubic overall volume, framed by classical quoins on the corners and a crowning corbeled cornice. While the Medici Palace borrowed a number of details from Florence's Priors' Palace that subtly suggested Cosimo's control of the reins of Florentine power, the Ca' Foscari more blatantly copied the design of the Doge's Palace loggia (quatrefoil tondi over pointed ogee arches; fig. 5) for its second piano nobile loggia to indicate unambiguously Doge Foscari's occupation of the highest seat of Venetian governmental authority. The Florentine palace displays on its façades Medici arms and devices, but not as prominently as the long marble panel with two pairs of classicizing nude winged angels displays the Foscari coat of arms and the lion of St. Mark.

The typical Venetian plan of the Ca' Foscari includes a ground-floor *androne* running from front to back, which is lit by a large central watergate. Unlike the Ca' d'Oro, the Ca' Foscari was not a *casa-fondaco,* so the rooms flanking the *androne* functioned as integral parts of palace life. On the first and second piani nobili, two wide eight-bay columned and balconied loggias light the *porteghi* that run from front to back over the *androne,* while on the top floor a four-bay columned central window and the single flanking windows on either side light the uppermost *portego.* On either side of the central *porteghi* open a series of rooms with doors in an enfilde, with the corner *alberghi* on each floor lit by a pair of windows. The vertical continuity of these windows from bottom to top creates a subtle two-towered effect suggestive of the earlier palace. The extensive walled garden in the rear, with a cistern and a well, and the C-shaped southern lightwell help illuminate the interior rooms, including the grand staircase connecting the various floors.

Substantial classicizing stringcourses (decorative horizontal stone bands) separate the floors on the Medici Palace and serve as windowsills. On the Ca' Foscari, by contrast, the stringcourses are far less substantial and do not serve as windowsills, in order to maintain the typically Venetian effect of the façade as a nonstructural brick screen into which windows have been cut. The bottom and top floors are nearly equal in height, while the first piano nobile is

Venice in 1445 for bribery and corruption. Furthermore, in 1450 he was accused of the murder of Ermolao Donato, one of the members of the Council of Ten who had voted to exile him. Since only his grandsons could have expected to inherit the Ca' Foscari, the doge primarily must have intended the new palace, much like his tomb (fig. 36), to convey a message about his and his family's place in Venetian history and society.

As the former palace of two treasonous military commanders, the Ca' Foscari asserted the doge's ultimate success in checkmating the duke of Milan, expanding and consolidating the Venetian terraferma empire, and bringing peace to the region with the 1454 Treaty of Lodi. In addition, by choosing this particular site, at a bend of the Grand Canal, which served as a major focal point for boat traffic on long stretches on either side, Doge Foscari both emulated and outshone the earlier Florentine palace of Cosimo de' Medici (1389–

taller and the second piano nobile the tallest of all. All the windows and loggias above the ground floor are contained in rectangular stone frames and articulated by ogee arches. As the eye moves up the façade, the stone areas above the arches become progressively more open and ornate, a new development in Venice, which imparts a sense of lightness to the whole.

While adhering to many Gothic traditions in plan and articulation, in short, the Ca' Foscari exhibits a new classicism and a bold assertion of family status and personal political power that pays little heed to the unwritten rules of moderation and the submission of self to the greater good of the republic. It became the principal paradigm for a large number of other Gothicizing-classicizing palaces built in the middle decades of the fifteenth century, a veritable building boom, with some palaces preceding but most following the 1454 Treaty of Lodi, when the costly terraferma wars had largely ended and a measure of peace and prosperity had been restored.

CA' DARIO

The Ca' Dario (fig. 76), on the right (south) bank of the lower Grand Canal (fig. 6, no. 39), stylistically marks the transition from Gothic to early Renaissance. The palace's patron, the *cittadino* Giovanni Dario (1414–94), a native of Crete, served as the secretary of the Senate and the Council of Ten, as a diplomat to eastern Mediterranean sovereigns in Constantinople, Persia, and Egypt, and as the grand guardian (1492–93) of the Confraternity of St. John the Evangelist (see fig. 9). In 1479 he negotiated the Treaty of Constantinople with Sultan Mehmed II, concluding the 1463–79 Turkish war. Despite Venetian loses of Negroponte, Scutari, and Lemnos, the payment of an annual tribute of ten thousand ducats for trading rights in the Black Sea, and the repayment of a debt of one hundred thousand ducats for the rights to an alum mine, Venetians celebrated the treaty as a triumph, thankful that their loses were not greater. Accordingly, the Senate rewarded Dario with land near Padua, a dowry for his daughter Marietta, and a substantial gift of cash, with which he rebuilt a Gothic palace in the new Lombardesque classicistic style, inspired by the contemporaneous S. Maria dei Miracoli (fig. 28) and including an all-stone façade.

The design of the ground-floor façade imitates the Ca' Foscari (fig. 74) in its symmetry, while the upper floors echo the asymmetry of the Ca' d'Oro (fig.

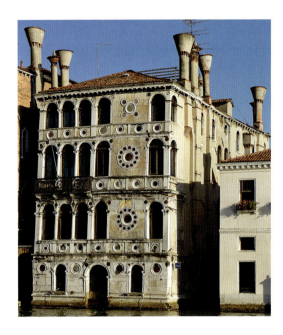

76. Circle of Pietro Lombardo, Ca' Dario, c. 1488, limestone and colored marbles, Grand Canal.

72). A three-bay loggia to the left and a pair of windows to the right respectively mark the *portego* and the *albergo* on all three upper floors. Progressively shorter piers frame the corners of each of these floors and divide the loggias from the paired windows of the *alberghi*. All the openings are round arched and carried on piers or columns. Only the crowns of the arches, rather than vertical supports, carry the entablatures and the cornices, creating a façade that from a classical viewpoint is rather more ornamental than structural. The colored marble panels and many marble disks set in elaborate limestone frames, derived in part from Islamic art, also indicate a continuing taste for Gothic ornamentalism. Nevertheless, the classicizing vocabulary and syntax of the façade, while lacking classical rigor, were new to Venetian palace design. Boldly and assertively, the well-traveled, cultured, and wealthy patron had his name in Latin (IOANNES DARIVS) inscribed on the ground-floor façade, but he also displayed proper moderation and humility by adding to this inscription that his success was achieved only "by means of the genius of the city" (VRBIS GENIO).

NONNARRATIVE DEVOTIONAL PAINTING

Devotional paintings were designed to hang in Venetian palaces—especially in bedrooms—as nonliturgical objects of domestic meditation, prayer, instruction, and aesthetic enjoyment (see figs. 58 and 59). They also served as talismans to protect the family against sickness, discord, and misfortune. The largest percentage of nonnarrative devotional images represented the Holy Family—sometimes with various other saints, more often just the Virgin and Child—the supreme model of a pious, loving, and harmonious patriarchal family and a microcosm of the ideal state of Venice, born under the protection of the Savior and his mother. The Virgin exemplified the wife's expected humility, obedience, and chastity, and the infant Jesus fostered her desire to produce and raise respectful and loving children, especially males. St. Joseph and other male saints reminded the husband to honor, protect, and support his family. For a couple's children, an image of the Holy Family offered an example of virtuous behavior and parental respect. Most important, such paintings taught the entire family the essential tenets of Christian theology and offered hope for salvation.

JACOPO BELLINI'S *VIRGIN AND CHILD*

Jacopo Bellini established the prototype for Venetian half-length depictions of the Virgin and Child in the fifteenth century, and his sons, Gentile and Giovanni, further developed the genre. In the course of the fifteenth and early sixteenth centuries the type became a specialty of the Bellini workshop, which produced dozens of examples—all variations on a few compositional themes—

in response to a great demand. Competing workshops painted countless others largely inspired by Bellinesque models.

These paintings usually employed two important visual devices that made them exceptionally effective. First, an illusionary marble parapet created a sill that allowed the viewer to approach the holy figures closely, as if they were standing at an open window, but simultaneously functioned as a barrier to separate them from the real world. Second, figures in the painting were represented as both poignantly human and serenely divine.

In Bellini's Lovere example (fig. 77), the dark neutral background projects the Virgin close to the picture surface, while the raking light from the upper left sculpts her body, her form instantly perceptible by means of its lucid silhouette. By depicting the Virgin at nearly life size, standing in a space behind the parapet similar to the space of the viewer standing in front, Bellini constructed an intimate eye-to-eye encounter between the Virgin and the observer. Her tender maternal flesh-on-flesh embrace of Jesus further heightens her humanity as a symbol of the earthly Church. However, she wears a gem-studded crown and broach, a gold-speckled robe, and a golden halo whose inscription identifies her as the blessed mother of God and queen of heaven. Her demeanor is also regal, even hieratic, as she looks down as if elevated slightly above the viewer's eye level.

Bellini also depicted the Christ child dualistically. On the one hand, he gazes lovingly out at the viewer—a plump, active, smiling baby caressing his mother's hand and wearing a red coral necklace as a charm against evil. On the other hand, he steps slightly forward to accept his divinely ordained mission to

redeem humanity and offers a precocious benediction, signaling the promise of salvation through his coming redemptive sacrifice, symbolized by his cruciform halo. Similarly, the open book with its pages still aflutter on the parapet appears to project into the observer's space as a material object, but it also represents the Scriptures, where the story of Christ has already been foretold.

Bellini casually affixed a naturalistic piece of paper with his signature to the parapet, as if piously petitioning to be remembered and protected by the Holy Family. On the other hand, the small placard also proudly declares the painting to have been made by Jacopo Bellini and suggests that just as he used his skill to translate his creative imagination into the physical act of painting, so too the painting facilitates the practiced prayers of the viewer to mediate between spirit and matter. Furthermore, a number of Italian churches displayed on their altars half-length independent icons of the Virgin and Child that the Evangelist Luke, the patron saint of painters, was believed to have painted from life. By imitating the prototype, Bellini showed himself to be a new St. Luke, who, through the power of his imagination, re-created an image of both of the earthly Virgin and the queen of heaven.

GIOVANNI BELLINI'S *VIRGIN AND CHILD* (*DAVIS MADONNA*)

In contrast to Jacopo Bellini's well-preserved image of the *Virgin and Child* (fig. 77), the badly abraded *Davis Madonna* (fig. 78) by his younger son, Giovanni, more strongly emphasizes the worldly aspects of the Holy Family. The Virgin is depicted in a landscape with brighter, more natural light, which both silhouettes and plays across her form to make her more sculpturally present to the viewer. Her cape—once a deep and vibrant blue made from crushed lapis lazuli—has more the look and feel of real cloth. The Christ child is fatter and more rosy cheeked as he stretches out to take a nap on the parapet, tipped up to make his physical presence nearer.

Yet paradoxically, Bellini has also intensified the supernatural aspects of the Holy Family. The landscape seems so low and distant that it monumentalizes the Virgin by contrast and projects her head against the sky, creating a cosmic halo that magnifies her gold halo, now almost entirely abraded. The Virgin's hands are joined in prayer, creating a small tabernacle over her infant son, and her expression is introspective and sad in her foreknowledge of his fate.

The sumptuous cushion under the infant's head is a sign of Jesus's sacredness. His sleep prefigures his redemptive sacrifice, and his left hand on his chest

77. Jacopo Bellini, *Virgin and Child,* signed, late 1440s, tempera on panel, 3 feet 2⅜ in. × 1 ft. 10⅞ in. (97 × 58 cm), Galleria dell'Accademia di Belle Arti Tadini, Lovere, Italy.

78. Giovanni Bellini, *Virgin and Child* (*Davis Madonna*), c. 1455–60, tempera on panel, 2 ft. 4½ in. × 1 ft. 6¼ in. (72 × 46 cm), Metropolitan Museum of Art, New York.

focuses attention on the site of the future wound in his side, from which will issue water and blood (John 19:34), prefiguring the sacraments of baptism and the Eucharist. Thus, the artist has symbolically transformed the parapet mediating between the viewer's space and the space of the painting into an altar mediating between death and renewed life.

GIOVANNI BELLINI'S *VIRGIN AND CHILD WITH TWO TREES*

In *Virgin and Child with Two Trees* (fig. 79), Bellini exploited to great advantage the new medium of oil painting, which he introduced to Venetian painting in the early 1470s. Compared to quick-drying, high-keyed tempera,

slow-drying oil offered a richer range of hue and saturation, allowing a much greater degree of naturalism than ever before. The light from the upper left, for example, casts warm, luminous shadows and sculpts the figures in space, slightly blurring their silhouettes, as if they were enveloped by a palpable atmosphere. Bellini also modulated the surfaces so that flesh, cloth, and hair all appear softer and more pliant than previously. This refined technique is especially evident on the patterned sheen of the watered-silk cloth of honor hanging behind the Virgin. In addition, the landscape setting, the casual postures, the tender interlacing of hands, the Virgin's sidelong glance at her son, and Jesus's gaze out at the viewer with an open mouth, as if about to speak, all express human warmth and intimacy.

Yet simultaneously, Bellini heightened the Holy Family's spiritual majesty and mission, through their delicate halos; the monumental, surreal scale of the Virgin relative to the landscape; the symbolic cloth of honor, which expresses divine sovereignty; and the trees, which symbolize the cosmos, even as far back as Mesopotamian art. The shootlike trees (*virga* in Latin) evoke the spiritual fecundity of the Virgin (*virgo* in Latin) and suggest the Garden of Eden or the Tree of Jesse, an emblem of Christ's genealogy from David to the Virgin (Isa-

iah 11:1–3). Finally, the Virgin's introspective, foreknowing expression and Christ's crossed feet and limp right arm foreshadow the coming Crucifixion, which will redeem humankind.

Christ's toes point to Bellini's signature, which, along with the open brushwork, reminds the viewer of the presence of a particular painter in a single moment of time. Yet the signature appears to be engraved permanently on the marble parapet, as if communicating Bellini's desire to offer his creative imagination as a meritorious act to assist the realization of his hoped-for immortality.

GIOVANNI BELLINI'S BRERA *VIRGIN AND CHILD*

Toward the end of his long career Bellini pushed even further the natural-supernatural duality to create works of even greater complexity and depth. In the Brera *Virgin and Child* (fig. 80), with its broad format, large three-quarter-length Virgin, detailed landscape, and broad expanse of sky, the title figures appear more than ever before to be in and of the natural world as they both gaze directly at the viewer. The exquisitely positioned hands express a tender

love between the innocent baby Jesus and his youthful mother. In addition, the faceted drapery and the crisply creased cloth of honor demonstrate Bellini's handling of texture, color, and light as far more sophisticated and naturalistic than previous attempts.

Yet the Virgin sits in triumph, more majestic that ever before, owing to her hieratic symmetry and bulk, the backdrop of mountains, and the cosmic halo of clouds. The Christ child blesses in the traditional pose of the savior of the world, stepping forward to begin his redemptive sacrifice as the tree leaves turn brown in anticipation of his death. At the lower right a shepherd guards his flock, evoking Christ's tutelage of his flock of believers. On the opposite side a pair of Adam and Eve–like lovers under a tree evoke humanity's fall from grace. In front of the lovers Bellini engraved his name and date on a classicizing sacrificial altar or gravestone on which sits a monkey, a traditional symbol of sin and evil. The eighty-year-old artist thereby expressed his unworthiness in the face of his approaching death. The monkey, however, also evokes the well-known classical phrase *ars simia naturae* (art apes nature) to indicate that, through his painterly skill and creativity, echoing God's creation, Bellini hoped to merit salvation.

NARRATIVE DEVOTIONAL PAINTING

The term *narrative devotional painting* applies to nonliturgical works for palace walls that depict some historical or hagiographic action based on narrative texts such as the Bible or the *Golden Legend*. In the case of Giovanni Bellini, however, as Pietro Bembo (1470–1547) explained to the marchioness of Mantua Isabella d'Este (1474–1539) in a letter dated January 1, 1505, published by Giovanni Gaye in 1840, the artist disliked commissions with specific narratives. Rather, the narratives had "to be accommodated to the fantasy of him who has to paint it [i.e., Bellini]," for "very precise terms do not suit his style, accustomed, as he says, always to roam at will in paintings" (vol. 2, pp. 71–72). Thus his narrative devotional paintings are often more evocative than illustrative and demand that the interpreter "roam at will," contemplating the artist's suggestions within the limits of visual traditions and Christian texts and theology. As a result, art historians have produced widely divergent readings of the three paintings discussed below, and those offered here make no claim to being definitive.

GIOVANNI BELLINI'S *BLOOD OF THE REDEEMER*

In the early *Blood of the Redeemer* (fig. 81) Bellini has employed a rigorous one-point perspective with steep orthogonals and a high focal point, at Christ's left pectoral. Since the focal point is at the presumed eye level of the viewer, the beholder appears to be looking down on the tiled floor from a point close to the small figure of Christ (about sixteen inches tall), who holds the cross of his crucifixion, draped with his crown of thorns.

81. Giovanni Bellini, *Blood of the Redeemer,* 1460s, tempera on panel, 1 ft. 6½ in. × 1 ft. 1½ in. (47 × 34 cm), National Gallery, London.

The checkerboard pavement and enclosing balustrades recall chapels and chancels of Venetian churches and suggest a consecrated space, with Christ standing in for the altar. The sacredness of the setting is heightened by the absence of cast shadows, Christ's halo, the golden clouds around his legs (now abraded), and the angel who humbly kneels to capture Christ's precious blood yet performs a priestlike elevation of the chalice, the liturgical reenactment of Christ's resurrection and a sign of exaltation and thanksgiving believed to produce the conjunction of heaven and earth. Thus, the scene's small scale and narrative action encourage the viewer to contemplate the meaning of Christ's sacrifice, transubstantiation, and the Eucharist.

The parapet includes two simulated classicizing reliefs. On the left, a toga-clad priest with a jug and a dish pours a libation on the altar's flame in the company of a satyr playing double pipes and a nude youth holding a spear. With his extended right hand, marked with a nail wound, Christ appears to cancel the left relief, suggesting the Christian belief that his crucifixion supplanted all previous pagan and Old Testament sacrifices and promised an era of spiritual peace. The relief on the right depicts a crowned sovereign seated on a sphinx throne, holding a caduceus, a symbol of peace, and gesturing toward an incense burner, into which a standing soldier wearing a helmet appears to drop incense. It has been suggested that the cross-armed nude youth behind the soldier is a captive and that the sovereign is performing a ritual of liberation. If so, Bellini intended that this scene of physical emancipation be understood as having been superseded by the Eucharistic ritual, which promises spiritual salvation.

The background adds further nuances to a pious viewer's meditation. To the right at the foot of the mountains, a classicizing ruin symbolizes the triumph of the new covenant over the old. In front of the ruins Bellini depicted a priest followed by a young acolyte, both dressed in the blue habit and distinctive skullcap of the secular canons of S. Giorgio in Alga, an important Venetian reforming order of patricians founded in 1404. Their presence in the barren landscape suggests that salvation through Christ's redemptive death is achieved through faith, prayer, and renunciation of the material world.

The left side of the landscape has a small fortified village with a chapel and its bell tower, alluding to the Church as the institutional gateway to salvation. The distant bluish but apparently fertile background features a large walled city, a traditional symbol of the new Jerusalem, seen just over Christ's right shoulder. The light-filled horizon—representing either dusk or dawn—appropriately evokes both Christ's death and his resurrection.

GIOVANNI BELLINI'S *ST. FRANCIS IN THE DESERT*

The Venetian nobleman Marcantonio Michiel (1484–1552) recorded in his 1525 *Notizia d'opere di disegno* (Notes on works of art; translated in 1969 as *The Anonimo*) that Bellini's *St. Francis in the Desert* (Michiel's title; fig. 82) had been commissioned by Giovanni (Giacomo) Michiel—a member of the Confraternity of S. Marco (as was Bellini) and its onetime grand guardian—but now hung in the palace of Taddeo Contarini (c. 1466–1540), a wealthy, humanist-trained Venetian merchant (1969 ed., pp. 104–5).

St. Francis and his Franciscan followers dedicated their lives to poverty, penitence, and prayer. They believed that they were engaged in a purifying ascetic pilgrimage of teaching and preaching through the desert of life, imitating Christ's forty days spent in the desert in preparation for his Passion (Matthew 4:2; Mark 1:13; Luke 4:2), commemorated liturgically by Lent, the forty-day period from Ash Wednesday to Easter Sunday. Christ, in turn, had imitated the forty-day fast of Elijah (3 Kings 19:8) and the forty years that Moses and the Israelites spent wandering in the desert.

The rocky foreground of Bellini's painting, therefore, represents the setting for Francis's desert pilgrimage. As the saint's anonymous biographer wrote in the *Speculum perfectionis* (Mirror of perfection), "When he [Francis] walked over stones he would walk with great fear and reverence for the love of Him who is called the Rock [i.e., Christ]; whence, when he recited that passage in the Psalms, 'Thou didst exalt me on a rock,' he used to say, out of great reverence and devotion, 'By the rock under foot thou has exalted me.'" This exaltation was achieved through Christ's redemptive sacrifice, symbolized by the rocks' many fissures, signs of the moment during the Crucifixion when "the earth quaked and the rocks were rent" (Matthew 27:51). The many plants growing from the rocks suggest regeneration.

Many other details evoke the saint's catharsis, the purging from his body of material desires to focus on the spirit, assisted by the three sacraments essential for salvation—baptism, penance, and the Eucharist. The juniper bush and jug of water directly behind Francis, for example, make reference to Elijah, who, in preparing to die, "cast himself down and slept in the shadow of a juniper tree" only to awake and find that "an angel of the Lord" had prepared "a hearth cake and a vessel of water" (3 Kings 19:5–6). The hearth cake and water were traditionally interpreted as symbols of baptism and the Eucharist, and the evergreen juniper as the promise of eternal life. Although Bellini did not depict a hearth cake, he did represent a vessel of water, a juniper, and (behind the juniper)

83. Giovanni Bellini, *Sacred Allegory,* c. 1480, oil on panel, 2 ft. 4¾ in. × 3 ft. 10⅞ in. (73 × 119 cm), Galleria degli Uffizi, Florence.

holding the sword with which he was martyred (and in Venice an emblem of justice), appears to drive away the turbaned Moor to the far left, an emblem of the Turks, who were constant threats to Christendom in the Renaissance. A cluster of grapes tied to the Virgin's canopy makes reference to Christ's redemptive sacrifice and to the Mass. Finally, the barefoot woman to the Virgin's right—dressed in green and white (the colors of hope and faith), her hands held in prayer—appears to embody *amor proximi,* as her loving gaze at the children indicates. If so, the woman to the Virgin's left—dressed in red and blue (the colors of charity and divinity), wearing a golden crown (a symbol of divine reward), and holding her hands in prayer—probably embodies *amor dei,* as her inward meditation and beatific smile suggest. Bellini therefore shows the three sacraments of salvation—baptism, penance, and the Eucharist—and the Theological Virtues, with emphasis on both aspects of charity, to be the means of reaching paradise.

radiance, a sign of a divine presence. The laurel aglow with light recalls Moses before the burning bush (Exodus 3:1–10), which was a common prefiguration of the Incarnation, since the shrub aflame yet unconsumed was equivalent to Mary, who although impregnated remained a virgin. In this same episode, God commanded Moses, "Come not nigh hither, put off the shoes from thy feet: for the place whereon thou standest is holy ground," just as Bellini has represented Francis, the new Moses, barefoot while standing on sanctified ground, radiant in the light of Christ. God also commanded Moses to liberate the Israelites from Egypt and lead them through the desert "into a land that floweth with milk and honey" (Exodus 3:8), which prefigured the mission of Francis and the Franciscan Order to lead humanity to salvation by imitating Christ's catharsis in the desert.

Significantly, the fall of divine light counterbalances the structure of the rocky foreground, creating a composition of crossing diagonals—one material, the other spiritual—that thematizes the content of the entire painting: from the rejection of the material world comes spiritual enlightenment, the fundamental premise of asceticism. Finally, the contrast between the rocky foreground and the verdant background, with its city, forest, stream, and donkey, evokes Isaiah's prophecy of paradise regained: "Once more there will be poured on us the spirit from above; then shall the wilderness be fertile land and fertile land become forest. In the wilderness justice will come to live Happy will you be, sowing by every stream, letting ox and donkey roam free" (Isaiah 32:14–20, Jerusalem Bible).

In the lower left foreground Bellini affixed an illusionistic strip of paper with his signature on the dry branch on which the bittern has alighted. By locating his signature on a dead plant near an abyss, Bellini suggested his profound awareness of his sinfulness and mortality. Yet the nearby spout of water and green plants growing from the barren rock, as well as the bittern poised to take flight, also evoke his hope for regeneration through his personal *imitatio Christi,* his virtuoso exercise of concentrated manual labor and creative imagination.

GIOVANNI BELLINI'S *SACRED ALLEGORY*

The orthogonals of this enigmatic painting (fig. 83) focus above a shepherd's cave, drawing the viewer's eye across the water to a village on the distant shore, where a man strides with a hoe over his shoulder, a muleteer drives a mule, and two figures converse. Behind the village Bellini depicted a rocky mountain, dense forest, villa, and fortified castle—all elements of the mundane world.

Even more insistently the orthogonals draw the eye to the nearer, right shore, where a shepherd sits in a cave surrounded by his flock. On a cliff above, a barren hermitage is delimited by a rustic stone altar, a crude masonry wall, a cross, and a wicker fence. The hermit is walking down the stairs from his hermitage and is about to meet a centaur on the shore. The centaur identifies the hermit as St. Anthony Abbot (c. 251–356), the founder of monasticism, who is setting off to visit the first Christian hermit, the 113-year-old St. Paul of Thebes (d. c. 340), and is shown the way by a centaur, according to the *Golden Legend.* The hermit and the shepherd suggest that an ascetic life of faith, penitence, and prayer promises salvation through Christ, the Good Shepherd, and the sacraments of the Eucharist and baptism, symbolized by the rustic altar and water.

The perspective, with its steep orthogonals and high focal point, makes it appear that the beholder is looking down at the balustrade-surrounded foreground enclosure. This enclosure appears to be a sign of paradise, owing to the sheer geometrical and mathematical perfection of its spatial construction, the material splendor of its marble paving, and the visual elegance of its design. In the enclosure, to the right, the standing, seminude SS. Job and Sebastian serve as intercessors against the plague, probably in reference to Venice's devastating 1478 plague.

In the center of the enclosure an infant shakes golden apples from a potted tree while three other innocents gather and contemplate the fruit. The tree recalls the Tree of Knowledge in the Garden of Eden, with its forbidden fruit, thereby reminding viewers of original sin and humanity's fall from grace. According to medieval tradition, the cross of the Crucifixion was fashioned from the Tree of Knowledge and was then revivified by Christ's blood to become the Tree of Immortal Life. The child seated on the cushion wearing a pure white shirt, therefore, surely must be understood as the infant Jesus. If so, then the enthroned woman—displaying a golden halo (now visible only in a reflectogram) and with her hands joined in prayer—is certainly the Virgin Mary, dressed in her usual red tunic, blue cape, and white veil. She sits under a canopy, a symbol of sovereignty and dominion, appropriate for the embodiment of the earthly Church. While the gate is open to the mundane world of sin and temptation beyond, the enclosure nevertheless remains a *hortus conclusus,* a closed (or closable) garden, symbolic of Mary's fruitful virginity.

The reference to the Church is enhanced by the presence of SS. Peter and Paul, the founders of the Church, who stand guard outside the balustrade. Peter, with his hands in prayer, gazes adoringly at the infant Jesus while Paul,

a plantain, a common weed that belongs to the lily family and proliferates along Italian roadsides. The plantain was nicknamed *waybread,* for its white flowers often reminded pilgrims of the Eucharist.

Francis's outstretched arms also draw the viewer's attention to a branch of fig leaves in the lower right foreground and a lightening-blasted fig tree with a single leaf under his right hand. They symbolize original sin and its punishment, which was redeemed by Christ's sacrifice and imitated by Francis's purgative life of atonement in the desert.

A rabbit, a symbol of fertility, pokes its head out of the garden wall just under Francis's right hand, evoking the regenerative potential of asceticism by reference to Proverbs 30:24, 26: "There are four very little things of the earth, and they are wiser than the wise," among which is "the rabbit, a weak people, which maketh its bed in the rock [i.e., has faith in Christ]."

Francis was particularly partial to birds, to which he preached, and on the edge of the cliff in the left middle ground Bellini represented a heron and in the lower left foreground, under the waterspout, a bittern. The heron and the bittern were known in the Bible as birds of solitude and were thus appropriate companions for Francis's solitary life in the desert. But like all birds, they were also emblems of liberated souls. The shepherd with his flock in the valley behind the heron alludes to Christ as the sacrificial Lamb of God and the savior of the Christian flock.

The donkey near the heron and the water trough projecting from the rock just above the bittern, which is aligned with the donkey, reference a specific event recorded by Bonaventure (1221–74) in his biography of Francis known as the *Legenda major* (7.12):

Another time, while traveling to a hermitage where he planned to devote himself to prayer, St. Francis rode an ass belonging to a poor laborer, because he was weak. It was summertime and, as the owner of the animal followed the saint into the mountains, he was exhausted by the long and grueling journey. Fainting with thirst, he began to cry out insistently, saying that he would die immediately if he did not get something to drink. Francis dismounted there and then and knelt on the ground with his hands stretched out to heaven, and there he prayed until he knew that he had been heard. When he had finished, he said to his benefactor, "Go to that rock and there you will find running water. In his goodness Christ has made it flow from the solid stone just now for you to drink." The man ran to the spot Francis pointed out and he had his fill of water, which had been produced from a rock by the power of one man's prayer, a drink which God offered him from solid stone.

The episode recalls Moses striking water from the rock, prefiguring the wound in Christ's side from which flowed water and blood, signs of baptism and the Eucharist. Francis's biographers repeatedly referred to the saint as both another Christ and a new Moses.

Francis's rustic study before his cell also makes many references to Christ and the sacraments. The reed cross with a crown of thorns on the lectern evokes the Crucifixion. The skull at the base of the cross recalls Adam, traditionally believed to have been buried at the foot of Jesus's cross on Golgotha (Place of the skull) and redeemed by Christ's blood. The grape arbor above the lectern signifies the Crucifixion and the Eucharistic wine. As St. Bonaventure wrote in *Vitis mystica* 6.1–2, "The woodwork of the trellis upon which the vine is often spread symbolized the cross Our vine, the good Jesus, is lifted up on it." The cave used as Francis's cell suggests Christ's tomb, and its gate made of severed yet sprouting willows his death and resurrection. Francis's walking stick, in the shape of the Greek tau, symbolizes salvation, for this letter was the sign that saved the Israelites at Passover (Exodus 12:7, 13) and is the emblem that will mark the foreheads of the elect at the Second Coming (Apocalypse 7:3). The bell suspended from the grape arbor and the Scriptures on the lectern transform the entire cell into a rustic chapel, evincing the Franciscan image of the Church as a desert pilgrimage. Francis's sandals under the lectern evoke his pilgrimage but also the mission of the Franciscan Order to preach, reform the Church, and lead the faithful toward salvation, just as Moses led the Israelites through the desert toward the Promised Land.

Pilgrims who had visited Francis's rugged hermitage on Mt. Alverna (La Verna) in Tuscany would have recognized that Bellini shaped the rocky foreground to recall the setting where Christ honored Francis with the stigmata. Thus, Francis is not just displaying but receiving the stigmata. He stands bathed in divine radiance, as was Moses when he received the Ten Commandments. As Bonaventure wrote in the *Legenda minor* (6.4), "He [Francis] came down from the mountain [Alverna] bearing in himself the form of Jesus Crucified, not portrayed upon tables of stone . . . but drawn upon his flesh by the finger of the living God." Bellini also suggests that Francis—depicted with his mouth open—is singing praise to God, by including under his knotted rope belt the still extant folded piece of parchment on which the saint wrote one of his famous lauds.

The laurel tree to the left was a classical symbol of victory and was sacred to the sun god Apollo. Apollo in turn was a common metaphor for the triumphant Christ, the sun of justice. The laurel bends in response to a golden

82. Giovanni Bellini, *St. Francis in the Desert,* signed, c. 1475–80, tempera and oil on panel, 3 ft. 11¼ in. × 4 ft. 5⅞ in. (120 × 137 cm), Frick Collection, New York.

10

PORTRAITS OF MEN

Portraits with accurate likenesses rendered in marble, bronze, and paint appeared in many contexts in Venetian Renaissance art: on public monuments (figs. 10, 12, and 14), tombs (figs. 35–40), coins, and medals. They were also found in altarpieces (figs. 135, 136, 139, and 141); manuscripts; votive reliefs and paintings (figs. 179 and 229) for palaces, administrative offices, and council chambers; narrative paintings for confraternities (figs. 9, 58, 60, 63, 67, and 71) and halls of state (figs. 237 and 242); and fresco decorations for villas (fig. 265). Marble and bronze portrait busts were also sculpted for domestic display, although only from about the mid-sixteenth century onward. But the concern here is for independent accurate likenesses of living people painted on panel or canvas, made to decorate the walls of palaces. In his life of Giovanni Bellini, Giorgio Vasari, who visited the city in the early 1540s, recorded that "in the houses of Venice are many portraits, showing family members going back four generations or more." Indeed, independent portraiture was a major genre of Venetian art, especially in the sixteenth century.

Autonomous painted portraits are known to have been made in antiquity, although none survive. In the postclassical period they first reappeared in the fourteenth century in the Franco-Flemish courts of northern Europe, as bust-length profile portraits of sovereigns. By the early fifteenth century, bust-length three-quarter-view portraits of both sovereigns and nonsovereigns had become a popular genre for northern European artists, whose paintings Venetians began to collect from about the mid-fifteenth century.

Beginning in the later fourteenth century in Venice, portraits or pseudoportraits of the unbroken succession of doges from the founding of the duchy in the eight century through the Renaissance were represented, probably initially very generically, in a frieze high on the walls of the Sala del Maggior Consiglio, but all were lost in a fire of 1577. The first Venetian independent portraits painted from life for a domestic context were likely created by the central Italian artists Gentile da Fabriano and Pisanello (c. 1395–c. 1455), who worked together in Venice from about 1408 to 1414, although none have survived.

GIAMBONO'S *PORTRAIT OF A MAN*

The circa 1432–34 *Portrait of a Man* (fig. 84) by Michele Giambono (c. 1395–1463), clearly influenced by the naturalistic style and silver-leaf technique of Gentile da Fabriano and Pisanello, is probably the earliest Venetian portrait to survive. The bust-length profile format, which emphasizes the subject's fur hat and sumptuous embroidered costume trimmed with marten fur, closely relates it to the portraiture of the Franco-Flemish courts.

The subject is unknown, but judging from his physiognomy and dress, he was certainly a high-ranking non-Venetian, perhaps a member of the court of Sigismund (1368–1437), the king of Hungary, Croatia, and Bohemia, who visited Italy in 1432–33, or perhaps one of several high-ranking individuals from the Balkan Peninsula given honorary Venetian patrician status under Doge Francesco Foscari to strengthen support for Venetian defenses along the shores of the eastern Adriatic.

Giambono's portrait—bust length and in profile, like the few other still extant Venetian portraits painted before 1470—has captured the essential char-

acteristics of an individual's likeness, making the subject easily recognizable and memorable. By recalling the profile portraits of Roman emperors on coins and medals and the early independent painted profile portraits of northern European rulers, the format evokes sovereignty and dominion. Yet it lacks mobility, spontaneity, and subtle nuances of character and emotion.

Both Marcantonio Michiel and Vasari record that Jacopo Bellini created independent painted portraits, but only a circa 1450–55 posthumous "portrait" of St. Bernardino of Siena survives. However, after about 1460 his older son, Gentile Bellini, became one of the most important portraitists in Venice. As the official portraitist for the doges in the second half of the fifteenth century, he (or his workshop) painted at least five surviving bust-length profile ducal portraits.

BASTIANI'S *DOGE CRISTOFORO MORO*

The best-preserved early ducal portrait, however, is not by Gentile Bellini but by a close follower of his, Lazzaro Bastiani. In his *Doge Cristoforo Moro* (fig. 85) the bust-length doge in profile is projected against a dark background and into a defused, nondirectional light, as if emerging from a cameolike matrix. His official costume, which flattens his corpulent form, consists of an elaborate floral brocaded gold and scarlet cape (a *bavaro,* which could also be pure white or scarlet) edged in ermine at the collar and buttoned in front with eight prominent gold buttons (*campanoni*). His distinctive ducal crown (*corno*), also in gold and red floral brocade, rests on a white linen cap (*veta*) covering his ears and tied beneath his chin. The cap was a sign that the doge had been ritually anointed as the quasi-sacred head of state. The individualized thickset head is characterized by a furrowed brow, arched eyebrows, eyes with crow's-feet and pouches, an aquiline nose, fleshy jowls set off by deep creases from the nose to the mouth, thin lips, a prominent chin, and a plump neck. The overall effect is one of iconic majesty and near-sacred dignity, expressed by the garb of the highest office combined with the physiognomy of an alert, benign, well-fed, and intelligent individual.

GIOVANNI BELLINI'S *JÖRG FUGGER*

The inscription once on the back of this painting (fig. 86) dated it 1474 and identified the blue-eyed subject as the twenty-one-year-old German merchant Jörg Fugger (1453–1506), the heir to the wealthy German banking family cen-

tered in Augsburg. Since Fugger was in Venice in 1474, residing at the Fondaco dei Tedeschi (fig. 2, no. 1), the portrait was surely painted from life. It is the earliest extant portrait by Giovanni Bellini, one of the first Italian portraits to use an oil medium, and one of the first known three-quarter-view bust-length portraits in Venetian art. The three-quarter pose was probably inspired by Netherlandish portraits known to have been in Venetian collections before 1470 or by the circa 1459–60 *Portrait of Cardinal Ludovico Trevisan* in Berlin by Andrea Mantegna (c. 1431–1506), Bellini's brother-in-law, who married Bellini's sister, Nicolosia (c. 1429–1475/89), in 1453.

The blue background has oxidized and turned nearly black but originally would have silhouetted and projected Fugger forward, making him appear more sculptural and immediate. Bellini visually animated the youth by means of his lively curled hair, the three-quarter turn of his head toward the light, his intense gaze leftward, and his introspective, slightly moody expression. A wreath made of small heart-shaped leaves and blue blossoms (amaranth?) encircles his head, suggesting that he aspired to be a poet or humanist—an impression enhanced by his radiant features.

ANTONELLO DA MESSINA'S *PORTRAIT OF A MAN*

This portrait (fig. 87), signed and dated 1475, typifies several that Antonello da Messina painted in Venice from late 1474 to early 1476. The bust-length, three-quarter-view, highly individualized figure emerges from a dark background into a strong raking light. He wears a brimless black cap (*berretta*), a long fur-lined doublet (*vesta*) tied at the neck, and a linen undergarment (*camicia*) visible just above his collar. His fashionable, shoulder-length Venetian hairdo (*zazzera*) rolls under to create bangs over his eyes and ears. Antonello animated his figure by turning the bust and head at a slight angle to the picture plane with the eyes gazing directly at the viewer. The oil medium also facilitated his acute observation and meticulous modulation of the surfaces, allowing him to capture a convincing likeness of a man in the prime of life. The subject's bristly stubble, bull neck, square jaw, clenched teeth, and puckered lips all communicate physical strength and mental resolve, resulting in the conventional title, *The Mercenary* (*Il Condottiero*), although this man is more likely to have been a Venetian *cittadino* or patrician.

Antonello also adapted the parapet used by some Flemish painters, such as Jan van Eyck, to intensify the portrait's immediacy, suggesting an eye-to-eye encounter between the subject and the observer through a windowlike open-

ing. However, the parapet also separates the subject from the viewer, conveying distance and superior virtue, emphasized by the dark background. The parapet serves as well to locate an apparently casually affixed scrap of paper with the artist's signature and date, as if affirming that "I, Antonello, was here on this date, and this is exactly what I saw and recorded." The placard also called attention to the technical virtuosity and lucid intelligence of the artist in successfully capturing the notoriously elusive nuances of character and personality.

After Antonello's sojourn in Venice, personalized bust-length three-quarter-view portraits painted in oil, often with a parapet, began to appear in ever larger numbers, especially from the Bellini workshop.

GENTILE BELLINI'S *SULTAN MEHMED II*

Gentile Bellini's 1480 *Sultan Mehmed II* represents an early manifestation of Antonello's influence (fig. 88). At the signing of the Treaty of Constantinople, which ended the 1463–79 war with the Turks, Mehmed II's ambassadors to Venice requested the services of "a good painter who knows how to make portraits" to work at the Ottoman court. The Venetian Senate sent Bellini, who in 1469 had been knighted by Holy Roman Emperor Frederick III (1415–

84. Michele Giambono, *Portrait of a Man,* c. 1432–34, tempera and silver leaf on panel, 1 ft. 8⅞ in. × 1 ft. 3¾ in. (53 × 40 cm), Musei di Strada Nuova, Palazzo Rosso, Genoa.

85. Lazzaro Bastiani, *Doge Cristoforo Moro,* c. 1462–69, tempera on panel, 1 ft. 8 in. × 1 ft. 4⅛ in. (51 × 41 cm), Museo Civico Correr.

86. Giovanni Bellini, *Jörg Fugger,* dated 1474, tempera and oil on panel, 10½ × 7⅞ in. (27 × 20 cm), Norton Simon Museum, Pasadena, California.

87. Antonello da Messina, *Portrait of a Man,* signed and dated 1475, oil on panel, 2 ft. 2¼ in. × 11¾ in. (36 × 30 cm), Musée du Louvre, Paris.

93). During his stay in Constantinople, from 1479 to 1481, Bellini was made a golden knight and a palace companion by the sultan for his artistic efforts.

Developing the format, motifs, and oil technique introduced by Antonello and his own brother, Giovanni, Bellini placed the bust-length three-quarter-view sultan—dressed in his traditional costume of fur-trimmed red kaftan and white turban around a red conelike cap—in a classicistic arched window and behind a marble parapet bedecked with a sumptuous jewel-studded cloth of honor. The elaborately framed opening allows an intimate visual encoun-

ter with the bearded and introspective sovereign but also separates and distances him from the viewer, as is appropriate for someone of such high rank, described on the parapet as a "world conqueror." The sultan's dynastic lineage is indicated by the crown shaped from pearls on the cloth of honor, a reference to the House of Osman, of which Mehmed II was the seventh sovereign. In addition, the six crowns that flank the archway are emblems of the previous six rulers of the Osman dynasty, while their arrangement in two groups of three evokes the three territorial components of the Ottoman Empire—Greece, Asia, and Trebizond.

GIOVANNI BELLINI'S *YOUNG SENATOR*

In his later portraits Giovanni Bellini generally followed the layout that Antonello popularized, bust-length three-quarter views of subjects often standing behind a parapet. In *Young Senator* (fig. 89) and a number of other portraits, beginning probably in the 1480s, Bellini added a background of sky and clouds to the formula, perhaps again following the lead of Antonello in his small, last *Portrait of a Man* (now in the Gemäldegalerie in Berlin), of 1478, depicting a young man in Venetian dress, which was documented in a Venetian collection in the eighteenth century. Bellini may also have been influenced by Hans Memling, whose portraits with landscape backgrounds of the 1470s and 1480s were collected in Venice. In either case, Bellini's portraits can be easily distinguished from his sources by the subject's idealized, unblemished features and impassive, emotionless gaze into the far distance, oblivious to the viewer, and the lack of symbols or hand gestures that might distract from the figure's serene dignity and decorum, indicative of noble status.

This blond, bluish-brown-eyed youth is dressed in the costume of a Venetian senator: a black cap (*berretta*) over his shoulder-length coiffure (*zazzera*), a scarlet toga (*vesta*) fastened in front over a white linen undergarment (*camicia*), and a dark sash (*becho*) over his right shoulder, which may signal membership in a special committee or council. Given his youth, the portrait may have been commissioned to commemorate the young man's entry into the Great Council, which happened normally at age twenty-five but exceptionally at age twenty if he happened to be one of thirty winners of an annual lottery—the Barbarella, or Balla d'Oro—and paid the required fee. Unlike in Bellini's earlier, darker backgrounds, here the sky and clouds locate the subject in a more natural, less claustrophobic, light-filled environment. However, by putting the figure behind a parapet and projecting him against the heavens with a cosmic halo of sorts, the artist elevates and almost deifies him, in spite of the individualization of the features and the particularization of the details. This was quite deliberate, as the Venetian nobles who ran the government viewed themselves as a quasi-sacred elite controlling a divinely ordained institution. They were expected to comport themselves with appropriate dignity and patriotism, suppressing competitiveness and emotions for the greater harmony of the republic. The handsome, refined features of this young noble and his clear-eyed expression of intelligence and modesty suggest that he was an idealized model of this educated governing class.

ALVISE VIVARINI'S *PORTRAIT OF A MAN*

This large, bust-length three-quarter-view portrait by Alvise Vivarini (c. 1442/43–c. 1503/5) represents a portly, middle-aged man with a shadow of a beard standing behind a parapet against a dark background and wearing a black *berretta* over his *zazzera* and a blue *vesta* over a white *camicia* (fig. 90). While it closely imitates the examples of Antonello (e.g., fig. 87) with regard to the highly particularized physiognomy and the eye contact with the viewer, the lengthening of the bust to allow the representation of the left hand gripping the blue robe and with the thumb pointing back to the face is new and suggests that the subject was from the citizen class. Indeed, citizen secretaries to the Council of Ten generally wore blue or violet robes. In any case, Vivarini has captured a memorable likeness of a unique and dynamic individual who dramatically turns toward the viewer with a quizzical expression and lips slightly parted, as if about to speak.

GIOVANNI BELLINI'S *DOGE LEONARDO LOREDAN*

Giovanni Bellini's superbly preserved portrayal of the humanist-trained merchant Doge Leonardo Loredan (fig. 91) was the first to break the mold of depicting the doge in profile, introducing instead the bust-length nearly frontal three-quarter-view figure behind a marble parapet against a sky-blue background, which had been the norm for much of his own patrician portraiture for some two decades. While working within his established formula, Bellini nevertheless achieved new results by creating a balance between the two competing demands of ducal portraiture: the representation of the quasi-sacred

centuries-old majesty of the supreme governmental officer and simultaneously a compelling image of the particular individual inhabiting the office at a specific moment in time—a dynamic equilibrium between permanence and transience.

The marble parapet, which allows an eye-to-eye intimacy yet acts as a distancing barrier, is not innovative. Neither is the sky-blue background, which locates the subject in a naturalistic atmosphere while raising him to a celestial realm suffused with divine radiance. What is new is the extraordinary intensity and mobility of the golden light entering from the upper left, which spotlights and animates the left half of the composition and fades gradually into deep shadows on the right, as well as the subtle movement of light and color in the background that modulates upward from light to deep blue, both projecting the image of the doge forward and elevating him heavenward.

88. Gentile Bellini, *Sultan Mehmed II,* dated 1480, oil on canvas, 2 ft. 1⅝ in. × 1 ft. 6⅞ in. (65 × 48 cm), National Gallery, London.

89. Giovanni Bellini, *Young Senator,* c. 1480s–1500, oil on panel, 1 ft. 1¾ in. × 10⅜ in. (35 × 26 cm), Musei d'Arte Medioevale e Moderna, Musei Civici, Padua.

90. Alvise Vivarini, *Portrait of a Man,* signed and dated 1497, oil on panel, 2 ft. ½ in. × 1 ft. 6½ in. (62 × 47 cm), National Gallery, London.

The doge's costume, unchanged for centuries, with its robe with eight large gold buttons and its ducal crown—both fashioned from damask of exquisite white silk and gold thread—expresses immutability and magnificence, yet Bellini has rendered the brocade with such masterful variation in brushstrokes—from rough stippling to polished sheen—that the viewer experiences the warp

91. Giovanni Bellini, *Doge Leonardo Loredan,* signed, c. 1502, oil on panel, 2 ft. ¼ in. × 1 ft. 5 in. (62 × 43 cm), National Gallery, London.

and woof of the cloth with exceptional tactile immediacy. The doge's furrowed brow, deeply creased jowls, wrinkled neck, and distant yet introspective gaze communicate the prudence, wisdom, and equanimity gained from long experience, appropriate for ducal leadership and justice. Yet the crow's-feet around the eyes and the tension of the facial muscles around the mouth suggest congeniality and perhaps even the beginning of a smile. The face is further animated by the contrast between its relatively unblemished, light-filled left half and its more shadowed and wrinkled right half. Similarly, the left tie of the white cap under the crown hangs vertically, while the diagonal of the right tie implies that the doge has just turned his head. The elevation of the doge's shadowed left shoulder and the placement of the crown's peak too far to the right, as if twisted on the doge's head, enhance this sense of movement. Finally, even the signature equivocates, between Bellini's physical presence and his claim to eternal fame, as it appears to be affixed casually, even temporarily, to the parapet on a scrap of folded paper yet is rendered in the incised block letters that the artist often used to seemingly chisel his name in marble.

Bellini, in sum, has created a masterful work that combines serenity and energy, immutability and contingency, and conformity and individuality.

II

PORTRAITS OF WOMEN

Among the extant or recorded independent portraits painted in the fifteenth century, the ratio of male to female portraits is about four to one—an accurate reflection of the relatively low status of women in Venetian patrilineal and patriarchal society. In his 1545 *Dialogo della institutione delle donne* (Dialogue on the institution of women), Lodovico Dolce (1508/10–68) succinctly expressed the contrasting social roles of men and women:

Many things are necessary to a man: prudence, eloquence, expert skill in governing the republic, talent, memory, ability and diligence in leading one's life, justice, liberality, magnanimity, and other qualities that would take too long to recount. If any of these are lacking, he should not be reproached, since he has some of them. But in a woman one does not look for profound eloquence or subtle intelligence, or exquisite prudence or talent for living or administration of the republic, or justice, or anything else except chastity. If this is not found in her, it would be as if all the abovementioned virtues were lacking in the man, because in a woman this is worth every other excellence.

Although according to Dolce the only virtue required of all women was chastity—virginity before marriage and monogamy after, or celibacy for a nun—other writing of the period frequently mentioned obedience to her husband; modesty in speech, behavior, and dress; care for domestic affairs; and education of children as equally essential. Furthermore, as Dolce implies, women were mostly excluded from Venetian political, intellectual, and commercial life. Even the doge's wife (*dogessa*) functioned only as an occasional state host-ess and was prohibited from engaging in politics, acting as a counselor, or inheriting her husband's office. Except in a few rare instances in patrician or citizen families where tutors were provided, women rarely received more than a grammar school education. A few women, including several courtesans such as Veronica Franco (1546–91), were self-educated and achieved a measure of independence and fame as scholars and poets. But for most women, especially of the patrician and citizen classes, marriage, child rearing, and household management or, alternatively, life in a convent or a brothel were about the only options available. To be eligible and competitive in the marriage market, women had to be provided with dowries, technically limited to sixteen hundred ducats in the fifteenth century but inflated to four thousand in the sixteenth century, although among the wealthiest families, dowries as high as twenty-four thousand ducats have been recorded. A dowry remained the property of the wife, and her husband was legally obligated to protect it though prudent investments. Only lower-class, *popolani* women worked in the commercial world, mostly as shopkeepers, sailmakers in the Arsenal, artisans (especially in the cloth industry), nurses, servants, or even laborers.

Venetian women of the upper classes were also expected to be on display at civic and religious processions as beautiful and chaste objects embodying Venetian purity and prosperity. A number of Renaissance prints and paintings, such as Gentile Bellini's *Procession in the Piazza S. Marco* (fig. 9), depict lavishly dressed woman at palace windows as essential, if marginal, components of civic rituals. To add luster and elegance, women were also almost always on display at state banquets and balls in the Doge's Palace and at social galas in

private palaces, often without their husbands. Venetian Renaissance diarists and chroniclers nearly always listed the number of women present as a measure of the event's importance and grandeur.

Yet Venetian women were not only marginalized and objectified but also criminalized, for it was perceived that women adorned in all their finery undercut the republican values of sobriety and equality expected in the dress and deportment of Venetian men. Women's sins of vanity and pride, in short, needed to be regulated. Therefore, a panel of magistrates was charged to write detailed sumptuary laws that prohibited immodesty or extravagance in most aspects of social life, including theater, dance, cuisine, and especially women's dress. The laws governed the expense and manufacture of materials used in dressmaking, the cut and length of sleeves, the amount of permissible décolletage, the types and value of jewelry, and much more. But given the conflicting demand for the public display of women during certain celebratory rituals, lack of enforcement and changes in fashion repeatedly circumvented sumptuary laws.

CARPACCIO'S *TWO VENETIAN WOMEN*

The title figures of Carpaccio's *Two Venetian Women,* probably a mother and her daughter or two sisters displaying themselves on a palace balcony, offer a vivid image of female comportment and dress in the 1490s (fig. 92). The luxuriousness of their dress and the sumptuousness of the marble balcony leave little doubt that these are patrician women. While the older woman, in the foreground, plays with the two dogs, both women sit quietly, interacting neither with each other nor with the young boy, surely the son of one of them. The painting contains a number of symbols suggesting that at least one woman is married, perhaps both. On the balustrade are two turtledoves, sacred to Venus, the goddess of love and beauty. Below them is a peacock, sacred to Juno, the goddess of marriage and childbirth. A white lily and evergreen myrtle, here in the two vases on the balustrade, were traditional emblems of purity and ev-

92. Vittore Carpaccio, *Two Venetian Women,* signed, c. 1490s, oil on panel, 3 ft. 1 in. × 2 ft. 1¼ in. (94 × 64 cm), Museo Correr. Carpaccio's *Hunting on the Lagoon,* in the J. Paul Getty Museum in Los Angeles, originally formed the upper part of this panel, continuing the white lily in the left-hand vase on the parapet. The two fragments formed a single panel, hinged as the right wing of a cabinet door or a window shutter. The left wing, which must have shown the rest of the dog biting the stick at the lower left, has been lost.

erlasting conjugal love. The pearls of the necklace worn by the younger woman and the pearls sewn into the neckline of both women's dresses could symbolize spotlessness and faithfulness. Dogs were common signs of marital fidelity. The apple on the balustrade, a standard symbol of Adam and Eve's original sin, provoked by concupiscence, serves as a quiet reminder of the necessity for chastity, while the birds signal the goal of the virtuous life—salvation. These two women, in sum, appear to represent ideal Venetian wives—modest, pious, obedient, and chaste.

A journal entry describing Venetian women by a priest from Milan, Canon Pietro Casola (1427–1507), passing through Venice in 1494 on a pilgrimage to the Holy Land, however, permits a more ambiguous reading of Carpaccio's painting:

> Their women appear to me to be small for the most part, because if they were not, they would not wear their shoes—otherwise called *pianelle*—as high as they do. For in truth I saw some pairs of them sold, and also for sale, that were at least half a Milanese *braccia* in height [a pair of red *pianelle* are under the peacock's tail]. They are so high indeed that some women appear to be giants . . . and are not safe from falling as they walk, unless they are well supported by their slaves. As to the adornment of their heads, they wear their hair so much curled over their eyes that at first sight they appear rather men than women. The greater part is false hair; and this I know for certain because I saw quantities of it on poles, sold by peasants in the Piazza S. Marco.
>
> These Venetian women, especially the pretty ones, try as much as possible in public to show their chests—I mean their breasts and shoulders—so much so that several times I saw them I marveled that their clothes did not fall off their backs. Those who can afford it, and those who cannot, dress very splendidly, and have magnificent jewels and pearls and gold on head and neck and in the trimming around their collars. They wear many rings on their fingers with great balas rubies, rubies, and diamonds. I said also those who cannot afford it, because I was told that many of them hire these things. They paint their faces a great deal, and also the other parts they show, in order to appear more beautiful. . . . Above all—at least indoors—these Venetian women, both high and low, have pleasure in being seen and looked at. (Trans. M. Newett, pp. 144–45)

The provocative display of back, shoulders, and cleavage that shocked Casola calls into question the chastity and modesty of Venetian women, and significantly, until recently Carpaccio's two Venetian women were often understood

93. Vittore Carpaccio, *Woman Holding a Book,* c. 1500, oil on panel, 1 ft. 4¾ in. × 1 ft. ¼ in. (43 × 31 cm), Denver Art Museum.

as a pair of prostitutes. In addition, the famous beauty of Venetian women, often noted by foreigners, was deceptive, as Casola observes, for they appeared to be unnaturally tall, unstable giants with painted faces, dyed hair, and false hairpieces. Their elaborately teased hair confused gender. Furthermore, their jewelry—often paste or rented—made the expression of wealth and social status problematic, muddling the distinction between a patrician, a citizen, and a courtesan.

CARPACCIO'S *WOMAN HOLDING A BOOK*

This image of a portly woman by Carpaccio follows the format popularized by Antonello and then Giovanni Bellini—bust length, three-quarter view, and a sky-blue background (fig. 93). Her brown hair, parted in the middle, has been gathered into a pearl-studded brown snood fashionable for Venetian married women, although a number of wavy strands fall loosely in front of her ears, framing her face. She wears over a white *camicia* a brown dress with a square neckline trimmed with plain and wavy bands of gold, fastened in front with a brown and white ribbon. Her gold necklace and the large pearls sewn into the neckline of her dress suggest her high rank, and the book that she holds might indicate her erudition. This has led to the suggestion that she may depict

the poet Gerolama Corsi Ramos (c. 1450–post-1509), who wrote a sonnet circa 1500 titled "Ad imaginem suam" (On her portrait) praising her depiction by Carpaccio for turning "the wooden panel into a living body" and making "her appear to be about to speak." There is no proof, however, that this is the painting to which she referred. This woman could just as well be a pious patrician with a book of hours. Indeed, the red cloth of honor, traditionally associated with images of the Virgin (e.g., fig. 52), perhaps favors the latter interpretation.

GENTILE BELLINI'S *CATERINA CORNARO*

The Latin inscription on the plaque suspended from a chain at the upper left of this portrait (fig. 94)—perhaps a sixteenth-century revision of the original underlying illegible inscription, visible in X-rays—names the subject and the painter, remarkably in the subject's voice: "[Descended] from the [ancient Roman] family of Cornelia, I bear the name of the virgin who is buried on Sinai [St. Catherine of Alexandria]. The Venetian Senate calls me daughter, and Cyprus, seat of nine kingdoms, is subject to me. You see how great I am, but greater still is the hand of Gentile Bellini that portrays me on such a small panel."

In 1468, at age fourteen, Caterina Cornaro was betrothed to King James II of Cyprus, whom she married on his island in 1472, at age eighteen. After the death of James in 1473 and of their baby son in 1474, Caterina became the queen of Cyprus, but in 1489 she was forced to abdicate in favor of the direct rule of the island by the Venetian government. In compensation, the Venetian Senate awarded her the title of Daughter of St. Mark and a tiny kingdom in Asolo (fig. 8), where she maintained a court that influenced Venetian culture.

While employing the traditional parapet (visible only without the present frame), behind which the figure in three-quarter view gazes leftward into the distance, Bellini has considerably lengthened the queen's torso to suggest, appropriately, that she is enthroned—the first implied sitter in Venetian portraiture. He has also reverted to the diffused light and nearly black background characteristic of early ducal portraiture (e.g., fig. 85), which elevates the queen to a realm of immobility and permanence. The absence of any movement or emotion and the careful attention to the details of the sumptuous costume and costly jewelry also contribute to the sense of supreme, immutable status.

The queen's white *camicia* is visible at her elbows and at her upper arms, where the sleeves attach with laces to the dark brown side and back panels of the dress. The side panels are decorated with gold rope trim in a pattern of

94. Gentile Bellini, *Caterina Cornaro,* c. 1500, oil on wood, 2 ft. ¾ in. × 1 ft. 7¼ in. (63 × 49 cm), Szèpmüvésti Múzeum, Budapest.

arches and a thick gold chain draped around the queen's massive waist. Bellini, however, has emphasized the reddish brown material of the dress's front panel and the sleeves, woven with an exquisite small diamond pattern. The front panel, laced tightly under her bosom, is joined to the dark side panels by a continuous gold band set with a multitude of alternating pearls and large rubies—the same trim used around the elbows. The scooped neckline of the dress is ornamented with a row of pearls and a white band with the same small diamond pattern. A long strand of pearls attached in two places at the neckline crosses her chest and wraps around her neck. She also wears a platinum gold necklace with a pendant pearl and a dark toothlike gemstone. Her earring is composed of three small pearls and a reddish gemstone. A gossamer veil worn over her brown, middle-parted hair outlines her forehead and face and falls gracefully over her shoulders. The veil defining the oval of her face terminates in three pendant pearls. A close-fitting damask cap with a wide padded embroidered band decorated with a small gold chain covers her head. Over the cap rests a gold crown set with pearls and gems and engraved with a pseudo-Arabic script. With this tour de force of descriptive detail, Bellini transformed the living queen into a hieratic icon encased in the trappings of nobility, wealth, and power and with the authority, per the inscription and unusual for a woman, to speak for herself.

PART II

SIXTEENTH-CENTURY VENICE

INTRODUCTION

Terraferma Empire and the Italian Wars

The Italian balance of power established by the Peace of Lodi in 1454 was dramatically upset when in 1494 the Valois king of France, Charles VIII (r. 1483–98), swept through the Italian peninsula with a large army equipped with field artillery. At the end of an expedition that disrupted the status quo and toppled existing regimes, he captured Naples, which he claimed by dynastic right. For the next sixty-five years, competing dynastic claims to the Kingdom of Naples and the Duchy of Milan between the Valois kings of France and the Hapsburg monarchs of Austria, Germany, Spain, and the Low Countries turned Italy into a battlefield. The Italian city-states were wealthy, militarily weak, and culturally invested in the new culture of the Renaissance—attractive targets for the exercise of these dynastic claims. After an endless series of alliances, counteralliances, treaties, and battles that ravaged Italy for more than half a century, the Hapsburgs prevailed. By the 1559 Peace of Cateau-Cambrésis, the Valois gave up all claims to Italy, which the Hapsburgs under the Spanish king Philip II (r. 1556–98) dominated for the remainder of the sixteenth century.

In their survival strategies during the Italian Wars, the various Italian states aligned with either the Valois or the Hapsburgs or played one off against the other. Venice, for example, joined the 1495 League of Venice, formed to engage (with minimal success) the army of Charles VIII on its return to France from its Neapolitan victory, and claimed in compensation the Apulian port of Trani and several other coastal towns in Apulia, all nominally belonging to the Kingdom of Naples. In 1499 the city changed sides and joined the new French king Louis XII (r. 1498–1515) to successfully drive its old enemy, Duke Ludovico Sforza (1452–1508), out of the Duchy of Milan, annexing Cremona as its reward. Then in the spring of 1508 the Venetians repelled an invasion of their northern territories by Holy Roman Emperor Maximilian I (1459–1519) and took as their spoils the traditionally Hapsburg cities of Pordenone, Gorizia, and Trieste in Friuli.

LEAGUE AND WAR OF CAMBRAI

Venice had long wanted to expand its authority in Romagna south of Ravenna, which it had annexed in 1440. When Pope Alexander VI (r. 1492–1503) died in 1503, Venice annexed Rimini, Faenza, and several other nearby towns and offered protection to the lords of Romagna against the newly elected Pope Julius II (r. 1503–13), who reclaimed all of Romagna for the Papal States. Infuriated by its encroachment on papal lands, Julius II placed Venice under interdict (ecclesiastical censure) and created the League of Cambrai in 1508 for the purpose of conquering the Venetian terraferma and dividing it up among the allies, which included the Hapsburgs, French, English, Hungarians, Mantuans, and Ferrarese. The allied forces crushed the Venetian army at Agnadello near Milan on May 14, 1509, and soon occupied all of Venice's terraferma, including its recent Apulian, Romagnol, and Friulian territories, leaving the Venetians demoralized and severely weakened financially and politically. Doge Loredan (fig. 91) lamented in a speech to the Great Council in 1509 that Venice should never have created a terraferma empire: "What stupidity ever drew us

away from the sea and turned us to the land, for navigation was an inheritance from our earliest ancestors and has left us with many reminders and warnings that we should remain intent on it alone. There we are masters over all, and conduct our affairs alone with true zeal."

Dissension and greed among the allies—as well as fear that the French were becoming too powerful in northern Italy—allowed Venice to begin to recoup its losses. Venetian forces overseen by Andrea Gritti (1455–1538) recaptured Padua in 1509 and defended it against a siege the next year by Maximilian I. Between 1510 and 1512 Venice joined Pope Julius II, Emperor Maximilian I, king of Aragon Ferdinand II (r. 1479–1516), and king of England Henry VIII (r. 1509–47) in a so-called Holy League to successfully drive the Valois out of Italy but was forced to cede its holdings in Romagna, including Ravenna, to the papacy. When Julius II died in February 1513, the Holy League collapsed, and Venice took advantage of the situation by again changing sides to join with the Valois—Louis XII, and after 1515 Francis I (r. 1515–47)—who after several key victories regained the Duchy of Milan in 1515 and in 1516–17 negotiated peace with the Hapsburgs. As a result, by 1517 Venice had recovered its terraferma empire except for its more recent acquisitions of Cremona and the cities in Romagna and Friuli.

After the death of his grandfather Maximilian I in 1519, Charles V (r. 1516–56) inherited all the lands of the Hapsburg monarchy—Spain, Austria, the Netherlands, Naples, Sicily, and the Americas—and the same year was elected the Holy Roman emperor, which gave him authority over most of Germany. Hapsburg-controlled territory now completely surrounded the lands of the Valois, and Charles V again pressed his dynastic claims to northern Italy. After a series of battles between 1521 and 1525, Charles V decisively defeated Francis I at the battle of Pavia. In the course of these events the Venetians elected a powerful new doge, Gritti (r. 1523–38), the hero of Padua, who changed sides twice.

LEAGUE OF COGNAC

In 1526 Venice joined the League of Cognac with Pope Clement VII (r. 1523–34), Francis I, the Republic of Florence, and Duke Francesco II Sforza of Milan (r. 1521–35) to drive Charles V out of Italy. But again the Spanish imperial forces proved superior in nearly every battle, including the brutal sack of Rome in 1527 and in 1530 the defeat of Florence after a long siege. While Clement VII was imprisoned in the Castel Sant'Angelo after the sack of Rome, the Venetians reclaimed Ravenna, acquired nearby Cervia in Romagna, and besieged Brindisi to reestablish their holdings in Apulia. The sack of Rome also led

many intellectuals and artists—including the architect and sculptor Jacopo Sansovino—to seek safe haven in Venice, which had important consequences for Venetian art and architecture.

Between 1529 and 1530 Clement VII and Charles V negotiated the Treaty of Barcelona and the Peace of Bologna. The Medici pope agreed to invest Charles V with the Kingdom of Naples and crown him Holy Roman emperor. In turn, Charles V agreed to the restoration of Medici rule in Florence. In addition, Clement VII reincorporated Ravenna and Cervia into the Papal States, and Charles V absorbed the Venetian Apulian outposts into his kingdom of Naples. While the Peace of Bologna stripped Venice of its more recent acquisitions, it also granted that the Venetian terraferma henceforth would be defined by the pre-Agnadello boundaries—which were never again seriously contested in the sixteenth century. But the era of Venetian expansion on the Italian mainland had come to a definitive end.

The Italian Wars between the Hapsburgs and the Valois continued until 1559, but Venice—now politically marginalized by the two new European superpowers—remained neutral, choosing to refashion itself as a city of peace and harmony.

Maritime Empire and the Ottoman-Venetian Wars

Throughout the sixteenth century a succession of powerful sultans orchestrated an Ottoman expansion that repeatedly attacked and often won the outposts of the Venetian maritime empire. During the 1499–1503 Turkish war, for example, the Venetians lost their important naval bases at Lepanto, near the Gulf of Corinth, and at Navarino, Modon, and Coron in the Morea (fig. 7). Then, when the Turks expanded into the Balkan Peninsula and Turkish cavalry began to raid Venetian holdings in Friuli, Venice capitulated and signed a peace treaty in 1503 with Sultan Bayezid II that officially conceded Turkish gains.

By 1517 Sultan Selim I (r. 1512–20) had expanded the Ottoman Empire to include most of the Middle East, from Syria to the Mamluk sultanate of Egypt, including the Arabian Peninsula. Soon after, Suleiman the Magnificent (r. 1520–66) and his army conquered Serbia (1521), captured Rhodes and expelled the Knights Hospitalers of St. John (1522), established Ottoman rule in central and southern Hungary (1526), and by 1529 had established control of most of North Africa up to Morocco.

In 1537 a large Ottoman fleet commanded by Hayreddin Barbarossa (1470s–1546) captured most of the Venetian bases in the Aegean islands and

unsuccessfully besieged Corfu. In response the Venetians encouraged Pope Paul III (r. 1534–49) to establish in early 1538 a Holy League (comprising the papacy, Spain, Austria, Genoa, Venice, and the Knights of Malta) to confront Barbarossa. At the battle of Preveza below Corfu in September 1538, the Holy League was soundly defeated, and the next year Barbarossa conquered the remaining Venetian fortresses in the Morea and in the Aegean Sea. The treaty that concluded the 1537–40 conflict forced the Venetians to recognize the Ottoman conquests, cede parts of Croatia along the Adriatic, and pay three hundred thousand gold ducats in indemnification.

In 1570 Sultan Selim II (r. 1566–74) invaded the island of Cyprus, a Venetian possession since 1489. While this conquest was in progress, the Venetians sought allies to counter the Ottoman advance. With the energetic support of Pope Pius V (r. 1566–72), a Holy League was formed in May 1571, which included the papacy, Spain, the Republic of Genoa, the Duchy of Savoy, the Knights of Malta, and the Grand Duchy of Tuscany, under the general command of Don John of Austria (1547–78). Sebastiano Venier (c. 1496–1578, doge 1577–78) commanded the Venetian fleet. Before the allies could set sail from Messina in Sicily, however, Famagusta—the last Venetian stronghold on Cyprus—fell to the Turks, on August 1. Two months later, on October 7, 1571, the enormous Christian and Ottoman fleets—estimated to have included about five hundred vessels, or 85–90 percent of all the warships in the Mediterranean—engaged in battle near Lepanto. The Turkish navy was completely routed, and many Ottoman ships were captured. While celebrated in Europe, and especially in Venice, as one of the greatest Christian victories ever over the infidel, the battle changed little strategically. The Turks completely rebuilt their forces within a year and again put pressure on the Venetian possessions in Dalmatia. And once again, rather than continuing to fight, the Venetians found it more prudent and cheaper to capitulate and pay a tribute to restore their trading privileges. Therefore, in 1573 the Venetians negotiated a separate peace with the Ottomans—seen as traitorous by other members of the Holy League—in which they officially ceded Cyprus and paid a war indemnity of three hundred thousand ducats.

By 1574 the huge expense and unprofitability of warfare had created a stalemate between the Christian and the Muslim forces, effectively ending Turkish expansion in the Mediterranean. While the Venetian maritime empire had been much weakened, it was not seriously threatened by the Turks again—at least not in the sixteenth century.

ECONOMY

Trade

Venetian maritime trade remained vigorous but gradually declined by nearly 50 percent over the course of the sixteenth century, becoming more regional than international. The expanding Mediterranean naval power of the Spanish, Portuguese, French, Genoese, and Florentines severely undercut Venetian maritime trade, including the transport of pilgrims and tourists. The 1498 discovery by Vasco da Gama (c. 1460/69–1524) of a new sailing route to the Indian Ocean around the Cape of Good Hope allowed the Portuguese and Spanish to compete successfully with the Venetians in the lucrative Asian spice trade. The development of new Mediterranean ports, such as Ragusa, Leghorn, and Marseilles, and the expanding population in such cities as Lisbon, London, and Antwerp greatly diminished Venice's once preeminent role as the major port of transshipment of goods from the Middle East and North Africa to Europe.

The two mainstays of the Venetian navy were galleys—small, fast, shallow-draft, highly maneuverable triremes (three oars to a bench) with one or two lateen (triangular) sails, bow and stern guns, and large and costly crews—and galleasses, or great galleys, larger but slower triremes with two or three lateen sails, which were more heavily armed, with bow, stern, and side guns. The galleys and galleasses that the state built in the Arsenal were primarily fighting ships but could also be used to transport lightweight but high-value cargo such as spices. In the 1540s and 1550s, shipbuilding in the Arsenal experienced a great boom as the state doubled the number of its galleys from about fifty to one hundred and added about a dozen great galleys to defend itself against the Turkish threat. But so many Turkish galleys were captured in the 1571 Battle of Lepanto that, beyond repairing them, shipbuilding nearly came to a halt for more than a decade.

For bulky cargo, the Venetian merchant marine used about thirty or so cogs and the similar but larger carracks—large-capacity, high-sided, all-weather, lightly armed round ships without oars (and therefore with smaller crews), propelled by ketch- or square-rigged sails on one to four masts, built mostly in private shipyards and financed by patricians.

But by the end of the century, the galleons developed by the Spanish, English, and Dutch had rendered all three types of ships obsolete. Galleons were smaller, lower, stronger, and faster than the Venetian cogs and carracks and were equipped with more advanced square-rigged sails and a greater number of more accurate cannon. They not only functioned effectively as combined

fighting and merchant ships but could also more successfully ward off pirate attacks—by both Christians and Turks—which in the sixteenth century grew exponentially throughout the Mediterranean to plague all shipping and substantially raise the cost of freight insurance. Finally, the depletion of oak forests within a reasonable distance of Venice so greatly increased the cost of Venetian shipbuilding that by the end of the century the industry could no longer compete with the cheaper and more efficient galleons. By 1600, galleons had displaced nearly all Venetian ships outside the Mediterranean and a substantial portion within.

Agriculture

As maritime commerce became riskier, more competitive, and less profitable, patricians and citizens alike began to shift their investments to the terraferma to become gentlemen farmers. The resulting sixteenth-century land boom was also fueled by the expansion and population growth of the Ottoman Empire, which greatly diminished the amount of produce, especially grain, available for Venetians to transport from the Muslim world. Largely due to refugees from the Italian Wars flooding into the city for safety, the population of Venice also grew, from about 115,000 in 1509 to about 180,000 by 1575, greatly increasing the demand for food. Finally, owning land in the terraferma removed the stigma that made Venetian patricians not true nobles in the eyes of Europeans, since landowning had always been the sine qua non for noble status.

As the drainage plain for the Alps and Apennines, much of the Venetian terraferma was swampy and malarial. To make the land suitable for agriculture, it had to be reclaimed by digging irrigation and drainage canals, raising levees, and dredging rivers for navigational channels to bring produce to market. This required an enormous workforce and large investments of money by consortia of landowners supported by the Venetian state. State support included the establishment by the Senate in 1501 of a Ministry of Waters for the control of water and silt entering the Venetian lagoon and for limited land reclamation. Beginning in 1545 the Senate annually appointed three overseers to assist in land reclamation, and in 1556 it established a permanent three-member board for the reclamation of uncultivated land, which professional hydrologists, surveyors, and cartographers assisted. By the end of the sixteenth century, more than 150,000 hectares, or 375,000 acres, of agricultural land had been reclaimed, which, along with improvements in irrigation and navigation, made agriculture the most productive sector of the Venetian economy and tripled the amount of land taxes the Venetian state collected.

Cloth, Luxury Goods, Arts, and Printing Industries

Aided by a multitude of artisans who fled from the mainland during the Italian Wars, the Venetian textile industry thrived in the sixteenth century, especially the spinning, dying, weaving, fulling, and finishing of woolen cloth. At the end of the century, production had increased tenfold from the century's start, with more than seven thousand people employed, some in shops with twenty-five or more looms. Venetian lace and silk were also in great demand, and their output grew threefold over the course of the century.

The production of other luxury goods—glassware, leatherwork, jewelry, and gold, silver, and bronze metalwork—greatly expanded. The major arts—painting, sculpture, and architecture—prospered as never before, further embellishing Venetian urban spaces, churches, confraternities, palaces, and villas. The major sixteenth-century Venetian painters were in great demand and produced a significant number of pictures for major Italian and European courts.

Finally, Venice became one of the largest centers of book printing and bookselling in Europe, an industry encouraged by the city's tolerant cosmopolitanism, relative lack of censorship, first-rate library of about a thousand Greek and Latin codices gifted to the city by Cardinal Bessarion in 1468, and unusually large, literate, and polyglot populace. Numerous scholars trained in the literatures of various languages served as editors, compositors, and proofreaders. In the fifteenth century about two and a half million copies of forty-five hundred titles were printed in Venice, while in the course of the sixteenth century more than 450 printers, publishers, and booksellers produced and sold nearly eighteen million copies of some 17,500 separate editions in Greek, Latin, Italian, Spanish, Hebrew, Arabic, Old Church Slavonic, Croat, and Armenian. Venice was also the leading European center of music and map publishing, fostered by the city's active musical culture and international trade.

RELIGION

The sixteenth century witnessed two major religious reform movements. The German monk Martin Luther (1483–1546) initiated the Protestant Reformation in 1517 when he nailed his Ninety-Five Theses to the door of All Saints' Church at Wittenberg. Luther, and subsequently all Protestant sects, believed that humanity was essentially sinful and could be justified (i.e., saved) only by faith alone (*sola fide*) through the free gift of God's grace. Contrition, confession, penance, good works, and the Mass were all unnecessary for salvation,

and therefore the entire hierarchy of the priesthood, from the pope on down, was equally superfluous. Rather, for Luther and his Protestant followers, the priesthood consisted simply of all believers. The Protestants also wished to return to the supposed purity and piety of the early Church, where the Bible was the principal source of authority. They thus rejected nearly all the subsequent traditions of the Church, on which many Catholic beliefs were based, a prime example being the doctrine of Petrine succession (the unbroken descent of Christ's spiritual authority through Peter to each successive pope).

The second reform movement was the Catholic Reformation, often termed the Counter-Reformation to emphasize its response to the Protestant reform. By the early sixteenth century both Catholics and Protestants had come to recognize the Roman Church as elitist, worldly, greedy, and corrupt. Most egregious was the doctrine of papal primacy, the exaggerated claim that papal power was universal and supreme, both spiritually and temporally. But almost equally notorious were the frequent lack of sufficient education, adherence to vows, and discipline in the priesthood and the widespread practices of nepotism (appointing family members to high office regardless of their merit), alienation (carving dynastic family states out of Church lands), simony (sale of Church offices), pluralism (assigning multiple offices and benefices to a single cleric), absenteeism (failure of priests to perform the duties of the offices with which they had been entrusted), and selling indulgences—believed to lighten the punishments of Purgatory—to help finance papal projects, such as the rebuilding of St. Peter's.

Renaissance Venice was an exceptionally religious city. It had more churches, monasteries, convents, and confraternities per capita than any other city in Europe, with the possible exception of Rome. As piety was believed to be a fundamental ingredient of civic patriotism, peace, and harmony, the Venetian government traditionally controlled nearly all Church institutions and clerical appointments within Venice and the terraferma, insuring that most ecclesiastical leaders were local Venetians sympathetic to state policies. This bought Venice into repeated conflicts with the pope, which only grew more intense in the course of the sixteenth century as the papacy became more centralized and autocratic.

Venice was also a tolerant city, open to pilgrims, travelers, merchants, seamen, and artisans of different nationalities with a variety of religious beliefs. The nearby University of Padua—where the law required all Venetian patricians to be educated—enrolled students with different faiths from many countries, including Protestants from northern Europe. Many of the merchants residing at the German trading house in Venice, the Fondaco dei Tedeschi, were Lutherans. And the Venetian printing industry made the principal texts of Protestant ideas easily available to a receptive audience—most notably the anonymous 1543 *Beneficio di Giesu Christo crocifisso verso i christiani* (The benefit of Christ's death for Christians), of which forty thousand copies were said to have been sold in Venice alone. As a result, many Venetians were outright Protestants of various persuasions.

At the other extreme, a number of Catholic monasteries, including the Camaldolese at S. Michele in Isola, the Observant Franciscan at S. Francesco della Vigna, and the Benedictine at S. Giorgio Maggiore, reformed themselves internally and returned to the strict observance of their vows of poverty, celibacy, and obedience to the Church.

In between were the so-called *spirituali,* Catholics who were sympathetic to many Protestant beliefs and tried to find common ground without abandoning the Church. Their leaders in Venice were the patrician diplomat Gasparo Contarini (1483–1542), who was created a cardinal in 1535, and the learned and pious Gregorio Cortese (1483–1548), the Benedictine abbot of S. Giorgio Maggiore from 1532 to 1537. They in turn were in close contact with many other reform-minded individuals outside Venice, especially as members of the Council to Reform the Church that Pope Paul III appointed in 1537.

This council laid the groundwork for Paul's call in 1545 for a general council to undertake a systematic and thorough reform of the administration and doctrine of the Church and to attempt to reconcile Catholic and Protestant beliefs. The resulting Council of Trent met in three sessions—1545–47, 1551–52, and 1562–63—and concluded with the publication of its complete canons and decrees in 1564. The canons and decrees—and subsequent papal commissions created to implement them—clarified doctrine, standardized liturgy and Scriptures, and corrected the worst abuses of nepotism, alienation of Church lands, simony, pluralism, absenteeism, and the sale of indulgences. The proper education of priests, effective ministering to the laity, and tighter control of all aspects of religious life by bishops also became high papal priorities.

By midcentury—as Trent was more clearly defining Church orthodoxy and reconciliation with the Protestants was deemed impossible—it had become dangerous to hold Protestant views in Italy, for Pope Paul III also reestablished the Inquisition in 1542 to enforce orthodoxy. Although the Venetian government had previously been relatively tolerant of various professions of faith, it nevertheless much preferred conformity and harmony to dissent and instability. So in 1547 the state established a commission of three patrician laymen to

work with the pope-appointed members of the Venetian Inquisition to suppress heterodoxy, but also to exercise a measure of control over the Inquisition's more extremist tendencies. In this new climate of increasing fanaticism, many Protestants and *spirituali* in Venice were accused of heresy and forced either to suppress or recant their views or to flee to Protestant Europe. As the Church implemented reforms and enforced orthodoxy, it also become more autocratic and less willing to tolerate the Venetian government's traditional control of clerical appointments, religious institutions, and Church property. The resulting power struggle finally resulted in a papal interdict of 1605–7, which almost led to war. International diplomacy averted this but left Venice in a weaker position vis-à-vis the resurgent papacy.

The canons and decrees of the Council of Trent and their subsequent implementation mandated a number of liturgical changes that had an important impact on church design. For example, in response to the belief of many Protestants that the bread and wine of the Mass were mere symbols of the sacrificial Christ—not mystically transubstantiated by the priest into the body and blood of Christ, and therefore not intrinsically salvific—the council made the Eucharistic liturgy more central than ever before to religious life. Priests were now required to celebrate Mass regularly and often, and the laity were likewise expected to attend Mass more frequently, as well as to engage regularly in confession, contrition, and communion. Effective preaching during the liturgy was given a much higher priority, as it was understood to be a major instrument of instruction and reform. In addition, the council decreed in its thirteenth session that the faithful must adore and worship the most holy Sacrament, the Eucharist, which was to "be celebrated with special veneration and solemnity every year on a fixed festival day, and . . . borne reverently and with honor in processions through the streets and public places" (Schroeder, p. 76). The council also decreed that the reserved Host (the transubstantiated bread left over from the Mass) be exposed in a tabernacle or a monstrance on or near the high altar of every church for the faithful to worship and be available for "carrying . . . to the sick" (Schroeder, p. 77). By the end of the sixteenth century nearly all seventy-two Venetian parish churches boasted a Confraternity of the Holy Sacrament, a group of volunteers who created sumptuous settings for the display of the consecrated Host. They also carried the Host through the streets of Venice in tabernacles, so that the sick and housebound could take communion or the public could adore it in civic processions. Finally, they arranged for High Masses to be celebrated with the greatest possible splendor by providing vestments for the priests, accessories for the high altar (altarpieces, vessels, altar cloths, candles, and flowers), and appropriate music and sermons to accompany the liturgy.

The reforms decreed at Trent also encouraged the faithful to live more austere lives, with greater piety, humility, and penitence. Therefore, destitute beggars and poor friars of the mendicant or begging orders (Franciscans, Dominicans, Capuchins, Augustinians, etc.) were often considered models of "sacred poverty," individuals removed from the temptations and vanities of the world who could serve as privileged examples of preparedness for Christian salvation. Indeed, in Matthew 25:35–40, Christ identifies himself with a beggar who receives charity to illustrate the nature of good works necessary for salvation at the Last Judgment: "For I was hungry, and you gave me to eat; I was thirsty, and you gave me to drink; I was a stranger, and you took me in. Naked, and you covered me; sick, and you visited me; I was in prison, and you came to me I say to you, as long as you did it to one of these my least brethren, you did it to me."

But few in the real world chose to live as a humble beggar or a pious friar. Furthermore, in response to the Protestant belief that good works were not essential for salvation, Catholics emphasized more strongly than ever before the importance of performing charitable acts. In the course of the sixteenth century numerous institutions were founded to provide opportunities for the fortunate—both clerics and laity—to perform works of mercy for the less fortunate. From the perspective of the individual these organizations facilitated the salvation of one's soul. From the viewpoint of the government, which chartered and oversaw most of them, they increased centralized state control of society, improved public health, promoted social justice, and supported the myth of the state's concord, stability, and divine ordination. These associations included (with their dates of founding) the Ospedale degli Incurabili (1522), to treat those with syphilis and other infectious diseases; the Ospedale dei Derelitti (1528), to care for plague victims, orphans, the destitute, the sick, and widows; the Casa delle Convertite (1530), to offer refuge to reformed and aging prostitutes; the Fraterna dei Poveri Vergognosi (1536), to assist financially, medically, and materially impoverished nobles; the Casa dei Catecumeni (1557), to convert Jews, Turks, and Moors, especially children, to Christianity; the Casa delle Zitelle (1559), to train poor young girls for marriage or domestic service so that they could avoid prostitution; the Scuola della Dottrina Cristiana (1575), to offer religious education to young boys; the Casa del Soccorso (1577), to shelter adulterous, abandoned, or battered wives and reformed prostitutes; the Compagnia della Carità del Crocefisso (1591), to assist debtors and crimi-

nals in jail; and the Ospedale dei Mendicanti (1594), to house and treat beggars and orphans. Additionally, many new or expanded hospices and hospitals, financed by the state, confraternities, guilds, monasteries, and patrician families, provided for those in need.

The increase of those needing social and health services—beggars, orphans, battered wives, widows, girls without dowries, prostitutes, debtors, the disabled, the wounded, the poor, the sick—resulted from many factors, including urban overcrowding owing to the migration to Venice of war refugees; intermittent periods of high unemployment in trade, commerce, and shipbuilding; periodic famines from drought and flooding approximately every decade; frequent outbreaks of plague, typhus, and pneumonia, the worst being the 1575–77 plague that killed about forty-five thousand people, reducing the population from 180,000 to 135,000; and finally, periods of high inflation from the influx of New World gold and silver.

SOCIETY

The sixteenth century was marked by a greater concentration than ever before of wealth and influence in the hands of fewer patricians and by the development of a less egalitarian society through stricter legislative definitions of nobility and citizenship.

The enormous expenses of war and defense, especially during the War of the League of Cambrai, put great pressure on the government to raise vast sums of money through high taxation and the sale of some offices, such as procuratorships. The loss of terraferma and maritime territory resulted in fewer remunerative administrative positions available for patricians. In this climate, the wealthy nobles were better able to gain control of the inner councils of authority (especially the Senate and Council of Ten), often by (illegally) buying the votes of the poorer nobles. In addition, with the rising cost of dowries (from sixteen hundred to four thousand ducats over the course of the century), the richer patricians were able to make the most advantageous unions to elevate their social status. Finally, as patricians began to shift their investments from trade and commerce to agriculture in the terraferma and as nobility was increasingly understood to depend on landownership, it was again the well-off nobles who were best positioned to control power in the government.

A series of laws passed between 1506 and 1535 required the registration with the communal lawyers of all noble births, marriages, dowries, and deaths to strengthen the process of evaluating who was noble and who was not. The aim was to ensure that patrician status would not be tainted by the illegitimate sons of nobles born to slaves, prostitutes, or women of low status, and to encourage noble endogamy (marriage within one's class). However, as trade and commerce declined over the century and fewer young nobles engaged in commercial enterprises, exogamy—marriage outside one's class, for instance to daughters of wealthy citizens, who would bring substantial dowries, or even to illegitimate daughters of patricians, who might not have large dowries but who could expand one's network of social relationships—became permissible. In short, to be certified as noble for entry into the Great Council in the sixteenth century, a young male patrician had to document fully that his birth was legitimate, his mother and spouse were not of low status, and his father (or in some cases grandfather) was or had been an active member of the Great Council. As a result of these laws, the patrician class was reduced by the late sixteenth century to 5 percent or less of the population.

"Original citizens" were initially rather vaguely defined in Venice as native-born descendants of families of long residence in the city. Some were illegitimate descendants of noble families or shared the surnames of noble families, while others were patricians who chose not to prove their nobility to enter the Great Council or had been forced by economic circumstances to take up a trade. In addition, most educated professionals, such as lawyers, physicians, notaries, professors, and publishers, were generally considered citizens. But in the course of the sixteenth century the definition of original citizenship became ever more formalized and rigid. By 1569, for example, the third-generation rule, long in existence but often not enforced, was now strictly applied: the applicant had to prove that both his father and grandfather were native-born Venetians, that neither had ever engaged in any manual trade, and that the applicant's birth was legitimate. Many lifetime appointments—as bureaucrats in the many offices of the Chancery and state magistracies, secretaries to the various governmental councils, and (especially for those trained from boyhood in languages, ciphers, and script) members of the diplomatic service—were reserved for this generally well-educated class. The grand chancellor, usually elected from the secretaries of the Council of Ten, held the highest office of the original-citizen class, ranked just under the doge, who oversaw the Chancery and presided over the Great Council.

Of lower rank were citizens of privilege, or naturalized citizens, foreigners who had lived for in Venice for many years (usually fifteen to twenty-five) and paid Venetian taxes. Some foreigners were granted citizenship by the Signoria after shorter residence if they possessed noble status from their place of origin.

This group was composed mostly of merchants who applied for citizenship to enjoy trading privileges and tax benefits inside and often even outside Venice. But many who were eligible did not apply, and only very few of those who did make application were accepted each year.

Together the original and naturalized citizens—who generally dressed and lived like the nobility and often were even wealthier—constituted about 6 percent or less of the population. While they could never become members of the ruling elite, the principal offices of all the large and many of the small confraternities were reserved for them, as long as they were not employed in the Chancery. If they were wealthy enough to provide large dowries, they often married their daughters to nobles, although the narrowing of the patriciate and the increasing practice of noble endogamy reduced exogamy in the sixteenth century to one in ten patrician males, compared to one in seven in the fifteenth century.

Even among the lower classes, distinctions were now more rigidly drawn. Highly skilled artisans whose trades required long apprenticeships—such as silver- and goldsmiths, master carpenters, printers, painters, sculptors, and architects—enjoyed greater social status than less- or unskilled laborers. Educated, elegant, and beautiful courtesans with their own lodgings, such as the poet Gaspara Stampa (1523–54) or the poet and musician Veronica Franco, were of higher class than ordinary prostitutes who worked in the state-owned brothels around the Rialto. Not coincidentally, the rise of a courtesan culture in the sixteenth century encouraged the development of erotic paintings of female nudes and seminudes, often cloaked in mythological disguise, destined for the bedrooms or studies of Venetian palaces.

Stressing hierarchy and privilege, drawing stricter class boundaries, and restricting social intermingling encouraged refined and opulent lifestyles of conspicuous consumption and even dissipation in the sixteenth century. The theory of magnificence that Aristotle (384–322 BC) formulated in his *Nicomachean Ethics* (1122a18–1123a30), revived in most Renaissance architectural treatises, holds that a palace should reflect the social status and class of its inhabitants. Indeed, among social-climbing patricians and citizens, attention was paid to those who had the grandest palace or villa, the costliest home furnishings, the most prestigious art collection, the most sumptuous clothing and jewelry, the most luxurious banquets and celebrations, the most refined and exotic foods, and the most expensive table service, or those who patronized the latest theatrical or musical performances, enjoyed the most beautiful and talented courtesans, or won or lost the largest sums at gambling. Even the con-

fraternities—especially the large confraternities—which were administered by the citizen class, entered into this competition, each trying to outdo its rivals by building and decorating ever more extravagant meeting halls.

All this ostentatious display by the upper classes conflicted with Venetian traditions of moderation, collective identity, and consensus. It also brought into sharp relief the reality of social inequality resulting from increasing numbers of those in need. Finally, it flew in the face of the Church reform movement that encouraged a pious life of austerity and humility with the performance of penitential works of charity to assist in salvation, a life that shunned the temptations of the material world for the rewards of the afterlife.

The responses to these paradoxes were threefold: (1) increased centralized state control of public health, morality, housing, food distribution, and parish churches, as noted above, to attempt to alleviate social inequality and disunity more efficiently and effectively; (2) an exponential expansion of institutions dedicated to serving the needy, as also outlined above; and (3) an ever increasing proliferation and consolidation of sumptuary laws, culminating in the establishment in 1560 of a permanent magistracy of pomp to "conserve equality between our nobles and citizens."

The sumptuary laws were intended to curb every kind of excess by controlling all aspects of home decoration, all items of jewelry, all articles of male and female dress (including the livery of servants and slaves), all types of private celebrations, all private banquets (including the number of guests that was allowed, the kinds and amounts of foods that could be served, and the number and type of serving dishes and place settings that could be employed), all masquerades, and all theatrical performances. However, they were nearly complete failures and much better indices than effective prohibitions of sixteenth-century aristocratic lifestyles. For example, even if simple robelike togas were accepted as the modest and decorous norm for the dress of all patrician males, differences in fabrics, colors, cuts of sleeves, shoulder ornaments, and headgear reflected clear distinctions in rank, social status, and wealth. Furthermore, patricians and citizens who did not have enough money to afford the latest fashion or the finest furnishings could use the flourishing rental and secondhand markets to outfit their wardrobe and lodgings with the outward appearance of social dignity and status.

These tensions, between splendor and frugality, rich and poor, religious and secular, unity and dissent, equality and inequality, are fundamental to sixteenth-century Venetian culture and are both reflected in and constructed by the art of the period.

CIVIC ARCHITECTURE AND URBANISM

PIAZZA S. MARCO

Pietro Bon's Procuratie Vecchie

In 1512 the twelfth-century Procuratie Vecchie (fig. 3, no. 7; fig. 9), with its street-level shops and apartments above on the north side of the Piazza S. Marco, burned to the ground. While little building was undertaken in Venice in the two decades of economic depression following the 1509 battle of Agnadello, the rebuilding of the Procuratie Vecchie began almost immediately, because its rental income was essential for the upkeep of the Piazza and Piazzetta S. Marco and the church of S. Marco.

The new building—enlarged from two to three stories to create more rental space—was perhaps designed by a little-known Tuscan architect, Giovanni Celestro, but more likely by the procurators' architect, Pietro Bon (active 1489–1529), who, in any case, oversaw its construction between 1513 and 1529 (fig. 95). The exceptionally long façade—about five hundred feet (152 meters)—was built from a limited number of standardized parts. On the ground floor fifty-one identical Tuscan piers frame twenty-five arched and vaulted portico bays. On the upper two stories 202 mass-produced fluted Corinthian columns define one hundred bays, fifty on each floor. From these 202 columns spring

Sansovino's Plan for the Piazza and Piazzetta S. Marco

Andrea Gritti—a diplomat at the Ottoman court during the 1499–1503 Turkish war and a key commander in the Venetian reconquest of the terraferma after Agnadello—was elected doge in 1523. Obsessed with the grandeur of Venice and the dignity of his ducal authority, Gritti encouraged the procurators of S. Marco to commission a major transformation of the piazza and piazzetta (fig. 97) that emphatically declared Venice to be a new Rome, especially significant after Venice's great rival, the papacy, was humiliated by the 1527 sack of Rome.

The Florentine architect and sculptor Jacopo Sansovino—who worked in both Florence and Rome and was thus well acquainted with the art of classical antiquity and the High Renaissance—fled to Venice during the sack of Rome. In 1529 he was appointed architect for the procurators of S. Marco, replacing the recently deceased Bon. This position—which included an apartment in the rebuilt Procuratie Vecchie, security of employment, and a good salary—led to the commission to redesign the piazza and piazzetta (1531–38). The design included on the south, facing the lagoon, a small, one-story Doric building with five shops (1531) replacing three earlier shops (fig. 3, no. 15) and the replacement of the old Mint (fig. 3, no. 16) with a massive new two-story Mint (1536) with fireproof masonry vaults for smelting and stamping gold and silver coinage.

For the west side of the piazzetta, Sansovino designed a new Library (1537)—replacing five inns, a butcher shop, and a bakery (fig. 3, no. 13)—which counterbalanced the Doge's Palace on the east side. He aligned the long façade of the Library with the Campanile's east flank, where he attached a new Loggetta (1538), replacing a previous wooden loggia in the same location. The Loggetta projected into the piazzetta in response to the thrust into the piazzetta by the narthex of S. Marco opposite. Together these two richly decorated jutting forms narrowed the visual channel to the Clock Tower, enhancing its effectiveness as a focal point for the piazzetta's north-south longitudinal axis. The Loggetta also served as a counterweight to the Porta della Carta, to more clearly define the piazzetta's east-west cross axis and to provide a magnificent focal point for the doge and his retinue when exiting from the Doge's Palace.

For the south side of the Piazza San Marco, Sansovino planned in 1537 to replace the thirteenth-century offices and apartments of the procurators (fig. 3, nos. 17 and 18; fig. 9) with a new two-story Procuratie Nuove, containing ground-floor shops and upper-floor apartments for the procurators. Since he died before the Procuratie Nuove was begun, his successor, Simon Sorella (d. 1599), appointed as the architect for the procurators in 1572, and his followers executed the Procuratie Nuove (1582–1640)—now the Correr Museum—following a design by Vincenzo Scamozzi (c. 1522–1616) that slightly revised Sansovino's design and added a third story. The façade of the old offices and residences of the procurators had been aligned with the north face of the Campanile and abutted its west face. Sansovino, however, aligned the façade of the Procuratie Nuove with the north end of the new Library. He thereby widened the piazza by about sixty-five feet (twenty meters) and created two new right angles, which regularized both the piazza and the piazzetta and more nearly centered the façade of S. Marco on the piazza. He also liberated the Campanile from its previous architectural encroachments, including the unsightly stalls of money changers and bakers at its base, to open a visual corridor between the façade of the Procuratie Nuove and the Campanile to the Porta della Carta and the Doge's Palace, uniting them more effectively with the church of S. Marco when viewed from the west end of the piazza. The now freestanding Campanile, more emphatically than ever before, served as the vertical linchpin of the entire design, uniting the piazza and piazzetta at the right angle of their intersection. Finally, he arranged to have the stalls cluttering the bases of the Columns of SS. Theodore and Mark relocated.

Viewed as a whole, Sansovino's redesign regularized and integrated the spaces of the piazza and piazzetta, cleared them of undignified market stalls, clarified axial relationships, enhanced the views of the major buildings, and transformed the piazza and piazzetta into an image of a stately Roman forum by employing the vocabulary and syntax of classical architecture and the ancient urban design principles of symmetry, axiality, focus, hierarchy, and unity.

Sansovino's Loggetta

Sansovino designed this architectural gem (fig. 98) to provide a privileged gathering place for Venetian patricians to congregate, especially before their regular Sunday meetings in the Great Council, and to view the ceremonial life of the piazza and piazzetta. Although the Loggetta counterbalanced the Porta della Carta (fig. 10), the contrast in styles could not have been more stark—one flamboyant Gothic and the other High Renaissance—yet the circumstances of their making were similar. The Porta della Carta was begun in 1438 in part to celebrate the expansion of Venice's terraferma and to enhance the princely dignity of Doge Francesco Foscari, who oversaw that expansion. The Loggetta, begun in 1538, exactly one hundred years later, commemorated in part the terraferma's recapture and international recognition with the 1530 Peace of Bologna and glorified Doge Gritti as a leader in a Roman imperial mold. However, the Peace of Bologna also marked the increasing domination of Italy by trans-

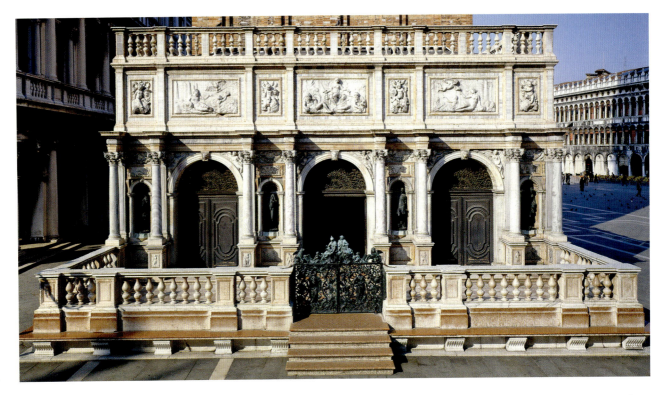

98. Jacopo Sansovino, Loggetta, 1538–45, rebuilt with modifications after the 1902 collapse of the Campanile, white Istrian limestone and Carrara, Verona, and Byzantine colored marbles, Piazzetta S. Marco. Elevated terrace with balustrade, 1653–63; bronze gate, 1733–42. Giorgio Massari widened the attic by the width of the rectangular end panels in 1749–50.

alpine powers and the end of Venetian terraferma expansion. The 1537–40 Turkish war, during which the Loggetta was designed and largely built, also resulted in the loss of most of Venice's fortresses in the Aegean Sea and the Morea and signaled the end of Venetian expansion in the Mediterranean, yet the 1540 Turkish peace was sustained for three decades. The Loggetta, then, marks a moment in Venetian history when a victory (in 1530) resulted in territorial containment and political marginalization, and a defeat (in 1540) gave birth to an era of relative peace and prosperity. Not surprisingly, therefore, it communicates both triumphalism and defensiveness.

The Loggetta's design—three arches framed by four pairs of freestanding Composite columns on pedestals supporting an attic with a crowning balustrade—based on the Arch of Titus in Rome, is the most classically correct interpretation of a Roman triumphal arch yet to appear in Venetian architecture, an apt motif for Gritti's vision of Venice as a new Rome. The winged Victories

in the spandrels of the arches and the panels of trophies in the attic heighten the triumphalism of the ensemble. The use of luxurious multicolored materials carved with exquisite craftsmanship and the accurate employment of both the grammar and the syntax of classical architecture also expressed Venetian claims to prosperity and cultural sophistication.

The central attic relief portrays the standard personification of Justice/Venice holding a sword and scales and seated on a Solomonic lions' throne of wisdom. She is flanked by a pair of classicizing river gods, symbolic of the Venetian terraferma empire. The relief to the right with two sea nymphs swimming near a shore allegorizes the island of Cyprus, where Venus, here reclining nude (a stand-in for Venice), was supposedly buried, in the temple of Venus represented behind her. She disarms a voluptuous Cupid (his bronze arrow lost) to signify the triumph of celestial love over terrestrial, the classical equivalent of Charity on the Porta della Carta. The relief to the left represents a titanic fig-

one hundred arches, fifty carrying the intermediate entablature and fifty the crowning entablature. Fifty round windows pierce the frieze of the uppermost entablature to light a mezzanine under the roof.

This system of arches carried on Corinthian piers and columns marks the Procuratie Vecchie as the most thoroughly classical building in Venice to date. However, the roof line's cresting, in spite of its motif of classicizing vases, still imparts an ornamental Gothic character to the whole, much like the cresting on the Doge's Palace (fig. 5). Furthermore, arches rather than columns carry the entablatures, which feature unusually wide, nonclassical friezes. Finally, alternate columns on the upper floors rest over the portico's arches, unsupported from below, thereby compromising the façade's expression of load and support.

Nevertheless, the building's strong horizontality and the rhythmic march of columns and arches across its surface created a perfect complement to the processional life of the piazza. With three times more space devoted to openings than to solid mass, its design was also ideal for shops and apartments. Indeed, the airy transparency of the building's open façade remained unsurpassed until the nineteenth century, when the introduction of iron and steel framing made all-glass façades possible.

Pietro Bon's Campanile Spire

Jacopo de' Barbari's 1500 *View of Venice* depicts the late medieval Campanile, whose original spire lightning destroyed in 1418, terminating rather bluntly in a colonnaded bell chamber (fig. 3, no. 9). When an earthquake in 1511 damaged the Campanile, the procurators of S. Marco commissioned their architect, Bon, to repair the shaft and build a new spire. Bon terminated the long brick medieval pilasters of the shaft with classicizing round shell-niched arches, united by a classical entablature in Istrian limestone (fig. 96). He then added a new vaulted bell chamber, with a Doric arcade on each of the four sides, framed by massive Doric corner piers. Finally, he capped the ensemble with a pyramidal spire that rises from a nearly cubic red brick pedestal and terminates in a gilt bronze weathervane representing the Archangel Gabriel, recalling the founding of Venice on the Feast of the Annunciation in 421 AD. Two sides of

the spire's pedestal are adorned with sculptural reliefs that represent the lion of St. Mark displaying the Latin text of the angel's prophecy to Mark: "Peace be to you, my Evangelist [here your body will lie]." The two opposite sides feature the crowned figure of Justice/Venice holding a sword and seated on a Solomonic lion's throne of wisdom.

The Campanile's decoration marked Venice as a sacred, apostolic city founded on divine justice. It was also perfectly attuned to the dual religious and secular functions of the tower's bell, which called Venetians to worship and to state rituals, summoned government officials to meetings, warned citizens of danger, and celebrated victories. As the highest bell tower in Venice (almost 328 feet, or 100 meters), it also unified the city spiritually and politically, an especially important function after the defeat at Agnadello.

95. ◀ Pietro Bon, Procuratie Vecchie, c. 1513–29, Piazza S. Marco. Jacopo Sansovino completed the northwest end in the 1530s.

96. Pietro Bon, Campanile spire, 1511–14, Piazza S. Marco. The Campanile collapsed in 1902 and was rebuilt in 1902–12.

CLOCK
TOWER

PROCURATIE VECCHIE

CHURCH OF
S. MARCO

PIAZZA S. MARCO

CAMPANILE

LOGGETTA

PROCURATIE NUOVE

5

6

1 2 3

4

7

COURTYARD

PIAZZETTA
S. MARCO

LIBRARY

SALA DEL MAGGIOR
CONSIGLIO

DOGE'S PALACE

COLUMN OF
ST. THEODORE

COLUMN OF
ST. MARK

SHOPS MINT

MOLO

N
W E
S

■ DOGE'S PALACE, FIRST PIANO NOBILE
■ DOGE'S PALACE, SECOND PIANO NOBILE

97. Plan of the Piazza and Piazzetta S. Marco after the renovations of Jacopo Sansovino and his followers: 1 Porta della Carta, 2 Porticato Foscari, 3 Arco Foscari, 4 Scala dei Giganti, 5 Sala del Collegio, 6 Senate, 7 Sala dello Scrutinio.

99. Jacopo Sansovino, *Jupiter Receiving a Scepter from an Eagle on Crete,* 1538–45, marble, Loggetta, Piazzetta S. Marco.

100. Jacopo Sansovino, *Apollo,* 1538–45, bronze, 4 ft. 8⅞ in. × 1 ft. 7⅝ in. (144 × 50 cm), Loggetta, Piazzetta S. Marco.

101. Jacopo Sansovino, *Mercury,* 1538–45, bronze, 4 ft. 8⅞ × 1 ft. 7⅝ in. (144 × 50 cm), Loggetta, Piazzetta S. Marco.

ure of Jupiter, the supreme deity of the classical pantheon, reclining on a shore with his thunderbolts and receiving his scepter of supreme authority from an eagle (fig. 99). A temple of Jupiter, the Labyrinth of the Minotaur, and a Triton and Nereid in the water near the shore identify the locale as Crete, where Jupiter was said to be interred. Jupiter with his thunderbolt and scepter—the classical equivalent of St. Mark on the Porta della Carta—signified the spiritual and temporal sovereignty of Venice, and Jupiter and Venus together symbolized Venice's maritime empire. Justice, Jupiter, and Venus also evoked Venice's divine ordination and its mission to exercise charity toward God and its subjects and to establish justice and peace throughout its dominions.

For the Loggetta's niches Sansovino created four slightly under-life-size deities—the first freestanding bronze classical figures in Venetian sculpture—which added yet more color and texture to the rich ensemble. To the far left Pallas Athena (or Minerva), the goddess of wisdom, agriculture, and the arts and crafts—outfitted as the goddess of war, with a Roman helmet, cuirass, Medusa shield, and (broken) spear—embodied Venetian military power and the virtues of ideal rule, Arms and Letters, with an emphasis on Arms. The counterbalancing allegory of Peace to the far right, torching a classical helmet and cuirass, was derived from medals inscribed PAX AUGUSTI commemorating the pacification of the then known world by Emperor Augustus (r. 63 BC–14 AD). Since Sansovino's son wrote in his guidebook to Venice that the figure also signified "that peace which the Lord gave to our protector, St. Mark" (1663 ed., p.

308), the sculpture embodied both temporal and spiritual peace—specifically, the state's role in establishing peace in its terraferma and maritime empires and promoting the salvation of its subjects through divine justice.

Sansovino's Apollo (fig. 100), the god of the sun, poetry, and music, paired with Pallas Athena in the second niche from the left, was closely modeled on the Vatican *Apollo Belvedere.* His lyre (broken off) and a quiver of arrows are his attributes as both the *sol iustitiae* (sun of justice) and the *sol invictus* (unconquerable sun). Thus he too personifies Arms and Letters, but here with an emphasis on Letters, and by his graceful contrapposto—the first so fully developed in Venetian freestanding sculpture—the vitality and harmony of the Venetian state.

Inspired largely by Donatello's bronze *David* (c. 1455–60), Sansovino's Mercury (fig. 101), the god of commerce, in the third niche from the left, appears uncharacteristically warlike, as he stands victorious over the severed head of

102. Jacopo Sansovino, Library, 1537–90, limestone over a brick core, Piazzetta S. Marco. Cardinal Bessarion's books installed by 1564; opened to the public in 1570; completed by Simon Sorella in 1591.

the watchful, many-eyed Argus, whom he beheaded after lulling him to sleep with music (Ovid, *Metamorphoses* 1.668–724). As a triumphant figure, Mercury forms an appropriate pair with Peace. His elegant gestures, upturned head, and winged hat also suggest his roles as the god of eloquence, messenger of the gods, and conductor of souls to the underworld. Therefore, as a symbol of the Venetian government's mediation between secular prosperity and spiritual salvation, Mercury also made a worthy companion for Apollo.

Sansovino's Library

In 1468 the Greek Cardinal Bessarion bequeathed to Venice his valuable collection of more than a thousand Greek and Latin manuscripts on the condition that the city construct a public library to house them. Initially the books were inadequately stored in the Sala dello Scrutinio of the Doge's Palace and in the upper galleries of S. Marco, not easily accessible to scholars. But as interest in classical studies and publishing classical texts grew in Venice and well-trained humanists were increasingly in demand for governmental and diplomatic service, a public library became essential, as Pietro Bembo, the great Venetian humanist, poet, literary theorist, and later cardinal, eloquently argued when he was appointed state librarian in 1530 (see F. Sansovino, 1663 ed., p. 309). The Ve-

netians were also well aware that they were being outshone by the major republican, ducal, and papal regimes in Italy that had already built important public or semipublic libraries as essential adjuncts of political power: in Florence the library in the Dominican monastery of San Marco, founded in 1438 by Cosimo de' Medici; in Urbino the library in the ducal palace, founded in 1464 by Duke Federico da Montefeltro (1422–82); in Rome the Vatican Library in the papal palace, founded in 1475 by Pope Sixtus IV; in Siena the Piccolomini Library in the cathedral, founded in 1502 by Cardinal Francesco Piccolomini (1439–1503); and in Florence again the Laurentian Library in the Augustinian monastery of San Lorenzo, founded in 1523 by Pope Clement VII.

In 1537 the procurators therefore commissioned Sansovino to build a public library as a great showpiece to surpass all previous examples. Closely following descriptions of ancient libraries mentioned by such classical writers as Vitruvius (active 46–20 BC) in *De architectura* 6.4.1, Pliny the Elder (23–79 AD) in *Natural History* 35.2.9, and Pausanias (c. 110–180 AD) in *Description of Greece* 1, Sansovino designed the Library to be freestanding in the civic center—not within a monastery, cathedral, or palace, like all previous Italian Renaissance libraries—with a façade richly articulated with classical columns and classicizing sculptures punctuating the skyline (fig. 102), a design derived in part from

103. Ground-floor and piano nobile plans, Library, Piazzetta S. Marco: 1 Portico fronting shops, 2 stairway entrance to the piano nobile, 3 upper stairway landing, 4 vestibule housing the Accademia Veneziana between 1570 and 1591 and thereafter the Statuario Pubblico, 5 reading room.

104. Reading room, Library, Piazzetta S. Marco.

the Basilica Aemelia and the Theater of Marcellus in Rome. He also faced it eastward, to receive the best morning light for reading and to reduce dampness harmful to books.

Behind the twenty-one arched openings of the ground-floor façade, a barrel-vaulted portico provided a sheltered walkway for a series of small shops (fig. 103), rented out by the procurators to help finance the Library's construction and the ongoing maintenance of the Piazzetta and Piazza S. Marco. The central bay gives access to a monumental barrel-vaulted stairway leading to the piano nobile landing, covered by a domical vault. To the south of this landing were offices for the librarian and the procurators. To the north a square vestibule with an image of Wisdom executed in the vault by Titian in 1560 was lit by three windows on the east and west. In 1570 it opened as a humanist school for noble youths, the Accademia Veneziana. But between 1591 and 1596 Scamozzi remodeled the vestibule to house a public museum containing 217 works of antique sculpture donated by the Grimani family, the largest collection of antiquities outside Rome. By emulating the public classical sculpture museums founded by Pope Sixtus IV on the Capitoline Hill in Rome and by

Pope Julius II in the Vatican Cortile del Belvedere, the Statuario Pubblico fortified Venice's claim to being a new Rome.

From the vestibule one entered the large reading room, lit by seven tall windows on the east and three on the north (fig. 104). The twenty-one panels of its gilt wooden ceiling, completed by seven artists in 1557, represent various allegories associated with wisdom, including the Virtues and the Liberal Arts, while Tintoretto executed the six philosophers between the windows in 1571–72.

Sansovino articulated the ground-floor façade with the Doric order, termed masculine by Vitruvius, as an appropriate expression of the commercial strength and political stability of the Venetian patriarchal state (fig. 105). His sophisticated and rigorous application of classical details on the capitals and entablatures was also a sign of erudition appropriate for a library. These include Doric capitals with a necking ring decorated with rosettes, and an echinus ornamented with egg-and-dart molding under an abacus that carries a classically correct entablature with a plain architrave, a frieze composed of metopes and triglyphs sandwiched between taenia, regulae, mutules, and guttae, and a cornice adorned with bead-and-reel and denticulated moldings (see glossary, s.v.

"Doric"). Sansovino strengthened his trabeated Doric design by engaging it with an arcuated system of massive piers and arches to support the weight of the upper story and to buttress the lateral thrust of the masonry vaults of the portico. He decorated the keystones of the ground-floor arches with heads of classical deities and Mark's lion, the spandrels with male river gods holding turtles and cornucopias, and the metopes with trumpets, lions, and libation dishes—all victorious signs of the new Rome's dominion, prosperity, and sanctity.

On the upper story Sansovino employed Ionic columns—halfway between the masculine Doric and the feminine Corinthian—to suggest a virile femininity apt for Venice. He also engaged the trabeation here with an arcuated system, to buttress the masonry vaults originally planned for the interior to fireproof the building. But in 1545 the foundations proved to be unstable, a typical problem with Venice's sandy soil, which caused the vaults under construction in the reading room to collapse. This minor disaster cost Sansovino a brief stint in jail, forfeiture of two years' salary, repairs at his own expense, and the substitution of wooden ceilings for masonry vaults on the piano nobile.

Sansovino supported the arches of his second-story façade on both piers and paired freestanding fluted Ionic columns, in a configuration called the Serlian or Palladian window. Originating in antiquity as a frame for the appearance platforms of Roman emperors, the Serlian motif was associated with sovereignty, dominion, victory, and divine favor. Sansovino's sculptural decoration—keystones with heads of Pallas Athena and Mark's lion and spandrels with youthful, bare-breasted winged Victories holding books, palms, globes, cornucopias, and trumpets—complemented these meanings and added wisdom and prosperity.

To accommodate the oval windows of the mezzanine under the roof, Sansovino designed an exceptionally wide frieze for the crowning entablature, which he richly decorated in high relief with classicizing infants dancing over the Ionic columns and holding garlands draped below alternating lion and female heads, a design inspired by a fragment of a Hadrianic sarcophagus in the Grimani collection.

Sansovino projected both the Doric and the Ionic cornices unusually far out from the building to emphasize the horizontality of the entablatures. When viewed from an oblique angle, the entablatures function much like orthogonals of a perspective construction, emphasizing the north-south longitudinal, processional axis of the piazzetta. But the massive piers and arches and the powerful vertical thrust through the superimposed columns, pedestals, danc-

105. Façade detail, Library, Piazzetta S. Marco.

ing infants, and classical deities and obelisks on top of the crowning balustrade not only counterbalance the downward horizontal pressure of the entablatures but also offer a transcendent spiritual release along the skyline.

The two-story, monochromatic, round-arched High Renaissance Library, celebrating Venice as a new Rome, on the west side of the piazzetta was counterbalanced on the east by the four-story, multicolored, pointed-arched Gothic Doge's Palace, which associated the Venetian government with the refinement and elegance of northern European royal courts. While the two buildings could not be more different, Sansovino was so sensitive to the aesthetics of Venetian architecture that they actually harmonize. Both have strong and regular lateral rhythms, framing the processional life of the piazzetta. Both have multiple parts and broken skylines, creating a rich play of texture, pattern, solid, void, light, and dark across their façades. Although smaller and less voluminous, the Library, the seat of wisdom, nevertheless holds its own against the Doge's Palace, the seat of justice, by means of its greater length, solidity, and classical refinement.

RIALTO

Scarpagnino's Fondaco dei Tedeschi

A fire in 1505 destroyed the large Gothic-style, state-owned German trading house, the Fondaco dei Tedeschi (fig. 2, no. 1), on the left bank of the Grand Canal near the Rialto Bridge, where Arnold von Harff stayed (see prologue). Since rent of the space and taxes on the goods that passed in and out of this major trading house were essential for the Venetian economy, the Council of Ten immediately commissioned the Milanese architect Antonio Abbondi, called Lo Scarpagnino (c. 1465/70–1549), to rebuild it at state expense as quickly and economically as possible, using plastered brick with a minimum of stone trim. Despite the crowning Gothic crenellation, the Fondaco dei Tedeschi represents the earliest purely Renaissance civic building in Venice in the bold geometric clarity of its overall mass and the stark simplicity of its plan and articulation (fig. 106), although the frescoes by Giorgione and Titian that once decorated the façade would have softened its current austerity.

On the front façade, facing the Grand Canal, massive chamfered Doric stone piers support the five arches of the watergate, while smaller Doric stone piers carry the arches of the windows defining the piano nobile. The five stories are organized into three horizontal layers defined by two simple classiciz-

106. Antonio Scarpagnino, Fondaco dei Tedeschi, 1505–8.

ing stone cornices and a crowning corbeled cornice. The central section of the façade is framed by two thin stone pilasters that contain the five-bay watergate on the ground floor and three rows of five paired windows above, each row defining five identical rooms behind.

This central section is also flanked by two towerlike blocks with five rows of two pairs of windows, each pair lighting a large room behind. Arched windows and balconies emphasize the piani nobili of these "towers."

The large, square internal courtyard in the center of building—imitated from central Italian palaces—is articulated with four superimposed porticoes (fig. 107): five groin-vaulted bays on each side on the ground floor and ten bays with wooden ceilings on each side on the upper three floors. The porticoes serve as corridors giving access to the rental shops on the ground floor and the various storerooms, offices, and living quarters on the upper floors. The chamfered Doric piers that carry the arches of the porticoes are doubled at the corners for strength and the visual closure of each side and become progressively shorter at each successive level. Overall, the courtyard communicates an exceptional sense of both visual rhythm and structural strength, recalling a Roman aqueduct, without a trace of Gothic ornamentalism.

107. Ground-floor plan and section, Fondaco dei Tedeschi.

108. Antonio Scarpagnino, Palazzo dei Dieci Savi and Fabbriche Vecchie, 1514–23.

Scarpagnino's Palazzo dei Dieci Savi and Fabbriche Vecchie

In 1514 an even worse fire than the one that destroyed the Fondaco dei Tedeschi, on the opposite side of the Rialto Bridge, destroyed the offices of the state tax collectors (Palazzo dei Dieci Savi; fig. 2, no. 7); the shops for silk and linen cloth dealers, tailors, goldsmiths, jewelers, shoemakers, rope sellers, spice merchants, bankers, and many others (Fabbriche Vecchie; fig. 2, no. 8); and the Merchants' Portico (fig. 2, no. 5). Again the Council of Ten immediately commissioned Scarpagnino to rebuild the interconnected Palazzo dei Dieci Savi and the Fabbriche Vecchie, and he again employed a stripped-down classical utilitarian style of plastered bricks articulated with a minimum of stone trim (fig. 108). His design consisted of a long Doric portico on the ground floor with shops behind and two floors of offices and storerooms above, separated by two full stone entablatures and crowned by a corbeled cornice. The cornice of each entablature also serves as the windowsill for each of the plain, stone-trimmed rectangular windows.

Guglielmo Grigi's Palazzo dei Camerlenghi

The 1514 fire also damaged the Palazzo dei Camerlenghi (fig. 2, no. 6), one of the first pure office buildings in Europe, devoted entirely to the administration of Venetian finances and commerce. It served more than eighteen departments, includ-

ing offices for the state treasurers (*camerlenghi*), state cashiers, overseers of public revenue, mangers of the public debt, auditors of finance, members of the stock exchange, magistrates for the sale of salt, and supervisors of the debtors' prison.

The triangular section at the north end, completed in 1488 in the early classical style of Pietro Lombardo's S. Maria dei Miracoli (fig. 28), mostly survived the fire (fig. 109). But because of damage to other parts of the building, the entire fabric was rebuilt or upgraded between 1525 and 1528 by Guglielmo Grigi il Bergamasco (c. 1490–c. 1533) and made fireproof by using Istrian limestone for the walls and the masonry vaults over the interior spaces.

The building is remarkable for the profusion of rectangular and tall round-headed windows, which provide excellent light for the various offices, as well as for the sparing use of a flattened classical articulation. Plain Doric piers frame the roundheaded windows, and paired channeled pilasters define the corners of the façades, Corinthian on the first two levels and, rather uncanonically, Doric on the top. The corner pilasters and the crowns of the window arches carry a full entablature on each of the two lower levels and at the top a crowning frieze and corbeled cornice. The entablatures mark the floor divisions, and their cornices serve as sills for the windows of the upper two floors. The restrained articulation, expressing only a minimum of load and support, is enlivened by the wreaths and garlands carved on the friezes and by the wreaths inlaid with porphyry disks in the channeled pilasters, all reminiscent of the ornamental classicism of the Lombardo workshop. The final result is an elegant showpiece of the financial prosperity and administrative efficiency of the state in a most prominent location on the Grand Canal, precisely in the years just before the 1530 Peace of Bologna, the international treaty that recognized Venice's terraferma empire.

Sansovino's Fabbriche Nuove

The Fabbriche Nuove was yet another utilitarian building facing the Grand Canal in the market area of the Rialto (fig. 6, no. 12), commissioned by state overseers to serve as the fruit market, replacing earlier wooden buildings on the site. Since the state was financing the building, it had to be finished as quickly and economically as possible so that the rents could begin to pay off the cost of construction. Yet compared to the Fabbriche Vecchie (fig. 108) or the Palazzo dei Camerlenghi (fig. 109), its design, by Sansovino, was far more classicistic, crisp, and elegant (fig. 110).

As a precaution against fire, the new building was constructed to the extent possible of stone or plastered bricks with masonry vaults. The slight an-

109. Palazzo dei Camerlenghi, completed 1488, rebuilt 1525–28 by Guglielmo Grigi il Bergamasco.

gular bend of the main façade between the ninth and tenth bays (reading downstream) responds to a curve of the Grand Canal and enlivens the design of the very long building. The ground floor consists of a tall rusticated portico of carved Istrian limestone with twenty-five round arched bays. The middle floor is articulated with simplified Doric pilasters on tall pedestals carrying a full entablature, and the top floor with streamlined Ionic pilasters carrying a crowning corbeled cornice. All the windows rest on either the Doric podium or the Doric cornice and are capped with uniform triangular pediments. These windows lit the two floors of storerooms on either side of a long barrel-vaulted central hallway, reached by a single stairway.

Although it was constructed relatively quickly using mass-produced trim, Sansovino's design transformed this utilitarian commercial building into a work of classical dignity—reinforcing the image of Venice as a prosperous new Rome—along a major portion of the Grand Canal.

110. Jacopo Sansovino, Fabbriche Nuove, 1554–58.

Antonio da Ponte's Rialto Bridge

The Rialto Bridge completed the Renaissance urban renewal of the Rialto area. As Jacopo dei Barbari's *View of Venice* (fig. 2, no. 2) and Vittore Carpaccio's *Miracle near the Rialto Bridge* (fig. 67) illustrate, the only bridge across the Grand Canal in 1500 was a wooden drawbridge. The Council of Ten proposed a stone bridge as early as 1507, and both minor and major architects, including Sansovino, Andrea Palladio (1508–80), and Scamozzi, produced a variety of two-, three-, or five-arch designs over the course of the sixteenth century. But in the end a local builder well versed in the construction of Venice's some 450 bridges, the aptly named Antonio da Ponte (c. 1512–97), was finally commissioned to build the bridge between 1588 and 1592 based on his elegant single-arch design at the enormous cost of nearly 250,000 ducats (fig. 111).

In a technical tour de force, Da Ponte employed terraced foundations to minimize the amount of excavation and the length of piles, and diagonally coursed stonework slanted toward the canal to counteract the lateral thrust of the arch. He designed the span to be high enough for two large boats to pass underneath simultaneously yet low enough to minimize the gradient of the pedestrian ramps carried on top of the arch. Finally, he made the bridge wide enough for two rows of twelve shops and three walkways, one down the center and one on either side. Da Ponte was assisted by Benedetto Banelli and Antonio Contin

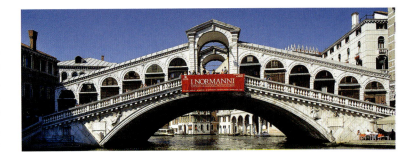

111. Antonio da Ponte, Rialto Bridge, 1588–92.

(1566–1600), architects of the Salt Office, which paid for the construction, who designed the classicizing superstructure of the twenty-four shops, with arched openings front and back, based largely on the Roman Arena in Verona. Each row of shops culminates at the center of the bridge in a rusticated and vaulted belvedere in the form of a triumphal arch, celebrating the perpetual triumph of Venice as a new Rome. In the spandrels of the arch, sculptural reliefs of the Annunciation recall the sacred bond of Venice with God from the day of its foundation in 421 AD, marking the city as a new Jerusalem.

13

FREESTANDING PUBLIC SCULPTURE

SANSOVINO'S *MARS* AND *NEPTUNE*

Many of the Renaissance architectural and sculptural additions to the civic center and several of the ducal tombs discussed so far glorified to an unusual degree the authority of the most militaristic doges of the fifteenth and the first four decades of the sixteenth centuries. Nearly all these doges—Francesco Foscari, Niccolò Tron, Pietro Mocenigo, Agostino Barbarigo, Leonardo Loredan, and Andrea Gritti—either served as military commanders or else energetically promoted wars to expand or protect Venice's territories on land and sea. But the governing patricians—distrustful of strong doges and protective of their collective power—increasingly circumscribed the limits of ducal authority in the continually revised *promissione ducale,* the book of rules by which each doge swore to abide at his coronation.

The doge was not allowed outside the ducal palace or permitted to consult anyone inside without the presence of his advisers. No one except a foreign ambassador was permitted to kiss the doge's hand or kneel before him. He could not read or write official documents, make decisions, or execute actions without the presence and consent of his councilors and other relevant government officials. He was not allowed to display his family coat of arms or his portrait anywhere outside the Doge's Palace except on his tomb monument, and his portrait was banned on state coinage.

Within the Doge's Palace, the display of the doge's coat of arms was limited to the Sala dello Scudo, in the ducal apartment. His portrait was restricted to the unbroken chronological sequence of ducal portraits in the frieze of the Sala del Maggior Consiglio, except that in the sixteenth century he was ex-

pected to supply at his own expense a votive picture with his portrait for the decoration of one of the many state rooms. While they certainly glorified the doge to some degree, the emphasis in these ex-votos was on thanksgiving to divinity for grace received, such as a military victory or the cessation of a plague. Finally, a doge could be deposed for his own crimes or those of his family, as when Foscari was deposed in 1457 for his son's corruption and treason.

Following a doge's death, a council of inquisitors carefully investigated his regime. If it found that the doge had engaged in fraud, profiteering, or personal aggrandizement, his heirs could be fined—as happened in the cases of Doges Agostino Barbarigo and Leonardo Loredan after their respective deaths in 1501 and 1521—and the *promissione* revised to prevent such abuses from recurring.

Yet doges with strong personalities frequently circumvented these restrictions, especially in times of great economic, political, or military challenges to the city, as evidenced by the numerous self-aggrandizing ducal portraits, coats of arms, and inscriptions on the Renaissance monuments in the civic center such as the Porta della Carta, Arco Foscari, Scala dei Giganti, and Clock Tower (figs. 10 and 12–14).

In reaction to these infractions of the rules, in 1554 the Senate ordered the overseers of the Doge's Palace to commission from Jacopo Sansovino two gigantic marble figures of Mars and Neptune, nearly fifteen feet tall—the first colossal sculptures in Venetian art. Designed to dwarf the doge on his land throne and diminish his personal charisma, they embodied and exulted the predestined imperial power of the Venetian state on land and sea. They were also intended to surpass the colossal sculptures promoting Florentine regimes

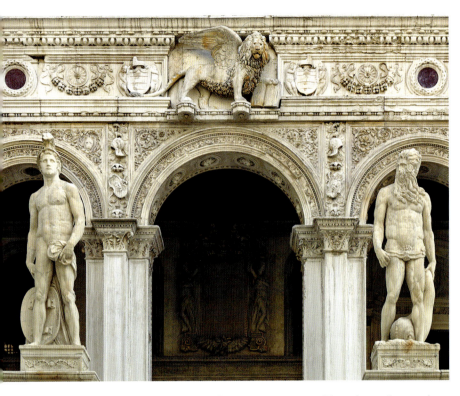

112. Jacopo Sansovino, *Mars* and *Neptune,* 1554–67, marble, each c. 14 ft. 5¼ in. (c. 440 cm), Scala dei Giganti, courtyard, Doge's Palace.

on the entrance stairs to the governmental palace in the civic center of Florence—*David* (1501–4) by Michelangelo (1475–1564) and *Hercules and Cacus* (1534) by Baccio Bandinelli (1488–1560)—and, like those figures, to heroicize, mythologize, and legitimate the city's dominion and sovereignty as the new Rome.

Mars, the god of war—wearing a classical helmet, originally holding a (now lost) bronze sword in his right hand, and standing over a shield and the head of a battle-ax—slightly rotates his shoulders and torso away from the stairs while turning his head and eyes back toward them (fig. 112). *Mars* does not exhibit a

true contrapposto, since both arms are lowered and both feet firmly planted on the base along the same plane—a deliberately flat-footed and steady stance (derived from Bandinelli's *Hercules*), to create a visual analogue to the stability and strength of the terraferma.

The more energetic figure of Neptune, the god of the seas, was appropriately inspired by *Admiral Agrippa as Neptune,* a much restored classical Roman sculpture in the Venetian Grimani collection. Scantily clad in seaweed across his loins, Neptune strides over a dolphin, his weight borne by his left leg and his left shoulder slightly lowered to grasp the dolphin's tail with his left hand. By contrast, his relaxed right leg is pulled back and his right shoulder slightly raised, in response to the lost bronze trident, once held in his right hand, which angled diagonally across his thick torso. To complete his dynamic contrapposto—the visual equivalent of the constant movement of the seas—Neptune turns his furrowed brow toward *Mars* into what appears to be a stiff sea breeze, which whistles through his beard and hair. He thus evokes the dramatic *Quos ego* moment in Virgil's *Aeneid* (1.124–143), when—furious at Juno's attempt to usurp his sovereignty over the oceans to destroy the fleet of Trojans escaping from their city, which the Greeks have devastated—Neptune rises from the depths of the sea to calm the waters, exclaiming, "Quos ego": "I am he [who commands the waves]," not Juno. Neptune thereby saved the Trojans who supposedly settled in and around the Venetian lagoon and whose descendants, converted by St. Mark on his mission to Aquileia, founded the sacred Venetian republic.

Mars and *Neptune* mark both the end of charismatic doges publicly displaying their authority in the Piazza and Piazzetta S. Marco and a renewed emphasis on the city's God-given imperial destiny as a new Rome—precisely at the moment when Venice's political and economic preeminence had begun to wane.

RIZZO'S *MARS*

Antonio Rizzo's marble *Mars* (fig. 113), carved for the niche on the south side of the Arco Foscari (fig. 12), represents the beginning of the classical revival in Venetian freestanding public sculpture, while Sansovino's *Mars* and *Neptune,* created some seventy-five years later, embody its full flowering. The works of the two artists are united ideologically by the notion that Venice inherited the mantle of imperial power from ancient Rome and Byzantium but are otherwise vastly different, in scale, muscular power, movement, and classical authority.

Rizzo's *Mars* wears ancient Roman military dress—helmet, cuirass, leather skirt, togalike cape, and Medusa-head shield—and displays a measure of classical contrapposto. Yet the figure is somewhat awkward, with more than a trace of the Gothic sway in its stance. In addition, the waist is too thin, the muscles too anatomically incorrect, the expression too melancholy, and the long hair better suited to a figure of Apollo. Rizzo's warrior thus appears to be at war with himself, incorporating elements of both Gothic and early Renaissance styles. This *Mars* celebrates the military accomplishments of Doge Foscari on the terraferma, while Sansovino's *Mars* and *Neptune* were intended to diminish the importance of any individual doge and to champion the divinely ordained imperial destiny of Venice: establishing peace and justice in its land and sea dominions and assisting its subjects in achieving salvation. In this regard, it is noteworthy that the dolphin—an attribute of both Neptune, who straddles and controls one here, and Venus (a stand-in for Venice) and often understood to be the fish that swallowed but ultimately saved Jonah—is one of the oldest Christian symbols of faith and salvation.

113. Antonio Rizzo, *Mars,* late 1470s, marble, 7 ft. 1⅞ in. (218 cm), originally on the south face of the Arco Foscari, now inside the Doge's Palace.

14
CHURCHES

GIORGIO SPAVENTO AND TULLIO LOMBARDO'S S. SALVADOR

The seventh-century Bishop Magnus, said to have founded S. Maria Formosa (figs. 31–34) on the basis of a vision of the beautiful (*formosa*) Virgin, was also believed to have been prompted by a dream to build the original church of S. Salvador near the Rialto Bridge (fig. 2, no. 12). According to Marin Sanudo, "There appeared to him Jesus Christ, the Savior of the world, and he ordered him to build a church at a location indicated by a red cloud in the middle of the city [emblematic of the Savior's sacrifice] ... and it was dedicated to S. Salvador."

The seventh-century S. Salvador was rebuilt in the twelfth century under Doge Sebastiano Ziani and consecrated, according to local lore, by Pope Alexander III, who awarded Doge Ziani the ducal *trionfi* for mediating and resolving the dispute between the papacy and Frederick I Barbarossa. The church was thus associated with the claim that the doge's authority and sovereignty equaled those of the pope and the emperor. The 1267 acquisition of the relics of St. Theodore—an important early Christian military saint from Asia Minor and the first patron saint of Venice, preceding even St. Mark—enhanced the church's importance. In 1450 the Venetian Senate decreed an annual ducal procession to S. Salvador on Theodore's feast day (November 9) to balance the long-standing celebration of Mark's feast day (April 25) in the church of S. Marco. These two ducal rituals to honor the Eastern military and Western ecclesiastical protectors of Venice in the Rialto and Piazza San Marco—the

commercial and political centers of Venice—symbolically confirmed Venice's self-perception as a triumphant new Constantinople, new Rome, and new Jerusalem, much like the two victory columns of SS. Theodore and Mark in the Piazzetta S. Marco (fig. 3, nos. 11 and 12). Finally, on May 23, 1506, the Council of Ten ordered S. Salvador to be completely rebuilt at state expense—an action taken in direct competition with the papacy in Rome, where only a little more than a month before (April 18, 1506), Pope Julius II had laid the cornerstone for the new St. Peter's, designed by Bramante (c. 1443/44–1514). As the new Rome, Venice was not going to be outdone by the old.

The cornerstone of S. Salvador was laid on March 25, 1507, the Feast of the Annunciation, symbolically refounding Venice under the protection of the incarnate Christ and recalling the city's foundation in 421 AD. The church was serviced by the wealthy order of Augustinian Canons Regular. Antonio Contarini (1450–1524), the Augustinian prior when the church was begun and elected the patriarch of Venice in 1508, captured the importance of the new church dedicated to the Savior when he wrote that Venice was "blessed by God, steeped in the blood of Christ from its very origins, and fed and led to greatness by it." The church's religious and political significance indicates why it was one of the few architectural projects carried out during the depression that followed the defeat at Agnadello in 1509. The importance of the relics of the Eastern St. Theodore and the competition with St. Peter's new church in Rome also explain S. Salvador's combined Byzantine and Roman design and great scale—it was the largest Renaissance church to date in Venice.

clerestory of the nave into rectangular bays, each alternate bay with a round-headed window; these pilasters support a corbeled cornice, from which springs the coved ceiling.

After Doge Gritti's death in 1538, the Grimani family became the principal patrons of the church, and in 1542 they purchased the rights to build the still incomplete façade as a tomb memorial honoring Doge Antonio Grimani (r. 1521–23), although the tomb was never executed. In 1562 Giovanni Grimani (c. 1506–93)—the patriarch of Aquileia, the highest Church position in the Veneto—commissioned Andrea Palladio to design a classicizing façade for the church (fig. 118). The architect faced the challenge of adapting a classical pagan temple façade—with columns carrying an entablature and triangular ped- iment fronting a simple rectangular space, or cella—to a Christian church façade. As many other Italian architects before him had discovered, the task of designing a proportional and integrated facade using the syntax and grammar of classical antiquity while satisfactorily expressing the spaces of the high nave and the lower side chapels or side aisle lying behind was most difficult. Palladio solved the problem by creating two proportionally related, interlocking Corinthian temple fronts resting on a single high base (fig. 119). The outside bays and partial pediments of the minor temple front—wider, lower, and more recessive—express the sloping roofs and spaces of the side chapels behind. The major temple front—narrower, taller, and more projective—expresses the roof line and space of the nave behind.

118. Andrea Palladio, façade, S. Francesco della Vigna, designed 1562, completed 1570. Bronze *Moses* and *St. Paul,* 1590s, by Tiziano Aspetti (c. 1559–1606). The pediment eagle (*aquila*) puns on Aquileia. Latin inscriptions, reading from top to bottom and left to right: "[Dedicated] to God, the builder and restorer of every temple. Approach here lest you forsake the spiritual [life] and not continue to battle internally and externally"—an apt motto for the church's ascetic friars.

119. Diagram of the two interlocking temple fronts of S. Francesco della Vigna.

from old patrician families and were educated humanists steeped in classical philosophy and architectural theory. A memorandum of understanding between Fra Giorgi and the architect dated April 1, 1535, makes clear that the overseeing friars required that Sansovino's design employ proportional dimensions based on musical harmonies (see R. Wittkower, pp. 155–57).

Pythagoras (sixth century BC) is credited with first discovering musical harmonies composed of simple whole ratios. He found, for example, that two taut vibrating strings, one twice as long as the other (in a ratio of 1:2), sounded a musical octave. Strings in a ratio of 3:4 created a musical fourth, and in a ratio of 2:3 a musical fifth. Both Pythagoras and Plato (c. 428–348 BC) were so impressed by the clarity, rationality, and simplicity of musical ratios that they believed divinity had constructed the universe with them, producing an inaudible *musica universalis,* or music of the spheres (Pliny, *Natural History* 2.18.20; Plato, *Republic* 7.12). Vitruvius (active 46–20 BC) in his *On Architecture*—the only treatise on the theory and practice of classical architecture to survive from antiquity—applied harmonic ratios to architecture, implying that a building employing them in its dimensions would be tuned to resonate in harmony with the cosmos.

Giorgi's memorandum, approved by Sansovino, demonstrates that these ideas informed the plan for S. Francesco della Vigna. The proportional dimensions, to be executed in paces (one pace equaled about 1.8 meters or about six feet), were as follows: The width of the nave was nine paces—"the square of three, the first and divine number" (for Giorgi, a reference to the Trinity)—and its length twenty-seven, creating a ratio of 1:3, although Giorgi understood that twenty-seven was composed of one musical fourth and two musical fifths, a proportional progression from 9:12 (3:4) through 12:18 (2:3) to 18:27 (2:3). The width (six paces) and length (nine paces) of both the chancel and the retrochoir generated ratios of 2:3, the same ratio as between the width of the chancel (six paces) and the width of the nave (nine paces). The width (six paces) and length (three paces) of each transept arm, the width (three paces) and length (four paces) of the two transept chapels, and the width and length (both three paces) of each nave chapel formed ratios of 2:1, 3:4, and 1:1 respectively. Fi-

nally, the width (nine paces) and height (twelve paces) of the nave produced a ratio of 3:4. "Thus," Fra Giorgi wrote, "all the measurements of the plan, lengths as well as widths, will be in perfect [musical] consonance, and will necessarily delight those who contemplate them, unless their sight be dense and disproportionate."

Following the lead of Vitruvius, who believed that stout Doric columns or pilasters were best suited for shrines to male divinities, Fra Giorgi also recommended for the interior the use of the Doric order, "proper to the saint [Francis] to whom the church is dedicated." Sansovino thus defined each chapel with Doric piers and pilasters, which carry a cornice from which springs a barrel vault; he also lighted the chapels with an oculus in the lunette and two roundheaded windows below, framing the altarpiece. Sansovino articulated the nave with Doric pilasters that rest on high pedestals between the entrances to the side chapels and carry a full entablature unifying the entire cruciform space of nave, transepts, chancel, and retrochoir. He also employed paired pilasters to articulate the arched openings to the barrel-vaulted transepts, the dome-vaulted chancel, and the barrel-vaulted retrochoir, thus clearly distinguishing each type of space. Finally, he used Doric pilasters to divide the

116.◄ Ground plan and longitudinal section, S. Francesco della Vigna (Jacopo Sansovino, architect), begun 1534, consecrated 1582: 1 nave, 2 transepts, 3 chancel, 4 retrochoir, 5 aisle chapel, 6 transept chapel.

117. Interior, S. Francesco della Vigna.

SANSOVINO AND PALLADIO'S S. FRANCESCO DELLA VIGNA

A reformed order of Observant Franciscans who strictly observed their vows of poverty, chastity, and obedience commissioned S. Francesco della Vigna (figs. 116 and 117), one of Jacopo Sansovino's earliest Venetian architectural projects. A small Gothic church from about 1300 previously occupied the site, which was believed to have been the location of the angel's prophecy to St. Mark. Doge Andrea Gritti, whose family palace of 1525–38 stood near the church's façade, was the first major patron of the project. He lobbied Pope Clement VII for the necessary papal brief to replace the original church (authorized in 1533), laid the cornerstone on the Feast of the Ascension, August 15, 1534, and donated one thousand ducats for a family tomb in the new chancel, where he was ultimately buried.

Owing to the reforming zeal of the Franciscans and the sensitivity of Sansovino to their needs, S. Francesco della Vigna was the first church in Venice to be built according to the new requirements of Counter-Reformation sanctuaries, well before these reforms became standard practice for church designs throughout Italy. The requirements included:

a Latin-cross plan, with nave, crossing, transepts, and chancel, to emphasize symbolically the central importance of Christ's sacrifice on the cross;

a dome over the crossing to symbolize heaven—here planned but never executed;

an ample, vaulted, well-lit, unencumbered, undecorated gray nave, to
> accommodate increasingly large numbers of laity,
> form a discrete space for preaching,
> provide superior acoustics for sermonizing,
> eliminate visual distractions for the auditors and evoke, through lack of pictorial adornment, humility and piety, and
> create a bright space bathed symbolically in divine illumination;

barrel-vaulted side chapels—replacing the traditional side aisles—raised above the floor of the nave and closed off by balustrades to emphasize the integrity of the nave as a separate preaching space while providing for the simultaneous celebration of multiple Masses by the friars required to celebrate Mass regularly and often;

a barrel-vaulted retrochoir behind the high altar, replacing the rood screen and choir stalls in the nave in front of the high altar—previously a standard feature in nearly all monastic churches—to protect the cloistered privacy of the friars, create a sonorous space for their chanting, and give the laity clear visibility of the high altar from the now unencumbered nave;

and finally, a chancel elevated above the level of the nave and transepts, a domical vault over the chancel, and superior side and back lighting for the high altar to emphasize the importance of the Eucharistic liturgy at high Mass and the adoration of the reserved Host when Mass was not being celebrated.

Three friars—including the superior of the monastery, Fra Francesco Giorgi (1466–1540), the author of a book on the harmony between the macro- and the microcosm (*De harmonia mundi totius* [Venice, 1525])—were assigned to consult with Sansovino and act as overseers of the project. All three descended

114. Ground plan and longitudinal section, S. Salvador (Giorgio Spavento and Tullio Lombardo, architects), 1507–34: 1 Jacopo Sansovino and Alessandro Vittoria's Tomb of Doge Francesco Venier (fig. 143), 2 Titian's *Annunciation* (fig. 138). Vincenzo Scamozzi added the lanterns in the three hemispherical domes in 1574.

115. Interior, S. Salvador.

Giorgio Spavento (c. 1440–1509) and Tullio Lombardo designed a Latin cross, standard in Western church architecture, with a nave, side aisles, transepts, a crossing, and a chancel (figs. 114 and 115). This plan provided the long processional routes through the church ideal for ducal visitations. But the church's plan and elevation also incorporate three overlapping quincunxes, terminating in three semicircular eastern apses, in close imitation of the Byzantinizing design of S. Marco (fig. 15). The three quincunxes symbolize the Trinity, fitting for the church's dedication to the Savior, while the hemispherical dome over the crossing provided the appropriate canopy for the doge when he and his retinue visited the church on the Feast of St. Theodore. Massive piers articulated with channeled Corinthian pilasters on high pedestals support the three domes—symbolic heavens. The shorter pilasters carry the arches and pendentives supporting the minor domical vaults, while the giant pilasters sustain a full entablature surrounding and unifying the entire cruciform space. Above the entablature the architects added an attic level decorated with circles in rectangles to raise the height of the vaults and to create a triumphal arch motif expressive of an ever-victorious Christ and a triumphant Venice.

The complex and tightly integrated design not only marked the climax of the Byzantine revival in Venice but also for the first time rigorously employed the vocabulary, grammar, massing, and vaulting characteristic of Roman classical architecture. Stylistically, S. Salvador marks the transition from early to High Renaissance.

The diameter of the smaller columns (two *piedi*, or feet) serves as the module for the entire proportional design. Their height is twenty feet, creating a 1:10 diameter-to-height ratio, not uncommon for the more (according to Vitruvius) "feminine" Corinthian order, while the giant columns are proportionally identical—four feet in diameter and forty feet high. The width of the center bay is twenty feet and its height from the column bases forty feet (1:2). The large temple front—twenty-seven modules wide and twenty-seven modules high from the ground to the entablature (1:1)—relates to the length of the nave (twenty-seven paces), which it fronts, and derives its ratios from the same harmonic progression of 9:12:18:27 (3:4, 2:3, 2:3). Once these basic proportional relationships are established, many additional ones automatically follow.

Rather than a traditional rose window to light the nave, Palladio employed above the entrance a tripartite semicircular thermal window, so called because it was widely used in ancient Roman baths. He also strengthened the corners of the design, by pairing the smaller Corinthian columns with a Corinthian pilaster. The major criticisms of this solution from a classical perspective are that the high base with the projecting pedestals for the giant order is overscaled for the minor temple front and that the smaller columns flanking the entrance offer a rather inelegant framing of just the top half of the doorway.

Nevertheless, S. Francesco della Vigna remains supremely important in the history of Venetian architecture, for its interior design, which first met so fully the requirements of the Counter-Reformation Church; for its dimensions, which are the first documented use of harmonic ratios in Renaissance architecture; and for its façade, which was the first to so satisfactorily apply classical orders to a Christian church.

PALLADIO'S S. GIORGIO MAGGIORE

In 982 Doge Tribuno Memmo (r. 979–91) donated the island of S. Giorgio to the Benedictines. Their original, tenth-century church there (fig. 6, no. 16) was dedicated to the popular third-century military saint from Asia Minor St. George, who, like St. Theodore, served as a protector of Venice, especially its maritime possessions. As the patron saint of the crusaders, George also enhanced the Venetians' conception of themselves as zealous protectors of the Church. In 1110 the Benedictines added St. Stephen (d. c. 35 AD), the first Christian deacon and martyr, to the church's dedication when they acquired his important relics from Constantinople. Finally, in 1462—well after the church had been rebuilt in a Gothic style, owing to an earthquake in 1223—the

Benedictines acquired the supposed head of St. George, making the church's dedication all the more tangible. From early on, the doge—accompanied by the usual retinue of high-ranking governmental officials and the *trionfi*—made two annual visits to S. Giorgio Maggiore. The first, accompanied by a citywide celebration, was a candlelit procession by boat on Christmas Day to celebrate vespers in honor of St. Stephen. When the doge alighted on the island from his ceremonial sea throne, the Bucintoro, he was greeted by the Benedictine monks in their ceremonial habits and given a multigun salute by Dalmatian troops. After the service, the doge and his retinue returned to the Piazza S. Marco—glittering with thousands of candles—and entered the Doge's Palace for a celebratory Christmas banquet. The second ducal visit occurred late the next morning (December 26, the Feast of St. Stephen), when the doge and his retinue returned by boat to S. Giorgio to pay their respects to the relics of St. Stephen, attend a High Mass, and share a banquet with the monks in their refectory. These rituals on Christmas and St. Stephen's day demonstrated the city's piety and love of God by celebrating Jesus's birth, announced nine months earlier on the day of the city's legendary founding, March 25, and honoring St. Stephen's faith and self-sacrifice in imitation of Christ. In addition to hosting these rites, the monastery of S. Giorgio served as the state guesthouse for visiting dignitaries.

In 1419 the monastery joined S. Giustina in Padua as part of the general reform and unification of several Benedictine monasteries in Italy, which both introduced new centralized administrative procedures and required monks to adhere strictly to their vows and practice lives of austere asceticism. By 1504 Monte Cassino had assumed leadership of the Benedictine reform movement, uniting all the Benedictine houses in Italy under the so-called Cassinese Congregation. Throughout the sixteenth century, however, S. Giorgio Maggiore continued to be one of the leading centers of Church reform in Venice, which prompted the Benedictines there to undertake a decades-long process of completely rebuilding their Gothic monastery and church in a new, reformed Romanizing classical style commensurate with the great importance of their church in state ritual and the Catholic Reformation.

Giovanni (1450–1513) and Andrea (active 1518–66) Buora completed new dormitories and new cloisters in 1540. In 1560 Palladio became the project's supervising architect, designing and building a new refectory between 1560 and 1562. In 1565 he was commissioned to make a wooden model of the new church, for which the Venetian government agreed to contribute substantial financial assistance. Abbot Andrea Pampuro, Doge Girolamo Priuli (r. 1559–

RETRO-
CHOIR

CAPPELLA
DEI MORTI

CHANCEL

PRE-CHANCEL

TRANSEPT CROSSING TRANSEPT

AISLE AISLE

NAVE

67), and Venetian patriarch Giovanni Trevisan (r. 1560–90) laid the corner-stone on March 13, 1566.

Palladio designed a Roman Latin cross church, although more than a hint of a Byzantine quincunx is configured at its core by the domed crossing, the adjoining barrel-vaulted bays of the nave, transepts, and prechancel, and the four adjacent groin-vaulted aisle bays, all containable within a square (fig. 120). He also devised a modular plan, remarkable for its clarity, unity, and proportionality. The square area of the crossing constitutes the plan's module. One

120. Ground plan, S. Giorgio Maggiore (Andrea Palladio, architect), designed 1565, executed 1566–89 (except the façade [fig. 126]), consecrated 1610.

121. Nave, crossing, prechancel, and chancel, S. Giorgio Maggiore.

122. ▶Aisle, S. Giorgio Maggiore.

modular unit also defines the retrochoir, the chancel, the prechancel, and each transept. Each apse of the two transepts and of the retrochoir can be contained in half a module. Two modules define the nave, and one-quarter of a module encompasses each of the eight aisle bays. The areas of the plan, therefore, relate to one other in terms of the simple ratios of 1:1, 1:2, and 1:4.

In both antiquity and the Renaissance, the stable square (or cube) symbolized earth, while the circle (or sphere)—without beginning or end and with every point equidistant from the center—signified heaven. Therefore, the square of the crossing capped by a hemispherical dome spatially constructed the intersection between earth and heaven reenacted at every Mass on the high altar. Significantly, the crossing of S. Giorgio Maggiore falls in the exact center of the plan (excluding the retrochoir), to indicate the centrality of the Church and its liturgy for mediating between here and hereafter. Palladio particularly emphasized the crossing visually, with eight pairs of giant Composite pilasters

and half columns engaged to massive piers that support the pendentives, drum, and dome (fig. 121).

Alongside this central emphasis, Palladio also unified the areas that compose the Latin cross by employing barrel vaults over the nave, transepts, and prechancel, and a continuous entablature surrounding the entire cruciform space. This clear demarcation of and emphasis on the Latin cross symbolized Christ's sacrifice and the entire body of Christendom. It also epitomized the Counter-Reformation's insistence on the centrality of Christ and the Church for redemption.

Following the lead of Sansovino's S. Francesco della Vigna, Palladio discreetly segregated the component parts of his plan to indicate different functions within the general unity of the design. He articulated the nave with giant Composite half columns on pedestals engaged to massive arched piers. The sheer size of the nave served to accommodate the crowds not only on Christmas and St. Stephen's Day but also on other days as well, now that the laity were expected to attend Mass and take communion weekly or even daily, and not merely at Christmas and Easter, as previously. The barrel vault of the nave provided an acoustically resonant sounding board for preaching, instructing the laity, and instilling the spirit of piety and participation. The six thermal windows piercing the sides of the vault flooded the nave with light, symbolic of the presence of divinity. Finally, Palladio's sober off-white limestone articulation over white plastered walls reflected and encouraged the congregation's expected piety and humility.

The aisles are distinguished by groin vaults supported by massive piers articulated on two faces with pairs of engaged Corinthian pilasters and on another face with a single engaged half column (fig. 122). Structurally the aisles buttress the barrel vaults of the nave, transepts, and prechancel. Functionally they provided circulation routes through the church, especially during the ducal visits.

The eight aisle bays and the two transept apses (fig. 123) each contain an altar and an altarpiece framed by single or paired Corinthian columns carrying an entablature and a triangular pediment. These multiple altars provided for the simultaneous celebration of many Masses in order to accommodate the Counter-Reformation requirement that all ordained priests celebrate Mass regularly, usually at least once a day. Previous churches, of course, also contained multiple chapels with multiple altars, but these often served as private family burial chapels, some with locked metal gates, to be used exclusively by family members. Palladio's altars were accessible to all.

Palladio designed the two apsidal transepts and the prechancel to accommodate the ducal party as near as possible to the high altar during its annual Christmas and St. Stephen's Day visits. The transept apses were also particularly important, for the relics of St. Stephen were transferred in 1581 from the old high altar to the altar of the left transept, while the altar of the right transept was dedicated to St. Benedict, the founder of the Benedictine order. As a result, Palladio ensured that the transepts were exceptionally well lighted, with large thermal windows cut into their barrel vaults and four rectangular windows cut into the walls of each apse, whose lower two windows were framed by fluted Corinthian columns supporting a rounded pediment.

The architect illuminated the crossing with four rectangular windows in the drum, articulated by Doric pilasters carrying a cornice from which springs the hemispherical dome. The dome, an emblem of the heavenly sphere, lighted by a lantern, a sign of Christ's resurrection, provided a canopy for the doge in front of the altar.

To free the high altar visually from the obstructions of a rood screen and choir stalls in the nave, which were standard in most previous monastic churches, Palladio followed Sansovino's plan for S. Francesco della Vigna and created a retrochoir behind the altar.

He also distinguished the chancel from the rest of the church by elevating it by three steps, separating it from the prechancel by a low balustrade, and covering it with a groin (rather than a barrel) vault (fig. 124). Palladio also articulated the chancel far more richly than the rest of the church. In the four corners he placed two overlapping giant Composite pilasters and a giant free-standing fluted Composite column, each with separate pedestals. They support in succession the groin vault's transverse arches, its diagonal groins, and its longitudinal arches, which frame a large thermal window on each side wall. These windows and two additional thermal windows cut into the walls below bathe the high altar in radiance. The altar was also immersed in the celestial music from the cloistered monks chanting in the retrochoir and from the magnificent

123.◀ Transept, S. Giorgio Maggiore.

124.◀ Chancel, S. Giorgio Maggiore.

125. Aerial view of exterior, S. Giorgio Maggiore.

126. Façade, S. Giorgio Maggiore, designed 1565, constructed 1607–11. Sculptures: *Doge Tribuno Memmo* and *Doge Sebastiano Ziani* in the tabernacles; *St. Stephen* and *St. George* in the niches; *St. Mark* and *St. Benedict* on the lower pediment; *Christ as Salvator Mundi* on the upper pediment, flanked by two *Angels; St. George* on the dome's lantern.

organ, carried aloft by the rood screen of Corinthian pilasters and freestanding fluted Corinthian columns mediating between the chancel and retrochoir. The chancel, then, more than ever before, constituted a discreet holy of holies—highly visible to the laity—for the celebration of High Masses and the display of the Host. This glorification of the high altar, through elaborately articulated forms, intense light, and harmonious sound, was a quintessential feature of nearly all Counter-Reformation churches. It reflected the period's renewed emphasis on the Eucharist, the sacramental means of salvation.

Far more than the architects of previous Venetian churches, Palladio captured at S. Giorgio the massiveness and spatial grandeur of ancient Roman architecture to symbolize the reformed Church's stability and universality. He also employed throughout a rounded cushion frieze for all of the entablatures and a pronounced entasis for all the columns and the pilasters to express a lively elasticity of forms that symbolically communicated the renewed vitality of the reformed Church. In addition, his repetition throughout the church of an in-terlocked trabeated and arcuated triumphal arch motif signaled the Church's victory over heresy and sin. Finally, his design's proportional harmony, symphonic composition of circular forms, lucid volumes, and bright light all envisioned the celestial perfection sought by the faithful through the Church's mediation.

An aerial view of S. Giorgio demonstrates that Palladio's clarity and rationality of interior space are precisely reflected on the exterior, where the general cruciform shape and the separate spaces of the nave, aisles, transepts, crossing, prechancel, chancel, and retrochoir are all easily discernible (fig. 125).

The façade was constructed between 1607 and 1611, after Palladio's death, but based on his wooden model with few modifications (fig. 126). It represents a more impressive solution to the challenge of adapting classical forms to a Christian church than had his earlier façade for S. Francesco della Vigna (figs. 118 and 119). Corinthian pilasters on low pedestals carry the secondary entablature and the outer segments of the lower triangular pediment, avoiding the prob-

lem of the disproportionally high base of the smaller order at S. Francesco della Vigna. These pilasters divide the wider, recessive temple front into five bays, the central bay slightly narrower than the others. At the corners the pilasters have been doubled for visual strength. In the center of the façade, four giant Composite three-quarter engaged columns on tall pedestals carry the primary entablature, with a cushion frieze and a full triangular pediment. Palladio divided this taller, more projective temple front into three bays, the central one considerably wider, to accommodate the entrance. The two overlapping temple fronts anticipate the spaces and articulation of the nave and aisles and add decorative splendor to the exterior. This magnificent Romanizing frontispiece across the water from the Doge's Palace provided a dramatic focal point for the annual ducal processions. It also symbolized the grandeur, antiquity, and universality of the reformed Church.

PALLADIO'S IL REDENTORE

During the devastating plague that swept through Venice between 1575 and 1577, killing some forty-five thousand residents, or about 25 percent of the population, the Venetian Senate vowed to build a church and visit it annually, in the hope that God would end the epidemic. When the plague finally abated, the Senate fulfilled its vow by commissioning Palladio in 1577 to build Il Redentore on the island of the Giudecca (fig. 6, no. 14). After its completion, a temporary pontoon bridge was (and still is) built annually across the wide Giudecca Canal for the Feast of the Redeemer (the third Sunday of July), to allow the doge and his retinue to process to the church and give thanks for deliverance from the contagion. The church was assigned to the Capuchin order, a branch of Observant Franciscans founded in 1528, which was noted for its strict adherence to Franciscan rule and ascetic lifestyle. The church therefore required a retrochoir for the seclusion of the friars, conformity with the by now well-established design principles of Catholic Reformation churches—recently codified by the archbishop of Milan Carlo Borromeo (1538–84) in his 1577 *Instructionum fabricae*—and special attention to the requirements of a votive church visited annually by governmental officials.

Palladio employed a harmonically proportioned modular plan using the square of the domed crossing, including its masonry supports, as the module (fig. 127). He contained the nave in two modules, the retrochoir in one, and the side chapels each in one-sixth, for ratios of 1:1, 1:2, and 1:6. To provide superior

127. Ground plan, Il Redentore (Andrea Palladio, architect), designed 1577, consecrated 1592: 1 crossing, 2 nave, 3 side chapels, 4 transepts, 5 chancel, 6 retrochoir.

acoustics for preaching, he designed a barrel vault over the nave. To brightly light the nave with divine illumination, he added three thermal windows on each side of its vault, suggestive of the Trinity (fig. 128). He articulated the walls of the nave with giant Corinthian half columns and pilasters, with entasis, on low pedestals, and engaged to massive piers. They support the full upper

entablature encircling and unifying the entire church. To enhance the congregation's concentration on humility, piety, and asceticism, the nave was left entirely undecorated.

The giant order of the nave overlays shorter Corinthian pilasters with entasis, supporting the lower entablature encircling the six side chapels and threading its way around the entire church behind the giant order, to unite the chapels to the nave and the rest of the church. Yet to emphasize the integrity of the nave as a separate preaching space, Palladio elevated each side chapel by three steps and closed it off with a balustrade. However, the side chapels also echo the design of the nave, with barrel vaults and large thermal windows lighting their altars. Palladio framed each chapel altarpiece with engaged fluted Corinthian columns, an entablature, and a triangular pediment. He also designed these chapels with exceptionally thick and malleable side walls with apses, to help buttress the nave's barrel vault and to impart an appropriate solidity and gravity to the entire church. He interconnected the side chapels by opening passageways through the side-wall apses for the circulation of the friars who offered multiple daily Masses. Together the interlocked trabeated and arcuated systems articulating the nave and side chapels create a triumphal arch motif, symbolic of the triumph of Christ and the Church.

Palladio separated the nave from the crossing by narrowing the opening to the crossing and elevating it three steps above the nave. He supported the crossing drum and dome on pendentives carried on four massive complex piers articulated with giant engaged Corinthian half columns and pilasters. He also made the crossing more dynamic than the nave by placing the complex piers at 45 degree angles relative to the central longitudinal axis of the church, which visually charged the mediation between heaven (symbolized by the hemispherical dome) and earth (signaled by the square crossing) effected at the celebration of every Mass. The crossing dome also served as a canopy for the doge, to express the sacredness of the ducal office.

Palladio reduced the transepts to semicircular apses with semidomes articulated by four giant Corinthian pilasters (fig. 129). The pilasters frame two banks of three rectangular windows, the lower windows framed by shorter Corinthian pilasters carrying an entablature and one segmental and two triangular pediments. As they contain no altars, Palladio designed these exceptionally well-lighted apsidal transepts to illuminate the high altar and to accommodate the large contingent of governmental officials during the annual visits on the Feast of the Redeemer.

128. Nave and side chapels, Il Redentore.

To allow the doge and his retinue to be as close to the votive high altar as possible, the architect also reduced the chancel to a semicircular apse. He supported its semidome on four freestanding giant Corinthian columns, which also served as a screen for the retrochoir and allowed the high altar to be dramatically backlit and suffused with celestial harmony by the chanting of the friars.

The weaving together of the separate elements of Il Redentore into a tightly interlocked system of major and minor columns, pilasters, and entablatures engaged to thick sculpted walls, and the compact clustering of circular, semicircular, and hemispherical forms and spaces, created an interior that offers a

129. Transept, Il Redentore.

130. Exterior, west flank, Il Redentore.

most dynamic yet stable expression of the reformed Church. Equally remarkable, Palladio created an exterior massing that lucidly expresses the interior volumes (fig 130).

For the façade, Palladio arrived at a definitive solution to the problem of applying a classical temple front to a Christian church (fig. 131). Both the major and minor overlapping temple fronts now share a uniform low base, which he achieved by lowering the principal pediment so that its peak reaches only as high as the crown of the nave vault behind. He then added behind the pediment a rectangular segment as high as the point of the pediment and as wide as its entablature and capped it with a hipped roof that covers the wooden truss-work supporting the roof above the vault. He inclined the hipped roof at the same angles as the main pediment so that it reads visually as a subsidiary pediment. He also incorporated into the design the external buttresses that help to support the nave vault by treating the two at the front, on either side, as subsidiary, broken pediments with a slope conforming to the angles of the major and minor temple-front pediments.

131. Façade, Il Redentore. Sculptures: *St. Mark* and *St. Francis* in the niches; statues of St. Lorenzo Giustiniani (1380–1456), the first patriarch of Venice, and St. Anthony of Padua (c. 1193–1231) on the minor pediments; *Faith* flanked by two *Angel*s on the hipped roof; *Christ the Redeemer* on the lantern.

Palladio widened the central bay of the main temple front so that the arched entrance could be framed with its own minitemple front, consisting of two tall engaged Corinthian columns supporting an entablature and a triangular pediment with the same slope as that of all the other diagonal elements. He articulated the main temple front with two giant pilasters on the corners, to relate to the pilasters defining the minor temple front, and with two giant engaged columns in between, to relate to the two engaged columns of the entrance. Finally, he designed two stairway and bell towers, probably inspired by Muslim minarets, to both frame and emphasize the dome, the symbol of salvation.

A comparison with Mauro Codussi's scenographic façade of S. Michele in Isola (fig. 22) vividly testifies to how much the understanding of the classical language of architecture had evolved in Venice over the course of about a century and how Palladio exploited that understanding to create one of the most satisfying expressions of the reformed Church in the history of Venetian architecture.

15

ALTARPIECES

Venice's well-developed trade and transport network along the coast of the Adriatic and within the terraferma provided an extensive export market for paintings. This lucrative trade encouraged large workshops, especially family enterprises, like that of the Bellini, which were more common in Venice than elsewhere in Italy. Even the Bellini-influenced Giorgione (1477/78–1510), who primarily painted sophisticated secular paintings for elite collectors in Venice during his brief career, exported his one and only altarpiece (his largest work) to his hometown in Castelfranco Veneto (see fig. 8), a work that marks the beginning of the High Renaissance style in Venetian painting (fig. 132).

The six ribs on the coat of arms in the painting's tondo pun on the name of its patron, Tuzio Costanzo (*costa* in Italian means "rib"). Costanzo—a noted Sicilian mercenary whose father, Muzio (d. 1479), had been the vice-king of Cyprus—had served as a knight for Queen Caterina Cornaro (fig. 94) in Cyprus. When she was exiled to Asolo in 1489, he settled in nearby Castelfranco, where he could continue to serve her—and work as a mercenary for the Venetians. He commissioned Giorgione's painting in about 1504 for his family chapel in S. Liberale in Castelfranco in memory of his son Matteo, also a knight, who had died in Ravenna in 1503 at age twenty-three while serving under the command of the mercenary Bartolomeo d'Alviano (1455–1515).

The figure on the left, holding the banner of the crusading Order of St. John of Jerusalem, appears to be St. Nicasius, a Sicilian knight of that order martyred in 1187. St. Nicasius's Sicilian origins would no doubt have been important to the Costanzo family, and the patron's younger brother and one of his sons were also knights of the Order of St. John of Jerusalem. St. Nicasius's cult was closely connected with St. Francis, represented on the right. However, since the Costanzo chapel was dedicated to St. George and the church to St. Liberale, the painting's knight might instead represent either of these saints.

The rectangular altarpiece employs correct one-point perspective, opening a window onto an expansive and unified space. The steep orthogonals of the tessellated floor and the Virgin's throne focus precisely on the Virgin's womb and Jesus's left heel, thus drawing attention to both the Incarnation and Christ's fated mission to step into the world to redeem humanity. The sleeping Christ child, his mother's sad expression, and the deep-red porphyry base of the throne, resembling a sarcophagus or an altar, also foreshadow Christ's coming sacrifice and its liturgical commemoration in the Mass.

Compared to most of the Bellini altarpieces (e.g., figs. 49–52), Giorgione's *Castelfranco Altarpiece* presents a more naturalistic image of the earthly Church. The tiled floor mimics the two-color pavements common in Venetian churches and perhaps in the original Costanzo chapel. The shallow space, only three and a half tiles deep to the break in the pavement, locates the two saints near the worshiper, with whom they make eye contact. A bright light from the upper right casts strong shadows, illuminating the scene naturally and atmospherically, a remarkable achievement for a work executed in egg tempera.

Yet simultaneously Giorgione represents the celestial Church more powerfully than did Bellini. Behind the break in the floor, Giorgione extended the space back to a depth of sixteen tiles, to a wall draped with the saints' scarlet velvet cloth of honor. Within this ample space the massive and exceptionally

132. Giorgione, *Castelfranco Altarpiece* (*Virgin and Child with SS. Nicasius and Francis*), c. 1504, tempera on panel, 6 ft. 6⅞ in. × 4 ft. 8⅞ in. (200 × 144 cm), S. Maria Assunta e S. Liberale, Castelfranco Veneto. S. Liberale was rebuilt in the eighteenth century, destroying the original Costanzo chapel, which first housed this painting.

high throne without stairs locates the Virgin in an inaccessible mystical zone and against an infinite sky aglow with divine light. Similarly, the steep orthogonals defining a Λ-shaped configuration both focus attention on the Virgin and Child and distance them from the viewer.

By draping the Virgin in a green tunic (rather than her usual blue), red cape, and white veil, Giorgione also abstracted her into an embodiment of the Theological Virtues, Faith (white), Hope (green), and Charity (red). The resplendent cloth of honor on the back of the Virgin's throne, seemingly descending from the sky, creates a golden aura, marking Mary as the queen of heaven.

Giorgione constructed a number of other paradoxical relationships in this dual material and spiritual universe. The ascetic St. Francis—honored by the stigmata—embodied the contemplative life. Yet he stands closest to the worshiper, actively looking and gesturing outward. The serene landscape above the saint, anything but the desert of his hermitic life, evokes paradise regained, and the mysterious city in the far background suggests the new Jerusalem. The tiny armored knights with lances in the meadow, perhaps an allusion to the companions of Matteo Costanzo mourning the loss of their captain, introduce a note of conflict that ties the penitential St. Francis to St. Nicasius.

St. Nicasius personified the active life in defense of the Church, yet he stands farther back in space and is a more contemplative figure than St. Francis. The steep fortified village above him, its tower decorated with the lion of St. Mark, appears to be abandoned, perhaps desolated by war or plague. Yet the landscape is verdant, as if regeneration awaits those who defend the faith.

The diagonal of St. Nicasius's lance balances the light falling diagonally across St. Francis to configure visually a steep V shape. Together the material lance and the immaterial light also create parallels to the active and contemplative lives of the saints and to the Eucharist, which is both materially present and mystically transcendent. Similarly, every tangible object in the work has been largely abstracted into either pure geometry or an immaterial optical film of color and light.

This intellectualized equilibrium of contrary impulses defines the essence of a High Renaissance style called forth by such Christian dualities as matter/spirit, earth/heaven, and here/hereafter.

TITIAN'S *ASSUMPTION OF THE VIRGIN*

Most fifteenth-century Venetian altarpieces represented the type designated *sacra conversazione*—holy figures of various historical periods engaged in a "sa-

cred conversation" in a heavenly court (e.g., figs. 48–52). But the ambitious and brilliant young Titian (c. 1490–1576)—eager to claim the leadership of Venetian painting after the deaths of his two mentors, Giorgione and Giovanni Bellini—was offered an opportunity to perfect a type rarely used previously, the dramatic narrative, when in 1516 he was commissioned to paint an *Assumption of the Virgin* for the high altar of S. Maria Gloriosa dei Frari (figs. 133 and 134), a work flanked by the tombs of Doge Francesco Foscari (fig. 36) and Doge Niccolò Tron (fig. 39). Titian's *Assumption* was not only the largest Renaissance altarpiece in Venice (more than twenty-two feet tall) but also the most dynamic. Bellini had produced several purely narrative altarpieces, but they lacked the energy of Titian's work, while the earlier examples of Venetian altarpieces illustrating the Assumption lacked Titian's dramatic focus, including as they did saints extraneous to the narrative, as in a *sacra conversazione.*

The Latin inscription on the pedestals of the frame's freestanding columns translates as "Fra Germano [da Casale, abbot of the Conventual Franciscans of the Frari] commissioned and erected this altar in 1516 to the Mother of the eternal creator assumed into heaven." Therefore, as was typically the case with high altars, the church authorities did not sell but instead retained the patronage rights, and the dedication of the altar was identical to the dedication of the church, as further indicated by the altarpiece's subject matter and the disks inscribed "Blessed Glorious Virgin" ("Beata Virgo Gloriosa") and "Glorious St. Mary" ("S. Maria Gloriosa") held by two angels flanking the Virgin's head to the extreme left and right.

Collaborating with the sculptor Giambattista Bregno (c. 1476–post-1518), Titian designed the frame of the altarpiece as a classicizing triumphal arch articulated with a pair of freestanding fluted Corinthian columns—the order, according to Vitruvius, especially appropriate for a female deity. The artists ornamented the entablature's frieze with emblems of death (bull crania) and symbols of renewed life (cherubs and garlands) and decorated the pedestals of the columns and the spandrels of the arch with signs of victory (trophies and winged Victories). At the bottom of the frame Titian designed a small relief of the Man of Sorrows, against which the Host was juxtaposed at the elevation to visually confirm the doctrine of transubstantiation. This relief and the large freestanding sculpture of the resurrected Christ at the top of the frame bracket the central vertical axis with representations of the death and resurrection of Christ, to visualize the essence of the Eucharistic liturgy. The artists, in short, translated the triumphal arch, classically interpreted as a liminal passageway between war and peace, into an expression of the ritual mediation between sacrifice and salvation.

Titian designed the altarpiece to relate to the architecture of the apse by making its height and breadth equivalent to the height and breadth of the two lancet windows it covers. He thereby set up a sharp contrast between the Gothic apse and the classical frame—between filigreed forms dematerialized by light and structural forms expressing load and support—to serve as a visual analogy of the Eucharist's mediation between spirit and matter. In addition, since the Frari is one of the few monastic churches to have preserved its rood screen and choir for the friars in front of the high altar, it is evident that Titian designed the altarpiece to be framed by the rood screen's arched entrance, which supported a crucifix. When worshipers walked up the nave, they experienced the visual juxtaposition of the crucifix and the *Assumption,* illustrating the sacrifice of Christ and the triumph of the Church.

The interests and ideology of the church authorities were shown in the two freestanding sculptures above the columns of the frame, glorifying the founder of the Franciscans, St. Francis, and the order's eloquent preacher and miracle worker, St. Anthony of Padua. The high altar's dedication to the Assumption also supported the Franciscans' promotion of the doctrine of the Immaculate Conception, for if the Virgin was born without original sin, she could not have died but rather was assumed directly into heaven.

Almost all previous representations of the Assumption showed the Virgin rising to heaven from a sarcophagus, as it was widely believed that before her glorification she experienced a three-day Dormition (sleep) in a tomb, just as Christ remained three days in his tomb before the Resurrection. But Titian followed the rare precedent of Andrea Mantegna's circa 1457 *Assumption,* in the church of the Eremitani in nearby Padua, by omitting the tomb. He thereby emphasized more powerfully the doctrine of the Immaculate Conception.

At the Dormition, it was believed, the apostles were mystically transported from all over the world to grieve the Virgin's passing and witness her Assumption. Here the apostles, draped in the colors of the Theological Virtues (white, green, and red), register their intense emotions with their joyful gestures and pious expressions, which are heightened by the bright light on the horizon marking the dawn of a new day. In the center of the group, Titian represented the cofounders of the church, SS. Peter and Paul, recognizable by their beards and facial types. Peter sits on a boulder, in reference to the biblical episode in which Christ puns on his name (Petrus) by calling him the rock (*petra*) upon which he will found his church (Matthew 16:18–19).

In the upper zone it appears that the apse of the Frari has suddenly been opened to the heavens as the Virgin ascends triumphantly into paradise on

133. Titian, *Assumption of the Virgin,* signed, 1516–18, oil on panel, 22 ft. 7⅝ in. × 11 ft. 9¾ in. (690 × 360 cm), high altar, S. Maria Gloriosa dei Frari.

134. Titian, *Assumption of the Virgin* in situ, S. Maria Gloriosa dei Frari.

a cloud surrounded by a circular glory of angels, some derived from classical putti, who sing to the accompaniment of pipes and a tambourine. Their exuberance was perhaps inspired by the recovery in the very years when Titian was at work of Venice's terraferma after the defeat at Agnadello.

Drawing on the example of the circa 1513 *Sistine Madonna* by Raphael (1483–1520), now in Dresden, Titian depicted the Virgin in a dynamic con-

trapposto, expressing two contrary impulses. She steps and gestures rightward while simultaneously turning her upper torso leftward to come face to face with God, an anatomical torsion appropriate for the embodiment of the visible Church. While also inspired by the dynamic gestures and muscularity of Michelangelo's God the Father on the Sistine Chapel ceiling (1508–11), Titian created a figure of God so strongly foreshortened that he almost appears to be

disembodied—simply an aged head, symbolic of Eternal Wisdom, and a pair of outstretched, welcoming arms. Flanked by angels carrying the Virgin's victory wreath and heavenly crown, God rotates rightward, in the direction of his gaze, to bring the drama to a climax as he engages the Virgin's eyes, infuses her with divine knowledge, and prepares to crown her the queen of heaven.

Titian underlined the Virgin's role as the mediator between earth and heaven with the drapery tied in a knot at her womb. This symbolized the ancient and Renaissance philosophers' *nodus et copula mundi* (knot and bond of the universe), conjoining spirit and matter. The significance of the knot is heightened by her cape's blue (symbolic of divinity) and by the infant caught in its folds, suggestive of the Word made flesh. The Virgin's red tunic evokes love of God and neighbor, her outstretched arms recall the early Christian *orant* posture of prayer, and her veil suggests a nun's consecration as Christ's virgin bride, which together express the Virgin's charity, piety, and purity. Finally, her beatific expression; platform of clouds, which casts a shadow on the apostles; and circular aureole of golden light also associate her with Wisdom of the Old Testament and the prophecy of the Incarnation, the Assumption, and the Church triumphant described in Ecclesiasticus 24:6–7: "I [Wisdom] made that in heaven there should rise a light [Christ] that never faileth, and as a cloud [the vessel of divine light] I cover all the earth [the universal Church]. I dwelt in the highest places, and my throne is in a pillar of a cloud." The sunlike sphere of light also recalls the Apocalyptic Woman of the New Testament, a prophecy of the Incarnation, the universal Church, and Resurrection recorded in Apocalypse 12:1–5: "A great sign appeared in heaven: A woman clothed with the sun. . . . And she brought forth a man child [Christ], who was to rule all nations . . . [and] was taken up to God and to his throne." Although the drama unfolds in the present, the Virgin fills the entire universe from beginning to end as Wisdom, the vessel that gave birth to the light of the world, and as the queen of heaven.

An austere and symbolic compositional structure contains this high drama. A solid rectangle, anchored by a boulder and washed with waxing natural light, defines the visible Church. An ethereal sphere ablaze with golden radiance and edged with reddish seraphim, symbols of divine love, constructs the invisible Church. The domains are conjoined by a steep, visually dynamic red triangle, symbolic of the Trinity, which embraces a moment in history (the Son), all history (the Spirit), and eternity (God the Father).

To achieve this masterpiece, Titian drew inspiration from works of antiquity and his most innovative contemporaries. However, he surpassed their efforts in clarity, drama, light, color, and sensitivity to site. Aware of his achievement, he engraved his name illusionistically on Peter's symbolic rock, as if for all eternity he offered the mental and physical labor of his creative genius as a meritorious work for the salvation of his soul.

TITIAN'S TREVISO *ANNUNCIATION*

Titian's *Annunciation* (fig. 135)—another example of the strong Venetian art export trade—was commissioned by a canon of the cathedral of Treviso, Broccardi Malchiostro (his initials and coat of arms are represented to the left of the Virgin), for his burial chapel, consecrated in 1523 with a dedication to the Annunciation and St. Andrew. The Confraternity of the Annunciation, of which the patron was a member, met in the chapel and helped to finance the altarpiece, accounting for its subject matter.

Titian employed a rigorous but eccentric one-point perspective that greatly enhances the dramatic action. The orthogonals focus not at the center of the painting, as was customary, but at the far right—at Archangel Gabriel's belt—with the horizon line at about the eye level of the donor kneeling in the background and the viewer standing in the chapel. For the perspective to appear correct, the viewer must stand to the right directly opposite the angel, which creates a dramatic zigzag configuration of forms, reading from the standing viewer to the kneeling Virgin to the standing angel to the kneeling patron. This compositional structure integrates both the viewer and the donor into the drama of salvation and explains the otherwise odd placement of the patron.

The principal drama, however, is between the angel and the Virgin. The angel races into the picture space from the right, arms extended, wings flapping, drapery billowing, and mouth open in the salutation recorded in Luke 1:28, 31: "Hail, full of grace, the Lord is with thee Behold thou shalt conceive in thy womb, and shalt bring forth a son; and thou shalt call his name Jesus."

Simultaneously, the Virgin has dropped her book and spiraled around to face Gabriel with a bowed head, an expression of humility, and her left hand on her breast in a gesture of piety and acceptance. Her response to Gabriel from Luke 1:38 is inscribed on the frame: ECCE ANCILLA DOMINI (Behold the handmaid of the Lord[; be it done to me according to thy word]). To enhance the altarpiece's dramatization of this moment when the Spirit was made flesh, Titian painted Gabriel's drapery a whitish gold, symbolic of the spirit, and the Virgin's robes the traditional colors suggestive of the mediation between spirit and matter—blue, evocative of heaven, and red, signifying charity or love of God and neighbor.

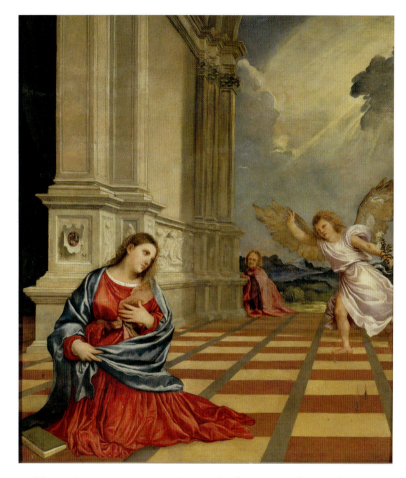

135. Titian, *Annunciation,* c. 1520, oil on panel, 6 ft. 10⅝ in. × 5 ft. 9¼ in. (210 × 176 cm), Chapel of the Annunciation and St. Andrew, Cathedral, Treviso.

Titian, however, emphasized the materiality of the Virgin as the embodiment of the earthly Church, by depicting her on a red-and-white-tiled floor, which echoes the paving of the actual chapel, by locating her close to the picture plane, and by placing behind her a monumental barrel-vaulted structure that recalls a church's chancel. To further enhance the spatial illusionism and the Virgin's materiality, Titian highlighted Mary with light that responds to the chapel's natural light from a window in front of and to the right of the altarpiece, as indicated by the diagonal shadows falling across the tiled floor behind her and on the back half of the architecture.

Yet simultaneously Titian illustrated the Virgin's mediation between the terrestrial and the celestial Church, by depicting the right half of the barrel-vaulted chancel open to the heavens, with a supernatural golden radiance symbolic of the divine spirit streaming in from the upper-right background. Thus, while the natural light cuts across the orthogonal structure from outside the painting, the spiritual light parallels the orthogonals from the inside. This contrary push and pull of illumination both intensifies the drama and acts as a visual metaphor for the Mass, which mediates between here and hereafter. Indeed, the elevated Host would appear precisely between the material Virgin and the spiritual Gabriel.

But the internal light does even more, for this radiance is contained within a cloud to evoke Ecclesiasticus 24:6–7, which alludes to the Virgin as the vessel of the incarnate divine light and as the universal Church. But since Wisdom speaks this passage, the Virgin is also associated with divine wisdom and justice, symbolized by her book. Similarly, the angel carries a white lily, the standard attribute of the Annunciation and emblematic of the Virgin's purity but also evocative of her divinity by reference to the celestial fleur-de-lis.

Finally, the classicizing Titans and Nereids on the base of the architecture were associated with death in antiquity and the Renaissance, but by their loving vitality they were primarily metaphors for renewed life. Similarly, Gabriel, atypically depicted here as a child, emphasizes youthfulness and spiritual regeneration.

Titian was spurred to create such a dynamic painting by a desire to surpass his rival, Giovanni Antonio Pordenone (c. 1483–1539), who slightly earlier had painted the chapel's vault with a particularly dramatic fresco.

TITIAN'S *PESARO ALTARPIECE*

The Dominican Jacopo Pesaro (1464–1547), the bishop of Paphos (Cyprus), commissioned Titian's *Pesaro Altarpiece* (fig. 136) in 1519 for his family burial chapel, dedicated to the Immaculate Conception, in the Frari. The donor—who at his death was buried in the wall tomb to the right of the altarpiece—is portrayed tonsured and kneeling with gloved hands in prayer before the Virgin and Child, in the most favored position, to the holy figures' right. Titian represented kneeling in the foreground on the opposite side the bishop's four living

legitimate brothers and a nephew, all dressed in their luxurious patrician robes, who at their subsequent deaths were buried in a floor vault in front of the altar: (from left to right) Francesco (1451–1553), Antonio (c. 1458–pre-1529), Giovanni (1459–1533), Antonio's young son and heir, Leonardo (b. 1509), and Fantino (1468–post-1547). Not surprisingly in patriarchal Venice, where women only rarely patronized works of art, this first portrait of a family to appear in a Venetian altarpiece consists entirely of males.

Behind Jacopo Pesaro a white-turbaned Turk is held captive by an armored knight lifting a banner with the coat of arms of Pope Alexander VI and topped with a laurel branch of victory. These allude to the bishop's appointment in 1501 by Pope Alexander VI as papal legate and commander of a papal Mediterranean fleet, which was victorious on August 30, 1502, in a naval battle against the Turks at the island of Santa Maura (also called Leucas; now Lefkada)— a minor episode of no lasting significance in the 1499–1503 Venetian-Ottoman war, as a treaty ceded the island to the Turks the next year. Yet the knight and the Turk were intended to recall the donor's good work in defending the Church against the infidel and to assist in his salvation.

Standing on the steps of the Virgin's high cubic throne—symbolic of Christ, the cornerstone of the Church—St. Peter, the founder of the Roman Church, holds open a book of Scriptures, where Christ's life is foretold, and mediates between the bishop and the Holy Family. Peter's power to save and damn is signaled by the keys that Christ consigned to him (Matthew 16:18–19), resting on the steps at his feet, and visually enhanced by the blue and gold of his robes, symbolic of the heavens and divine light. On the right, SS. Francis and Anthony of Padua, name saints of the two older brothers and protectors of the Frari's Franciscans, intercede for Jacopo's family.

The altarpiece is on the fourth altar in the church's left aisle. Since any worshiper walking up the nave toward the high altar first views the painting at an oblique angle, Titian created a dynamic asymmetrical composition, with the painted architecture turned at about a 45 degree angle to the picture plane. The orthogonals focus to the left, well outside the painting, on the horizon line, which runs across the top step at approximately the eye level of a standing worshiper. Yet the composition reads equally well when viewed straight on, with its dramatic crescendo of ever more active figures running diagonally upward from left to right, toward the high altar: from the kneeling Jacopo Pesaro to the standing St. Peter, leaning rightward but twisting his head and torso leftward to look down at the donor, and to the enthroned Virgin, who leans toward and gazes at the donor as her cloth of honor cascades over the

136. Titian, *Pesaro Altarpiece* (*Virgin and Child with SS. Peter, Francis, and Anthony of Padua and Donors*), 1519–26, oil on canvas, 15 ft. 8¼ in. × 8 ft. 9½ in. (478 × 268 cm), S. Maria Gloriosa dei Frari.

throne's base from under her feet. The Christ child, standing on his mother's left thigh—the climax of the upward diagonal thrust—directs the compositional energy downward with his gaze toward the two Franciscan intercessors. St. Anthony of Padua looks downward as St. Francis gazes up adoringly at the Virgin and Child while spreading his arms wide to simultaneously display the stigmata and embrace the bishop's brothers and his young nephew, who brings the composition to a close with his outward gaze at the worshiper. Jesus—the most active figure in the painting—precociously anticipates his mission to step out into the world to save humanity by kicking his left leg forward and foreshadows his self-sacrifice by extending his arms in a cruciform posture while grasping the Virgin's white veil, a symbolic shroud.

The two most innovative and influential features of the altarpiece—ones that were achieved only by much trial and error, as X-rays and a technical analysis of the underpainting show—are the two truly mammoth, diagonally placed columns on high pedestals, which extend heavenward well beyond the top of the pictorial field. They serve as the visual equivalent of a full organ sounding a sustained, victorious fanfare, celebrating and monumentalizing the figures of St. Peter and the Holy Family and their mediating roles between the terrestrial and celestial Churches. The celestial Church is explicitly visualized in the two active angels on a dark cloud—one looking down to earth, the other up to heaven—who elevate Christ's salvific cross and carry it skyward. The dark cloud in the foreground and the light-filled cloud in the background associate the Virgin once again with Wisdom in Ecclesiasticus 24:6–7. This mystical background light, internal to the painting, plays against the natural light from outside the painting that falls from the upper left, casts a shadow on the steps, and cuts diagonally across the orthogonals. This contrast between divine and natural light not only further animates the composition but also creates another spiritual/material dialectic analogous to the significance of the Mass.

Similarly, the stairway leading to the Virgin's throne recalls one of Mary's standard epithets, Stairway to Heaven, again emphasizing her role as mediator between matter and spirit. When the priest celebrating Mass elevates the Host, its proximity to the steps, keys, and St. Peter thus visualizes the worshiper's understanding of the Eucharistic liturgy within the Church as the reenactment of Christ's birth, death, and resurrection and the conjunction between heaven and earth.

Finally, it appears most likely that the Franciscans of the Frari and the Confraternity of the Immaculate Conception, which met in the chapel, understood the altarpiece's glorification of the Virgin as both the embodiment of the Church and the queen of heaven as confirmation of the doctrine of the Immaculate Conception, which the Franciscans championed.

TITIAN'S *MARTYRDOM OF ST. LAWRENCE*

The patrician Lorenzo Massolo (d. 1557), a friend of Titian's, in 1547 commissioned *Martyrdom of St. Lawrence* (fig. 137) to honor his name saint. When he died in 1557, his beautiful and learned wife, Elisabetta Querini (d. 1559), oversaw the completion of the work, even though it was not installed above the altar of the Massolo-Querini family chapel in S. Maria dei Crociferi (rechristened as S. Maria Assunta dei Gesuiti when the Jesuits rebuilt it in the eighteenth century) until sometime after 1564. In the long decade of the altarpiece's making, political, religious, and economic crises gripped the Church: the Hapsburgs dominated Italy politically and militarily, and the Protestants, who relentlessly exposed the Church's corruption, worldliness, and abuses of power, had converted much of northern Europe to Protestantism, costing the papacy nearly half of its previous revenues and considerable self-confidence. In response, the Church returned ever more nostalgically to its primitive roots for solace, especially to the heroic age of Roman persecutions, when, in spite of the most severe trials, it had persevered through faith and self-sacrifice. Titian's altarpiece representing Lawrence's nocturnal nightmare of being burned alive on a gridiron captured the Church's sense of persecution but also expressed its hope that it would ultimately be saved by God's grace, as was St. Lawrence (d. 258).

The painting was also produced in the context of an artistic crisis manifest in a debate between Venetian and central Italian artists concerning *disegno* and *colorito*. *Disegno* connoted both the physical act of drawing and the mental process of designing, of composing by outline. *Colorito* meant coloring, the active process of composing and painting directly on the canvas, without or largely without drawings. This debate was conducted through three important publications—*Dialogue on Painting* (1548) by Paolo Pino (1534–65), *Lives of the Artists* (1550) by Giorgio Vasari (1511–74), and *L'Aretino* (1557) by Lodovico Dolce—and in lively discussions in artists' workshops.

For Venetians, especially Titian, *colorito* was the unique essence of painting in Venice. For Vasari and his central Italian followers, *colorito* was subordinate to *disegno,* which constituted the great unifying principle of all art, whether painting, sculpture, or architecture. *Disegno*—best illustrated for Vasari by the works of Michelangelo—emphasized sharp contours and vir-

137. Titian, *Martyrdom of St. Lawrence,* signed, c. 1547–58, oil on canvas, 16 ft. 2⅛ in. × 9 ft. 1 in. (493 × 277 cm), S. Maria Assunta dei Gesuiti.

tuoso foreshortenings, precisely the qualities Venetian *colorito* tended to play down. While Vasari recognized *colorito* as a necessary component of *disegno,* for him Raphael, not Titian, best combined the two. Titian gained a new understanding of the *disegno/colorito* debate on a 1545–46 trip to Rome, where for the first time he saw the great Roman works of Michelangelo, Raphael, and antiquity. In *Martyrdom of St. Lawrence* he addressed the *disegno/colorito* debate by demonstrating his superiority in combining both equally.

Inspired by Raphael's *Liberation of Peter* (1511–14), in the Stanza d'Eliodoro in the Vatican Palace, Titian animated the composition by employing four sources of nocturnal light, arranged in a zigzag pattern on the canvas. To further intensify the drama, he steeply foreshortened the grill, temple, and stairway; focused their orthogonals well beyond the left side of the painting, at about the height of Lawrence's upraised hand; and depicted the rays of moonlight, the torch standards, Lawrence, the soldiers, the prod, the lance, and the banner along various dynamic diagonals. Titian based the figure of St. Lawrence, appropriately, on the Hellenistic fragmentary marble sculpture the *Falling Gaul* in the Grimani collection but in a virtuoso performance worthy of Michelangelo outdid the ancient source by making his saint—heroically struggling against the pulling and prodding of his tormentors—more muscular, massive, and dramatically foreshortened. And he certainly had Michelangelo in mind, for Titian's wood carrier and fire stoker to the extreme left quote Michelangelo's similarly employed sons of Noah in the Sistine Ceiling's *Sacrifice of Noah* (1508–11)—a most intelligent quotation, for as Michelangelo's scene prefigured Christ's sacrifice, Titian's Lawrence imitated it. Finally, the persecutor pulling Lawrence onto the grill by his shoulders was derived from the Hellenistic *Laocoön* discovered in 1506 in Rome and on display in the papal sculpture court in the Vatican.

Looking upward with his arm raised in wonder, Lawrence alone perceives the descent of the silvery moonlight breaking through the dark clouds—and the moon basking in the light of the sun was an age-old metaphor for the earthly Church bathed in the radiance of the resurrected Christ. This light, then, visualizes the conjunction of heaven and earth, just as the elevated Host juxtaposed with Lawrence's performance of an *imitatio Christi* recalled Christ's redemptive sacrifice, reenacted in the liturgy of the Mass.

Titian appropriately framed the path of the divine light with a seemingly authentic Roman setting: To the left an image of the Roman virgin goddess Vesta—one of the idols that Lawrence refused to worship—on an elaborate classicizing urnlike pedestal holds a statuette of a winged Victory. To

the right, Vesta's foreshortened Corinthian temple is modeled on the second-century AD Temple of Hadrian in Rome but modified to read as a triumphal arch, with four pairs of columns framing three arched openings, a sort of colossal version of Jacopo Sansovino's Loggetta (fig. 98). Ironically, of course, the scene commemorates not Vesta's victory but Lawrence's triumph over paganism.

By a massive creative effort of mental concentration and manual dexterity, Titian demonstrated his mastery of all the arts—painting, sculpture, and architecture, both ancient and contemporary—and complete command of both *disegno* and *colorito*. He also identified with the saint, expressing his wish for spiritual transcendence by locating his glowing red signature on the end of the grill, as if engraved in iron yet consumed by fire. The recent restoration of the painting has also revealed a self-portrait of Titian at the lower left, between the wood carrier and the fire stoker, observing the martyrdom.

TITIAN'S S. SALVADOR *ANNUNCIATION*

Titian's S. Salvador *Annunciation,* commissioned in 1559 by the wealthy *cittadino* textile merchant Antonio Cornovi della Vecchia (d. 1572), depicts a row of massive fluted columns standing on a red-and-white-tiled floor, common to most Venetian churches, and is constructed according to one-point perspective, with its focal point just below the Virgin's left knee, at about the viewer's eye level (fig. 114, no. 2; fig. 138). The orthogonals, therefore, support the rapid stride from left to right of the nearly life-size Gabriel toward the Virgin, with wings spread, drapery fluttering, and arms crossed over his chest as a sign of deference before the chosen vessel of God. The orthogonals also echo the Virgin's rightward lean against her prie-dieu as she twists around from her reading, raising her right hand in startled reaction to the towering spiritual presence before her.

Titian added two foreground steps at the base of the painting parallel to the picture plane to suggest that the painted space is continuous with that of the viewer, who might even step into the Virgin's bedroom, with its bed just visible to the right of her head. The spatial illusionism, Mary's placement near the picture plane, the ecclesiastical paving, and the colonnade of exceptionally tall fluted columns opening on to a landscape all evoke the Virgin's role as the embodiment of the earthly Church. Yet by extending the colonnade well beyond the top of the pictorial field and depicting in the top half of the painting the dove of the Holy Spirit against a golden blaze of divine radiance, surrounded

138. Titian, *Annunciation,* signed, c. 1559–66, oil on canvas, 13 ft. 2⅜ in. × 7 ft. 8½ in. (403 × 235 cm), S. Salvador (fig. 114).

by a glory of a dozen jubilant angels, Titian also suggested the celestial Church conjoined with the terrestrial at the moment of the elevation of the Eucharist.

To visualize the Mass's reenactment of Christ's birth and death, the dove of the Holy Spirit and the angels have been arranged largely on diagonals running in the opposite direction from the orthogonals, to focus on the Virgin at the moment of the Incarnation. Titian also depicted the Virgin marking her place in the Scriptures with her left index finger as a sign of her foreknowledge of her son's coming sacrifice. Similarly, the gesture of Mary's left hand in startled response to Gabriel's spiritual presence includes lifting her veil, which recalls both the veil that a nun receives at her consecration as the chaste bride of Christ and the shroud of Christ.

By comparison with earlier altarpieces, Titian here created a grander illusionistic space—more insistently continuous with the viewer's—articulated with more massive and solid architectural forms. He depicted each figure in stronger states of anatomical torsion, engaged in more vigorous movement, and more dynamically interacting with the others. Titian fashioned, in short, a more convincing image of the material world.

On the other hand, he used a deeper, more somber palette and freer, more open brushwork. The surface texture of the broken brushstrokes tends to compromise the physicality and spatial presence of his forms and suggests the dissolution of matter. Yet as the brushstrokes dematerialize, they also make manifest the presence of his creative painterly hand, as gesture, color, and light evocative of regeneration. This newly evolved technique and palette thus create a visual analogue to the liturgy of the Mass by simultaneously evincing birth, death, and renewed life.

Titian makes his new approach explicit with two symbols and a Latin inscription. The inscription on the top step translates, "Fire that burns yet does not consume," which alludes to Exodus 3:2, where the Lord appears to Moses "in a flame of fire out of the midst of a bush," but the bush "was not burnt." Similar to Titian's technique that dissolves form yet evokes the act of creation, the flame of God burns (consumes matter) yet does not consume (saves the spirit). The burning bush was also always interpreted as a prefiguration of Mary's virginity, which was not "consumed" at the Incarnation or birth of Christ.

At the lower right Titian depicted a clear glass vase filled with water. Since light passes through glass and water without changing substance, this too was a common symbol of Mary's virginity. The water also symbolizes the cleansing and regenerative power of baptism. At first glance the vase appears to hold a bouquet of red roses, age-old symbols of the Virgin, yet they are not flowers but

flames that burn but do not consume. Even the artist's signature on the bottom step, which before later overpainting read TITIANVS FACIEBAT ("Titian was making this," in the imperfect tense), suggests both completed and continuing action, burning yet not consuming.

TITIAN'S *PIETÀ*

Titian wished to be buried in the second chapel of the right aisle of the Frari, dedicated to the Crucifixion—a clear indication of just how successful and lucrative his career had been, since few Renaissance artists had the means to endow a chapel in such a major church. For the chapel's altarpiece he chose to paint a Pietà (fig. 139)—the conventional Italian name for an image of the Virgin holding the dead Christ on her lap. He flanked the Virgin and Christ with representations of SS. Mary Magdalene and Jerome and with simulated marble statues of Moses (inscribed MOYSES) and the Hellespontine Sibyl (inscribed ELLESPONTICAS). A Latin inscription at the bottom of the painting by Titian's pupil Palma Giovane (c. 1548–1628)—"What Titian left unfinished Palma reverently completed and dedicated the work to God"—suggests that Titian was unable to add the final touches to the altarpiece before he and his son Orazio Vecellio (c. 1515–76) died during the 1575–76 plague. In any case, the painting was never installed in its intended location.

Titian arranged the more-than-life-size figures along a diagonal that gathers physical and emotional intensity from the kneeling, imploring St. Jerome through the seated, mourning Virgin to the frenzied Mary Magdalene, who strides forward while twisting her torso and head leftward. The turned heads of the Hellespontine Sibyl and Moses also echo Mary Magdalene's leftward gesture and gaze. The painting's action, therefore, would have reflected the regular procession of clergy and faithful up the nave of the Frari toward the liturgical center of the church, the high altar, adorned with Titian's earlier masterpiece the *Assumption of the Virgin* (fig. 133). This movement would have been intensified by light falling from the upper right toward the lower left, its path indicated by the candle-bearing angel hovering near the upper right and the crouching infant angel with Mary Magdalene's ointment jar at the lower left. This diagonal fall of light would have responded directly to the natural light from a rose window in the Frari's façade lighting the aisle, demonstrating once again Titian's unusual sensitivity to site.

The painted light also constructs a descending diagonal of immaterial light that counterbalances the crescendo of material figures along the opposite di-

agonal—a visual analogue to the Mass, mediating between matter and spirit. Yet the contrast is even more subtle, for the immaterial light descending diagonally on the right is natural light, while the diagonally ascending material forms on the left are animated by the spiritual power of prayer, piety, and lament. The monumental architectural background anchors and unifies these crossing diagonals.

The architecture appropriately resembles many ancient Roman and early Christian tombs articulated with pedimented niches. And according to the sixteenth-century architect and antiquarian Pirro Ligorio (c. 1513–83), a broken pediment—such as the one Titian used here—was "suitable only for tombs." The nine burning lamps on the pediment also evoke a funerary nocturne and Christ's death on the ninth hour, while the stone dais on which the Virgin sits would have echoed the altar table below, a symbol of Christ's tomb slab. Finally, Titian represented in the apse a gold mosaic with an image of a pelican pecking its breast to feed its blood to its young, a traditional symbol of Christ nurturing humankind with the blood of his sacrifice. According to Titian's friend Sebastiano Serlio in his seventh book on architecture, published in Frankfurt am Main in 1575, precisely the year when Titian was painting this canvas, rusticated architecture was particularly appropriate for gardens. Since Titian's rusticated niche is attached to a wall, it evokes the Virgin's *hortus conclusus* (closed garden), an emblem of virgin birth, and the Garden of Paradise, lost at the Fall and regained by Christ's sacrifice. He painted winged Victories in the spandrels of the arch to recall a traditional classical triumphal arch and underline the suggestion of paradise regained by Christ's death and triumphal resurrection. Similarly, he depicted a golden glow emanating from the niche's apse to connote, as with Christ's halo, celestial illumination. Finally, the three keystones mystically suspended in front of the broken pediment allude to Christ's epithet Keystone of the Church. Finally, the keystones and the nine lamps arranged in groups of three suggest the Trinity, expressive of the mediating function of the Church: the Son representing a moment in history, the Holy Spirit of God's grace uniting past, present, and future, and God the Father existing eternally outside space and time.

Michelangelo's St. Peter's *Pietà* inspired Titian's representation of Christ as a muscular classical hero. Christ's placement in a garden niche may have been suggested by Michelangelo's Florentine *Pietà,* which he made for his own tomb chapel and, after his death in 1564, was displayed in a niche in the Bandini garden in Rome, as Vasari recorded in the 1568 edition of his *Lives.* However, Titian's Virgin is not the youthful figure of St. Peter's *Pietà* but rather a massive

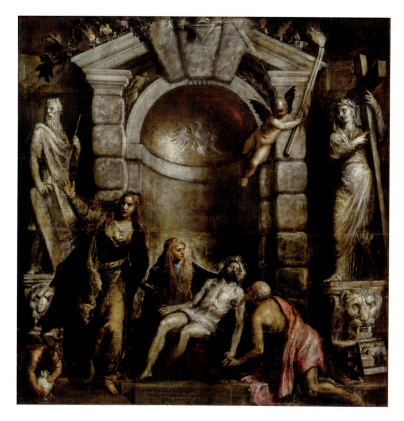

139. Titian, *Pietà,* 1570–76, oil on canvas, 12 ft. 4⅞ in. × 11 ft. 4⅝ in. (378 × 347 cm), Gallerie dell'Accademia.

mature embodiment of the Church—for if she were to stand, she would nearly fill the niche—draped in the gold of divinity, green of hope, and red of love. In another difference from Michelangelo's work, Titian composed the two Pietà figures on contrary diagonals, resolving them into the focused nexus of the entire painting, the Virgin on the diagonal of material movement and Christ on the diagonal of immaterial radiance.

He developed the figure of Mary Magdalene from a relief carved on a sarcophagus in Mantua—a city that he had visited on several occasions—representing Venus lamenting the death of her lover Adonis, killed by a wild boar

(Ovid, *Metamorphoses* 10.708–39). Venus's love for Adonis was an apt prefiguration of Mary Magdalene's love for Christ, and Adonis—a fertility and vegetation god—appropriately alluded to Christ, the deity of regeneration. In fact, representations of Venus mourning Adonis may have inspired the late medieval invention of the Pietà as an art subject.

Moses also foreshadowed Christ. The water that he struck from the rock with his rod prefigured the piercing of Christ's side, from which flowed both water and blood (John 19:34), traditional signs of baptism and the Eucharist. To make this allusion absolutely explicit, Titian even based his Moses in part on Donatello's Abraham in his remarkable 1421 sculpture *The Sacrifice of Isaac,* depicting another Old Testament prefiguration of Christ's death, a meaning heightened by the fig branch hanging over the wall just above Moses's head, which connotes the fall of Adam and Eve, which made Christ's sacrifice necessary. But Moses's head, beard, and horns also clearly make reference to Michelangelo's *Moses* on the tomb of Pope Julius II, which Titian had seen in Rome. With the horns, Michelangelo had indicated that Moses had just received the tablets of law from God and was still suffused with divine radiance, since in Exodus 34:29 of the Latin Vulgate, the relevant passage reads, "And when Moses came down from the mount Sinai, he held the two tables of the testimony, and he knew not that his face was horned [a mistranslation of the Hebrew for 'radiant']." By Titian's time this mistranslation was well understood, and he clearly represented Moses's divine radiance with a silvery pigment. But he deliberately chose to make his debt to Michelangelo clear and his figure more sculpturelike by including the horns.

Sibyls were female seers of classical antiquity, equivalent to Old Testament prophets, who were believed to have prophesied much of Christ's life. Here the Hellespontine Sibyl is youthful, joyous, and upward-pointing, expressive of the prophecies of virgin birth and resurrection for which she was best known. Titian emphasized the point by adding a green plant above her head and modeling her figure on the reverse of Michelangelo's 1521 *Risen Christ* in S. Maria sopra Minerva, a work that he had seen in Rome and a small copy of which he owned and kept in his studio. But the sibyl also holds a cross and wears a crown of thorns, standard attributes of Christ's sacrifice. Titian reinforced her allusion to Christ's birth, death, and resurrection, reenacted in every Mass, by depicting a flying angel nearby who carries a large paschal candle, used to commemorate Christ's resurrection during the Easter liturgy.

Finally, Titian represented on the two statue bases massive lion heads, symbols of Solomon's throne of divine wisdom and justice, Christ's fortitude and magnanimity, and St. Mark. These particular lions, however, derived from classical sarcophagi, signaling the destructive, devouring force of time, a symbolism appropriate for a Pietà.

According to Church doctrine, the faithful were saved in part by baptism, which washes the taint of original sin from the soul and is here evoked by Moses's rod. On this, most Protestants agreed with Catholics. But after the Council of Trent, the Catholic Church insisted that the faithful cooperate with God's gratuitous grace by repenting personal sins (as distinguished from original sin) through the sacrament of penance. Here the Protestants parted company with the Catholics, since they believed, according to the famous formulation of Martin Luther, that one was justified (saved) by faith alone (*sola fide*), making penance unnecessary. For Catholics, two of the most outstanding examples of repentant sinners were SS. Mary Magdalene and Jerome. Mary Magdalene, the reformed prostitute, manifests her penitence in her anguished expression and agitated movement. Her jar of ointment, held by the infant angel, also recalls her anointing of Christ's feet as a demonstration of her humility and penitence.

Titian depicted Jerome as a seminude penitent in reference to the four years that he spent in the Syrian desert living the ascetic life of a hermit, during which he most famously beat his bare chest frequently with a rock. As Jerome kneels humbly and penitently, he boldly grasps the limp arm of Christ in an appeal for his mercy. Significantly, not only did Titian represent the hermit in the guise of his own self-portrait, but he also depicted at the lower right a votive tablet with a portrait of himself and his painter son, Orazio, in prayer before a celestial vision of a Pietà, probably at the very moment when the plague was raging though Venice. To accentuate his penitential humility, Titian even renounced his sophisticated art on the simulated votive panel, instead favoring a folkloric style there. He also contrasted the tablet's celestial Pietà with the main canvas's earthbound one to create yet another visual parallel to the Mass and its mediation between spirit and matter.

Despite the implication of Titian's humble penitence in this *Pietà,* he paradoxically also claimed high social and economic status in it, even though like nearly all Renaissance artists he came from the lower or middle socioeconomic class. Behind the votive tablet Titian depicted his coat of arms, with the imperial double eagle signifying his knightly rank as count palatine, conferred on him in 1535 by Emperor Charles V. Furthermore, in his lifetime, Titian, like Michelangelo and Raphael, was honored as *divino* (divine) by admiring critics. Just as God was the master artist and nature his handiwork, so artists who

convincingly imitated nature seemed akin to demigods. Through his virtuoso handling of light, color, form, movement, and emotion, Titian demonstrated his sovereign mastery of nature in all its diversity.

But to earn praise as a *divino artista* required more than mimesis. The artist also had to achieve a surpassing beauty, by recombining the best parts of nature into a more splendid whole or by imitating the finest examples of past art that had already transformed nature into artifice. The most famous classical example of such an artist was Zeuxis (fifth century BC), who took the finest parts of the most beautiful maidens of Croton and recombined them in his imagination to create an image of Helen of transcendent beauty for the Temple of Juno (Pliny, *Natural History* 35.36). By referencing some of the most famous examples of classical and Renaissance art in his *Pietà,* Titian amply demonstrated his ability to synthesize his visual tradition into a sophisticated aesthetic ensemble, becoming a new Zeuxis.

By quoting primarily some of the major works and types of ancient and modern sculpture and architecture, he also more completely than ever before took up the challenge of the Venetian / central Italian *colorito/disegno* debate. While for Venetians, and especially for Titian, *colorito* reigned supreme, here the artist showed himself equally accomplished in *disegno* as any central Italian artist, including his principal rival, Michelangelo.

Titian was an octogenarian when he painted the *Pietà.* Eyewitnesses reported that dimmed eyesight and a tremor forced him to employ large brushes, broad strokes, thick impasto, and even his hands and fingers in an extreme technique of *colorito.* As a result, his forms appear fragmented at close range, dissolved into patches of light and color, an effect that would have been even more evident had Palma not touched up the work to a minor extent. X-rays also show that Titian worked on the painting over a considerable period of time, frequently changing the composition and even enlarging it by adding six pieces of canvas. But with a lifetime of artistic experience, he was still in full command of representation, and, when seen from a distance, the painting resolves, as we have seen, into monumental, clearly contoured sculptural and architectural forms typical of *disegno.*

Titian developed his late technique of *colorito* not purely as a result of the tremors of old age but rather as a conscious choice, as indicated by his *impresa,* or emblem, created while he was at the height of his artistic powers. According to legend, a bear cub was born shapeless. The mother bear then licked her cub into the form of a bear with her tongue. Titian's emblem shows a she-bear licking a lump of matter into the form of a bear with the motto NATURA POTEN-

TIOR ARS (Art is more powerful than nature). In order words, he saw himself as a powerful she-bear using his creative intelligence and wet brushes and pigment to give form to nature. He also insisted on making manifest the licks, or brushstrokes, that produced the ideal forms.

This oscillation between *disegno* and *colorito*—at once dissolving material form and resolving it into ideal spiritual form—was the technical equivalent of the painting's subject matter, expressing the transition from death to renewed life. The *colorito* evoked the ongoing process of creation and suggested Titian's profound humility and recognition of the impossibility of fully achieving godlike perfection in life. Yet the painting's *disegno*—to borrow a characterization that contemporaries applied to the work of Michelangelo—manifests a *terribilità,* an awesome imaginative power and a magisterial technical mastery that transcends nature and tradition, and registers Titian's hope of becoming truly *divino,* merited by his godlike mental prowess and manual dexterity.

VERONESE'S *S. SEBASTIANO ALTARPIECE*

The Girolamite church in Venice was founded in 1398, rebuilt in the mid-fifteenth century with dedications to St. Sebastian and S. Maria delle Grazie, rebuilt again by Antonio Scarpagnino between 1508 and 1548, and consecrated in 1562. The learned prior of the monastery between 1542 and 1572, Fra Bernardo Torlioni da Verona (c. 1491–1572), commissioned a fellow native of Verona, Paolo Veronese (1528–88), to decorate the interior with three canvases depicting scenes from the life of Esther (1555–56) on the ceiling of the nave, frescos with scenes from the life of St. Sebastian and an *Annunciation* (1558) on the upper walls of the nave, organ shutters with *The Presentation of Jesus in the Temple* (1559–60), a fresco of the coronation of the Virgin (destroyed in 1852) in the dome above the chancel, and two narrative canvases of the life of St. Sebastian flanking the high altar in the chancel (1565). This decoration is one of the earliest examples in Venice of what would become ever more standard for Counter-Reformation and Baroque churches—a cohesive and unified iconographical program throughout the sanctuary. Here the unifying themes were the glorification of the Virgin and St. Sebastian, the church's two dedicatees.

While the present church was still under construction, the patronage rights to the chancel were sold in 1532 to Cateruzza Cornaro (d. 1554), a niece and namesake of Queen Caterina of Cyprus and the widow of Giovanni Soranzo (d. 1500). But with the death in 1554 of both Cornaro and her only son, Pietro Soranzo (1496–1554), and the death in 1558 of Pietro's son Giovanni Soranzo,

140. Paolo Veronese, *S. Sebastiano Altarpiece* (*Virgin and Child in Glory with Angels and SS. Sebastian, Catherine, Elizabeth[?], John the Baptist, Peter, and Francis*), c. 1559–1564/65, oil on canvas, 13 ft. 9⅜ in. × 7 ft. 6½ in. (420 × 230 cm), high altar, S. Sebastiano.

responsibility for commissioning the high altarpiece fell to the younger Giovanni Soranzo's widow, Lise Querini. The patronage of Cornaro and Querini is noteworthy, for women art patrons—usually widows concerned with family burial chapels, as here, or nuns, as at S. Zaccaria (see ch. 5 and fig. 45)—were relatively rare in Venetian Renaissance art. Since Veronese had earlier professional ties to both the Cornaro and Soranzo families and was already working in the church, it is not surprising that Querini commissioned him to paint the high altarpiece, in about 1559 (fig. 140). As the culmination of Veronese's decoration in the nave, chancel dome, and chancel walls, the painting commemorated the church's two dedicatees, depicting the Virgin in heavenly glory surrounded by angels and St. Sebastian tied to a fluted column, pierced by two arrows.

The saints grouped around Sebastian were chosen to honor the name saints of the family members of Querini's husband buried in the vault below the high altar. St. Catherine, with a crown and martyr's palm, honored her husband's paternal grandmother, Cateruzza Cornaro. St. John the Baptist, dressed in a hair shirt, with the symbolic sacrificial Lamb of God at his feet, and holding a reed cross, commemorated her husband's paternal grandfather and her husband, both named Giovanni Soranzo. St. Peter, with his keys and a book of Scriptures, honored her husband's father, Pietro Soranzo. Finally, St. Francis, holding a cross and displaying the stigmata, memorialized her husband's mother, Francesca Emo, and his illegitimate brother, Francesco. The name saints (John and Peter) of the two most important male members of the Soranzo family—Querini's husband and his father—along with St. Sebastian form in the foreground the stabilizing pyramidal core of the lower part of the composition.

Since the altarpiece was in part a monument to patrician wealth, status, and piety, Veronese loosely modeled its composition and iconography on Titian's *Pesaro Altarpiece* (fig. 136), another bold commemoration of noble dignity. From Titian he borrowed the seated Virgin and Child, the two obliquely placed columns enveloped by clouds and extending toward infinity, Peter's keys on the steps, the pyramidal group of foreground figures—which, combined with the other saints, creates two strong diagonal thrusts upward—and finally, the dynamic counterbalanced composition with architecture to one side and landscape to the other. The pillars, the Virgin enthroned in heaven, and the clouds casting a shadow on the figures below also associate the Virgin, as in the *Pesaro Altarpiece,* with Eternal Wisdom, by evoking Ecclesiasticus 24:6–7. From Titian's *Assumption of the Virgin* (fig. 133) Veronese derived

the glory of joyous angels surrounding the Virgin—here blue-winged cherubs, symbols of divine wisdom; three music-making angels with a bass viola da gamba, a viola, and a rebec; and two angels opening Mary's cape to recall her role as the Virgin of Mercy, most appropriate for a burial chapel. Veronese also silhouetted the Virgin against a golden radiance, thus associating her, as in the *Assumption,* with the Apocalyptic Woman, triumphant at the end of time, recorded in Apocalypse 12:1–5.

St. Sebastian, by his steadfast faith and self-sacrifice, performs an *imitatio Christi.* He also looks heavenward to witness a vision of the infant Jesus symbolically stepping out to accept his fate as he grasps his mother's veil, a symbolic shroud. As the priest elevates the Host, then, the painting dramatically visualizes for the worshiper the essence of the Mass—the birth, death, and resurrection of Christ, the mystery of transubstantiation, and the conjunction of earth and heaven, promising salvation for the faithful.

Compared to the saints in Titian's *Pesaro Altarpiece,* those in Veronese's work have been depicted with greater anatomical torsion, more fervent gestures, and more intense expressions of ecstasy particularly expressive of this moment in the Counter-Reformation. In addition, although the saints celebrate the Soranzo family on one level, on a doctrinal level they insist, as did the Council of Trent, on three essential sacraments for salvation—the Eucharist (Sebastian), baptism (John), and penance (John and Francis)—administered by the priesthood of the Church (Peter). Finally, compared to Titian's *Martyrdom of St. Lawrence* (fig. 137), the much larger number of martyrs here reflects the ever increasing attacks on the Church by Protestants, while Lawrence's ecstatic vision of heaven offered a more zealous hope that the Church would ultimately triumph over its persecutors.

VERONESE'S *ST. PANTALEON EXORCISES A DEMON*

Veronese's last altarpiece, painted for the high altar of the church of S. Pantaleone, depicts a scene from the life of St. Pantaleon (d. c. 305), to whom the church and the high altar were dedicated (fig. 141). It represents another example of the reformed Church turning to the persecutions of the early Christian martyrs to express the righteousness of its cause and its hope for ultimate victory over the blistering attacks of the Protestants. St. Pantaleon was raised as a Christian by his mother and trained as a physician. However, as an adult he rejected his Christian faith and succumbed to a luxurious life as the court physician in the pagan court of Galerius (c. 260–311) in Nicomedia. Veronese depicted Pantaleon's profession with the red of his costume, the usual color worn by Renaissance doctors. The saint's bulging money pouch, his ermine-lined silk cape, and the sumptuous attire of his assistant—black velvet with gold stripes—also indicate the extravagance of the imperial court. Over time, Hermolaus, a priest living in Nicomedia, here depicted at the lower left, reconverted Pantaleon to Christianity. With his renewed faith, Pantaleon gained the ability to exorcise demons and turned from healing bodies to saving souls. The altarpiece depicts him curing a possessed boy held by Hermolaus as the exorcized demon writhes at the lower right.

During the great persecution of Christians sparked by Galerius in 303 AD under Emperor Diocletian (r. 284–305), Pantaleon refused to recant his faith and was executed. Veronese has alluded to the saint's coming martyrdom and heavenly reward with the palm held by the infant angel hovering at the upper right. The artist also contrasted Pantaleon, looking heavenward, with the fragmentary ancient Roman statue of a satyr—employed as a building block—looking downward, to suggest the triumph of Christianity over Roman paganism.

The gaze of the palm-bearing angel defines the diagonal path of divine illumination highlighting the faces of the saint, priest, and possessed boy, and the angel's vigorous movement visually anticipates the boy's imminent cure. By contrast, the demon and the cantilevered privy on the side of a house, which constitute the contrary compositional diagonal, suggest the foulness of the evil that Pantaleon has overcome. The possessed boy supported by Hermolaus recalls a Pietà to suggest that Pantaleon imitates Christ, often called *Christus medicus* (healing Christ). The saint's *imitatio Christi* also inflects his costume's color, not just a sign of his profession as doctor but also an indication of his motivating virtue of charity, both love of God and love of neighbor.

Veronese linked the saint's miracle to the Mass by depicting Pantaleon gesturing with one hand toward the Christlike boy and with the other pointing to the location of the elevated Host as he looks upward at the divine angel. The bridge he creates between the exorcized boy, the Host, and the angel demonstrates the liturgy's mediation between heaven and earth and its salvific efficacy.

Veronese represented Hermolaus with the features of Bartolomeo Borghi, the parish priest of S. Pantaleone from 1585 to 1605, who commissioned the painting. He thereby insisted on the doctrine of the reformed Church that the priesthood alone was empowered to convey the salvific benefits of Christ's sacrifice to the faithful, through the Eucharist—in sharp contrast with the Protestant doctrine of the priesthood of all believers. Indeed, Borghi was an

141. Paolo Veronese, *St. Pantaleon Exorcises a Demon,* 1587, oil on canvas, 7 ft. 5⅜ in. × 5 ft. 3 in. (227 × 160 cm), originally for the high altar, now in the second chapel on the right, S. Pantaleone (fig 6, no. 23).

archpriest of the Nine Congregations of Clerics, charged with enforcing the decrees of the Council of Trent.

Pantaleon was perhaps intended to be a youthful, regenerated self-portrait of Veronese, a year before the artist's death at age sixty. At the very least he stands in for the artist, as his assistant hands him not medicine but an open paint box with a protruding paintbrush. Veronese was a master at representing the Venetian aristocracy as idealized figures of worldly wealth and splendor, which brought him great fame and success. But here he subtly undercuts Venetian material luxury as a glittering illusion and equates his performance as a painter with the saint's saving a soul. Both artists and physicians were trained to represent and diagnose the realities of the physical world, and here Veronese and Pantaleon employ their crafts to reveal and confront evil and sin. By presenting his artistic talent as a good work equivalent to Pantaleon's deed, Veronese also expressed his hope for salvation through God's salvific power, celebrated in the Mass.

TINTORETTO'S *ENTOMBMENT OF CHRIST*

Tintoretto designed the *Entombment* about a year before his death at age seventy-five (fig. 142). Since all four Gospels recount that the Entombment occurred at sundown, the subject was most appropriate for the altarpiece in the evening choir chapel of the Benedictine monks at S. Giorgio Maggiore (fig. 6, no. 16), the Cappella dei Morti (fig. 120). In the distant background Tintoretto depicted Golgotha with the crucified good and bad thieves still flanking Christ's now empty cross. In the middle ground the Virgin, dressed in white, red, and blue and supported by two holy women, swoons with grief, her arms outstretched as if reenacting the crucifixion of her son. In the foreground, Christ—colored coordinated with his mother—is surrounded by his loyal friends: Mary Magdalene (with a halo); Joseph of Arimathea (lower left, in front of Mary Magdalene), who gave his tomb to Christ; Nicodemus (behind Christ), the Pharisee who came to Christ by night for instruction; and Christ's beloved apostle, John the Evangelist (lower right). Christ's body, still in the posture of his crucifixion, is lowered into the tomb by Joseph and John, who support his torso with a pole resting on their shoulders, and by Nicodemus, who supports Christ's head. The altarpiece, in short, combines a Crucifixion, Lamentation, and Entombment.

Tintoretto's composition zigzags from background to foreground to impart a dramatic charge to the narrative and intensify the separation of the mother

from her son. The artist further magnified the expression of pain and loss at Christ's death by emphasizing the setting sun low on the horizon, heralding the approaching night; the bloodied body and shroud of Christ; and his crown of thorns, resting on the lip of the tomb. By the date of this painting, devotion, love, and service had become major watchwords of the Catholic Reformation. Tintoretto has therefore depicted the holy figures—despite their grief—reacting to Christ's death with unquestioning faith, reverence, and solicitude.

The altarpiece is as sacramental as it is dramatic. The tomb and shroud are visually juxtaposed to the altar, symbolic of Christ's sepulcher, which during the Mass was draped with a linen corporal, an emblem of Christ's shroud. While Joseph, John, and Nicodemus are lowering Christ into his resting place, they also appear be lifting him up to display his body, anticipating and echoing the elevation of the Host and confirming the mystery of transubstantiation.

Although Tintoretto has emphasized Christ's death, he has also communicated the promise of redemption in the Savior's heroic stature, the verdant vegetation above his head, and the two adoring angels at the upper left, who mark the diagonal descent of divine mercy and love and conjoin heaven and earth. Their gazes are counterbalanced by the diagonal fall of the light from the upper right indicating the dawn of a new day and the descent of God's saving grace.

The altarpiece, in sum, embodies a quintessential concern of the Catholic Reformation: it is a clear, straightforward presentation of the drama of Christ's sacrifice yet makes explicit reference to the sacramental celebration of the Eucharist.

Tradition said that Nicodemus was an artist. Tintoretto appears to have depicted him in the guise of a self-portrait, thereby showing that he too is a faithful and loving devotee of Christ. Through his artistic prowess he stakes a claim to meritorious service to Christ and the Church to further his hope of salvation.

142. Jacopo Tintoretto and workshop, *Entombment of Christ,* 1593–94, oil on canvas, 9 ft. 5⅜ in. × 5 ft. 5⅜ in. (288 × 166 cm), Cappella dei Morti, S. Giorgio Maggiore.

16

DUCAL TOMB

SANSOVINO AND VITTORIA'S TOMB OF FRANCESCO VENIER

From among the many ever grander High Renaissance Venetian tombs, that of Doge Francesco Venier (r. 1554–56) in S. Salvador (fig. 114, no. 1), designed by Jacopo Sansovino and executed with the assistance of Alessandro Vittoria (1525–1608), best exemplifies the full evolution of the floor-mounted, triumphal-arched ducal tomb that had begun in the fifteenth century (fig. 143). While clearly influenced by Tullio Lombardo's tomb of Doge Andrea Vendramin (fig. 40), Sansovino's tomb is more luxurious, unified, and classicistic. The entire ensemble rests on an unbroken, unifying base with a bench. A crowning pediment emphasizes the central arch more strongly than does the one on the Vendramin tomb, yet the flanking wings are more harmoniously integrated to the whole, by means of both their greater width and the four uniform freestanding Composite marble columns that define all three bays. Sansovino also treated the two flanking, shell-topped sculptural niches as independent tabernacles framed by Corinthian colonnettes supporting volutes and triangular pediments. Two properly proportioned freestanding Ionic columns—rather than two overly stout Ionic piers, as on the Vendramin tomb—frame the attic. Sansovino's characteristic use of a cushion (rounded) frieze for his entablatures also imparts greater vitality to the play of load and support. The opulent textures and splendid colors of the materials broadcast the wealth and aristocratic rank of the doge more powerfully than ever before. Finally, his status is strongly underlined by the elevation of his sarcophagus and recumbent effigy on a high pedestal with its fulsome inscription and by the placement of a pair of very large gilt ducal coats of arms in the attic.

Inspired by Michelangelo's *Leah* and *Rachel* on the tomb of Pope Julius II, the Virtues in the niches flanking the sarcophagus represent *amor proximi* (love of neighbor) on the left and *amor dei* (love of God) on the right, both signed by Sansovino. *Amor Dei,* a full-bodied classicizing figure with arms crossed over her breasts in humility, looks upward with a poignant expression of devotion. Her spiraling turn toward the high altar echoes the two ducal images, which both face in the same direction. *Amor Proximi* looks down and appropriately turns toward worshipers coming up the nave. The child in her arms looks out, engaging those who enter from the side entrance of S. Salvador directly opposite the tomb, while the child at her feet strides forward to parallel the worshipers' movement toward the high altar. In the lunette Vittoria represented in a marble relief the doge kneeling in penitential prayer before a Pietà accompanied by Francis, his name saint, rather than already having been received into the heavenly court, like Vendramin on his tomb.

The tomb's iconography is remarkable for the absence of SS. Mark or Theodore, warriors, battle scenes, the Cardinal or Theological Virtues, allegorical classical myths, the apotheosis of the doge, or allusions to Venice's sacred founding and its land and sea empires. Furthermore, the tomb's panegyric inscription praises the doge generically for his modesty, honesty, wisdom, peacefulness, and fairness without mentioning any outstanding accomplishments (indeed, the sickly, little-liked Venier is remembered for none). Rather, in a pe-

riod when successful military men were rarely elected doge, when Venice had begun its slow but steady decline from greatness, and when the Catholic Reformation had created an atmosphere of increasing stringency and religiosity, the tomb primarily expressed—beyond the expected nobility and wealth of the doge—dependence on Christ's sacrifice and mercy for salvation. Even its general form of a triumphal arch and the classicism of its style suggest less the victory of Venice, the new Rome, and more the triumph of God's divine justice and peace, which the doge hoped to have merited with his piety, penitence, and charity.

43. Jacopo Sansovino and Alessandro Vittoria, Tomb of Doge Francesco Venier, 1557–61, lt colored marbles and limestone, right aisle, fourth bay, S. Salvador.

REFECTORIES

VERONESE'S *MARRIAGE AT CANA*

Andrea Palladio completed the refectory (dining hall) at S. Giorgio Maggiore (fig. 6, no. 16) between 1560 and 1562. The large hall, measuring about ninety-eight by thirty-four by forty-three feet (30 by 10.41 by 13 meters), is crowned with a barrel-groin-barrel sequence of vaults and lighted by eight large windows, four each on the east and the west (fig. 144). In front of the room's wainscoting, long tables and benches with seating for about fifty monks ran along three sides of the room in a U-shaped arrangement, standard for most Italian refectories. From a pulpit high on the center of the west wall—visually emphasized by the central groin vault—one monk read Scriptures as the others ate in silence.

Girolamo Scrocchetto da Piacenza, the abbot of S. Giorgio Maggiore between 1559 and 1564, commissioned Paolo Veronese's *Marriage at Cana* (fig. 145) in 1562 to hang on the south end wall, above the central, abbot's table, an enormous painting executed in situ over sixteen months. The banquet at Cana, where Christ performed his first miracle and confirmed his divinity to the apostles, is recorded only in the Gospel of John (2:1–11):

And the third day, there was a marriage in Cana of Galilee: And the mother of Jesus was there. [In Veronese's painting Mary sits to Christ's right at the center of the table.]

And Jesus also was invited, and his disciples, to the marriage. [SS. Peter and Paul flank Christ and Mary, while the other ten disciples are seated to Paul's left.]

And the wine failing, the mother of Jesus saith to him: They have no wine.

144. Refectory, S. Giorgio Maggiore, from Vincenzo Maria Coronelli (1650–1718), *Singolarità di Venezia* (Venice, 1709). The inscription's attribution of the architecture to Sansovino is incorrect.

And Jesus saith to her: Woman, what is that to me and to thee? My hour is not yet come.

His mother saith to the waiters: Whatsoever he shall say to you, do ye.

Now there were set there six water-pots of stone, according to the manner of the purifying of the Jews, containing two or three measures apiece. [One stone jar is in the left foreground, two flank the musicians, and three are in the right foreground.]

Jesus saith to them: Fill the water-pots with water. And they filled them up to the brim.

And Jesus saith to them: Draw out now, and carry to the chief steward of the feast. And they carried it. [To the right, a barefoot servant dressed in gold is pouring the water-turned-wine while a wine steward behind contemplates a raised goblet in awe of the miracle.]

And when the chief steward had tasted the water made wine, and knew not whence it was, but the waiters knew who had drawn the water; the chief steward calleth the bridegroom. [The chief steward, with his symbols of rank—a dagger and a purse—stands in the foreground before the bride and groom, seated at the left end of the table.]

And saith to him: Every man at first setteth forth good wine, and when men have well drunk, then that which is worse. But thou hast kept the good wine until now. [By his gesture and stance the chief steward appears to taunt the groom about saving the best wine for last, as a young black slave presents the groom with a goblet of wine poured from a stone jar by a barefoot servant.]

This beginning of miracles did Jesus in Cana of Galilee; and manifested his glory, and his disciples believed in him.

Veronese faithfully included everything that John described, but he greatly elaborated the sketchy account, as if to portray a contemporary marriage banquet of a wealthy Venetian aristocrat. He staged the scene in a vast, two-level outdoor space between six monumental classicizing buildings, three per side, with twenty-eight sumptuously dressed guests seated at a U-shaped table mirroring the tables in the refectory. The lay figures sit at the left and the ecclesiastics at the right, to emphasize the dual secular and religious nature of sixteenth-century marriage rituals. One hundred and two servers, musicians, and observers attend the guests.

The clothes, gestures, and expressions of the twelve apostles, seated to the right, are widely varied. Some engage in conversation, some look heavenward, and some meditate with sorrowful expressions, but only one appears to be aware of the miracle—the apostle seated at the right end near the toy span-

iel standing on the table. To the right of this witness, the viewer is afforded a glimpse of the Venetian lace that trims the white tablecloth, laid over an Asian carpet. Three portraitlike figures among the apostles include two Benedictine monks, dressed in black, and a layman in green. The Benedictine seated in front of the middle Doric column near the end of the table is probably Scrocchetto, the abbot who commissioned the painting. The Benedictine seated farther back, near the table's right angle (just in front of a standing steward holding his red baton), may be Andrea Pampuro da Asolo, Scrocchetto's successor as abbot in 1564, which would explain why this likeness was painted on paper and glued to the surface after the painting was completed in 1562. The lay brother dressed in green between the two monks is perhaps a Venetian citizen who helped pay for the painting.

The six figures with red staffs (two to the right on either side of the table and four about equally spaced behind the balustrade of the upper level) represent stewards of the type involved in contemporary Venetian banquets—highly trained specialists responsible for the table service, wine, cooking, carving, serving, and clearing, all under the direction of the chief steward.

A dwarf in front of the chief steward holds a parrot. Dwarfs were common features of Renaissance aristocratic courts, serving mostly as scapegoats for merciless jokes. Here the discrepancy between the dwarf's diminutive size and his military dress, with its prominent codpiece, would have been considered amusing. The dwarf's abnormality also would have confirmed the supposed normalcy of the nobles and signaled the high status and wealth of the groom, who could afford to maintain him.

The groom displays his rank and prosperity with his luxurious blue silk tunic, long sleeveless red silk toga embroidered with gold, gold brocaded cape fastened with two large cameos and two gold chains, and a turban of pink fabric with a gold ornament. He holds on his lap a typical Venetian toy spaniel, which eyes with seeming distrust the standard-size spaniel seated on the floor beside the groom, adding a note of levity.

The bride, seated to the groom's left, makes an even more extravagant display of wealth, with her spectacular brocaded dress in the latest Venetian fashion, with gems set in gold around the collar, a bridal crown with rubies and pearls, pearl earrings, a pearl necklace, a gold necklace with a huge gemstone, a gold bracelet, and several gold rings set with precious stones. In a Renaissance wedding, the dress and jewelry normally would have been the part of the bride's trousseau supplied by the groom. Venetian sumptuary laws prohibited such lavish displays, but they were routinely circumvented, especially on festive occasions.

145. Paolo Veronese, *Marriage at Cana,* 1562–63, oil on canvas, 22 ft. 2½ in. × 32 ft. 7⅜ in. (677 × 994 cm), Musée du Louvre, Paris.

Behind the bride stands a jester with bells on his cap, another type of entertaining character found in Renaissance courts. Between the bride and St. Peter, Veronese represented six males and three females, attended by servants. These guests include three exotic males near the bride—one of whom, a black African, turns to address a servant—dressed in blue, red, green, and gold cloth and wearing turbans and fine jewelry. Two guests with Asian features, dressed in colorful silk, one skewering a morsel of food, sit at the back of the table. These five figures appear to be non-Venetians, perhaps foreign dignitaries of the type that would often have been seen at S. Giorgio Maggiore, the official guesthouse of the Venetian state. They would embody the geographical breadth of the Venetian empire and Venice's far-flung commercial and military interests. Spaced among these males, three lavishly dressed blond women, one holding a napkin and picking her teeth with a fork, exhibit their youth and beauty as embodiments of the splendor of Venice and its government. Such beautiful women were expected to be on display at most Venetian banquets and were much commented on in contemporary accounts. Since the serving trays set before these guests are filled with fruits and sweetmeats, Veronese has indicated that the banquet is coming to an end, just when one would expect to run out of wine.

The sideboard glimpsed behind the Corinthian columns at the left is filled with exquisite gold and silver vases and trays for wine and food. Two servants dressed in green and seated at a table in front of the columns track the use of each vessel in a ledger as a standing steward with his staff looks on. Such displays of tableware were common at Renaissance feasts, and the levels of display were regulated by rules of etiquette: one level for nonnobles, two for a baron, three for a count, four for a prince, five for a king, and six for an emperor. Here the eight levels suggest a rank of such height that it falls outside courtly norms.

Veronese, in short, has provided a feast for the eyes with the exceptional quantity and diversity of table service, foods, fabrics, costumes, jewelry, animals, and social classes. To this he added an aural feast.

In the center foreground he depicted a small orchestra composed of a sackbut, two viole da gamba, a mute cornett, a rebec, and a contrabass. This particular ensemble of Renaissance instruments could perform either sacred music, designed to stir the soul, or secular music, to excite the passions. Above the Composite columns at the upper left, in a balcony whose balustrade a carpet covers, a group of thee figures listen to a lute player. Solo lutes were used in the Renaissance primarily to accompany secular love songs, which Veronese made explicit by placing a sculpture of Venus, the goddess of love, beside the lutanist. The evocation of both sacred and profane music in the painting was entirely

suitable for the dual religious and secular rituals of Renaissance weddings. The musicians also add another social class to the scene, since performers were usually from the lower or lower-middle class.

In elaborating the brief biblical text to create an idealized vision of Venetian society—problematic given the work's primary audience of reformed Benedictine monks, who rigorously observed their vows and lived lives of ascetic austerity—Veronese appears to have been inspired by another text besides the Bible. In 1535 the humanist Pietro Aretino (1492–1556) published in Venice the popular and repeatedly reprinted *I quattro libri de la humanità di Christo* (Four books on the humanity of Christ), which similarly embroidered John's biblical account of the marriage at Cana. For example, Aretino embellished just the first two verses of John's account as follows:

In those days in Cana of Galilee they were celebrating a wedding where with royal pomp there appeared the most distinguished, noblest, and most elegant persons in the city. To solemnize the occasion Christ had been invited with His brethren, and Mary, driven by her desire to see Him, also came. The tables were laden with elaborate vessels of pure gold and silver. The most important guests sat at their ease in ornate chairs and looked at Christ, who, retiring within His quiet humility, sat beside His Mother in the lowest place. But as the master of the house insisted He rose together with the Virgin and moved to a seat of greater honor. Thus Christ taught the true value of humility—for meekness rises to Heaven in the act of bowing upon this earth. (Trans. P. Fehl, 1992, p. 266)

This is the first mention ever of the bride and groom exchanging places with Jesus and Mary. Since the exchange so dramatically illustrates the triumph of meekness and humility over pomp and circumstance, it was featured in many subsequent representations of the marriage at Cana. Locating the mother and son in the center of the composition also transforms the scene into a mystical marriage of Christ and the Virgin—the union of the terrestrial and the celestial Church—thus explaining the eight levels of silver and gold service on the sideboard as a reference to the sovereignty of Christ and Mary, who far outranked any earthly ruler.

Aretino's treatise continues:

He [Christ] tasted the victuals sparingly and with the glance of His eyes offered correction to everyone. Whoever looked at Him was moved to trepidation and remorse and—touched by an indefinable sense of awe—forgot the feasting.

Jesus from time to time sighed with such feeling that each guest's heart trembled. And when He spoke His voice stilled that freedom and merriment which wine and food bring forth from the souls of those who delight in the joys of feasting. Both the groom and the bride, resplendently arrayed in their nuptial garments, attentively looked at Him as He spoke. [Here follows a sermon by Christ to the bride and groom about loving and respecting each other, having children without carnal pleasure, and shunning divorce and adultery.]

Anyone capable of seeing how the words of Christ affected the feasting guests would have seen a crowd so enthralled that they clung to every word and listened as one listens to the teller of a story full of marvels and joy. The waiters too who changed the plates and vessels were overwhelmed and marveled at what they heard. Surely, the most exquisite food of which the guests partook was those sacred words. For no other reason did Christ accept many an invitation but to open the eyes of the mind which are blinded by the splendor of the pleasures of this world. (266)

In amplifying John's sacred text with Ciceronian rhetoric, Aretino created a vivid and magnificent theatrical drama reflecting the excesses of the Venetian aristocracy. Although he was a scurrilous libertine and unscrupulous, blackmailing "scourge of princes" (as Ludovico Ariosto [1474–1533] called Aretino in *Orlando furioso*), he took on the role of the moral conscience of Venice and contrasted this profligate display with Christ's demeanor and moralizing sermon on the ideal marriage. In following Aretino's lead, Veronese created an equally extravagant visual world reflective of Venetian noble society and then called this patrician grandeur into question by depicting Christ as a hieratic and radiant deity with lips parted as if sermonizing, as if "to open the eyes of the mind which are blinded by the splendor of the pleasures of this world." In addition, he represented the Virgin with a sorrowful, foreknowing demeanor, dressed in a nunlike habit, and holding an invisible glass, which alludes both to the exhaustion of the wine supply and to the Eucharistic wine, commemorating her son's imminent sacrifice. Together Christ and his mother, with golden auras of divinity, represent the ideal, chaste bride and groom—deeply spiritual, humble, self-sacrificing—in stark contrast to the worldly frivolity of the actual bride and groom.

But Veronese even goes beyond Aretino in elaborating the biblical text. Catching the eyes of two upward-looking apostles, a female onlooker standing in the balcony above the Doric colonnade on the right drops roses, flowers sacred to Venus and thus apt for a wedding. But roses were also attributes of the Virgin, their white and red expressing her purity and love, their spines her sorrow at her son's tragic fate. In addition, the white and gold costume of the bearded steward standing to the right and spotlighted against the dark right side of the painting is decorated with tuliplike flowers (symbols of love's rare beauty) and gold rings (signs of marital union) set with diamonds (emblems of love's clarity, radiance, and permanence). These symbols evoke Hymen, the god of chastity and marriage. But the cut of the steward's costume and the way he holds the goblet of wine also suggest a priest elevating a chalice, thus visually transmuting the miracle at Cana into a prefiguration of the Eucharist.

Turning to the all-important central axis, the viewer first notices a pair of greyhounds, status symbols and emblems of marital fidelity, proper for a marriage scene. Yet one sleeps, indifferent to the marriage and the miracle, while the other is alert and attentive, straining at the leash as he watches a black cat in the right foreground clawing at a lion carved on one of the jars of miraculous wine. Cats, especially black cats, were considered self-indulgent and deceitful, while lions often symbolized Christ's strength and magnanimity. Thus, the cat suggests the ever present Satan attempting to toy with Christ, while the greyhounds thematize two possible responses to the painting—indifference to luxuriousness or attentiveness to its sinful consequences.

The hourglass on the table covered with gold brocade just above the greyhounds is unrelated to music making. But it does recall Christ's statement to Mary "My hour is not yet come," reminding viewers that Christ's hour will come, just as the hour will come for all humanity. Only a fool would not prepare for death by following the teachings and example of Christ, which explains the depiction of a jester between the hourglass and Christ.

A pilgrim's gourd nestled between the balusters directly above Christ's head connotes the Eucharistic wine, an allusion reinforced by the grape arbor above the lutanist, in the upper left. Farther above Christ's head a servant with a knife carves a roast lamb, symbolic of Christ's sacrifice, as servants entering from between the Corinthian columns on the right carry in another trencher of roast lamb. The carving table's white tablecloth suggests an altar table covered with a corporal, symbols of Christ's tomb and shroud. Finally, the surrounding architecture—inspired by classical tragic stage sets described by Vitruvius (5.6.8) and illustrated by Sebastiano Serlio in his books on architecture—both heightens the work's theatricality and intensifies the evocation of Christ's sacrifice. But by creating a stage set far more imaginative and magnificent than Serlio's, Veronese evokes the majesty of the Church, cofounded by SS. Peter and Paul, who flank Christ and the Virgin.

Vitruvius wrote that the Doric order was suited to male gods, such as Jupiter, but in this context it would reference Christ, strong and stable. In addition, the ancient sacrificial symbols in the metopes of the Doric frieze—bull crania and libation dishes—make reference to Christ's sacrifice. The Corinthian order, according to Vitruvius, was best used for female deities, such as Minerva, but here would symbolize the Virgin, visually—and properly from a theological point of view—subordinate in the middle ground to the foreground Doric. Since the background Composite order combines elements of the Ionic and the Corinthian, it symbolizes union—between the bride and groom and between Christ and the Virgin.

The background church tower, surrounded by a cosmic halo of clouds, implies that the path to salvation is by way of the Church, while the birds flying above the tower signal liberated souls in heaven and the promise of renewal for all the faithful through Christ's death and resurrection. Atop the tower, St. George, the patron saint of S. Giorgio Maggiore, reminded the Benedictine monks of their role in the economy of salvation.

By manipulating the orthogonals of the stage set's perspective construction to create seven focal points, Veronese emphasized the painting's symbolic center and the importance of reading upward along the central axis. Four lower focal points map the four corners of the carving table, drawing the eye to the emblematic counterfeast of Christ's tragic sacrifice. Three additional focal points, placed progressively higher above the carving table on the vertical axis, draw the viewers' eyes heavenward to underline the Eucharist's promise of salvation. All these subtle devices prompted the monks, if alert to the painting's visual cues, to contemplate their action of supping as a symbolic reenactment of the Last Supper and the institution of the Eucharist.

To summarize, Veronese created a painting with four equally compelling levels of meaning. First, it illustrates the biblical wedding feast at Cana, where Christ performed his first miracle to demonstrate his divinity to his apostles, an event most fitting for contemplation by its primary audience of Benedictine monks. Second, the painting presents an image of an idealized contemporary Venetian patrician wedding, pertinent to a reformed and reforming order as an example of precisely the kind of extravagant display of wealth and vanity that its austere lifestyle rejected. Third, Veronese's accurate depiction of the triumphal splendor of Venetian patrician ideology and his sympathetic representation of the refined manners and prosperity of the aristocratic elite was on another level entirely suitable for a monastery with strong civic and governmental ties, a monastery that served as the state's guest lodge and was host to two of the most important ducal visits, at Christmas and on St. Stephen's Day. Finally, Veronese's subtle and symbolic allusions to Christ's humility, sacrifice, and resurrection and to the Eucharistic sacrament would have appropriately addressed all viewers—monks, governmental officials, and guests.

According to a tradition first recorded in the seventeenth century by Marco Boschini (1660, pp. 188 and 191; 1674, p. 61), the two foreground musicians are portraits of Veronese and Titian. The elegant viola da gamba player draped in pure white does in fact closely resemble Veronese's early self-portrait in the Hermitage in St. Petersburg. And the man on the contrabass—with his high forehead, long hooked nose, beard, large ears, and deep-set eyes—equally appears to be a portrait of Titian (cf. figs. 209 and 210), especially since he wears a robe of vibrant red, a color for which Titian was famous. If these identifications are correct, then Veronese was not only showing himself as equal to the most famous Venetian artist but perhaps even poking a little fun at him by depicting Titian laboriously sawing away on the contrabass, as if embodying primarily the hard, manual work of painting. By contrast, he depicts himself as embodying the imaginative side of art, as he plays the viola more effortlessly and elegantly, in response to the whispered instruction of the second viola player, an apparent likeness of Aretino (cf. fig. 205).

Regardless of their identities, the musicians are certainly metaphors for the act of painting. Both musicians' bows and artists' brushes were made from animal hair, manipulated by gestures of the arm and hand, and guided by the mind. Both music and painting unfold across time to create beauty and harmony, although painting—once completed—exists as a totality, accessible in a single glance. Nevertheless, Veronese's *Marriage at Cana,* more than almost any other Venetian painting, brings music to mind in the way it reveals its multilayered polyphony to the viewer only after prolonged contemplation. And a vivid and detailed visual imagining of sacred events, especially episodes from Christ's life, during private meditations quintessentially characterized Counter-Reformation spirituality, influenced in particular by the *Spiritual Exercises* (given papal approval in 1548) by the founder of the Jesuit order, Ignatius Loyola (1491–1556).

Furthermore, by associating his work with music, a liberal art, Veronese transcended the traditional classification of painting as a mechanical art. Following the lead of Aretino and composers of Venetian polyphonic music, he elaborated the spare themes, or leitmotivs, of the narrative and created a rich and harmonious symphonic visual structure. Yet underlying this grand and triumphant composition are a series of insistent minor chords, which, like the

teaching of Christ in Aretino's account, offer a subtle critique of Venetian luxury as a means of "open[ing] the eyes of the mind which are blinded by the splendor and the pleasures of this world." However, the biblical elaboration and narrative ambiguity of Veronese's *Marriage at Cana,* completed in 1563, the very year that the Council of Trent finished its work, were increasingly untenable within the reformed Church, which was determined to prohibit sacred art that was not textually clear and doctrinally orthodox. An important sign of this changing climate was the placement of Aretino's *La humanità di Christo* on the Church's index of prohibited books in 1558.

VERONESE'S *LAST SUPPER* (*FEAST IN THE HOUSE OF SIMON, FEAST IN THE HOUSE OF LEVI*)

A decade after completing *Marriage at Cana,* Veronese produced a similarly sumptuous refectory painting for the Dominican monastery of SS. Giovanni e Paolo (fig. 6, no. 30)—a Last Supper (fig. 146), by far the most common representation on the end walls of Italian refectories. He set the scene in a magnificent elevated three-arched loggia accessed by a double-ramp marble stairway, with a fanciful classicizing cityscape for a backdrop. Four giant Corinthian columns engaged to massive piers frame the loggia bays, whose arches spring from shorter freestanding Corinthian columns, creating three side-by-side Serlian motifs. As noted earlier, this motif—derived from the appearance platforms of Roman emperors—signified imperial authority, most appropriate for a gathering of Christ and his apostles. Monochrome winged Victories in the spandrels of the arches evoke the triumph of Christ, commemorated in the Eucharist, which the Last Supper established. The few orthogonals of the loggia and the background architecture focus well below the center of the painting, as if the viewer were standing at the bottom of the stairway and looking up into the loggia. The orthogonals of the tiled pavement, however, focus directly on Christ, as if the observer were standing on the stairway landing.

St. Peter occupies the honored seat to Christ's right and carves a lamb, symbolic of the coming sacrifice that Christ has just announced. The young St. John, at Christ's left, reacts with shock, as if proclaiming his innocence, while Judas, across from John, manifests his guilt as Christ's betrayer in his position—opposite the other apostles and in shadow—and the turn of his head away from Christ. The bread in front of Peter and John and the servant behind Peter "elevating" a chalice symbolize Christ's institution of the Eucharist. While they are difficult to distinguish, the twelve apostles are evenly distrib-

uted on either side of Christ—two on either side of him in the central arch, three within each of the two flanking arches, and two visible between a pier and a freestanding column, the one to the left picking his teeth with a toothpick and the one to the right looking away from Christ.

The figure dressed in red balancing Judas in front of the table is problematic. In his appearance before the Inquisition (more about this below), Veronese testified that this was "the owner of the inn, Simon," and "that Jesus Christ took [the Last Supper] with his Apostles in the house of Simon" (for these and the following quotations see D. Chambers, B. Pullan, and J. Fletcher, pp. 232–36). However, the feast with Simon the Pharisee (Luke 7:36–50) was separate from the Last Supper (Matthew 26:17–29; Mark 14:12–25; Luke 22:7–23; John 13:21–31), so Veronese clearly has conflated or confused the two.

Christ, the apostles, and Simon are attended behind the balustrade by twenty-four servants, including four turbaned adults (probably Turkish slaves), three young blacks (probably also slaves), and one white child. An additional thirteen figures stand outside the space of the table, on the stairs or on the landing, including an adult with a bloody handkerchief, three children (one black), a dwarf with a parrot, and three eating and drinking German soldiers (two with halberds). Among this grand total of fifty-one figures—most dressed in sumptuous and colorful fabric—the figure standing to the left on the stairway landing with his arms spread in a rhetorical gesture is likely a self-portrait of Veronese (cf. fig. 145). Finally, on the tiled floor of the central bay Veronese has depicted a dog standing behind the host and a dog sitting behind Judas looking with interest at the cat in shadow under the table. The dogs, as common emblems of fidelity, were probably intended to contrast with the unfaithfulness of Judas, while the cat perhaps suggests Judas's deceit.

While the composition is exquisitely balanced, varied, and animated, the splendor of the architecture and the multitude of diverse activities extraneous to the story all but overwhelm the drama of the announcement of Christ's betrayal and the institution of the Eucharist. As in *Marriage at Cana,* Veronese's intention may have been to create a contrast between worldly extravagance and the momentous spiritual drama of the institution of the first Mass, crucial for the salvation of the Catholic faithful. In any case, it is certain that the Church increasingly discouraged and even prohibited this kind of pictorial elaboration of biblical texts in ecclesiastical settings.

Veronese, in fact, was called before the Venetian Inquisition on July 18, 1573, to defend his work. He explained that the prior of the monastery of SS. Giovanni e Paolo—acting on an order from the Inquisition—had asked

according to the *Golden Legend,* to the fifteen psalms of degrees (Psalms 120–34), which describe the ascent of the soul toward God. Mary lifts her left hand to greet the high priest, who in turn raises both of his hands in welcome and wonder at her precocious spirituality. For the diminutive Virgin to command the focus of visual and thematic attention, Titian located her on the stairway's landing and silhouetted her against the Palace of Solomon's blue and gold marble Corinthian columns—the appropriate order, according to Vitruvius, for a female deity. Titian also heightened the Virgin's luminosity through the contrast between the figure behind her shading his eyes—dressed as a contemporary Christian and thus aware of her significance—and the egg seller, who, in personifying the Synagogue, remains unaware and in the dark. Finally, the brickwork of the palace seen behind the Corinthian colonnade deliberately recalls that of the Doge's Palace (fig. 5), the palace of justice, visually conflating the Virgin and Venice, divine law and secular justice.

Titian placed the Virgin between a woman at the foot of the stairs draped in gold and white and a second priest at the top of the stairs, to whom a young acolyte draws attention with his upward glance. They represent the Virgin's older cousin Elizabeth and the temple priest Zachary. Their offspring will be John the Baptist, the last of the prophets, Christ's precursor, and the first Christian saint. Titian emphasized their important role in the transition from the Old to the New Covenant by depicting the tonsured Zachary in robes resembling those of a Church cardinal.

CONFRATERNITY OF ST. ROCH

Building History

The Confraternity of St. Roch—founded as a small confraternity in 1478, a plague year in Venice—initially used a chapel in S. Maria Gloriosa dei Frari (fig. 6, no. 21) as its meeting place. But when some members exhumed and stole the body of St. Roch (d. 1327), probably from Voghera in Savoy, its membership and income expanded so dramatically that the Council of Ten designated it a large confraternity in 1489. It therefore commissioned Bartolomeo Bon il Bergamasco (c. 1450–1508/9) to build the Church of S. Rocco (fig. 6, no. 24) behind the Frari between 1489 and 1508, to house under the high altar its exceptionally important new relic of St. Roch, a major intercessor against the plague.

As the church was nearing completion, in 1507 the confraternity commissioned Bon's son, Pietro, to design a new meeting house, adjacent to the church

148. Façade, Confraternity of St. Roch, 1515–60.

of S. Rocco (fig. 6, no. 36). He laid the cornerstone in 1515 and oversaw the construction of the ground floor and most of the façade (figs. 148 and 149). By mentally removing the façade's freestanding columns and the pediments over the upper windows, which were added later, the observer will note that Bon's design closely emulates the façade of the Confraternity of St. Mark (fig. 53). Both feature on the ground floor a uniform base across the width of the façade supporting channeled Corinthian pilasters carrying a full entablature, which supports on the upper floor a uniform base, fluted Corinthian pilasters, and a full entablature. The façade of the Confraternity of St. Roch, however, lacks the Gothicizing coronas of the Confraternity of St. Mark and employs the most up-to-date Codussian design for the ground-floor windows (cf. fig. 66) and a more classicizing main entrance, framed by Composite columns carrying a triangular pediment.

The assembly room of the Confraternity of St. Roch (fig. 150) also imitates that at St. Mark's (fig. 55), with two rows of columns on high bases supporting a wooden beam ceiling and the floor of the chapter room above. Bon's columns, however, are more striking, with their octagonal bases inlaid with

147. Titian, *Presentation of the Virgin,* 1534–38, oil on canvas, 11 ft. 7¾ in. × 25 ft. 5⅛ in. (355 × 775 cm), in situ on the west entrance wall of the *albergo* of the Confraternity of St. Mary of Charity, now part of the Gallerie dell'Accademia. The composition incorporates the original entrance door on the right, but a second door installed in 1572 resulted in the loss of canvas at the lower left.

The two blue mountain peaks in the background and the orthogonals of the perspective, focusing at about Joachim's right elbow, highlight the Virgin's parents. Joachim steps forward and turns toward Anne, placing his left hand on her shoulder—a gesture of consolation and emotional comfort—as she prayerfully watches her young daughter leave the family fold. Together they bring to mind two other major concerns of the confraternity: the financing of dowries for young women to marry or enter a convent and the provision of material and spiritual support for the aged.

In contrast to the old parents of Mary, a youthful mother grasps her young son's left arm directly in front of Joachim as the boy holds a ring toy and joyously plays with his white terrier, an emblem of faith. This vignette of youth

and vitality creates an analogue to the Virgin and serves as a visual metaphor for the anticipated spiritual regeneration of the members through their faith, fostered by the confraternity's prayers and Masses to their protector, St. Mary of Charity.

The veiled woman seated at the foot of the stairs is selling a black lamb, a rooster, and eggs for Jewish temple sacrifices, which the Eucharist will supplant.

Above the egg seller, the Virgin—radiating an aureole of divine light—begins the process that will usher in the era under grace. She gathers her sky-blue garment in her right hand and with self-assurance ascends the stairs, evoking one of her standard epithets, Stairway to Heaven. The stairs also allude,

CONFRATERNITIES

Titian's *Presentation of the Virgin*

In 1534 the Confraternity of St. Mary of Charity commissioned Titian's *Presentation of the Virgin* (fig. 147) for hanging on the west wall of its *albergo,* above the *banca* facing the altarpiece by Antonio Vivarini and Giovanni d'Alemagna (fig. 48). In response to the natural light from windows on the south wall, Titian designed the work's painted light and narrative action to sweep across the pictorial field from left to right.

The observers whom Titian portrayed in his rendition of this apocryphal event from the *Golden Legend* represent a cross section of Venetian society—youths, elders, men, women, *popolani, cittadini,* and perhaps patricians—and include several portraits of members of the confraternity, who probably helped to finance the painting. To the left a bearded member dressed in a black toga and beret gives alms to a veiled woman holding a child (the standard image of *amor proximi*) while a beggar boy also holds out his right hand for charity. A backdrop of massive piers and arches resembling a Roman aqueduct—a motif that Titian borrowed from the Anianus reliefs on the façade of the Confraternity of St. Mark (fig. 57)—animates and magnifies this secondary drama, which enacts one of the major functions of the confraternity, contained in its very name. The arcade draws the eye to an obelisk—a symbolic sun ray to the Egyptians and a Renaissance emblem of divine light—and a cloud bank aglow from the sun low on the horizon. The light-filled clouds again recall Wisdom in Ecclesiasticus 24:6 (see ch. 15), who prefigures the Virgin, the Incarnation, and the founding of the universal Church.

Titian modeled his obelisk on the version then standing beside St. Peter's in Rome, the only one known with a culminating bronze ball, which was thought to contain the ashes of Emperor Augustus (r. 27 BC–14 AD), during whose reign Christ was born. Similarly, the palace architecture in the background, the massive stairs on which the infant Virgin ascends to the Temple of Jerusalem, and the marble torso to the extreme lower right also evoke *romanitas* (Romanness), a reference to the Roman Church, embodied by the Virgin. But *romanitas* also reminded the viewers that Venice, founded on the Feast of the Incarnation, was a new Rome, especially according to the state ideology during the reign of Doge Andrea Gritti, when Titian painted this canvas.

Standing just beyond the woman holding a child, a cluster of four confraternity members, dressed in togas and black berets (probably *cittadini*), may represent the four highest-ranking officers of the *banca*. The red toga and black shoulder sash of the man gesturing toward the viewer certainly identify him as the confraternity's grand guardian, suggesting that the others might be the *vicario, guardian da matin,* and *scrivan*. In any case, all four of these somber men serve to witness the event and authenticate its "historical" truth.

Just to the right of this group can be glimpsed the head and torso of a young member, probably a *popolano,* clad in the white processional habit of the confraternity, with its orange and black insignia over his heart. He signals, along with the friezelike composition, the processional obligations of the confraternity. He points with his right index finger to Joachim and Anne, the elderly parents of the Virgin, directly in front of him.

146. Paolo Veronese, *Last Supper* (*Feast in the House of Simon*, *Feast in the House of Levi*), dated April 20, 1573, oil on canvas, 18 ft. 2¼ in. × 41 ft. 11⅞ in. (554 × 1280 cm), Gallerie dell'Accademia.

him to replace one of the dogs with Mary Magdalene (appropriate only if the scene were the feast in the house of Simon, where she washed Christ's feet) but that he "did not understand how a figure of Magdalene would be suitable" (as indeed she would not be if the scene were the Last Supper, as it so clearly is). The inquisitors then questioned Veronese about the appropriateness of "the man whose nose is bleeding," "those armed men dressed as Germans, each with a halberd," the dwarf "dressed as a buffoon with a parrot on his wrist," "the drunkards," "the dogs," and "similar vulgarities." Veronese defended himself by claiming that "painters take the same license that poets and the jesters take" and that "if in a picture there is some space to spare, I enrich it with figures according to the stories . . . as I see fit and as my talents permit." But the inquisitors were not impressed. They chastised Veronese for lack of decorum—for painting figures that were not "suitable and proper to the

subject"—and for offering Protestants an opportunity "to mock, vituperate, and scorn the things of the Holy Catholic Church." They ordered him "to improve and change his painting within a period of three months . . . at the expense of the painter."

In response, Veronese simply inscribed on the stairway a quote in Latin from the Vulgate—"Levi made the Lord a great feast, Luke chapter 5[:29]"—thereby suggesting that Simon is truly Levi. The change in title to *Feast in the House of Levi* appeared to satisfy the inquisitors, but the painting remains a Last Supper, while also referencing, according to Veronese's testimony, the feast in the house of Simon. The 1564 decrees of the Council of Trent required bishops to insure that the art created in their dioceses clearly illustrated sacred texts and Church doctrines and to prohibit the type of artistic elaboration, conflation, and even confusion evident here.

149. Ground plan and cross section through the north staircase, Confraternity of St. Roch: 1 assembly room, 2 lower stair ramps, 3 upper stair ramp, 4 chapter room, 5 archive.

150. Assembly room, Confraternity of St. Roch.

151. Chapter room, Confraternity of St. Roch.

marble, fluted shafts (some even with spiral fluting), and more classically correct Composite capitals.

Finally, the chapter room and *albergo* of the Confraternity of St. Roch (figs. 151 and 152) also followed the lead of the Confraternity of St. Mark (fig. 56) but deliberately surpassed it with more lavish inlaid marble pavements, more ornate carved wooden benches, more sumptuous carved and gilt wooden ceilings, and an altar constructed of more expensive and colorful marbles.

Between 1521 and 1527 the confraternity was entangled in a dispute involving the design of the staircase. Four models were commissioned in 1521, but

152. *Albergo,* Confraternity of St. Roch.

the men of the *banca*—the membership of which changed annually—were in such disagreement about all of them that the Council of Ten had to intervene twice, eventually ordering the *banca* to use the design by the Tuscan architect Giovanni Celestro, which was modeled on Mauro Codussi's double-ramp stairway at the Confraternity of St. John the Evangelist (figs. 62 and 64–66). When Bon refused to execute this design, no doubt preferring his own, he was fired, in 1524, and Sante Lombardo (1504–60), the son of Tullio, was hired to execute Celestro's version and to continue work on the chapter room. But in 1527 both Lombardo and Celestro were fired for unknown reasons and replaced by Antonio Scarpagnino. By 1535 Scarpagnino had overseen the completion of the stairway, the chapter room, and the *albergo*.

Then in 1535 the *banca* commissioned Scarpagnino to redesign Bon's façade to compete with Jacopo Sansovino's design of 1531 for the new (and never completed) large confraternity of St. Mary of Mercy (fig. 6, no. 32), which envisioned the exterior clad entirely in Istrian stone and articulated with two rows of superimposed freestanding columns. Alterations of the St. Roch façade began in 1538. Two rows of four superimposed freestanding fluted Corinthian columns supported on projecting pedestals and carrying full entablatures were added to the left two-thirds of Bon's façade, fronting the assembly and chapter rooms. Scarpagnino also framed the five pairs of Bon's windows that light

the chapter room and *albergo* on the upper floor with freestanding Corinthian columns that rest on high cylindrical bases and carry entablatures and triangular pediments. The carved decorations encircling the four lower columns represent garlands made from oak, laurel, and olive leaves and grape vines. The oak references Christ's cross; the laurel (interwoven with a crown of thorns), Christ's sacrifice and victory over death; the olive, peace and salvation; and the grape vine, the Eucharist. On the upper level, sea creatures, garlands, masks, and infants, evocative of metamorphosis and renewed life, decorate the four fluted columns, the sixteen cylindrical bases of the window columns, and the frieze of the crowning entablature.

In 1545 Francesco Donà, a patrician member of the confraternity, was elected doge (r. 1545–53). He honored the confraternity by establishing an annual ducal procession on the Feast of St. Roch (August 16) to the church of S. Rocco, to be followed by a banquet in the chapter room of the confraternity. The men of the *banca* evidently felt that the recently completed double-ramp stairway, which had already caused great controversy, was not sufficiently grand for a doge's entrance to the chapter room. Therefore, it was destroyed, and Scarpagnino designed and built the present magnificent triple-ramp stairway with an archive room on top, which was intended to outdo the (never executed) grand staircase that Sansovino designed in 1535 for the Confraternity of St. Mary of Mercy.

The entrances from the assembly room to the two lower barrel-vaulted ramps consist of coffered arches carried on channeled Doric piers (fig. 153). Each opening is framed by a pair of freestanding Composite columns on square pedestals backed by Composite pilasters carrying heavy entablatures with a marble frieze. The two stairway ramps—articulated with engaged balusters, shallow banisters, and a flat entablature with a garland frieze—lead to two intermediate landings, each capped with a domical vault and lit by a richly carved roundheaded window. These two landings flank the tall barrel-vaulted landing of the third ramp, superbly lit by an oculus in the lunette of the barrel vault and four roundheaded windows (fig. 154). The third stairway ramp terminates in a hemispherical dome on pendentives just before the elaborate marble arched entrance to the chapter room. This opening is articulated with clusters of three marble Composite columns on each side, supporting entablatures, paired piers, and the arched opening to complete a classicizing triumphal arch motif.

After Scarpagnino's death in 1549, Giangiacomo Grigi (active late 1540s–early 1570s) became the confraternity's architect. The building was finally com-

153. Entrances to the lower stairway ramps from the assembly room, Confraternity of St. Roch.

154. Upper ramp of the stairway, seen from the chapter room, Confraternity of St. Roch.

pleted in 1560, at a total cost of forty-seven thousand ducats—exclusive of the carved and gilt wooden ceilings (fifty-five hundred ducats) and the interior decoration by Jacopo Tintoretto (twenty-five hundred ducats). In the context of the ever increasing piety and austerity of the Catholic Reformation, these huge expenditures, intended to honor the confraternity and make it outshine its rivals in material splendor, were not universally praised, especially by those in need, who suffered from the loss of charitable funds diverted to the building program. The Protestant-leaning goldsmith, gem trader, and poet Alessandro Caravia (1503–68) in 1541 published a particularly biting satire of the worldly pretensions and extravagant building expenses of the confraternity, titled *Il sogno di Caravia* (The dream of Caravia):

An account of grave errors to you I shall render
concerning some people who dress up in splendor;
and, though I may not list their names, they would tender
the saint of the plague [St. Roch] as their common defender.
They've had at the Scuola such mighty works done:
Festoons and harpies, fine beards by the ton,
columns all carved with fresh leaves in a cluster
to show that as bosses their work passes muster.

To tell you the truth, each new board's intention's
to show itself ever so full of inventions:

By moving the stairs and changing dimensions,
they make the doors useless; and so interventions
breed more interventions, with quarrels incontinent:
'So-and-so's schemes are all highly incompetent,
and as for old what's-his-name'—huffing and puffing,
they claim to know all, when in fact they know nothing.

Four-score thousand ducats they happily spend
where no more than six would achieve the same end.
The rest they hang on to: it's pointless to send
cash for the shoeless, the naked, befriend
all those groaning with hunger, for whom life is rough.
One word I would say to them, one—that's 'Enough!'
For, as charity goes, it's clear theirs is the cause
that fills up the coffers—but never withdraws.

(Trans. R. Mackenney, in D. Chambers, B. Pullan, and J. Fletcher,
pp. 213–16)

Owing to attacks such as this, the men of the *banca* appointed a commission of reformers in 1553 to try to control expenses with the following brief:

So many excessive expenditures are being made out of our own purse that the majesty of God is offended, and cause for gossip is given to those watching who believe that these funds that should be spent on the poor are being consumed in human ostentation, a thing that diminishes people's devotion. Therefore, our most illustrious leaders are constrained to take steps with our help to moderate these abuses among ourselves and not let this terrible practice continue; and these are also things that excite envy between brothers, so that fraternal love is not maintained, as it should be. (Trans. J. Levine, in M. Tafuri, 1989, p. 91)

However, even after the architecture of the building was completed, work continued on the interior decoration, which, when finished in 1587, was the most spectacular in Venice.

Albergo

TINTORETTO'S *APOTHEOSIS OF ST. ROCH*

The carved wooden ceiling (fig. 152) was the first project of the *albergo*'s interior decoration to be completed, in 1564. As Giorgio Vasari reported in the life of

155. Jacopo Tintoretto, *Apotheosis of St. Roch,* 1564, oil on canvas, 7 ft. 10½ in. × 11 ft. 9¾ in. (240 × 360 cm), *albergo* ceiling, Confraternity of St. Roch.

Battista Franco (c. 1510–61) in his 1568 *Lives of the Artists,* a competition with five competitors, three from Venice and two from central Italy, was held that year for a design representing the apotheosis of St. Roch for the ceiling's central oval. Instead of a sketch, Tintoretto completed a painting (fig. 155), smuggled it into place, donated it to the confraternity, and offered to paint the rest of the ceiling for free. The other competitors cried foul, and one official of the confraternity, Giovanni Maria Zignomi, was so incensed that he offered fifteen ducats to prevent Tintoretto from being offered the commission, but the members voted thirty-one to twenty to accept Tintoretto's offer.

Tintoretto was primarily inspired by a painting of similar subject and location—Titian's *Vision of St. John the Evangelist on Patmos* of circa 1550 (fig. 156) for the center of the ceiling of the *albergo nuovo* of the Confraternity of St. John the Evangelist (fig. 62, no. 5). Titian depicted the moment in the Apocalypse (1:10–12) when John experienced a vision of the Last Judgment on the island of Patmos. He describes his vision as follows: "I was in the Spirit of the

156. Titian, *Vision of St. John the Evangelist on Patmos,* c. 1550, oil on canvas, 7 ft. 8½ in. × 8 ft. 6¼ in. (235 × 260 cm), National Gallery of Art, Washington, DC.

Lord's Day and heard behind me a great voice. . . . And I turned to see the voice that spoke with me." In the painting the book signifies the record of John's vision; the fig leaf, humanity's fall, which led to the Last Judgment; and the eagle, John's attribute (from Apocalypse 4:7). Using a *dal sotto in su* perspective in response to the oblique viewing angle, Titian dramatized John's vision by employing a pinwheel-like contrapposto, windblown drapery, rhetorical gestures, turbulent clouds, a diagonal arrangement of forms, strong chiaroscuro, and open brushwork.

While clearly influenced by Titian's palette and design, Tintoretto increased the obliquity of the *dal sotto in su* illusionism and the foreshortening of the figures so that St. Roch appears to stand on the rim of the oval frame, conceived as a window opening on to heaven. The artist intensified the drama of the con-

frontation between God and the saint by bringing them literally face-to-face. Drawing on Michelangelo's *Separation of Waters from Firmament* (1511), on the ceiling of the Sistine Chapel, he also created a more powerful and active figure of God, who spreads his arms in welcome, to which St. Roch responds with an echoing open-armed gesture of awe. Tintoretto also added a larger cast. Three angels and six cherubs support and accompany God, while nine angels along the rim's oval, symbolizing the heavenly hierarchies, actively express adoration, prayer, and wonder as the rightmost angel holds St. Roch's pilgrim's staff. Finally, Tintoretto arranged the figures and the grassy meadow behind them to create an apsidal space, as if they constituted the conjunction of the fertile earth with the semidome of the heavens, flooded with a golden divine radiance promising spiritual regeneration.

Carlo Ridolfi (1594–1658), Tintoretto's biographer, recorded that the artist's motto was "Michelangelo's design and Titian's color" (trans. Enggass and Enggass, p. 16). As the *Apotheosis of St. Roch* demonstrates, this was an accurate characterization of Tintoretto's artistic formation and style. It was also a bold piece of self-fashioning, by which he created an artistic genealogy that made him heir to two of the greatest artists of the Renaissance.

TINTORETTO'S *CRUCIFIXION*

After Tintoretto completed the *albergo* ceiling, he was voted in as a member of the confraternity in 1565 and thereafter often served in various of its official positions. In that year he also completed the *Crucifixion* above the *banca* (figs. 152 and 157), for which he was paid 250 ducats in 1566. The choice of the Crucifixion rather than an episode from the life of St. Roch reflected the increasing Christocentrism of the Catholic Reformation. So too did the great scale of the work—one of the largest and most dramatic scenes of the Crucifixion ever painted, with its multitude of people engaged in a variety of activities yet all calculated to produce a unified effect.

The escarpment of Golgotha fans out along two diagonals from the base of the cross, while the crest of the hill curves, as if reflecting the curvature of the earth. The left diagonal also defines the path of light from the *albergo*'s right (north) windows. The bad thief on the right, with his back to Christ, is being tied to a cross that lies along the right diagonal as a soldier drills a hole in the crossbar with an auger. Just below, two soldiers "divide [Christ's] garments casting lots" (Matthew 27:35) in a rocky cave while a worker nearby digs a hole for the bad thief's cross. The bearded figure dressed in purple and observing the scene just above the digger may be Tintoretto's self-portrait. To the right of

157. Jacopo Tintoretto, *Crucifixion,* signed and dated 1565, oil on canvas, 17 ft. 7 in. × 40 ft. 2⅞ in. (536 × 1127 cm), above the *banca* in the *albergo,* Confraternity of St. Roch.

the digger, the mounted Roman commander, surrounded by mounted troops, supervises the crucifixions.

On Christ's favored, right side, the good thief, illuminated by a shaft of light, gazes at Christ as if saying, "Lord, remember me when thou shalt come into thy kingdom" (Luke 23:42). Christ looks back at the good thief and can be imaged to respond, "Today shalt thou be with me in paradise" (Luke 23:43). Tintoretto depicted the six soldiers erecting the good thief's cross as if they were Arsenal workers setting the mast of a galley. Their equipment in the foreground—hammer, adze, saw, pincers, ladder, and ropes—would have appealed to the confraternity's many craftsmen who were skillful with such tools.

On a ladder placed against the back of Christ's cross, a figure dips a sponge mounted on a reed into a bowl of vinegar and gall. This represents the cruel response to Christ's cry just before his death, "My God, my God, why hast thou forsaken me?" (Matthew 27:46) and indicates the full measure of pain and humiliation he endured to redeem humanity.

Just behind the good thief the mounted centurion Longinus relaxes, waiting to play his role after Christ's death, when he will pierce Christ's side with his lance and exclaim, "Indeed this is the son of God" (Matthew 27:54). From the wound will pour water and blood (John 19:34), signs of baptism and the Eucharist.

In the left background Tintoretto darkened the sky and bent the trees to indicate a brewing storm and to visualize the earth-shattering significance of Christ's death: "There was darkness over the whole earth ... and the earth quaked" (Matthew 27:45, 51). Yet in the gloom a lone obelisk points upward, a symbolic shaft of divine light promising regeneration.

In contrast to the luxuriously dressed mounted Roman commander on the right, Tintoretto represented to the extreme left the confraternity's grand guardian, Girolamo Rota, mounted on a white horse and dressed in contemporary armor. Aside from professional mercenaries, only nobles who were trained as knights wore armor and rode horses. Since the Venetian government fought its land wars with hired mercenaries, such knights were mostly nonexistent in Venice (although noble Venetian naval commanders did wear armor on shipboard). Therefore, Rota is surely a symbolic Christian knight, who would help to lead the confraternity to Christ, toward whom he points. He also looks down, drawing attention to the cartouche at the lower left, inscribed in Latin, "Jacopo Tintoretto painted this in 1565 during the time of his colleague, the magnificent lord Girolamo Rota." By linking his name to Rota's, Tintoretto claimed high social status and perhaps indicated that Rota helped him secure the commission for the *albergo* decoration.

In the center foreground Tintoretto constructed a pyramidal group that functions as the emotional center of the painting. On the left the group builds to a poignant climax from the kneeling figures of Joseph of Arimathea, John the Evangelist, and Mary Magdalene to the standing woman with her back turned. All but Joseph of Arimathea look up at Christ in disbelief and anguish. On the right, by contrast, the Virgin and a companion have collapsed into a swoon, and two other women lean forward to console the Virgin, their heads bowed in profound grief.

Tintoretto raised Christ above the horizon, silhouetting him against the setting sun and a circular aura of divine radiance, thereby evoking Christ's declaration "I am come a light into the world; that whosoever believeth in me, may not remain in darkness" (John 12:46). With the bottom of the cross obscured, Christ appears to loom against the picture plane, in close proximity to the viewer, while in fact he is in the middle ground. A multitude of gestures, glances, and diagonally arranged forms and actions draw the observer's eyes to Christ. Indeed, the entire world, with its universal cast of characters—good, bad, grief stricken, indifferent, workers, aristocrats, soldiers, artists, men, women, young, and old—appears to be caught up in the drama of the Cruci-

fixion, fulfilling Christ's prophecy "And I, if I shall be lifted from the earth, will draw all things to myself" (John 12:32). Just so were the members of the confraternity dependent on Christ's redemptive sacrifice and drawn to him and bonded to one another by their charity and faith, ever hopeful for salvation. And the men of the *banca*, who sat below this painting, were charged to do their part in administering God's justice to assist the membership to be worthy of salvation.

Chapter Room Ceiling

The carved wooden ceiling in the chapter room was completed about 1574 (fig. 151). On July 2, 1574, the Feast of the Visitation, Tintoretto offered to paint the huge central ceiling canvas free of charge and deliver it by August 16, 1576, the Feast of St. Roch. The offer was accepted, and the work was completed on schedule. On January 13, 1577, the Octave of Epiphany, Tintoretto volunteered to paint the remaining two large ceiling panels for the cost of materials and whatever else the *banca* deemed appropriate. A little over two months later—on March 25, the Feast of the Annunciation—he expanded his offer to include the entire ceiling. Both offers were accepted. Six months later, on November 27, at the beginning of Advent, Tintoretto offered to devote the rest of his life to decorating the confraternity "for the great love I have of our venerable confraternity and for devotion to the glorious St. Roch" (for this quotation and the following facts see T. Nichols, 1999, p. 175). He also vowed to deliver three paintings a year on August 16, the Feast of St. Roch. His only requirement was that an honorarium of one hundred ducats a year be paid to him for the rest of his life, an insurance policy of sorts against future disability. With a vote of fifty-two to four the offer was accepted. However, on February 16, 1578, a faction hostile to Tintoretto called for a revote, and of 101 votes cast, 40 were negative, yet the 61 favorable votes assured—although by a much slimmer margin than that of the earlier vote—the acceptance of his offer. Tintoretto was true to his word, and ten years later, in 1588, six years before his death, the sixty-five paintings decorating both floors of the confraternity were complete, at a total cost to the confraternity of twenty-five hundred ducats, well below the going rate. Furthermore, with few exceptions Tintoretto executed the paintings largely without the aid of assistants—a clear indication that he viewed the decoration of the confraternity as a labor of love, a work of *amor proximi* and *amor dei,* which he offered as a good work for the salvation of his soul.

The large block of votes in 1578 against accepting Tintoretto's offer of the year before and the relatively narrow margin of the vote in 1564 accepting the *Apotheosis of St. Roch* indicate that Tintoretto was a controversial figure. Indeed, he had evolved a new, reformist art and was more in tune with the Catholic Reformation than any other Venetian artist. His sympathetic depiction of workers was antiaristocratic and antielitist, no doubt appealing to the confraternity's lower-class members. He represented women frequently and positively, thereby making his art less paternalistic than that of other artists. His brushwork was often impetuous and his figures extravagantly energetic, lacking in moderation and mimetic verism. As a result, his paintings could be intensely contemplative and visionary and were often antinaturalistic and anticlassical. The middle-to-upper-class segments of the confraternity membership, which generally aligned themselves with the conservative aristocracy, who were concerned with decorum and nobility—and would have patronized Veronese or Titian—appear to have found his art unsympathetic.

Tintoretto also experienced the conflict between plebeian and more patrician values in his personal life. His father, Giovanni Battista Robusti, earned his living as a lower-class *tintor* (dyer of cloth). In about 1550 the artist married a woman above his station, Faustina Episcopi, from a nonnoble but elite family of original citizens. Soon after his marriage, however, he provocatively adopted the nickname Tintoretto (Little dyer), to proclaim his humble origins. This name asserted his allegiance with the *tintori* of the confraternity, who constituted about one-fourth of its membership, and aligned him with a major current within the Catholic Reformation that increasingly championed humility and poverty as socially positive.

TINTORETTO'S *BRAZEN SERPENT*

The *Brazen Serpent* (fig. 158), in the center of the chapter room, is flanked by the *Fall of Manna* (fig. 159) and *Moses Strikes Water from the Rock* (fig. 160). These Old Testament scenes respectively prefigure Christ's crucifixion, the institution of the Eucharist, and baptism and thus evoke the three essential sacraments of salvation—penance, the Mass, and baptism—as repeatedly emphasized during the Catholic Reformation.

The *Brazen Serpent* is the largest and most complex painting of the ceiling and was the first to be completed, in 1576. It depicts the moment when God

158. Jacopo Tintoretto, *Brazen Serpent*, 1575–76, oil on canvas, 27 ft. 6 in. × 17 ft. (840 × 520 cm), chapter room ceiling, Confraternity of St. Roch.

sent a plague of snakes to punish the Israelites for their rebellion against Moses for the harsh desert life they had endured after their escape from Egypt (Numbers 21:4–9), a repetition of Adam and Eve's initial rebellion against God. When the Israelites repented, God ordered Moses to erect a bronze serpent as a memorial to their rebellion and punishment and promised that those who looked on it would be healed—a foreshadowing of the Crucifixion, as John the Evangelist expressed (John 3:14–15): "As Moses lifted up the serpent in the desert, so must the Son of man be lifted up."

At the lower left a man struggling with a snake and a bare-breasted woman holding a child, whom she does not nurse, rotate in opposite directions. They emphasize the diagonal fissure that runs from the lower left toward the upper right and thematize the Israelites' turning away from God and neighbor, rejecting *amor dei* and *amor proximi,* the confraternity's raisons d'être. In the gloom of the lower third of the composition Tintoretto represented an extraordinary array of contorted bodies struggling in agony against the coiling snakes. Some fall into the snake pit, some plunge into the abyss in front of the Israelite encampment at the lower right, and some writhe in the final throes of death. Here Tintoretto has vividly captured the terror, guilt, and helplessness of contemporary Venetians traumatized in 1575 and 1576 by the plague that swept through the city, killing about a quarter of the population as he was painting the canvas. The confraternity alone lost about four hundred of its members.

In the middle of the painting's land bridge Tintoretto represented two couples reclining in bright light. The couple to the right has died, while the couple to left appears to be awakening, rising, and turning to look upon the bronze serpent for the forgiveness of their sins. Above them, silhouetted against the sky, additional figures rise up from the dark contagion of snakes, their salvation suggested by the green tree in their midst and by the soul that appears to escape the earth and rush toward heaven at the extreme right. Just in front of the tree a healed male throws up his arm in exaltation as the woman standing in front of him spirals around and points with a rhetorical gesture to the brazen serpent raised on a cross on the Golgotha-like hill. At the base of the hill and the foot of the cross a group of reviving and adoring figures focus attention on Moses, a standard Christ type. With drapery billowing, Moses spins around in a double contrapposto, looking downward and gesturing upward, mediating between earth and heaven. An angel circumscribes a foreshortened circle of mystical light around his head like a cosmic halo.

Tintoretto opposed this terrestrial drama, which zigzags from the lower left foreground to the upper left background, with an explosive V-shaped celestial glory that moves from the upper left background to the upper right foreground. God and his troop of angels cast a shadow over the earth symbolic of the punishing plague of snakes. Yet the energy of their twisting, titanic bodies and the radiance from which they emerge signify the promise of salvation.

TINTORETTO'S *FALL OF MANNA*

Since the fall of manna (Exodus 16:11–36; Numbers 11:7–9) prefigured the Mass, this painting (fig. 159) was appropriately above the chapter room's altar.

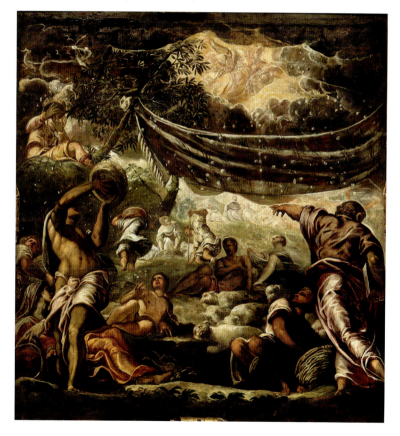

159. Jacopo Tintoretto, *Fall of Manna,* 1577–78, oil on canvas, 18 × 17 ft. (550 × 520 cm), chapter room ceiling, Confraternity of St. Roch.

In the center of the composition several sleeping lambs allude to the sacrifice of Christ, the Lamb of God. The canopy covering them prefigures the Church, the site of Eucharistic celebration, and the Church's universal sovereignty. The stone on which the foreground lamb reclines symbolizes an altar, while the olive trees to which the tent is fastened signal eternal peace, promised by the Mass. To the right, Moses—luminous shafts of light emanating from his head—spirals around to indicate the miraculous fall of manna. He is counterbalanced on the left by a mirroring serpentine figure reaching upward with his basket to capture the manna. Together these two figures lead the eye to God, seen through the dark clouds as a mere rapid sketch of golden radiance. A dark shadow covering most of the figures evokes sin and death, but their bodily energy expresses the potential for renewed life.

TINTORETTO'S *MOSES STRIKES WATER FROM THE ROCK*

The scene in the ceiling at the façade end of the meeting hall (fig. 160) represents Moses striking water from a rock (Exodus 17:8–16), always understood as a prefiguration of the piercing of Christ's side at the Crucifixion, from which water and blood flowed, traditional symbols of the sacraments of the Eucharist and baptism.

Tintoretto depicted Moses as a highly dramatic, spiraling figure in the center of the composition, initiating the action with a dramatic flourish. A series of serpentine figures on the left twist and turn upward in a crescendo to receive the life-giving water. Their torsion and dynamism are emblematic of the water's potential for renewal. This potential is validated by the figure of God in the upper right, depicted in a running, spiraling posture—the circle of transparent light surrounding his legs graphically illustrating his spiritual energy and perfection. The water also gushes from underneath a fig tree in arcs of pure and perfect light, to signal redemption from original sin. The principal arc of water leads the viewer's eye to a woman at the lower right who nurses a child while looking heavenward and to a dog, a pointer, which leads one's eye back to the miracle. The woman and the child symbolize *amor proximi,* the dog *amor dei.*

The battle scene in the background represents the next episode in Exodus (17:8–16): Joshua's victory over Amelek, a powerful sign of the ultimate victory of God's chosen people over sin.

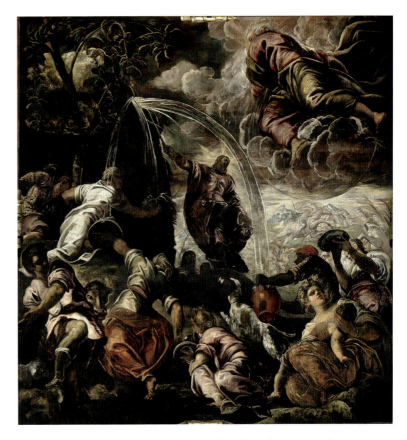

160. Jacopo Tintoretto, *Moses Strikes Water from the Rock,* 1577–78, oil on canvas, 18 × 17 ft. (550 × 520 cm), chapter room ceiling, Confraternity of St. Roch.

Chapter Room Walls

The twelve paintings on the walls—executed between 1578 and 1581—depict the two principal plague saints, SS. Roch and Sebastian, on the façade wall between the windows, and ten scenes from Christ's life, including his birth, baptism, miracles, temptation, Passion, Resurrection, and Ascension, on the side walls. The narratives are arranged not chronologically but in cross-wall pairs to emphasize their symbolic significance, especially concerning the three essential sacraments of salvation—baptism, penance, and the Eucharist. The first

cross-wall pair nearest the façade wall, opposite the altar, represents the adoration of the shepherds on the east wall and the temptation of Christ on the west.

TINTORETTO'S *ADORATION OF THE SHEPHERDS*

The *Adoration of the Shepherds* (fig. 161) illustrates the epiphany of Christ to the Jews (Luke 2:8–20; Mark 14:66–72). The humble cast of characters and the rustic setting perfectly express the Catholic Reformation's concept of sacred poverty, which was especially appealing to the lower classes of the confraternity. The orthogonals created by the foreshortened ladder and the roof beams draw the viewer into a deteriorating rural barn filled with hay, barnyard animals, and farm implements to underline the poverty and humility of the Holy Family. They are represented in the upper hayloft, where an errant rafter cuts across the orthogonal structure to point directly to the Virgin and Child. She lifts a veil to reveal Jesus, glowing with an inner radiance and asleep in a simple woven basket on a bed of straw. In the roof's gable a trinity of seraphs, symbols of divine love, flood the hayloft with a mystical orange light, transforming it into a harmonious, albeit unpretentious, shrine exalting the Holy Family.

In the lower level of the scene Tintoretto depicted acts of piety and charity. To the extreme right two shepherds kneel in adoration. The shepherd to the right, holding a staff, looks up at the Christ child while his companion, with hands in prayer, gazes at a woman before him holding a plate of food for the Holy Family. She also points to the ox, a reminder that Isaiah (1:3) prophesied that the Jews would reject Christ as a savior: "The ox knows its owner [Christ] . . . but Israel, my own people, has no knowledge, no discernment." At the left, two young men in dynamic postures prepare food for the Holy Family. One reaches into a basket of eggs and raises a loaf of bread while the other lifts a covered bowl up to the hayloft. In the loft a wet nurse holds a spoon and bowl in front of her bared breast in preparation to feed Jesus as a second woman kneels in prayer. Tintoretto thus gave unprecedented emphasis to nurturing men and women, which would have reminded viewers of their obligations to their families, confraternity members, and community at large. The occasional heads of wheat in the hay and the elevation of the bread and bowl also recall Christ's spiritual nourishment administered through the Eucharist, promising immortality, symbolized by the peacock.

Tintoretto also alluded to human sinfulness and frailty, which necessitated Christ's redemptive sacrifice, for the rooster evokes Peter's denial of Christ during his Passion. When Christ was being tried in the court of the Jewish high priests, Peter was three times asked if he knew Christ, and three times he

161. Jacopo Tintoretto, *Adoration of the Shepherds*, c. 1578–81, oil on canvas, 17 ft. 9⅜ in. × 14 ft. 11⅛ in. (542 × 455 cm), east wall, chapter room, Confraternity of St. Roch.

claimed, "'I know not the man.' . . . And immediately the cock crew. And Peter remembered the word of Jesus which he had said: Before the cock crow, thou wilt deny me thrice" (Matthew 26:72–75). Peter's actions are thus the antithesis of charity, just as the peacock, often a symbol of vanity and pride, could represent the antithesis of humility.

Finally, Tintoretto represented the entire scene as a nocturne, as if it were an internal mystical experience, here thematized by the quiet meditation of Jo-

seph, seated behind the Virgin. Meditative internalization of biblical events as a form of prayer was a prime devotional method that the reformed Church promoted, especially as formulated in the popular medieval *Meditations on the Life of Christ* (*Meditationes vitae Christi,* wrongly attributed to Bonaventure), the *Spiritual Exercises* by Ignatius Loyola, and the treatises of the Spanish Carmelites St. Teresa of Avila (1515–82) and St. John of the Cross (1542–91). According to Ridolfi in his *Life of Tintoretto* (trans. Enggass and Enggass, p. 70), the artist himself spent considerable time in meditation in his parish church of Madonna del Orto, where he is buried.

TINTORETTO'S *TEMPTATION OF CHRIST*

Tintoretto visually linked the *Temptation of Christ* to the *Adoration of the Shepherds* (fig. 161) through the two-level composition, Christ's shedlike hermitage, and his placement at the upper right (fig. 162). Yet in the *Temptation* Christ is mocked by Satan and challenged to transform rocks into bread, a challenge that he declined as he continued his fast in the desert before his Passion (Matthew 4:1–11; Mark 1:12–13; Luke 4:1–13). This scene, then, concerns not nurture but self-denial, although paradoxically Christ's self-sacrifice resulted in spiritual nourishment for all humanity.

Tintoretto depicted Satan as a herculean foe, his impact intensified by the silhouetting light as he thrusts two rocks toward Christ. This action constitutes the negative counterpart of the charitable elevation of bread in the *Adoration.* Satan is winged like an angel, but his androgyny, sensuality, and peacocklike vanity (indicated by his jeweled armbands) signal his status as a fallen rebel. In contrast to his forward lunge, Christ hovers above on a contrary diagonal, emphasized by the hermitage's roof supports. He counters the devil's sneer with compassion, his pride with humility, his backlighting with a radiant halo, and his sterility with fertility (cued by the green vegetation).

TINTORETTO'S *LAST SUPPER*

The fifth and last pair of scenes on the side walls—the *Last Supper* to the left and the *Multiplication of the Loaves and Fishes* to the right—appropriately frame the altar, since both scenes make reference to the institution of the Eucharist.

In the *Last Supper* (fig. 163) Tintoretto employed a rigorous perspective construction, with the orthogonals tracing the flow of light from the altar—the traditional source of illumination in most religious decorative cycles. The orthogonals focus toward the extreme left, just above the stairway under the

162. Jacopo Tintoretto, *Temptation of Christ,* c. 1578–81, oil on canvas, 17 ft. 8⅛ in. × 10 ft. 9⅞ in. (539 × 330 cm), west wall, chapter room, Confraternity of St. Roch.

163. Jacopo Tintoretto, *Last Supper,* c. 1578–81, oil on canvas, 17 ft. 8 in. × 16 ft. (538 × 487 cm), east wall, chapter room, Confraternity of St. Roch.

kitchen hood. This displacement of the focal point and the alignment of the low table of the Last Supper on a much stronger oblique angle than the orthogonals respond to the oblique viewing position of the viewer, standing or kneeling before the altar. Positioning the focal point about eight feet above eye level also has the effect of mystically elevating the viewer, as if he or she were looking down on the scene.

Tintoretto depicted the event (recorded in Matthew 26:17–30; Mark 14:12–25; Luke 22:7–23; John 13:21–30) as a nocturne set within a spacious hall with framed mirrors hanging on the right wall, yet the architecture is nonclassicistic, with exposed bricks and beams—more like the ground-floor *androne* of a palace, where servants would work. In addition, the extremely low, makeshift table, with only one rustic stool, requires most of the barefoot apostles to humbly kneel to eat. However, the checkerboard pavement—typical of Venetian churches—identifies this as a sacred space, and the five rows of tableware on the sideboard in the background suggest a royal banquet (see also ch. 17).

The orthogonals and a bright golden aura focus the viewer's attention on Christ and the sleeping John the Evangelist, his head in Christ's lap. The betrayal of Christ, often the principal narrative action in scenes of the Last Supper, has here been deemphasized, as Judas—the only apostle without a halo, his highlighted back turned to the viewer—simply leans away from Christ as he gazes back at him. Rather than giving Judas the sop of bread as a sign of his guilt, as was traditional, Christ gives communion to a haloed apostle who leans toward him with his arms humbly crossed over his breast to receive the sacrament. Similarly, the response of the other apostles is not shock at Judas's betrayal but rather expressions of awe, wonder, and devotion at the institution of the Eucharist.

Seated in the foreground, a seminude man and a clothed woman have food, drink, and clothing set before them on the step. The food and drink suggest the Eucharistic elements of bread and wine, while the white dog between them—aligned along an orthogonal and eagerly observing the Last Supper—symbolizes faith and marital fidelity. The seated figures therefore embody a pious Christian couple of deserving poor, a type toward whom the confraternity's charity was directed.

Compared to the elevated classicistic setting, aristocratic decorum, and narrative ambiguity of Veronese's *Last Supper* (fig. 146), Tintoretto's scene offers the viewer direct access to a world of humility, piety, and sacramentality.

TINTORETTO'S *RESURRECTION OF CHRIST*

The third pair of scenes, in the middle of each wall, represent the conclusion of Christ's life on earth: the Resurrection (Matthew 28:1–6) and the Ascension (Luke 24:50–53; John 20:17; Acts 1:9–12). As the members of the confraternity processed from the assembly room up the triple-ramp stairway to the chapter room, the first image they encountered on arrival was Christ exploding out of his tomb diagonally away from the altar yet looking toward it while offering

ing themselves in strained postures, and two airborne—to magnify the drama of Christ's eruption from his tomb. Above them Christ soars—a blinding light enveloping his body, as if from a blast furnace—his titanic stature magnified by his gesture of triumph, the unfurling banner of victory, and his billowing drapery of blue and purple (colors suggestive of his divinity and imperial majesty).

TINTORETTO'S *ASCENSION OF CHRIST*

When the members of the confraternity exited the chapter room, Christ ascending toward heaven in the direction of the altar was the last scene they would see before descending the stairs (fig. 165). Tintoretto constructed the composition on parallel diagonals in alternating bands of light and dark defined by the apostles, the landscape, the angels, and the arms and gaze of Christ. Despite some spatial recession near the bottom, most figures are close to the picture plane and of about equal weight and density. The net effect is an overwhelming drive leftward and upward toward the altar, the site of the Mass, which promises salvation.

Tintoretto also constructed the scene according to an inversion of naturalistic norms. Rather than ethereal and immaterial, the celestial world is vibrant and verdant, filled with palm fronds and laurel branches (symbols of sacrifice and victory) and swirling angels in dynamic torsion. The angel to the extreme left appears to run at an oblique angle through space. The kneeling Christ twists in a double spiral, gesturing forward and back, his movement echoed and varied by the angels, whose wings and palm fronds slice through the air. The deep chiaroscuro and limited palette with only flashes of brilliant color further heighten the bulk of these celestial figures. Tintoretto, in sum, has materialized the spiritual world.

By contrast, the terrestrial world appears parched and barren, and the apostles, with one exception, seem relatively small, insubstantial, and passive. The massive apostle counterbalancing Christ at the lower left holds a large open book, leans powerfully leftward, splays his legs, rotates his shoulders leftward, and looks rightward. Yet while a twisted, serpentine figure of exceptional strength and potential for movement, he remains heavily earthbound. He has been reading the Scriptures—presumably enlightening him about Christ's Ascension—but does not see the miracle, only imagines it inwardly. The other ten standing and seated apostles also appear largely to experience the miracle contemplatively. The terrestrial natural world, in short, has been spiritualized, conjured up meditatively as a nocturnal vision.

164. Jacopo Tintoretto, *Resurrection of Christ,* c. 1578–81, oil on canvas, 17 ft. 4⅜ in. × 15 ft. 11 in. (529 × 485 cm), east wall, chapter room, Confraternity of St. Roch.

a benediction (fig. 164). The angle of his body draws the eye to the left background, where the two Marys arrive on Easter morning to witness the empty tomb proving that Christ was resurrected. They approach the tomb silhouetted against the rising sun at the dawn of a new day. But the daylight has not yet penetrated the foreground, where the sleeping soldiers who guard the tomb have been reduced to near illegible forms in the darkness, appropriate for the unseeing, unthinking role they play in the drama. By contrast, four heroic angels struggle with the tomb's massive lid—two standing on the ground, brac-

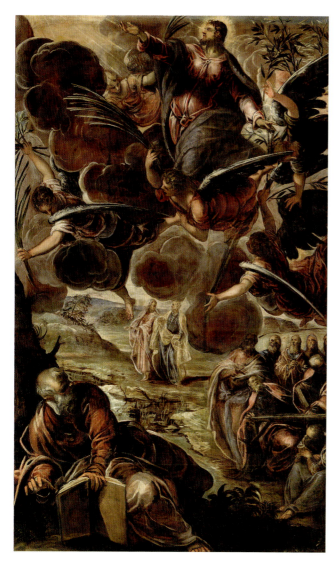

165. Jacopo Tintoretto, *Ascension of Christ,* c. 1578–81, oil on canvas, 17 ft. 8 in. × 10 ft. 8 in. (538 × 325 cm), west wall, chapter room, Confraternity of St. Roch.

Tintoretto intensified the visionary character of the natural world through his technique, which forces us to acknowledge that we are viewing a painting, an artifice, and not an objective illustration of reality. The viewer can see the herringbone weave of the canvas through the thin paint—especially in the areas of the highest intensity of light—and can imagine the artist's hand dragging a loaded brush across the coarse texture of the canvas, leaving behind a semitransparent pattern of pure, disembodied color and light. The rapid and sure sweep of the calligraphic brushstrokes also insists on the mental act of creation, on the mind guiding the brush. In short, Tintoretto's sketchy technique—by its very nature antiaristocratic, anticlassical, and antiacademic—draws attention to itself as a performance, one that communicates efficiency, cost effectiveness, spontaneity, improvisation, and a craftsman's delight in production.

Assembly Room

In contrast to the paintings in the chapter room, which primarily depict the mission and Passion of the adult Christ in cross-wall pairings, Tintoretto's eight paintings (1582–87) for the assembly room (fig. 150) are arranged chronologically around the room and focus on the Virgin Mary and the infant Christ and conclude with Mary's Assumption.

TINTORETTO'S *ANNUNCIATION*

At the Annunciation, it was traditionally believed, the Virgin had been sitting in her bedroom reading a prophecy of Isaiah (7:14)—"Behold a Virgin shall conceive and bear a son"—and spinning and weaving a purple veil for the Temple of Solomon. Accordingly, Tintoretto depicted a Bible on her lap, a spinning wheel behind her, a sewing basket at her feet, and a spindle and purple cloth on her table (fig. 166). The Virgin looks up startled but engages in a dynamic interaction with Gabriel, indicated by their open mouths, responsive gestures, torqued postures, and muscular bodies. The red and white ecclesiastical floor evokes Mary's sanctity, and the bed canopy over her head her sovereignty and dominion.

The orthogonals of the perspective and the flow of light—responding to the natural light from a window in the façade wall to the left—focus to the right of Gabriel, intensifying the narrative action from left to right. By tradition the Annunciation occurred at twilight, to combine Christ's incarnation with a suggestion of his coming sacrifice. Therefore, here the light low on the horizon can be read either as the dawn of a new day, appropriate for the Incar-

166. Jacopo Tintoretto, *Annunciation,* 1582–87, oil on canvas, 13 ft. 10 in. × 17 ft. 10½ in. (422 × 545 cm), east wall, assembly room, Confraternity of St. Roch.

167. Jacopo Tintoretto, *Mary Meditating in a Landscape,* c. 1587, oil on canvas, 13 ft. 11¼ in. × 6 ft. 11 in. (425 × 211 cm), east wall, assembly room, Confraternity of St. Roch.

nation, or as dusk, evocative of the Crucifixion. Yet this natural light has also been transmuted to a golden spiritual light by the glory of blue-winged seraphs, symbols of divine wisdom, arcing through the transom; the brilliance of the dove of the Holy Spirit; the radiance of Mary's halo; and the glimmering circles in the ceiling.

The bedroom's wall with a column base on a pedestal and its floor, with a checkerboard pavement, reflect the architecture of the assembly room (fig. 150), yet the Virgin's chamber, with its peeling plaster, exposed and crumbling brickwork, and frayed wicker chair, is modest. The semi-open-air carpentry shop to the left, in which Joseph saws wood on a workbench, appears to be improvised. In other words, Joseph and Mary are not highly idealized but instead embody the new Counter-Reformation emphasis on sacred poverty and

humility. They reminded members of their obligation to provide housing and assistance to the poor, especially the deserving, hard-working, and pious poor who are like Joseph and Mary.

TINTORETTO'S *MARY MEDITATING IN A LANDSCAPE*

In two of the assembly room's latest paintings, flanking the altar, Tintoretto turned from action, rhetorical gestures, and serpentine bodies to a world of spiritual contemplation, probably representations of the Virgin Mary reading and meditating in nature at night. Their solitude and darkness suggest that she is contemplating sin, sorrow, suffering, and death. An intense white light illuminates the Scriptures that she holds, further suggesting that she is meditating on Christ's life and his ultimate triumph over sin and death.

In the left-hand painting, Mary has looked up from her book to gaze at the verdant landscape, as if the natural world had become an outward projection of her inner thoughts on salvation (fig. 167). She sees a palm tree, which alludes to the beginning of Christ's Passion, with his palm-strewn entry into Jerusalem. The silvery moonlight washing over the scene symbolizes the Virgin, the embodiment of the Church, aglow with Christ's radiance. The light also ambiguously suggests the coming of either dawn or dusk, underlining the message of death bringing renewed life. It reflects most intensely off the stream, to signify Christ's redemptive grace channeled to the faithful through baptism. In this nocturnal world, forms have little existence beyond light. Tintoretto's expenditure of mental and physical energy thus registers with unusual force as pure calligraphic gesture, as a graphic expression of his enlightenment offered as a sacrificial labor of love for the salvation of his soul.

Comparing *Mary Meditating in a Landscape* of the 1580s to the *Apotheosis of St. Roch* of 1564 (fig. 155) provides a measure of Tintoretto's exceptional artistic and spiritual development at the confraternity over the course of about two decades. His art evolved from dynamism to quietude, from titanic to dematerialized forms, from exteriority to interiority, from illusion to allusion, from masculine paternalism to feminine nurturing, and from pride to humility.

PALACES

With the imposition of ever stricter rules for qualification as a noble and for enrollment in the Great Council, the number of patrician males declined from a peak of about twenty-six hundred to two thousand or fewer over the course of the sixteenth century. In this smaller elite, the gap between the extremely wealthy and the moderately wealthy or even impoverished grew ever larger. The wealthiest were best able to exploit the more restrictive marriage market, the corrupt practice of buying votes to gain control of governmental councils for economic advantage, and the shift from smaller investments in trade and commerce to much larger capital outlays for real estate both in Venice and on the terraferma. For example, by 1582 about 5 percent of the nobles owned nearly 70 percent of the real estate in Venice, and about half of the more than twelve hundred Venetian noble families lived in rental housing. This concentration of ever greater wealth in the hands of fewer nobles led inevitably to larger and more magnificent palaces for those who could afford to build them. This development was also encouraged by the classical theory of magnificence expounded in Aristotle's *Nicomachean Ethics* (1122a18–1123a30). It holds that men of means have a moral duty to live in splendid palaces, for the benefit of themselves, their family, and society. Leon Battista Alberti succinctly popularized this notion in the prologue to his widely read *On the Art of Building in Ten Books* (first Latin edition, Florence, 1486; first Italian edition, Venice, 1546): "When you erect a wall or portico of great elegance and adorn it with a door, columns, or roof, good citizens approve and express joy for their sake, as well as for yours, because they realize that you have used your wealth to increase greatly not only your own honor and glory, but also that of your family,

your descendants, and the whole city" (trans. J. Rykwert, N. Leach, and R. Tavernor, p. 4).

In the sixteenth century a key feature of central Italian palace design—the internal courtyard surrounded entirely or partially by porticoes and loggias—was introduced to Venice, principally by Antonio Scarpagnino (fig. 107) and Jacopo Sansovino. An internal courtyard provided greater light, air, and privacy for the inner rooms than did the walled garden at the back or side of fifteenth-century palaces (figs. 73 and 75). Such courtyards thus became the norm in the larger sixteenth-century palaces and were often articulated to echo the façade.

The piano nobile in a typical fifteenth-century palace was reached by an outside stairway in the walled garden (fig. 73). But in the sixteenth century—again following central Italian precedent—the use of internal switchback stairways, often accessed from the inner courtyard or the *androne,* became standard. Such stairways offered protection against the elements, allowed privacy of movement throughout the building for residents and servants, and could, if wide and spacious, create a grand ceremonial entrance for guests and visitors.

The floor plans of sixteenth-century palaces differ little from those of the fifteenth century, with the exception of a greater emphasis on the two corner rooms—the *alberghi* on the front of the palace, with the best light, air, and views—and a tendency toward the multiplication and specialization of rooms. In place of the earlier, somewhat generic bed-sitting rooms flanking the *portego,* rooms both proliferated as palaces grew and served more distinctive functions, utilized as reception rooms, antechambers, dressing rooms, informal dining rooms, studies, nurseries, and by the seventeenth century even librar-

ies, art galleries, ballrooms, and chapels. In addition, the development of more stable foundations allowed many to be vaulted, and most were more lavishly furnished and richly decorated than earlier rooms. Finally, very large palaces allowed the inclusion of more mezzanine rooms, often above all three floors, which could be rented out to less prosperous nobles. Indeed, rental income provided significant revenue for the wealthiest Venetian nobles.

With an ever greater emphasis on Venice as a new Rome and the increasing acceptance of humanist studies and values among the Venetian elite, sixteenth-century palaces distinguished themselves most conspicuously from those of the fifteenth century through a much more erudite, balanced, and integrated use of the vocabulary and syntax of classical architecture to articulate the façades and inner courtyards. The emphasis on the corner *alberghi* produced façades that were rigorously symmetrical, with visually strengthened corners framing the central *androne* and *porteghi*. The ever greater diversification of room functions also led to clearer distinctions in the articulation of the ground floor, the first piano nobile, the second piano nobile, and the mezzanines but without compromising the integrity and unity of the whole design.

CODUSSI'S PALAZZO LOREDAN

In 1479, six years before his marriage to Maria Badoer, the wealthy noble Andrea Loredan (1450–1513) acquired a residence on the Grand Canal near the Rio di S. Marcuola (fig. 6, no. 44), which, judging from Jacopo de' Barbari's *View of Venice* (fig. 1), had a typical Gothic U-shaped plan, with the *androne* and *portego* in the center, flanked by a series of sitting rooms and bedrooms on either side. The garden at the back contained an L-shaped outdoor stairway similar to the one at the Ca' d'Oro (fig. 73). Remodeling of the residence appears to have been completed by 1494, when Loredan was elected to the Senate. But with the 1501 election to the dogate of Leonardo Loredan (fig. 91), a relative from another branch of the family, and Andrea's election to the Collegio in 1502 as a *savio* of the terraferma, he decided to build a grand new façade for his residence more in keeping with the Loredan family's status and dignity. As a patron of the Camaldolese monks at S. Michele in Isola (fig. 6, no. 22)—he owned the patronage right to the chancel (fig. 20), where he was eventually buried—Loredan knew Mauro Codussi's work and evidently admired it enough to commission the architect to design his new palace façade. Inspired largely by ancient Roman ruins in the Veneto and by Alberti's Palazzo Rucellai in Florence (c. 1455–70)—also essentially a Renaissance façade added to a me-

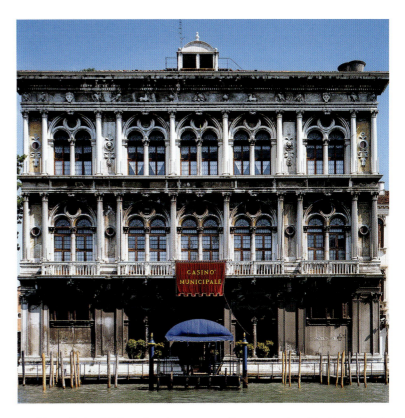

168. Mauro Codussi, Palazzo Loredan, c. 1502–9, limestone and marble, Grand Canal.

dieval building—Codussi created the first Venetian domestic façade employing a unified and symmetrical design based on the classical orders and on a scale that can truly be termed palatial (fig. 168).

Three round-arched openings in the center of each floor light the *androne* on the ground floor and the two *porteghi* above. The openings to the *androne* are flanked by two pairs of small rectangular windows placed high in the wall, giving light to the ground-floor storerooms. A pair of round-arched openings lighting the two *alberghi* on each of the upper two floors flank the *porteghi*. Within these arched openings—except those of the central watergate, on the ground floor—Codussi inserted his signature round-arched biforal windows

with an oculus above, an erudite classical variation on the upper portico of the Doge's Palace (fig. 5), appropriately expressing the close association of the Loredan family with the Venetian government.

Channeled Corinthian pilasters on the ground floor and freestanding Corinthian columns on the upper floors, all carrying full entablatures, frame the corners and every opening of the tripartite façade. However, reading horizontally from left to right, the fourth and seventh vertical supports can be read as paired either with the third and eighth to frame the wings or with the fifth and sixth as single vertical supports framing the openings of the *androne* and *porteghi*. This design visually strengthens the corners and the wings, clarifies the functions of the rooms, and adds a syncopated rhythm across the façade.

On the ground floor, carved garlands in a channeled band unite the capitals of the paired pilasters, while the spandrels of the *androne* windows and the watergate contain four porphyry disks and two classicizing marble portrait heads. Following the example of the Ca' Dario (fig. 76), the wall below the rectangular storeroom windows on the right bears an inscription: NON NOBIS (Not to us), from Psalm 113:9 ("Not to us, O Lord, not to us; but to thy name give glory"), intended to deflect praise for this magnificent palace from the Loredan family to God, whose protection of Venice, it suggests, provided the peace and prosperity that made the building possible.

Codussi emphasized the first piano nobile by fluting the Corinthian columns and adding balconies. The long central balcony unites the three windows of the *portego,* while the two shorter ones emphasize the flanking *alberghi.* Five porphyry rectangles decorate the frieze of the entablature, carved garlands in a channeled band unite the capitals, and fourteen porphyry disks decorate the spandrels of the windows and the four intervals between the paired columns of the wings.

On the top floor, shorter, nonfluted columns resting directly on the cornice of the entablature below—which also serves as a windowsill—carry the massive crowning entablature, with a projecting denticulated cornice that unifies the entire rectangular block and terminates the upward thrust of the vertical supports. Codussi adorned the frieze of the crowning entablature with nine spread eagles, two flaming vases, two unicorns, and two shields with the Loredan coat of arms. Finally, ten porphyry disks decorate the spandrels of the windows, carved garlands join the paired columns, and classicizing trophies featuring two large porphyry disks and two lion heads embellish the four spaces between paired columns.

Never before had a Venetian façade employed the vocabulary and syntax of classical antiquity to express such structural strength and stability in such a rigorously trabeated and arcuated design, nor so clearly manifested in its rich decoration and complex rhythmic organization such a unified artistic vision. The Loredan palace thus marks the transition from the early to the High Renaissance, from a *casa* designed by stonemasons to a palace designed by an architect.

SANSOVINO'S PALAZZO DOLFIN

The Palazzo Dolfin, on the Grand Canal near the Rialto (fig. 6, no. 43), replaced a Gothic palace (fig. 2, no. 13). The nobleman Giovanni Dolfin (c. 1490–1547)—a wealthy shipping and trading merchant active in governmental affairs, especially in matters concerning the terraferma—commissioned the new palace a little over a decade after his marriage in 1526 to Chiara Vendramin (d. 1547), from an old noble Venetian family. Jacopo Sansovino's design introduced the first completely Romanizing façade to Venice (fig. 169), with each of the three floors articulated with classical pilasters or engaged columns carrying full entablatures and without a hint of the Gothic pictorialism still evident in Codussi's Palazzo Loredan (fig. 168). It also included a new internal square courtyard with a loggia on one side of the ground floor and with balconies on the upper floors. The tripartite façade of the upper two floors, however, reflects a traditional Venetian plan, with the four arched openings in the center marking the *portego* and the four flanking arched openings defining the two *alberghi* on each floor.

To gain more space for the upper rooms, Sansovino extended the upper floors out over a public walkway, which supported them on a trabeated and arcuated Doric portico that also functioned as a watergate, giving access to the six long and narrow storerooms behind each arch. The main watergate, on the right (Rio di S. Salvador) side of the building, opened into the courtyard and an internal switchback stairway to each of the upper two apartments.

Sansovino articulated the first piano nobile with engaged Ionic columns on pedestals supported by the cornice of the ground-floor entablature. A balustrade emphasizes this main floor by extending uniformly across the entire façade. The articulation of the second piano nobile repeats that of the floor below, except that here Sansovino employed the Corinthian order and confined the balustrades to just the window openings. He uniformly articulated all the windows with channeled Doric piers on pedestals and visually strengthened

169. Jacopo Sansovino, Palazzo Dolfin, 1538–45, limestone, Grand Canal.

the corners of the upper two floors by coupling an engaged column with a pier sharing a common pedestal. Finally, he emphasized the crowning entablature with twelve lion heads in the frieze and a corbeled cornice.

The Palazzo Dolfin was the first Venetian palace to display the sequence of classical orders derived from the Colosseum in Rome (Doric, Ionic, Corinthian), which was deemed canonical. It was also the first to locate the entablatures in close correspondence with the floor levels, heightening the expression of the structural solidity of the whole.

SANSOVINO'S PALAZZO CORNARO DELLA CA' GRANDE

Sansovino's High Renaissance palace masterpiece, the enormous Palazzo Cornaro della Ca' Grande (fig. 6, no. 42; figs. 170 and 171), replaced a Gothic palace that Procurator Giorgio Cornaro (1475–1527), a brother of Queen Caterina Cornaro (fig. 94), had acquired in 1480 and subsequently refurbished.

In a spectacular conflagration on August 16, 1532, the Gothic palace burned to the ground.

Giorgio's sons immediately petitioned the Venetian government for fifty thousand ducats to assist in rebuilding the palace. Their request was based on their status as the legal heirs to Caterina's dowry of sixty-one thousand ducats, which she had deposited with the state in 1489 after abdicating the throne of Cyprus in favor of the Venetian republic. In 1533 the state agreed to transfer thirty thousand ducats to the Cornaro family to assist in the rebuilding. But reconstruction did not begin until about 1545, when the family assets were finally divided among Giorgio Cornaro's heirs, with the share that included the site of the burned palace falling to Giorgetto Cornaro (1523–87), a son of Giacomo Cornaro (d. 1542) and a grandson of Giorgio.

Sansovino's design for the new palace in some respects follows the typical tripartite Venetian plan. On the ground floor he included the standard watergate and *androne* flanked by offices and storerooms for wheat, sugar, and cotton, produced on the vast Cornaro estates on Cyprus. But he added a groundbreaking entrance vestibule before the *androne* as well as three internal switchback stairways off the *androne* leading to the upper floors. Each of the upper two floors features a typical central *portego* flanked by *alberghi* on the façade and a series of other rooms arranged in an enfilade behind the *alberghi*. The *androne* and the upper *portego,* however, culminate at their north ends in a central Italian–inspired square internal courtyard, articulated to mirror the façade. The land entrance, on the east side of the building, also opened into an innovative entrance vestibule—echoing that of the *androne* in size and articulation—which provided access to the courtyard and the rooms surrounding it. Finally, a mezzanine was included above each level.

For the first time, a Venetian domestic palace façade had a massive rusticated ground floor, to serve as the base for the upper stories. Sansovino framed the two outermost ground-floor windows with tall rusticated Doric pilasters to visually strengthen the palace's corners and visually support the corbeled cornice, which carries the pedestals of the columns and the balconies of the piano nobile. He defined the watergate with a triumphal arch motif with three tall openings and articulated the ground-floor windows with rustic Doric engaged columns carrying Doric entablatures and round pediments decorated with large scallop shells. He framed the mezzanine window just above with large imaginative volutes resting on blocks, derived from the architecture of Michelangelo.

170. Jacopo Sansovino, Palazzo Cornaro della Ca' Grande, begun c. 1545, completed shortly after 1581, Grand Canal.

171. A Ground-floor plan, B piano nobile plan, C longitudinal section, Palazzo Cornaro della Ca' Grande: 1 entrance vestibule, 2 *androne,* 3 courtyard, 4 land entrance vestibule, 5 *portego,* 6 *alberghi.*

Inspired by Donato Bramante's Palazzo Caprini in Rome (c. 1510), Sansovino framed every window of the upper two floors with paired engaged columns—Ionic on the piano nobile and Corinthian on the top floor, each pair sharing a common base—supporting a full entablature. From the bottom to the top of the all-stone façade, therefore, he again employed the Colosseum sequence, in vertical continuity from Doric to Ionic to Corinthian. As in the Palazzo Dolfin, Sansovino uniformly articulated all fourteen of the arched windows on the upper floors with Doric piers on pedestals.

On both of the two upper floors he slightly widened the three central windows, to mark the *porteghi* and allow the maximum amount of light into these long rooms. The eight windows defining the high-ceilinged *alberghi* are narrower, to provide more wall space around them and thus visually strengthen the corners of the building. Sansovino introduced rhythmic variation across the façade through the use of balconies: one long balcony unifying the three central windows of each *porteghi,* and individual balconies for the flanking windows of the *alberghi.* The classicizing heads used as the keystones of the window arches and the trophies (arms, armor, and trumpets) carved in the spandrels of the windows carry the triumphalism of the watergate's arches to the upper stories. Finally, to accommodate oval cartouche–shaped windows to light the servants' mezzanine, the crowning entablature, unifying the entire block, features an exceptionally wide frieze and a strongly projecting corbeled cornice.

Never before had a Venetian palace façade displayed such a sophisticated understanding of the vocabulary and syntax of classical architecture, imaginatively and subtly integrated to express load and support held in equilibrium. Nor had a façade so fully expressed the strength and vitality of Venice as the new Rome. The magnificence of the commodious palace thereby fully communicated the prestige, wealth, and classical erudition of the noble Cornaro family, which claimed descent from the ancient Roman Cornelia clan, some of whose members were believed to number among the original settlers of the Veneto. Subsequent sixteenth-century Venetian palaces elaborated and refined Sansovino's masterwork, but none surpassed it.

NONNARRATIVE DEVOTIONAL PAINTING

GIORGIONE'S *VIRGIN READING WITH THE CHRIST CHILD*

The Bellini workshop established the archetypal nonnarrative devotional image in the early fifteenth century and continued to create dozens of variations on the prototype, those of Giovanni Bellini being the most inventive and widely imitated by contemporaries (figs. 77–80). Since Giorgione was strongly influenced by Bellini, many of the compositional devices and motifs of his *Virgin Reading with the Christ Child* (fig. 172) originated in the Bellini workshop. These include the asymmetrical composition, Jesus reclining on a cushion on a parapet, the Virgin seated on the ground behind the parapet as the Madonna of Humility, and the Virgin's creased green and gold cloth of honor, symbolic of her spiritual sovereignty. Yet Giorgione's image is very different from anything painted by the Bellini.

Giorgione lowered the parapet so that fully three-quarters of the Virgin's body is visible. She does not face the viewer but sits in three-quarter profile, a pose that emphasizes her exceptional stature. Although at first glance Mary appears to be indoors, reading by a window, the window casement is actually the brick wall of a garden with plants growing from its cracks and crevasses—an allusion to the traditional metaphor of the Virgin as a closed garden (Song of Songs 4:12), signifying both her virginity and her fertility. She does not just hold a Bible, as in many previous devotional images, but for the first time reads to her child. By emphasizing her studious foreknowledge, Giorgione conflates the Virgin with divine Wisdom of the Old Testament, who, it was believed, ex-

172. Giorgione, *Virgin Reading with the Christ Child,* c. 1504, oil on panel, 2 ft. 5⅞ in. × 2 ft. (76 × 61 cm), Ashmolean Museum, Oxford.

isted from the beginning of time, when God preordained the entire course of human history. Wisdom was thus closely associated with the third person of the Trinity—the Holy Spirit, coursing through all space and time—which Giorgione visualized in Mary's blue cape (the color of the heavens), gold head scarf (the color of divine illumination), and monumental figure (suggestive of a classical seer).

In several devotional images from the Bellini workshop, the infant Jesus reclines on a cushion on a parapet, forming the center of attention, while behind him the Virgin discreetly adores her child with hands folded in prayer (e.g., fig. 78). But here the Virgin is the active and dominant central figure, while Jesus is located to one side of the parapet, passively but attentively listening to his mother read. Furthermore, in all previous Venetian devotional images, the parapet was depicted as if made of stone or marble, suggestive of both a windowsill and an altar, symbolically Christ's tomb. Giorgione by contrast represented the parapet as a massive wooden beam, evoking the cross of the Crucifixion, no doubt the subject of the passage the Virgin is reading. Yet the plants growing from the brick wall that frame Christ's head and the green hue of the cloth of honor evince the promise of regeneration from Christ's sacrifice.

Most unusual of all, the view beyond the garden wall is not a landscape but a representation of the Piazzetta S. Marco (cf. fig. 3). Therefore, Giorgione equated the Virgin not only with Wisdom but also with Venice, thus supporting the belief that Venice was a sacred city preordained from the beginning of time and governed by divine Wisdom. Never before had a devotional image so clearly expressed civic ideology.

TITIAN'S *GYPSY MADONNA*

Titian may have been trained by Giovanni Bellini and certainly absorbed much of his style and mode of composition. In his *Gypsy Madonna* (fig. 173) Titian borrowed from Bellini's nearly contemporary Brera *Virgin and Child* (fig. 80) the large rectangular format, the bright focused light from the upper left, the vivid colors, and the creases and sheen of the green and red cloth of honor. Other works by Bellini account for the asymmetrical composition, the opening on to a broad landscape beyond the cloth of honor, and the downcast eyes and brooding introspection of both the Virgin and Christ.

Yet Titian's colors are more vivid and intense, the sharp creases and luminous shine of the cloth of honor more naturalistic, and Jesus more active and spontaneous. Titian also divided the parapet wall in two, the front half serv-

173. Titian, *Gypsy Madonna* (*Virgin and Child*), c. 1510–11, oil on panel, 2 ft. 1 in. × 2 ft. 8 in. (63 × 81 cm), Gemäldegalerie, Kunsthistorisches Museum, Vienna.

ing as a platform for Christ and a symbolic altar, the rear half a windowsill opening to the landscape. The Virgin thus stands in a narrow space between the two walls, close to the picture plane, making her appear more accessible to the viewer.

Simultaneously, the introspection of both Christ and the Virgin as they ponder his fate appears more poignant and the physiognomy of Titian's Virgin less girlish, communicating rather the loveliness and grace of a goddess. The breadth of her silhouette, the bold sweep of her drapery, and the depth of the landscape also impart great majesty to the Virgin. Similarly, Christ's expression signifies wisdom beyond his years, as if he were an infant god.

Finally, Titian handles the light with more sophistication than Bellini. Is it dawn or dusk? The very ambiguity helps to account for the figures' profound expressions, as if they are contemplating the paradox of the promised renewal of a new day, achieved only through the darkness of night.

TITIAN'S *MADONNA OF THE CHERRIES*

Titian's *Madonna of the Cherries* (fig. 174) dates from only about five years later than his *Gypsy Madonna* (fig. 173), but he has transformed the contemplative nature of most previous nonnarrative devotional paintings into a delightful drama. As in the earlier painting, the composition is pyramidal, here made more stable by the addition of two flanking saints and the placement of the cloth of honor symmetrically in the center. But now Titian uses the partial parapet to allow an eager infant John the Baptist to rush in playfully with a handful of cherries, which he offers to the Virgin. Simultaneously, his father, Zachary, reaches around to give him a warm embrace. The leftward lean of the Virgin and the angle of St. Joseph's staff echo and intensify the diagonal thrust of John's action.

174. Titian, *Madonna of the Cherries* (*Virgin and Child with the Infant John the Baptist and SS. Joseph and Zachary*), c. 1516, oil on panel transferred to canvas, 2 ft. 7⅞ in. × 3 ft. 3⅛ in. (81 × 99 cm), Gemäldegalerie, Kunsthistorisches Museum, Vienna.

Christ's action counterbalances John's. He does not merely stand on the parapet, as in countless works by the Bellini, but strides toward his mother with excitement about the tasty new treat of cherries his cousin John has found. Joseph's loving glance, the Virgin's embrace, and the natural light entering the painting diagonally from the upper right support his movement. Far more than the earlier *Gypsy Madonna,* this painting presents a drama of human interaction, showing affection between loving parents and innocent children.

But at the same time it expresses a greater spirituality and sacramentality. The banderole that John places on the parapet, inscribed ECCE AGNVS DEI (Behold the Lamb of God), refers to Christ as the sacrificial lamb, and John's hair shirt—anticipating his hermetic and preaching life in the desert—evokes the sacraments of baptism and penance. Christ's action foreshadows his stepping out into the world to accept his fate, while the parapet evokes his tombstone, and the veil draped over his chest and left arm his shroud. This symbolism transmutes the diagonal shaft of natural light to divine radiance mediating between matter and spirit. The cherries too, with their red color and sweet taste, were traditional symbols of Christ's redemptive sacrifice and the promise of salvation. Finally, the two children, on contrary diagonals, evoke the fullness of universal time, as John was the last prophet of the old dispensation and the precursor of Christ, while Christ ushered in the era of the new dispensation.

TITIAN'S *MADONNA OF THE RABBIT*

In the *Madonna of the Rabbit* (fig. 175) Titian depicted Mary, Jesus, and Catherine in a luxuriant landscape on a picnic outing. The Virgin sits on the flower-strewn grass to signal her humility and fecundity. This Madonna of Humility type visualizes the pun on *humus* (earth) and *humilitas* (humility). With one hand Mary tenderly caresses Jesus's head, as a sign of her motherly humanity, while with her other hand she holds a timid rabbit, to indicate her fecundity. The Virgin's sanctity is symbolized by a gold cushion on which she partially sits and a golden veil creating a divine aura around her head. A distant church steeple silhouetted against the horizon associates the Virgin with the Church, while a rushing stream behind her shoulder recalls the sacrament of baptism, the channel of God's refreshing grace to the faithful. Typical of Titian's work, the sun low on the horizon representing either dusk or dawn suggests that the Virgin, as the embodiment of the Church, mediates between death and renewed life.

175. Titian, *Madonna of the Rabbit* (*Virgin and Child with St. Catherine and a Shepherd*), 1530, oil on canvas, 2 ft. 4 in. × 2 ft. 10¼ in. (71 × 87 cm), Musée du Louvre, Paris.

The royal-born St. Catherine of Alexandria is dressed in sumptuous attire and kneels on the broken spiked wheel of her martyrdom, an emblem of her steadfast faith. She holds Jesus with hands veiled in pure white cloth, signaling his sanctity but also alluding to his shroud.

As Jesus affectionately pats Catherine on her chin, he reaches toward the rabbit with childish glee, actions evincing his love for fallen humankind, which he will redeem with his sacrifice. The apple and grapes in the basket further symbolize humanity's fall from grace and redemption by way of the Eucharist.

Recalling the image of Christ as the Good Shepherd, the wreathed shepherd to the right, framed by a rustic shelter and guarding his flock, echoes the holy figures' postures and tender caresses as he fondly strokes the head of a black

animal, probably his faithful sheepdog. With his right hand and right foot he indicates a stone and a wine cask, emblems of Christ as the foundation stone of the Church and the wine of the Eucharist. The shepherd appears to be a portrait of the painting's probable patron, Federico Gonzaga (1500–1540), the duke of Mantua, suggesting that the duke, like Christ, guarded his subjects and assisted their salvation with his just rule.

Along with its abundant symbols, Titian created a work of exceptional vitality and harmony, through the exchange of glances; the anatomical torsion of the figures leaning, twisting, and splaying their limbs in responsive postures; the dynamic counterbalancing of the foreground figures and the background landscape; and the bold interaction of hues and drapery patterns.

VERONESE'S *VIRGIN AND CHILD WITH SS. BARBARA, JOHN THE BAPTIST, AND JOSEPH*

Inspired by Titian's asymmetrical, diagonally organized compositions, Paolo Veronese designed his *Virgin and Child with SS. Barbara, John the Baptist, and Joseph* (fig. 176) along a diagonal defined by the sleeping Christ child, framed by two stabilizing background columns. As the Virgin gazes tenderly and introspectively down at the infant John, Joseph bends down, leans forward, and lightly grasps John's bare shoulder to assist him to kiss Christ's foot, a moving act of *amor dei*. Barbara too leans forward and reaches toward John, as if cautioning him not to awaken Jesus, who unselfconsciously grips his genitals as a sign of his humanity. The child's sleep, shadowed body, and white, shroudlike bedding and John's reed cross all signal Christ's coming redemptive sacrifice.

The Virgin's gesture of covering a breast—with which she has presumably just nurtured her son—evokes the Church's nurturing of the faithful through the Eucharistic sacrament, a reenactment of Christ's redemptive self-sacrifice. As the baptizer of Christ, John recalls the sacrament of baptism, and his hair shirt, emblematic of his hermetic life in the desert, the sacrament of penance.

St. Barbara—dressed in an elegant gold-striped silken gown—holds a palm of martyrdom in her left hand, displays a ring on her right hand, and wears a laurel crown and a string of pearls in her blond hair, which flows like spun gold over her shoulders. In short, she is adorned as a young bride, the bride of Christ, an honor she earned with her pious devotion and ultimate sacrifice at

176. Paolo Veronese, *Virgin and Child with SS. Barbara, John the Baptist, and Joseph,* c. 1564, oil on canvas, 2 ft. 9⅞ in. × 4 ft. (86 × 122 cm), Galleria degli Uffizi, Florence.

177. Titian, *Virgin and Child,* c. 1570, oil on canvas, 2 ft. 5¾ in. × 2 ft. ⅞ in. (76 × 63 cm), National Gallery, London.

the hands of her pagan father, as the *Golden Legend* recounts. The splendid costumes and stunning beauty of both Barbara and the Virgin, typical of Veronese's work generally, transmute the entire painting into a noble vision of celestial grace.

TITIAN'S LONDON *VIRGIN AND CHILD*

In his late London *Virgin and Child* (fig. 177), executed shortly before his death, Titian returned to the Madonna of Humility type that offered a pyramidal composition of utter clarity and stability. Although the painting is small and the Virgin young, she appears to be a massive figure encircling her son with both arms, containing him completely and lovingly within her silhouette. She leans forward—an action that the diagonally arranged background drapery underlines—to lift Jesus onto her knee, thus enabling him to nurse. Simultaneously Christ spirals around with splayed legs to eagerly embrace her bared

breast with both hands, his cheek flushed. Together they create a dynamic and poignant picture of reciprocal love.

Yet the nocturnal light and dark tonalities and the Virgin's sad, downcast eyes express the tragedy of Christ's coming sacrifice. In addition, the loose brushwork, rendering form as spots of light and color, typical of Titian's late work, tends to heighten the pathos by dematerializing or spiritualizing the Virgin and Child. Titian's late style also expresses the artist's frailty and approaching death, as his dimmed eyesight and trembling hands compelled him to simplify form, blur outlines, and generalize detail. Yet the imaginative power achieved through a lifetime of experience has allowed him to create with limited means a monumental image of youthful nurture and affection, while its very creation—a process of painterly oscillation between the description and the dissolution of form, between solid substance and immaterial color and light—serves as a metaphor for the work's content: through the agency of devotion and faith, earthly sacrifice offers spiritual renewal.

NARRATIVE DEVOTIONAL PAINTING

GIORGIONE'S *THREE PHILOSOPHERS (THREE MAGI)*

In 1525 Marcantonio Michiel located both Giovanni Bellini's *St. Francis in the Desert* (fig. 82) and Giorgione's *Three Philosophers (Three Magi)* in the palace of Taddeo Contarini. He described the latter (fig. 178) as an "oil on canvas of three philosophers in a landscape, one standing and one seated who contemplate the sun's rays with a marvelously imitated rock" (trans. Paolo Mussi, p. 102). The painting appears to have been based on the fifth-century commentary on the Gospel of St. Matthew called the *Opus imperfectum in Mattheum* (Incomplete commentary on Matthew; 1st printed ed., Cologne, 1487; 2nd ed., Venice, 1503). This treatise understands the Magi as astronomers and philosophers who watched from Mount Victory for a sign of the promised Messiah, which eventually materialized in the Star of Bethlehem. The anonymous author also wrote that Mount Victory had a cave and a pool for purifying baths among choice trees—much like Giorgione's cave amid trees with a stream.

There has been much debate and little agreement about whether or not Giorgione associated the figures with specific ancient astronomers, philosophers, or theologians and if so, which ones. But their attributes at least suggest the nature of their search for a savior. The young, seated magus, holding a compass and a set square, appears to seek divinity primarily through the logical perfection of mathematics and geometry. He stares into the cave's darkness at the nearly invisible fig leaves, barely glimpsing these signs of humanity's fall from grace, which God punished with a sentence of death—indicated by the barren ground on which he sits and the dead trees behind him. Yet his costume of

178. Giorgione, *Three Philosophers (Three Magi)*, c. 1507–8, oil on canvas, 3 ft. 11⅝ in. × 4 ft. 7½ in. (121 × 141 cm), Gemäldegalerie, Kunsthistorisches Museum, Vienna.

white and green suggests his faith and hope in the prophecies of the coming of the Messiah, while his youth, the purifying stream, and the ivy growing from the top of the cave all evince ultimate salvation.

The magus to the far right, wise with age, appears to search for the Messiah through astronomy, as shown by his compass and his slate, inscribed with the word *celus* (heaven) and diagrams of the earth, a crescent moon, and the sun, the last marked 2, 3, 4, 5, 6, and 7, totaling twenty-seven—the number signifying cosmic harmony, as it contains all the whole numbers that make up the harmonic ratios. The sun, however, has also been plausibly identified as a diagram of a spoked nocturnal, an instrument used to find local time at night by sighting on the North Star and one or more other stars. In either case, the emblems on the tablet establish the magus as an astronomer, and his gold drapery suggests that he is about to sight the Star of Bethlehem, which will bathe the world with divine illumination like a sun, while the moon evokes the Church, basking in the radiance of Christ, and the green trees behind the astronomer imply the promise of regeneration.

The central, middle-aged magus, with half the trees behind him alive and the other half dead, mediates between youth and age, life and death, and earth and heaven. His thumb hooked in his knotted belt emphasizes his mediating role, for the knot was the sign for classical and Renaissance philosophers of man as the knot that binds the universe (*nodus et copula mundi*). Finally, the colors of his costume evoke the means by which heaven and earth are bound: red for *amor proximi,* sky blue for *amor dei.*

Giorgione's compositional structure consists of two interlocking triangular segments. The dark, upper segment, with the cave, is associated with disobedience, expulsion, and death with only a hint of salvation. The lower, light-filled triangular segment builds in a crescendo from rocky barrenness to leafy regeneration, from the colors of hope (green) to faith (white) to charity (red) to divine enlightenment (gold).

In the center of the painting, where the diagonals cross, the sun is setting in the west, suggesting coming darkness and death, here emphasized by the distant mill—a traditional symbol of Christ's sacrifice. But another source of light, from the upper left, outside the painting, has begun to illuminate the cave, suggesting the dawn of a new day that will announce the birth of a messiah who has come to dispel the darkness of ignorance and redeem humanity.

With the subtle intelligence of a great magus, Giorgione orchestrated the material that must have been in part given to him and created a work demanding calculation and discovery for its understanding, a process analogous to the Magi's search for a savior.

Giorgione's *Three Philosophers* and Bellini's *St. Francis in the Desert* not only both hung in the Contarini palace but are also within a few centimeters of being the same size. Both represent caves with rocky terrain on one side, are composed with crossing diagonals, have a mystical light descending from the upper left, and are filled with erudite symbols requiring contemplation and knowledge—two early conversation pieces, in short, appealing to the sophisticated tastes of educated humanist aristocrats such as the Contarini. It thus appears likely that Taddeo Contarini specifically commissioned Giorgione to paint a pendant for Bellini's painting. If so, when displayed side by side these magnificent paintings would have dramatically illustrated the difference between early and High Renaissance styles, the latter being more imaginative than textual and more allusive than explicit and characterized by forms of greater breadth and power and colors of greater depth and resonance.

TITIAN'S *ECCE HOMO*

Compared to Giorgione's cerebral *Three Philosophers* (fig. 178), Titian's large 1543 *Ecce Homo* (based on Luke 23:13–22; John 19:13–15) is a significantly more theatrical and classicistic work typical of mid-sixteenth-century narrative painting (fig. 179). The composition recalls Titian's even larger *Presentation of the Virgin in the Temple* (fig. 147), executed about a decade earlier. In both, the narrative unfolds laterally across the surface, the figures are placed close to the foreground, and a highlighted girl or young woman ascends a massive stairway. But in the *Ecce Homo* Titian has employed a stronger chiaroscuro, a deeper and more resonant color, and a more classicizing architecture, which he radically truncated to focus more tightly on the figures, depicted in stronger states of bodily torsion and with more energetic gestures.

Pontius Pilate (r. 26–36 AD), the Roman governor of Judaea, stands at the top of the stairs in classical Roman military costume in the guise of Pietro Aretino (cf. fig. 205). Titian no doubt included his friend and publicist because of Aretino's sympathetic portrayal of Pilate in his 1535 *I quattro libri de la humanità di Christo* (Four books on the humanity of Christ), dedicated to the Hapsburgs, as a man who tried to tell the truth about Christ's innocence, just as Aretino fancied himself a truth teller. Titian suggested Pilate's majestic authority with the massive rusticated *praetorium* (judgment hall) behind him,

179. Titian, *Ecce Homo,* signed and dated 1543, oil on canvas, 7 ft. 11¼ in. × 11 ft. 10⅛ in. (242 × 361 cm), Gemäldegalerie, Kunsthistorisches Museum, Vienna.

which the artist modeled on Jacopo Sansovino's 1536 rusticated Mint to also suggest the stability and prosperity of Venice. Gesturing toward Christ, Pilate appears to address the Jews below in the words recorded by John (19:4), "Behold the Man [*Ecce homo*], I bring him forth unto you, that you may know that I find no case against him." The four pairs of raised arms and the halberd and pike piercing the sky imply the crowd's angry response: "Crucify him, crucify him" (John 19:6). Since the cloth leggings and elaborate headgear of the soldier pushing Christ from behind closely resemble the military dress of a Turkish Janissary, Titian no doubt intended to express that the first-century persecution of Christ by the Jews was analogous to the sixteenth-century persecution of Christians by the Turks.

The innocent but muscular Savior bows his head, bleeding from his scourging by the Roman soldiers, who mocked him as a false king by adorning him with a crown of thorns, a pseudoregal purple robe, and a reed scepter. Titian intensified the drama by contrasting the humility of Christ with the pomposity of the Jewish high priest Caiaphas—the bald and pudgy figure standing to the right decked out in a scarlet toga with an ermine collar—and by depicting a look of horror on the crouching boy at the lower left, his dog symbolizing faith in Christ. Even the soldier leaning on his shield next to the youth appears to recoil from the harsh demands of the mob. Finally, Titian staged the drama to read from right to left, against the Western norm, as if the event unfolds against nature.

The painting was commissioned by Titian's close friend Giovanni d'Anna (d. 1567), a Flemish cloth merchant living in Venice, which accounts for the choice of its subject matter—far more popular in northern Europe than in Venice. D'Anna had moved to Venice in 1537 with his wealthy wool merchant father, Martino d'Anna (1478–1556); his mother, Carla von Ghent; and his brother, Daniele (d. 1579). Shortly after their arrival, Martino purchased from Ludovico Talenti his recently completed palace on the Grand Canal at S. Benedetto (fig. 6, no. 46), an early case of a foreign merchant taking advantage of the increasing exodus of the Venetian patriciate to the terraferma to establish a permanent residence in Venice in a prime location. Titian's *Ecce Home* hung in the *portego* of this palace. Martino and his descendants had been ennobled in 1529 by Ferdinand I, the Hapsburg king of Bohemia and the brother of Emperor Charles V, explaining the imperial double-headed eagle on the shield of the recoiling soldier in the painting as well as Titian's signature ("Titian, an imperial knight, made this"), which recalls his ennoblement by the Hapsburgs in 1535. Due to Martino's knighthood, wealth, and commercial importance for Venice, he and his family were awarded Venetian citizenship *de gratia* (free from the usual long residency and taxation requirements) in 1545, only eight years after they had settled in the city.

To the extreme right of the *Ecce Homo* Titian depicted mounted on horseback, dressed in contemporary armor, and pointing toward Christ the marquis Alfonso d'Avalos del Vasto (1502–46; cf. fig. 217)—one of Charles V's most important military commanders, his governor of Milan, and his ambassador to Venice. The mounted Turk with a white turban beside the marquis is a portrait of Sultan Suleiman the Magnificent, whom the marquis defeated in Hungary in 1532 and at Tunis in 1535. His presence in the painting as a captive implies that just as Christ ultimately triumphed over his tormentors, so too Christians of the Holy Roman Empire would eventually vanquish the Turks.

The bearded man holding a pilgrim's staff just behind Caiaphas has been convincingly identified as a portrait of Giovanni d'Anna, while behind him his bearded brother Daniele raises a Roman imperial banner that reads SPQR (the Latin abbreviation for "Senate and People of Rome") as the patron's clean-shaven son Paolo (1533–91), by his first wife, Jerolima Cordes (d. 1534), looks on. A young spotlighted woman dressed in white, lovingly embracing a young child, like a personification of Charity, and ascending the stairs barefoot, functions as the design's fulcrum, mediating between the contemporary portraits on the right and the biblical narrative on the left. It has been suggested that these two figures are portraits of Giovanni d'Anna's second wife, Maria Lucadelli, and their daughter Silvia. While there are no known contemporary portraits to support these identifications, Titian's representation of the sun emerging from the clouds directly above the young woman to bathe the scene in vibrant and dappled chiaroscuro certainly evokes Ecclesiasticus 24:6–7, the text that prefigured the Incarnation, suggesting that at a symbolic level the young woman was intended as a stand-in for the Virgin, the miraculous preordained founding of Venice on the Feast of the Annunciation, and the final triumph of the Church.

The references in the painting to the community of nonnative residents (Aretino from Arezzo, Sansovino from Florence and Rome, Titian from Cadore, the d'Anna family from Flanders) stand as visual testimony to the vibrant diversity and internationality of Venetian society and culture and the links of friendship, patronage, and common interests that bound this community together. In addition, the vivid representation in the *Ecce Homo* of Venice as a divinely favored, ever victorious defender of the Christian faith indicates that this community fully embraced the city's ideology, as a means of integrating itself with Venetian patrician society. Their exclusion from the elite ruling class, however, freed these nonnative Venetians somewhat from the established patrician norms of collective identity, moderation, and equality and allowed them to celebrate themselves in portraits, coats of arms, and signatures as Christian pilgrims, knights of the Holy Roman Empire defending the faith, truth-telling authors, and consummate artists and architects.

VERONESE'S *AGONY IN THE GARDEN*

The Venetian citizen and ducal secretary Simone Lando commissioned Paolo Veronese to paint an *Agony in the Garden* (based on Matthew 26:36–46; Mark 14:32–42; Luke 22:39–46) for his palace (fig. 180). In his last will and testament of March 1584, however, Lando donated the painting and several others from his palace to the Church of S. Maria Maggiore, the same one for which he had commissioned Veronese to paint an *Assumption* for the high altar (now in the Gallerie dell'Accademia) and in which he was buried. Such a transfer of a painting from a domestic to an ecclesiastical context was rare but serves to highlight its devotional function.

Immediately after the Last Supper, where he had announced his betrayer, Christ went with Peter, James, and John to Gethsemane to pray and prepare

180. Paolo Veronese, *Agony in the Garden,* c. 1580, oil on canvas, 3 ft. 6½ in. × 5 ft. 10⅞ in. (108 × 180 cm), Pinacoteca di Brera, Milan.

for his death. He commanded the apostles also to pray, "that ye not enter into temptation" (Matthew 26:41), but they soon fell asleep. Christ prayed, "My Father, let this chalice pass from me" (Matthew 26:29), but also vowed to do God's will. In other words, his prayer in the garden represented the agony between his human nature, which feared death, and his divine nature, which embraced it.

In traditional representations of the subject, an angel offers a chalice to the kneeling Christ to emphasize the episode's sacramental significance. But here Veronese uniquely depicted Christ fainting from fear and held upright by a heavenward-looking angel. The artist thus dramatized more powerfully than

had previous representations the struggle between death and rejuvenation and quite literally illustrated Luke 22:43: "There appeared to him an angel from heaven, strengthening him."

Veronese enhanced the mood of Christ's dreadful loneliness with the ruined architecture, nocturnal light, and apostles' sleep. But he also evoked Christ's eventual victory over death through the shaft of divine radiance illuminating him, the fragmentary triumphal arch in the background, and the verdant landscape. He further intensified the drama with a dynamic V-shaped, counterbalanced composition that constructs a visual contrast between light and dark, spirit and matter.

SECULAR PAINTING

Paintings with secular subject matter created for domestic settings were based mostly on classical history and myths but might nevertheless have religious significance. These paintings adorned the *alberghi, porteghi,* and especially studies of Venetian palaces.

The study—designed to house manuscripts, printed books, paintings, and collections of precious objects, including carved gems, coins, medals, vessels, and statuettes both ancient and modern—had become a common feature of Italian aristocratic palaces by the late fifteenth and early sixteenth centuries. Carpaccio's *St. Augustine's Vision of St. Jerome* (fig. 71) illustrates a particularly sumptuous and idealized example. The study served as a place of refuge for reading and contemplation, where the master of the house could cultivate his mind and put on display for friends, family, and descendants his erudition, taste, and wealth. As the Venetian publisher Paolo Manuzio (1512–74) phrased it in a letter of 1552, Andrea Loredan's study in his palace by Mauro Codussi (fig. 168) would "bear witness" to Loredan's "fine mind ... and very noble thoughts in future centuries." And the wealthy nobleman Gabriele Vendramin (1484–1552) in his 1548 will requested that his collections of books, paintings, and ancient artifacts in his study be kept intact for the pleasure of future virtuous scholars "most of all because [these items] have brought a little peace and quiet to my soul during the many labours of mind and body that I have endured in conducting the family [soap] business" (trans. J. Fletcher, in D. Chambers, B. Pullan, and Fletcher, p. 429; see also A. Ravà, p. 156).

GIORGIONE'S *TEMPESTA*

In 1530 Marcantonio Michiel recorded that Giorgione's *Tempesta* (fig. 181) was displayed in Gabriele Vendramin's study. He described it as "a small landscape on canvas with a storm [*tempesta*] and a gypsy and a soldier by the hand of Giorgione of Castelfranco" (trans. Paolo Mussi, p. 123). And indeed the man to the left wears slashed pants with a codpiece similar to those worn by many Renaissance soldiers. A 1569 inventory of the Vendramin palace, however, described the painting as representing "a gypsy and a shepherd in a small landscape with a bridge" (A. Ravà, p. 177). Since the man holds no weapon, only a large staff, he might be a shepherd, as the inventory states. But his youth, hairstyle, and parti-colored hose also suggest that he might be a member of one of the twenty-eight Venetian Companies of the Sock, those associations of unmarried noble Venetian youths organized to perform sacred dramas on major religious feast days. If Vendramin, a lifelong bachelor, commissioned the *Tempesta,* he would have been in his early twenties at the time and presumably a member of one of these organizations. The youth, then, might make a personal reference to Vendramin, although it remains possible that the nobleman acquired the *Tempesta* from some other, unknown patron.

Lacking a clear subject, this enigmatic painting has provoked well over a hundred different interpretations. One theory holds that it represents the Old Testament story of Adam and Eve, after their fall from grace and expul-

181. Giorgione, *Tempesta,* c. 1503–8, tempera and oil on canvas, 2 ft. 8¼ in. × 2 ft. 4¾ in. (82 × 73 cm), Gallerie dell'Accademia.

mans to death, which the artist enhanced with the broken columns and ruins, the dry shrub just above the snake hole, and the barren patch of ground at the lower right. This interpretation is not entirely convincing, however, for previous scenes of the post-Eden world generally depicted both brothers, Cain and Abel, Adam holding a hoe, and Eve with a spindle—all in a harsh landscape. In addition, Eve was rarely shown nursing.

A New Testament interpretation notes that the Virgin Mary, the second Eve, was frequently depicted nursing and often shown seated on the ground (*humus*) as a sign of her humility (*humilitas*), with the ground sometimes represented as part barren and part fertile, as here. In addition, the Virgin was often located in close proximity to a stream with a bridge providing a path to a background church—the stream, the bridge, and the church all emblems of Mary's mediating role between earth and heaven through the sacrament of baptism. If this woman were the Virgin, then the thunderbolt would represent the descent of the Holy Spirit; the nursing child, Jesus; and the man, one of the shepherds to whom Christ was first revealed (Luke 2:8–18). But this interpretation is also problematic, for the Virgin was never represented nude and the man might not be a shepherd.

Shifting from a biblical to an allegorical reading, the nursing woman could well represent Charity. *Amor proximi,* however, was generally represented with two or more children. If the man were a soldier, he could be an allegory of Fortitude, often depicted with a broken column as an attribute. However, Fortitude was nearly always personified by a woman, and her attribute was generally a single, not a double, column. Finally, lightning could sometimes if rarely represent Fortune.

The resemblance of the nude woman to images of a crouching Venus with Cupid has led to classical interpretations. As a goddess of fertility, Venus would appropriately sit in a verdant landscape. Furthermore, X-rays show that Giorgione originally had the nude woman seated near the lower left with her feet dangling in the stream, which would have more clearly indicated that he intended her to represent Venus as nature's Source. This might account for the identification of the woman as a gypsy in both Michiel's description and the Vendramin palace's inventory, for the word *gypsy* could connote a primitive woman living close to nature. If Giorgione did intend the nude woman to be Venus or the Source, then he might have wished the thunderbolt, sky, landscape, and stream to symbolize the four elements of fire, air, earth, and water. If the man is a soldier, then he might be Venus's lover Mars. However, there are

sion from the Garden of Eden. If so, Adam holds a staff as an emblem of the work he must now perform, while Eve nurses Cain, the future fratricide, her shame covered by a bush. A snake, symbolic of Satan, slithers into a hole at the lower right near the bank of the stream as a sign of Adam and Eve's disobedience and guilt (although the "snake" has also been interpreted as a root). In this reading, the lightning bolt signifies God's wrath condemning the first hu-

no classical images of Venus nursing Cupid, and the man does not appear sufficiently bellicose to be Mars.

Recently R. Stefaniak has offered another classical interpretation, suggesting that the painting illustrates the passage in Plato's *Symposium* (203–4) where Socrates (469–399 BC) describes the birth of Eros as the seer Diotima recounted it to him:

On the day that Aphrodite [Venus] was born, the gods were feasting, among them Poros [Wealth] the son of Metis [Invention]; and after dinner, seeing that a party was in progress, Poenia [Poverty] came to beg and stood at the door. Now Poros was drunk with nectar—wine, I may say, had not yet been discovered—and went out into the garden of Zeus, and was overcome by sleep. So Poenia, thinking to alleviate her wretched condition by bearing a child to Poros, lay with him and conceived Eros [Love]. Since Eros was begotten on Aphrodite's birthday, and since he has also an innate passion for the beautiful, and so for the beauty of Aphrodite herself, he became her follower and servant.

If the painting is based on this myth of the birth of Platonic love—the love of material beauty that elevates the soul to a love of divinity—then the elegantly dressed male would represent Wealth, the woman Poverty, and the child Love, while the lightning would indicate the setting as the garden of Zeus. This fable would have been congenial to Venetians, since it would have recalled the birth of Venice on Venus's day (*venerdì*, or Friday), on the day of the Annunciation (March 25), and its foundation on divine law and its dedication to the love of God.

Political and economic readings of the painting suggest that a woman who evokes without clearly representing the Virgin, Venus, and Charity might be understood as a personification of Venice. Certainly the domed church and chimney pots in the background represent familiar Venetian motifs, and Giorgione depicted in red a barely visible winged lion of St. Mark on the tower in the central background. In addition, the walled town looks much like Montagnana (fig. 8), southwest of Padua, which Giorgione recorded in a red chalk drawing now in Rotterdam (Museum Boijmans Van Beuningen). If so, the woman might embody the Venetian terraferma, poor and undeveloped like Poenia but made productive and prosperous by Poros. Poros as the father of Eros might also have evoked the belief of the Venetian nobility that their development of the terraferma manifested their love of and loyalty to the sacred Ve-

netian state. The battlements and lightning might conjure up the contest over Venetian control of the terraferma by the League of Cambrai, formed in 1508, and its infliction of a disastrous defeat on Venice at the battle of Agnadello in 1509—if the painting dates this late, about which there is much disagreement. This political reading might be confirmed by the barely visible four-wheeled cart depicted above the gateway at the end of the bridge, an emblem of the Paduan Carrara family, enemies of Venice in the fourteenth and early fifteenth centuries. Furthermore, since the Vendramin family possessed agricultural estates around Padua, Gabriele Vendramin would have been intimately acquainted with the political and economic issues of the Venetian terraferma.

Whomever Giorgione intended—Eve, Mary, Venus, Poverty, Charity, Venice, Nature, the Source, a gypsy, or someone else—he without question fashioned an unambiguous image of fertility by means of a nursing woman seated in a lush landscape. He heightened the sense of her fruitfulness through the vitality of her movements. She leans forward, turns her torso, and lifts her right leg to embrace and shelter the child and to bring her full left breast to the infant's lips. Giorgione also created an erotic figure with beauty, youth, and nudity—the last enhanced by the drapery, grass, hair, and baby flesh that lightly brush her skin. In addition, her splayed legs expose her most intimate parts to the man's gaze, while the shrub indicates more than conceals them. Finally, in a culture that trained women to keep their eyes modestly lowered, she brazenly and erotically gazes out at the painting's viewers.

The woman's eroticism and piercing gaze suggest a literary interpretation related to Petrarchan love poetry, in which the lover's gaze signals male sexual desire. As Petrarch (1304–74) wrote in *Rime sparse* 133, "Love has set me up like a target for arrows. . . . From your eyes the mortal blow came forth. . . . With all these weapons Love pierces me, dazzles me, and melts me" (trans. R. Durling, p. 270). Pietro Bembo, the most successful practitioner of Petrarchan love poetry in contemporary Venice, published his dialogue on love, *Gli Asolani* (Venice, 1505), very close in time to the painting of the *Tempesta*. In Petrarchan love poetry, it was important that the male lover's longing remain unfulfilled, for desire was a metaphor for poetic inspiration, and sexual tension equivalent to creative energy. Giorgione appears to have visualized the man's sexual desire in his gaze, codpiece, and shaft, and his unrequited love in the stream separating the "lovers." Love poetry commonly expressed the turbulent emotions of a frustrated lover with a storm, here evoked by the lightning in the hushed and humid landscape at the instant before the thunderclap and heightened by

a foreground patch of barren ground with dead vegetation and a background with forbidding battlements. A Petrarchan interpretation is problematic, however, for a lover with a child was foreign to the genre.

The *Tempesta* has also been interpreted as making reference to the *Hypnerotomachia Poliphili* (*Poliphilo's Dream of Love's Strife*, Venice, 1499) by the Dominican priest Francesco Colonna (1433–1527). Indeed, Colonna describes a relief decorating the portal of the Temple of Love that shows the nude Venus holding her infant Cupid, who is being taught by Mercury. Colonna goes on to describe the ruined Polyandrion Temple, writing that its broken walls and columns symbolize the torments of love, the major theme of the entire romance. Again, while suggestive, these two episodes are so minor in Colonna's book that they seem unlikely sources for the *Tempesta*.

Yet it does appear possible that the *Tempesta* has a different literary source— *Arcadia* (Venice, 1502) by Jacopo Sannazaro (1458–1530), who revived classical pastoral poetry evoking a lost golden age of rustic simplicity and abundance. In *Arcadia* an earth goddess calms the storms of the lover's chaotic emotions, just as Giorgione's nude woman might be imagined doing for her male companion. In addition, this eclectic pastoral poem alludes to the social, political, and cultural anxieties of contemporary urban life through veiled allegorical allusions, as the *Tempesta* apparently does.

Whomever Giorgione intended the virile young man to represent—soldier, shepherd, noble thespian, Adam, Fortitude, Mars, Wealth, Petrarchan lover, or someone else—this figure displays the most sophisticated handling of paint in Venice to date, its technique characterized by vibrant color, thick impasto, and spontaneous brushwork. More than in any previous Venetian painting, the artist reveals by this technique the physical process of applying earthy pigments to coarse canvas. Moreover, the man closely resembles Giorgione's self-portrait (fig. 199), and his gaze—at once direct and dreamy, lucid and poetic—suggests the artist's analytical yet creative mind. If this is a self-portrait, the man's gaze would also recall the principal goal of Renaissance art—the expression of surpassing beauty—for in Renaissance art theory a woman drawn from nature but perfected by the artist's imagination embodied the pinnacle of artistic achievement. This idea derived from a classical topos recorded in Pliny's *Natural History* (35.36) in which the painter Zeuxis employed five beautiful Crotonian maidens, noted the best features of each, and then recombined them in his creative mind to paint an image of a transcendent Helen of Troy, considered the most beautiful woman of the classical world.

But Giorgione did Zeuxis one better, by creating for the first time in Renaissance art a convincing image of the most fleeting phenomenon in nature, a lightning bolt, emphasized by the heron, a herald of tempests, on the wooden roof of the tower with a balcony. Here he emulated Apelles (fourth century BC), who Pliny records had the rare ability to paint "bolts of lightning" (35.96), and with great virtuosity captured an instantaneous moment for contemplation over time. Just as a storm violently commingles the four elements, so too does it provoke multiple emotions, from terror to exhilaration, and a wide range of visual images, from destruction and death—accompanied by wind, rain, thunder, floods, and darkness—to refreshment and regeneration. Giorgione, in short, has created an evocative, multivalent painting resonating with biblical, classical, allegorical, cosmological, mythological, political, and poetic traditions and circumstances, both reflecting and constructing Gabriele Vendramin's interior life as he read and reflected in his study-retreat. In a famous simile in *Ars poetica* (361) Horace (65–8 BC) wrote, "As is poetry so too is painting" ("ut pictura poesis"). According to this definition of painting, Giorgione proved in his *Tempesta* to be a poet of the highest imaginative power.

GIORGIONE AND TITIAN'S DRESDEN *VENUS*

In 1525 Marcantonio Michiel described Giorgione's life-size *Venus* (fig. 182) in the Venetian palace of Girolamo Marcello as "a canvas with a nude Venus sleeping in a landscape with Cupid" (trans. Paolo Mussi, p. 105). X-rays, in fact, have revealed a badly damaged Cupid at the feet of Venus, painted over in 1843 by a restorer. Michiel also recorded that Titian completed the painting, presumably after Giorgione died from the plague in October 1510. The farm buildings on the right, which reappear in two other early paintings by Titian, corroborate Michiel's report, and a technical examination of the painting further suggests that Titian added the foreground drapery, enlarged the outcropping against which Venus leans, and touched up the landscape.

Marcello married Morosina Pisani on October 9, 1507, raising the strong possibility that he commissioned the painting for their bridal chamber. Nearly life-size images of reclining nude women had appeared earlier in bedrooms, painted on the undersides of lids of wedding chests, but none were so classicistic or so clearly representations of Venus. And Venus mattered to the Marcello family, for, according to private lore, their lineage descended from the goddess by way of her son Aeneas and his descendants, who constituted the ancient Ro-

182. Giorgione (completed by Titian), *Venus,* c. 1508–10, oil on canvas, 3 ft. 4½ in. × 5 ft. 6⅞ in. (103 × 170 cm), Gemäldegalerie, Staatliche Kunstsammlungen, Dresden.

man clan of the Marcellii. A reclining image of Venus also recalled ancient epithalamia (marriage poems)—for example in the *Carmina minora* (25.1–10) by Claudian (c. 370–404 AD)—which often evoked the resting or sleeping Venus to celebrate marital union. Although images of the sleeping Venus with Cupid were known in antiquity, if extremely rare, this reclining Venus—cradling her head with her raised right arm in the Greco-Roman gesture of sleep—derives from another well-known classical reclining woman associated with marriage, the sleeping Ariadne, the mythical daughter of King Minos of Crete, whom her lover Theseus abandoned on the island of Naxos. While asleep, as Philostratus (third century AD) recounted in his *Imagines* (1.15), Ariadne was discovered by Bacchus, who consoled and then married her.

The sleeping Ariadne type had inspired a Latin epigram written in Rome in the 1460s by the humanist Giovanni Antonio Campano (1429–77), a biographer of Pope Pius II. In the poem, which imitated Hellenistic pastoral lyric poetry found in a collection known as the *Greek Anthology,* the sleeping nymph of a spring speaks as follows:

> Nymph of the grot, these sacred springs I keep,
> And to the murmur of these waters sleep.
> Ah, spare my slumbers, gently tread the cave,
> And drink in silence, or in silence lave.
>
> (trans. Alexander Pope [1688–1744], 1725, cited by E. MacDougall, p. 365)

By the 1480s, Renaissance scholars and antiquarians believed the widely disseminated poem to be ancient. They also thought that the fountain nymph was related to the Castalian Spring on Mount Parnassus, where Apollo and his nine Muses resided, and thus understood her as both nature's Source and the source of poetic inspiration. The poem's supposed classical authority inspired

183. *Fountain of Venus,* woodcut, from Francesco Colonna's *Hypnerotomachia Poliphili* (Venice, 1499), p. e1; reproduced in Colonna, *Hypnerotomachia Poliphili: The Strife of Love in a Dream,* trans. Joscelyn Godwin (New York: Thames and Hudson, 1999), p. 73.

ΠΑΝΤΩΝ ΤΟΚΑΔΙ

numerous Renaissance garden fountains, grottoes, and paintings—often inscribed with Campano's epigram—in which a nymph, a nude of the Ariadne type, sleeps by a stream as the embodiment of nature's fruitfulness and poetry's inspiration.

Giorgione would have known the sleeping Ariadne type from a woodcut in Colonna's *Hypnerotomachia Poliphili* representing Ariadne's discovery by a satyr in Bacchus's retinue (fig. 183). The text describes the sleeping woman as part of a fountain with hot and cold water streaming from her breasts, thus conflating Ariadne with Campano's nymph of the grotto. Colonna also fuses Ariadne with Venus, for the fountain is described as carved from marble on one side of the Temple of Venus and the woodcut illustrating it is inscribed in Greek "Parent of All," a common allusion to Venus. In addition, doves, represented in the pediment of the woodcut's frame, were sacred to Venus and pulled her celestial chariot. Similarly, Giorgione surely understood his figure asleep in nature to be

both Venus, the goddess of love, and the Source—a most appropriate commingling in celebration of a marital union, with its hopes of mutual affection and healthy offspring.

It was well known in the Renaissance from Plato's *Symposium* (180–215) that Venus had two natures, terrestrial and celestial. Ariadne also had two natures, as she was the carnal lover of Theseus and Bacchus but gained immortality when Bacchus transformed her crown into the constellation Corona Borealis. Giorgione and Titian indicated Venus's dual nature with the red and white drapery on which she reclines, symbols of passion and purity. The artists further evoked her terrestrial nature with her bed of grass and flowers, the verdant knoll echoing the gentle curves of her body, the distant mountains responding to the rise of her breasts, and the outcropping of rock mimicking her backrest of pillows. Her youthful maturity and swelling abdomen also suggest sexual potency. Beginning with Galen (129–c. 200/217 AD), most classical and postclassical medical treatises expressed the belief that a woman's orgasm was essential for conception, and they therefore generally condoned female masturbation to promote procreation. Therefore, Giorgione transformed the gesture of concealment of the classical Modest Venus to overt self-stimulation to serve as another sign of Venus's fertility. On the other hand, he and Titian emphasized her celestial nature with the grace and beauty of her figure, the broad expanse of sky, and the laurel, a sign of victory and transcendence, growing from the outcropping of rock. To the bridal couple, faced with the certainty of ultimate impotence and death, referenced by Venus's sleep and the severed tree precisely above her genitals, the painting would have offered a Neoplatonic meditation on love and desire in which marital desire served as a springboard to the contemplation of divine love for the salvation of one's soul.

The distant lagoon with the suggestion of a city on the horizon evokes Venice. As Marcello, the painting's politically active patron, who fought in the War of the League of Cambrai, would have been acutely aware, the years in which Giorgione and Titian painted the Dresden *Venus,* which included the formation of the league, the disastrous defeat at Agnadello in 1509, and its immediate aftermath, constituted one of the bleakest periods in Venetian history. Like the woman of the *Tempesta* (fig. 181), then, the *Venus* might have consciously or unconsciously symbolized La Serenissima (The most serene), as the Venetians called their city, expressing love, tranquility, and prosperity in a time of troubles.

Also like the *Tempesta,* this work might have been a meditation on painting, with Venus embodying art's highest aim—the creation of ideal beauty, based on but surpassing nature. Inspired by classical epithalamia and Campano's

184. Titian, *Sacred and Profane Love*, c. 1514–16, oil on canvas, 3 ft. 10½ in. × 9 ft. 1⅞ in. (118 × 279 cm), Galleria Borghese, Rome.

poem, thought to be ancient, Giorgione might have wanted to claim that his creative imagination equaled that of the famous poets of antiquity by demonstrating the truth of Horace's simile "ut pictura poesis" ("as is poetry so too is painting," *Ars poetica* 361), which raised the status of the painter from a practitioner of mechanical arts to one of liberal arts. Finally, drawing on two of the most famous sculptural images of antiquity for his Venus, the *Modest Venus* and the *Sleeping Ariadne,* Giorgione might have been engaging in a common Renaissance *paragone* (comparison of the arts) demonstrating the superiority of painting over sculpture.

TITIAN'S *SACRED AND PROFANE LOVE*

The coat of arms in the center of the sarcophagus of Titian's *Sacred and Profane Love* (fig. 184) belonged to the Venetian citizen Niccolò Aurelio (1453–

1535), who served as the secretary for the powerful Council of Ten until 1523, when he was appointed grand chancellor, the highest office available to a non-noble civil servant. Since the painting dates stylistically to about 1514–16 and Aurelio married the Paduan widow Laura Bagarotto on May 17, 1514, the work appears to have been commissioned for their bedroom to commemorate their nuptials. Laura had previously been married to a Paduan nobleman, Francesco Borromeo. After Venice's defeat in the battle of Agnadello in 1509, Padua revolted against it and established a short-lived independent republic. Venetian forces soon recaptured the city, and many of the Paduan nobles, including Laura's husband and her father—Bertuccio Bagarotto, who taught canon law at the University of Padua—were declared traitors and had their property and assets confiscated, including Laura's dowry. Laura and her mother were also forced to witness the hanging of their husbands in the Piazza S. Marco on December 1, 1509. As the secretary of the Council of Ten, which was charged with

state security, Aurelio had most likely prepared the orders that set these actions in motion, through which he met Laura.

The day before their marriage, the Council of Ten restored Laura's dowry of twenty-one hundred ducats and her property, jewels, and wedding gown. Five years later it dropped the charges of treason against her family and rehabilitated the Bagarotto name. Aurelio surely played a key role in promoting these decrees.

Given the marriage context and Cupid's presence in the center of Titian's painting, there can be little doubt that the two golden-haired women with nearly identical features represent the terrestrial and celestial natures of Venus described by Plato. Pliny in his *Natural History* (36.20) also recorded that the famous ancient Greek sculptor Praxiteles (fourth century BC) had carved a draped terrestrial and a nude celestial Venus, and Philostratus in his *Imagines* (1.2) described two Venuses, one draped and one nude, at Hymen's wedding feast. Thus, the traditional title, *Sacred and Profane Love,* which dates back only to the late seventeenth century, adequately characterizes the painting's subject.

Titian's terrestrial Venus is crowned with myrtle and holds roses, symbols of marital love. She wears a dress of white silk—perhaps a facsimile of Laura's marriage gown—for white, a symbol of chastity, was the traditional color of wedding dresses. In addition, her outward gaze, red sleeve, low-cut and high-belted bodice, loosened hair, splayed legs, and gold-rimmed vessel, over which she drapes her arm, all appear to signify passion and sexual availability. Her gloved hands signal high rank, but in Petrarchan love poetry, gloves also served as sexual fetishes. In Petrarch's sonnet 199, for example, the poet hopes to caress his lover's hands like her gloves do but is frustrated by the gloves' concealment of her hands' beauty.

The close juxtaposition of the silver and gold scalloped bowl to the phallic bronze spout in the painting's center evokes sexual union, especially since the spout waters a wild rose bush, sacred to Venus, the goddess of love. The grass and flowers of the foreground and the pair of rabbits in the left middle ground also symbolize love's fruitfulness. Indeed, Laura produced two children, Giulia and Antonio.

The left background, however, ascends steeply as a rider gallops toward a fortified village, a variation of the farm buildings that Titian painted in the Dresden *Venus* (fig. 182). In the right background two mounted huntsmen with dogs and a falcon pursue a rabbit. Both of these sets of details evoke strife and death. In addition, the relief on the sarcophagus depicts a man pulling a woman's hair, an unbridled horse, one figure beating another, and a couple with a

pole. Together these vignettes add an undercurrent of potential conflict and lust, cautionary notes for the bride and groom.

Silhouetted against the sky, celestial Venus sits a head higher than her terrestrial counterpart, at whom she gazes. Her demurely crossed legs, midriff band of white drapery, and frontal nudity evince her purity. Her flaming vase, held against a cosmic halo of sun-tinted clouds, and her red cape billowing skyward symbolize divine love.

Reading from left to right, then, Niccolò and Laura were encouraged to contemplate a Neoplatonic ascent from carnal to spiritual love, from *amor proximi* to *amor dei.* Between the Venuses, Cupid stirs the fructifying water, indicating that the couple's lives will partake of both. Yet a fountain fashioned from a sarcophagus, the barren patch of right foreground with a dead tree stump, the hunting scene, and the sun low on the horizon all foretell the bareness and darkness of death and admonish the bridal couple to remember their ultimate fate. The shepherd with his flock and the steeple in the right background perhaps evoke the path to salvation, through the redemptive sacrifice of the Good Shepherd and the Church.

ALFONSO I D'ESTE'S *CAMERINO*

Alfonso I d'Este (1476–1534), the duke of Ferrara, had a humanist education and was a passionate art connoisseur and collector of classical antiquities. As the Ferrara court humanist Mario Equicola (c. 1470–1525) wrote in a 1513 letter to the duke's sister, Isabella d'Este (fig. 218), the duke cared only about "commissioning pictures and seeing antiquities." However, he was also a professional soldier and an expert on the manufacture and use of field artillery who fought with the League of Cambrai against Venice and with the French forces against the Holy League. He thus embodied the two principal Renaissance virtues of rule, Arms and Letters.

To display his virtue of letters, the duke asked Equicola in 1511 to conceive a now lost program based on classical texts for paintings to decorate his *camerino* (study). Alfonso commissioned the most famous living painters of Venice, Rome, and Florence—Bellini, Raphael, and Fra Bartolomeo (1472–1517), respectively—to each execute one, indicating that he had the wealth to command the finest artists and the sophistication to appreciate their diverse styles. In 1514, two years before his death, Bellini completed his contribution, *Feast of the Gods* (fig. 185). Fra Bartolomeo and Raphael had made only drawings for their paintings by the time of their deaths, in 1517 and 1520 respectively. There-

fore, Alfonso commissioned Titian, now the greatest living Venetian artist, to create three paintings, two of which are discussed below. The entire decoration of the study was completed by 1528.

Giovanni Bellini's *Feast of the Gods*

In the *Feast of the Gods* (fig. 185) Bellini followed Equicola's program, derived from Ovid's *Fasti* (1.391–44) and Macrobius's *Saturnalia* (1.18.7–10), to represent the third annual bacchanal of nymphs and satyrs in honor of Bacchus, the god of wine. According to Ovid, the bacchanal occurred at the winter solstice, which the artist emphasized by representing on a dry branch in the foreground a halcyon (kingfisher), a bird thought to nest and procreate only during the halcyon days of the solstice; a pheasant in the tree above Priapus, a game bird hunted in the winter; and the sun low on the horizon, casting long shadows and creating the deep tonalities of December's twilight. He also depicted Bacchus as an infant, which, according to Macrobius, connoted the shortest day of the year.

Ovid also recounted that during this bacchanal, in a grassy meadow on the banks of a maple-lined stream an episode occurred that resulted in the subsequent annual sacrifice of a young ass in honor of Priapus, the virile god of marriage and fertile gardens. At night after all were drowsy with wine and "overcome with sleep," Priapus, who had "lost his heart" to the nymph Lotis,

> stole [to her] secretly and silently on tiptoe, lifted her garment, and prepared to snatch the wished-for hour. But lo, Silenus' saddle-ass, with raucous weasand braying, gave out an ill-timed roar! The nymph in terror started up, pushed off Priapus, and flying gave the alarm to the whole grove; but, ready to enter the lists of love, the god in the moonlight was laughed at by all. The author of the hubbub [the ass] paid for it with his life, and he is now the victim dear to the Hellespontine god [Priapus]. (Trans. J. G. Frazer, p. 33)

Bellini captured the text's spirit of a "joyous wassail" by representing two wine casks, Bacchus filling a pitcher from the larger cask, Jupiter and Apollo thirstily imbibing, intoxicated nymphs with "flowing locks" and "ripped robes" exposing shoulders and breasts, and a multitude of drinking vessels. He also emphasized the revelers' wine-kindled "amorous fires" verging on debauchery by framing the composition with the figures of Pan, the goat-legged god of panic and irrationality, and the lustful Priapus, intent on rape, while be-

185. Giovanni Bellini (with additions by Titian), *Feast of the Gods,* signed and dated 1514, oil on canvas, 5 ft. 7 in. × 6 ft. 2 in. (170 × 188 cm), National Gallery of Art, Washington, DC. The gods (with their attributes) from left to right: Pan (metal pitcher), Silenus (saddle ass, wine cask), infant Bacchus (grape-leaf wreath, wine cask, glass wine pitcher), Faunus (pine wreath), Mercury (winged sandals, caduceus, petasos [brimmed hat]), satyr (porcelain bowl), Jupiter (laurel wreath, drinking cup, eagle), nymph (porcelain bowl), Persephone (quince), satyr (ivy wreath, flute), Pluto (trident), two nymphs (ivy wreath, ceramic pot), Ceres (wheat wreath), Apollo (laurel wreath, drinking bowl, *lyra da braccio*), Priapus (floral crown, tumescent member, scythe in tree), the sleeping nymph Lotis. X-rays show that Titian added the mountainous landscape to the left to harmonize with his paintings for Alfonso d'Este's *camerino* (figs. 186 and 187).

tween them Pluto fondles Persephone's thigh and a nude drunken satyr, who appears to be pleasuring himself, plays a flute—an instrument believed to produce the visceral music of passion.

Ovid's text does not mention the Olympian gods, but they have been included probably either because of their relationship to Bacchus (Jupiter was his father, and Mercury assisted at his birth and conveyed the infant to the nymphs, who nursed him) or else to emphasize the winter solstice: the central couple (Persephone and Pluto) recall Persephone's rape, which resulted in the dormancy of nature during the winter due to the grief of her mother, Ceres, the goddess of the harvest, who failed to make the crops grow until Persephone was allowed to return from the underworld for six months of each year, bringing spring in her train. Bellini suggested nature's dormancy with the brown leaves on the tree above Lotis and the friezelike stasis of the composition.

Yet while the winter solstice marked the end of the old year and the death of nature, it also gave birth to the new year and the new sun, promising nature's renewal, which Bellini expressed in the luxuriant landscape, with a clear stream of life-giving water in the foreground, in Persephone's fondling of Pluto while holding a quince, commonly associated with marriage and fertility, and in Ceres's loving embrace of Apollo, the sun god, as if encouraging the sun to increase its warmth to promote the growth of new crops. Indeed, this verdant land is shown to have produced the apples and grapes heaped in front of Persephone and Pluto in a porcelain bowl. Symbolically, apples generally recall humanity's fall from grace, and grapes Christ's redemptive sacrifice, celebrated in the Eucharist, while the crystal-clear stream might suggest the rite of baptism, which cleanses the soul of the taint of original sin. In any case, Bellini appears to have emphasized the pivotal point between death and regeneration with the reciprocal postures of Lotis and Mercury, Lotis erotically displaying a breast and with legs spread yet in a deep sleep and dressed in "chaste" white, while Mercury contemplates the nymph, ready to mediate between heaven and the underworld in his dual role of messenger to the gods and guide of souls to Hades.

It has been convincingly suggested that the painting also expresses the classical and medieval medical belief—derived from Aristotelian thought and from the theory of bodily humors—that the sexual desire of men, who are "hot" and "dry," was strongest at the winter solstice (as exemplified by the enflamed Priapus), when women, who are "cold" and "moist," were least interested in coitus and procreation (as embodied by the frigid Lotis).

186. Titian, *Bacchanal of the Andrians,* signed, 1523–25, oil on canvas, 5 ft. 8⅞ in. × 6 ft. 4 in. (175 × 193 cm), Museo Nacional del Prado, Madrid.

Bellini thus created for Duke Alfonso a subtle but profound meditation on love, death, and regeneration—themes that must have been much on the mind of the eighty-four-year-old artist. The painting might also have been intended to evoke the joys and sorrows of Alfonso's second marriage, near the winter solstice (December 30, 1501), to the beautiful and learned Lucrezia Borgia (1480–1519), the daughter of Pope Alexander VI.

Titian's *Bacchanal of the Andrians*

Titian's *Bacchanal of the Andrians* (fig. 186) re-creates an ekphrasis (a rhetorical description of a work of art) from a passage in Philostratus's *Imagines* (1.25), which he could have read in Demetrius Moscus's Italian translation from the Greek made between 1503 and 1515. The narrator in the *Imagines* describes a series of most likely imaginary paintings on the walls of a Neapolitan villa, ostensibly for the education and enjoyment of a young boy. One depicts, he recounts, a "stream of wine which flows on the island of Andros and the Andrians made drunk by the river" "sent to them by Bacchus." It includes a nude river god "lying on a bed made of grapes," "branches wound about with tendrils of vines," nude Tritons "who dip up the wine" and drink, "Andrians crowned with ivy and sage" who "sing to their women and children, dance, or recline on the ground," and Bacchus "sailing to the feast bringing with him Laughter and Komos, both very cheerful gods and great experts at feasting" (trans. A. Fairbanks).

The urinating child, a well-known classical type of sculpture, embodied laughter by association with a woodcut in Colonna's 1499 *Hypnerotomachia Poliphili* (p. e7) that depicts a fountain with a seminude infant who holds his penis and, according to the text, appeared to urinate on any who approached, thereby provoking much laughter. The reclining female nude signifies Komos (Revel) by punning comically on *koma* (deep sleep).

Titian enhanced the high-spirited revelry of the text by displaying in the central foreground a joyous four-part musical canon with French lyrics—"He who drinks and drinks not again, he knows not what drinking is"—and by creating a dynamic composition. At the left, the V-shaped configuration of trees heightens the dramatic activity of four nude Tritons, drinking, transporting, dipping, and pouring wine, and the two fully dressed, ivy-crowned Andrians singing under the trees. These figures set in motion the dramatic crescendo of energy that, following the flow of light, rises diagonally from the three central reclining figures to reach a climax in the five wildly dancing Andrians, one of whom humorously ponders the philosophical question of whether his glass pitcher is half full or half empty.

In terms of Aristotelian medical beliefs about the libido and procreation, the scene represents summer, since the man and the dog in the central background of the painting allude to the myth of the origin of the Dog Star, Sirius, which at its height in the night sky marks the summer solstice, when "cold" and "moist" females experience the zenith of their sexual desire. Indeed, the two reclining Andrian women in contemporary dress, with partially exposed shoulders and breasts, hold their recorders most suggestively and are encircled by three vigorous and flushed nude Tritons, one of whom fuels the auburn-haired woman's desire by filling her wine cup, while the reclining nude Triton seductively fondles her leg. The frenzied dancing and urinating of the putto imply ecstasy and orgasmic release, which, however, abruptly terminate with the old, seemingly impotent river god and the drunken stupor of Komos, suggesting that at the summer solstice male desire is at its nadir and thus the potential for procreation minimal.

Beyond their similar themes, Titian carefully related his painting formally to Bellini's *Feast of the Gods* (fig. 185). Although his picture is far more animated, he created an analogous frieze of figures with many vessels set along the banks of a foreground stream with the narrative action reading from left to right. The Triton carrying a wine krater on his shoulders, the guinea fowl in the tree, and the unconscious Komos also echo Bellini's Pan, pheasant, and sleeping Lotis in the corresponding locations. Yet by depicting Komos close to the picture plane and painting her nude in an arched and receptive posture, Titian placed the duke in the role of Priapus, forcing him to confront more directly the paradox of *koma and komos,* or impotence and regeneration. In addition, the contrast between the river god's age and Komos's youth and beauty evokes both death and renewal. In a Christian culture where wine signified the Eucharist and the twice-born Bacchus was often symbolic of the twice-born Christ, Duke Alfonso might also have contemplated the painting as a meditation on death and resurrection.

Titian's *Worship of Venus*

In the *Worship of Venus* (fig. 187) Titian employed a thicket of trees and a deep landscape to harmonize with similar features in the *Bacchanal of the Andrians* (fig. 186) and the *Feast of the Gods* (fig. 185), which he amended, while illustrating another passage from Philostratus's *Imagines* (1.6). With exceptional fidelity to the text (here taken from the Loeb Classical Library, trans. A. Fairbanks), Titian re-created "a swarm of cupids" "flitting about" "gathering apples, golden and red," from the "ends of branches" of "straight rows of trees" where the cupids have "hung their quivers." "The baskets into which they gather the apples" are adorned with "sardonyx, emeralds, and pearls." "In the grass lie their broidered mantles of countless colors" as cupids with "dark blue wings" "enjoy eating the apples," "dancing, running about, sleeping," "throwing an apple back

187. Titian, *Worship of Venus*, c. 1518–19, oil on canvas, 5 ft. 7¾ in. × 5 ft. 8⅞ in. (172 × 175 cm), Museo Nacional del Prado, Madrid.

nus holding a seashell, emblematic of her birth from the sea and her sexuality, based on a well-known classical image of the goddess of love.

In terms of Aristotelian medical beliefs about desire and procreation, Venus marks the autumnal equinox, when the libidos of both men and women are balanced, a propitious time for coitus and procreation, as the fructifying water issuing from under Venus's shrine, the abundance of fruit, the rabbit, and the multitude of frolicking babies suggest. Indeed, Philostratus's narrator used the scene to introduce his young interlocutor to the importance of love in human affairs, the joys of friendship, and the obligation of paying homage to the heavenly gods, who "govern all mortal kind." Titian added a Christian touch by structuring the painting to emphasize the traditional Christian duality of love—*amor proximi,* enacted by the cupids on the left, and *amor dei,* represented by the nymphs rushing on the right following the flow of light as they bring offerings to Venus.

It has been persuasively suggested that Duke Alfonso decorated his *camerino* at least in part to instruct his heirs—especially his son Ercole II (1508–59), who married Renée de France (1510–74) in 1528 just as the *camerino* was completed—in the most up-to-date medical knowledge on desire and procreation, to insure their virility, their sexual health, and the continuity of the d'Este dynastic line. Indeed, the continued investiture of the d'Estes with the duchy of Ferrara, held in fief from the papacy, depended on a male heir, and after Ercole II's son Alfonso II (1533–97) proved to be sterile and died without a male heir, Pope Clement VIII (r. 1592–1605) reclaimed it in 1598.

At the opening of Philostratus's *Imagines* the narrator justifies his ekphrastic text in terms of Horace's "ut pictura poesis" (*Ars poetica* 361): "Whosoever scorns painting is unjust to truth; and he is also unjust to all the wisdom that has been bestowed upon poets—for poets and painters make equal contribution to our knowledge of the deeds and looks of heroes."

However, Equicola, the inventor of the study's program, disparaged painting in his circa 1508–15 *Istitutioni al comporre in ogni sorte di rima della lingua vulgare* (Fundamentals of composing Italian poetry):

To whatever extent painting may be worthy of praise, nonetheless it is judged to be quite inferior to poetry both in authority and dignity. Painting is more a labor of body than soul, most often performed by idiots. It is content with only one of the four mathematical disciplines [i.e., geometry] and concerned with no form or knowledge other than the imitation of nature with variously appropriate colors,

and forth," or practicing their "archery." "Cupids further away are engaged in a wrestling match," one "gripping his opponent with his legs," "choking him," and "biting his ear." Other cupids "hunt down a hare," one "hurling himself upon it" and "catching it alive as an offering most pleasing to Venus." Nearby, nymphs "have established a shrine" to Venus by an "overarching rock" and brought her gifts of "a silver mirror" and other offerings. Titian, in short, based almost every detail of his painting on the text and brilliantly captured its playful humor and reciprocal exchanges of love. He added only a statue of Ve-

lines, shadows, and perspectives. The poet [by contrast] uses all the disciplines, with figures, tropes, and meters to amaze the learned and induce admiration in the unlearned. The poet's intellect works with appropriate words to preserve the decorum of the personae. Painting perishes with time, while the fame of the good poet increases. Therefore, just as the soul is superior to the body, and just as immortality must be preferred to mortality, so too poetry exceeds painting in excellence. (Trans. A. Colantuono, 1991, p. 240; see also 1st posthumous ed., Milan, 1541, pp. 12–13)

Yet paintings of Bellini and Titian continue to delight and teach, while Equicola's work is relatively unknown. Furthermore, Bellini and Titian transformed the program they were given into original and imaginative visual poems, providing the duke with aesthetic feasts that subtly explore philosophical, medical, and theological nuances and ambiguities only implicit in their sources. Through their creative intelligence these artists transformed themselves from craftsmen into visual poets. By translating Ovid's poetic myths and Philostratus's verbal descriptions of ancient paintings into real Renaissance paintings, they also claimed a status equal to that of the greatest painters of classical antiquity, such as Zeuxis and Apelles.

TITIAN'S *VENUS OF URBINO*

In 1534 Guidobaldo II della Rovere (1514–74), the duke of Urbino, married the ten-year-old Giulia Varano. He might have commissioned the *Venus of Urbino* (fig. 188) at that time, to commemorate their betrothal, but it is documented that he bought the picture from Titian only in 1538 (R. Goffen, ed., *Titian's "Venus of Urbino,"* pp. 80, 87–88 n. 26). This would have been about the time that Giulia reached puberty, at age fourteen, when they would have consummated their marriage. Titian's painting—surely decoration for the ducal bedroom—would have celebrated this nuptial moment.

Titian closely followed the composition of the Dresden *Venus* (fig. 182) but made a number of important changes. He added to Venus's right hand a bouquet of her sacred red roses, symbols of love. He replaced Cupid with a toy spaniel, a sign of marital fidelity. He also moved Venus indoors, to the bed of a grand bridal chamber adorned with an inlaid marble floor, wall tapestries, a potted myrtle (an emblem of marital bliss), and a pair of marriage chests, from one of which two servants have removed a luxurious gown.

188. Titian, *Venus of Urbino,* c. 1534–38, oil on canvas, 3 ft. 10⅞ in. × 5 ft. 5 in. (119 × 165 cm), Galleria degli Uffizi, Florence.

Far more clearly than Giorgione's *Venus,* then, the *Venus of Urbino* paralleled its presumed function of commemorating a nuptial. Titian also made his Venus more erotic, by depicting her on rumpled sheets and with her hair unfastened and her eyes addressing the bride and groom, as if to provoke sensual love through the example of her own erotic body. In addition, the green curtain projects Venus toward the picture plane by blocking the painting's spatial recession, and the curtain's vertical edge focuses attention on her gesture of self-stimulation, believed to facilitate conception. Titian, in short, domesticated Venus, by transferring her from an idyllic pastoral setting to the court and emphasizing her carnal and procreative nature, important for the continuance of the ducal dynastic line.

By taking Giorgione's *Venus* as his exclusive model, Titian implicitly expressed the superiority of painting to sculpture. But he also addressed a related

Renaissance philosophical question: namely, what is the surest path to knowledge, touch or sight? Sculptors such as Michelangelo generally held the Aristotelian position, that touch is superior, for what we know, they argued, is entirely a direct result of our experience of the physical world, and thus tactile experience offers the best window onto the diversity and multiplicity of nature. But painters such as Leonardo da Vinci (1452–1519) held the Platonic position, that apprehending abstract form through sight and reason is the superior route to knowledge, for ideal form best expresses the perfection of divinity and the unity of creation.

One could argue that Venus's left-handed gesture and Titian's brushwork—vividly caressing as it describes the textures of fabric, flesh, and hair—prove that Titian favored Aristotle's belief in the superiority of the objective experience of the world. However, he also appears to champion the Platonic view that sight is the best path to knowledge by adding at the right an Albertian one-point perspectival projection into depth—the Renaissance sign of vision and divine perfection par excellence. The majestically appointed and geometrically prefect bedroom, then, suggests the heavenly abode of the celestial Venus, with her handmaidens, the Hours, preparing her garments as Venus Urania.

In the end, of course, Titian embraced the tactile and the visual basis of his art simultaneously by creating a dynamic counterbalanced composition that foregrounds the carnal Venus yet also expresses her spirituality with her transcendent beauty. In addition, he constructed the perspective so that the focal point of the orthogonals is at the edge of the curtain in the exact center of the painting, emphasizing Venus's tactile gesture of self-stimulation, yet with the horizon line running exactly between Venus's eyes, to suggest the celestial Venus under the rubric of sight.

TITIAN'S NAPLES *DANAË*

On September 20, 1544, Giovanni della Casa (1503–56)—a papal ambassador to Venice, a poet, and the author of the famous manual of courtly etiquette *Il Galateo,* published posthumously in 1558—wrote to Cardinal Alessandro Farnese (1520–89), a grandson of Pope Paul III, to recommended Titian as a portraitist for the Farnese family. Titian, he wrote, would agree to paint the family portraits in exchange for an annual benefice (the revenue from an ecclesiastical office) for his second son, Pomponio, who had become a priest:

189. Titian, *Danaë,* c. 1544–45, oil on canvas, 3 ft. 11¼ in. × 5 ft. 7¾ in. (120 × 172 cm), Museo e Gallerie Nazionali di Capodimonte, Naples.

Messer Titian gave me an image of Our Lord by his hand and elegantly convinced me to be his advocate. But I remind Your Most Reverend Lord of his agreement: that one should find a recompense for that archbishop, in a way that he [Pomponio] can have this benefice, which makes the summit of his [Titian's] happiness. He is ready to paint portraits of the entire Illustrious House of Your Most Reverend Lord, everyone including the cats. And if Don Giulio [Clovio (1498–1578), a noted miniaturist in Farnese's employ] sends him the sketch of the sister-in-law of Signora Camilla [a reference to Cardinal Farnese's favorite courtesan], he will enlarge it.... In addition to this he has almost finished, by commission of Your Most Reverend Lordship, a nude [the *Danaë* (fig. 189)], which would bring the devil upon Cardinal San Silvestro [the Dominican Tommaso Badia (1483–1547), noted for his austerity and piety]; for compared to this one, that which your Most Reverend Lordship saw in Pesaro in the rooms of the Lord Duke of Urbino [the

Venus of Urbino (fig. 188)] is a Theatine nun; one could stick on the head of the above-mentioned sister-in-law [on the *Danaë*], if it meant that the benefice would come. (*Titian: Prince of Painters,* exh. cat., p. 267)

Della Casa's advocacy proved effective. In 1545 Titian traveled to Rome on the invitation of Pope Paul III, carrying with him the *Danaë* that Cardinal Farnese had commissioned, no doubt as an adornment for his bedroom in the Farnese Palace. Titian stayed in the Cortile del Belvedere in the Vatican, with Giorgio Vasari serving as his guide to the city and its art.

According to classical myth (Ovid, *Metamorphoses* 4.607–13), Acrisius, the king of Argos, attempted to avoid a prophecy that his grandson would kill him by having his only daughter, Danaë, locked in a tower to prevent her from ever bearing a child. But news of her exceptional beauty reached Jupiter, who raped her in the guise of a shower of gold. The product of their union was Perseus, the famed killer of Medusa, who eventually did accidentally kill his grandfather Acrisius, with a discus.

Titian located Danaë on a bed in an imaginary classical boudoir articulated with a gigantic column whose enormous shaft extends heavenward, a symbol of Jupiter's might. On the right he added a winged Cupid, not called for by the myth, adapted from well-known copies of *Cupid Stringing His Bow*, invented by the Greek sculptor Lysippus (fourth century BC), which Titian knew from a copy in the Venetian Grimani collection. But rather than stringing his bow, Cupid has already inflamed Danaë with his arrow and is now exiting the scene as he turns back to look up at the luminous shower of gold, his glance echoing Danaë's rapturous upward gaze. The triangulated glances of Cupid and Danaë define both the fall of natural light from the upper left (marked by Danaë's torso and Cupid's wings and arms) and the fall of gold along a contrary diagonal (reinforced by the curtain, the angle of Danaë's right thigh, and Cupid's torso).

Titian derived Danaë's pose primarily from Michelangelo's sculpture *Night* (1519–34) in the Medici Chapel in S. Lorenzo in Florence. But he also critiqued Michelangelo's work by offering, in place of *Night*'s hard muscularity, soft, pliant flesh subtly modulated by color and chiaroscuro. Rather than the restless, contorted figure of *Night,* haunted by nightmares of lust and oblivion, Titian portrayed a woman experiencing pleasure, even ecstasy, communicated by her relaxed posture, contented expression, and sensuous fondling of the bed linen and apparently herself.

In the discourse of the many late medieval and Renaissance commentaries on Ovid, some commentators interpreted Danaë as a lascivious prostitute. Titian's erotic figure with a shadowed head willingly receiving the gold shower would allow an interpretation of Danaë as a figure of lust and greed. For other commentators, Danaë, secure in her locked tower, symbolized chastity, and Titian's depiction of her loosened hair and white bedsheets could suggest an available but still virgin bride. For moralizers who wished to reconcile Ovidian myths with Christianity, Danaë represented the Virgin Mary impregnated by the radiant spirit of God, and her son Perseus a Christ type. Titian's motif of the drawn curtain on the left, by long tradition a sign of divine epiphany, and Danaë's expression of ecstasy could make this reading compatible with the image. Finally, commentators with a philosophical bent interpreted the myth as describing a Neoplatonic ascent of the soul, the shower of gold an emblem of divine grace and Danaë a symbol of the soul liberated by God's love. This might be an acceptable reading, given the column's ascent to heaven, the broad expanse of sky, and the sun's position low on the horizon, perhaps evoking the beginning of a new day. Furthermore, from a Neoplatonic perspective Danaë's sublime beauty would represent the outward material expression of her inner spiritual grace.

In the 1568 edition of his *Lives of the Artists,* Vasari wrote,

One day, when Michelangelo and Vasari visited Titian at the Belvedere, they saw a painting which he had brought with him of a woman as Danaë with Jupiter in her lap, transformed into a shower of gold, and praised it greatly as was polite. After they had gone, Buonarroti, talking about Titian's work, praised him a good deal, saying he liked his coloring and style, but that it was a pity good design was not taught in Venice from the first, and that her painters did not have a better method of study. Such that if this man, said he, were aided by art and design as he is by Nature, especially in imitating from life, he would not be surpassed, having a fine wit and a most charming and vivacious style. This is very true, for without design and a study of selected ancient and modern work, skill is useless, and it is impossible by mere drawing from life to impart the grace and perfection of Nature, so that certain parts frequently lack beauty. (Trans. J. C. Bondanella and P. Bondanella, pp. 500–501)

Vasari and Michelangelo willfully overlooked Titian's references to "selected ancient and modern work"—the sculpture of Lysippus and Michelan-

gelo, superb examples of design—and chose to see only naturalism. But Titian was acutely aware of his intentions, demonstrating to the discriminating Roman elite his supreme mastery of central Italian *disegno* and Venetian *colorito,* sight and touch, imitation and invention, naturalism and idealism, painting and poetry.

TITIAN'S *DIANA AND ACTAEON*

The presence of foreign armies of occupation on Italian soil during the Italian Wars resulted in the widespread diffusion of Italian Renaissance classicizing art and culture to the rest of Europe. This provided opportunities for many Italian artists to secure lucrative commissions from the powerful European courts, often working as resident court artists or, in the case of Titian and Paolo Veronese, supplying paintings to the various Hapsburg courts from Venice.

In the late 1540s Emperor Charles V announced his plan to abdicate his titles and retire to the Hieronymite monastery of St. Yuste in Extremadura, Spain—a plan he carried out in 1556—and to invest his son Philip II with the throne of Spain. Therefore, Titian made a trip (his second) to the imperial court at Augsburg, Germany, in 1550–51 to secure a long-term contract from Philip to replace his profitable patronage from Charles. He negotiated to supply Philip with ten *poesie* (poetic mythological paintings), one per year, for two hundred scudi each, plus an additional steady income of three hundred scudi a year from Hapsburg assets in Naples and Milan. Titian conceived the *poesie* as pairs to hang flexibly in various arrangements in any one of the numerous palaces where the peripatetic monarch happened to be living. One pair of the six canvases that he eventually completed represented Diana and Actaeon (fig. 190) and Diana and Callisto (fig. 191), based on Ovid's *Metamorphoses* (3.138–253 and 2.442–53).

According to Ovid, while Actaeon was hunting in the woods with his dogs, he came upon Diana and her nymphs bathing. For violating her privacy, an enraged Diana splashed him with water, transforming him into a stag, which his own dogs ran down and devoured. For some of the late medieval and Renaissance commentators on Ovid, Actaeon was an impious and lustful voyeur who deliberately desecrated the sacred space of Diana and her nymphs and thus fully deserved his death. Indeed, the nymph reclining on the fountain made from a classical sarcophagus, evocative of death, pulls back a bright red curtain, the color of passion, apparently catching Actaeon by surprise in the act

of spying on the goddess, causing him to drop his bow and raise his hands in dismay. Titian enhanced the action of the reclining nymph and the gesture of Actaeon by means of the nymph with her back turned, who yanks up a white drapery, the color of purity.

Titian implied Actaeon's grisly fate by representing deerskins hanging from the trees, Diana's terrier yapping at him with bared teeth, and a stag's skull resting trophylike on the rusticated pier toward which he turns. However, by omitting two of the fundamental ingredients of the story always depicted previously—Diana splashing Actaeon and Actaeon turning into a stag—Titian called the protagonist's fate into question.

Several commentators on Ovid, in fact, believed Actaeon to be a blameless victim who encountered Diana by accident and thus a symbol of the Christian Everyman, who seeks salvation though faith and love. This interpretation is encouraged by Actaeon's red-lined boots and his companion spaniel—red the color of love and the dog a sign of faith—as well as the garlands and infants on the sarcophagus, suggestive of renewed life after death. In addition, the forward movement of Actaeon, indicated by his stance, the fluttering ribbon on his quiver, and his skirt's agitation, implies that he has been running forward and just this instant stopped short as he stumbled by chance upon the bathing scene. Finally, Titian leads the viewer's eye from Actaeon's outstretched hand and the edge of the red curtain to the lion-headed keystone of an arch, an emblem of the constellation Leo. According to medieval moralizations of the myth, Actaeon was transformed into a star of this zodiacal sign, thereby achieving immortality.

Some commentators on Ovid even understood Actaeon to be an innocent Christ type whose death foreshadowed the Savior's sacrifice. Titian embraced this interpretation by basing Actaeon on the famous marble *Apollo Belvedere* (Roman copy of c. 130 AD after a Greek original of c. 330 BC), which he would have seen in the Vatican's Cortile del Belvedere. In the Renaissance, Apollo was commonly understood as a prefiguration of Christ, the sun of justice. Titian also framed Actaeon with a rusticated, rib-vaulted structure evocative of a Christian chapel. A vault usually signified the heavens, as here, where it frames an expansive sky, its mosaics glow with a mystical reddish light, and the keystone of its supporting arch represents a lion, an emblem of Christ and the constellation Leo. In addition, the transparent vase on the fountain, through which light passes without change, is an age-old symbol of the Incarnation, when the Word penetrated the Virgin's womb without altering her purity, as

190. Titian, *Diana and Actaeon,* signed, 1556–59, oil on canvas, 6 ft. 2⅞ in. × 6 ft. 9½ in. (190 × 207 cm), National Gallery of Scotland, Edinburgh.

191. Titian, *Diana and Callisto,* signed, 1556–59, oil on canvas, 6 ft. 1⅝ in. × 6 ft. 8¾ in. (187 × 205 cm), National Gallery of Scotland, Edinburgh.

noted above (see Titian's S. Salvador *Annunciation, ch.* 15). In this context, the fountain's transforming yet fructifying water evinces baptism, the rite of renewed life through which the grace of Christ's redemptive sacrifice is channeled to the faithful.

As a vengeful huntress, Diana was often associated with Hecate, the cruel witch goddess, whose attributes were a mirror and a vase, both represented on the fountain. Diana also personified the waxing and waning moon—and by extension changeable Fortune—which Titian indicated with the traditional crescent in her hair and a black handmaid, the first in Venetian art, whose dress and arms also configure crescents. Titian enhanced Diana's ruthless and fickle nature with the topsy-turvy setting, almost completely lacking in stabi-

lizing verticals or horizontals, and the contrast between the nude Diana with a contemplative, even compassionate expression open to Actaeon's gaze and her clothed handmaid with an angry glare, who acts to cover the goddess with red and white drapery. By representing Diana as erotic and sexually potent in a luxuriant setting, Titian also suggested her positive character as the protector of nature, pregnant women, and childbirth.

Titian portrayed Diana and Actaeon in reciprocal postures with related gestures to indicate their interconnected natures. As she embodies cruel fate, so he brings his own downfall by transgressing the boundary between nature and divinity. As she represents chaste fertility, so he is the innocent victim. As he appears in the guise of the Apollonian Christ with sunlight flowing over his

shoulders, she—basking in his light like the moon—represents a Virgin type, the embodiment of the Church, underlined by the churchlike architecture. Titian emphasized the dual natures of both Diana and Actaeon with the juxtaposition of the stag's skull to the intensely green leaves of an overhanging branch, the green also vividly reflected in the water below, which both transmutes and cleanses.

The central nymph, seated on the fountain next to the rusticated pier, is modeled in both light and shadow. With her feet resting on a book, she leans toward Diana and looks toward Actaeon, actions echoed by the two nymphs on either side of the rusticated pier, the one behind looking at Actaeon and the one in front leaning toward the hunter as she dries Diana's leg. Titian appropriately derived the seated nymph from the well-known classical sculptural type of Venus, the goddess of love, crouching to bathe. With this citation, he suggested that mutual love between humanity and divinity was the mediating force between death and regeneration, sin and salvation.

TITIAN'S *DIANA AND CALLISTO*

The companion painting to *Diana and Actaeon* (fig. 190) illustrates the myth of Callisto (fig. 191), a nymph in the company of Diana. Raped by Jupiter in the guise of Diana, Callisto became pregnant and was expelled from Diana's company. She bore Jupiter a son, Arcas, who became a hunter, after which Juno, the jealous wife of Jupiter, transformed her into a bear. Eventually Arcas killed Callisto, and Jupiter immortalized both mother and son, Callisto as the constellation Ursa Major (Big Bear) and Arcas as Arcturus (Bear guardian), the brightest star in the constellation Boötes.

Some commentators on Ovid understood Callisto as a sensuous and lustful woman who willingly encouraged and submitted to Jupiter's advances and thus fully merited Juno's punishment. Titian encouraged this reading with Callisto's flushed cheeks and red boots and the assault of four erotic nymphs—paralleling Jupiter's lesbianlike rape—who uncover her pregnancy. On the other hand, many other commentators, as well as Ovid himself, believed Callisto, like Actaeon, to be an innocent victim of capricious and vengeful deities. Indeed, Titian represented Callisto with a pained and remorseful expression, not one of ecstasy. He also arrayed against her an overwhelming display of divine majesty. Two of the most powerful goddesses, Diana and Juno, are depicted under a makeshift baldachin of gold brocade, a sign of their sovereign authority, lording over Callisto—especially Diana, who makes an imperious gesture

of banishment. The four nymphs surrounding Diana and Juno are armed with spears, bows, quivers, and hunting dogs. At the upper left, Jupiter manifests his splendor in the form of a lightning bolt. Guilty or innocent, Callisto has no chance against this display of divine power and, also like Actaeon, will be punished and eventually killed. Titian alluded to Callisto and Actaeon's common fate by representing a stag hunt in the upper relief on the pier.

Some commentators who understood Callisto as an innocent victim allegorized Jupiter's transformation into the guise of Diana as God's descent in Christ's human form to found his Church, and Jupiter's ravishment of Callisto as Christ's infusion of the Church with divine grace. Titian encouraged this interpretation by citing a well-known classical sculptural type at the top of the pier, the boy with an urn, juxtaposed to the painting's greenest branch to indicate that the water pouring from the youth's vase symbolizes fertility, or in sacramental terms the cleansing rite of baptism, by which Christ's redemptive grace is channeled to the faithful. Furthermore, he depicted Diana fully lighted, frontally displaying her beauty without concealment as the full moon, or symbolically the chaste Church reflecting the light of Christ. Her gesture can be read as one not just of banishment but also of choosing, and both she and Juno look on with expressions more of concern than of cruelty. The dogs are quiet, the nymphs' weapons are downturned, Jupiter's lightning bolt casts a golden radiance over the scene, and Callisto looks heavenward, as if experiencing a divine revelation. Finally, one of Diana's nymphs—again in the center, mediating between the two main protagonists, and again based on the classical crouching Venus type—appears to plead Callisto's case, suggesting that love or charity constitutes the principal means of salvation.

Titian carefully composed both *Diana* paintings to function as a pair, with the *Actaeon* to the left. The landscapes and rivers of both paintings conjoin, and when paired they are framed by hanging draperies. Near the center of each composition a rusticated pier with signs of death (a stag's skull and a relief of a stag hunt) is juxtaposed to a nymph based on the crouching Venus sculptural type to express regeneration through love. Red-booted Actaeon with the nymph yanking back the curtain and red-booted Callisto with the nymph jerking up her golden robe form contrasting pairs. Indeed, the two paintings generally express their content contrapuntally. The *Actaeon* emphasizes the willed action and personal responsibility of the hunter, while in the *Callisto* the nymph is the hunted, acted on by divinity independent of her will, although each painting also suggests the opposite. In the *Actaeon* Diana appears more the unpredictable punishing goddess, in the *Callisto* more a compassion-

ate redeeming deity, although again she can be interpreted oppositely in both. This strong interdependent duality between the paintings corresponded to Counter-Reformation theology: on the one hand, humankind was utterly dependent on the mercy and grace of God for salvation, but on the other, every individual was obligated to cooperate with God's grace by willfully engaging in good works, by exercising *amor proximi* and *amor dei.*

By inscribing his signature on the *Callisto* between the relief depicting a stag hunt and the boy pouring life-giving water from his urn, Titian registered his awareness of the paradoxical dualities of life and death, sin and salvation, good works and gratuitous grace. By further demonstrating his command of classical and Gothic architecture and ancient sculpture and relief he engaged the *paragone* debate, claiming the superiority of painting. By imaginatively manipulating classical forms and mythological texts, he also created profound and original *poesie,* fulfilling Horace's dictum of "ut pictura poesis" (*Ars poetica* 361) and establishing his art as equal to the best of classical poetry.

VERONESE'S *ALEXANDER AND THE FAMILY OF DARIUS*

The cultured merchant Francesco Pisani (1514–1567) commissioned Veronese's *Alexander and the Family of Darius* (fig. 192) for his suburban palace in Montagnana, near Padua, built by Andrea Palladio between 1552 and 1555. As numerous classical sources recount, Alexander the Great (356–323 BC), the Macedonian king, defeated and put to flight Darius III (r. 336–330 BC), the Persian king, at the battle of Issus in 333 BC. Alexander and his loyal friend, bodyguard, and commander Hephaestion (356–324 BC) then paid a visit to the tent of Darius's family (transformed by Veronese into a splendid palace complex), who, according to Persian custom, had accompanied him on campaigns. The family included Darius's mother, Sisygambis (d. c. 323 BC); his exceptionally beautiful wife, Stateira (d. c. 332 BC); and his two daughters, Stateira II (d. c. 323 BC) and Drypteis (d. c. 323 BC). As the two commanders approached, Sisygambis prostrated herself in submission before the taller Hephaestion, mistaking him for Alexander. Alexander graciously responded, "He also is another Alexander," thus simultaneously excusing her blunder and paying tribute to Hephaestion as a mirror of himself. Although the captive women were completely at Alexander's mercy as spoils of war, he treated them magnanimously, preserving their wealth, dignity, and virtue. Alexander therefore exemplified the ideal Venetian husband—respectful and protective of women and children, loyal to his friends, in full control of his libido and emotions, and free

from lust, pride, and vengeance. He also embodied the ideals of Venetian governance, derived from the Platonic virtues of rule—strength, justice, prudence, and temperance.

By creating a composition that reads as a long frieze across the surface, Veronese continued the narrative style of Carpaccio (figs. 58, 61, 69, and 70) and Titian (figs. 147 and 179), although he developed the tradition further in terms of theatricality. He located the action on a narrow elevated stagelike tiled platform separated from the background by a stone balustrade. A chained monkey sits on the left end of the balustrade, looking down at the head and shoulders of a halberdier standing in the sunken forecourt of the palace complex. This soldier not only indicates the perspectival eye level of the viewer looking up at the action but also draws the viewer's eye into the forecourt, populated with more soldiers and three unbridled horses, one rearing. The forecourt features a massive obelisk, a symbol of victory, with a rusticated base decorated with bronze statues, and a wide triumphal arch articulated with paired fluted Corinthian columns and winged Victories in the spandrels, recalling Jacopo Sansovino's Loggetta (fig. 98) and thus equating Alexander's triumphs with Venice's. Indeed, at its height, the maritime empire of Venice nearly equaled that of the Macedonian king. The figures behind the balustrade on top of the triumphal arch and at the base of the obelisk, who are dressed in both Venetian and Persian garb, further conflate the past and present. Compositionally, the three arches serve to direct the viewer's eye from the left to the interaction between Darius's family and Alexander. Finally, the neutral tones of the background architecture set off the colorfully costumed figures silhouetted against it in the foreground.

The foreground is framed at the left by a columnar group of Persians: a standing halberdier in Venetian dress looking toward Darius's family, the head of a young boy, two kneeling servants in exotic Asian dress (one with a small spaniel), and a dwarf looking at but turning anxiously away from the central action while holding a frightened spaniel. Their passivity, fear, or diminutive stature—along with the unbridled horses nearby—set off by contrast the serene self-control, strength, and moderation of Alexander. On the other hand, the dynamic assembly of Macedonians to the extreme right mirrors Alexander's self-discipline, sovereign power, and loyalty. These include a bridled war-horse, the supposedly untamable Bucephalus, whom Alexander nevertheless mastered (Plutarch 33.6); three helmeted soldiers, one of whom controls Alexander's collared dog, who gazes lovingly at his master; and a young page—inspired by the soldier leaning on his shield in Titian's *Ecce Homo* (fig. 179)—crouching over Alexander's shield, which is embossed with a siren, one

192. Paolo Veronese, *Alexander and the Family of Darius*, c. 1565–67, oil on canvas, 3 ft. ⅝ in. × 6 ft. 1⅝ in. (93 × 187 cm), National Gallery, London.

of those beautiful and dangerous fishtailed women who lure sailors to ship-wreck on the rocks of their island but is here reduced to harmless decoration.

Darius's kneeling family is sumptuously adorned in contemporary Vene-tian fashion. Sisygambis is dressed in the manner of a *dogessa* (the wife of the doge), in an ermine-lined deep blue silk toga. Her quizzical expression, open mouth, and splayed fingers of her right hand communicate her confusion, yet with her left hand she points decisively to Darius's wife, Stateira, who wears a low-cut, long-sleeved embroidered gold dress and a sheer silk veil draped over her shoulders and bosom. Her two daughters are dressed nearly identically in blue and white embroidered outer dresses with plunging necklines fastened at the waist, worn over low-cut rose tunics. All three women wear veils over their

blond hair (braided with a strand of pearls and done up in a bun), pearl ear-rings, pearl chokers, and gem-studded gold necklaces with a large pendant. In other words, they are dressed as Venetian brides (cf. fig. 145). According to the narrative, the exquisite gold crown that Stateira II holds could only belong to her mother, Darius's queen. Yet on another level, the crown and the bridal out-fits that the two sisters wear allude to their marriages the next year (324 BC) at Susa, where Stateira II became Alexander's queen and Drypteis the wife of Hephaestion. Also, according to the classical sources, the standing male could only be the eunuch who pointed out Sisygambis's error of identification. How-ever, his splendid costume, monumentalization by the rusticated base of the obelisk, and important narrative and compositional role as the advocate for the

193. Paolo Veronese, *Allegory of Love,* c. 1576, oil on canvas, 6 ft. 1½ in. × 6 ft. 2¼ in. (186.6 × 188.5 cm), National Gallery, London.

194. Paolo Veronese, *Allegory of Love,* c. 1576, oil on canvas, 6 ft. 2¾ in. × 6 ft. 2¾ in. (189.9 × 189.9 cm), National Gallery, London.

family of Darius suggest that he portrays the patron, Pisani, who, although unable to sire children, was devoted to his extended family and generous to their offspring. If this is he, he must have intended the painting as a solace for his sterility and as a model of the ideal husband for his close male relatives to ensure the continuity of the Pisani lineage.

The painting's narrative culminates with Alexander, wearing a classicizing imperial-red military costume trimmed with gold and gems. With his right hand he offers the classical palm-down gesture of peace to Sisygambis to al-

leviate her misperception and fear. With his left he indicates his slightly taller friend Hephaestion, who makes a self-referential, right-handed gesture to confirm his mirroring of Alexander, an equivalence further emphasized by the two crossed halberds. Telescoping the past into the present, Hephaestion has classicizing sandals and leggings to match Alexander's but otherwise wears contemporary Renaissance armor under a russet cape.

Veronese's exceptionally intelligent coordination of architecture and narrative, his fine-tuned sense of color, and his subtle rhythmic pacing of the drama

195. Paolo Veronese, *Allegory of Love,* c. 1576, oil on canvas, 6 ft. 1¼ in. × 6 ft. 4½ in. (186.1 × 194.3 cm), National Gallery, London.

196. Paolo Veronese, *Allegory of Love,* c. 1576, oil on canvas, 6 ft. 1¾ in. × 6 ft. 1½ in. (187.4 × 186.7 cm), National Gallery, London.

as it builds to a dramatic climax create a visual spectacle outshining in theatrical brilliance all previous works in the tradition of Venetian narrative painting.

VERONESE'S *ALLEGORY OF LOVE*

The Hapsburg Rudolf II (1552–1612)—one of the greatest art collectors of the Renaissance—was educated in the Spanish court of his uncle Philip II, where he developed a passion for art and science. He was crowned the king of Hun-

gary in 1572, king of Bohemia in 1575, and Holy Roman emperor in 1576. He established his court in Prague in 1573 and—no doubt inspired by Titian's *poesie* that he had admired in Spain—appears to have commissioned Veronese to paint four classicizing canvases on the theme of love to decorate one of the rooms of the Prague Castle, where they were first documented in 1637 (see C. Gould, p. 151). Given their subject matter, an allegory of love, and oblique *dal sotto in su* perspective, they might have hung high on the walls or on the sides of a vaulted ceiling in the imperial bedroom.

In one painting (fig. 193) a strongly foreshortened, seminude, and bearded male with outstretched arms sprawls helplessly on a fragment of a classical corbeled cornice in the posture of the Hellenistic marble sculpture *Falling Gaul* in the Venetian Grimani collection. Above him in niches of the ruined architecture loom two fragmented marble sculptures—a pointy-eared satyr and a goat-legged Pan holding a syrinx. As unruly spirits of nature, Pan and the satyr embodied humanity's irrationality, even bestiality. The panpipe's shrill music was believed to incite frenzied passion, here suggested by the red cloth that drapes the man's loins. Veronese thereby implied that the fallen hero is consumed with lust and has lost his moral rectitude, symbolized by the ruins, his inelegant posture, and the presence of Anteros—Eros's brother, who embodies spiritual love—who beats him with his bow.

A bare-chested woman, perhaps the man's fiancée or wife, looks down at him with disdain as if to reject his immoderate desire. She also holds hands with another beautiful woman, who looks heavenward toward the light and shelters an ermine in her drapery. An ermine commonly symbolized chastity, for according to legend the animal would die if its white coat were soiled. As a pair, then, the women suggest a turning away from carnal to chaste love.

In a second canvas (fig. 194) the fiancée or wife of the previous painting now experiences the torments of sexual desire. She sits with her bared back to the viewer, a fig branch growing from her brick perch. Figs, especially when cut open, were ancient symbols of female genitalia. Fig leaves also signaled the fall of Adam and Eve, generally blamed on Eve's lust. In addition, Eros, the spirit of carnal love, tugs on her left leg to reveal even more clearly to the two men her vaginal splendors. Yet by contrast the winged Anteros plays a clavichord—a stringed instrument ranked high in the musical hierarchy—to deter the actors' carnal desires with his celestial music.

The woman's right hand holds that of the man on the right—the same bearded man as in the previous scene—presumably her fiancé or husband. But she is also attracted to the beauty of the youth on the left, to whom she hands a love letter inscribed "Let that one possess [her]" ("Che uno posede"), a message suggesting the turmoil of a love triangle, enhanced by the masterful manner in which Veronese has woven together the three adult figures through the arrangement of the trees.

Reflecting the contrast between Eros and Anteros, the men appear conflicted. The bearded man holds his fiancée's or wife's hand as a token of union, but his splayed legs and intense gaze at the woman's sexual charms,

fully exposed to his view, suggest his lustful desire. The youth stands looking high-mindedly to heaven but nevertheless accepts with his right hand the woman's presumed invitation of illicit sex. The painting thus recalls the classical myth of Hercules at the crossroads, where a choice must be made between virtue and vice.

In a third painting (fig. 195) the same bearded warrior—now wearing Roman armor and the cape of a supreme commander—steps onto a dais with outstretched arms, looking heavenward into the light. Tugging at the warrior's sword, Eros suggestively points with his arrow to the pudenda of the same woman in the previous two paintings, now provocatively nude and sexually available as she sprawls out asleep under a red canopy and on a mattress draped in red in a posture inspired by Giorgione's Dresden *Venus* (fig. 182) and Titian's *Danaë* (fig. 189). The open glass vessel under her buttock and the vase on the ledge above her knee symbolically underline her sexual availability. The sword, arrow, and vase all evoke a phallus.

The warrior, however, is restrained from Eros's tempting offer by an older and wiser alter ego, who grips his arm from behind. The scene of the continence of Scipio frescoed in the vault above the hero's head emphasizes his abstinence. This event was known from the *History of Rome* (26.50) by Livy (59 BC–17 AD) and *Africa* (4.375–88) by Petrarch. After the conquest of New Carthage in Spain, Scipio received a beautiful maiden as booty. When he learned that she was already engaged, he reunited her with her fiancé and gave her a dowry of gold taken from her parents' ransom. Veronese thus implied that, like Scipio, the warrior has triumphed over his baser instincts and pursues a higher love, as befits a virtuous commander.

In the last canvas (fig. 196) the torments of love have been mostly resolved through matrimony. The same bearded man and the same woman together hold an olive branch, a symbol of peace and concord. In the background the Ionic column, a blend of Doric and Corinthian, signifies resolution and harmony, and the marvelously rendered spaniel in the lower right loyalty and fidelity. The sumptuously dressed bride is being crowned with a myrtle wreath, a symbol of marital bliss, and her hair has been loosened to signify preparation for the consummation of the marriage bond.

But who is the woman who crowns the bride and wears the belt of Venus beneath her breasts? One might assume Venus, the goddess of love. But she sits on a cornucopia and a huge marble sphere, attributes of unstable Fortune, who can bring prosperity and happiness but, with a turn of the sphere, misfor-

tune and discord. Furthermore, Eros (mirroring in reverse his posture in the previous painting) tugs at the golden chain of marital union, an allusion to the possibility of disharmony and strife though carnal desire. However, lacking wings, a bow, and a quiver of arrows, the infant might not be Eros at all but instead the progeny of this marital union, who tightens rather than disrupts the golden chain of union.

Seen as a set, this series has two paintings that emphasize the immoderate desires of the woman (figs. 194 and 195) and two her chaste virtue (figs. 193 and 196). Similarly, two depict the excessive lust of the man (figs. 193 and 194) and two his uplifting restraint (figs. 195 and 196). All four, then, suggest the turmoil of love in a Neoplatonic sense. That is, beauty can stimulate desire and lead one to descend to the depths of carnality and even bestiality, or it can inspire the soul to shun the physical and ascend toward the perfection of divinity. It is remarkable that Veronese includes women in this struggle, whereas in previous paintings concerned with Neoplatonic love they merely served as the passive objects of men's desire, whether carnal or spiritual.

TITIAN'S *FLAYING OF MARSYAS*

The patron of Titian's late *poesia* the *Flaying of Marsyas* (fig. 197) is unknown, but its scale (nearly seven feet square) and its secular subject matter suggest a sovereign of a European court. According to the myth of Apollo and Marsyas—told in Ovid's *Metamorphoses* (6.382–400), Ovid's *Fasti* (6.693–710), and Philostratus's *Imagines* (2)—Minerva invented a flute to please her father, Jupiter, but threw it away in disgust when the gods laughed at her puffed cheeks as she played the instrument. The satyr Marsyas discovered it and became so proficient in playing that he dared Apollo to engage in a musical contest. When he lost, Apollo had him flayed alive for challenging an Olympian god.

In antiquity there were many depictions of the Apollo and Marsyas myth in reliefs on sarcophagi and in large-scale freestanding sculpture, which showed Marsyas as a pointy-eared, craggy-featured, grimacing satyr tied standing upright against a tree, often in profile. Apollo was shown observing the flaying done by his assistants, including a bloodthirsty Phrygian knife sharpener whom Philostratus mentions. But Titian chose to imitate a small fresco of the 1530s by Giulio Romano (c. 1499–1546) in the Palazzo del Te in Mantua depicting Marsyas as a goat-legged Pan with a panpipe, tied upside down to a tree, and Apollo personally flaying him (as he never did in classical repre-

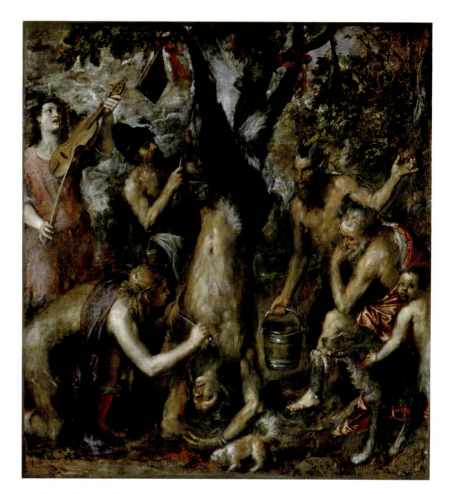

197. Titian, *Flaying of Marsyas,* signed, c. 1572–76, oil on canvas, 6 ft. 11½ in. × 6 ft. 9½ in. (212 × 207 cm), Státní Zámek, Kroměříž, Czech Republic.

sentations), aided by two assistants, one holding the god's lyre. Titian also followed Romano by including another Pan, with goat's legs, ears, and horns, who carries a bucket, and King Midas, who observes the event. The transformation of Marsyas from a satyr with a flute to a Pan with panpipes and the inclusion

of Midas indicate that both artists deliberately conflated two famous ancient musical contests: between Apollo and Marsyas and between Apollo and Pan (*Metamorphoses* 11.146–193).

Just as Titian hung deerskins from the trees in *Diana and Actaeon* (fig. 190) to evoke Actaeon's fate, so here he represented Marsyas's skin hanging at the upper right edge of the canvas, which indicates that he knew the Apollo and Marsyas story from Giovanni Bonsignori's 1377 Italian translation of the *Metamorphoses,* reprinted seven times in Venice between 1497 and 1522, for the text reads in part, "After Apollo had flayed Marsyas [this is the first time that Apollo is said to have flayed Marsyas] he cleaned the hide—or rather the skin—and hung it up high in a temple, to make an example for anyone who saw it there, so that no one, for any reason whatsoever, should put himself up against the gods" (trans. P. Fehl, 1992, pp. 130–46). The woodcut accompanying this text in the 1497 edition illustrates Apollo in the act of flaying and Marsyas's skin hanging from a temple at the upper right. Titian also followed Ovid by adding to the lower right Olympus, the goat-legged young satyr who was Marsyas's friend and pupil. No text, however, accounts for the large bloodhound or the toy spaniel at the bottom of the painting.

In contrast to the standing Marsyas with "glaring eyes, his wild and squalid hair all bristling," as described by Philostratus, or the coarse-featured, scowling satyr in profile of classical sculpture or the screaming and writhing Pan of Romano's fresco, Titian depicted the upside-down Marsyas frontally, with heroic strength and quiet dignity, looking stoically upward toward the light, his arms bound at the wrists, creating a luminous nimbus around his head. Rather than the barren tree of previous representations, Titian tied Marsyas with bloodred ribbons to a leafy tree in a fertile thicket, raising the possibility that his fate might offer regeneration and not merely humiliation.

Titian's figure standing at the upper left, dressed in a tunic of imperial reddish purple and holding a Renaissance *lyra da braccio,* cannot be Apollo's assistant, as in Romano's fresco, but must be a second representation of Apollo himself, since he is so clearly inspired by the Apollo in Raphael's frescoed *Parnassus* (1508–11) in the Vatican's Stanza della Segnatura. Furthermore, by depicting him bathed in light descending from the upper left and with a heavenward gaze, an open mouth, and his instrument at the ready, as if having just played his winning melody, Titian equally clearly intended him to embody the Apollonian ideal of celestial harmony and light, although he conceived the scene as a nocturne, with ominous storm clouds in the distance evocative of

Marsyas's impending death. Titian also accurately equipped Apollo's *lyra da braccio* with seven pegs and strings, the same as the number of the universe's planetary spheres, to emphasize that Apollo plays a measured, magisterial, cosmic music, in contrast to the passionate, earthy sounds of the panpipe, poignantly hanging upside down from the tree as the victor's trophy. Yet the syrinx hangs above the *lyra* and is constructed from seven pipes, as if it too might be capable of celestial music.

Titian's second image of Apollo assumes the kneeling posture of the bloodthirsty Phrygian knife sharpener in classical descriptions and representations of the myth. He wields a knife, cutting, scraping, and pulling handfuls of flesh from Marsyas's torso with, as Ovid describes, his "golden head wreathed with laurel of Parnassus, and his mantle, dipped in Tyrian [purple] dye, sweeping the ground." Significantly, Titian layered on with a palette knife the purple of Apollo's mantle, giving it the color and texture of congealed blood, and painted his boots the same color as Marsyas's blood pooling on the ground, which a toy spaniel laps up, its tail apparently wagging in enjoyment.

The Phrygian knife sharpener of classical myth has become in Titian's rendition Apollo's assistant, wearing a Phrygian hat and flaying Marsyas's right goat leg. This bearded, coarse-featured, wild-haired figure more closely resembles classical representations of Marsyas than does Titian's clean-shaven Marsyas with his grave expression of resignation.

The Pan holding a bucket echoes the posture of the Apollo with his *lyra,* although his crude and bearded visage with a lecherous goat-toothed expression typifies the drunken, orgiastic followers of Dionysus. On the other hand, he poignantly gestures as if pleading for mercy toward Marsyas's skin hanging from a tree and in an act of compassion carries a refreshing bucket of water to ease Marsyas's suffering. The water also evokes Ovid's description of the "sylvan deities" who "all wept for him" and whose tears mixed with Marsyas's blood to form the Marsyas River, "the clearest river in all Phrygia." The metamorphosis of the blood and tears into a pure and fertile river implies the possibility of Marsyas's transformation from death to renewed life.

In the musical duel between Apollo and Pan as described by Ovid, Apollo punished not the loser but the Phrygian king Midas, a devout follower of Pan, who judged Pan to be the winner. Enraged by Midas's lack of aural acuity and sound judgment, Apollo provided him with a set of ass's ears. Titian, however, depicted Midas as a king crowned with a pearl-and-gem-studded gold diadem but without ass's ears and in the guise of a self-portrait, as if he were decid-

ing the contest. But by also depicting Midas in a posture derived in part from Michelangelo's Jeremiah, the prophet of Lamentations, on the Sistine Ceiling (1508–12) and in part on the female figure in Albrecht Dürer's print *Melancholia* (1514), personifying both debilitating depression and creative genius, Titian claimed to be not a foolish critic, as was King Midas, but rather a profoundly insightful judge of the destructive consequences of hubris on a master artist. He enhanced Midas's posture of deep introspection and artistic enlightenment by contrasting him compositionally with the standing Phrygian, who unselfconsciously but cruelly flays Marsyas.

Titian counterbalanced the kneeling Apollo—calmly, methodically, and pitilessly stripping Marsyas of his flesh—with the standing infant satyr Olympus. Consistent with his sylvan and Dionysian character he engages the viewer with an expression of fear and even panic at the gory punishment unfolding before him. Yet with empathy for the agony of Marsyas, he restrains the bloodhound by its red collar, preventing it from joining the toy spaniel in the blood feast.

As was well known from Plato's *Republic* (3.399) and Aristotle's *Politics* (8.1341a.20), the Dionysian embodied those dark, instinctual aspects of human nature manifested in chaos, frenzy, disorder, bestiality, irrationality, panic, and destruction. The Apollonian represented the rational and creative side of human nature, expressed by reason, beauty, self-control, order, and harmony. Remarkably, Titian has structured his composition to reveal the Dionysian within the Apollonian and the Apollonian within the Dionysian. This interlocked duality was compatible with the Christian belief that understood human nature as godlike but corrupted by the prideful disobedience of Adam and Eve, whom a wrathful God justly punished with suffering and death. Yet God was also merciful and redeemed penitent and faithful humanity through Christ's redemptive sacrifice, his grace channeled to the faithful by the rites of baptism and the Eucharist, which promise salvation after death. And Marsyas's blood sacrifice evokes the Eucharist, the clear water of the Marsyas River baptism, and the verdant setting regeneration.

In the guise of King Midas, Titian here pondered at the very end of his life the profound mystery of classical and Christian dualities by creating a painting whose every detail holds in unresolved equilibrium matter and spirit, dark and light, instinct and reason, vengeance and compassion, dissonance and harmony, death and salvation, chaos and order, suffering tears and regenerating water, transience and permanence. He also contemplated the nature of his own

art, following Dante (1265–1321) in his opening to *Paradiso* (1.19–21) in the *Divine Comedy,* where the poet evokes Apollo: "Enter my breast and infuse me with your spirit as you did to Marsyas when you tore him from the cover of his limbs." With these words Dante appealed to Apollo for poetic inspiration, the flayed Marsyas serving as a metaphor for the agony of artistic creation, necessary to approach divine understanding. For Titian, Apollo brandishing his *lyra*'s animal-hair bow, scraping and cutting with a flaying knife, and grasping a handful of flesh paralleled his own application of paint with brushes, palette knife, and fingers, while Marsyas's blood pooling at the bottom of the painting connoted the viscosity and materiality of oil paint, especially the red for which Titian was justly famous. These references to the physical labor of painting represent the Dionysian side of his art and the materiality of the natural forms it imitates. On the other hand, Apollo's heavenward gaze, Marsyas's patient, wide-eyed contemplation of the celestial light, and Midas's deep introspection evince the Apollonian, intellectual and imaginative aspect of art, which reveals the divine perfection and beauty underlying nature. The very subject of the painting—a contest between two master musicians, one playing the celestial lyre, the other the terrestrial panpipe—further conjures up the classical and Renaissance art theory that painting has to imitate the full breath and diversity of nature but also perfect and harmonize it to express the underlying universal forms and values.

A musical contest can only unfold across time, and Titian at the end of his career had evolved a style of broad, broken, and layered paint application that recorded the action of his hand and mind over time. Viewed closely, these late works dissolve into pure pigment and gesture, the perfect sign of the physical, Dionysian nature of art and life. From a distance, paint and color emerge from the flat raking light to resolve into solid and substantial forms composed according to a complex, exquisitely equilibrated harmony to express the imaginative, Apollonian aspect of art. Titian's late technique thus served as a metaphor for the hope of Marsyas, Titian, and Everyman for the ultimate triumph of spirit over matter, immortality over mortality.

Pliny recorded (*Natural History* 35.66) that one of Zeuxis's most famous paintings, in the Temple of Concord in the Roman Forum, depicted the flaying of Marsyas. By re-creating the same painting and referencing works of Romano, Raphael, Michelangelo, Dürer, classical sculpture, and poetry, Titian proudly yet humbly laid claim to immortality as a new Zeuxis, equal to the best artists of the ancient and modern worlds.

Finally, the painting seems to have had a poignant historical context. On July 31, 1571, Famagusta (fig. 7), Cyprus's major port, fell to the Turks after a thirteen-month siege. Vastly outnumbered and short of supplies, the Venetian governor and commander Marcantonio Bragadin (1523–71) surrendered his troops to the notoriously cruel Turkish commander Lala Mustafa Pasha (c. 1500–1580). In spite of a promise of safe passage to Crete for all the Christians, Mustafa promptly massacred all the Venetian troops and civilians in the city and threw Bragadin into prison after cutting off his ears and nose. Two weeks later he had Bragadin flayed alive and decapitated and his head mounted atop his straw-filled skin for use as a grotesque figurehead for Mustafa's ship and a trophy for the Turkish sultan. News of this event reached Venice only in early September, and the city was devastated by the humiliating loss of one of its major military bases and by the gruesome sacrifice of Bragadin, who became an instant hero.

In mid-October of the same year the Venetians received news of the major victory of the allied Christian fleet over the Turks on October 7 at Lepanto. It seems likely that this Venetian civic experience of searing defeat and glorious triumph in the span of one month prompted the aged Titian, then in his mid-eighties, to explore through the universal truths of classical myth the pain of his approaching death and his hope for salvation. Perhaps there was no patron after all, and Titian painted the *Flaying of Marsyas* for himself as his last will and testament.

23

PORTRAITS OF MEN

GIORGIONE'S SAN DIEGO *PORTRAIT OF A MAN*

Before it was cut on the bottom and sides, Giorgione's San Diego *Portrait of a Man* (fig. 198) probably resembled Giovanni Bellini's *Portrait of a Young Senator* (fig. 89), although it presents a more sophisticated physical description and a more subtle psychological characterization. Giorgione's subject communicates a lively and penetrating intelligence and radiates great dignity and authority. Yet he also remains somewhat introspective and aloof, perhaps even a little arrogant. The differences between the two portraits are in large part due to Giorgione's use of a subtle Leonardesque sfumato (or "smokiness," achieved by adding black to the shadows), a technique that he may have learned as a result of Leonardo's visit to Venice in about 1500.

GIORGIONE'S *SELF-PORTRAIT AS DAVID*

Giorgione's *Self-Portrait as David* (fig. 199) was inventoried in the Venetian palace of Giovanni Grimani in 1528 as "a portrait of Giorgione by his own hand as David and Goliath" (see J. Anderson, 1997, p. 306). In the 1568 edition of his *Lives of the Artists,* Giorgio Vasari located the work in the same palace and described it as a self-portrait "with hair falling down to his shoulders; . . . and the arm with which David is holding the severed head of Goliath and his chest are covered in armor" (trans. J. C. Bondanella and P. Bondanella, p. 300). A 1650 etching by Wenceslaus Hollar (1607–77) illustrates the state of the painting (in reverse) before it was severely cut (fig. 200), eliminating the head of Goli-

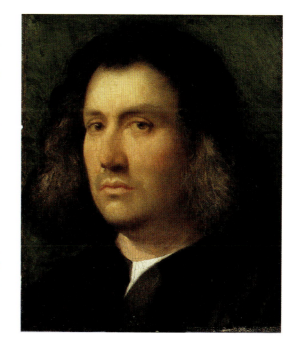

198. Giorgione, *Portrait of a Man,* c. 1506–8, oil on panel, 11¾ × 10½ in. (30 × 27 cm), San Diego Museum of Art.

199. Giorgione, *Self-Portrait as David,* c. 1508–10, oil on canvas, 1 ft. 8½ in. × 1 ft. 4⅞ in. (52 × 43 cm), Herzog Anton Ulrich Museum, Brunswick.

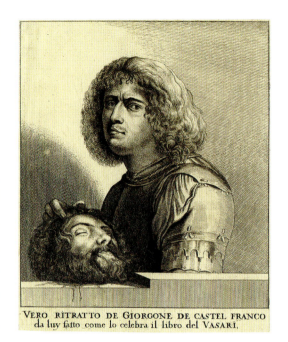

VERO RITRATTO DE GIORGONE DE CASTEL FRANCO da luy fatto come lo celebra il libro del VASARI.

200. Wenceslaus Hollar, after Giorgione's *Self-Portrait as David,* signed and dated 1650, etching, 10¼ × 7⅝ in. (26 × 19 cm), British Museum.

ath and the parapet. The parapet—popularized in portraiture by Antonello da Messina (fig. 87) and the Bellini workshop (figs. 88, 89, 91, and 94)—implied the whole body standing behind the barrier and thus created a sense of both eye-to-eye intimacy and distance between the subject and the viewer.

Raphael and his teacher Pietro Perugino (c. 1450–1523) might each have painted a self-portrait just a few years before Giorgione's work, but consensus is lacking among art historians about the attributions, dates, and subjects of the two paintings in question. Many earlier artists' portraits and self-portraits were represented on bronze medals and bronze doors and in painted narrative scenes. But Giorgione's painting is the first fully documented independent painted self-portrait in Italian art. Its appearance probably depended on the production of the first high-quality flat mirrors in Italy by the Dal Gallo brothers on Murano starting in 1503, although murkier and distorting concave mirrors of blown glass were known as early as the twelfth century. In addition, Albrecht Dürer, who had earlier created several extraordinary painted and en-

graved self-portraits in his native Nuremberg—not coincidently another production center of high-grade flat mirrors—paid a second visit to Venice in 1505–6 and most likely brought examples of his work that might have inspired Giorgione.

But unlike in previous self-portraits, here the artist presented himself in the guise of David, dramatically lifting Goliath's still-bleeding head onto the parapet. He visually intensified his action by notching the parapet, turning his torso and Goliath's head obliquely to the picture plane, tilting his head back on a diagonal axis opposite that of Goliath's, and engaging the observer with his gaze. By depicting himself with exceptionally broad features, flooding his face with illumination falling diagonally from the upper left, and making the giant's head the same size as his own, he also magnified his physical and intellectual stature to suit his nickname, Giorgione (Big George), an appropriate name, according to Vasari, "because of his [broad] physical features and his greatness of spirit" (trans. Bondanella and Bondanella, p. 299). Giorgione fur-

ther emphasized his physical and mental prowess by assuming a leonine pose, with knit brow, piercing gaze, and manelike hair—a classical convention expressing ferocious strength—and by cladding himself in the armor of victory, for the Bible recounts that David rejected Saul's armor before battle (1 Kings 17:38–39) and only donned Jonathan's armor after his defeat of Goliath (1 Kings 18:4). Giorgione's armament also evokes high social status, for in Renaissance Venice only noble naval commanders generally wore armor. His heroic self-representation may also have been intended as his declaration of self-proclaimed artistic triumph over the finest previous Venetian artist, Giovanni Bellini. Furthermore, by assuming the persona of David—the author of the Psalms, who sang to the accompaniment of a lyre—Giorgione reminded the viewer of his musical accomplishments, for, as Vasari wrote, he "was so greatly pleased by the sound of the lute that, in his time, he played and sang divinely; he was for that reason often engaged for various musical events and gatherings of the nobility" (trans. Bondanella and Bondanella, p. 299).

David was an odd choice for a Venetian self-portrait. He was popular in Florentine art, where—as the embodiment of the Florentine republic—he was represented repeatedly in painting and sculpture, the most famous example being Michelangelo's colossal *David* (1501–4), with its leonine expression. From a well-known preparatory drawing, it is certain that Michelangelo personally identified with *David* to express his physical and mental triumph over a supposedly ruined block of marble. By also choosing to identify himself with David, Giorgione might have wished to make one of the earliest known Venetian *paragone* (comparisons)—between his painting and Michelangelo's sculpture, or between Florentine *disegno* and Venetian *colorito,* with Giorgione claiming the crown for painting and Venetian *colorito.*

TITIAN'S *MAN WITH A BLUE SLEEVE*

Titian evolved over the course of his career into one of the greatest and most prolific portraitists of the Renaissance, especially popular with the principal sovereigns of Italy and elsewhere in Europe. During his long life he produced more than two hundred portraits that brought him international renown, great wealth, and a noble title.

The *Man with a Blue Sleeve* of circa 1512—Titian's earliest great masterpiece in portraiture—is possibly a self-portrait (fig. 201). Rather than merely a device for creating both intimacy and distance, the parapet here serves a more

201. Titian, *Man with a Blue Sleeve,* signed, c. 1512, oil on canvas, 2 ft. 8 in. × 2 ft. 2⅛ in. (81 × 66 cm), National Gallery, London.

aesthetic function—a solid base for the figure's bulky, bell-like form, symmetrically aligned along the vertical axis. Titian projected the subject against a neutral, dimly lit background, and by turning the figure's torso to a position almost perpendicular to the parapet and strongly illuminating him with a raking light from the upper left, he gave the subject great sculptural presence in a naturalistic atmosphere.

The voluminous quilted blue sleeve, the white shirt, and the black brocaded cape draped over the left shoulder define the figure's powerful arm, bull neck, and thick torso. The outlines of the furred beret held in the right hand, the neatly trimmed beard, and the shoulder-length rolled hair add further curvilinear life to the figure. By turning the head to locate the piercing right eye in a field of light and the left eye in shadow, Titian simultaneously evoked the subject's intelligence and a degree of mystery. The sleeve's aggressive physicality in a cool color acts as a visual equivalent of the subject's enigmatic yet alert demeanor. Finally, the virtuoso handling of the white-highlighted tones of blues defining the seams, hollows, and sheen of the satin sleeve also transform

the work from merely a convincing truncated fragment of a larger being into a self-contained aesthetic object of great visual authority and grandeur—or, especially if this is indeed a self-portrait, an aesthetic object that serves as a visual metaphor for Titian's artistic prowess.

TITIAN'S *MAN WITH A GLOVE*

By the time he painted the life-size *Man with a Glove* of circa 1524–25 (fig. 202), Titian had developed portrait devices that he would use repeatedly for the remainder of his career. These included a half-length format with the figure anchored to the bottom of the pictorial field by arms and hands unsupported by a parapet; a composition that depended more on internal contrasts and asymmetries than on balanced geometry and axiality; and a reduction of the palette to mostly blacks, ochers, and whites, with only the essential, expressive features of face and hands highlighted. Thus, here the young nobleman leans on a block of stone engraved with Titian's signature (TICIANVS), his diagonal inclination relative to the central vertical axis indicated by the long V-shaped opening in his tunic, which reveals a white pleated shirt that visually connects his head and his right hand. The illumination enters from the upper left on a contrary diagonal axis, lighting his graceful hands and intelligent face with its intense but sidelong glance. His lower right hand, pointing downward, lightly grips his belt while, by contrast, his higher, gloved left hand is sharply bent at the wrist and loosely grips the other glove. The ruffs at the neck and wrists and the slashed gloves are painted with great bravura and represent the height of Venetian fashion to express the youth's refined taste. The gold chain with a sapphire and pearl pendant and a gold index finger ring further indicate his wealth and rank, which he displays elegantly yet without ostentation.

His casual stance and reserved demeanor represent the essence of *sprezzatura*—the ideal of noble deportment described by Baldassare Castiglione (1478–1529) in *The Courtier,* published in Venice in 1528, although a draft was in circulation already by 1508. Castiglione defined *sprezzatura* as the bearing and manner of studied grace that nevertheless appeared spontaneous and natural.

TITIAN'S *FRANCESCO MARIA I DELLA ROVERE*

Francesco Maria I della Rovere (1490–1538)—the duke of Urbino and one of the greatest military commanders of the sixteenth century—commissioned

202. Titian, *Man with a Glove,* signed, c. 1524–25, oil on canvas, 3 ft. 3⅜ in. × 2 ft. 11 in. (100 × 89 cm), Musée du Louvre, Paris.

Titian to paint his portrait shortly before his premature death at age forty-eight (fig. 203). By this time Titian had developed a large, nearly square format to accommodate the three-quarter- or full-length life-size figures and the symbols of rank and power de rigueur for the state portraits of the European elite. Here, for example, the red cloth of honor signals Francesco Maria's ducal rank; the winged-dragon helmet crest, his hereditary rights to Sora and Arce in the Kingdom of Naples, acquired through his 1508 marriage to Eleonora Gonzaga (1493–1570); the gold baton with papal arms, his 1503–13 appointment by his uncle Pope Julius II as the captain general of the papal army; the silver baton, his 1522–23 appointment as the captain general of the Florentine forces; and the black baton in his right hand, embellished with the Venetian and della Rovere arms, his 1523–38 position as the captain general of the Venetian army.

Titian enlivened these symbols through the duke's militant posture; the dynamic torsion of his body, at an angle to the picture plane and with one hand gripping the baton raised toward the picture plane and the other lowered at

203. Titian, *Francesco Maria I della Rovere,* signed, c. 1536–38, oil on canvas, 3 ft. 8⅞ in. × 3 ft. 4½ in. (114 × 103 cm), Galleria degli Uffizi, Florence.

204. Titian, *Doge Andrea Gritti,* signed, c. late 1530s (or late 1540s?), oil on canvas, 4 ft. 4½ in. × 3 ft. 4⅝ in. (133 × 103 cm), National Gallery of Art, Washington, DC.

his side clutching his sword; and the light glinting off his armor's angular metallic surfaces. The costly armor was manufactured by Lorenz (active 1467, d. 1515) and Kolman (1471–1532) Helmschmied of Augsburg and sent to Titian in 1536 to assure complete accuracy, since it communicated so forcefully the duke's wealth, rank, and martial expertise.

The three batons and the duke's codpiece suggest the sexual potency necessary to preserve the ducal line, and the sprouting oak branch between the papal and Florentine batons on the shelf puns on his name (*rovere,* meaning "oak") and alludes to his military prowess. The branch's banderole, inscribed SE SIBI (By himself alone), also evokes his independence, intelligence, and classical learning, underlined by his broad features, probing gaze, and illuminated face. Titian, in short, has depicted Francesco Maria as the ideal Renaissance ruler, competent in both Arms and Letters.

By signing the picture on the cloth of honor, Titian also claimed intelligence and nobility for himself, justified by his investiture as a count palatine in 1535 by Emperor Charles V.

TITIAN'S *DOGE ANDREA GRITTI*

A comparison of Titian's *Doge Andrea Gritti* (fig. 204) to the earlier *Doge Cristoforo Moro* by Lazzaro Bastiani (fig. 85) and *Doge Leonardo Loredan* by Giovanni Bellini (fig. 91) both provides an index of the evolution of Renaissance Venetian ducal portraiture and highlights the great inventiveness of Titian.

Bastiani's bust-length portrait emphasizes the centuries-old majesty of the ducal costume, with the doge's physiognomic likeness rendered in profile, a mode of representation that captures characteristic features but inhibits the expression of movement, emotion, and personality. Bellini's frontal bust-length figure with a three-quarter turn of the head and a meticulously described costume and physiognomy captures in perfect equilibrium the sacred splendor of the ducal office and the unique and lively individuality of Doge Loredan. Titian imitates the iconic clarity of Loredan's bell-shaped frontal torso, the three-quarter turn of the head to the left, the slight elevation of the

right shoulder, and the angled fall of the loose ties of the white cap (*veta*) to underline the head's rotation. But he employed a pictorial field more than twice the length and width of Bellini's, eliminated the distancing parapet, and introduced a waist-length figure. The half-length format allowed Titian to depict the leather belt that indicates the doge's massive bulk and his powerful right hand, which grasps the edge of his ermine-lined gold brocaded cape (*bavaro*) and displays the ring of ducal authority, also a symbol of Venetian maritime supremacy. Titian also rejected Bellini's sky-blue background in favor of an earthier, reddish brown version and directed the doge's gaze more strongly leftward to create an image of greater physical torsion and dynamism. The partially unbuttoned cape not only exposes the vibrant, deeply creased scarlet robe beneath but creates two dramatic diagonals down which cascade twelve (rather than the canonical eight) gold buttons (*campanoni*). The broad and rapid brushwork further enhances the doge's energy, and his chiseled features, with piercing gaze, knit brow, clamped jaw, and downturned lips, express fierce determination. Titian, in sum, has captured the well-known commanding personality and intense energy of Andrea Gritti.

The doge's dynamic torsion, colossal bulk, authoritative expression, and mighty, pawlike hand recall Michelangelo's famous *Moses* (c. 1515) on the tomb of Pope Julius II in Rome. The reference is most apt, since *Moses* personifies the volcanic energy, bold vision, and unwavering resolve of Julius, and only Gritti among the sixteenth-century Venetian doges displayed such audacity. This reference to Michelangelo has led many scholars to consider the portrait posthumous, dating after Titian's visit in 1545–46 to Rome, where he would have seen *Moses* firsthand. But there are numerous references in Titian's work to Michelangelo's Roman and Florentine painting and sculpture before he traveled to central Italy, works he would have known from the circulation of drawings, prints, and statuettes.

TITIAN'S PITTI *PIETRO ARETINO*

Titian completed this stunning portrait of his friend Pietro Aretino (fig. 205) just before traveling to Rome in 1545, using essentially the same formula that he had employed for the *Man with a Glove* (fig. 202), a half-length life-size figure standing before a dark neutral background with his head turned rightward, his inner garment visible behind the V-shaped lapels of his outer garment, which frame his head, and his gloved hands animating and closing

205. Titian, *Pietro Aretino*, 1545, oil on canvas, 3 ft. 2⅛ in. × 2 ft. 6⅛ in. (96.7 × 76.6 cm), Galleria Palatina, Palazzo Pitti, Florence.

the form, although here Aretino grips a lapel with his left hand and holds his right behind his back. The gold chain that he wears may be the one weighing five pounds that Francis I, the king of France, sent in 1533 to bribe "the scourge of princes" (as Ludovico Ariosto called Aretino in *Orlando furioso*) to write well of him. Titian, in short, presents the autodidact Aretino, the son of a cobbler from Arezzo, as if he were a Venetian patrician.

The great difference between the two portraits lies in Titian's bold intensity of color and rapid application of paint in the later work, also characteristic of *Doge Andrea Gritti* (fig. 204). This technique led Aretino to quip that had Titian been paid more he would have brought the painting to a higher state of finish. But while the painting literally sparkles with golden highlights dancing freely across the surface, Titian's touch remains so sure that the texture, sheen, stitching, and drape of the fabrics read clearly and convincingly, "an awesome marvel," as Aretino wrote in a letter of April 1545 (for this and the following quotation see L. Freedman, 1995, pp. 66–67).

As always, Titian also displays his remarkable ability to render a flattering and compelling likeness. Aretino's light-filled high forehead, searching eyes, and full beard cascading down from his broad features express the writer's versatile intelligence and satiric wit—so true to life, Aretino wrote in a letter of October 1545 to the Florentine duke Cosimo I de' Medici (1519–74), that the portrait "breathes, its pulse throbs, and its spirit moves, just as I do in life." The subject's parted, sensuous lips, great bulk, aggressively colored costume with sweeping wide lapels, and almost slapdash brushwork further suggest Aretino's unscrupulous ambition, irreverence, and libertinism.

Aretino sent this picture to Cosimo in an unsuccessful bid for patronage for himself and Titian. But the spontaneity and bravura of Titian's style were poorly received by the Medici court, where the meticulous, almost microscopic, portrait style of Agnolo Bronzino (1503–72) was the contemporary norm.

TITIAN'S *POPE PAUL III WITH OTTAVIO AND ALESSANDRO FARNESE*

Titian traveled to Rome in 1545 to paint several portraits of Pope Paul III and his family, including the impressive (although unfinished) *Pope Paul III with Ottavio and Alessandro Farnese*—a large-scale group state portrait with full-length figures (fig. 206). The twenty-two-year-old Ottavio (1534–86) walks into the painting from the right, removing his beret and steadying his sword with a gloved hand as he begins his genuflection to kiss the pope's ring, a standard ritual of obeisance. The diagonally arranged, intense red-orange drapery in the background echoes and magnifies his action. Paul had appointed Ottavio, his grandson, the captain general of the papal army, and the young man's sword and pendant chain of the Order of the Golden Fleece, the most prestigious military order in Europe, underline his knightly rank. As Titian was painting the picture, Ottavio was preparing to lead the papal army to Germany to join forces with Emperor Charles V in his successful war against the Protestant Schmalkaldic League (1531–47), which ended with the league's defeat at Mühlberg on April 24, 1547.

In the center of the painting the frontal, slightly bent seventy-two-year-old pontiff sits enthroned, bathed in light, and dressed in his regal but nonliturgical dress of ermine-lined red *camauro* (cap), red mozzetta (cape), and white cassock, the red-orange background drapery serving as his vibrant cloth of honor.

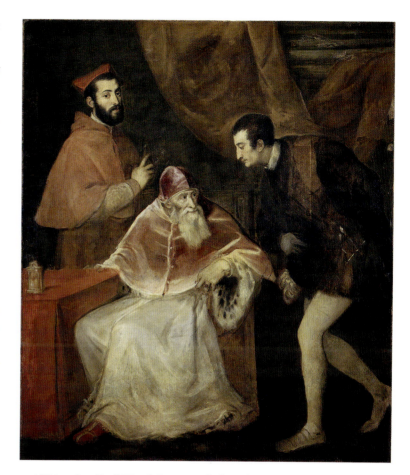

206. Titian, *Pope Paul III with Ottavio and Alessandro Farnese,* 1546, oil on canvas, 6 ft. 10⅝ in. × 5 ft. 8½ in. (210 × 174 cm), Gallerie Nazionali di Capodimonte, Naples.

He displays his slipper with a gold cross that marks him as Christ's vicar, and makes it available to be kissed, another common ritual of obeisance. The pope had been facing the table but turned at the entrance of Ottavio with an alert and welcoming expression.

Standing at the same angle as the table, the twenty-six-year-old Cardinal Alessandro Farnese holds a breviary, the embodiment of the contemplative life, counterbalancing his younger brother, the personification of the active life. Titian positioned Alessandro so that his outward gaze discharges the energy of the painting's dynamic compositional diagonal back toward the viewer. He also placed Alessandro's head at the same angle as Paul's to emphasize the similarity of their features and to subtly allude to the pope's careful—but unsuccessful—grooming of his grandson for the papacy. When Titian painted this portrait, Alessandro was serving as the pope's secretary of state and preparing to accompany his brother to Germany as the pope's legate to the Schmalkaldic War.

A clock, here placed on the table, was a common memento mori (reminder of death), and the pope was to live only three more years. It was also a symbol of prudence and temperance and thus serves as an image of the well-run papal state. The Farnese brothers are shown to contribute to its harmony by balancing their services to the Church between its military and ecclesiastical spheres, thereby underlining the pope's claim to command both supreme temporal and supreme spiritual authority, a point that sixteenth-century Protestants vigorously contested.

Titian's composition appears to have been modeled on a remarkably similar scene, of Mercury receiving the newborn Bacchus from the leg of Jupiter (Ovid, *Metamorphoses* 3.310–12) on a second-century AD Roman relief in the Vatican, which illustrates the climax of one of Jupiter's many infidelities. After Jupiter had impregnated Semele—the daughter of Cadmus, the founder of Thebes—his jealous wife, Juno, knowing that the power of his lightning would reduce a mortal to ashes, persuaded Semele that she should insist that he make love to her in his full glory. Jupiter reluctantly complied with Semele's demand, killing her, but her fetus (Bacchus) was saved by being sewn into Jupiter's thigh until reaching full term, when he was received by Mercury, as the relief illustrates. In Titian's painting Paul plays Jupiter; Ottavio, Mercury; and Alessandro, Jupiter's attendant. The borrowing was highly appropriate, for in Farnese circles the pope was commonly called a Jupiter wielding thunderbolts of excommunication. Thunderbolts also constituted a personal device of Cardinal Alessandro Farnese, which was invented in 1546 as a sign of the Jovian power invested in him as the pope's legate, to hurl against the Lutherans of the Schmalkaldic League. Bacchus born from Jupiter's thigh (and Titian made the pope's thigh unusually prominent) also alluded to Pope Paul III as Christ's earthly vicar, for just as Bacchus, the god of wine, was "twice born" (once from

Semele and again from the leg of Jupiter), so too was Christ (once from the Virgin Mary and again from the Holy Sepulcher). As the messenger of the gods, Mercury was an appropriate guise for Ottavio, who mediated between the pope and the secular world. And just as Semele dared to challenge the majesty of Jupiter and was consumed by his powerful lightning, so too the Protestants would suffer a similar fate at the hands of the pope and his legate. Such appropriation of a classical source appears rarely in Renaissance portraiture but here was employed brilliantly by Titian to aggrandize the cast of characters by mythologizing them in support of Farnese political ideology.

TITIAN'S *EQUESTRIAN PORTRAIT OF CHARLES V AT MÜHLBERG*

Titian first encountered Charles V at his coronation as Holy Roman emperor by Pope Clement VII in Bologna in 1530. They met again in Bologna in 1533, when Charles promised to make him a count palatine. His 1535 patent of nobility stated that just as Apelles had been the sole portraitist of Alexander the Great (Pliny, *Natural History* 35.85), so too only Titian would paint the imperial portraits. After defeating the Protestant defensive Schmalkaldic League in 1547, Charles V called Titian in 1548 to Germany, where he was attending the Diet of Augsburg to arrange a settlement between Catholics and Protestants called the Augsburg Interim. On the first of his two visits to Augsburg, Titian was commissioned to execute the *Equestrian Portrait of Charles V at Mühlberg* (fig. 207), commemorating the decisive victory in which the emperor inflicted heavy casualties on the Protestants; captured most of their commanders, including the supreme commander and elector of Saxony, Johann Frederick I (1503–54); and suffered the loss of only a few of his own men.

The armor, lance, and horse's caparison with which Charles rode into battle (still extant, in the Royal Armory in Madrid) were put at Titian's disposal to enable him to depict the emperor at life size and exactly as he looked at the battle of Mühlberg. Titian depicted Charles wearing the red sash of a supreme commander around his helmet and across his torso and with the emblem of the Order of the Golden Fleece hanging from a red cord around his neck. Charles appears to be just emerging from a thicket of trees and advancing rightward, his forward movement communicated by the horse's spirited prancing, the caparison's agitation, the lance's tilt, the light's diagonal flow from the upper left, and the landscape's oblique spatial recession to the banks of the Elbe and the hills beyond on the right. With his erect posture, determined expres-

by the dark background and nocturnal lighting. With unflinching honesty Tintoretto examines in a mirror his physical decline, manifest in his sagging features, wrinkled brow, and gray hair—his silent and solitary introspection heightened by the beard that covers both his mouth and ears. Through those deep-set, shaded eyes he seems to plumb the very depths of his soul, poignantly measuring both his shortcomings and his faith. He may also be pondering the fact that with the deaths of his rivals Titian (1576) and Veronese (1588), his approaching demise (in 1594) will bring an end to the great golden age of Venetian Renaissance painting. Yet despite his austere dress and introspective melancholy, his intelligent, radiant face and the virtuoso rendering of his dynamic and asymmetrical beard express continuing vitality and strength. The Christlike frontal hieratic pose and the lighting of the face directly from above, as if from a higher, spiritual source, also evoke the oft repeated Renaissance notion that the creative genius of superior artists approached the divine. All in all, the painting constitutes one of the most haunting and moving images of Venetian portraiture.

PORTRAITS OF WOMEN

GIORGIONE'S *LAURA*

Seventeenth-century inventories identified Giorgione's *Laura* (fig. 213) as a portrait of Petrarch's lover Laura, her name indicated by the background laurel leaves. If this is true, Giorgione may have imaginatively re-created the famous (but now lost) portrait of the poet's paragon of beauty and virtue painted by Simone Martini (1284–1344), which Petrarch praised in two well-known sonnets (*Rime sparse* 77–78). Petrarch's Laura, however, was blond with blue eyes, while Giorgione depicted a brunette with brown eyes.

Perhaps, then, the portrait represents Daphne (Greek for "laurel"), who was saved from being raped by Apollo by being transformed into a laurel tree (Ovid, *Metamorphoses* 1.452–567). Daphne was usually interpreted as the embodiment of modesty and chastity and her laurel as a sign of triumphant virtue. Furthermore, Giorgione's subject wears a head veil, usually a sign of a married woman. These clues suggest that the painting is a marriage portrait of the wife of a certain Messer Giacomo, who, according to an inscription on the back of the panel, commissioned the work. If so, her covered left breast might evoke modesty, while the erotic display of her right breast might refer to conjugal sex. Since she wears no *camicia* (undergarment), her fur-lined robe and a sheer silk scarf caress her bare breast, which might even signal the woman's sensual enjoyment, believed necessary for conception. However, the absence of jewelry and other signs of rank and status, which were usual features of marriage portraits, calls this interpretation into question.

The woman might have been a poet, for the laurel was sacred to Apollo, the

213. Giorgione, *Laura,* 1506, tempera and oil on canvas affixed to panel, 1 ft. 4⅛ in. × 1 ft. 1¼ in. (41 × 34 cm), Gemäldegalerie, Kunsthistorisches Museum, Vienna.

god of poetic inspiration, and verbal eloquence in a woman was often equated with erotic bodily display. As one contemporary phrased it, "The speech of a noble woman can be no less dangerous than the nakedness of her limbs." In addition, Giorgione's woman appears to control the display of her body, moving her right hand to either reveal or conceal her breast. While an autonomous and sensuous female poet would be antithetical to the ideal of a chaste, silent, and obedient wife, the painting might be intended to evoke the culture of self-educated courtesans who often took classical names such as Laura or Daphne. In 1509, just three years after Giorgione painted this picture, Marino Sanudo, the Venetian historian and diarist, recorded, probably with some exaggeration, that there were 11,654 prostitutes in Venice, close to 10 percent of the population. Among these women were a few higher-class courtesans—beautiful, talented, self-educated, and independent women in high demand, not only for their sexual favors but also for their talents as poets, musicians, dancers, and conversationalists. *Degli habiti antichi et moderni di diverse parti del mondo* (On ancient and modern costume of various parts of the world; Venice, 1590) by Titian's nephew Cesare Vecellio (c. 1521–1601) supports this interpretation by recording that fur-lined robes were common winter garb of courtesans. Therefore, perhaps this woman was the talented mistress of Messer Giacomo. But where would he display such a portrait?

Whomever the woman represents—Laura, Daphne, wife, poet, courtesan, or someone else—Giorgione brilliantly captured the ambiguity and anxiety attending Renaissance Venetian women, and he did so in a way that comments on the nature of his art. More clearly than had ever been done before in Venetian painting, he expressed his painterly presence though vigorous brushwork. With the woman's unadorned beauty he evoked both the idealism and the naturalism expected of art, according to classical and Renaissance art theory. As an ideal Petrarchan beauty capable of provoking both the suffering and the ecstasy of love, especially unrequited love, she could have visualized for Giorgione both the physical labor of painting and the joy of creative imagination necessary to achieve his poetic laurel.

In any case, a comparison between Gentile Bellini's *Caterina Cornaro* (fig. 94) and Giorgione's *Laura* vividly demonstrates the difference between early and High Renaissance Venetian portraiture, the latter distinguished by its more sophisticated painting technique, its greater degree of both naturalism and idealism, and its more complex and multivalent content.

214. Giorgione, *Old Woman,* c. 1509, tempera and oil on canvas, 2 ft. 2¾ in. × 1 ft. 11¼ in. (68 × 59 cm), Gallerie dell'Accademia.

GIORGIONE'S *OLD WOMAN*

In the 1567–69 inventory of Gabriele Vendramin's palace, Giorgione's *Old Woman* (fig. 214) is described as "a portrait of Giorgione's mother by the hand of Giorgione" (see A. Ravà, p. 178). Whether or not this is true, the painting—nearly identical to *Laura* (fig. 213) in format, figure placement, and lighting—appears to question all that *Laura* might signify.

Spotlighted from the upper left and projected against a dark background, the old woman is depicted with unkempt hair escaping from her white headscarf, wrinkled skin, an open mouth displaying rotted teeth, a careworn expression, and a penetrating gaze directed toward the viewer. She makes an urgent self-referential gesture with her right hand as she appears to speak the words inscribed on her banderole, COL TEMPO (With the passage of time), as if evoking the full sentence "With the passage of time, I have come to this," or, in the words of a contemporary poem by Pietro Bembo, "With time everything is dissolved into earth." It might also be possible to interpret the inscription positively: "With time I have transcended earthly desires and turned to a love

of God," as her gesture to the heart would seem to indicate, or, more succinctly, as in Bembo's poem, "With time every obscurity turns into light" (trans. P. F. Brown, 1996, pp. 226 and 291).

Giorgione presented his remarkably naturalistic and loquacious old woman in terms of the standard portrait formula of many previous portraits (see figs. 87–91, 199–201, and 213)—an active, bust-length, pyramidal figure angled to the picture plane and anchored by a parapet, which imparts to the subject both animation and stability, accessibility and distance. While the formula in previous works supports the idealization of the subject, here it is in tension with the old woman's imperfections and imperative harangue. Thus, if *Laura* embodies the Petrarchan lover who provokes desire with her erotic gesture of exposing a breast but also anguish with the sheer unattainable perfection of her unembellished beauty, mythologized by the background of laurel, a metaphor for the torment and bliss of verbal or visual poetic creativity, then the *Old Woman* ironically ridicules emotional desire and material beauty—or the suffering and joy of imagination—as transitory illusions of pride, soon ravaged by time, and urgently demands a turn from material beauty to spiritual love.

Yet Giorgione also appears to subtly exalt his craft and creative prowess by claiming kinship with two of the most famous Greek artists of antiquity, who also painted portraits of old women: Protogenes (fourth century BC), Apelles's rival, painted a portrait of Aristotle's mother (Pliny, *Natural History* 35.106), and Zeuxis's portrayal of an old woman caused him burst out laughing when he saw it again at a later date (Marcus Verrius Flaccus, *De Verborum Significatu* [*On the meaning of words*], in Sextus Pompeius Festus, s.v. "pictor," p. 209, line 10, ed. Müller). Giorgione might also have been claiming intellectual status as a classical rhetorician—a practitioner of the liberal rather than mechanical arts—by visualizing a particular type of classical rhetoric known as paradoxical encomium, enthusiastic but ironic praise. By visually rather than verbally making such a claim, he would demonstrate the truth of Horace's simile "ut pictura poesis" (*Ars poetica* 361) and don the mantle of poet.

TITIAN'S *LA SCHIAVONA*

Of the more than two hundred portraits from Titian's shop, only fifteen depict women. The earliest, the traditional but misnamed *La Schiavona* (The Dalmatian woman), portrays a woman with her black hair tied up in a gray silk snood (hairnet) interwoven with gold thread, a typical Venetian hairdo of the period,

215. Titian, *La Schiavona,* signed, c. 1511–12, oil on canvas, 3 ft. 11 in. × 3 ft. 2 in. (119 × 97 cm), National Gallery, London.

generally associated with married women (fig. 215). Therefore, she probably represents a chaste Venetian wife, elegantly but modestly clothed in a low-cut reddish brown taffeta dress with voluminous slashed sleeves, synched at the waist with a wide green-gray silk sash. In conformity with Venetian sumptuary laws her only jewelry is a thin double-strand gold necklace. Titian gave her a vivid physical and psychic presence with her three-quarter-length, large, overweight body with a double chin, gaze directed at the viewer, and congenial smile. He enlivened the portrait by depicting one arm lowered and the other upraised to create a lively pattern with her white linen *camicia* erupting unevenly through her slashed sleeves. He also placed her off center, rotated her torso in one direction while turning and tilting her head in the opposite, and arranged her transparent gray-hued silk scarf asymmetrically across her shoulders.

On the large, notched parapet Titian captured a likeness of the woman as younger and more beautiful in a simulated marble relief based on a Roman coin of Antonia the Elder (b. 39 BC), the older daughter of Mark Antony (83–30 BC) and Octavia (69–11 BC). This implies that the portrait's subject

belonged to an old Venetian noble family that claimed ancient Roman roots or that she was named Antonia. The relief also suggests that her beauty, virtue, and nobility are worthy of permanent commemoration. Titian's two likenesses, composed on a diagonal axis corresponding to the flow of light from the upper left, create a visual dialogue that contrasts verisimilitude and ideal beauty, middle age and youth, and transience and permanence—contrasts especially meaningful to Venetian women, who were appreciated primarily for their beauty and youth.

With these naturalistic and idealized images Titian also evoked the art theory of classical antiquity, revived in the Renaissance, that claimed artistic beauty consists of both imitating nature through arduous practice and then perfecting nature through the imagination, refined by knowledge of previous art. Titian also addressed the *paragone* debate about the relative value of painting and sculpture. By painting two equally convincing images—one apparently living and the other immobilized in marble relief—Titian clearly championed painting as superior to sculpture. By imaginatively re-creating and enlarging a Roman coin and illusionistically engraving his initials, TV (for Titianus Vecellius), in the simulated stone parapet, he also claimed for himself status and fame equal to those of the renowned artists of antiquity.

216. Titian, *Flora,* c. 1515–20, oil on canvas, 2 ft. 7⅜ in. × 2 ft. 1 in. (80 × 64 cm), Galleria degli Uffizi, Florence.

TITIAN'S *FLORA*

Titian's so-called *Flora* (fig. 216), a half-length frontal image, developed Giorgione's *Laura* (fig. 213) to a higher level of natural and ideal beauty but remains equally ambiguous. The subject's bouquet of roses, jasmine, and violets appears to identify her as Flora, the goddess of flowers. Either named Flora or in the guise of Flora, she might depict a Renaissance patrician bride, as suggested by the gem-set ring on the ring finger of her right hand and her partially loosened hair. Giovanni Boccaccio (1313–75), however, understood women named Flora as prostitutes in his fourteenth-century *On Famous Women* (64), and Flora was a name that courtesans in both antiquity and the Renaissance often assumed. Similarly, the flowers could allude to love and beauty or to the transience of both, just as "to deflower" in Italian as in English can signify either initial conjugal intercourse or illicit sex.

The woman's actions and formal presentation are equally equivocal. Emerging from a dark background, she is flooded with a raking light that flows diagonally down from the upper left parallel to the lean of her body, tilt of her head, and neckline of her *camicia.* Her gaze, right upper arm, brocaded rose-colored satin *gamurra* (outer garment), and partially bared breast construct contrary diagonals. She extends her right hand to offer her bouquet but curls her fingers as if simultaneously withdrawing it. Her unbelted *camicia,* draped loosely over her right shoulder, has fallen from her left shoulder to partially expose her left breast—lightly caressed by her auburn hair—implying sexual availability. Yet she modestly lifts her brocaded robe with her left hand as if about to dress. She looks leftward with wide-open eyes but appears introspective. The sensuousness of her ample body under the *camicia* is more grasped by the viewer's imagination than actually perceived through Titian's description. Similarly, she appears self-possessed and active in the triangulated centers of interest—the two hands and the face—but ultimately registers more as a projection of the observer's poetic fantasy, which is aided by her averted, somewhat dreamy gaze.

The painting thus frames and mediates the conflicted position of women, who were either glorified as paragons of chastity or marginalized as whores in a

society where courtesans were often indistinguishable from patricians and patrician women were often reduced to meretricious public display. It also suggests that women possessed the power to provoke desire, which could lead to either lust or creative inspiration, just as the conflicted law, morality, and social structures of the Venetian patriarchal order both circumscribed and fostered the power of women's beauty and sexuality.

TITIAN'S *ALLEGORY OF THE MARQUIS ALFONSO D'AVALOS DEL VASTO*

In 1531 the marquis Alfonso d'Avalos del Vasto, a military commander for Charles V, wrote to Pietro Aretino asking Titian to paint a group portrait of himself; his wife, Maria d'Aragona (post-1503–68); and his two-year-old son, Ferrante, in the guise of Cupid before he set off on a military campaign against the Turks in Hungary. Assuming that figure 217 is the painting that Titian supplied, then the artist complied with an allegorical rather than literal portrait.

The white linen *camicia* of the idealized, Venuslike seated Maria—the right sleeve of which is secured with a gold armband set with a ruby—has fallen from her shoulders to expose her right breast. Over the *camicia* she wears a green taffeta robe and a pink silk scarf that drapes over her right shoulder and trails into her lap. The braids of her blond hair woven with a strand of pearls are arranged on top of her head, with the exception of one that falls to her right shoulder. Both the exposed breast and the fallen braid express intimacy. Maria holds a transparent globe, which might symbolize the perfection of the couple's marriage and the purity of their love but as an attribute of Fortune could also evoke the fragility of affection and the uncertainties of life as the marquis sets off on another military campaign, where he risks death.

Standing in the center background, the marquis, a Marslike figure dressed in contemporary Renaissance armor, places his left hand on his wife's left breast as a sign of tenderness, of *amor proximi,* but also as an evocation of the loss of the joys of conjugal life during their coming separation. Both husband and wife appear to contemplate this upcoming parting with sadness.

At the lower right, the young Ferrante in the guise of Cupid, the spirit of both carnal and celestial love, shoulders a bundle of bound arrows, an emblem of the ancient Roman fasces, symbolizing concord and peace. In the context of a leave-taking, Cupid's bound arrows emphasize the couple's higher spiritual

217. Titian, *Allegory of Alfonso d'Avalos del Vasto,* c. 1531–32, oil on canvas, 3 ft. 11⅝ in. × 3 ft. 6⅛ in. (121 × 107 cm), Musée du Louvre, Paris.

affection for each other and their son, which will not only sustain the relationship during their separation but even serve to turn their thoughts toward *amor dei,* or love of God. The remaining two figures reinforce this message: The central figure to the right, dressed in gold, wearing a myrtle wreath, an emblem of married bliss, and gesturing piously toward her heart with her right hand, suggests Faith, both marital and spiritual. The figure at the upper right, holding heavenward a basket of flowers silhouetted against the sky, evokes Hope, for a fertile and happy marriage and for a transcendent spiritual love that promises the ultimate reward of eternal life.

TITIAN'S *ISABELLA D'ESTE*

Isabella d'Este, exceptionally among Renaissance women, was given a superb humanist education, by tutors from the school in Ferrara founded by Guarino da Verona (1374–1460), including his son Battista (1434–1513). In 1490, at age sixteen, she married Francesco II Gonzaga (1466–1519), the marquis of Man-

211. Jacopo Tintoretto, *Self-Portrait,* c. 1547, oil on canvas, 1 ft. 6⅛ in. × 1 ft. 3 in. (46 × 38 cm), Philadelphia Museum of Art.

212. Jacopo Tintoretto, *Self-Portrait,* c. 1588, oil on canvas, 2 ft. × 1 ft. 8 in. (61 × 51 cm), Musée du Louvre, Paris.

acuity, which is underlined by the illumination of the face from the upper left, the scholar's skullcap, and the depiction of the executing right hand—by necessity a product of memory and imagination. The exceptionally thin layers of paint that allow the warp and woof of the canvas to show through also insist on the craft of painting, yet the image is painted so thinly as to appear almost ghostly. This painterly restraint is enhanced by the almost monochrome black costume and by the diminution in size from the Berlin *Self-Portrait* of the chain of knighthood. In other words, in the context of the ever greater austerity and pietism of the Counter-Reformation, Titian underplayed the external display of manual virtuosity and social status of the earlier self-portrait and embraced more decisively the internal, indeed spiritual, expression of his creative imagination.

TINTORETTO'S PHILADELPHIA *SELF-PORTRAIT*

Jacopo Tintoretto depicted himself bust-length in his late twenties as a proud, confident, intelligent, and ambitious artist, his bearded head turned to a three-quarter view as he gazes intensely at himself in a mirror with a fierce, classicizing leonine expression communicated by his curly, manelike hair, knit brow, and fiery eyes underlined in red (fig. 211). The bravura application of thick impasto and the assured handling of nocturnal light offer a virtuoso demonstration of his rapid execution and technical control as he reached full maturity as an artist.

TINTORETTO'S LOUVRE *SELF-PORTRAIT*

Some forty years after creating his Philadelphia *Self-Portrait* (fig. 210), at the height of the Counter-Reformation, when he was about seventy, Tintoretto painted in a dramatically different manner the bust-length frontal Louvre *Self-Portrait* (fig. 212), part of a series of sixty or so bust-length portraits for the Bavarian merchant and collector Hans Jacob König (1536–1601/3). His buttoned, wide-lapelled, fur-lined black Venetian toga and the collar of his white shirt visible underneath express his prosperity and social status as a citizen. But affluence and rank are much understated in the face of death, evoked

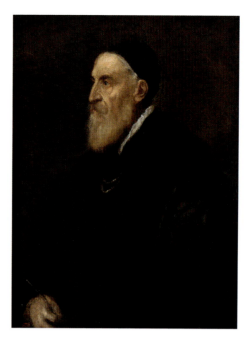

209. Titian, *Self-Portrait*, c. 1562 or earlier, oil on canvas, 3 ft. 1¾ in. × 2 ft. 5½ in. (96 × 75 cm), Gemäldegalerie, Staatliche Museen, Berlin.

210. Titian, *Self-Portrait*, c. 1565–70, oil on canvas, 2 ft. 9½ in. × 2 ft. 1½ in. (85 × 65 cm), Museo Nacional del Prado, Madrid.

Titian's massive and torqued backlit torso leans leftward. His light-filled face is furrowed and chiseled, his averted gaze contemplative. Together these features evoke physical vigor, deep concentration, acute perception, and time-tested wisdom, which Titian demonstrated visually by presenting himself in a pose that cannot be rendered while looking into a mirror but only re-created from memory and introspection. A table in a portrait traditionally displayed significant attributes commenting on the character and personality of the sitter (e.g., figs. 206 and 219). But Titian displayed only his tense right hand against a tablecloth with the color and texture of the painting's support of coarse canvas twill. By the rotation of his left shoulder Titian has also brought to the picture plane his equally flexed left hand, poised on his knee, which the crinkled white satin sleeve emerging from his wide-lapelled, fur-lined sleeveless robe strongly emphasizes. The smudged paint representing both hands suggests that Titian painted them with his fingers rather than a brush to register forcefully his manual dexterity. As Marco Boschini (1613–78) recorded in his 1660 *Carta del navegar pitoresco* (Navigational map for painting) based on Palma Giovane's eyewitness account, Titian finished his paintings "more with his fingers than with the brush," "blending with his fingers the transitions from highlights to half-tones." Titian, in short, presents here a magisterial display of his memory, imagination, and manual dexterity.

TITIAN'S PRADO *SELF-PORTRAIT*

In his Prado *Self-Portrait* (fig. 210) Titian adopted a somewhat different approach from that of the Berlin *Self-Portrait* (fig. 209). To emphasize his craft of painting and his physical act of execution, he included a thin paintbrush in his right hand. He also depicted his torso in three-quarter view and his head in nearly full profile, perhaps to recall ancient portrait medallions and thus subtly allude to himself as a new Apelles. In any case, his nearly profile head instantly captures in silhouette his essential physiognomic characteristics, while the three-quarter torso presents his figure as a clear geometric shape with minimal torsion. This abstract visual clarity expresses Titian's mental

208. Titian, *Philip II in Armor,* 1551, oil on canvas, 6 ft. 4 in. × 3 ft. 7¾ in. (193 × 111 cm), Museo Nacional del Prado, Madrid.

table serves as a cloth of honor that stabilizes and monumentalizes Philip but also creates a dynamic diagonal into depth counterbalancing the fall of light from the upper left, which animates the sheen of the velvet and reflective surfaces of his armor.

By contrasting Philip's thin frame, pointed features, haughty, piercing gaze, impeccably trimmed mustache and goatee, and full, sensuous lips with the grandeur of the setting and the splendor of the armor, Titian appears to have captured something of his contradictory character: he was sensual yet ascetic, intellectually versatile yet religiously fanatical, sincere and generous yet cruel and parsimonious, a meticulous and cautious bureaucrat yet often reckless in warfare. In any case, lively and idealized state portraits such as this are so compelling and convincing that to this day they constitute the canonical images of most of the sixteenth-century European elite.

TITIAN'S BERLIN *SELF-PORTRAIT*

Titian's Berlin *Self-Portrait* (fig. 209) resembles his *Pietro Aretino* (fig. 205) in scale, pose, costume, and brushwork. It differs most notably in the addition of a skullcap and a table, behind which the artist sits. Both of these attributes were most often associated with images of scholars and high-ranking ecclesiastical and secular officials (e.g., fig. 206). His heavy three-strand gold chain indicates his rank as a count palatine and his investiture in 1535 by Emperor Charles V with knighthood in the Order of the Golden Spur, an honor that included exemption from Venetian guild regulations and the right to wear spurs and carry a sword in public. Although Titian was born into a middle-class family of timber and grain merchants from the provincial town of Cadore (see fig. 8) and possessed at most a grammar-school education, he proudly presented himself as a scholar, knight, and aristocrat. Indeed, Lodovico Dolce in his 1557 *L'Aretino: Dialogo della pittura* (Aretin: A dialogue on painting) wrote that Titian was "a very fine conversationalist, with powers of intellect and judgment . . . and copiously endowed with an extreme courtesy of behavior" (trans. M. Roskill, p. 195). Vasari in his 1568 *Lives of the Artists* remarked that Titian was "very kind and well-bred, being possessed of the gentlest habits and manners" (trans. Bondanella and Bondanella, p. 508). And Carlo Ridolfi in his 1648 *Le maraviglie dell'arte* (The marvels of art) reported that "Titian had courtly manners . . . and by frequenting the courts, he learned every courtly habit" (trans. Bondanella and Bondanella, p. 136).

sash of a military commander. His codpiece and sword hilt connote the sexual potency necessary to preserve the continuity of the Hapsburg dynasty. At the left, the massive column rising from a tall pedestal and extending well beyond the painting makes his military and sexual prowess appear yet more heroic. It likely also alludes to the Pillars of Hercules device of the Hapsburgs: two columns signifying the vast extent of their dominion. Titian brings this icon of state power to life through Philip's contrapposto and his actions of gripping his sword, reaching for his helmet, and gazing at the viewer. The velvet-covered

207. Titian, *Equestrian Portrait of Emperor Charles V at Mühlberg,* 1548, oil on canvas, 10 ft. 10¾ in. × 9 ft. 1⅞ in. (332 × 279 cm), Museo Nacional del Prado, Madrid.

panse of sky, and depicting him moving from rosy dawn to the full light of day, Titian imparted to Charles such imperial majesty that he appears to have single-handedly defeated the enemies of the Church and empire. The scene's tranquility and Charles's steady gaze also anticipate the coming peace.

Titian added historical depth to Charles's splendor and authority by employing the compositional formula of a prancing horse and lance-carrying rider in full or three-quarter profile that recalled common images on antique coins and countless paintings and prints of Roman emperors or Christian knights departing on victorious military campaigns in defense of the empire or the faith. According to Pliny (*Natural History* 35.96), Apelles had painted an equestrian portrait of Antigonus (c. 328–301 BC), the foremost commander under Alexander the Great. But Titian, the emperor's new Apelles, outdid Apelles by painting an equestrian portrait of the emperor himself. In the process he created such a compelling image of sovereign power that it initiated an entirely new genre of painted equestrian portraits, which flourished until horse-mounted warfare became obsolete.

TITIAN'S *PHILIP II IN ARMOR*

Shortly after Charles V announced his plan to abdicate the Spanish throne in favor of his son Philip II, Titian made a second trip to the imperial court at Augsburg, in 1550–51, to secure a long-term contract from the twenty-four-year-old Philip for ten *poesie* (figs. 190 and 191). While there, he also painted the prince's portrait (fig. 208). Philip had prepared for his destined role of succeeding his father with thorough training in Arms and Letters, the virtues of the ideal prince. Some of the most noted scholars of the period schooled him in classical culture, Christian theology, art, and music, and he knew Latin, Italian, French, Portuguese, and his native Spanish. When Titian painted his portrait in 1551, Philip had not yet assumed any of his most important titles—king of Naples and Sicily (1554), duke of Milan (1554), governor of the Netherlands (1555), king of Spain (1556), and king of Portugal (1580). Therefore, Titian portrayed him as a warrior prince, employing the full-length life-size format he used exclusively for the state portraits of European aristocrats so that, when the painting was hung high on a wall, the subject towered over and dominated the viewer.

Philip is dressed in exquisite damascened parade armor as if already victorious in battle. He wears around his neck the chain of the exclusive chivalric Burgundian Order of the Golden Fleece, and his helmet carries the burgundy

sion, and slight rotation in the saddle, which sets off a virtuoso display of light flashing off his armor, Charles expresses great dignity, resolve, and vitality. The wrinkles around his all-seeing eyes and the gray in his beard also evoke his wisdom and the great weight of his responsibilities. By adding generous splashes of red, isolating the emperor from his troops, silhouetting him against a broad ex-

218. Titian, *Isabella d'Este,* 1534–36, oil on canvas, 3 ft. 4⅛ in. × 2 ft. 1¼ in. (102 × 64 cm), Gemäldegalerie, Kunsthistorisches Museum, Vienna.

219. Titian, *Eleonora Gonzaga,* c. 1536–37, oil on canvas, 3 ft. 8⅞ in. × 3 ft. 4½ in. (114 × 103 cm), Galleria degli Uffizi, Florence.

tua, by whom she produced six children. The marchioness was responsible for making the Mantuan court one of the most cultured in Italy.

When Titian painted her portrait (fig. 218), Isabella was an overweight, double-chinned woman in her early sixties. But she asked him to paint her as a youth, using as his model her now lost 1511 portrait by Francesco Francia (c. 1450–1517), in which she wore a costly dress designed by the tailor Niccolò da Correggio, embroidered in gold and silver with the knot design of her personal device. Francia had based his portrait on an even earlier one by Lorenzo Costa (c. 1460–1535), also lost, of unknown date but probably circa 1508, when Costa succeeded Andrea Mantegna as the court painter. For an aristocratic noblewoman, in short, a convincing likeness was secondary to her presentation as a woman of youth, beauty, and wealth.

Titian rotated Isabella's enthroned figure slightly leftward and directed her gaze a little rightward, not quite engaging the viewer. He added grace to her erect and noble bearing by structuring the composition in terms of ovals defined by the arms, turban, and face. He enlivened the composition's strict ge-

ometry by framing her almost babyish face with tight, springy curls and by emphasizing the dynamic asymmetry of her neckline and ermine sash. He counterbalanced the sash with a diagonal shaft of light from the upper left. The picture's principal interest, however, lies in the virtuosity of Titian's brushwork, deployed to highlight the external signs of status, affluence, and loveliness that made noblewomen marketable. As Isabella admitted in a letter of 1536, "The portrait by Titian's hand is of such a pleasing type that we doubt that we were ever, even at the age that he represents, of such beauty that is contained in it" (see *Titian: Prince of Painters,* exh. cat., p. 218).

TITIAN'S *ELEONORA GONZAGA*

Eleonora Gonzaga—the firstborn daughter of Isabella d'Este and Francesco II Gonzaga—married Francesco Maria I della Rovere, the duke of Urbino, in 1508, at age fifteen. When she was temporarily resident in Venice at age forty-three, Titian was commissioned to paint her portrait (fig. 219), as a pendant to his

portrait of her husband (fig. 203). Hence the identically sized canvases with both subjects illuminated from the upper left, depicted three-quarter length with one arm raised and the other lowered, and turned in three-quarter profile, although the duke stands in a militant pose while the duchess is enthroned, a posture of triumph. Eleonora's portrait closely follows the format, pose, and physiognomy of Titian's slightly earlier image of her mother (fig. 218), which has been cut on the top and sides. As a duchess rather than a marchioness, however, Eleonora makes a grander display. She wears an exquisite low-cut black dress with puff sleeves trimmed with a multitude of gold bows, black and gold being the heraldic colors of the Duchy of Urbino. The dress is worn over a long-sleeved and gathered white silk blouse that covers her chest and shoulders—its V-neckline defined by a lavish gold-chain necklace set with eight large gemstones—and terminates at the neck and wrists with delicate ruffs. The dress is accessorized with a tight-fitting turban shot through with gold thread, pearl earrings, a delicate gold necklace with a filigreed gold pendant with three dangling pearls, two thick gem-set gold bracelets, four rings (three set with gems), and a knotted gold rope belt with gold tassels, from which hangs by a thick gold chain a sable fur piece with an elaborate gold and jeweled head. Titian enthroned Eleonora in a room, in front of a table covered with green velvet and near a window opening on to an expansive landscape. On the table he displayed the symbols of her virtue: a brown and white spaniel, an emblem of marital fidelity, and a clock, which, as in *Pope Paul III with Ottavio and Alessandro Farnese* (fig. 206), symbolizes temperance and prudence but also serves as a memento mori (reminder of death). The latter meaning is reinforced by the setting sun and the church's spire rising against the distant horizon, signaling that only faith offers a path to redemption at the end of life.

Compared to Isabella's portrait, the larger spatial environment of Eleonora's allowed Titian to emphasize her strong physical presence, backlight her lively silhouette, and counterbalance her asymmetrical, angled placement with a spatial drive into the deep landscape. But in contrast to her husband, who is shown in a more aggressive, armored posture, surrounded by emblems of his dominion and sovereignty and the virtues of rule, Arms and Letters, Eleonora—with a rather placid, tight-lipped expression on her youthful, unblemished face—is represented as a chaste, almost hieratic icon of loyalty, modesty, discretion, piety, and prosperity. Her passivity and subordination, especially in relation to her husband's portrayal, give little clue that she played an active role in ruling the Duchy of Urbino when her husband was out in the field on his many military campaigns.

220. Titian, *La Bella,* c. 1536, oil on canvas, 3 ft. 3⅜ in. × 2 ft. 5⅞ in. (100 × 76 cm), Galleria Palatina, Palazzo Pitti, Florence.

TITIAN'S *LA BELLA*

Titian's three-quarter-length *La Bella* (fig. 220) appears to be a portrait of a young patrician beauty, who stands at an angle to the picture plane and gazes at the viewer with her cheeks rouged and her auburn hair parted in the middle, elaborately braided, and primly knotted on top of her head—with the exception of one long curl that falls to her right shoulder. Titian animated the figure by lowering her right hand, which holds the end of her belt, and raising her left hand, which points to the costly black sable fur piece draped over her lowered right arm, yet he visually unified her hands with the gold belt, the cylinders of which, judging from contemporary practice, were most likely filled with perfumed herbs. Her sumptuous low-cut blue damask dress, belted at the waist and with puff sleeves and a pleated skirt, is worn over a white linen *camicia* gathered along the neckline of the bodice and at the wrists. The blue damask is embroidered with plant motifs in gold thread and adorned with strips of black sable that have been sewn on the bodice and the puff sleeves and decorated with red bows. The white *camicia* has been pulled through the slashes of the

long burgundy sleeves, which are embroidered with a fine design of gold thread and have been attached to the puff sleeves. A silk veil drapes across her shoulders, with one end hanging freely between her right arm and bodice. Pendant earrings set with rubies and pearls, a long gold-chain necklace, and a heavy braided gold belt complete her attire. Almost every aspect of La Bella's dress violated contemporary sumptuary laws, which prohibited furs, earrings, pearls, two colors of fabric, and ornamentation of the fabric.

Although he may not have commissioned the work, the duke of Urbino Francesco Maria I della Rovere (fig. 203) certainly resolved to purchase it in 1536. In letters to the jurist and diplomat Gian Giacomo Leonardi (1498–1562), his agent in Venice, the duke refers to the painting as "a portrait of that woman in a blue dress" and again as "the painting of that woman" (see M. Ciatti, F. Navarro, and P. Riitano, p. 41), suggesting that it portrays a real person but that he was not particularly interested in her identity, rather valuing it for its artistry and the seductive beauty of its subject.

Her hairdo, exquisite costume, and youthfulness might imply that she is a newly married noblewoman of the highest social standing and wealth. Yet a new bride normally would have had all her hair loosened, while a spouse generally would have had all her hair formally done up on the top or the back of her head. Furthermore, the one loosened curl, the direct gaze at the viewer, the erotic display of much of the milky skin of her bosom, and the absence of a wedding ring suggest that she was a courtesan. She appears, in sum, both virtuous and promiscuous.

TITIAN'S *WOMAN IN A FUR COAT*

Titian's *Woman in a Fur Coat* (fig. 221), of about the same date as *La Bella* (fig. 220), also inhabits the blurred boundary between chaste and fallen women in Venetian society. The artist has depicted the same woman (perhaps even using the same cartoon) in a nearly identical pose to that of *La Bella* but now with her braids entirely on top of her head, entwined with a strand of pearls, and wearing pearl earrings, a pearl necklace, a gold bracelet, and a gold ring, the last two both set with precious gems. While the hairdo and jewelry might suggest a noblewoman, the display of her right breast and her direct gaze at the viewer appear to tip the scales in favor of her being a courtesan. In addition, courtesans commonly wore exotic fur robes of the type here sensuously caressing her skin (a *zimarra,* of Turkish origin) during the winter, according to Vecellio in his book of costumes. Yet to compound the ambiguity, both *La Bella* and the

221. Titian, *Woman in a Fur Coat,* c. 1536–38, oil on canvas, 3 ft. 1⅜ in. × 2 ft. ¾ in. (95 × 63 cm), Gemäldegalerie, Kunsthistorisches Museum, Vienna.

Woman in a Fur Coat closely resemble Titian's *Venus of Urbino* (fig. 188), *Isabella d'Este* (fig. 218), and *Eleonora Gonzaga* (fig. 219)—depicting a goddess and two noblewomen of the highest rank—and the Woman in a Fur Coat is mythologized with her gesture's reference to that of the classical modest Venus. In other words, Titian deliberately evoked both chaste wives and promiscuous courtesans in *La Bella* and the *Woman in a Fur Coat,* to heighten their seductive appeal and, through the classical philosophy principle of *concordia discors* (discordant harmony), to express an ideal of transcendent beauty based in nature but perfected by the imagination.

In terms of Petrarchan love poetry, the eroticism of each woman could provoke a burning desire but the sheer perfection of her beauty could also induce a love of divinity. The emotional anguish of the poet trapped between carnal lust and spiritual love expressed the torment and bliss of poetic creation. Similarly, each of these beautiful women stands as a metaphor for the sublime beauty of painting itself, in which, through the difficult and messy craft of applying paint to canvas, the ideal Venus of Titian's imagination comes to life, as she did for Pygmalion (Ovid, *Metamorphoses* 10.243–97).

222. Jacopo Tintoretto, *Woman in Mourning,* signed, c. 1555, oil on canvas, 3 ft. 5 in. × 2 ft. 10¼ in. (104 × 87 cm), Gemäldegalerie, Staatliche Kunstsammlungen, Dresden.

223. Paolo Veronese, *La Bella Nani,* c. 1560s, oil on canvas, 3 ft. 10⅞ in. × 3 ft. 4½ in. (119 × 103 cm), Musée du Louvre, Paris.

TINTORETTO'S *WOMAN IN MOURNING*

Of Jacopo Tintoretto's more than 150 extant portraits, only twelve represent women. Images of women in mourning in Venetian art are even rarer. Perhaps for this reason he appears to have drawn inspiration for his *Woman in Mourning* (fig. 222) from Titian's *La Schiavona* (fig. 215), painted more than four decades earlier, including its format, scale, illumination, background, stone parapet, three-quarter length, and placement of hands. Tintoretto rendered with great economy of means the gauzy black veil draped over the widow's hair, which is parted in the middle, edged in curls at her forehead, and apparently done up in a bun at the back of her head. According to an illustration in Vecellio's book of costumes, a widow would have covered her entire head with a veil when out in public.

Tintoretto used the same spare and rapid technique for the woman's simple low-cut black mourning dress, with its subtle gray design, worn over a white linen *camicia* covering her shoulders and chest. The gloves held in her left hand and the wedding ring worn on her left ring finger indicate that she was not only married but of high station, while the rosary held in her right hand suggests her piety. Her introspective expression of grief is made more poignant by her action of turning away from the light. It is likely that she also turned to observe with her blue eyes a pendant portrait of her deceased husband—a possible candidate being Tintoretto's *Portrait of a Gentleman,* now in the Museu Nacional d'Art de Catalunya in Barcelona, of similar size, date, and composition.

VERONESE'S *LA BELLA NANI*

Of Paolo Veronese's about forty extant portraits, fifteen represent women, and the so-called *La Bella Nani* of about the 1560s is one of the most impressive (fig. 223). He closely followed the formula of Titian's *La Bella* (fig. 220) by depicting the three-quarter-length figure with crimson cheeks against a black background, dressed in a sumptuous blue velvet dress with one arm raised and the other lowered, and with her braided blond hair parted in the middle and

apparently gathered in a bun at the back of her head. Her long-sleeved white *camicia,* with lacework along the neckline and at the wrists, shows through the plunging laced opening of the bodice and the elaborately designed cut velvet sleeves. A long diaphanous silk veil draped over her shoulders and bosom cascades toward the ground and is secured by two enormous cartouchelike gold epaulettes, each decorated with a cameo and four pearls. Two thin strands of gold chain drape across the bodice, suspended from two gold ornaments, each set with a large gem, that have been pinned above her breasts along the low-cut neckline. The gathered, plunging waistline of the dress, cut to emphasize the hips, is adorned with a heavy twisted gold belt that is set with various gems at regular intervals and terminates over the abdomen in a large cartouche mask ornamented with five gems and a pearl. A few pearls are woven into her braids, and she wears a pearl necklace, two gem-set gold bracelets, and three rings, two set with gemstones. Her left hand, which delicately fingers her veil, rests on a parapet covered with an Asian carpet. Finally, she tilts her head leftward, averts her gaze with an introspective expression, and raises her right hand to her breasts in a gesture of modesty and piety.

As the description makes clear, Veronese was apparently uninterested in the tension between erotic seduction and chaste virtue that characterizes Titian's *La Bella* and similar images. Rather, his portraits of women all appear to depict modest, respectable wives with the elaborate costumes and costly jewelry that express their elite social status and wealth. Their rank and affluence were further enhanced by the brilliance of Veronese's color harmonies and delicate brushwork, which rendered with such verisimilitude the look and feel of braided hair, alabaster skin, plush velvet, stiff lace, gauzy silk, translucent pearls, sparkling gems, shimmering gold, and rough carpet. He perhaps learned his exceptional sensitivity to fashion, fabric, and ornament from his older brother Antonio (b. c. 1524), who was an embroiderer. In the specific case of *La Bella Nani,* the cut of the dress and the accessories that emphasize the breasts, hips, and abdomen also subtly allude to the subject's potential to bear children, for the continuation of the family line. Indeed, several of Veronese's portraits of women include their young children.

Recent research (J. Garton, pp. 194–95; D. Howard 2011, p. 57) has shown that *La Bella Nani* cannot depict a member of the Nani family but might represent Giustiniana Giustiniani (c. 1517–72), the wife of Marcantonio Barbaro (1518–95). Indeed, her frescoed image at the Villa Barbaro at Maser (fig. 265), painted at about the same time, is similar, as are the design and color of her dress. In any case, *La Bella Nani* is a superb example of Veronese's portraits of fashionable and poised patrician wives—icons of wealth, beauty, and grandeur.

HALLS OF STATE

A hall of state is an audience room or council chamber where political power is exercised and commemorated. In the Venetian context, therefore, all halls of state were in the Doge's Palace.

The Doge's Palace architecturally and functionally both reflected and constructed the Venetian social and governmental hierarchy (fig. 3, no. 3; figs. 5 and 97). The ground floor, with its open, easily accessible portico, was primarily for the use of the general populace (*popolani*), a segment of society completely excluded from governing. The portico provided a sheltered and convenient walkway, emblematic of the government's role of protecting its citizens and providing for their well-being. Two floors of minor governmental offices were behind this portico. The next floor, the third, housed most of the government's major bureaucratic offices, staffed largely by educated nonnoble citizens (*cittadini*). The upper portico provided access to these offices for the staff and those who had business with them. Above the upper portico, the first and second piani nobili contained two levels of council chambers, reception rooms, waiting rooms, and courtrooms, and the east wing of the first piano nobile had the suite of rooms constituting the doge's apartment (not shown in fig. 97). In these two uppermost levels, the legislative, executive, and judicial business of ruling Venice and its land and sea empires was conducted. The exterior balconies, near the centers of the Sala del Maggior Consiglio and the Sala dello Scrutinio on the south (Molo) and west (piazzetta) façades, served as appearance platforms for the controlled display to the *popolani* of the highest executive officials of the government. Access to these richly decorated and

well-lighted halls of state was tightly controlled, just as access to the levers of power was highly restricted.

The large amount of wood used for floors and ceilings in Venetian architecture made fires a constant hazard. In 1483 a major fire in the east wing of the Doge's Palace swept through the doge's apartment. In 1574 there was an even more disastrous and extensive fire in the same wing, and three years later the south and west wings burned. After each fire the Doge's Palace was rebuilt and redecorated more lavishly than before in a bid to outshine the latest trends in the governmental centers of competing regimes throughout Italy, especially in Florence and Rome. Nearly all of the interior decoration and some of the exterior articulation of the Doge's Palace, therefore, date to the periods after the fires.

SALA DEL COLLEGIO

Shortly after the 1574 fire, Paolo Veronese was commissioned to paint the ceiling and north wall of the Sala del Collegio (figs. 97 and 224). The room served as the meeting chamber for the highest executive body of the Venetian government, the twenty-six-member Collegio, composed of the ten-member Signoria and the sixteen-member Consulta. The Signoria comprised the doge, the six councilors (*consiglieri*) representing Venice's six districts (*sestieri*), and the three heads of the judiciary (Capi della Quarantia Criminal). The Consulta, drawn from the Senate, consisted of six councilors (Savi del Consiglio), five overseers of the army and the defenses of the land empire (Savi di Terraferma),

and five overseers of the navy, the Arsenal, and the harbors and fortresses of the Venetian maritime empire (Savi agli Ordini). The Collegio met daily to oversee the execution of all laws, supervise all governmental institutions and offices, draft legislation for Senate debate, and restrain the power of the doge or maintain continuity in leadership when the doge was ill or had died and not yet been replaced. On occasion, the Collegio functioned as a court, settling disputes concerning ecclesiastical benefices, privileges of subject cities, custom tolls, and so on. It also received all foreign and domestic ambassadors, diplomatic dispatches, visiting dignitaries, and public officials returning from abroad and on the basis of the information gleaned from these sources formulated Venetian foreign policy for debate by the Senate. Veronese's decoration for the Sala del Collegio was designed to express the august authority of this supreme executive body, representing the majesty of Venice.

Veronese's *Faith*

The large oval in the center of the Sala del Collegio ceiling (fig. 225) represents Faith (fig. 226). Arranged along a diagonal in an oblique *dal sotto in su* perspective, four colorfully dressed Jews present their offerings of two sacrificial lambs, an incense burner, and a bowl of blood to a shadowed high priest, who spoons the blood on to the flaming altar. From the dark smoke emerges a white cloud, on which a white-robed personification of Christian Faith kneels and elevates a chalice covered with a corporal (a white linen cloth on which the chalice and paten are placed during the Mass). Her action indicates that the Eucharist—commemorating Christ's redemptive sacrifice—has replaced Jewish blood sacrifices. Faith also turns to gaze at the golden celestial light of the new dispensation, which supplants the fall of natural light that enters on an opposite diagonal to illuminate the old dispensation of the Jewish sacrifice.

The scene is inscribed in Latin at the top and bottom, "The Never Neglected Cornerstone of the Republic." It was important to feature *Faith* in the center of the ceiling, as the foundation of the Venetian Republic, because in spite of the important role that the Venetian navy had played in the 1571 victory of the Christian fleet over the Turks at Lepanto, the pope had accused the Venetians of a self-serving betrayal of faith for signing a separate peace treaty with the Turks in 1573.

224. Sala del Collegio, looking toward the tribune (north end), 64 ft. 5⅝ in. × 26 ft. 3 in. × 27 ft. 4¾ in. (1965 × 800 × 835 cm), Doge's Palace. See figs. 225–28 for details of the ceiling and fig. 229 for a detail of the north wall.

225. Sala del Collegio ceiling, 1575–76, Doge's Palace. The eight L- and T-shaped lateral scenes represent virtues of the Venetian state; the six monochrome scenes depict deeds of ancient heroes exemplifying Venetian virtues. See figs. 226–28 for details of the three large scenes.

226. Paolo Veronese, *Faith,* oil on canvas, 10 ft. 6 in. × 6 ft. 6¾ in. (320 × 200 cm), detail of fig. 225.

227. Paolo Veronese, *Mars, Neptune, and the Lion of St. Mark,* oil on canvas, 8 ft. 3⅜ in. × 5 ft. 10⅞ in. (252 × 180 cm), detail of fig. 225.

228. Paolo Veronese, *Venice Enthroned with Justice, Peace, and the Lion of St. Mark,* oil on canvas, 8 ft. 3⅜ in. × 5 ft. 10⅞ in. (252 × 180 cm), detail of fig. 225.

Veronese's *Mars, Neptune, and the Lion of St. Mark*

The large rectangular scene at the south end of the Sala del Collegio ceiling, inscribed in Latin "The Strength of the Empire," references the duties of the Savi di Terraferma and the Savi agli Ordini under the leadership of the doge, the standard-bearer of St. Mark (fig. 227). Using an effective *da sotto in su* perspective, Veronese represented three foreshortened figures arranged on a diagonal. Mars, the god of war, to the left with his plumed war-horse, symbolizes Venice's army and terraferma empire. Dressed in a Roman cuirass, he also indicates that Venice had become the new Rome, yet leaning on a sixteenth-century cannon and with contemporary armor at his feet and around his neck he further evoked the modern military might of the city. Holding the baton and wearing the cape of a supreme commander, he looks heavenward toward an angel who delivers his helmet to suggest that his battles are fought in defense of the faith. To the right, the emblem of Venice's navy and maritime empire—the hairy-legged and bearded Neptune, here framed by the masts of two Venetian warships—brandishes his mighty trident as an angel descends with a conch shell with which he will trumpet the call to arms to defend Venetian dominions. Finally, in the center of the composition the winged lion of St. Mark signals Venice's sacred bond with God, underlined by the Campanile (cf. fig. 96) rising to heaven with its image of Justice/Venice seated on the Solomonic throne of wisdom and, at its very top, the Archangel Gabriel weathervane recalling Venice's founding on the Feast of the Annunciation in 421 AD as a new Jerusalem.

Veronese's *Venice Enthroned with Justice, Peace, and the Lion of St. Mark*

The rectangular scene at the north end of the Sala del Collegio ceiling, *Venice Enthroned with Justice, Peace, and the Lion of St. Mark*, is inscribed in Latin "Guardians of Liberty" (fig. 228). To the right, Peace climbs the stairs to offer the personification of Venice two olive branches of concord while to the left Justice offers her sword and scales, signs of retributive and distributive justice. Between them the winged lion of St. Mark symbolizes the unique compact between God and Venice, spelled out in Mark's dream (see the introduction to part 1). The personification of Venice—enthroned above the stairway on an enormous terrestrial globe and under a baldachin, emblems of dominion and sovereignty—wears an ermine-lined ducal cape and holds a scepter, insignias of ducal power. Crowned with jewels, indications of Venetian prosperity, and bathed in divine radiance, symbolic of Venice's sacred destiny, she reigns su-

preme as the embodiment of the majesty of the Collegio, seated below on the tribune.

To enliven the ensemble of the ceiling's three central paintings (fig. 225), Veronese constructed the first and third scenes on contrary diagonals, while the central one mediates between them with its compositional structure based on two crossing diagonals.

Veronese's *Doge Sebastiano Venier Gives Thanks for the Victory at Lepanto*

The painting above the dais on the north wall of the Sala del Collegio (fig. 224) located between simulated niche sculptures of SS. Justina of Padua and Sebastian and viewed through two pairs of illusionistic Ionic marble columns is *Doge Sebastiano Venier Gives Thanks for the Victory at Lepanto* (fig. 229), a typical votive painting commemorating a Venetian triumph, which all sixteenth-century doges were expected to provide at their own expense for the decoration of the Doge's Palace. At the time of the Battle of Lepanto, in 1571, the doge was Alvise Mocenigo (r. 1570–77), who planned a votive painting for this location showing himself giving thanks for the allied victory. At his death in 1577, however, Sebastiano Venier, the supreme naval commander of the Venetian fleet at Lepanto, was elected doge, whereupon he reserved for himself the scene of thanksgiving in the prime location above the tribune, although he died before Veronese completed the painting. The subject of Mocenigo's votive painting was changed to the doge giving thanks for the cessation of the plague in 1576, and Tintoretto and his workshop executed it for the right (east) wall, perpendicular to the tribune, with Veronese's St. Sebastian serving as an appropriate transitional figure between the two works.

In Veronese's painting Doge Venier—wearing the armor of a naval commander under his splendid white-and-gold-brocaded and red-silk-lined ducal robe—kneels in piety before the winged lion of St. Mark, gesturing toward the personification of Faith, who is clad in white and holds a chalice. Two elegantly dressed young pages hold the train of the doge's robe's and his helmet. Between the doge and Faith stands the early Christian princess St. Justina of Padua, on whose feast day (October 7) the victory at Lepanto was won. St. Justina, regally adorned with a gem-studded gold crown, gold necklace set with jewels, and ermine-lined red silk robe, gestures toward Faith and holds her dagger and palm of martyrdom, the same attributes depicted in her simulated statue to the left.

The bearded St. Mark gestures toward his winged lion as he leans protectively over the doge. Mark is framed by a sumptuously dressed personification

229. Paolo Veronese, *Doge Sebastiano Venier Gives Thanks for the Victory at Lepanto,* 1581–82, oil on canvas, 9 ft. 3 in. × 18 ft. 8⅜ in. (282 × 570 cm), north wall, Sala del Collegio, detail of fig. 224. The flanking monochromes represent SS. Justina of Padua and Sebastian.

of Venice holding the jeweled ducal crown and by St. Mauro in armor, holding the banner of the Church in commemoration of an earlier Venetian/papal victory over the Turks, near the island of Santa Maura, south of Corfu, on August 30, 1502 (see also ch. 15 and fig. 136). As the Battle of Lepanto rages along the horizon in the background, the group is blessed by a celestial vision of Christ holding a crystal globe as the *Salvator mundi* and surrounded by a glory of more than two dozen music-making angels with palms and olive branches. Christ's celestial globe recalls the terrestrial orb on which Venice sits in the ceiling above and the self-perceived role of the Venetian government to aid in the salvation of the citizens and subjects of its land and sea dominions.

The intrusion of the triangular pediment of the doge's throne into the pictorial field inspired Veronese to construct his composition along opposing diago-

nals. The major diagonal encompasses Doge Venier, Justina, and Christ, while two minor contrary diagonals are defined by Faith, Justina, and Mauro and by Doge Venier, Mark, and Venice. Veronese also arranged the two pages along crossed diagonals. The effect of this structure is to firmly link earth and heaven and to express the sanctity of the Venetian government, blessed by Christ and directed by the Collegio seated below.

This glorification of the doge and the Venetian republic is remarkable for what it suppresses. There is no reference to the two other members of the Holy League, Spain and the papacy, or to the supreme commander of the entire Christian fleet, John of Austria. Nor has the glory of victory been tempered by the fact that within a year the Turks had replaced in their shipyards at Constantinople the 150 or so galleys they lost at Lepanto to again become the dom-

Andrea Vicentino's *Pope Alexander III Consigns the Ring to Doge Ziani*

The eighth scene on the north wall of the Sala del Maggior Consiglio (fig. 232, no. VIII), by Andrea Vicentino (c. 1542–1617), above the door to the Sala dello Scrutinio, illustrates the episode of Doge Ziani's victorious return to Venice on Ascension Day after his defeat of Barbarossa's imperial navy and the capture of Otto (fig. 235). Pope Alexander III supposedly met the doge near the entrance to the lagoon at the tip of the Lido, in the Benedictine church of S. Niccolò, whose façade and campanile are depicted in the background. With the doge's warship safely anchored in the distant background, the ducal victory procession of soldiers and dignitaries has passed through a triumphal arch with winged Victories in its spandrels and approached the pope, who is dressed in full pontificals and enthroned on a high dais under a baldachin. Dressed in armor and with the ducal cape over his shoulders and his white linen cap on his head, the doge genuflects to receive from the pope the *trionfo* of the ring with which to marry the sea as a perpetual sign of Venetian maritime supremacy. Behind the doge a young page holds the ducal crown and a warrior carries the banner of St. Mark. Otto—the young, sumptuously dressed captive beside the doge—has placed his helmet on the lowest step of the dais and kneels on a carpeted step to kiss the pope's foot, a standard ritual of obeisance to Christ's vicar.

Although a complete historical fiction, the pope's consignment of the ring to the doge was considered to be the origin of the annual spring ritual on the Feast of the Ascension (the Sensa) when the doge was rowed in his ceremonial sea throne, the Bucintoro, first to the church of S. Niccolò for prayers and then to the mouth of the lagoon, where he symbolically married the sea and confirmed Venice's naval power and the city's prosperity for the coming year.

Andrea Vicentino's *Fourth Crusaders Conquer Zara*

The scene of the conquest of Zara (fig. 236) in the cycle of paintings illustrating the Fourth Crusade on the south wall of the Sala del Maggior Consiglio (fig. 232, no. XVI) uses the classical and medieval conventions of depicting warfare: drummers and trumpeters sounding the charge as battle banners billow in the breeze; armored knights on rearing and twisting horses, including the commander, with his plumed helmet and baton of command, a banner carrier, and a soldier plunging his lance into a fallen foe; foot soldiers in strong states of anatomical torsion lunging, thrusting, chopping, and pounding with swords, daggers, axes, and mallets; troops climbing the fortifications on scaling lad-

234. Francesco Bassano, *Pope Alexander III Consigns a Sword to Doge Ziani as He Embarks on a Successful Naval Campaign against Otto, Son of Emperor Barbarossa,* 1590, oil on canvas, 18 ft. 4½ in. × 18 ft. 4½ in. (560 × 560 cm), north wall, Sala del Maggior Consiglio.

was charged with defeating those who challenged the Church. The processional cross just above his head also reminds the viewer of Christ's redemptive sacrifice and the role of the Venetian government in suppressing the rebellious impulses of its citizens and subjects to assist them toward salvation.

ern Mediterranean maritime power. In contrast to the twelve scenes opposite, which represent mostly peacemaking events, these depict mostly battles. War and peace were consistently the two great themes in most halls of state.

Both cycles begin at the head of the hall, toward the east, and—unfolding chronologically down the side walls—conclude at the foot of the hall, on the west.

Leandro Bassano's *Pope Alexander III Consigns a White Candle to Doge Ziani*

On the north wall of the Sala del Maggior Consiglio above a window (fig. 232, no. III) is the representation by Leandro Bassano (1557–1622) of Pope Alexander III enthroned on a dais under a baldachin in the chancel of the church of S. Marco, the candlelit high altar with its lavish medieval Pala d'Oro (Gold Altarpiece) visible in the background (fig. 233). The pope, surrounded by cardinals and bishops, bestows the *trionfo* of a white candle on Doge Ziani for his faithful protection of the papacy and the Church. The doge is also surrounded by a multitude of figures—including two young pages holding his crown and the train of his cape, the Signoria, high governmental officials, ducal guards from the Arsenal, citizens, and the musicians of S. Marco—many of which appear to be contemporary portraits. The solemn ceremony confirmed Venice's faith and sanctity.

Francesco Bassano's *Pope Alexander III Consigns a Sword to Doge Ziani*

The fifth scene on the north wall of the Sala del Maggior Consiglio (fig. 232, no. V), by Francesco Bassano (1549–92), depicts Pope Alexander III presenting another *trionfo*, the sword, to Doge Ziani (fig. 234). The bare sword was carried just behind the doge in every ducal procession by the supreme magistrate of the Venetian judiciary as a sign of Venetian justice.

Crowned and wearing armor under his ducal robe, the doge prepares to embark on a naval campaign against Otto, a son of Barbarossa, in defense of the Church. From the background to the middle ground a solemn file of clerics and governmental officials in scarlet togas process from the church of S. Marco through the piazzetta to the quay. A mass of spectators in front of Jacopo Sansovino's Library and in the windows and under the porticoes of the Doge's Palace observe them. In the left foreground a variety of men in gondolas and other boats, some of whom are engaged in rescuing a man and a dog from the water, counterbalance the doge's warship in the right foreground, lying at the

233. Leandro Bassano, *Pope Alexander III Consigns a White Candle to Doge Ziani in San Marco,* c. 1605, oil on canvas, 9 ft. 2¼ in. × 11 ft. 3⅞ in. (280 × 345 cm), north wall, Sala del Maggior Consiglio.

ready with its billowing banner of the lion of St. Mark as a trumpeter blows a parting salute.

Bassano decreased the height of the Doge's Palace to exaggerate the perspectival recession into space and to enhance the grandeur of the piazzetta. He also chose a viewpoint that facilitates the clear perception of the Doge's Palace, the Column of the Lion of St. Mark, S. Marco, the Clock Tower, the Campanile, the Loggetta, and the Library—symbols of Venice's sanctity, justice, peace, piety, wisdom, and triumph. The artist also aligned Ziani with the Gothic sculptures *Archangel Michael* and *Temptation and Fall of Adam and Eve* on the southwest corner of the Doge's Palace to emphasize that just as Michael was God's instrument to punish the first disobedience of humanity, so the doge

231. Anonymous, *Sala del Maggior Consiglio,* eighteenth century, oil on canvas, 2 ft. 1⅜ in. × 2 ft. 9¼ in. (64 × 84 cm), Museo Correr.

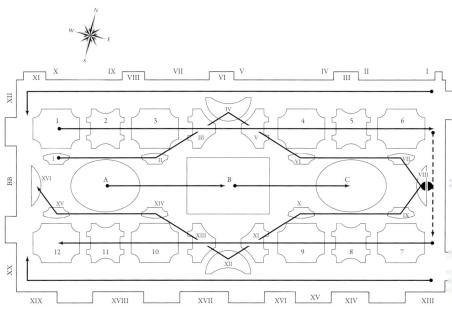

232. Diagram of the chronological organization of the scenes on the walls and ceiling of the Sala del Maggior Consiglio.

to three thousand eligible patrician males. A quorum of six hundred was required, but attendance could run as high as sixteen hundred. These members sat on double rows of seats placed under the wooden wainscoting along the side walls and the foot of the hall and on nine rows of back-to-back benches arranged perpendicular to the dais (fig. 231). From rostrums in the center of the room proclamations and reports were read concerning actions taken and recommendations made during the previous week by the various inner governmental councils. The members would then vote on new legislation prepared by the Senate. They also elected from their ranks the members of all the inner administrative, legislative, and judicial councils, whose terms of office expired according to a regular timetable, generally after one year, and, when necessary, selected the electors who would choose a new doge.

The painted decoration after the 1577 fire consisted of a multitude of historical, pseudohistorical, and allegorical scenes illustrating the legitimacy,

sovereignty, dominion, justice, and virtues of the ever triumphant and sacred Venetian state. Eleven scenes on the north wall and one on the west wall—as opposed to twenty-two scenes on three walls in the prefire hall—depict the mostly fictitious story of Pope Alexander III (fig. 232, nos. I–XII), in which the Venetian government mediated a conflict between Alexander and Barbarossa, playing the role of defender of the Church and European peacemaker. These scenes emphasize the pope's bestowal on Doge Ziani and his successors of the ducal regalia, or *trionfi*—including a sword, a candle, a throne, a cushion, an umbrella, eight trumpets, and eight banners—always carried in ducal processions to signal that the doge's rank equaled that of popes and emperors.

Seven scenes on the south wall and one on the west wall illustrate events from the Fourth Crusade, of 1202–4 (fig. 232, nos. XIII–XX). They depict Venice, the new Byzantium, as both the defender of Christendom and an east-

inant Mediterranean naval power, or that, as a condition of a separate peace signed with the Ottomans in 1573, Venice gave up its island of Cyprus.

As with all halls of state, however, the purpose of the decoration of the Sala del Collegio was to display the magnificence, not the shortcomings, of the regime and to awe its citizens and subjects through the evocation of its divinely sanctioned power, wisdom, and wealth.

SALA DEL MAGGIOR CONSIGLIO

The largest Venetian hall of state, for the Great Council, occupied the first piano nobile in the south (Molo) wing, built between 1341 and 1365, of the Doge's Palace. It connected at a right angle to the Sala dello Scrutinio, in the west (Piazzetta) wing, built between 1424 and 1438 for the law courts. In the Renaissance these two high-ceilinged halls of state were reached from the courtyard by a now destroyed fifteenth-century covered stairway, the Scala Foscari, placed parallel to the Porticato Foscari, which gave access to the north end of the Sala dello Scrutinio (fig. 97).

The original Sala del Maggior Consiglio—a huge space, about 173 feet long, 81 feet wide, and 60 feet high (5270 by 2465 by 1828 centimeters)—boasted a wooden ship's-keel ceiling painted with stars. At the head of the hall on the east the Paduan painter Guariento (1310–70) frescoed a scene of paradise between 1365 and 1368. Between 1365 and 1419, on the three remaining sides of the room Guariento, Gentile da Fabriano, Pisanello, and other artists frescoed twenty-two scenes from the twelfth-century conflict between Pope Alexander III and Holy Roman Emperor Frederick Barbarossa which led to the consignment of the *trionfi* to Doge Sebastiano Ziani. Not until the decoration was completed did the Great Council hold its first meeting in the room. But as the frescoes soon began to deteriorate in Venice's humidity, they were gradually replaced from 1474 to 1564 by paintings on canvas by Gentile and Giovanni Bellini, Alvise Vivarini, Pietro Perugino, Vittore Carpaccio, Titian, Pordenone, Veronese, Jacopo Tintoretto, Orazio Vecellio, and others. The 1577 fire that gutted the south and west wings of the Doge's Palace destroyed all these paintings.

After the 1577 fire, the ship's-keel ceiling was replaced with a sumptuous flat gilt wooden ceiling (figs. 230), designed by Cristoforo Sorte (1510–95), about twenty-two feet (678 centimeters) lower owing to the extensive trusswork required to support it from above. From the completion of the new ceiling in

230. Sala del Maggior Consiglio, looking toward the tribune (east end), 172 ft. 10¾ in. × 80 ft. 10½ in. × 37 ft. 8¾ in. (5270 × 2465 × 1150 cm), Doge's Palace.

1582 until about 1610, the entire room was redecorated according to a program that considerably expanded the subject matter and the number of scenes of the previous cycle of paintings.

The seven thrones on the tribune at the head of the hall accommodated the doge and his six counselors. Seated near them were the three heads of the judiciary, the three heads of the Council of Ten, the two censors, the chief state lawyers, and the grand chancellor—elected for life and ranked just below the doge—who directed the meetings of the Great Council.

The Great Council met on Sundays, confirming the sanctity of the Venetian state. Its members were chosen from a pool of about twenty-six hundred

235. Andrea Vicentino, *Pope Alexander III Consigns the Ring to Doge Ziani in S. Niccolò after the Capture of Otto, Barbarossa's Son,* c. 1600, oil on canvas, 12 ft. 11½ in. × 10 ft. 4⅛ in. (395 × 315 cm), north wall, Sala del Maggior Consiglio.

236. Andrea Vicentino, *Fourth Crusaders Conquer Zara,* 1580s–90s, oil on canvas, 18 ft. 10⅜ in. × 13 ft. 7⅜ in. (575 × 415 cm), south wall, Sala del Maggior Consiglio.

ders; and retreating or fallen victims in contorted postures. All are arranged in a dense and animated frieze close to the picture plane, with the Venetian and allied forces mostly contained in a triangle on the left occupying more than half of the composition. The walls of Zara echo the hypotenuse of this triangle, creating a diagonal perspectival drive into depth, while the troops scaling the walls in the middle ground cut across the two diagonals to initiate the final assault, whose victory the allies' superior numbers visually assures. The structure of crossing diagonals and the perspective rush into space, combined with the dynamism of the equine and human bodies, create a powerful visual charge appropriate for the subject matter.

The chronological unfolding of Venetian history on the walls continues on the ceiling with twelve scenes (fig. 232, nos. 1–12) depicting the great era of expansion of the terraferma empire, from 1427 to the 1509 reconquest of Padua, soon after the defeat at Agnadello. A set of sixteen small monochrome scenes (fig. 232, nos. I–XVI) represents the heroic deeds of governmental officials and private citizens spanning four centuries. In both of these ceiling series the narrative begins at the foot of the hall (west end), unfolds chronologically toward the head of the hall (with the dais), and continues back to the foot.

Palma il Giovane's *Reconquest of Padua*

The *Reconquest of Padua* (fig. 237) by Jacopo Palma il Giovane (1544–1628) concludes the main series on the ceiling of the Sala del Maggior Consiglio (fig. 232, no. 12), concerned with the defense, consolidation, and expansion of the terraferma empire. Three major Paduan landmarks in the background identify the scene: the basilica of San Antonio, the cathedral Baptistery, and the main entrance gate. The commander Andrea Gritti, in black armor and with the baton and red cape of a Venetian commander, is set off by his placement in the center of the composition, his glance out of the picture, and the arrangement of his body on a diagonal contrary to the forward march of his troops. Mounted knights with lances and banners and foot soldiers with halberds, harquebuses, pikes, drums, and a baggage wagon march through the gate at the right, transforming the battle into a victory parade though a triumphal arch. The motif of troops marching through a triumphal arch, used repeatedly throughout the decoration, also evokes those liminal zones of anxiety that military conflict occasions: the passage between war and peace, periphery and center, and sacrifice and prosperity.

Palma il Giovane's *Venetian Women Offer Their Jewels to the Republic*

The painting concluding the set of monochrome scenes on the ceiling of the Sala del Maggior Consiglio, over the foot of the hall (fig. 232, no. XVI), rep-

237. Jacopo Palma il Giovane, *Reconquest of Padua,* 1587–90, oil on canvas, 13 ft. 9⅜ in. × 18 ft. 2½ in. (420 × 555 cm), ceiling, Sala del Maggior Consiglio.

238. Jacopo Palma il Giovane, *Venetian Women Offer Their Jewels to the Republic,* 1587–90, oil on canvas, 6 ft. 10⅝ in. × 12 ft. 9½ in. (210 × 390 cm), ceiling, Sala del Maggior Consiglio.

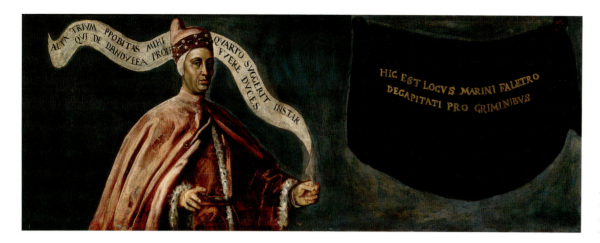

Inscriptions visible in image:
ALTA TRIVM PROBITAS MIHI QVI DE DANDVLEA PROLE QVARTO SVGGERIT FVERE DVCES INSTAR

HIC EST LOCVS MARINI FALETRO DECAPITATI PRO CRIMINIBVS

239. Domenico Tintoretto, *Doges Andrea Dandolo and Marino Faliero,* 1580–90, detail of the frieze at the top of the walls, Sala del Maggior Consiglio.

resents the generosity of the Venetian women who offered their jewels to the doge to help finance the republic's War of Chioggia against Genoa between 1378 and 1380 (fig. 238). The preceding scenes depict individuals performing deeds exemplifying such virtues as justice, piety, prudence, courage, fortitude, patriotism, constancy, perseverance, and military brilliance.

Domenico Tintoretto's *Doges Andrea Dandolo and Marino Faliero*

A frieze of paired portrait busts of doges at the top of the walls of the Sala del Maggior Consiglio (fig. 230) begins with the ninth doge, Obelerio Antenoreo (r. 804–9), above the northeast window (above no. III, fig. 232). This window originally might have been a doorway to a wooden external stairway, long since destroyed, which would account for the series's beginning at this point. In any case, the portraits run clockwise around the room in unbroken sequence through the eighty-first doge, Francesco Venier, and then continue in the frieze of the Sala dello Scrutinio, where they end with the last, 120th doge, Ludovico Manin (r. 1789–97), whom Napoleon deposed when he ended the Venetian republic in 1797. The series of doges illustrated the divinely ordained perpetuity of the ducal office, in direct imitation of two similar series of popes in Rome that visualized the unbroken chain of Christ's vicarage from St. Peter onward.

The inscriptions on these portraits mostly recount ducal deeds of military valor and conquest for the defense and expansion of Venetian dominions on sea and land, about the only actions that a doge could take relatively autonomously, and always outside Venice. A few inscriptions, however, emphasize the doge's devotion, righteousness, and peacemaking, while two others note that from the twelfth century onward, doges were deprived of the right to select a successor or to carry a scepter. Indeed, in Venetian Renaissance art only personifications of Venice, never a doge, are shown holding a scepter. In addition, in a segment of the frieze by Domenico Tintoretto (1560–1635) with Doge Andrea Dandolo (r. 1343–54) and Doge Marino Faliero (r. 1354–55), the bust of Faliero has been replaced with an inscribed back banner warning that if a doge became too powerful or corrupt, he risked deposition and decapitation, which was Faliero's fate (fig. 239). The ideal doge, then, was shown to be a brave commander defending the maritime and terraferma empires and an exemplar of piety, justice, and peace.

The vast scale of the hall and the multiplicity of scenes depicting events over a large geographical area create a structure of centrifugal dispersion, suggesting almost limitless imperial expansion. This is consistent with the abundant scenes illustrating the growth of Venice's dominions and evoking the plenitude of Venice's material and intellectual resources. Indeed, the room's triumphalist program is so complex and dispersive that it required an expert committee to conceive and oversee its execution and a 128-page booklet, published in 1587, to explain it. The committee consisted of the Florentine Camaldolese monk and historian Girolamo Bardi (1544–94), who wrote the booklet (see bibliog-

raphy), and two noble overseers representing the Grand Council, Jacopo Marcello (1530–1603) and Jacopo Contarini (1536–95).

In contrast to the centrifugal dispersion, however, the structuring of the sequences of narrative scenes to begin or end at the head or foot of the hall created a centripetal focus on the east and west ends, emphasizing the hall's longitudinal axis. This organization also concentrated attention on the doge and his advisers, seated on the dais at the head of the hall, and suggested that they were heirs to the sovereignty and dominion whose acquisition the narrative scenes on the walls and ceiling represent. The emphasis on the longitudinal axis also focused attention on the scene in the center of the foot of the hall (fig. 232, BB; fig. 240) and the large paintings along the central axis of the ceiling (fig. 232, A–C; figs. 241–243), toward which the doge and his advisers from their end constantly directed their gazes. Typically in halls of state, as here, the scenes at the head of the hall suggested the regime's sacred authority, while the scenes at the foot of the hall and on the ceiling, oriented to the gaze of the governing official on the dais, were intended as reminders of official duties.

Veronese's *Triumphal Entry of Doge Andrea Contarini into Venice*

In the published program of the Sala del Maggior Consiglio paintings, Girolamo Bardi recounts (pp. 45–46) that during the War of Chioggia (1378–80) the Genoese were firmly entrenched in and around Chioggia, at the southern end of the Venetian lagoon (fig. 8). They were on the point of conquering Venice itself when, in a final effort under the leadership of Doge Andrea Contarini (r. 1368–82), the Venetians saved the city by routing the enemy and capturing a multitude of Genoese galleys and more than four thousand prisoners, including some thousand nobles. This victory established Venetian naval supremacy in the Mediterranean and marked the foundation of Venice's maritime empire.

Rather than depict the battle, Veronese represented a dense crowd of figures participating in and witnessing Doge Contarini's triumphal return to Venice (fig. 240). As three Venetian galleys row toward the Molo in the background, the crowned doge, clad in the splendid ducal toga of gold and white brocade with a red silk lining, has already disembarked and enters the piazzetta near the victory column of St. Mark, partially visible to the extreme right behind some spectators who have climbed up its base. He is flanked by a young page carrying a victory wreath and by his armored captains, one of whom holds a banner with the arms of the republic. Just under the banner appears the ducal *trionfo* of the umbrella, an emblem of Venetian sovereignty. In the right fore-

240. Paolo Veronese, *Triumphal Entry of Doge Andrea Contarini into Venice,* signed, c. 1585–86, oil on canvas, 18 ft. 8⅜ in. × 20 ft. 8 in. (570 × 630 cm), west wall (opposite the tribune), Sala del Maggior Consiglio.

ground, amid spectators and two dogs, symbols of faith and loyalty, cower several captives guarded by armored soldiers, one of whom carries a white banner of peace. The right half of the painting, in short, expresses victory, dominion, and concord. Addressed to the gaze of the doge and his advisers enthroned on the tribune at the opposite end of the hall, the scene made the point that the primary function of the doge and accompanying officials was the defense of Venice and its territories.

The left half of the painting depicts signs of the Venetians' faith and the city's sacred destiny, as if the triumph were both righteous and divinely ordained. Here a large mass of spectators and government officials dressed in scarlet togas have gathered before the Doge's Palace, which is adorned with banners. The chief priest of S. Marco, wearing a miter and flanked by two priests, and five young acolytes carrying the processional cross and four lighted candelabra lead the victory parade to S. Marco for the Mass of thanksgiving. Again, the prominence of the corner sculpture on the Doge's Palace of the *Temptation and Fall of Adam and Eve* (cf. fig. 234) evokes the duty of the government under the leadership of the doge to provide peace and justice to restrain its citizens' innate sinfulness and assist them toward salvation, a message that the sun rising on the eastern horizon further signals.

Palma il Giovane's *Venice Crowned by Victory Gathers Her Subject Provinces*

In the oval scene near the foot of the Sala del Maggior Consiglio (fig. 232, A), also addressed to the gazes of the doge and his advisers on the tribune, Palma il Giovane used a *dal sotto in su* perspective to represent in profile the crowned personification of Venice, holding a scepter of sovereignty and enthroned on a high dais before a scarlet cloth of honor and under a scarlet baldachin, both brocaded with images of the winged lion of St. Mark (fig. 241). As Venice is crowned victorious by a winged Victory, Venetian commanders, one with the banner of St. Mark, offer in tribute a plenitude of conquered subjects and captive armor. The stairway leading to the dais teems with more foreshortened trophies and chained captives. Again, the message conveyed to the officials on the tribune was their responsibility to protect Venice and pacify its territories.

Jacopo Tintoretto's *Doge Niccolò da Ponte Receives Subject Cities and Provinces*

In Jacopo Tintoretto's large-scale rectangular scene in the center of the ceiling of the Sala del Maggior Consiglio (fig. 232, B) conquered cities and provinces pay tribute to Venice (fig. 242). Their representatives carry up a flight of stairs in an effective *dal sotto in su* zigzag composition keys, charters, ledgers, coats of arms, banners, and a chest of tribute money, to be received and administered by the doge and his advisers. According to Bardi, these figures represent "the people dominated by this glorious republic, all of whom, although deprived of their communal liberty, at least live secure in not being prey to the cruelty and avarice of tyranny" (p. 63v).

241. Jacopo Palma il Giovane, *Venice Crowned by Victory Gathers Her Subject Provinces,* 1578, oil on canvas, 30 ft. 10 in. × 19 ft. ⅜ in. (940 × 580 cm), ceiling, Sala del Maggior Consiglio.

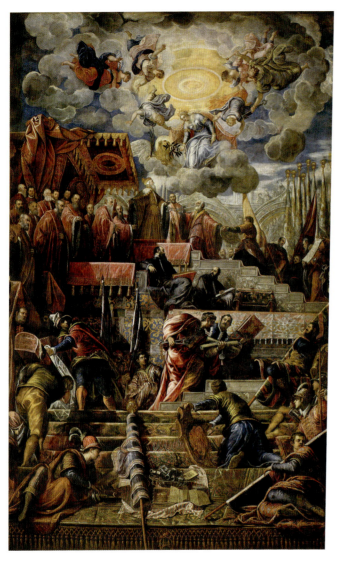

242. Jacopo Tintoretto, *Doge Niccolò da Ponte Receives Subject Cities and Provinces,* 1584, oil on canvas, 36 ft. ⅛ in. × 22 ft. 7⅝ in. (1098 × 690 cm), ceiling, Sala del Maggior Consiglio.

With the façade of the church of S. Marco as backdrop, the doge stands militantly and triumphally on a red carpet on the highest landing of the stairs and receives representatives of captive cities and provinces with outstretched arms, while the rest of the Collegio has assembled on a red carpet on a lower landing, under a red canopy. The *trionfi* of eight banners that Pope Alexander III consigned to Doge Ziani are displayed to the right—here all white to signal that Venice was at peace. Surrounded in the sky by a glory of seven angels, symbolic of the seven spheres of the cosmos, and accompanied by the lion of St. Mark, the crowned personification of Venice, holding a scepter, bends down to offer a victory wreath to Doge Niccolò da Ponte (r. 1578–85) and to confirm the sacred bond between divine justice and the Venetian government. Oriented to be viewed from the tribune, the scene again reminds the doge and his advisers of their duty to pacify Venetian dominions and govern their subjects with divine justice.

Indeed, while only a scant selection has been considered, all of the narrative scenes in the Sala del Maggior Consiglio in various ways construct the divine mission of the Venetian government to expand and consolidate its terraferma and maritime empires, to protect the Roman Church from heathens and heretics, to assist the city's citizens toward salvation by upholding the Christian faith and divine justice, and to establish peace and prosperity in Italy. As Paolo Novello from Belluno phrased it in an oration to Doge Marcantonio Trevisan (r. 1553–54) in 1553, the Venetian republic had been "bestowed by God so that the Catholic faith might be preserved, the Holy Church defended, and the Italian name made illustrious."

The arrangement of highly selective, self-serving, and sometimes fictional historical scenes in chronological order fostered the illusion that the history of the regime had unfolded according to divine plan and from victory to victory. The decoration therefore prophesied a triumphant future for the regime, up to its final apotheosis. And it is the final apotheosis of Venice that is the subject of Veronese's oval scene above the tribune (fig. 232, C; fig. 243) and of Tintoretto's *Paradise* (figs. 244 and 245), behind the tribune (fig. 232, AA), both oriented to be seen from the center of the hall.

Veronese's *Apotheosis of Venice*

According to Bardi, Veronese's *Apotheosis of Venice* (fig. 243) represents the "the effects of joy and universal jubilation of the people dominated by this glorious Republic" (p. 63v). In the center of the composition, enthroned on a cloud, the personification of Venice is crowned by a foreshortened winged Victory while

243. Paolo Veronese, *Apotheosis of Venice,* c. 1579–84, oil on canvas, 30 ft. 10 in. × 19 ft. ⅜ in. (940 × 580 cm), ceiling above the tribune, Sala del Maggior Consiglio.

yet another winged Victory, at the top of the scene, trumpets far and wide her eternal fame. Bardi also recorded that Venice—exquisitely dressed in the ducal robes of ermine and white and gold brocade and holding a scepter—was inspired by classical medals of Roma, to represent Venice as the new Rome. Finally, he wrote that the celestial court of Venice, gathered on a semicircular cloud at her feet, represented (from left to right) Honor (with an olive branch and laurel crown), Peace (with an olive branch), Security (with a caduceus and crown), Felicity or Good Fortune (reclining seminude), Abundance (nude, with wheat in her hair and a cornucopia), and Liberty (with a red Phrygian cap).

Since the doge at the time of the work's execution was Niccolò da Ponte, Veronese depicted his coat of arms, with a bridge (*ponte*), on the center of the bridgelike balustrade. At the bottom of the scene, under a golden image of the lion of St. Mark, a victory parade unfolds, with mounted knights, halberdiers, a drummer, a trumpeter, a nude captive, booty, and a faithful dog—all observed from the bridge by a characteristic cross section of Venetian society: men and women, young and old, patricians and nonnobles, laity and clerics, and locals and foreigners, including a black slave and two turbaned Asians.

Behind the balustrade rises a massive classicizing triumphal arch with freestanding Composite spiral columns inspired by those in St. Peter's, which were believed to have been taken from the Temple of Solomon in Jerusalem. They visualize Venice's ideological claim of being a new Jerusalem and a new Rome. The medieval towers flanking the personification of Venice recall the entrance to the Arsenal, evoking Venetian naval strength and its maritime empire. Standing on top of the spiral columns and symbolizing Venetian commerce and military strength, Mercury holds a caduceus on the left and Hercules a club and lion skin on the right. But Mercury, the messenger of the gods and the guide to the underworld, and Hercules, a Christ type, further suggest the Venetian government's role in the economy of salvation, just as Abundance with her wheat-filled cornucopia recalls the Eucharist. Drawing, in short, on mythological, Judaic, Roman, Christian, medieval, and contemporary sources and motifs, Veronese masterfully depicted an eternally triumphant Venice that was secure, peaceful, honorable, felicitous, prosperous, and free.

Jacopo Tintoretto's *Paradise*

Above the tribune, on the east wall of the Sala del Maggior Consiglio (fig. 232, AA), Jacopo Tintoretto and his workshop covered Guariento's damaged fresco with a vast canvas (about twenty-five by eighty-one feet) representing paradise (figs. 244–46), shortly before Tintoretto's death in 1594. Veronese and Fran-

244. Jacopo Tintoretto, Domenico Tintoretto, and workshop, *Paradise,* 1588–92, oil on canvas, 24 ft. 5¼ in. × 80 ft. 10½ in. (745 × 2465 cm), east wall (above the tribune), Sala del Maggior Consiglio.

cesco Bassano had won the competition for the commission, which the Venetian government had staged in about 1582, but when Veronese died in 1588 before starting to execute the work, it passed to Tintoretto and his workshop.

At the upper center, holding a transparent globe, Christ the *Salvator mundi* sits in glory with the dove of the Holy Spirit. The Virgin kneels before him in adoration, interceding for the Venetians at the Second Coming as the Apocalyptic Woman, signaled by her crown of stars (Apocalypse 12:1). The Archangels Gabriel, with lilies, and Michael, with scales, flank them, evoking the founding of Venice on the Feast of the Annunciation and Venetian justice. Below these four figures Tintoretto represented the four Evangelists, Mark with

his lion given pride of place to Christ's right, followed by Luke with a bull, Matthew with an angel, and John with an eagle. Beneath the Evangelists, a host of angels frame a stream of ascending souls along the central vertical axis. These angels create a heavenly baldachin over the doge's throne to signify the mission of Venice to assist in the salvation of its citizens and subjects, mediated through the leadership of the standard-bearer of St. Mark and the Venetian government, as preordained by God.

Extending outward from Gabriel and Michael to the painting's upper corners flies a multitude of angels, labeled with the names of seven of the ranks of the celestial hierarchy: Seraphim, Cherubim, Thrones, Dominations, Vir-

245. Jacopo Tintoretto, *Paradise,* detail of fig. 244.

tues, Powers, and Principalities. Not coincidently, the tribune contains seven thrones, for the doge and his six councilors. Although the centrality and greater elaboration of the doge's throne declared him to be first among equals, the entire group of officials seated on the dais mirrored the heavenly hierarchy and mediated between earth and heaven. Similarly, the members of the Great Council who sat in files in front of the painting reflected the ranks and files of souls in the work's celestial vision to illustrate the ideological claim that the Venetian government and the city it represented constituted the new Jerusalem. This linkage between the *Paradise* and the entire Venetian government dramatically distinguished the Sala del Maggior Consiglio from halls of state elsewhere in Italy, where the entire decorative focus was on the sacred authority of a single supreme sovereign—pope, duke, or marquis.

To the left of the Evangelists, Tintoretto painted the patriarchs and prophets, including Noah, David, Moses, and John the Baptist. They represent Judaism, which prepared and prefigured Christianity. To the right of the Evangelists, Tintoretto represented Adam and Eve, the apostles—including most prominently SS. Peter and Paul—the four Latin Doctors (Jerome, Ambrose, Gregory, and Augustine), and various other bishops and popes. They represent the hierarchy, theology, and salvific mission of the Roman Church, which, according to state ideology, the Venetian government had a special mission to protect and defend.

Between the tribune and the doors and above the doors are scattered numerous saints: protectors of Venice (e.g., St. Theodore); founders and martyrs of important religious orders (e.g., Dominic, Francis, and Anthony of Padua);

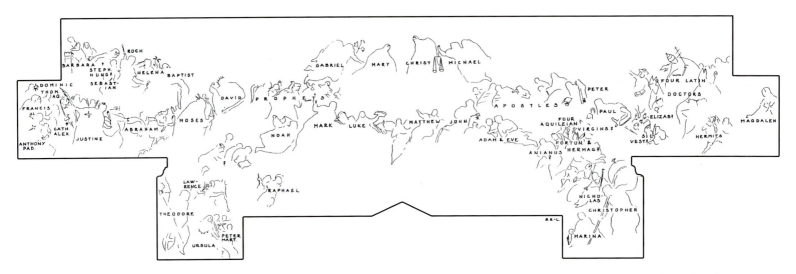

246. Diagram identifying some figures represented in Tintoretto's *Paradise* (fig. 244), from Staale Sinding-Larsen, *Christ in the Council Hall: Studies in the Religious Iconography of the Venetian Republic,* Acta ad archaeologiam et atrium historiam pertinentia 5 (Rome: Institutum Romanum Norvegiae, 1974), plate CVI.

patrons of the major lay confraternities (e.g., Ursula, Sebastian, and Roch); and overseers of Venice's major military victories and peace treaties (e.g., Nicholas supervised the conquest of Constantinople in 1204, Christopher the 1454 Peace of Lodi, Marina the 1509 reconquest of Padua, and Justina of Padua the 1571 victory over the Turks at Lepanto). Finally, when viewing the *Paradise* in conjunction with Veronese's *Apotheosis of Venice* (fig. 243), both uniquely oriented to be seen from near the center of the hall looking toward the dais, it becomes clear that Tintoretto deliberately created a visual parallel between the triumph of Venice in Veronese's work and the apotheosis of the Virgin in his own.

More powerfully than had ever been done before in Italian art, Tintoretto represented the Second Coming not as a judgment but as a vision of universal salvation, specifically the salvation of Venice, within a boundless space that expands centrifugally yet focuses centripetally on the doge and his advisers, who mediated between the end of time and the beginning of eternity, when the last souls will be saved. No wonder Tintoretto's biographer Carlo Ridolfi recounted in 1642 that "it seemed to everyone that heavenly beatitude had been disclosed to mortal eyes in order to give a foretaste of that happiness which is

hoped for in the life to come as a reward for doing good" and that the "senators congratulated him [Tintoretto] and affectionately embraced him for having brought to conclusion that great piece of work to the enormous satisfaction of the Senate and the entire city" (trans. C. Enggass and R. Enggass, pp. 68–69).

Just as political power in Venice was broadly diffused through the Collegio, Senate, Council of Ten, and various other inner councils, with the doge having much less centralized authority than dukes and popes in the rest of Italy, so too no single artist or workshop was put in sole charge of the decoration of this principal Venetian hall of state. Therefore, no artist or workshop could systematically impose a rigorous structure and uniform style, as the large and efficient workshops supervised by Raphael, Giorgio Vasari, and others routinely did in central Italy. Indeed, twenty-one painters and their workshops were commissioned to execute the 101 paintings in the Sala del Maggior Consiglio over about thirty years.

The conservative Venetian government viewed artists essentially as craftsmen and employees of the state working under the direct supervision of specially appointed committees of patrician overseers from within the gov-

ernment and any outside specialists, such as Bardi, whom they chose to employ. These committees generally hired artists who offered the lowest price and could be counted on to produce competent work on schedule or were personal favorites of the overseers. The committees were mostly concerned that artists repeat familiar compositions and motifs that confirmed a scene's historical truth. They cared less about encouraging competitions between artists to provoke bold new inventions, compositions, or feats of execution, unlike in central Italy. When they did stage a rare competition, they thought nothing of awarding the commission to two artists of widely divergent styles, such as Veronese and Francesco Bassano in the case of the *Paradise*.

The government also required all artists to belong to a guild, with such major painters as Veronese and Tintoretto belonging to the same guild and having the same legal status as gilders, textile designers, embroiderers, leather workers, playing-card makers, mask makers, sign painters, and illuminators. While the artists' academies founded in Florence and Rome in 1564 and 1590, respectively, championed the independence and intellectual status of artists of the major media (painting, sculpture, and architecture), freeing them somewhat from guild control, the equivalent Venetian College of Painters was not founded until 1682 and was still essentially a guild under governmental control. The artistic production for the Sala del Maggior Consiglio, in sum, mirrored the political structure as well as the ideology of the government that commissioned the decoration.

VILLAS OF THE VENETO

In the thirteenth century many Venetian patrician families owned castles on feudal estates near Venice in the Alpine foothills, and by the early fourteenth century more than half the nobles of the Great Council owned land around Treviso and Padua (fig. 8). With the fifteenth-century expansion of the terraferma, ever greater numbers of patricians, wealthy citizens, and even *popolani* acquired working farms in the Veneto, which produced small incomes and served as weekend and summer retreats. Many Venetians viewed this development of villa culture and the consequent retreat from Venice's traditional strength of maritime commerce as largely responsible for the decline of Venetian moral fiber, leading to the disastrous defeat at Agnadello in 1509. For example, the Venetian nobleman Girolamo Priuli (1476–1547) wrote in his diary,

> Since the noblemen and citizens of Venice had enriched themselves, they wished to enjoy their success and to live in the terraferma and elsewhere, devoting themselves to pleasure, delight, and the country life, meanwhile abandoning navigation and maritime activities. These [maritime activities] were certainly more laborious and troublesome, but it was from the sea that all benefits came. We can judge the damage inflicted by the terraferma on the city of Venice from the way in which her intoxicated nobles, citizens, and people bought estates and houses on the terraferma and paid twice as much as they were worth. They paid 20 to 25 ducats per campo [5.205 square meters] of land, which yielded less than 3 to 4% per annum, and subsequently erected palaces and houses on these estates that consumed large sums of money Nonetheless, there was no man of means, among nobility, cit-

izenry, or populace, who failed to buy at least one estate and house on the terraferma, especially in the Padovano and Trevigiano [the areas around Padua and Treviso], for these were nearby regions, and they could go and stay there and return in a day or two. (Trans. J. S. Ackerman, 1990, pp. 92–93)

But the sixteenth-century decline of the Mediterranean grain trade; periodic famines caused by draught, floods, and the devastation of the land during the Italian Wars; and the demographic shift from the country to the cities created such a large demand for agricultural produce that farming in the Veneto became a profitable enterprise, despite the enormous costs of reclaiming the swampy terrain.

Agricultural reclamation required large investments, a huge labor force, and specialized knowledge. As they gained experience, especially with regard to hydraulic engineering, the gentlemen farmers of the Veneto disseminated their knowledge in about a dozen treatises written in the sixteenth century. They in turn drew heavily on several well-known agricultural treatises from Roman antiquity, and the praise of agriculture that they found in these treatises encouraged them to counter the attacks of those like Priuli by claiming that their move to the land was a sacred and patriotic duty that both served and glorified Venice. In a letter of 1542 to the Paduan humanist Sperone Speroni (1500–1588), for example, the architectural theorist Alvise Cornaro (1484–1566) wrote, "I have acquired [my wealth] by the best means, more praiseworthy than any other—by the means of holy agriculture [*santa agricoltura*]; and not

by means of arms and attacks, and damages to other people; nor by means of sailing the sea with infinite dangers to my life; nor by other means full of unfavorable aspects" (trans. D. E. Cosgrove, p. 46).

Since Venetian gentleman farmers perceived life on their rural estates largely through the lens of classical agricultural writers, they demanded villas that were classicizing monuments to sacred agriculture and to their patriotic allegiance to Venice, the new Rome, as well as expressive of their classical erudition and noble or pseudonoble status based on the ownership of land. Since overseeing a profitable agricultural estate required long periods of residence, they also required their villas to combine urban comforts with the practical needs of agriculture—a palacelike core joined to utilitarian service buildings that had sheltering porticoes (*barchesse*), held equipment, supplies, animals, and produce, and were generally oriented to provide cool workspaces in the summer, when the sun was high, and warm workplaces in the winter, when the sun was low. Compared to trading or merchandising in the city, agriculture generated a much smaller rate of return on investments, so villas also had to be built economically, with local materials—generally stuccoed brick walls, terrazzo-covered plank floors, wooden beamed ceilings, and tiled roofs—and a minimum of more costly masonry vaults and classical embellishments. As working farms, they would most often have to be among the flat, hot fields or along rivers and canals and not, like villas elsewhere in Italy, elevated on high promontories to take advantage of spectacular views and cooler climates.

VILLA PORTO-COLLEONI AT THIENE

Although much remodeled in later periods, the Villa Porto-Colleoni, set in a large farmland estate, is one of the earliest villas to have survived in the Veneto (fig. 247). It features two projecting three-story crenellated towerlike wings embracing a crenellated two-story central block (now with a roofed third story) incorporating a ground-floor portico with five slightly pointed arched bays. This design can be traced back to an ancient villa type found in various parts of the Roman Empire that most likely survived into the medieval period in the Veneto, although none are now known.

The five-bay Gothic arched loggia in the center of the piano nobile defines a typical Venetian *portego,* running from the front to the back of the building to create a cool breezeway. The two trilobed pointed Gothic windows flanked by two small square windows indicate the two *alberghi* flanking this loggia. Fi-

247. Villa Porto-Colleoni, 1440s, with later remodeling, Thiene.

nally, the tall, spark-arresting chimney pots reflect a typical Venetian sensibility. The villa, in short, is a hybrid, drawing in part on an ancient Roman villa type and in part on Venetian Gothic palaces.

TULLIO LOMBARDO'S VILLA GIUSTINIANI AT RONCADE

The Villa Giustiniani at Roncade, commissioned by Agnesina Badoer (1472–1542) and her second husband, Procurator Girolamo Giustiniani (1470–1532), was built in a crenellated walled precinct with four corner watchtowers and a two-towered entrance gate, all surrounded by a moat (fig. 248). Against the inside walls of the large area in front of the villa, arched porticoes (*barchesse*) served as shelters for farm equipment, produce, and animals. Symmetrically balanced gardens and orchards at the sides and back of the living quarters provided fresh food for the kitchen. Finally, a church, stables, an inn, a mill, and lodging for farmhands—in effect, a small village—surrounded the walled precinct.

248. Domenico Gallo, map of the Villa Giustiniani, 1536, Fondo Cartografico, 2, Biblioteca Comunale, Treviso.

249. Tullio Lombardo?, Villa Giustiniani, c. 1514–22, Roncade.

The living quarters of the villa proper, in the center of the walled enclosure, featured an important innovation for the Veneto: a round-arched three-bay vaulted Doric portico on the ground floor supporting a Doric loggia with a balustrade and beam ceiling on the piano nobile, crowned by a wide frieze with an oculus and a triangular pediment (fig. 249). The projecting portico and the loggia mark *androne-* and *portego*-like breezeways that run from the front to the back of the residence block, longitudinally bisecting it into symmetrical halves. This classicizing frontispiece apparently derived from the villa at Poggio a Caiano (begun in 1485) near Florence, designed by Giuliano da Sangallo (c. 1445–1516) for Lorenzo the Magnificent de' Medici (1449–92), the first Italian villa to employ a classical temple front on the principal façade. The symmetrical plan, facing *barchesse,* and frontispiece were important precedents for Andrea Palladio's villas.

250. Giangiorgio Trissino, Villa Trissino, 1530s, Cricoli.

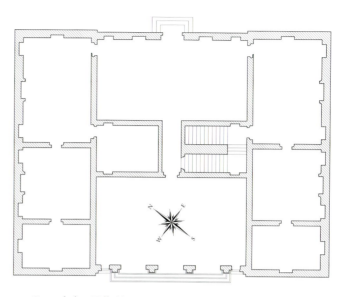

251. Ground plan, Villa Trissino.

GIANGIORGIO TRISSINO'S VILLA TRISSINO AT CRICOLI

Giangiorgio Trissino (1478–1550)—a noble from Vicenza educated as a humanist in Milan—spent his early career at the d'Este court in Ferrara (1512), the Medici court in Florence (1513), and the papal court in Rome under the Medici popes Leo X (r. 1513–21) and Clement VII (r. 1523–34), where he served as a papal diplomat and man of letters. In 1534 he returned to his native Vicenza and opened a humanist school for the sons of the local aristocracy.

As an amateur architect, in the 1530s he also remodeled his villa at Cricoli, just outside Vicenza (fig. 8), with a design of two towers flanking a loggia that recalls the ancient Roman villa type also reflected in the Villa Porto-Colleoni (fig. 247) but is strongly influenced by Roman High Renaissance architecture (fig. 250). The plan of the rectangular block is noteworthy for its symmetry and its vaulted rooms with doors in an enfilade (fig. 251). The ground-floor loggia is articulated with three round-arched bays carried on four Doric piers, the two wider, outside piers pierced by a smaller round-arched opening and an oculus.

Trissino engaged to this arcuated design a trabeated system of six fluted Ionic pilasters on high pedestals carrying a full entablature, with the outer pair of pilasters on each side more closely spaced. This entablature supports three wide pedestals for the classicizing pedimented windows lighting the large *salone* on the piano nobile and six narrower pedestals for the unfluted Corinthian pilasters that carry a full entablature with a denticulated cornice. The two niches on the piano nobile feature sculpted reliefs highly appropriate for Trissino's rural academy: Minerva, the goddess of wisdom, to the left and Ceres, the goddess of agriculture, to the right.

One of the stonemasons for this project was the nearly thirty-year-old Andrea di Pietro della Gondola, whom Trissino decided to educate as an architect in his academy by focusing his studies on classical architecture, engineering, and ancient topography. By 1540 Trissino had also given the stonemason the name Palladio—derived from Pallas Athena, Minerva's Greek counterpart, and the fourth-century AD writer on agriculture Rutilius Taurus Aemilianus Palladius—in anticipation of his career as one of the first classically trained architects in the Veneto and the premier designer of classicizing villas.

Between 1538 and 1541 Trissino moved with Palladio to Padua to join the humanist circle of Alvise Cornaro, where Palladio became familiar with Cornaro's ideas on architecture and agriculture. As an expert on hydraulic engineering, Cornaro vigorously championed reclaiming the swampy Po Valley, especially its Adriatic River deltas, for productive farmland and became a major force in persuading the Venetian republic to subsidize land reclamation in the Veneto. But most influential for Palladio was Cornaro's belief that villas, while emulating classical architecture, should more importantly be comfortable, economical, and practical.

Palladio traveled in 1541 with Trissino to Rome—and returned three more times in the 1540s—where he studied and measured ancient ruins and absorbed the work of the major Renaissance architects. Under Trissino's tutelage he also read the principal classical and Renaissance architectural treatises, including those by Vitruvius, Leon Battista Alberti, and Sebastiano Serlio (1475–1554).

SANSOVINO'S VILLA GARZONI AT PONTECASALE

The Garzoni—wealthy Venetians who had come from Bologna in 1289 and were ennobled in 1381—founded in 1430 one of the principal banks in Venice. When it failed in 1498—due largely to the decline in trade with the East—they took up agriculture at Pontecasale on land they had acquired between 1440 and 1470. When their father, Natale Garzoni, died in 1529, Alvise (d. 1575) and Girolamo (d. 1559) Garzoni inherited the land and soon became among the first Venetians to pioneer a land reclamation consortium, joining with the local canons of Candiana and the monks of the Abbey of Santa Giustina to reclaim land that would benefit the agricultural activities of all three parties.

As this project was in progress and after Alvise married Maddaluzza Bellegno, in 1539, the two brothers commissioned Jacopo Sansovino, in about 1540, to design a villa in the midst of the Garzoni farmland, the first Venetian villa in a grand classical style (fig. 252). Located in a large symmetrical walled rectangular precinct with L-shaped *barchesse,* reminiscent of the Villa Gius-

252. Jacopo Sansovino, Villa Garzoni, c. 1540s, Pontecasale.

253. Entrance portico and loggia, Villa Garzoni.

254. Ground plan, Villa Garzoni.

255. Courtyard, Villa Garzoni.

tiniani at Roncade (fig. 248), the residence proper consists of a large two-story U-shaped residence block, with a tiled hip roof, embracing a square courtyard that rests on a rectangular podium built over vaulted basement rooms supported by massive brick walls. The five-arched Doric entrance portico on the first floor—approached by a long and wide stair ramp—and the open Ionic loggia above on the second floor (fig. 253) together mark the central axis of the symmetrical plan (fig. 254). Sansovino derived this arcuated and trabeated frontispiece from his Library in Venice (figs. 102 and 105), but lacking the Library's costly sculptural detail, the design also closely resembles that of the Theater of Marcellus in Rome, which Serlio published in his *Le antiquità di Roma* (The antiquities of Rome; Venice, 1540).

The villa was divided along its central axis into two identical two-story apartments, one for each of the brothers. Two doors at each end of the entrance portico gave access to the large *salone* of each apartment, behind the façade, and three rooms with doors in an enfilade followed each *salone* on the sides. The central door of the entrance portico opened on to the one-story Doric portico built along three sides of the internal square courtyard (fig. 255). Double-ramp stairways at either end of the central section of the courtyard portico led to the second floor of each apartment, laid out exactly like the rooms below and connected by the Ionic loggia. Just as the three rooms on each side of the courtyard could be entered from the courtyard portico, so the rooms on the top floor could be entered from the walkway on top of this portico. Fireplaces in the centers of their outside walls heated all the rooms on both floors.

The villa's grand scale evoked the wealth and status of the Garzoni, while its classicizing design broadcast the patrons' classical learning and linked them patriotically to Venice, the new Rome. The villa's multiple views on to the surrounding landscape, through porticoes, loggia, courtyard, and windows, also underlined the patrons' roles as gentlemen farmers. And Sansovino's use of relatively inexpensive brick covered with stucco to simulate stone for the walls and classical details attested to the patrons' practicality and good business sense. The Villa Garzoni constituted an important precedent for Palladio.

PALLADIO'S VILLA BARBARO AT MASER

Palladio's nearly forty villa designs best exemplified the aims, ambitions, and attitudes of the Venetian gentleman farmer. And it was at Maser, near Asolo—where he worked in close cooperation with the most distinguished of all his many patrons, Daniele Barbaro (1514–70) and his younger brother Marcantonio Barbaro (1518–95)—that his ideas first coalesced into a mature and integrated design.

The noble Barbaro family traced its lineage back to about 800 AD, near the beginning of Venice as a ducal state, and over the centuries various members had almost continuously served the city as statesmen, military commanders, and churchmen. Daniele was educated at the University of Padua (1537–45), where he studied theology, mathematics, Greek, Latin, and classical philosophy, history, and literature and became a distinguished scholar of Aristotle. He also redesigned the university's botanical garden, an early indication of his interest in agriculture. He served as Venice's ambassador to England (1548–51) and in 1550 was elected to succeed Giovanni Grimani (1506–93) as the patriarch of Aquileia, the highest Church position in the Veneto. But he was never invested with the office, as Grimani, who outlived him by more than three decades, was never made to relinquish the title, despite serious accusations that he sympathized with Protestant theology. Yet as a celibate churchman and the patriarch-elect of Aquileia, Daniele was free from family obligations and service to the Venetian state, allowing him time to pursue his studies. Two of his studies were especially important for their impact on Palladio and villa architecture: an Italian translation of and commentary on Vitruvius's *Ten Books on Architecture,* titled *I dieci libri dell'architettura di M. Vitruvio* (Venice, 1556) and illustrated with woodcuts by Palladio, and a treatise on mathematics, *La practica della perspecttiva* (The practice of perspective; Venice, 1568).

In 1554 Daniele and Palladio traveled together to Rome, where Palladio published a thirty-nine-page guidebook to Roman ruins, *L'antichità di Roma* (The antiquities of Rome), the most reliable guide of its time, based on a thorough study of the ruins and a solid knowledge of Roman topography, derived from classical sources.

Marcantonio, also educated at the University of Padua, in 1543 married Giustiniana Giustiniani, from a distinguished Venetian noble family, who brought him a dowry of ten thousand ducats, more than twice the legal limit, and bore him five sons. He dedicated his life to serving the Venetian government, becoming a member of the Great Council in 1544 and in 1559 a senator. He served repeatedly throughout the rest of his life as one of the Savi di Terraferma and the Savi del Consiglio and in many other short-term appointments, advising on and overseeing matters in the terraferma concerning troops, fortifications, agriculture, waterways, and the reform of the University of Padua and in Venice concerning the Arsenal, public health, and the Mint. He also served as an ambassador to Constantinople (1568–74), where he negotiated the peace of 1573 after Lepanto, by which Venice gave up Cyprus. In 1572 he was elected for life as one of three procurators in charge of the Piazza and Piazzetta S. Marco buildings and their maintenance and was therefore one of the men in charge of the rebuilding and redecoration of the Doge's Palace after the fires of 1574 and 1577 (see ch. 25). Between 1587 and 1593 he served as an overseer for the rebuilding and maintenance of the Rialto Bridge (fig. 111). Finally, according to Pietro Aretino and Carlo Ridolfi, Marcantonio was even an amateur sculptor (see D. Howard, 2011, pp. 3–5).

The Barbaros had made their money in shipping and trade in the early days of the republic. But they owned farmland at Maser already by the fourteenth century and greatly expanded their holdings there and around nearby villages in the first half of the sixteenth century. According to a 1537 tax declaration, the Maser property included "a house, orchard, and vegetable garden" (see D. Howard, 2011, p. 18). Shortly after the death of their father, Francesco Barbaro (1484–1549), when Daniele and Marcantonio inherited his estate, the brothers moved to Maser semipermanently to become landed gentry. In about 1554 they commissioned Palladio to redesign and expand the farmhouse as a classicizing villa.

Architecture

To take advantage of the superb view of the fields stretching out to the south, the original two-story stone farmhouse was set on the low foothills of the Dolomites. To emphasize this view and accentuate his new façade, Palladio designed a north-south visual corridor, extending outward from the central axis of the façade, which consists of a wide carriageway that is bounded by low stone walls and terminates at the south end in a fountain surrounded by a semicircular walled piazza and at the north end in a classicizing Ionic temple front applied in stone and stucco to the preexisting building, used as living quarters (figs. 256 and 257). To give the temple front greater prominence Palladio designed a paved entrance terrace as wide as the façade, accessed by four steps.

The temple front's four evenly spaced Ionic columns with their crisply carved capitals carry a full entablature featuring a frieze with elegantly engraved Roman block letters and a corbeled cornice (fig. 258). Palladio interrupted the entablature supporting the triangular pediment over the central bay to accommodate an arched window with a balcony, which reflects the high, barrel-vaulted hallway on the piano nobile. The resulting syncopated A-B-A bay rhythm is enriched by the pediments of the four classically framed rectangular windows in the side bays, triangular on the piano nobile and segmental on the ground floor. The design of this frontispiece—derived from the Temple of Mars Ultor in the Forum of Augustus in Rome—powerfully expresses the notion of "sacred agriculture" and evokes the sovereignty of the Roman Church, which Daniele Barbaro served, and of Venice, the new Rome, which both brothers served.

The application of a temple front to a villa to add grandeur and magnificence and to express the sacred and patriotic nature of agriculture was justified, according to Palladio in his architectural treatise, *I quattro libri dell'architettura* (*The Four Books on Architecture*; Venice, 1570), by his (incorrect) belief that ancient temple fronts evolved from early houses:

256. Andrea Palladio, Villa Barbaro, c. 1554–58, Maser.

257. Living quarters, Villa Barbaro.

258. Pediment sculpture, Villa Barbaro.

In all the villas and also in some of the city houses I have put a frontispiece on the forward façade where the principal doors are, because such frontispieces show the entrance of the house, and add very much to the grandeur and magnificence of the work, the front being thus made more eminent than the other parts. Besides, they prove to be especially useful for the builders' coats of arms, which usually are put in the middle of the façades. The ancients also used them in their buildings, as may be seen in the remains of temples and of other public edifices. And, as I said in the preface to the first book, it is very likely that they got the invention and concept from private buildings, that is, from houses. (Trans. R. Tavernor and R. Schofield, bk. 2, ch. 16, p. 69)

At Maser the frontispiece not only was useful for the builders' coat of arms but became a signboard for the brothers' patronage, status, and allegiances. The Latin inscription in the frieze names the patrons "Daniele Barbaro, Patriarch [*sic*: Elect] of Aquileia, and Marcantonio his brother, sons of Francesco." In the center of the pediment the papal tiara and the Barbaro coat of arms reference Daniele's service to the Roman Church and the family's traditional support of the papacy. The imperial double-headed eagle and the two eagles on the garlands allude to the Barbaro family's relationship by marriage to the Hapsburgs and the Hapsburg control of Aquileia. The bull, the form of the Egyptian god of agriculture, Apis, was a hieroglyphic sign for peace, as was well known from Alberti's *Ten Books on Architecture* (8.4). This emblem thus served as a potent reminder—especially after the recent devastation of the terraferma during the Italian Wars and the resulting periodic famines—that agriculture could flourish only in a land of peace. As a classical animal of sacrifice, the bull also would have recalled that Christ's redemptive sacrifice supplanted such animal sacrifices. The garlands of fruit and vegetables just below the pediment evoked the abundance of the Venetian terraferma, while the two pairs of powerful, sexually potent Tritons and Nereids riding dolphins symbolized the fruitfulness of the Venetian maritime empire—official concerns of Marcantonio over the course of his public service career. Dolphins were also among the earliest Christian symbols of regeneration through the sacrament of baptism, while the cupids in each corner further suggest love, fertility, and renewal. The classical rosettes, to the extreme right and left, allude to the royal Tudor rosette awarded to Daniele by King Edward VI (r. 1547–53) as a mark of honor when he served as an ambassador to England. The coat of arms to the left under the garlands belonged to the mother of the Barbaro brothers, Elena Pisani (c. 1495–

1541), while the escutcheon to the right pertained to Marcantonio's wife. Finally, the Latin inscriptions in the friezes under the pediments of the four side windows offer hospitality and shelter to all visitors, regardless of rank, as part of the Barbaro brothers' exercise of charity (*amor proximi*): "Nothing hidden under this roof. Guest no stranger. Everything safe for good men. Not only for lords."

The central block, with the living quarters, dominated the design of the villa with its centrality, forward projection, two-story height, and temple front. But despite Palladio's statement that his classical frontispieces showed villa entrances, here the door gave access only to the kitchen, storage rooms, and service areas. The piano nobile was reached rather by the two stairways at either end of the covered porticoes of the *barchesse*, which led to the north end of a cruciform hall, or *crociera* (fig. 259). The *crociera*, which served as *portego*-like breezeways, consisted of two intersecting barrel vaults terminating in arched windows with balconies at three ends and in the doorway opening into the Room of Olympus at the north end. Paolo Veronese frescoed this room, the two flanking rooms, the two rooms at the front of the villa, and the *crociera* in 1561 and 1562 (see "Frescoes," below).

On either side of the projecting block with the frontispiece, the first five bays of the rusticated porticoes of the *barchesse* are articulated with rectangular Tuscan Doric piers with simplified bases and capitals from which spring round arches with drafted stucco voussoirs with large stucco masks serving as keystones. To close the architectural composition of the entire villa and frame the central temple front, Palladio designed the end of each portico as a subordinate and terminating frontispiece projecting forward slightly and consisting of three round-arched bays framed by four double-wide Doric piers with rectangular sculpture niches. The masklike keystones of the arches carry a simplified entablature, which supports a square attic framed by volutes and capped with a triangular pediment echoing the pediment of the central frontispiece. The eight niches at the ends of the two *barchesse* wings contain classical divinities, executed in stucco by Marcantonio, who were closely associated with farm life and nature's fruitfulness: Venus, Bacchus, Ceres, and Apollo on the west end and Mercury, Diana, Vertumnus, and Pomona on the east—deities respectively of fertility, grape vines, wheat, the sun, flocks, hunting, gardens, and orchards. The surface of each attic provided space for a sundial, about which Daniele had special expertise, having written an unpublished treatise on their construction. The room behind each attic served as a dovecote, to provide birds for the table and fertilizer for the wheat fields. The ground-floor rooms behind

259. Plan and elevation, Villa Barbaro: **1** *crociera,* **2** Room of Olympus, **3** stairs down to the *barchesse,* **4** nymphaeum. From Andrea Palladio, *I quattro libri dell'architettura* (Venice, 1570), bk. 2, p. 51.

the porticoes of the *barchesse* were primarily service and storage rooms. In particular, Palladio's woodcut plan and elevation of the Villa Barbaro in his *Quattro libri* (bk. 2, p. 51; fig. 259) indicates that the room to the extreme upper left contained stalls for horses, while the room to the extreme upper right held the large storage jars for such items as olives, olive oil, and vinegar. The rooms on the upper level of the *barchesse* connected to the piano nobile of the central block, expanding the living quarters for Daniele and for Marcantonio and his family.

Except in the central frontispiece and the preexisting stone house, the relatively inexpensive construction technique that Palladio employed here, as in nearly all of his villas, consisted largely of brick covered with drafted plaster to simulate stone for the walls, a limited use of masonry vaults, and tiles for the roof.

The rooms at the back of the villa had convenient access to a large rectangular courtyard cut into the hill at the height of the piano nobile. To balance the hemicycle in front of the villa, the courtyard terminated in a semicircular nymphaeum fed by a natural spring, its design derived from similar classicizing nymphaea in papal villas in Rome, especially the Villa Giulia (1551–53), built for Pope Julius III (r. 1550–55). Palladio described the nymphaeum in his *Quattro libri* as follows: "This fountain forms a little lake that serves as a fishpond [providing food for the table]; having left this spot, the water runs to the kitchen [on the ground floor] and then, having irrigated the gardens to right and left of the road, which gently ascends and leads to the building, forms two fishponds with their horse troughs on the public road; from there it goes off to water the orchard, which is very large and full of superb fruit and various wild plants" (trans. Tavernor and Schofield, bk. 2, p. 51).

The dimensions that Palladio supplied on the woodcut plan and elevation of the Villa Barbaro show that he designed it according to a Pythagorean musical system of harmonic concordances. Considering just the main residential block, the two rooms on the front are twelve by twenty Vicentine feet (about fourteen inches each), a harmonic ratio of 3:5. The dimensions of middle rooms (six by twelve), in front of the stairs, are 1:2. The widths of the three back rooms (nine, eighteen, and nine), facing the nymphaeum, have a ratio of 1:2:1 and form ratios of 3:4, 3:2, and 3:4 with the widths of the two front rooms and the longer arm of the *crociera* (twelve, twelve, twelve). The width to length of the entire central residential block (thirty-six by seventy-two) is 1:2. And so on throughout the design. This harmonic—even fugal and symphonic—planning is impressive, especially because Palladio was working in part with a preexisting fabric. But in view of Daniele Barbaro's expertise in mathematics and architec-

tural theory and the fact that Palladio's complex harmonic designs date to after his first meeting with Daniele, it appears certain that the two men collaborated on the design of the Villa Barbaro. Indeed, excerpts from Daniele's commentaries on Vitruvius relate closely to the plan of the villa:

> The whole secret of art consists in proportionality.... It is not enough to order measurements simply one after the other, but it is necessary that those measurements be related to one another, that is to say that there must be some proportion between them.... The possibilities of using now one, now another proportion are unlimited.... Every work of art must be like a very beautiful verse, which runs along according to the best consonances, one followed by the other, until they come to the well-ordered end.... This beautiful manner in music and in architecture is called harmony, mother of grace and delight.... One cannot sufficiently praise the effect of proportion, on which is based the glory of architecture, the beauty of the work, and the miracle of the profession.

In other words, if agriculture was sacred, then the microcosm of the villa should be ordered according to harmonic ratios, to resonate in harmony with the macrocosm of God's universe.

Sculpture

Stone sculptures of classical deities decorate the axial approach to the villa. The fountain of Neptune in the center of the hemicycle to the south evokes Venice's maritime empire, the original source of the Barbaro wealth, from sea trade (fig. 256). As a Quos Ego type (see ch. 13), depicting the calming of the seas that Juno disturbed in her attempt to destroy the ships of the Trojans (Virgil, *Aeneid* 1.124–43), the figure of Neptune evinced maritime peace and balanced the bull in the pediment of the temple front, a sign of terraferma peace. Juno's usurpation of Neptune's sovereignty over the oceans, however, also suggested the potentially disruptive force of women's anger, pride, and vanity in the patriarchal Venetian social order.

The fountain is flanked on the west by Saturn, the god of agriculture, and on the east by Fortuna, the goddess of good fortune, both appropriate in the context of a prosperous farm. Yet Saturn can also signify all-devouring time and Fortuna bad luck, thus together warning of the risks of farming and the potential destructiveness of nature. The beginning of the wide carriageway is overseen on the east by a statue of Mars, the god of war, who signaled the strength of Venice's terraferma and recalled Marcantonio's many appointments concerned with its military defenses. Opposite Mars, Minerva, the goddess of wisdom, agriculture, and domestic crafts, alludes to the superb humanist education of the Barbaro brothers, which they used to further their new roles as gentlemen farmers. Yet this pair also expresses an undercurrent of disharmony, destruction, lust, and disruptive female empowerment, as Minerva was a goddess of war and in two famous contests over her authority bested both Mars and Neptune (Homer, *Iliad* 5.825–908; Ovid, *Metamorphoses* 6.70–82), and Mars remained always a brutal and destructive force, despite once having been tamed by an illicit love affair with Venus (Homer, *Odyssey* 8.266–365; Ovid, *Metamorphoses* 4.171–89).

At the end of the walkway toward the villa proper (fig. 257), Vulcan, the god of blacksmithing, stands at the west opposite his wife, Venus, the goddess of love, gardens, and fertility. Together they educe the farm's chores, the family's love, and nature's abundance. Yet since Venus cuckolded Vulcan in her lust for Mars, and Vulcan in revenge captured the lovers in an invisible net to expose them to the ridicule of the other gods, the pair also warned of the potential pitfalls of married life.

The series of freestanding sculptures conclude on either side of the four stairs leading up to the stone terrace. On a high pedestal to the east, Jupiter, the highest god in the Olympian pantheon and the ultimate source of all fertility, is paired with his wife, Juno, on the west, the goddess of marriage and childbirth. Since Jupiter's attributes of an eagle and lightning bolts could symbolize Christ and his supreme, divine power to save and damn, and Juno's attribute of a peacock traditionally signified immortality, the couple prefigured Christ and the Virgin and expressed the ultimate aim of the Barbaro brothers—to achieve salvation through faith and the practice of good works in patriotically serving the Venetian state. Indeed, immediately in front of Jupiter and Juno, on low pedestals, stand two sculptures of the lion of St. Mark with its paw on a globe, denoting the dominion and sovereignty of Venice and its sacred destiny to establish justice, peace, and prosperity and to prepare its citizens for the final judgment day. However, the infidelities of Jupiter and the cruel revenge that Juno took on her husband's many lovers once again imply a subtext of lust and discord.

The nymphaeum features a grotto in the center of the semicircular wall surrounding the fishpond, which has ten sculpture niches and a wide, low, curved triangular pediment (figs. 260 and 261). It is probable that Daniele conceived

and Marcantonio executed its program of stucco sculpture. Four colossal atlantids flanking the arched entrance to the grotto and the ends of the hemicycle support the pediment's cornice. Among them the stucco figures in the ten niches are paired left to right (reading from the hemicycle's ends toward the grotto) as follows:

Pan with tortoise and bladder	Satyress with wine skin, serpent, and flowers
Juno with peacock and flowers	Bacchus with leopard, grape leaves, and bird
Actaeon with two dogs and antlers	Diana with crescent moon, armor, bow, and quiver
Amphitrite with vase and dolphin	Neptune with trident (lost) and two hippocamps
Helios/Apollo with wings	Venus and Cupid with dolphin

The Italian couplets addressing the viewer inscribed under each figure help to elucidate the significance of the deities. While Pan and the satyress embody the untamed, wild, and even destructive Dionysian aspects of nature, Pan in his couplet specifically cautions against *sloth*, for "whoever is slow to perform good works ends up only with his hands full of wind" (i.e., not saved). The satyress asks, "Which was the most powerful in the world, wine, apple trees, or the serpent?" suggesting that evil and temptation in paradise (signified by "the serpent" and "apple trees") resulted in humanity's fall from grace, which was redeemed only by the Eucharist, thus making wine the most powerful. Together the two nature spirits evoke the Counter-Reformation doctrine that salvation depends both on God's gratuitous grace, channeled through baptism and the Eucharist, and on willed cooperation with grace through the performance of good works.

Juno warns against those who claim superiority over all, because "in the end *pride* results in grief." Bacchus comments that "whoever flies to heaven pure and immaculate [like the bird he holds, a common symbol of the resurrected soul] is freed from the howling of *envy*." In addition, this twice-born god of wine prefigured the twice-born Christ, who flew to heaven pure and immaculate and free of envy, and Juno, the goddess of marriage and childbirth, foreshadowed Christ's bride, the Virgin, the embodiment par excellence of humility, the opposite of pride.

Actaeon, attacked by his dogs and sprouting antlers on his head, warns against *lust:* "He who spies that which he ought not [i.e., the nudity of the goddess Diana] receives antlers instead of joy." As she draws an arrow from her quiver, Diana, dressed in a chiton, rhymes in Italian, "I flee Cupid [carnal love] and pursue wild beasts, as one does not conquer love [lust] without fleeing [avoiding temptation]." Yet as in the *poesie* by Titian (figs. 190 and 191), Diana, the chaste goddess of childbirth, protector of nature's wildlife, and a Virgin type, could also be the fickle goddess of destructive fortune, while Actaeon, the innocent everyman in search of divine enlightenment, could be understood as a Christ type.

The sea goddess Amphitrite, the wife of Neptune, cautions against *greed* and *envy,* "Don't with bitter longing usurp from others, since all rivers one day return to the sea [the dominion of Neptune]," presumably a reference to Juno's failed attempt to usurp Neptune's rule of the ocean during the Trojan war (Virgil, *Aeneid* 1.124–43). By contrast, Neptune complains with *wrath* as he raises his (lost) trident and frowns, "I rule the waves and the sea obeys me, but it is a pain to rule so far from heaven." Yet together Amphitrite and Neptune embody the fruitfulness of the sea and, by extension to the political and religious realms, the sovereign strength and prosperity of the Venetian maritime empire and the power of the water of baptism to cleanse the soul of the taint of original sin.

Helios/Apollo, the sun god, dressed in a chiton, proclaims in his couplet, "I alone announce to others that which I hear, so that everyone establishes his fame according to his deeds." This alludes to the myth that while making his daily passage across the sky in his chariot, Helios discovered Venus *lustfully* consorting with Mars and reported their indiscretion to Vulcan, who captured the lovers in a net and exposed them to the mockery of the other Olympian gods. This explains the unusual depiction of the sun god with wings and upraised head and arms, suggesting his journey across the sky but also alluding to Fame and Victory, both traditionally represented as winged. A sculpture designed to conflate the all-knowing sun, fame, and victory was surely intended to evoke the omnipotent resurrected Christ, the sun of justice, rewarding or withholding divine grace based on the merits of faith and works. The couplet under Venus, the goddess of love and beauty, suggests that she is a *glutton* for love: "I am the daughter of the sea and the mother of fire [i.e., Cupid, the embodiment of desire], but to extinguish [the heat of] love the ocean is insufficient." Yet as the goddess of spiritual love, Venus also foreshadowed the

260. Nymphaeum, left side, Villa Barbaro.

Virgin and evokes the pure devotion and faith required to achieve the benefit of Christ's redemptive sacrifice.

Above the arched opening to the grotto the Barbaro family coat of arms reigns supreme, while above Juno, Bacchus, Amphitrite, and Neptune are coats of arms that reference the husbands of Daniele and Marcantonio's sisters (Marietta married Giovanni de Canal in 1535 and Adriana married Andrea Gradenigo in 1538) and the wives of their father Francesco (Elena Pisani) and Marcantonio (Giustiniana Giustiniani). The insertion of these armorial bear-

ings into the sculptural program appears to serve as a warning to the family to avoid committing any of the seven deadly sins, which the couplets mention or imply. Yet the male-female pairing of the classical deities, the eight panels of classicizing trophies between the niches, the lush garlands straddled by cupids and strung along the spandrels of the niches, the infants riding seahorses in the corners of the pediment, and the putti and winged Victories in the center of the pediment supporting garlands draped around the arched entrance to the grotto all emphasize fertility, abundance, and peace on land and sea and em-

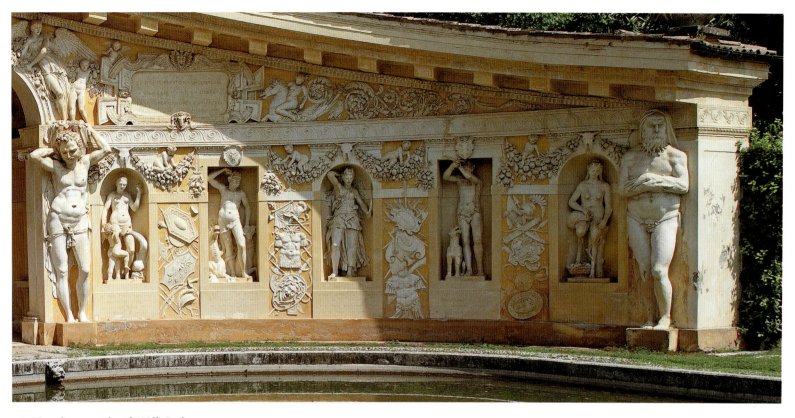

261. Nymphaeum, right side, Villa Barbaro.

body the Barbaro family's hope of achieving salvation through God's grace and their faith and good works for the Venetian state.

Combining nature and art, the back wall of the grotto (fig. 262) is constructed with lightweight porous pumice to imitate pumice caves found in nature, which in the Renaissance were believed incorrectly to manifest nature's process of generation rather than the destructive force of volcanic eruptions. The grotto's cave is also decorated with a large reclining river god and a small kneeling girl holding a goose. Since the Barbaro brothers are known to have owned a copy of Pausanias's *Description of Greece,* it appears certain that these statues derived from his description of the shrine at Lebadeia in central Greece dedicated to Trophonius, a son of Apollo who was swallowed up by the earth to become an underground oracle. Pausanias describes the grove of Trophonius by the river Herkyna as follows:

They say that here Herkyna [a nymph], when playing with Kore [Persephone], the daughter of Demeter [or Ceres, the goddess of the harvest], held a goose, which

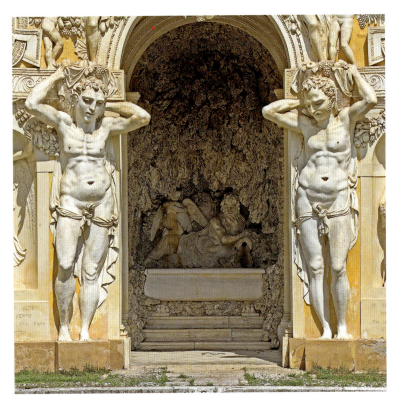

262. Nymphaeum grotto, Villa Barbaro.

against her will, she let loose. The bird flew into a hollow cave and hid under a stone; Kore entered and took the bird as it lay under the stone. The water flowed, they say, from the place where Kore took up the stone, and hence the river received the name Herkyna, in which is a maiden holding a goose in her arms. In the cave is the source of the river. (9.39.2–14)

Persephone—raped by Pluto, the god of the underworld, but allowed to return to earth once each year, bringing springtime and summer in her wake and then initiating fall and winter on her return to Hades (Ovid, *Metamorphoses* 5.385–424; *Fasti* 4.417–50)—embodied the unending cycle of nature's birth, death, and regeneration. The grotto at the shrine dedicated to Trophonius was

believed in antiquity to be Persephone's portal to and from the underworld. Therefore, the focal point of the hemicycle—the source of a life-giving spring yet also implicitly the gateway to the underworld—conjures both the cycle of the four seasons and the cycle of Christian life, from birth to life to death to renewed life.

The entire decorative program, in sum, creates interlocking associations between the Barbaro family, the fertility of the nature, the prosperity and sacred destiny of the Venetian state, and the family's hope for salvation through their good works and the sacraments of baptism and the Eucharist, even amid the temptations of the seven deadly sins, challenges to patriarchal authority, and the ever present fears of famine, plague, war, destruction, and death.

Frescoes

As a master of illusionistic classicizing architecture (e.g., figs. 145 and 146), Veronese created a graceful and ordered structural system of decoration in the cruciform hall and the six principal rooms of the Villa Barbaro, which harmonized perfectly with Palladio's architecture. In the *crociera* he frescoed a series of paired fluted Corinthian columns and piers that appear to support Palladio's cornice and intersecting barrel vaults (fig. 263). The columns also frame eight simulated sculpture niches in the transverse arms of the *crociera* and six arched openings in the longitudinal arms. The six arched openings appear to give on to lush, idyllic landscapes filled with classical ruins, echoing Palladio's three arched windows at the ends of the *crociera* with views of the actual landscape. The barrel vaults were originally frescoed with the classical motif of a vine-covered trellis (also revived in Renaissance Roman villas, including the hemicycle at the Villa Giulia), which further enhanced Veronese's dialectic between stable enclosure and open nature across time from antiquity to the present, which also informs Palladio's architectural design.

In the niches, Veronese depicted eight classically dressed women in various states of contrapposto with musical instruments—tambourine, portable organ, trumpet, flute, recorder, lute, lyre, and viola. They visualize the underlying harmonic plan of the villa and its resonance with the music of the spheres. Cameos under the musicians depicting mounted warriors and the displays of trophies—lances, pikes, halberds, banners, and trumpets—in the corners flanking the real windows symbolize the potential for war and discord always present in the Renaissance Venetian world but here triumphantly held at bay by classicizing order and harmony. Finally, representations of an adult and a child—perhaps Barbaro family members—appear to enter the transverse arms

263. Cruciform hall (*crociera*) with frescoes by Paolo Veronese, Villa Barbaro.

264. Paolo Veronese, landscape, c. 1560–62, fresco, east wall, Room of Olympus, Villa Barbaro.

of the *crociera* through illusionistic doors opposite the pair of actual doors. They add a lighthearted note of spontaneity and contemporaneity to the otherwise rather nostalgic evocation of a lost classical golden age and the hope for paradise regained.

In the villa's main *salone*—the barrel-vaulted, nearly square Room of Olympus—the door and two windows on the north wall open on to the nymphaeum. Flanking the doors on the other three walls, Veronese frescoed pairs of fluted Corinthian columns raised on an elaborate base that appear to support the cornice and the barrel vault above (fig. 264). Between the columns, he created four illusionistic rectangular openings in the east and west walls that show distant classicizing landscapes. Between the paired columns on the south wall, by contrast, he depicted two niches filled with simulated bronze allegories of Peace and Faith.

In the barrel vault Veronese represented the heavenly cosmos of the Olympian gods (fig. 265). In the center of the octagonal opening to the sky he depicted the rather esoteric Aristodama astride a dragon, based on Pausanias's

265. Paolo Veronese,
Olympian Cosmos, c.
1560–62, fresco, vault,
Room of Olympus,
Villa Barbaro.

266. Paolo Veronese, *Allegory of Winter and Spring*, c. 1560–62, fresco, lunette, Room of Olympus, Villa Barbaro.

267. Paolo Veronese, *Allegory of Summer and Fall*, c. 1560–62, fresco, lunette, Room of Olympus, Villa Barbaro.

description of the shrine of Asclepius at Sicyon: "There are various figures that appear suspended from the ceiling. The woman who is seated on the dragon they say is Aristodama, the mother of Aratus, who here is honored as the son of Asclepius" (*Description of Greece* 2.10.3). As the wife of Asclepius—the classical god of physical healing, who prefigured Christ, the deity of spiritual healing—Aristodama, silhouetted against a circle of divine illumination, is surely intended to allude to the Virgin Mary, the embodiment of divine Wisdom and the Church. Her domination of a dragon, a traditional symbol of evil, chaos, and heresy, also suggests divine harmony. Surrounding Aristodama, Veronese represented embodiments of the ancients' seven planets—Jupiter, Mars, Apollo (the sun), Venus, Mercury, Diana (the moon), and Saturn—accompanied by the twelve zodiacal signs. Embodiments of the four elements sit on clouds seen through illusionistic openings in the corners: Neptune (water), Juno (air), Vulcan (fire), and Cybele (earth).

In the north and south lunettes of the barrel vault Veronese represented the four seasons. In one (fig. 266), Vulcan with blacksmith's tongs embodies winter, while his nude, reclining wife, Venus—decked out with jewels and accompanied by her four handmaidens, the Hours, and four winged cupids—personifies spring. Persephone, just behind Vulcan and Venus, holds a chariot yoke, alluding to her annual passage to and from Hades, thus embodying the

transition between winter and spring and the cycle of life, death, and regeneration. The Hours and the cupids gather and scatter Venus's sacred roses to underline the fertility of spring. The Hour to the extreme right offers maternal love to a reclining and smiling cupid, while the leftmost Hour disarms a cupid by taking his quiver of arrows, which indicates that he represents Anteros, who inspires the production of happy, healthy children through married love, in contrast to the illicit lust that the blindfold Eros, depicted with Vulcan in the corner opening just above and to the right, provokes by randomly shooting arrows.

In the lunette opposite (fig. 267), Ceres, the goddess of the harvest and embodiment of summer, holds a sheaf of wheat and displays wheat in her hair. To her right, Bacchus, the god of wine and personification of fall, crushes grapes over a bowl. Five nymphs and two cupids accompany them. One cupid reclines on a bed of wheat, while the other holds a cornucopia filled with grapes, together surely intended to evoke the sacrament of the Eucharist.

Behind an illusionistic balcony to Aristodama's left, the elegantly but modestly dressed wife of Marcantonio Barbaro, Giustiniana Giustiniani (cf. fig. 223), holds Venus's roses of love and marriage, her youth, nobility, and beauty set off by her children's old nursemaid to her left. A parrot on the balustrade signals her aristocratic rank, while a toy spaniel symbolizes her marital fidelity.

268. Andrea Palladio, Villa Emo, c. 1555–61, Fanzolo.

269. Living quarters, Villa Emo.

She embodies, in short, the ideal Renaissance wife, who maintained the social order of the villa household, reflective of the cosmic order represented in the vault above. To Giustiniana's right appears her youngest child, Alvise (1554–1611), while on the opposite balcony Veronese represented her two oldest sons alive at the time—Francesco (1546–1616) and Ermolao or Almarò (1548–1622). Together they represent the four ages of humanity: infancy, adolescence, maturity, and old age.

The four spiral columns illusionistically supporting the octagonal opening to the heavens imitate those in the church of St. Peter's in Rome that mark the tomb of St. Peter and were believed to have come from the Temple of Jerusalem (see also fig. 243). In this context, these columns transform the whole classicizing universe of the Olympian gods into a harmonious celestial new Jerusalem to emphasize the sacredness of agricultural life. Finally, the octagonal opening through which the Olympian gods appear was probably intended to symbolize

Christ's resurrection on the eighth day after his entry into Jerusalem and the Barbaro family's hope for salvation.

PALLADIO'S VILLA EMO AT FANZOLO

The noble Emo family had owned farmland around Fanzolo near Treviso since at least the fifteenth century, but they expanded their holdings tenfold, to more than two hundred hectares (about five hundred acres), between 1505 and 1564. They also invested in extensive irrigation canals to water their fields, which grew various grains, including maize, recently imported from the New World. Leonardo Emo (1532–86) inherited the Fanzolo estate from his grandfather of the same name (d. 1540) and his uncle Giovanni Emo (d. 1549) but came into possession of the land only in about 1553, when he turned twenty-one. In about 1555 he commissioned Palladio to construct a magnificent

270. Plan and elevation, Villa Emo: **1** entrance porch, **2** vestibule, **3** *salone,* **4** *barchesse.* From Andrea Palladio, *I quattro libri dell'architettura* (Venice, 1570), bk. 2, p. 55.

villa, which was completed well before his 1565 marriage to Cornelia Grimani (d. 1601), who bore him two sons and eight daughters—of whom three married nobles, four became nuns, and one remained at home.

Palladio located the villa directly in the fields and aligned its longitudinal and transverse axes with the general orientation of the surrounding fields and roads (fig. 268), which in turn reflected the ancient centuriation—the surveyed grid of square plots that the Romans used for the layout of villages, fields, and roads. He enhanced the link to this long history of farming in the area by designing a characteristic classicizing two-story, four-columned Doric temple front projecting slightly from the center of the principal façade, with the

Emo coat of arms in the pediment, supported by two reclining winged Victories (fig. 269). He emphasized the piano nobile of the tiled, hip-roofed central rectangular block of rooms by elevating it on a high podium containing the semibasement kitchen, storage areas, and service rooms. A wide paved walkway establishes the central axis of the design and terminates in a long vaulted ramp that in three gentle stages provides access to the wide, deep, and high entrance porch, with a beamed and coffered wooden ceiling, on the piano nobile. The large central door of the porch opens on to a barrel-vaulted vestibule, which is flanked by the stairwells leading to the upper mezzanine and lower basement rooms (fig. 270). From the vestibule one enters the main *salone,* at

the back, with a high beamed and coffered wooden ceiling flooded with light from two banks of windows and a doorway opening on to a stairway down to the rear garden. Doors in enfilades on the piano nobile allow easy circulation through the seven rooms and the porch arranged around the vestibule. The two *barchesse* attached symmetrically to this central block contain, in Palladio's words, "the wine cellars, granaries, stalls, etc., . . . and at the extreme ends two dovecotes" (*Quattro Libri,* Bk. II, p. 55).

The dimensions that Palladio provided on his woodcut of the plan and elevation show that he created a proportional design using almost entirely simple harmonic ratios based on multiples of one, two, three, and five. The front two rooms in the central block flanking the porch each measure sixteen by sixteen Vicentine feet, and the large *salone* measures twenty-seven by twenty-seven—ratios of 1:1. The dimensions of the two rooms flanking the *salone,* sixteen by twenty-seven, are based on the harmonic progression of 16:18:24:27 and use its 2:3 ratios, 16:24 and 18:27. The rooms in the *barchesse* measure twelve by twenty (3:5), twenty-four by twenty (6:5), and forty-eight by twenty (8:5), a harmonic progression of 12:24:48, with ratios of 1:2. The dimensions of the porticoes of the *barchesse*—two (the thickness of the Doric piers), three (the width of the piers), nine (the space between the piers), twelve (center to center of the piers), and fifteen (the width of the porticoes)—produce harmonic ratios of 2:3, 1:3, 3:4, and 4:5. In sum, this compact and harmonious design of utmost simplicity, utility, and comfort, based on the classical planning principles of axiality, symmetry, focus, hierarchy, and unity, was ideally suited to the Venetian gentleman farmer.

PALLADIO'S VILLA ROTONDA NEAR VICENZA

The Villa Almerico, or Villa Rotonda, just outside Vicenza (fig. 8), was commissioned by Paolo Almerico (1514–89), who, according to Palladio (*Quattro Libri,* bk. 2, p. 18), had retired from serving Popes Pius IV (r. 1559–65) and Pius V (r. 1566–72) as a referendary—the recorder of and adviser on petitions addressed to the pope. Different from most of Palladio's villas, the Villa Rotonda was built as a suburban retreat where the retired cleric could entertain and relax, not as a working farm, although when it was sold to the Capra family in 1591, it did become the center of their vast agricultural estate, with *barchesse* built by Vincenzo Scamozzi. It was also not in the fields but on a hilltop, to take advantage of the magnificent panoramic views and the cooler

breezes during the hot summers. This location encouraged Palladio to create his most compact and centralized design, with four identical façades (fig. 271) oriented to the ordinal points of the compass for enjoying "the delightful surrounding hills, which have the aspect of a very large theater, all cultivated and abundant in excellent fruit and very fine produce" (*Quattro Libri,* bk. 2, p. 18).

The vaulted ground floor, square in plan, contains the storage and service rooms and a central cistern, surrounded by an annular-vaulted passageway (fig. 272). It serves as a podium for the piano nobile, reached by stairways attached to all four façades. Each stairway, also square in plan, is supported by a vaulted passageway with doors opening into the service rooms. The stairways, contained within ten-foot-high walls, lead to platforms that each support a tile-roofed and cove-vaulted entrance porch articulated on the sides with an arched opening and on the front with six freestanding Ionic columns carrying a full entablature and a corbeled triangular pediment, the peak of which corresponds to the height of the upper story. The entablatures of the temple fronts wrap around the entire building, unifying the four porches with the rest of the building and separating the piano nobile from the upper story. Palladio designed the block of rooms on the piano nobile and the floor above, containable within a cube, around a two-story cylindrical rotunda thirty feet in diameter, capped by a hemispherical dome to focus and unite both the exterior and the interior.

The large central door of each porch opens on to a barrel-vaulted passageway leading directly to the central rotunda. Four larger rooms and four smaller rooms, all with doors in enfilades for easy circulation, surround the rotunda. The four small triangular spaces reached from doors in the rotunda contain stairways down to the ground-floor service rooms and up to a balcony with a balustrade surrounding the inside of the rotunda, which provides access to the upper rooms, arranged in the same pattern as the rooms on the piano nobile.

The design of the Villa Rotonda marks an important event in the history of architecture. For the first time the two most unique features of classical religious buildings—the Greek temple front, with columns, architrave, and pediment, and the Roman cylindrical interior with a hemispherical dome—were combined in a secular building. The invention of this hybrid resulted in part from the desires of the patron, who had long lived in Rome and knew classical architecture firsthand, in part from the hilltop site, and in part from the evolution of Palladio's classicizing style toward ever greater unity and clarity. Once he had conceived, built, and publicized it, the Villa Rotonda became the

271. Andrea Palladio, Villa Rotonda, 1566–70, Vicenza.

most influential example of Renaissance architecture. It constitutes the ur-source of literally hundreds of governmental buildings throughout the world. This enormous popularity resulted from the close correspondence between what governments wanted to believe they represented and what the design expressed—stability, focus, hierarchy, unity, harmony, and mediation between earth (symbolized by the square and cube) and heaven (signified by the circle and hemisphere).

272. Plan, elevation, and section, Villa Rotonda, from Andrea Palladio, *I quattro libri dell'architettura* (Venice, 1570), bk. 2, p. 19.

CONCLUSION
Patronage

Patronage underlies the flourishing of all Venetian art production—regardless of genre, style, function, subject matter, or material.

The Venetian state was by far the most important patron of the city's art and architecture. To a degree without precedent in other European cities, the government was the largest owner of the city's land and real estate, with unfettered control over the major hubs, including the Piazza and Piazzetta S. Marco, the Rialto, and the Arsenal (figs. 2–4). Decisions to architecturally develop state-owned property could originate in the Maggior Consiglio (fig. 5, piazzetta wing), the Collegio (figs. 106 and 107), or the Senate (fig. 14). Strong-willed doges the likes of Francesco Foscari, Agostino Barbarigo, and Andrea Gritti were also able to imprint their personal agendas on state projects (figs. 10–14 and 97). The powerful Council of Ten (which usually met with the doge and his six councilors), however, either ordered or approved nearly all state architectural commissions (figs. 106–11, 114, and 115). An ad hoc or standing committees of noble *provveditori* (overseers), usually chosen from the Senate, had responsibility for the oversight of each project. The state's four largest hospitals, for example, were built and managed by the Provveditori alla Sanità (Public health overseers) or the Provveditori sopra gli Ospedali (Hospital overseers); the streets, bridges, and waterways by the Provveditori di Comun (Communal overseers); and the navigational channels and lagoon defenses by the Magistrato alle Acque (Waterways commission) or the Provveditori alle Fortezze (Fortress overseers).

The Salt Office—located on the Rialto and staffed by the Provveditori al Sal (Salt commissioners), six nobles chosen from the Senate—oversaw the sale of salt, a state monopoly, produced in the salt pans of Chioggia (fig. 8); it also collected the rents from the shops, stalls, warehouses, and quays on the Rialto. With these considerable funds, the Salt Office financed the majority of the state architectural projects, especially on the Rialto but throughout the city as well (figs. 10 and 127–31). To assist them, the *provveditori* employed a *protomaestro* (architect), such as Bartolomeo Bon il Bergamasco or Antonio Scarpagnino, and other specialists as necessary.

However, responsibility for overseeing the maintenance and improvement of the Piazza and Piazzetta S. Marco and their surrounding buildings (figs. 3 and 95–105) fell primarily to a group called the Procuratia de Supra. Appointed for life, these procurators developed considerable expertise and provided continuity and consistency in the development of city's governmental center. They also employed their own *protomaestro*—such as Pietro Bon, Jacopo Sansovino, or Simon Sorella—to make recommendations and manage projects, which were funded primarily by offerings made to the church of S. Marco and the rents collected from the shops, taverns, apartments, hostelries, banking tables, and market stalls on the piazza and piazzetta. Two other groups of procurators—the Procuratia de Citra and the Procuratia de Ultra—were responsible for the supervision of state projects on either side of the Grand Canal (fig. 6), including the state-run hospitals and several hundred rental houses and hospices maintained for Venetians and pilgrims. The Salt Office, rents, bequests, taxes, and state investments in Venice and on the terraferma financed the projects of the procurators *de citra* and *de ultra*.

Paintings, frescoes, stucco work, and sculpture decorating the exterior and interior of the Doge's Palace (figs. 112 and 224–46) and such state office buildings as the Fabbriche Vecchie and Palazzo dei Camerlenghi were generally commissioned by the Senate or by officials—both nobles and citizen bureaucrats—who worked in particular meeting rooms or offices. These projects were usually approved by the Council of Ten and financed by the Salt Office. The decoration of the Library (fig. 104), however, was commissioned and financed by the Procuratia de Supra. Like architectural projects, decorative campaigns were usually overseen by a standing or ad hoc committee of *provveditori* who hired the artists and devised the programs, sometimes with the aid of specialists, as in the case of the redecoration of the Maggior Consiglio after the 1574 and 1577 fires (figs. 230–46), in which two patrician members of the Maggior Consiglio, Jacopo Marcello and Jacopo Contarini, collaborated with the Camaldolese monk Girolamo Bardi.

The Salt Office also funded the *sansaria,* an annual benefice of 120 ducats for a leading painter of Venice, whom the Senate chose, including most notably Gentile Bellini, Giovanni Bellini, and Titian. The primary responsibility of this semiofficial state artist was painting portraits of the doges (figs. 91 and 204) and votive and history paintings to adorn the Doge's Palace. Doges were expected to help decorate the major meeting rooms of the Doge's Palace at their own expense, by commissioning votive paintings commemorating their deeds, giving thanks for divine intervention, and glorifying the state (fig. 229).

After the state, confraternities were the most significant patrons of Venetian art and architecture. Not only did the six *scuole grandi* (large confraternities) construct and richly decorate showy meeting halls (figs. 9, 48, 53–57, 62–67, and 147–67), but so too did a number of the *scuole piccole,* or small confraternities (fig. 17, no. 5; figs. 58–61 and 68–71). At the very least, nearly every *scuola piccola*—and by the end of the sixteenth century there were well over two hundred—commissioned at least one altarpiece, whether for its meeting hall or the chapel in a monastic or parish church where it assembled (fig. 50). In addition, all the wealthy *scuole grandi* and a number of the *scuole piccole* built and managed hospitals, hospices, rest homes, rental housing, and pharmacies to serve their members and raise money to further their charitable activities. By the end of the sixteenth century, for example, the Confraternity of St. Roch owned about one hundred houses and apartment blocks and the Confraternity of St. John the Baptist about eighty. Members of the citizen class administered the large confraternities and as part of their duties generally chose the

projects, programs, architects, and artists, which membership fees, dues, bequests, rents, and special assessments on the wealthiest members funded.

Wealthy Venetian nobles constituted the third important block of art and architectural patronage. They built the grand palaces along the Grand Canal and other important waterways (figs. 72–75 and 168–71) and the villas that dotted the agricultural estates on the terraferma (figs. 248, 249, 252–59, and 268–70). These palaces and villas were sumptuously adorned with devotional and secular paintings (figs. 82, 178, 181, 182, 192, and 263–67), portraits (fig. 89), sculptures (figs. 260–62), textiles, ceramics, and other decorative arts. Most noble families also owned the rights to a burial chapel in some church, and for those rights they were expected to ornament the chapel with tombs, altarpieces (figs. 52, 136, and 140), paintings, furnishings for the Mass, and vestments for the priest and to fund an endowment for the maintenance and servicing of the chapel or even for the construction of the church itself, as at S. Francesco della Vigna (figs. 116–19). Ducal families in particular competed with one another to erect grand tombs to commemorate a doge's greatest deeds and to exalt Venice (figs. 35–40 and 143). Many noble families, such as the Badoers and the Priulis, engaged in charity by constructing and maintaining private hospices for individuals in need—the destitute, sick, aged, or widowed—or by offering financial assistance to a confraternity, such as the Loredan family's support of the Confraternity of St. Ursula (fig. 61). Most noble patrons were men, but a few women, mostly widows, also commissioned art works (figs. 93 and 94) or oversaw the completion of projects that their husbands had begun (figs. 137 and 140).

Some citizen-class merchants and civil servants were wealthier than many nobles and enjoyed a patrician lifestyle, with impressive villas, burial chapels (fig. 138), and palaces (fig. 76) that were richly decorated (figs. 179, 180, and 184), even though they were excluded from the governance of the state. In one notable case, a *cittadino* family even spearheaded the construction of a major church (figs. 28–30). In addition, educated and prosperous citizen professionals, such as doctors, lawyers, notaries, scholars, and civil servants, often commissioned works of art, especially portraits (figs. 90 and 205) and devotional paintings or, less frequently, altarpieces.

Ecclesiastics—especially abbots (figs. 19–22, 120–26, 133–34, 142, and 144–46), abbesses (figs. 23–27 and 45), and parish priests (fig. 141)—often supported by noblemen and noblewomen (figs. 31–34), were also important patrons of art and architecture, building and rebuilding churches and refectories and overseeing their decoration. State subventions of money and materials often aided

churches important for state rituals, such as S. Zaccaria (figs. 23–27), S. Salvador (figs. 114 and 115), and S. Giorgio Maggiore (figs. 120–26). Many religious orders—especially the new sixteenth-century reforming orders, such as the Jesuits and Theatines—founded and managed hospitals for plague and typhus victims, orphanages for foundlings, and shelters for young girls, reformed prostitutes, battered wives, and so on. By the end of the sixteenth century, Venice had more than forty such hospitals, hospices, and shelters, built and managed by a combination of the state, confraternities, guilds, noble families, and religious orders.

In the Venetian terraferma and maritime centers outside Venice, local nobles, ecclesiastics, citizens, and even mercenary knights were eager to acquire high-quality Venetian paintings produced in the city's numerous workshops (figs. 49, 86, 132, and 135). But in the Italian and other European courts, the demand was almost exclusively for the works of Titian and to a much lesser extent for those of Bellini and Veronese (figs. 175, 185–91, 193–96, 203, 206–8, and 217–19). Titian's many self-portraits (figs. 137, 139, 209, and 210), which promoted his unique genius; his inimitable portraits capturing a convincing physiognomic likeness and psychic presence while also conveying social status, dignity, intellect, and strength, which transformed the Venetian portrait tradition (figs. 203 and 206–8); and his complex, classicizing, and often erotic *poesie* (figs. 186–91), which revitalized Venetian narrative painting, strongly appealed to the sophisticated and erudite European courts. Titian exploited the demand for his paintings by charging much higher prices—sometimes twenty times higher—than the going rates in Venice, making him by far the richest painter in Renaissance Venice. His ambition, greed, self-promotion, and international circle of aristocratic patrons were major disruptive influences on how painters viewed themselves in traditional Venetian workshops and guilds, leading one

major scholar (T. Nichols, 2013) to view Titian's career as marking the end of the Renaissance.

A unique characteristic of Venetian art production was the substantial, widespread, and continuous patronage over centuries by the state, made possible by the government's wealth, power, stability, and longevity. Protected by the waters of its lagoon, Venice never experienced the disruptive and destructive waves of competing regimes and shifting political agendas common to most other Italian cities. Venetian artistic styles and techniques were thus slow to change, and when they did, new modes were generally absorbed without the abrupt abandonment of the old. The persistence of established and widely shared traditions was fostered by the broad participation of the patrician class in the government, the elaborate mechanisms established to prevent any individual or family from seizing absolute control, and the ideology of *mediocritas*—the notion that individuals of all classes (nobility, *cittadini,* and *popolani*) always had to subordinate their ambitions, deeds, and social interactions to the common good and the well-being of the republic. The carefully crafted ideology, refined over centuries, of Venice as the new Constantinople, the new Rome, and a divinely favored new Jerusalem, with a sacred mission to Christianize and civilize its subjects, also gave artistic expression—in works patronized mostly by the elite—a special character: the repeated exaltation of the state, especially its sanctity, piety, and justice. Patrons of squares, administrative and office buildings, churches, confraternities, palaces, hospitals, and hospices, therefore, all generally understood their patronage as a means of upholding state ideology. Artists and architects also believed that their role was to glorify the republic and subordinate their creative innovations to expressions of piety and justice. As a result, Venice exhibits a cohesion and unity that make it one of the most artistically unique and striking cities in the world.

TIMELINE

Politics, Religion, and Culture	Architecture and Sculpture
1400–1425	
1401 Venice annexes Corfu.	1400–13 First monumental sculptural representation of the doge kneeling before the lion of St. Mark, on the south (Molo) façade of the Doge's Palace.
1404–54 Major Venetian expansion into the terraferma.	1421–36 Ca' d'Oro by Matteo Roverti and Giovanni and Bartolomeo Bon.
	1424–38 Piazzetta wing of the Doge's Palace built.
	1423 Pietro Lamberti and Giovanni di Martino da Fiesole carve the tomb of Tommaso Mocenigo in SS. Giovanni e Paolo.
1425–1450	
1435 Leon Battista Alberti's treatise *On Painting* published in Latin.	Bartolomeo Bon constructs the Porta della Carta, which includes a figure of Fortitude.
1436 Alberti's treatise *On Painting* published in Italian.	1439–98 Arco Foscari constructed.
1440 Venice annexes Ravenna.	1442–44 Chapel of S. Tarasio in S. Zaccaria rebuilt in its present Gothic form.
	1440s Villa Porto-Colleoni at Thiene constructed.
	1447–60 Alberti constructs the Tempio Malatestiano in Rimini.
1450–1475	
1452 Alberti completes *On the Art of Building in Ten Books*.	c. 1453–54 Ca' Foscari constructed.
1453 The Turks conquer Constantinople.	c. 1455–70 Alberti constructs the Palazzo Rucellai in Florence.
1454 Peace of Lodi among Venice, Milan, and Florence establishes a stable Italian balance of power for four decades.	

Painting	Reigns of European Sovereigns	Reigns of Doges
	HAPSBURGS: 1424–93 Frederick III, archduke of Austria **POPES:** 1417–31 Martin V **OTHERS:** 1387–1437 Sigismund, king of Hungry and Croatia 1412–47 Filippo Maria Visconti, duke of Milan	1400–1413 Michele Steno 1414–23 Tommaso Mocenigo 1423–57 Francesco Foscari
c. 1432–34 Michele Giambono, *Portrait of a Man*. 1443 Antonio Vivarini and Giovanni d'Alemagna, *S. Tarasio Chapel Polyptych,* in S. Zaccaria. 1446 Antonio Vivarini and Giovanni d'Alemagna, *Virgin and Child with Four Latin Doctors,* for the *albergo* altarpiece of the Confraternity of St. Mary of Charity, now in the Gallerie dell'Accademia. Late 1440s Jacopo Bellini, Lovere *Virgin and Child*.	**POPES:** 1431–47 Eugenius IV 1447–55 Nicholas V **TURKS:** 1444–46 Sultan Mehmed II **OTHERS:** 1433–44 Gianfrancesco Gonzaga, marquis of Mantua	
c. 1455–60 Giovanni Bellini, Davis Madonna. 1460s Giovanni Bellini, *Blood of the Redeemer*. c. 1462–69 Lazzaro Bastiani, *Doge Cristoforo Moro*.	**POPES:** 1455–58 Callistus III 1458–64 Pius II 1464–71 Paul II	

Politics, Religion, and Culture	Architecture and Sculpture

1450–1475 continued

1457 Doge Francesco Foscari deposed for his son's corruption and treason.

1462 Senate authorizes a one thousand ducat subvention for S. Zaccaria.

1463–79 Venetian-Turkish war.

1464 Pope Pius II launches the Second Crusade in Ancona; it is cancelled when he dies that year.

1468 Cardinal Bessarion gifts his personal library of about one thousand manuscripts to Venice.

1469 Holy Roman Emperor Frederick III knights Gentile Bellini.

1470 Venice loses Negroponte to the Turks.

1471 Venetians break the Turkish siege of Scutari.

1457–70s Niccolò di Giovanni Fiorentino carves the tomb of Francesco Foscari in S. Maria Gloriosa dei Frari.

1458–90s Antonio Gambello and Mauro Codussi rebuild S. Zaccaria.

c. 1467–70 Pietro Lombardo carves the tomb of Pasquale Malipiero in SS. Giovanni e Paolo.

1468–80s Codussi constructs S. Michele in Isola.

1470s–early 1480s Antonio Rizzo carves Adam, Eve, and Mars for the Arco Foscari.

1475–1500

1478 Plague in Venice kills about thirty thousand inhabitants.

1479 Treaty of Constantinople, by which the Venetians lose all but three of their fortresses in Albania—Negroponte, Scutari, and Lemnos—to the Turks, whom they also have to pay an annual tribute of ten thousand ducats for trading rights in the Black Sea.

1483 Fire in the east wing of the Doge's Palace.

1485 Decree creating a new ritual of ducal coronation.

1485 *Life and Death of Jerome* (*Hieronymus vita et transitus*) published in Venice.

1486 First Latin edition of Alberti's *On the Art of Building in Ten Books* published.

1489 Venice annexes Cyprus.

1494–1559 Italian Wars.

1494 Canon Pietro Casola's visit to Venice.

1495 League of Venice formed to engage Charles VIII, the king of France.

1497 Arnold von Harff's visit to Venice.

1498 Vasco da Gama sails around the Cape of Good Hope.

1499 Publication of Francesco Colonna's *Hypnerotomachia Poliphili* in Venice.

1499–1503 Venetian-Turkish war. Venice loses bases at Lepanto near the Gulf of Corinth and at Coron, Modon, and Navarino in the Morea to the Turks.

1476–80 Rizzo carves the tomb of Niccolò Tron in the Frari.

c. 1476–81 Pietro, Tullio, and Antonio Lombardo carve the tomb of Pietro Mocenigo in SS. Giovanni e Paulo.

1480–89 Pietro Lombardo constructs S. Maria dei Miracoli.

c. 1486–97 Rizzo constructs the Scala dei Giganti.

1487–95 Pietro Lombardo and Codussi construct the Confraternity of St. Mark, whose façade includes two large reliefs from the life of St. Mark by Tullio Lombardo.

c. 1488 Ca' Dario constructed.

1491–1505 Codussi constructs S. Maria Formosa.

c. 1492–95 Tullio Lombardo carves the tomb of Andrea Vendramin, now in SS. Giovanni e Paolo; includes a figure of Adam.

1496–99 Codussi constructs the Clock Tower.

1498–1505 Codussi constructs the staircase for the Confraternity of St. John the Evangelist.

1500–1525

1500 Venice annexes Cremona.

1501 Senate establishes a Ministry of Waters.

1501–6 Pietro Lombardo adds wings to the Clock Tower.

c. 1502–9 Codussi renovates the Palazzo Loredan.

1527–29 Severe epidemic of plague and typhus in Venice.

1528 Ospedale dei Derelitti founded to care for plague victims, orphans, the destitute, the sick, and widows.

1528 Baldassare Castiglione's *The Courtier* published in Venice.

1529 Ottoman Empire controls most of North Africa from Egypt to Morocco.

1529–30 Treaty of Barcelona and Peace of Bologna. Venice's pre-Agnadello terraferma empire is recognized but Venetian expansion on the Italian mainland is over.

1530 Florence falls to troops of Charles V after a long siege.

1530 Casa delle Convertite founded to offer refuge to reformed and aging prostitutes.

1532 Forces of Charles V defeat the Turks in central Hungry.

1535 Charles V creates Titian a count palatine and knight of the golden spur.

1535 Pietro Aretino's *Humanity of Christ* published in Venice.

1535 Forces of Charles V capture Tunis from the Turks.

1536 Fraterna dei Poveri Vergognosi founded to assist financially, medically, and materially impoverished nobles.

1537 Sebastiano Serlio's *General Rules of Architecture Concerning the Five Orders for Buildings* published in Venice.

1537–40 Venetian-Turkish war.

1538 The Turks defeat the Holy League at the battle of Preveza.

1540 Venice signs a peace treaty with the Turks conceding the loss of most of its bases in the Morea, the Aegean, and parts of Croatia and pays three hundred thousand ducats in war indemnification. End of Venetian maritime expansion.

1540 Serlio's *Antiquities of Rome* published.

1541 Alessandro Caravia's *Dream of Caravia* published in Venice.

1542 Pope Paul III reestablishes the Inquisition.

1543 *Beneficio di cristo* published Venice.

1545 Senate appoints three overseers to assist in land reclamation in the terraferma.

1545 *Dialogue on the Institution of Women* by Lodovico Dolce published.

1545–47 First session of the Council of Trent.

1546 First Italian edition of Alberti's *On the Art of Building in Ten Books* published in Venice.

1547 Venetians appoint a commission of three overseers to work with the Inquisition in Venice.

1548 *Dialogue on Painting* by Paolo Pino published in Venice.

1548 Diet of Augsburg and the Augsburg Interim.

1548 Titian travels to Augsburg.

1535 Memorandum of understanding between Francesco Giorgi and Sansovino concerning the design of S. Francesco della Vigna.

1537 Sansovino begins the redesign of the Piazza and Piazzetta S. Marco.

1537–90 Sansovino and followers construct the Library.

1530s Giangiorgio Trissino constructs the Villa Trissino at Cricoli.

1538–45 Sansovino constructs the Loggetta, which includes the relief *Jupiter Receiving a Scepter from an Eagle on Crete* and bronze statues of Apollo and Mercury.

1538–45 Sansovino constructs the Palazzo Dolfin.

c. 1540s Sansovino constructs the Villa Garzoni at Pontecasale.

c. 1545–c. 1582 Sansovino rebuilds the Palazzo Cornaro della Ca' Grande.

Painting	Reigns of European Sovereigns	Reigns of Doges
c. 1500 Gentile Bellini, *Caterina Cornaro*.	**HAPSBURGS:**	1501–21 Leonardo Loredan
1502 Carpaccio, *Funeral of St. Jerome,* for the Confraternity of St. George.	1516–56, Charles V, king of Spain and Holy Roman emperor	1521–23 Antonio Grimani
c. 1502 Giovanni Bellini, *Doge Leonardo Loredan*.	1521–64 Ferdinand I, archduke of Austria	1523–38 Andrea Gritti

c. 1500 Gentile Bellini, *Caterina Cornaro*.

1502 Carpaccio, *Funeral of St. Jerome,* for the Confraternity of St. George.

c. 1502 Giovanni Bellini, *Doge Leonardo Loredan*.

1502–7 Carpaccio, *St. George and the Dragon,* for the Confraternity of St. George.

1502–07 Carpaccio, *St. Jerome and the Lion,* for the Confraternity of St. George.

1502–7 Carpaccio, *St. Augustine's Vision of St. Jerome,* for the Confraternity of St. George.

c. 1503–8, Giorgione, *Tempesta*.

c. 1504 Giorgione, *Castelfranco Altarpiece*.

c. 1504 Giorgione, *Virgin Reading with the Christ Child*.

1506 Giorgione, *Laura*.

c. 1506–8 Giorgione, San Diego *Portrait of a Man*.

c. 1507–8 Giorgione, *Three Philosophers (Three Magi)*.

c. 1508–10 Giorgione and Titian, Dresden *Venus*.

c. 1508–10 Giorgione, *Self-Portrait as David*.

c. 1509 Giorgione, *Old Woman*.

1510 Giovanni Bellini, Brera *Virgin and Child*.

c. 1510–11 Titian, *Gypsy Madonna*.

c. 1511–12 Titian, *La Schiavona*.

1511–28 Alfonso I d'Este's *camerino* programmed by Mario Equicolo and decorated by Giovanni Bellini and Titian.

c. 1512 Titian, *Man with a Blue Sleeve*.

1514 Giovanni Bellini and Titian, *Feast of the Gods,* for Alfonso I d'Este.

c. 1514–16 Titian, *Sacred and Profane Love*.

c. 1515–20 Titian, *Flora*.

c. 1516 Titian, *Madonna of the Cherries*.

1516–18 Titian, *Assumption of the Virgin*.

c. 1518–19 Titian, *Worship of Venus,* for Alfonso I d'Este.

1519–26 Titian, *Pesaro Altarpiece*.

c. 1520 Titian, Treviso *Annunciation*.

1523–25 Titian, *Bacchanal of the Andrians,* for Alfonso I d'Este.

c. 1524–25 Titian, *Man with a Glove*.

1530 Titian, *Madonna of the Rabbit*.

c. 1531–32 Titian, *Allegory of Alfonso d'Avalos del Vasto*.

1534–36 Titian, *Isabella d'Este*.

POPES:

1503 Pius III

1503–13 Julius II

1513–21 Leo X

1522–23 Adrian VI

1523–34 Clement VII

TURKS:

1512–20 Sultan Selim I the Grim

1520–66 Sultan Suleiman the Magnificent

OTHERS:

1505–34 Alfonso I d'Este, duke of Ferrara

1508–38 Francesco Maria della Rovere, duke of Urbino

1509–47 Henry VIII, king of England

1519–40 Federico II Gonzaga, duke of Mantua

1521–24 Francesco II Sforza, duke of Milan

1502 Jacopo Sannazaro's *Arcadia* published in Venice.

1503 Venice annexes Rimini and Forlì.

1503 Peace treaty with Sultan Bayezid II confirming Venetian losses of bases at Lepanto, Coron, Modon, and Navarino.

1505 Pietro Bembo's *Gli Asolani* published in Venice.

1506–35 Series of laws passed to strengthen the certification of noble status.

1508 Venetians repel an attack by Maximilian I and annex Pordenone, Gorizia, and Trieste.

1508–17 League of Cambrai formed to drive the Venetians out of the terraferma.

1509 Battle of Agnadello. Venetians lose their terraferma empire to the League of Cambrai.

1509 Andrea Gritti recaptures Padua.

1509 Population in Venice about 115,000.

1510–12 Holy League formed to drive the Valois out of Italy; Venice cedes its holdings in Romagna to the papacy.

1510–14 Plague in Venice; Giorgione succumbs in 1510.

1517 Venice recovers most of its terraferma empire.

1517 Martin Luther nails his Ninety-Five Theses to the door of All Saints' Church at Wittenberg, bringing the Protestant Reformation to a head.

1517 Under Sultan Selim I the Ottoman Empire expands from Syria through the Arabian Peninsula and the Mamluk Sultanate of Egypt.

1521 Sultan Suleiman the Magnificent conquers Serbia.

1522 The Turks capture Rhodes and expel the Knights of St. John.

1522 Ospedale degli Incurabili founded to treat those with syphilis and other infectious diseases.

1525 Charles V defeats Francis I at Pavia.

1525 Francesco Giorgi's *De harmonia mundi totius* (On the harmony of the universe) published in Venice.

1505 A fire destroys the Fondaco dei Tedeschi.

1505–8 Antonio Scarpagnino rebuilds the Fondaco dei Tedeschi.

1507–34 Giorgio Spavento and Tullio Lombardo construct S. Salvador.

1511–14 Pietro Bon constructs the Campanile spire.

1512 The Procuratie Vecchie on the Piazza S. Marco burns to the ground.

c. 1512–29 Pietro Bon begins the rebuilding of the Procuratie Vecchie, which Jacopo Sansovino completes.

1514 A fire destroys much of the Rialto area.

c. 1514–22 Tullio Lombardo(?) constructs the Villa Giustiniani at Roncade.

1514–23 Scarpagnino rebuilds the Palazzo dei Dieci Savi and the Fabbriche Vecchie.

1515–60 Pietro Bon, Sante Lombardo, and Scarpagnino construct the Confraternity of St. Roch.

1526 Turks conquer central and southern Hungary.

1526 League of Cognac formed to drive Charles V out of Italy.

1527 Troops of Charles V sack Rome.

1525–28 Guglielmo Grigi il Bergamasco rebuilds the Palazzo dei Camerlenghi.

1534–82 Sansovino and Andrea Palladio construct S. Francesco della Vigna.

Painting	*Reigns of European Sovereigns*	*Reigns of Doges*
c. 1473–76 Giovanni Bellini, *Pesaro Altarpiece*. 1474 Giovanni Bellini, *Jörg Fugger*. 1475 Antonello da Messina, *Portrait of a Man*.	1471–84 Sixtus IV **TURKS:** 1451–81 Sultan Mehmed II **OTHERS:** 1450–66 Francesco I Sforza, duke of Milan 1452–93 Frederick III, Holy Roman emperor 1464–73 James II, king of Cyprus 1471–1516 Vladislaus II, king of Bohemia and Hungry 1472–82 Federico da Montefeltro, duke of Urbino 1474–89 Caterina Cornaro, queen of Cyprus	1457–62 Pasquale Malipiero 1462–71 Cristoforo Moro 1471–73 Niccolò Tron 1473–74 Niccolò Marcello 1474–76 Pietro Mocenigo
c. 1475–80 Giovanni Bellini, *St. Francis in the Desert*. c. 1478–80 Giovanni Bellini, *S. Giobbe Altarpiece*. c. 1480 Giovanni Bellini, *Sacred Allegory*. 1480 Gentile Bellini, *Sultan Mehmed II*. c. 1480s–1500 Giovanni Bellini, *Young Senator*. 1487 Giovanni Bellini, *Virgin and Child with Two Trees*. 1488 Giovanni Bellini, *Frari Triptych*. c. 1490s Vittore Carpaccio, *Two Venetian Women*. 1493 Carpaccio, *Ursula's Martyrdom and Burial,* for the Confraternity of St. Ursula. 1494 Gentile Bellini, *Procession in the Piazza S. Marco,* for the Confraternity of St. John the Evangelist. 1494 Bastiani, *Donation of the Relic of the True Cross,* for the Confraternity of St. John the Evangelist. 1494 Carpaccio, *Miracle near the Rialto Bridge,* for the Confraternity of St. John the Evangelist. c. 1494–95 Carpaccio, *Arrival in Rome,* for the Confraternity of St. Ursula. 1495 Carpaccio, *Ursula's Dream,* for the Confraternity of St. Ursula. c. 1496–1500 Carpaccio, *Arrival of the Ambassadors,* for the Confraternity of St. Ursula. 1497 Alvise Vivarini, *Portrait of a Man*.	**VALOIS:** 1483–98 Charles VIII, king of France 1498–1515 Louis XII, king of France **HAPSBURGS:** 1479–1516 Ferdinand II of Aragon 1493–1519 Maximilian I, archduke of Austria and Holy Roman emperor **POPES:** 1484–92 Innocent VIII 1492–1503 Alexander VI **TURKS:** 1481–1512 Sultan Bayezid II **OTHERS:** 1483–1519 Francesco II Gonzaga, marquis of Mantua 1489–1500 Ludovico Sforza, duke of Milan	1476–78 Andrea Vendramin 1478–85 Giovanni Mocenigo 1485–86 Marco Barbarigo 1486–1501 Agostino Barbarigo
1500 Jacopo de' Barbari, *View of Venice*. c. 1500 Carpaccio, *Woman Holding a Book*.	**VALOIS:** 1515–47 Francis I, king of France	

1534–38 Titian, *Presentation of the Virgin,* for the *albergo* of the Confraternity of St. Mary of Charity.

c. 1534–38 Titian, *Venus of Urbino.*

c. 1536 Titian, *La Bella.*

c. 1536–37 Titian, *Eleonora Gonzaga.*

c. 1536–38 Titian, *Francesco Maria I della Rovere.*

c. 1536–38 Titian, *Woman in a Fur Coat.*

c. late 1530s (or late 1540s?) Titian, *Doge Andrea Gritti.*

1543 Titian, *Ecce Homo.*

c. 1544–45 Titian, *Danaë,* for Cardinal Alessandro Farnese.

1545 Titian, Pitti *Pietro Aretino.*

1546 Titian, *Pope Paul III with Ottavio and Alessandro Farnese.*

c. 1547 Jacopo Tintoretto, Philadelphia *Self-Portrait.*

c. 1547–58 Titian, *Martyrdom of St. Lawrence.*

1548 Titian, *Equestrian Portrait of Charles V at Mühlberg.*

POPES:

1534–49 Paul III

OTHERS:

1525–35 Francesco II Sforza, duke of Milan

1534–59 Ercole II d'Este, duke of Ferrara

1538–74 Guidobaldo II delle Rovere, duke of Urbino

1547–53 Edward VI, king of England

1539–45 Pietro Lando

1545–53 Francesco Donà

1550 – 1575

1550 First edition of the *Lives of the Artists* by Giorgio Vasari published in Florence.

1551–52 Second session of the Council of Trent.

1554 Andrea Palladio publishes his *Antiquities of Rome*.

1556 Charles V abdicates the Spanish throne in favor of his son Philip II.

1556 Senate establishes a permanent three-member board to oversee the reclamation of land.

1556 Daniele Barbaro's translation of and commentary on Vitruvius published; illustrated by Palladio.

1557 *L'Aretino* by Lodovico Dolce published.

1557 Casa dei Catecumeni founded to convert Jews, Turks, and Moors, especially children, to Christianity.

1558 Giovanni della Casa's *Il Galateo* published posthumously.

1559 Peace of Cateau-Cambrésis ends the Italian Wars and marks the beginning of Hapsburg supremacy in Italy, which lasts to the end of the century.

1559 Casa delle Zitelle founded to train poor young girls for marriage or domestic service so that they could avoid prostitution.

1560 Magistracy of Pomp established to enforce sumptuary laws.

1562–63 Third session of the Council of Trent.

1568 Second edition of Vasari's *Lives of the Artists* published in Florence.

1568 Daniel Barbaro's *Practice of Perspective* published in Venice.

1570 Palladio's *Four Books of Architecture* published in Venice.

1570 Under Sultan Selim II the Turks capture Famagusta in Cyprus.

1570–73 Venetian-Turkish war.

1571 Holy League formed to fight the Turks.

1571 Holy League victorious over the Turks at Lepanto.

1573 Venetians sign a peace treaty ceding Cyprus to the Turks and pay a war indemnity of three hundred thousand ducats.

1574 Ottoman expansion effectively ends in the Mediterranean.

1574 Fire in the east wing of the Doge's Palace.

1554–58 Sansovino constructs the Fabbriche Nuove.

c. 1554–58 Palladio constructs the Villa Barbaro at Maser.

1554–67 Sansovino carves *Mars* and *Neptune* for the Scala dei Giganti.

c. 1555–61 Palladio constructs the Villa Emo at Fanzolo.

1557–61 Sansovino and Alessandro Vittoria carve the tomb of Francesco Venier in S. Salvador.

1562–70 Palladio designs and constructs the façade of S. Francesco della Vigna.

1565–89 Palladio designs and constructs S. Giorgio Maggiore (consecrated 1610; façade constructed 1607–11).

1566–70 Palladio constructs the Villa Rotonda near Vicenza.

1575 – 1600

1575 Population in Venice about 180,000.

1575 Scuola della Dottrina Cristiana founded to offer religious education to young boys.

1575 Casa del Soccorso founded to shelter adulterous, abandoned, or battered wives and reformed prostitutes.

1575–77 Plague in Venice kills about forty-five thousand, reducing the population to about 135,000.

1577–82 New gilt wooden ceiling by Cristoforo Sorte constructed and installed over the Sala del Maggior Consiglio.

1577–92 Palladio constructs the Church of the Redeemer (Il Redentore).

1588–91 The present stone bridge, designed by Antonio da Ponte, replaces the wooden Rialto Bridge.

Painting	*Reigns of European Sovereigns*	*Reigns of Doges*
c. 1550 Titian, *Vision of St. John the Evangelist on Patmos,* for the *albergo* of the Confraternity of St. John the Evangelist.	**HAPSBURGS:** 1556–98 Philip II, king of Spain 1572–1611 Rudolf II, king of Hungry and Bohemia	1553–54 Marcantonio Trevisan 1554–56 Francesco Venier 1556–59 Lorenzo Priuli 1559–67 Girolamo Priuli 1567–70 Pietro Loredan 1570–77 Alvise Mocenigo
1551 Titian, *Philip II in Armor.*		
c. 1555 Jacopo Tintoretto, *Woman in Mourning.*		
1555–65 Veronese's decoration in S. Sebastiano		
1556–59 Titian, *Diana and Actaeon* and *Diana and Callisto.*	**POPES:** 1550–55 Julius III 1555 Marcellus II 1555–65 Pius IV 1566–72 Pius V 1572–85 Gregory XIII	
1559–64/65 Veronese, *S. Sebastiano Altarpiece.*		
c. 1560s Veronese, *La Bella Nani.*		
c. 1560–62 Veronese executes the fresco decoration in the Villa Barbaro at Maser.		
c. 1560–66 Titian, S. Salvador *Annunciation.*		
c. 1562 or earlier Titian, Berlin *Self-Portrait.*		
1562–63 Veronese, *Marriage at Cana,* for the refectory at S. Giorgio Maggiore.	**TURKS:** 1566–74 Sultan Selim II 1574–95 Sultan Murad III	
1564 Jacopo Tintoretto, *Apotheosis of St. Roch,* for the *albergo* of the Confraternity of St. Roch.		
c. 1564 Veronese, *Virgin and Child with SS. Barbara, John the Baptist, and Joseph.*		
1565 Jacopo Tintoretto, *Crucifixion,* for the *albergo* of the Confraternity of St. Roch.	**OTHERS:** 1559–97 Alfonso II d'Este, duke of Ferrara	
c. 1565–67 Veronese, *Alexander and the Family of Darius.*		
c. 1565–70 Titian, Prado *Self-Portrait.*		
c. 1570 Titian, London *Virgin and Child.*		
1570–76 Titian, *Pietà.*		
c. 1572–76 Titian, *Flaying of Marsyas.*		
1573 Veronese, *Last Supper* (*Feast in the House of Simon, Feast in the House of Levi*).		

Painting	*Reigns of European Sovereigns*	*Reigns of Doges*
1575–76 Veronese, *Faith; Mars, Neptune, and the Lion of St. Mark;* and *Venice Enthroned with Justice, Peace, and the Lion of St. Mark,* for the ceiling of the Sala del Collegio.	**POPES:** 1585–90 Sixtus V 1590 Urban VII 1590–91 Gregory XIV 1592–1605 Clement VIII	1577–78 Sebastiano Venier 1578–85 Niccolò da Ponte 1585–95 Pasquale Cicogna 1595–1605 Marino Grimani
1575–76 Jacopo Tintoretto, *Brazen Serpent,* for the chapter room ceiling of the Confraternity of St. Roch.		
c. 1576 Veronese, four *Allegory of Loves.*		
1577–78 Jacopo Tintoretto, *Fall of Manna* and *Moses Strikes Water from the Rock,* for the chapter room ceiling of the Confraternity of St. Roch.		

1577 Fire in the south and west wings of the Doge's Palace.

1577 Carlo Borromeo's *Instructionum fabricae,* on Catholic Reformation church design, published in Milan.

1587 Publication of Girolamo Bardi's program for the Sala del Maggior Consiglio.

1590 Cesare Vecellio's *On Ancient and Modern Costumes of the Various Parts of the World* published in Venice.

1591 Compagnia della Carità del Crocefisso founded to assist debtors and criminals in jail.

1594 Ospedale dei Mendicanti founded to house and treat beggars and orphans.

1600 By this date, about 375,000 acres of land in the Veneto had been reclaimed for agricultural production.

Collegio Twenty-six-member executive branch of the Venetian government, composed of the Signoria and the Consulta.

colonnade Succession of columns joined by an entablature, often supporting a roof.

colonnette Small column.

column Round supporting pillar consisting of a base, a shaft, and a capital; see order.

Composite See order.

concordia discors Discordant harmony.

confraternity Lay society dedicated to religious and charitable activities.

consecration In liturgy, the moment in the Mass when the priest transforms the bread and wine into the body and blood of Christ; see transubstantiation. In architecture, the ritual by which a church is dedicated to sacred use.

consiglieri See Signoria.

Consiglio dei Dieci See Council of Ten.

Consulta Sixteen-member advisory body within the Collegio, comprising six councilors (Savi del Consiglio), five overseers of the army and the defenses of the land empire (Savi di Terraferma), and five overseers of the navy, the Arsenal, and the harbors and fortresses of the Venetian maritime empire (Savi agli Ordini), all drawn from the Senate.

contrapposto Lit. set in opposition; a human posture in which weight is carried on one leg and the other is relaxed, and the body is counterbalanced on either side of the rotated spinal axis.

Conventuals Franciscan friars who accumulated common property and followed a mitigated Rule of St. Francis; see Observants.

corbel Architectural member that projects from a wall to support a weight.

Corinthian See order.

cornice Upper part of an entablature, or a projecting horizontal member that crowns a structure; see Doric and order.

corno Doge's crown.

corona In architecture, a curved or semicircular pediment.

corporal In liturgy, the linen cloth on which the bread and wine are consecrated during the Mass.

Council of Ten or **Consiglio dei Dieci** Ten-member council responsible for state security and most state-financed art and architectural projects; generally met with the doge and his six councilors.

crenellation In architecture, a defensive parapet at the top of a building with alternating indentations (embrasures) and raised portions (merlons); often purely decorative.

crociera Cross-shaped hall with two intersecting barrel vaults.

crossing In a church, the space at the intersection of the nave, chancel, and transepts, often domed.

crown of a vault Highest point from the floor.

Crucifixion Christ's sacrifice on the cross.

cruciform Cross shaped.

cuirass Ancient Roman breastplate.

cushion frieze Rounded frieze of an entablature, suggesting elasticity and pressure, characteristic of much of Palladio's architecture; also called a pulvinated frieze.

dais Raised platform denoting the high status of a seated individual or individuals.

dal sotto in su **perspective** Perspective constructed to be seen from below by someone looking obliquely upward.

dentils or **denticulation** Ornamental motif consisting of a row of small blocks resembling teeth.

disegno Drawing and design; defining form by outline.

distance point In perspective, a point level with the horizon line whose position determines the illusion's depth.

doge Duke; supreme head of the Venetian government, elected for life but with limited power.

dogessa Doge's wife.

dome or **domical vault** Vault of even curvature erected on a circular or polygonal base or drum.

Doric (See diagram at right.)

dowry Money, goods, or land that a woman brings to a marriage.

drum In architecture, circular or polygonal wall supporting a dome.

ducat Unity of currency.

Easter In Christian liturgy, the feast day celebrating the Resurrection.

Ecce homo "Behold the man" (John 19:4), words spoken by Pontius Pilate to the Jews after he found Christ to be innocent.

Ecclesiasticus 24:6–7 "I made that in the heavens there should rise light that never faileth, and as a cloud I covered all the earth. I dwelt in the highest places, and my throne is in a pillar of a cloud." Spoken by Wisdom and understood in the Renaissance to prefigure the Incarnation, the foundation of the Church, and the ultimate triumph of the Church at the Assumption and Coronation of the Virgin.

echinus See Doric.

effigy Image or representation of a person.

barchesse Utilitarian service buildings of a villa for keeping equipment, supplies, animals, and produce; usually with porticoes.

barco In Venetian church architecture, rood screen and singing loft built across the nave.

barrel vault A continuous vault, semicircular in section, unbroken in its length by cross vaults; cf. *crociera*.

bay In architecture, divisions of a structure's design defined by columns, pilasters, or vaults that divide a wall (interior or exterior) or a space into successive and repeating units.

bavaro Doge's white or scarlet cape edged in ermine and buttoned with eight gold buttons.

bead-and-reel Ornamental molding formed by beads alternating with disks placed edgewise.

becho Shoulder sash worn by senators and other high-ranking governmental officials.

belvedere Open loggia on top of a building, offering a commanding view.

berretta Brimless cap or beret.

bier Support on which a corpse or coffin is placed to lie in state.

biforal window Window with two openings.

braccio (pl. *braccia*) Lit. an arm's length; a unit of measure equal to about twenty-three inches (about fifty-eight centimeters).

breviary Liturgical book containing psalms, hymns, lessons, and prayers.

buttress Projecting structure for supporting a wall or vault.

Bucintoro or **Bucintauro** Doge's state galley and sea throne.

ca' Abbreviation for *casa* (house or palace).

caduceus Staff with two entwined snakes and two wings on top, an attribute of Mercury.

camauro Ermine-lined cap worn by the pope.

camerino Study; also called *studiolo*.

camicia Undergarment, usually of white linen.

campanile Bell tower.

campanoni Bell-like gold buttons on the doge's cape (*bavaro*).

Candia Crete.

canon Clergyman staffing a cathedral or collegiate church.

Capi della Quarantia Criminal See Signoria.

capital In architecture, uppermost part of a column or pilaster; see order.

cardinal Highest-ranking Roman Catholic ecclesiastical official after the pope.

Cardinal Virtues Justice, Fortitude, Prudence, and Temperance, known as the virtues of rule from Plato's *Republic;* cf. Theological Virtues.

carrack See cog.

cartoon Drawing used to transfer a design to a panel, canvas, wall, or tapestry.

casa House or palace; abbreviated *ca'*.

casa-fondaco Venetian palace used as both a residence and a warehouse/trading center.

cassock Long ankle-length robe, generally white or black, worn by Catholic clerics.

chamfer Beveled edge.

chancel The part of a church at the end of the nave containing the high altar and seats for the clergy.

chapter room In a confraternity, large meeting room, usually on the piano nobile, used for communal Masses, prayers, singing, meetings, elections, and funerals.

cherub (pl. cherubim or cherubs) Winged infant angel, usually colored blue, symbolic of divine wisdom.

chiaroscuro Use of light and shadow to model form in paintings, prints, and drawings.

choir Walled-off area in the nave before the high altar with stalls where the clergy sing the divine services, most typical of medieval monastic churches; cf. retrochoir.

Christus medicus Healing Christ.

Church Militant Earthly Church.

Church Triumphant Heavenly Church.

citizens of privilege Foreigners considered citizens by virtue of long residence in Venice (at least ten to fifteen years), payment of Venetian taxes, and never having worked in a manual occupation; or a grant of citizenship by the Signoria; or the possession of noble status from their place of origin. Cf. original citizens.

cittadini originarii See original citizens.

clerestory Upper walls of a church's nave pierced by windows above the roofs of the aisles.

closed garden See *hortus conclusus*.

cloth of honor Rich fabric of silk or brocade hanging vertically behind a saint or sovereign to indicate high rank and special authority.

coffer Decorative recessed panel in a ceiling or vault.

cog or **carrack** All-weather high-sided round ship with ketch- or square-rigged sails on one to four masts with a small crew, large cargo holds, superior steering, advanced navigational devices, and some protective armaments.

GLOSSARY

abacus See Doric.

absenteeism Failure of priests to perform the duties of the offices with which they had been entrusted.

aisle Lower part of a church flanking the nave and often the transepts.

albergo (pl. alberghi) In a confraternity, executive meeting room of the *banca,* usually to one side of the chapter room; in a palace, a principal living room, usually against the front façade of the piano nobile.

alienation Carving dynastic family states out of Church lands.

altana Rooftop deck for sunning and drying clothes.

alter Christus Another Christ, often said of St. Francis.

ambulatory Vaulted passageway around a church's chancel.

amor dei Love of God, an aspect of Charity.

amor proximi Love of neighbor, an aspect of Charity.

androne Long breezeway running from the front to the back of the ground floor of a Venetian palace, often used for the storage of a gondola and other supplies.

Annunciation Archangel Gabriel's announcement to the Virgin of Christ's conception; cf. Incarnation.

Apocalyptic Woman The prophecy of the Incarnation, the universal Church, and the Resurrection in Apocalypse 12:1–5: "A great sign appeared in heaven: A woman clothed with the sun . . . And she brought forth a man child [Christ], who was to rule all nations . . . [and] was taken up to God and to his throne."

apse Vaulted semicircular or polygonal termination of a chancel or chapel.

arcade Succession of arches carried on columns or piers; cf. portico.

arch Curved structural member spanning an opening or serving as a support.

architrave Lower part of a horizontal entablature resting on the capitals of columns, piers, or pilasters; see Doric and order.

arcuation Structural support system based on the principle of the arch; cf. trabeation.

Arms and Letters Virtues of rule derived from classical sources and the Justinian Code.

Arsenal Shipyard of Venice.

ars simia naturae Art apes nature.

articulation Method of formally defining and uniting an architectural structure by using, for example, classical orders or classical vocabulary.

assembly room In a confraternity, ground-floor room where members assembled for processions, stored processional paraphernalia, held occasional banquets, and disbursed charity.

attic Low story above the principal entablature, as on a triumphal arch.

baldachin Honorific canopy, usually over a saint, altar, pope, or ruler, symbolic of temporal and/or spiritual sovereignty.

balustrade Row of short supports (balusters) carrying a rail, as on a balcony or staircase.

banca In a confraternity, executive administrative council, usually with fourteen to sixteen members.

baptism Sacramental rite of spiritual regeneration through water cleansing the soul of the taint of original sin and channeling God's grace to the believer.

1578 Jacopo Palma il Giovane, *Venice Crowned by Victory Gathers Her Subject Provinces,* for the ceiling of the Sala del Maggior Consiglio.

1578–1610 Sala del Maggior Consiglio redecorated after the 1577 fire.

c. 1578–81 Jacopo Tintoretto, *Adoration of the Shepherds, Temptation of Christ, Last Supper, Resurrection of Christ,* and *Ascension of Christ* for the chapter room of the Confraternity of St. Roch.

c. 1579–84 Veronese, *Apotheosis of Venice,* for the ceiling of the Sala del Maggior Consiglio.

c. 1580 Veronese, *Agony in the Garden.*

1580–90 Domenico Tintoretto, *Doges Andrea Dandolo and Marino Faliero,* for the frieze of the Sala del Maggior Consiglio.

1580s–90s Andrea Vicentino, *Fourth Crusaders Conquer Zara,* for the south wall of the Sala del Maggior Consiglio.

1581–82 Veronese, *Doge Sebastiano Venier Gives Thanks for the Victory at Lepanto,* for the north wall of the Sala del Collegio.

1582–87 Jacopo Tintoretto, *Annunciation* and *Mary Meditating in a Landscape,* for the assembly room of the Confraternity of St. Roch.

1584 Jacopo Tintoretto, *Doge Niccolò da Ponte Receives Subject Cities and Provinces,* for the ceiling of the Sala del Maggior Consiglio.

c. 1585–86 Veronese, *Triumphal Entry of Doge Andrea Contarini into Venice,* for the west wall of the Sala del Maggior Consiglio.

1587 Veronese, *St. Pantaleon Exorcises a Demon.*

1587–90 Jacopo Palma il Giovane, *Reconquest of Padua,* for the ceiling of the Sala del Maggior Consiglio.

1587–90 Jacopo Palma il Giovane, *Venetian Women Offer Their Jewels to the Republic,* for the ceiling of the Sala del Maggior Consiglio.

c. 1588 Jacopo Tintoretto, Louvre *Self-Portrait.*

1588–92 Jacopo Tintoretto, Domenico Tintoretto, and workshop, *Paradise,* for the east wall of the Sala del Maggior Consiglio.

1590 Francesco Bassano, *Pope Alexander III Consigns a Sword to Doge Ziani,* for the north wall of the Sala del Maggior Consiglio.

1593–94 Jacopo Tintoretto and workshop, *Entombment of Christ,* for the Cappella dei Morti of S. Giorgio Maggiore.

c. 1600 Andrea Vicentino, *Pope Alexander III Consigns the Ring to Doge Ziani,* for the north wall of the Sala del Maggior Consiglio.

c. 1605 Leandro Bassano, *Pope Alexander III Consigns a White Candle to Doge Ziani,* for the north wall of the Sala del Maggior Consiglio.

Diagram of Doric order

egg-and-dart Ornamental molding based on alternating ovals and arrow points.

ekphrasis Rhetorical literary form consisting of an ornate verbal description of a visual, often imaginary, work of art.

elevation In architectural renderings, the vertical plane of an interior or exterior wall; in liturgy, the moment in the Mass when the priest raises the Eucharist heavenward in thanksgiving.

endogamy Marriage within one's class.

enfilade Alignment of doors to produce a continuous view through a series of rooms.

engaged column Half or three-quarter column attached to a wall.

entablature Horizontal beam resting on top of the capitals of columns, piers, or pilasters, comprising the architrave (bottom), frieze (middle), and cornice (top); see order.

entasis Slight convexity of a column shaft to suggest its dynamic counteraction to the pressure of compressive weight.

epiphany Divine appearance or revelation.

epithalamium (pl. epithalamia) Marriage poem.

Eucharist Lit. thanksgiving (in Greek); the Mass, or the bread and wine transubstantiated into the body and blood of Christ.

Evangelists SS. Matthew, Mark, Luke, and John.

exogamy Marriage outside one's class.

façade Exterior wall of a building, usually with the main entrance.

faldstool Folding field throne.

Fall According to Church doctrine, Adam and Eve's disobedience of God's command not to eat the fruit from the tree of knowledge and the resulting fall from grace of humanity; Christ's sacrifice redeems humankind from this original sin.

fenestra caelo Window to heaven; epithet of the Virgin.

flutes or **fluting** In architecture, shallow concave grooves running vertically on column shafts, pilasters, capital necks, or triglyphs; see Doric.

focal point In perspective, the point to which the orthogonals converge.

foreshortening The proportional contraction of form to create the illusion of projection or recession in space.

fresco Technique of painting on freshly spread moist lime plaster.

friar Male member of a mendicant religious order; cf. monk.

frieze Plain or ornamented band on an entablature, between the architrave and the cornice; see Doric and order.

galleass or **great galley** Large-crew trireme, slower than a galley, with two or three lateen (triangular) sails, heavily armed with bow, stern, and side guns for war; carried light, high-value cargo.

galleon Low, strong, fast fighting and merchant ship equipped with advanced square-rigged sails and a multitude of accurate cannons.

galley Fast, large-crew trireme (three oars to a bench) with one or two lateen (triangular) sails, bow and stern guns for war, and light, high-value cargo.

gamurra A woman's outer garment.

gastaldo In a small confraternity, the highest administrative official, who presided over the *banca;* see *guardian grande.*

Golden Legend Immensely popular collection of stories and legends compiled about 1260 from a wide variety of sources, recounting the lives of the saints, Christ, and the Virgin, arranged according to the liturgical calendar by Jacopo da Vorag-

ine (c. 1230–98), a Dominican friar and the archbishop of Genoa from 1292. The *Golden Legend* was the source for much Renaissance narrative art.

Golgotha Lit. place of the skull; Calvary outside Jerusalem, where Christ was crucified.

Gothic sway In figural sculpture or painting, an S-shaped posture.

grand chancellor A citizen who presided over the Great Council of nobles.

grand guardian See *guardian grande*.

Great Council or **Maggior Consiglio** The largest, six-hundred- to sixteen-hundred-member Venetian governmental council, of nobles from about two hundred noble families, that approved legislation and elected members of inner councils during its weekly Sunday meetings, directed by the grand chancellor.

Greek cross Cross with four equal arms.

griffon Eagle-headed lion.

groin vault Vault produced by the intersection at right angles of two barrel vaults.

guardian da matin In a confraternity, the processions' marshal.

guardian grande In a (usually large) confraternity, the highest administrative official, who presided over the *banca;* see *gastaldo.*

guttae See Doric.

halo Golden aura of light around the head of a holy person.

harmonic ratios Ratios of whole numbers that produce musical harmonies; e.g., 1:2 = a musical octave, 3:4 = a fourth, 2:3 = a fifth.

hieratic Of or relating to the highly stylized, formal, or rigid pose of a holy person.

hip roof Roof whose sides all slope downward to the walls.

Holy Spirit See Trinity. In visual art, represented by a dove.

horizon line In perspective, the horizontal line intersecting the focal point.

hortus conclusus Lit. enclosed garden; in art, often a symbol of the Virgin Mary's virginity and fertility (from Song of Songs 4:12; Ezekiel 44:2–3); cf. *porta clausa.*

Host Consecrated bread or wafer that, along with consecrated wine, is the focus of the Eucharistic rite.

iconography Study of the signs and symbols in art.

imitatio Christi Imitation of Christ's self-sacrifice.

Immaculate Conception According to Catholic doctrine, the Virgin Mary's conception free from original sin in the womb of her mother, St. Anne.

impost Block or capital on which an arch rests.

Incarnation According to Christian dogma, the union of the divine Word and human flesh in Jesus Christ.

indulgence According to Catholic doctrine, a special remission of sin or purgatorial punishment granted by the pope or a bishop for the performance of some ritual or good work by the faithful.

in situ In its original position.

in transito Lit. in transit, from death to renewed life.

Ionic See order.

Janissary Soldier in the highly trained, well-organized, and rigorously disciplined army of the Turkish sultans.

keystone Central, wedge-shaped stone at the crown of an arch or a rib vault, often symbolic of Christ.

lancet window Tall, narrow window with a pointed arch at the top; a characteristic feature of Gothic architecture.

lantern Small windowed turret crowning a roof or dome; in a church, usually symbolic of divine light and the resurrected Christ.

lapis lazuli Blue semiprecious stone often ground to make a bright blue pigment.

Last Judgment According to Christian theology, humanity's judgment by God at the end of the world.

Latin cross Cross with the bottom arm longer than the other three.

Latin Doctors SS. Ambrose, Augustine, Gregory the Great, and Jerome.

Lent Forty-day period between Ash Wednesday and Easter Sunday.

leonine personality Lionlike character, depicted in classical and Renaissance images by a knit brow, piercing gaze, and curly, flamelike hair.

lira da braccio Early violin.

loggia Room or structure open on one or more sides, usually supported on piers or columns.

lunette Semicircular opening or surface.

Madonna Virgin Mary.

Madonna of Humility Devotional image of the Virgin Mary seated on the ground, punning on *humus* (earth) and *humilitas* (humility).

Maggior Consiglio See Great Council.

mandorla Almond-shaped halo.

Man of Sorrows Devotional image of the dead Christ (based on Isaiah 53:3), usually in his tomb and often supported by angels.

Mass Liturgical celebration of the Eucharist.

mediocritas Lit. moderation; in Venice, the notion that all individuals were expected to subordinate their ambitions, deeds, and social interactions to the common good and well-being of the republic.

Medusa Snake-haired Gorgon whose glance turned people to stone; beheaded by Perseus.

memento mori Reminder of death, often symbolized by a clock or hourglass.

mendicant order Religious order, such as the Franciscans or the Dominicans, combining monastic life and outside religious activity; originally a begging order.

metope Square block between two triglyphs, often decorated in relief; see Doric.

mezzanine In architecture, a low story between two higher ones or under the roof.

module Unit of measurement regulating a building's proportions.

Molo Mole, or stone quay, in front of the south side of the Doge's Palace.

monk Male member of a religious order who lives in a monastery; cf. friar.

Morea Peloponnese.

mozzetta Short shoulder-length cape worn by a pope or cardinal, often with a hood.

mutule See Doric.

Nativity Birth of Jesus Christ.

naturalized citizens See citizens of privilege; cf. original citizens.

Natura potentior ars Art is more powerful than nature; motto on Titian's emblem.

nave Main central space of a church leading to the high altar.

nepotism Appointing family members to high office regardless of their merit.

Nereid Sea nymph.

niche Recess in a wall or pier, often concave and arched, usually containing a statue or other decoration.

nodus et copula mundi Lit. knot and bond of the universe; ancient philosophers' sign of the union of heaven and earth.

nun Female member of a religious order who lives in a convent.

Observants Reformed Franciscan friars who observed exactly the primitive Rule of St. Francis; cf. Conventuals.

oculus Circular opening in a wall or dome.

ogee arch Pointed arch with an S-shaped curve on each side, characteristic of Gothic architecture.

one-point perspective Method of representing three-dimensional space on a flat surface.

orant **posture** Early Christian posture of prayer with raised arms and hands.

order Column, pier, or pilaster supporting an entablature, the whole ensemble decorated and proportioned according to one of the accepted classical modes, including Tuscan, Doric, Ionic, Corinthian, and Composite; a monastic or mendicant society or fraternity.

Order of the Golden Fleece Burgundian military order of knights, the most prestigious in Europe.

original citizens or *cittadini originarii* Native-born Venetians descended from families of long residence in the city who had paid taxes and never worked in a manual occupation, or educated professionals such as lawyers, physicians, and notaries.

orthogonal In linear perspective, diagonal line converging at the focal point.

Palladian motif See Serlian motif.

papal supremacy The pope's claim to supreme spiritual authority over the entire Church hierarchy and to supreme temporal authority over Christendom.

paragone Comparison of the arts, often between painting and sculpture.

parapet In painting, low wall placed to separate the viewer from the subject; in architecture, low wall positioned to protect a place where there is a sudden drop.

Passion According to Christian doctrine, the suffering of Christ between the Last Supper and his death.

paten Small gold or silver plate on which the Eucharistic bread is consecrated.

patera Libation dish.

pedestal Base supporting a column, statue, or other superstructure; see order.

pediment Triangular architectural member forming the gable of a low-pitched roof; a similar structure above a window or door; or a similar semicircular architectural member called a corona or a segmental pediment (segment of a circle).

penance According to Catholic doctrine, the repentance of personal sins, involving contrition, confession, and satisfaction; one of the seven sacraments.

pendentive Concave triangular architectural member (a section of a cone) supporting the base of a circular dome over a square space.

petasus Broad-brimmed hat, an attribute of Mercury.

Petrine Succession Unbroken descent of Christ's spiritual authority through Peter to each successive pope.

piano nobile Main floor of a palace, usually over the ground floor; very large palaces can have a first and a second piano nobile.

piazza Public square or open space surrounded by buildings.

pier Pillar, usually rectangular in cross section, as distinguished from a column.

pilaster Shallow pier or flattened column projecting only slightly from a wall.

pluralism The holding of multiple offices and benefices by a single cleric.

poesia (pl. *poesie*) Lit. poetry; in painting, an imaginative invention, usually based on poetry or mythology.

polyptych Multiple-paneled altarpiece.

pope Head of the Roman Catholic Church and bishop of Rome elected from and by the College of Cardinals.

popolani Nonnoble, noncitizen commoners, often merchants, shopkeepers, tradesmen, artisans, laborers, and the destitute.

porphyry Rare stone composed of feldspar crystals embedded in a compact dark red or purple groundmass.

porta clausa Closed door; often a reference to the Virgin's virginity (from Ezekiel 44:1–2); cf. *hortus conclusus*.

portego (pl. *porteghi*) Long breezeway running from the front to the back of the piano nobile of a Venetian palace that served as the principal reception, entertainment, and banqueting room.

portico Roofed or vaulted walkway at the entrance of a building, around a courtyard, or facing a square, carried on columns or piers and open on one side; cf. colonnade.

praedestinatio Prophecy of the angel to St. Mark that Venice would be founded in the Venetian lagoon and that Mark would be buried there.

predella Base of an altarpiece with narrative scenes related to the main panel(s) above.

procurator High-ranking noble charged with the acquisition, building, and maintenance of Venetian state property and the execution of citizens' wills. The procurators were divided into three groups: the Procuratia de Supra was responsible for the Piazza and Piazzetta S. Marco, while the Procuratia de Citra and the Procuratia de Ultra supervised state projects on either side of the Grand Canal.

promissione ducale Statement of duties and restrictions that a doge swore to obey at his coronation.

protomaestro or *proto* Supervising architect.

provveditori Overseers, generally nobles; e.g., Provveditori alla Sanità (Public health overseers), Provveditori sopra gli Ospedali (Hospital overseers), Provveditori di Comun (Communal overseers), Provveditori alle Fortezze (Fortress overseers), Provveditori al Sal (Salt commissioners).

pulvinated frieze Rounded frieze, expressing compressive force; also called a cushion frieze.

Purification of the Virgin Feast of the presentation of Christ in the temple forty days after his birth, at which time the Virgin was also purified, or cleansed from having given birth (Leviticus 12:2–8).

quadrant corona Approximately a quarter segment of a round or segmental pediment.

quadriga Four-horse chariot.

Quarantia Criminal Forty-member, judicial branch of the Venetian government.

quatrefoil Symmetrical ornamental architectural form with four partially overlapping lobes, each a segment of a circle of the same size.

quincunx Most characteristic feature of Byzantine church design, named for its five domes and defined as a Greek cross plan within a square. A high masonry hemispherical vault surmounts its central square bay, the largest of its nine bays, while lower domical or groin vaults cap the four smaller square corner bays. The vault over the central bay is carried on pendentives (sections of a cone), which in turn are supported by massive square piers, and is buttressed by high barrel vaults over the rectangular bays on the four sides of the central bay, as well as by the four compact corner bays.

quoin Solid block of stone articulating and protecting a building's corner.

Real Presence According to Christian doctrine, the Eucharistic bread and wine transformed into the actual sacrificial body and blood of Christ.

rebec Pear-shaped one-to-five-stringed bowed medieval and early Renaissance fiddle.

refectory Dining hall.

regula See Doric.

relief Mode of sculpture in which forms are raised from a flat surface.

reliquary Container for relics.

Resurrection According to Christian belief, Jesus Christ's miraculous rising from death to renewed life on the Sunday following his Friday crucifixion.

retrochoir Area behind the chancel with stalls where the clergy sing the divine services.

rib vault Framework of diagonal arched ribs carrying the cells covering the spaces between.

rinceau (pl. rinceaux) Ornamental vinelike foliage.

riva Waterside entrance to a Venetian palace; water gate.

rood screen Architectural screen set across a church's nave, closing off the chancel or choir.

rosette Rose-shaped architectural ornament.

rose window Round window, often ornamented with tracery, usually lighting the nave or an aisle of a church.

rostrum Raised platform for public speaking.

rustication Masonry cut in blocks with beveled edges, often left in a rough state, usually suggestive of strength or nature.

sacra conversazione Altarpiece depicting holy figures of various historical periods gathered together in a heavenly court and engaged in "sacred conversation," as opposed to one that represents a single biblical drama, such as the Crucifixion.

sacraments According to Catholic doctrine, seven sacred rites (baptism, confirmation, Eucharist, penance, Extreme Unction, Holy Orders, and matrimony), which channel God's grace proper to each sacrament to the faithful.

sacristy Room in a church, usually adjacent to the chancel, used for storing sacred vessels and vestments, sometimes also used as a chapel or chapter room.

sail vault Dome over a square space such that the diagonal of the square is the diameter of the dome.

salone Large hall.

Salt Office Oversaw the sale of salt and collected rents from the shops, stalls, warehouses, and quays on the Rialto.

Salvator mundi Savior of the world.

sansaria Benefice given to the semiofficial state artist selected by the Senate.

Savi agli Ordini See Consulta.

Savi del Consiglio See Consulta.

Savi di Terraferma See Consulta.

savio Lit. wise man; a Venetian senator with long experience and special expertise who advised the doge.

scrivan In a confraternity, the bookkeeper.

scuola (pl. *scuole*) In Venice, a confraternity; they were of two types, *scuole grandi* (large confraternities) and *scuole piccole* (small confraternities).

Second Coming Final return of Christ, as judge of the world; the Last Judgment.

segmental pediment A pediment composed of a segment of a circle, as distinct from a triangular pediment.

Senate One-hundred-and-twenty-member legislative and deliberative council of the Venetian government.

Sensa Feast of the Ascension.

seraph (pl. seraphim or seraphs) The highest order of winged angels, colored red, symbolic of divine love.

Serlian motif Archway or window with three openings, the central one arched and wider than the flanking ones, which are rectangular and lower in height; used in Roman antiquity as the frame for imperial appearances. Named after Sebastiano Serlio, who first illustrated the motif in his 1537 *Regole generale;* also called a Palladian motif, after Andrea Palladio, who used it frequently in his designs.

serrata Lit. closure; laws limiting membership in the Great Council to certain noble families.

sestieri Lit. sixths; the six districts of Venice.

Seven Deadly Sins Sloth, pride, envy, lust, greed, wrath, and gluttony.

sfumato Lit. smoky; technique in painting in which black is added to hues, tones are subtly graduated, and contours are blurred to create a soft, hazy appearance; developed by Leonardo da Vinci and widely imitated by successive artists, in Venice beginning with Giorgione.

sibyl Female seer of classical antiquity, equivalent to Old Testament prophets, who were believed to have prophesied the coming of Christ.

Signoria Ten-member advisory council within the Collegio, comprising the doge, six councilors (*consiglieri*) representing Venice's six districts (*sestieri*), and the three heads of the judiciary (Capi della Quarantia Criminal).

sill Lower horizontal part of a window frame.

simony Sale of Church offices.

sol invictus Invincible sun, an aspect of Apollo.

sol iustitiae Sun of justice, an aspect of Apollo.

spandrel Space between the exterior curve of an arch or vault and the enclosing right angle.

spire Tall, pointed structure rising from a tower or roof.

stigmata The five wounds of Christ.

stilted arch Arch whose springing line is raised by a vertical section some distance above the impost level.

stringcourse Continuous horizontal molding set into a wall of a building.

studiolo (pl. *studioli*) Study; also called *camerino*.

sumptuary laws Laws enacted in most Italian cites to regulate extravagant expenditure and behavior.

syrinx Panpipe.

taenia See Doric.

tempera Technique of painting using pigment mixed with egg yolk.

temple-front motif Triangular pediment carried on a row of columns, piers, or pilasters joined by an entablature; characteristic of the façades of classical temples.

terrazzo floor Floor of polished marble chips set in mortar.

terribilità Awesome power.

tessellated Tiled.

Theological Virtues Faith, Hope, and Charity; cf. Cardinal Virtues.

thermal window Semicircular window usually divided into three lights, derived from ancient Roman baths.

tondo (pl. tondi) Round painting or relief.

trabeation Construction using a post and beam principle; cf. arcuation.

tracery Open interlocked ornamental stonework in Gothic windows.

transept Principal transverse arm of a church, which lies perpendicular to the nave.

translatio Translation of the body of St. Mark from Alexandria to Venice for burial in S. Marco in the ninth century.

transubstantiation Mystical transformation of the bread and wine into the body and blood of Christ performed by a priest at the consecration of the Mass.

transversal In one-point perspective, line parallel to the horizon line.

triglyph Stone block with two vertical grooves at the center and half grooves at the edges, placed between the metopes in a Doric frieze; see Doric.

Trinity According to Christian doctrine, the unity of the Father, the Son, and the Holy Spirit as three persons in one Godhead.

trionfi (sing. *trionfo*) Doge's regalia: seals, candle, sword, ring, faldstool, foot cushion, umbrella, eight silver trumpets, and eight banners.

tripartite Divided into three parts.

triptych Three-paneled altarpiece.

Triton Sea-god, half man and half fish.

triumphal arch motif The most influential and distinctive motif of ancient Roman architecture, consisting of a large central archway carried on piers, each articulated with single or paired pilasters or columns (freestanding or engaged) carrying an entablature and an attic (or sometimes a pediment); the large central arch is often flanked by two, usually smaller, arched or rectangular openings or niches between paired articulating pilasters or columns.

Tuscan See order.

ut pictura poesis As is painting so too is poetry (from Horace, *Ars poetica* 361).

Veneto The terraferma territory on the Italian mainland under Venetian control.

vespers Evening prayer service.

vesta Doublet or toga.

veta Doge's white linen cap worn under his crown (*corno*).

via triumphalis Triumphal way.

vicario In a confraternity, the vice-head, or second-highest administrative official.

Vicentine foot A measurement of about fourteen inches.

vigil Mass Mass celebrated a day before a major feast day.

villeggiatura Country villa, or summer retreat to a country villa.

viola da gamba Bowed, fretted, and stringed musical instrument.

volute Spiral scroll on an Ionic, Corinthian, or Composite capital; spiral scroll often used on the façades of Renaissance churches to mark the transition from the nave to the aisles.

voussoir Wedge-shaped stone of an arch.

wainscoting Paneled wooden lining on a wall.

zazzera Man's hairdo with rolled-under shoulder-length hair and bangs.

zimarra Fur robe of Turkish origin.

zonta Group of officials augmenting the Venetian Senate or the *banca* in a confraternity, often charged with special duties, such as examining accounts.

zucchetto Priest's skullcap.

SELECTED BIBLIOGRAPHY

Ackerman, James S., *Palladio* (Harmondsworth: Penguin, 1966).
———, *Palladio's Villas* (Locust Valley, NY: Augustin, 1967).
———, "Observations on Renaissance Church Planning in Venice and Florence, 1470–1570," *Florence and Venice: Comparisons and Relations,* vol. 2, 287–307, Villa I Tatti Papers (Florence: La nuova Italia, 1979–80).
———, *The Villa: Form and Ideology of the Country House* (Princeton: Princeton University Press, 1990).
Addona, Victoria, "Boundaries of License: The Materiality of the Painted Facades in Cinquecento Venice" (MA thesis, McGill University, 2010).
Adriano, Aymonino, "La Pala di San Pantaleon: Imagine devozionale e manifesto politico," *Venezia Cinquecento* 15, no. 30 (2005), 159–200.
Aikema, Bernard, ed., *Tiziano: Venezia e il Papa Borgia* (Pieve di Cadore: Centro Studi Tiziano Vecellio/Alinari, 2013).
——— and Beverly Louise Brown, eds., *Renaissance Venice and the North: Crosscurrents in the Time of Bellini, Dürer and Titian* (Venice: Bompiani, 1999).
Ajmar-Wollheim, Marta, and Flora Dennis, eds., *At Home in Renaissance Italy,* exh. cat. (New York: Abrams, 2006).
Alabiso, Anna Chiara, *La Danaë di Tiziano: Il mito, la storia, il restauro* (Naples: Electa, 2005).
Alberti, Leon Battista, *On the Art of Building in Ten Books,* trans. Joseph Rykwert, Neil Leach, and Robert Tavernor (Cambridge, MA: MIT Press, 1988).
Ames-Lewis, Francis, ed., *New Interpretations of Venetian Renaissance Painting* (London: Birckbeck, 1994).
Anderson, Jaynie, "The Provenance of Bellini's *Feast of the Gods* and a New/Old Interpretation," *Studies in the History of Art* 45 (1993), 264–87.
———, *Giorgione: The Painter of "Poetic Brevity"* (Paris: Flammarion, 1997).

———, ed., "Women Patrons of Renaissance Art, 1300–1600," special issue, *Renaissance Studies* 10 (1996).
Aretino, Pietro, *Pietro Aretino* (includes *L'umanità di Cristo,* 347–501), ed. Giulio Ferroni, Carlo Serafini, and Luciana Zampolli (Rome: Istituto poligrafico e Zecca dello Stato, 2002).
"Art in Sixteenth-Century Venice: Context, Practices, Developments: Proceedings of a Conference in Honour of Peter Humfrey," special issues, *Artibus et historiae* 67–68 (2013).
Avcioglu, Nebahat, and Emma Jones, eds., *Architecture, Art and Identity in Venice and Its Territories, 1450–1750: Essays in Honour of Deborah Howard* (Aldershot: Ashgate, 2014).
Avery, Victoria, *Vulcan's Forge in Venus' City: The Story of Bronze in Venice, 1350–1650* (Oxford: Oxford University Press, 2011).
Bacchi, Andrea, Lia Camerlengo, and Manfred Leithe-Jasper, *La Bellissima Maniera: Alessandro Vittoria e la scultura veneta del Cinquecento,* exh. cat. (Trent: Provincia autonoma di Trento, Servizio beni culturali, 1999).
Bailey, Meryl Faith, "More Catholic than Rome: Art and Lay Spirituality at Venice's Scuola di S. Fantin, 1562–1605" (PhD diss., University of California, Berkeley, 2011).
Ballarin, Alessandro, *Il Camerino delle pitture di Alfonso I,* 6 vols. (Padua: Bertoncello, 2002–7).
Banzato, Davide, Franca Pellegrini, and Ugo Soragni, eds., *Giorgione a Padova: L'enigma del carro,* exh. cat. (Milan: Skira, 2010).
Barbaro, Daniele, ed. and trans., *I dieci libri dell'architettura di M. Vitruvio* (Venice: Franceschi, 1556).
———, *La pratica della perspecttiva* (Venice: Borgominieri, 1568).

Barbieri, Franco, and Guido Beltramini, *Vincenzo Scamozzi, 1548–1616,* exh. cat. (Venice: Marsilio, 2003).

Bardi, Girolamo, *Dichiaratione di tutte le istorie che si contengono nei quadri posti novamente nelle Sale dello Scrutinio & del Gran Consiglio del Palagio Ducale della serenissima republica di Vinegia* (Venice: Valgrisio, 1587).

Bätschmann, Oskar, *Giovanni Bellini* (London: Reaktion, 2008).

Beltramini, Guido, *Andrea Palladio: The Complete Illustrated Works* (New York: Universe, 2001).

———, *The Private Palladio* (Zurich: Muller, 2012).

——— and Howard Burns, eds., *Andrea Palladio e la villa veneta: Da Petrarca a Carlo Scarpa,* exh. cat. (Venice: Marsilio, 2005).

———, Howard Burns, and Davide Gasparotto, eds., *Pietro Bembo e le arti: Atti del Seminario Internazionale (Padova 24–26 febbraio 2011)* (Venice: Marsilio, 2013).

Beneficio di Cristo, ed. Salvatore Caponetto (Florence: Sansoni; Chicago: Newberry Library, 1972).

Berenson, Bernard, et al., *Palladio, Veronese, e Vittoria a Maser* (Milan: Martello, 1960).

Bernardini, Maria Grazia, ed., *Tiziano: Amore sacro e amor profane,* exh. cat. (Milan: Electa, 1995).

Biadene, Susanna, ed., *Titian: Prince of Painters,* exh. cat. (Munich: Prestel, 1990).

Biferali, Fabrizio, *Paolo Veronese tra Riforma e Controriforma* (Rome: Artemide, 2013).

Black, Christopher F., *Italian Confraternities in the Sixteenth Century* (Cambridge: Cambridge University Press, 1989).

Bober, Phyllis Pray, and Ruth Rubinstein, *Renaissance Artists and Antique Sculpture: A Handbook of Sources* (Oxford: Miller, 1986).

Boschini, Marco, *La carta del navegar pitoresco* (Venice: Il Baba, 1660).

———, *Le riche minere della pittura veneziana* (Venice: Nicolini, 1674).

Bosworth, R. J. B., *Italian Venice: A History* (New Haven: Yale University Press, 2014).

Boucher, Bruce, *The Sculpture of Jacopo Sansovino,* 2 vols. (New Haven: Yale University Press, 1991).

———, *Andrea Palladio: The Architect in His Time* (New York: Abbeville, 1998).

Bouwsma, William J., *Venice and the Defense of Republican Liberty: Renaissance Values in the Age of the Counter Reformation* (Berkeley: University of California Press, 1991).

Braham, Allan, "Veronese's Allegories of Love," *Burlington Magazine* 112 (1970), 205–12.

Branca, Vittore, and Carlo Ossola, eds., *Cultura e società nel Rinascimento tra riforme e manierismi* (Florence: Olschki, 1984).

———, eds., *Crisi e rinnovamenti nell'autunno del Rinascimento a Venezia* (Florence: Olschki, 1991).

Brilliant, Virginia, and Frederick Ilchman, eds., *Paolo Veronese: A Master and His Workshop in Renaissance Venice,* exh. cat. (London: Scala, 2012).

Brown, David Alan, ed., *Virtue and Beauty: Leonardo's Ginevra de' Benci and Renaissance Portraits of Women,* exh. cat. (Princeton: Princeton University Press, 2001).

——— and Sylvia Ferino-Pagden, eds., *Bellini, Giorgione, Titian and the Renaissance of Venetian Painting,* exh. cat. (New Haven: Yale University Press, 2006).

Brown, Horatio F., *The Venetian Printing Press, 1469–1800* (Amsterdam: Van Heusden, 1969).

Brown, Katherine T., *The Painter's Reflection: Self-Portraiture in Renaissance Venice, 1458–1625* (Florence: Olschki, 2000).

Brown, Patricia Fortini, "Honor and Necessity: The Dynamics of Patronage in the Confraternities of Renaissance Venice," *Studi veneziani* 14 (1987), 179–212.

———, *Venetian Narrative Painting in the Age of Carpaccio* (New Haven: Yale University Press, 1988).

———, *Venice and Antiquity: The Venetian Sense of the Past* (New Haven: Yale University Press, 1996).

———, *Art and Life in Renaissance Venice* (New York: Abrams/Prentice Hall, 1997).

———, "Carpaccio's *St. Augustine in His Study*: A Portrait within a Portrait," *Augustine in Iconography, History and Legend,* ed. Joseph C. Schnaubelt and Frederick Van Fleteren, 507–47 (New York: Peter Lang, 1999).

———, *Private Lives in Renaissance Venice: Art, Architecture, and the Family* (New Haven: Yale University Press, 2004).

Brusegan, Marcello, ed., *San Michele in Isola—Isola della Conoscenza: Ottocento anni di storia e cultura camaldolesi nella laguna di Venezia,* exh. cat. (Turin: UTET, 2012).

Burns, Howard, *La villa italiana del Rinascimento,* trans. Ilaria Abbondandolo (Vicenza: Angelo Colla, 2012).

———, Lynda Fairbairn, and Bruce Boucher, *Andrea Palladio, 1508–1580: The Portico and the Farmyard,* exh. cat. (London, 1975).

Calabi, Donatella, and Paolo Morachiello, *Rialto: Le fabbriche e il ponte, 1514–1591* (Turin: Einaudi, 1987).

Calabrese, Omar, ed., *Venere svelata: La Venere di Urbino di Tiziano,* exh. cat. (Milan: Silvana, 2003).

Campagnol, Isabella, *Forbidden Fashions: Invisible Luxuries in Early Venetian Convents* (Lubbock: Texas Tech University Press, 2013).

Campbell, Caroline, and Alan Chong, eds., *Bellini and the East,* exh. cat. (London: National Gallery, 2005).

Campbell, Erin, ed., *Growing Old in Early Modern Europe: Cultural Representations* (Aldershot: Ashgate, 2006).

Campbell, Gordon, *The Oxford Dictionary of the Renaissance* (New York: Oxford University Press, 2003).

Campbell, Stephen J., "Giorgione's *Tempest, Studiolo* Culture, and the Renaissance Lucretius," *Renaissance Quarterly* 56, no. 2 (2003), 299–332.

Campenhausen, Britta von, *Eloquente Pittore, Pingente Oratore: Studien zu mythologisch-allegorischen Gemälden Paolo Veroneses* (Munich: Scaneg, 2003).

Carboni, Stefano, ed., *Venice and the Islamic World, 828–1797,* exh. cat. (New Haven: Yale University Press, 2007).

Cattoi, Domizio, and Domenica Primerano, *Arte e persuasion: La strategia delle imagine dopo il Concilio di Trento,* exh. cat. (Trent: Museo Diocesano-Temi, 2014).

Cellauro, Louis, "Daniele Barbaro and Vitruvius: The Architectural Theory of a Renaissance Humanist and Patron," *Papers of the British School at Rome* 72 (2004), 239–329.

Chambers, David S., *The Imperial Age of Venice, 1380–1580* (London: Thames and Hudson, 1970).

———, "Merit and Money: The Procurators of St. Mark and Their Commissions, 1443–1605," *Journal of the Warburg and Courtauld Institutes* 60 (1997), 23–88.

———, Brian Pullan, and Jennifer Fletcher, *Venice: A Documentary History, 1450–1630* (Cambridge, MA: Blackwell, 1992).

Checa Cremandes, Fernando, *Tiziano y las cortes del Renacimiento* (Madrid: Marcial Pons Historia, 2013).

Chojnacki, Stanley, "Social Identity in Renaissance Venice: The Second Serrata," *Renaissance Studies* 8, no. 4 (December 1994), 341–58.

———, "Identity and Ideology in Renaissance Venice: The Third Serrata," *Venice Reconsidered,* ed. John Martin and Dennis Romano, 263–94 (Baltimore: Johns Hopkins University Press, 2000).

———, *Women and Men in Renaissance Venice: Twelve Essays on Patrician Society* (Baltimore: Johns Hopkins University Press, 2000).

Christiansen, Keith, and Stefan Weppelmann, eds., *The Renaissance Portrait from Donatello to Bellini,* exh. cat. (New Haven: Yale University Press, 2011).

Ciatti, Marco, Fausta Navarro, and Patrizia Riitano, *Titian's "La Bella": Woman in a Blue Dress,* exh. cat. (Florence: Edifir, 2011).

Cioci, Francesco, *La "Tempesta" interpretata dieci anni dopo* (Florence: Centro Di, 1991).

Cocke, Richard, "Exemplary Lives: Veronese's Representations of Martyrdom and the Council of Trent," *Renaissance Studies* 10 (1996), 388–404.

———, *Paolo Veronese: Piety and Display in an Age of Religious Reform* (Burlington, VT: Ashgate, 2001).

———, *Veronese* (London: Chaucer, 2005).

Colantuono, Anthony, "Dies Alcyoniae: The Invention of Bellini's *Feast of the Gods,*" *Art Bulletin* 73 (1991), 237–56.

———, *Titian, Colonna, and the Renaissance Science of Procreation: Equicola's Seasons of Desire* (Burlington, VT: Ashgate, 2010).

Colonna, Francesco, *Hypnerotomachia Poliphili: The Strife of Love in a Dream,* trans. Joscelyn Godwin (New York: Thames and Hudson, 1999).

Concina, Ennio, *A History of Venetian Architecture,* trans. Judith Landry (Cambridge: Cambridge University Press, 1998).

Contadini, Anna, and Claire Norton, eds., *The Renaissance and the Ottoman World* (Farnham: Ashgate, 2013).

Cooper, Tracy E., *Palladio's Venice: Architecture and Society in a Renaissance Republic* (New Haven: Yale University Press, 2005).

Corsi Ramos, Girolama, "Rime di D. Girolama Corse, Toscana, raccolte da Marino di Lionardo Sanuto" (1509), MS It. IX 270, Biblioteca Nazionale Marciana, Venice.

Cosgrove, Denis E., *The Palladian Landscape: Geographical Change and Its Cultural Representations in Sixteenth-Century Italy* (University Park: Pennsylvania State University Press, 1993).

Cottrell, Philip, "Corporate Colors: Bonifacio and Tintoretto at the Palazzo dei Camerlenghi in Venice," *Art Bulletin* 82 (2000), 658–78.

Cranston, Jodi, *The Muddied Mirror: Materiality and Figuration in Titian's Later Paintings* (University Park: Penn State University Press, 2010).

Crouzet-Pavan, Elisabeth, *Venice Triumphant: The Horizons of a Myth,* trans. Lydia G. Cochrane (Baltimore: Johns Hopkins University Press, 2002).

Da Cortà Fumei, Monica, ed., *Il Paradiso di Palazzo Ducale: Da Guariento a Tintoretto* (Milan: 5 Continents, 2006).

Dal Pozzolo, Enrico Maria, "Giorgione a Montagnana," *Critica d'Arte* 56 (1991), 23–42.

Da Mosto, Andrea, *I dogi di Venezia nella vita pubblica e private* (Florence: Giunti, 1977).

Da Tiziano a El Greco: Per la storia del manierismo a Venezia, 1540–1590, exh. cat., Palazzo Ducale, Venice (Milan: Electa, 1981).

Davis, Robert C., *Shipbuilders of the Venetian Arsenal: Workers and Workplace in the Preindustrial City* (Baltimore: Johns Hopkins University Press, 1991).

D'Elia, Una Roman, *The Poetics of Titian's Religious Paintings* (Cambridge: Cambridge University Press, 2005).

De Maria, Blake, *Becoming Venetian: Immigrants and the Arts in Early Modern Venice* (New Haven: Yale University Press, 2010).

D'Evelyn, Margaret Muther, *Venice and Vitruvius: Reading Venice with Daniele Barbaro and Andrea Palladio* (New Haven: Yale University Press, 2012).

Di Monti, Michele, "La morte bella: Il martirio nella pittura di Tiziano, Tintoretto e Veronese," *Venezia Cinquecento* 11, no. 17 (1999), 91–179.

Dolce, Lodovico, *Dialogo della institutione delle donne* (Venice: Gabriel Giolito de' Ferrari, 1560).

———, *Aretin: A Dialogue on Painting* (London: Elmsley, 1770).

———, *L'Aretino: Dialogo della pittura,* ed. Guido Battelli (Florence: Le Monnier, 1910).

Duby, Georges, Guy Lobrichon, and Terisio Pignatti, eds., *The History of Venice in Painting* (New York: Abbeville, 2007).

Dunkerton, Jill, and Marika Spring, eds., *Titian's Painting Technique before 1540* (London: National Gallery/Yale University Press, 2013).

Edgerton, Samuel Y., Jr., *The Renaissance Rediscovery of Linear Perspective* (New York: Basic Books, 1975).

Eisler, Colin T., *The Genius of Jacopo Bellini: The Complete Paintings and Drawings* (New York: Abrams, 1989).

Eller, Wolfgang, *Giorgione: Catalogue Raisonne: Mystery Unveiled,* trans. Ingeborg Elizabeth Pendl (Petersberg: Imhof, 2007).

Evers, Sonia H., "The Art of Paolo Veronese: Artistic Identity in Harmony with Patrician Ideology" (PhD diss., University of California, Berkeley, 1994).

Falomir, Miguel, ed., *Tiziano,* exh. cat. (Madrid: Museo Nacional del Prado, 2003).

———, ed., *Tintoretto,* exh. cat. (Madrid: Museo Nacional del Prado, 2007).

———, ed., *Jacopo Tintoretto: Proceedings of the International Symposium Jacopo Tintoretto* (Madrid: Museo Nacional del Prado, 2009).

Fehl, Philipp, "Veronese and the Inquisition: A Study in the Subject Matter of the So-Called Feast in the House of Levi," *Gazette des Beaux-Arts* 58 (1961), 348–54.

———, *Decorum and Wit: The Poetry of Venetian Painting: Essays in the History of the Classical Tradition* (Vienna: IRSA, 1992).

Ferino-Pagden, Sylvia, ed., *Giorgione Entmythisiert* (Turnhout: Brepols, 2008).

———, ed., *Late Titian and the Sensuality of Painting,* exh. cat. (Venice: Marsilio, 2008).

——— and Giovanna Nepi Sciré, eds., *Giorgione: Myth and Enigma,* exh. cat. (Milan: Skira, 2004).

Festus, Sextus Pompeius, *De verborum significatione,* ed. Karl Otfried Müller (Leipzig: Weidmanniana, 1839).

Finlay, Robert, *Politics in Renaissance Venice* (New Brunswick, NJ: Rutgers University Press, 1980).

Fischer, Söoren, *Das Landschaftsbild als gerahmter Ausblick in den venezianischen Villen des 16. Jahrhunderts: Sustris, Padovano, Veronese, Palladio und die illusionistische Landschaftsmalerei* (Petersbert: Imhof, 2014).

Fleming, John V., *From Bonaventure to Bellini: An Essay in Franciscan Exegesis* (Princeton: Princeton University Press, 1982).

Fletcher, Jennifer, "Marcantonio Michiel: His Friends and Collection," *Burlington Magazine* 123, no. 941 (August 1981), 453–67.

Frank, Mary E., and Blake de Maria, *Reflections on Renaissance Venice: A Celebration of Patricia Fortini Brown* (Milan: 5 Continents, 2013).

Franzoi, Umberto, *Storia e leggenda del Palazzo Ducale di Venezia* (Venice: Storti, 1982).

———, Terisio Pignatti, and Wolfgang Wolters, *Il Palazzo Ducale di Venezia* (Treviso: Canova, 1990).

Freedman, Luba, *Titian's Independent Self-Portraits* (Florence: Olschki, 1990).

———, *Titian's Portraits through Aretino's Lens* (University Park: Penn State University Press, 1995).

Frommel, Sabine, *Sebastiano Serlio architetto* (Milan: Electa, 1998).

Garton, John, *Grace and Grandeur: The Portraiture of Paolo Veronese* (London: Miller, 2008).

Gasparini, Danilo, and Lionello Puppi, *Villa Emo* (Vicenza: Terra Ferma, 2009).

Gaye, Giovanni, *Carteggio inedito d'artisti dei secoli XIV, XV, XVI,* 3 vols. (Florence: Molini, 1839–40).

Gemin, Massimo, *Nuovi Studi su Paolo Veronese* (Venice: Arsenale, 1990).

Giorgi (or Zorzi), Francesco, *De harmonia mundi totius* (Venice, 1525).

Gleason, Elisabeth G., *Gasparo Contarini: Venice, Rome, and Reform* (Berkeley: University of California Press, 1993).

———, ed., *Reform Thought in Sixteenth-Century Italy* (includes the *Beneficio di Christo*) (Chico, CA: Scholars Press, 1981).

Goffen, Rona, "Icon and Vision: Giovanni Bellini's Half-Length Madonnas," *Art Bulletin* 57 (1975), 487–518.

———, "*Nostra Conversatio in Caelis Est:* Observations on the *Sacra Conversazione* in the Trecento," *Art Bulletin* 61 (1979), 198–222.

———, *Piety and Patronage in Renaissance Venice: Bellini, Titian, and the Franciscans* (New Haven: Yale University Press, 1986).

———, *Giovanni Bellini* (New Haven: Yale University Press, 1989).

———, *Titian's Women* (New Haven: Yale University Press, 1997).

———, *Renaissance Rivals: Michelangelo, Leonardo, Raphael, Titian* (New Haven: Yale University Press, 2002).

———, ed., *Titian's "Venus of Urbino"* (Cambridge: Cambridge University Press, 1997).

——— and Giovanna Nepi Sciré, eds., *Il colore retrovato: Bellini a Venezia,* exh. cat. (Milan: Electa, 2000).

Goldfarb, Hillair T., *Imaging the Self in Renaissance Italy,* exh. cat. (Boston: Isabella Stewart Gardner Museum, 1992).

Goodman-Soellner, Elise, "The Poetic Iconography of Veronese's Cycle of Love," *Artibus et historiae* 7 (1983), 19–28.

Gould, Cecil, *National Gallery Catalogues: The Sixteenth-Century Venetian School* (London: National Gallery, 1959).

Goy, Richard J., *The House of Gold: Building a Palace in Medieval Venice* (Cambridge: Cambridge University Press, 1992).

———, *Venice: The City and Its Architecture* (London: Phaidon, 1997).

———, *Building Renaissance Venice: Patrons, Architects and Builders, c. 1430–1500* (New Haven: Yale University Press, 2006).

———, *Venice: An Architectural Guide* (New Haven: Yale University Press, 2010).

Grabski, Jósef, "The Group of Paintings by Tintoretto in the "Sala Terrena" in the Scuola di San Rocco in Venice and their Relationship to the Architectural Structure," *Artibus et historiae* 1 (1980), 30–43.

Guidarelli, Gianmario, ed., *La Chiesa di San Salvador: Storia Arte Teologia* (Padua: Il Prato, 2009).

Gullino, Giuseppe, and Gaetano Cozzi, eds., *La chiesa di Venezia tra riforma protestante a reforma cattolica* (Venice: Studium Catolico Veneziano, 1990).

Habert, Jean, ed., *Les Noces de Cana de Véronèse: Une oeuvre et sa restauration* (Paris: Réunion des musées nationaux, 1992).

——, ed., *Il Paradiso di Tintoretto: Un concorso per Palazzo Ducale*, exh. cat. (Milan: 5 Continents, 2006).

—— and Vincent Pomarède, eds., *Tiziano e la pittura del Cinquecento a Venezia: Capolavori dal Louvre*, exh. cat. (Conegliano: Linea d'Ombra, 2004).

Hacke, Daniela, *Women, Sex and Marriage in Early Modern Venice* (Aldershot: Ashgate, 2004).

Häfele, Arnulf, *Giorgiones Himmel: Das Gemälde mit "den drei Philosophen" als Grenserfahrung der Ikonographie* (Hildesheim: Olms, 2013).

Hale, J. R., ed., *Renaissance Venice* (London: Faber, 1973).

Hall, James, *Dictionary of Subjects and Symbols in Art*, 2nd ed. (Philadelphia: Westview, 2008).

Hamilton, Paul C., "The Palazzo dei Camerlenghi in Venice," *Journal of the Society of Architectural Historians* 42 (1983), 258–71.

Harff, Arnold von, *The Pilgrimage of Arnold von Harff*, trans. Malcolm Letts (London: Hakluyt, 1946).

Hills, Paul, "Piety and Patronage in Cinquecento Venice: Tintoretto and the Scuole del Sacramento," *Art History* 6 (1983), 30–43.

——, *Venetian Colour: Marble, Mosaic, Painting, and Glass, 1250–1550* (New Haven: Yale University Press, 1999).

Hirdt, Willi, *I tre filosofi di Giorgione*, trans. Paolo Scotini (Florence: Società Editrice Fiorentina, 2004).

Hochmann, Michel, *Peintre et commandataires à Venise, 1540–1628* (Rome: Ecole française de Rome, 1992).

Holberton, Paul, *Palladio's Villas: Life in the Renaissance Countryside* (London: Murray, 1990).

——, "Giorgione's *Tempesta* or 'Little Landscape with the Storm with the Gypsy': More on the Gypsy, and a Reassessment," *Art History* 18 (1995), 383–403.

——, "To Loosen the Tongue of Mute Poetry: Giorgione's Self-Portrait as 'David' as a Paragone Demonstration," *Poetry on Art: Renaissance to Romanticism*, ed. Thomas Frangenberg, 29–47 (Donington: Shaun Tyas, 2003).

Hope, Charles, *Titian* (New York: Harper and Row, 1980).

——, ed., *Il regno e l'arte: I Camerini di Alfonso I d'Este, terzo duca di Ferrara* (Florence: Olschki, 2012).

—— et al., *Titian: Essays*, exh. cat. (London: National Gallery, 2003).

Hopkins, Andrew, "The Influence of Ducal Ceremony on Church Design in Venice," *Architectural History* 41 (1998), 30–48.

Howard, Deborah, *Jacopo Sansovino: Architecture and Patronage in Renaissance Venice* (New Haven: Yale University Press, 1975).

——, "Giorgione's *Tempesta* and Titian's *Assunta* in the Context of the Cambrai Wars," *Art History* 8 (1985), 271–89.

——, *Venice and the East: The Impact of the Islamic World on Venetian Architecture, 1100–1500* (New Haven: Yale University Press, 2000).

——, *The Architectural History of Venice* (New York: Holmes and Meier, 1981; rev. ed., New Haven: Yale University Press, 2002).

——, "San Michele in Isola: Re-reading the Genesis of the Venetian Renaissance," *L'invention de la Renaissance: La réception des formes "à l'antique" au début de la Renaissance*, ed. Jean Guillaume, 27–42 (Paris: Picard, 2003).

——, *Venice Disputed: Marc'Antonio Barbaro and Venetian Architecture, 1500–1600* (New Haven: Yale University Press, 2011).

—— and Malcolm Longair, "Harmonic Proportion and Palladio's 'Quattro Libri,'" *Journal of the Society of Architectural Historians* 41, no. 2 (1982), 116–43.

Humfrey, Peter, "The Bellinesque Life of St. Mark Cycle for the Scuola Grande di San Marco," *Zeitschrift für Kunstgeschichte* 48 (1985), 225–42.

——, *The Altarpiece in Renaissance Venice* (New Haven: Yale University Press, 1993).

——, *Painting in Renaissance Venice* (New Haven: Yale University Press, 1995).

——, "Altarpieces and Altar Dedications in Counter-Reformation Venice and the Veneto," *Renaissance Studies* 10 (1996), 371–87.

——, "Veronese's High Altarpiece for San Sebastiano: A Patrician Commission for a Counter Reformation Church," in *Venice Reconsidered: The History and Civilization of an Italian City-State, 1297–1797*, ed. John Martin and Dennis Romano, 365–88 (Baltimore: Johns Hopkins University Press, 2000).

——, *Carpaccio* (London: Chaucer, 2005).

——, *Titian: The Complete Paintings* (New York: Abrams, 2007).

——, ed., *The Cambridge Companion to Giovanni Bellini* (New York: Cambridge University Press, 2004).

——, ed., *Venice and the Veneto* (New York: Cambridge University Press, 2007).

Hunt, John Dixon, ed., *The Pastoral Landscape* (Washington, DC: National Gallery of Art, 1992).

Huse, Norbert, and Wolfgang Wolters, *The Art of Renaissance Venice: Architecture, Sculpture and Painting, 1460–1590*, trans. Edmund Jephcott (Chicago: Chicago University Press, 1990).

Ilchman, Frederick, et al., *Titian, Tintoretto, Veronese: Rivals in Renaissance Venice*, exh. cat. (Boston: MFA Publications, 2009).

Jaffé, David, ed., *Titian: Essays*, exh. cat. (London: National Gallery and Yale University Press, 2003).

Joannides, Paul, *Titian to 1518: The Assumption of Genius* (New Haven: Yale University Press, 2001).

Junkerman, Anne Christine, "The Lady and the Laurel: Gender and Meaning in Giorgione's *Laura*," *Oxford Art Journal* 16 (1993), 49–58.

Kahr, Madlyn, "The Meaning of Veronese's Paintings in the Church of San

Sebastiano in Venice," *Journal of the Warburg and Courtauld Institutes* 33 (1970), 235–47.

Kasl, Ronda, ed., *Giovanni Bellini and the Art of Devotion,* exh. cat. (Indianapolis: Indianapolis Museum of Art, 2004).

King, Catherine, *Renaissance Women Patrons: Wives and Widows in Italy, c. 1300–1550* (Manchester: Manchester University Press, 1998).

King, Margaret L., *Venetian Humanism in an Age of Patrician Dominance* (Princeton: Princeton University Press, 1986).

———, *Humanism, Venice, and Women: Essays on the Italian Renaissance* (Aldershot: Ashgate, 2005).

Kolb-Lewis, Carolyn, "The Villa Giustinian at Roncade" (PhD diss., Harvard, 1973; New York: Garland, 1977).

——— and Melissa Beck, "The Sculptures on the Nymphaeum Hemicycle of the Villa Barbaro at Maser," *Artibus et historiae* 18, no. 35 (1997), 15–40.

Krischel, Roland, *Jacopo Tintoretto, 1519–1594,* trans. Anthea Bell (Cologne: Könemann, 2000).

Laclotte, Michel, Giovanna Nepi Scirè, et al., *Le siècle de Titien: L'âge d'or de la peinture à Venise,* exh. cat. (Paris: Réunion des musées nationaux, 1993).

———, Olivier Le Bihan, Patrick Ramade, and Michel Hochmann, *Splendeur de Venise, 1500–1600,* exh. cat. (Paris: Somogy, 2005).

Lane, Frederic C., *Venice: A Maritime Republic* (Baltimore: Johns Hopkins University Press, 1973).

Lauber, Rosella, and Mario Bozzetto, *Giorgione: La Tempesta: Gallerie dell'Accademia di Venezia* (Milan: Bozzetto, 2010).

Law, John E., *Venice and the Veneto in the Early Renaissance* (Aldershot: Ashgate, 2000).

Lee, Rensselaer W., *Ut pictura poesis: The Humanistic Theory of Painting* (New York: Norton, 1967).

Lettieri, Dan, "Landscape and Lyricism in Giorgione's *Tempesta,*" *Artibus et historiae* 30 (1994), 55–70.

Lewis, Douglas, "Classical Texts and Mystic Meanings: Daniele Barbaro's Program for the Villa Maser," *Klassizismus: Epoche und Probleme: für Erik Forssman,* ed. Jürg Meyer zur Capellen and Gabriele Oberreuter-Kronabel, 288–307 (Hildesheim: Olms, 1987).

Liebenwein, Wolfgang, *Studiolo: Storia e tipologia di uno spazio culturale,* ed. Claudia Cieri Via, trans. Alessandro Califano (Modena: Panini, 1992).

Lieberman, Ralph, *Renaissance Architecture in Venice, 1450–1540* (New York: Abbeville, 1982).

Logan, Oliver, *Culture and Society in Venice, 1470–1790: The Renaissance and Its Heritage* (New York: Scribner, 1972).

Lotz, Wolfgang, "The Roman Legacy in Sansovino's Venetian Buildings," *Journal of the Society of Architectural Historians* 22, no. 1 (1963), 3–12.

Lowinsky, Edward E., "Epilogue: The Music in St. Jerome's Study," *Art Bulletin* 41 (1959), 298–301.

Lucco, Mauro, *La pittura a Venezia: Il Cinquecento,* 3 vols. (Milan: Electa, 1996).

———, ed., *La pittura nel Veneto: Il Quattrocento,* 2 vols. (Milan: Electa, 1990).

———, ed., *Antonello da Messina: L'opera completa,* exh. cat. (Milan: Silvana, 2006).

——— and Giovanni Carlo Federico Villa, eds., *Giovanni Bellini* (Milan: Silvana, 2008).

Luchs, Alison, et al., *Tullio Lombardo and Venetian High Renaissance Sculpture,* exh. cat. (New Haven: Yale University Press, 2009).

MacDougall, Elisabeth, "The Sleeping Nymph: Origins of a Humanist Fountain Type," *Art Bulletin* 57 (1975), 357–65.

Mack, Rosamund, *From Bazaar to Piazza: Islamic Trade and Italian Art, 1300–1600* (Berkeley: University of California Press, 2002).

Manca, Joseph, ed., *Titian 500,* exh. cat., Studies in the History of Art 45 (Washington, DC: National Gallery of Art, 1993).

Marini, Paola, and Bernard Aikema, eds., *Paolo Veronese: L'Illusione delle Realtà* (Milan: Electa, 2014).

Martin, John Jeffries, *Venice's Hidden Enemies: Italian Heretics in a Renaissance City* (Berkeley: University of California Press, 1993).

———, *Myths of Renaissance Individualism* (New York: Palgrave Macmillan, 2004).

——— and Dennis Romano, eds., *Venice Reconsidered: The History and Civilization of an Italian City-State, 1297–1797* (Baltimore: Johns Hopkins University Press, 2000).

Martineau, Jane, and Charles Hope, eds., *The Genius of Venice 1500–1600,* exh. cat. (New York: Abrams, 1983).

Martinis, Roberta, "Ca' Loredan-Vendramin-Calergi a Venezia: Mauro Codussi e il palazzo di Andrea Loredan," *Annali di architettura* 10/11 (1998–99), 43–61.

Mason Rinaldi, Stefania, *Palma il Giovane: L'opera completa* (Milan: Electa, 1984).

———, *Carpaccio: The Major Pictorial Cycles,* trans. Andrew Ellis (Milan: Skira, 2000).

Massimi, Maria Elena, "Jacopo Tintoretto e i confratelli della Scuola Grande di San Rocco: Strategie culturali e committenza artistica," *Venezia Cinquecento* 5, no. 9 (1995), 5–108.

———, *"La cena in casa Levi" di Paolo Veronese: Il processo reaperto* (Venice: Marsilio, 2012).

McAndrew, John, *Venetian Architecture of the Early Renaissance* (Cambridge, MA: MIT Press, 1980).

McNeill, William H., *Venice: The Hinge of Europe, 1081–1797* (Chicago: University of Chicago Press, 1974).

Meilman, Patricia, *Titian and the Altarpiece in Renaissance Venice* (Cambridge: Cambridge University Press, 2000).

Meneghin, Vittorino, *S. Michele in Isola di Venezia* (Venice: Stamperia di Venezia, 1962).

Michiel, Marcantonio, *Notizia d'opere di disegno* (Bassano: Morelli, 1800).

———, *The Anonimo,* trans. Paolo Mussi, ed. George C. Williamson (New York: Blom, 1969).

Mohler, Ludwig, *Kardinal Bessarion als Theologe, Humanist und Staatsmann,* 3 vols. (Paderborn: Schöningh, 1942).

Moriani, Gianni, *Palladio architetto della villa fattoria: Territorio, agricoltura, ville, barchesse, cantine e cucine nella terraferma Veneziana del XVI secolo* (Verona: Cierre, 2008).

———, *Le fastose cene di Paolo Veronese nella Venezia del Cinquecento* (Crocetta dei Montello: Terra Firma, 2014).

Morresi, Manuela, *Villa Porto Colleoni a Thiene: Architettura e committenza nel Rinascimento vicentino* (Milan: 1988).

———, *Piazza San Marco: Istituzioni, poteri e architettura a Venezia nel primo Cinquecento* (Milan: Electa, 1999).

———, *Jacopo Sansovino* (Milan: Electa, 2000).

Morse, Margaret A., "Creating Sacred Space: The Religious Visual Culture of the *Casa* in Renaissance Venice," *Renaissance Studies* 21, no. 2 (2007), 151–84.

Muir, Edward, "Images of Power: Art and Pageantry in Renaissance Venice," *American Historical Review* 84, no. 1 (1979), 16–52.

———, *Civic Ritual in Renaissance Venice* (Princeton: Princeton University Press, 1981).

Muraro, Maria Teresa, "La festa a Venezia e le sue manifestazioni rappresentative: Le Compagnie della Calza e le momarie," in *Storia della cultura veneta,* vol. 3, 315–41 (Vicenza: Neri Pozza, 1976).

Muraro, Michelangelo, "La Scala senza Giganti," *De Artibus Opuscula XL: Essays in Honor of Erwin Panofsky,* ed. Millard Meiss, 350–70 (New York: New York University Press, 1961).

——— and Paolo Marton, *Venetian Villas: The History and Culture* (New York: Rizzoli, 1986).

Nash, Jane C., *Veiled Images: Titian's Mythological Paintings for Philip II* (Philadelphia: Associated University Presses, 1985).

Newett, M. Margaret, *Canon Pietro Casola's Pilgrimage to Jerusalem in the Year 1494* (Manchester: Manchester University Press, 1907).

Newton, Stella Mary, *The Dress of Venetians, 1495–1525* (Aldershot: Scolar Press, 1988).

Nichols, Tom, *Tintoretto: Tradition and Identity* (London: Reaktion, 1999).

———, *Titian and the End of the Venetian Renaissance* (London: Reaktion, 2013).

Norwich, John Julius, *A History of Venice* (Harmondsworth: Penguin, 1983).

Ovid, *Metamorphoses,* trans. Frank Justus Miller, Loeb Classical Library (Cambridge, MA: Harvard University Press, 1984).

———, *Fasti,* 2nd ed., trans. James George Frazer, Loeb Classical Library (Cambridge, MA: Harvard University Press, 1989).

Palladio, Andrea, *L'antichità di Roma* (Rome: Lucrino, 1554).

———, *I quattro libri dell'architettura* (Venice: Dominico de' Franceschi, 1570; facsimile ed., Milan: Hoepli, 1976).

———, *The Four Books on Architecture,* trans. Robert Tavernor and Richard Schofield (Cambridge, MA: MIT Press, 1997).

———, *Palladio's Rome,* trans. Vaughn Hart and Peter Hicks (New Haven: Yale University Press, 2006).

Pallucchini, Rodolfo, *I Vivarini: Antonio, Bartolomeo, Alvise* (Venice: N. Pozza, 1961).

——— and Paola Rossi, *Tintoretto: Le opera sacre e profane,* 2 vols. (Milan: Electa, 1982).

Palumbo Fossati Casa, Isabella, *Intérieurs vénitiens á la Renaissance: Maisons, société et culture* (Paris: Éditions Michel de Maule, 2012).

Panofsky, Erwin, *Problems in Titian, Mostly Iconographic* (New York: New York University Press, 1969).

———, *Perspective as Symbolic Form,* trans. Christopher S. Wood (New York: Zone, 1991).

Paoli, Marco, *La "Tempesta" svelata: Giorgione, Gabriele Vendramin, Cristoforo Marcello e la "Vecchia"* (Lucca: Acini Fazzi, 2011).

Parrott, Dial, *The Genius of Venice: Piazza San Marco and the Making of the Republic* (New York: Rizzoli, 2013).

Paul, Benjamin, ed., *Celebrazione e autocritica: La Serenissima e la ricerca dell'identità veneziana nel tardo Cinquecento* (Rome: Viella, 2014).

Pavanello, Giuseppe, ed., *La basilica dei Santi Giovanni e Paolo: Pantheon della Serenissima* (Venice: Marcianum, 2012).

——— and Vincenzo Mancini, eds., *Gli affreschi nelle ville venete: Il Cinquecento* (Venice: Marsilio, 2008).

Pedrocco, Filippo, *Titian* (New York: Rizzoli, 2001).

Penny, Nicholas, *National Gallery Catalogues: The Sixteenth Century Italian Paintings,* 2 vols. (London: National Gallery, 2004–8).

Perry, Marilyn, "The Statuario Publico of the Venetian Republic," *Saggi e Memorie di storia dell'arte* 8 (1972), 75–150.

Petrarch, *Lyric Poems: The 'Rime sparse' and Other Lyrics,* trans. Robert M. Durling (Cambridge, MA: Harvard University Press, 1976).

Philostratus, *Imagines,* trans. Arthur Fairbanks, Loeb Classical Library (London: Heinemann, 1931).

Piana, Mario, and Wolfgang Wolters, eds., *Santa Maria dei Miracoli a Venezia: La storia, la fabbrica, i restauri* (Venice: Istituto Veneto di scienza, lettere et arti, 2003).

Pignatti, Terisio, *Le scuole di Venezia* (Milan: Electa, 1981).

——— and Filippo Pedrocco, *Veronese,* 2 vols. (Milan: Electa, 1995).

——— and Filippo Pedrocco, *Giorgione* (Milan: Rizzoli, 1999).

Pincus, Debra, "A Hand by Antonio Rizzo and the Double Caritas Scheme of the Tron Tomb," *Art Bulletin* 51, no. 3 (1969), 247–56.

———, "The Arco Foscari: The Building of a Triumphal Gateway in Fifteenth-Century Venice" (PhD diss., New York University, 1976; New York: Garland, 1976).

———, "The Tomb of Doge Nicolò Tron and Venetian Renaissance Ruler Imagery," *Art the Ape of Nature: Studies in Honor of H. W. Janson,* ed. Moshe Barasch and Lucy Freeman Sandler, 127–50 (New York, 1981).

———, "Venice and the Two Romes: Byzantium and Rome as a Double Heritage in Venetian Cultural Politics," *Artibus et historiae* 13 (1992), 101–14.

———, *The Tombs of the Doges of Venice* (Cambridge: Cambridge University Press, 2000).

Posselle, Laurence, ed., *Les Noces de Cana de Véronèse: Une oeuvre et sa restauration,* exh. cat. (Paris: Réunion des musées nationaux, 1992).

Priever, Andreas, *Paolo Caliari, Called Veronese: 1528–1588,* trans. Paul Aston and Fiona Hulse (Cologne: Konemann, 2000).

Pullan, Brian, *Rich and Poor in Renaissance Venice: The Social Institutions of a Catholic State, to 1620* (Oxford: Blackwell, 1972).

———, *Poverty and Charity: Europe, Italy, Venice, 1400–1700* (Aldershot: Variorum, 1994).

Puppi, Lionello, "Un letterato in villa: Giangiorgio Trissino a Cricoli," *Arte Veneta* 25 (1971), 72–91.

———, *Andrea Palladio,* rev. ed. (Milan: Mondadori Electa, 2006).

———, ed., *Alvise Cornaro e il suo tempo* (Padua: Comune, 1980).

———, ed., *Tiziano: L'ultimo atto,* exh. cat. (Milan: Skira, 2007).

——— and Loredana Olivato Puppi, *Mauro Codussi* (Milan: Electa, 1977).

——— and Letizia Lonzi, eds, *La notte di San Lorenzo: Genesi, contesti, peripezie di un capolavoro di Tiziano* (Crocetta del Montello: Terra Ferma, 2013).

Puttfarken, Thomas, *Titian and Tragic Painting* (New Haven: Yale University Press, 2006).

Queller, Donald E., *The Venetian Patriciate: Reality versus Myth* (Urbana: University of Illinois Press, 1986).

Radke, Gary M., "Nuns and their Art: The Case of San Zaccaria in Renaissance Venice," *Renaissance Quarterly* 54 (2001), 430–59.

———, "Relics and Identity at the Convent of San Zaccaria in Renaissance Venice," *Images, Relics, and Devotional Practices in Medieval and Renaissance Italy,* ed. Sally J. Cornelison and Scott B. Montgomery, 173–91, Medieval and Renaissance Texts and Studies 296 (Tempe: Arizona Center for Medieval and Renaissance Studies, 2006).

Ravà, Aldo, "Il 'Camerino delle antigaglie' di Gabriele Vendramin," *Nuova Archivio Veneto,* 3rd ser., vol. 39 (1920), 155–81.

Rearick, William R., *The Art of Paolo Veronese, 1528–1588,* exh. cat. (Cambridge: Cambridge University Press, 1988).

Reuterswärd, Patrik, "The Dog in the Humanist's Study," *Konsthistorisk Tidskrift* 50, no. 2 (1981), 53–69.

Ridolfi, Carlo, *Le maraviglie dell'arte* (Venice: Sgaua, 1648).

———, *The Life of Tintoretto, and of His Children Domenico and Marietta,* trans. Catherine Enggass and Robert Enggass (University Park: Pennsylvania State University Press, 1984).

———, *The Life of Titian,* trans. Julia Conaway Bondanella and Peter Bondanella (University Park: Pennsylvania State University Press, 1996).

Roberts, Helen I., "St. Augustine in 'St. Jerome's Study': Carpaccio's Painting and Its Legendary Source," *Art Bulletin* 41 (1959), 283–97.

Rogers, Mary, "An Ideal Wife at the Villa Maser: Veronese, the Barbaros and Renaissance Theories of Marriage," *Renaissance Studies* 7, no. 4 (1993), 379–97.

Romanelli, Giandomenico, *Ca' Corner della Ca' Grande: Architecttura e committenza nella Venezia del Cinquecento* (Venice: Albrizzi, 1993).

———, *Tintoretto alla Scuola Grande di San Rocco* (Milan: Electa, 1994).

———, *La luce e le tenebre: Tintoretto alla Scuola Grande di San Rocco* (Venice: Marsilio, 2011).

———, *Il mistero delle Due Dame* (Milan: Skira, 2011).

———, *Palazzo Ducale a Venezia* (Milan, Skira, 2011).

———, ed., *Venice: Art and Architecture,* 2 vols. (Cologne: Köneman, 1997).

——— and Claudio Strinati, *Veronese: Gods, Heroes, and Allegories,* exh. cat. (Milan: Skira, 2004).

Romani, Vittoria, *Tiziano e il tardo rinascimento a Venezia: Jacopo Bassano, Jacopo Tintoretto, Paolo Veronese* (Milan: Il Sole 24 Ore, 2007).

Romano, Dennis, *Patricians and Popolani: The Social Foundations of the Venetian Renaissance State* (Baltimore: Johns Hopkins University Press, 1987).

———, *Housecraft and Statecraft: Domestic Service in Renaissance Venice, 1400–1600* (Baltimore: Johns Hopkins University Press, 1996).

———, *The Likeness of Venice: A Life of Doge Francesco Foscari, 1373–1457* (New Haven: Yale University Press, 2007).

Rosand, David, "The Crisis of the Venetian Renaissance Tradition," *L'Arte* 11/12 (1970), 5–53.

———, "*Ut pictor poeta:* Meaning in Titian's *poesie,*" *New Literary History* 3 (1972), 527–46.

———, *Painting in Cinquecento Venice: Titian, Veronese, Tintoretto,* rev. ed. (Cambridge: Cambridge University Press, 1997).

———, *Myths of Venice: The Figuration of a State* (Chapel Hill: University of North Carolina Press, 2001).

———, *Véronèse,* trans. Odile Menegaux et Renaud Tempirini (Paris: Citadelles et Mazenod, 2012).

———, ed., *Titian, His World and His Legacy* (New York: Columbia University Press, 1982).

Roskill, Mark W., *Dolce's "Aretino" and Venetian Art Theory of the Cinquecento* (Toronto: University of Toronto Press, 2000).

Rossi, Paola, and Lionello Puppi, eds., *Jacopo Tintoretto nel quarto centenario della morte* (Padua: Il Poligrafo, 1996).

Rossler, Jan-Christoph, *I Palazzi veneziani: Storia, Architettura, Restauri: Il Trecento e del Quattrocento* (Venice: Scripta, 2011).

Ruggiero, Guido, *The Boundaries of Eros: Sex, Crime, and Sexuality in Renaissance Venice* (New York: Oxford University Press, 1985).

Salomon, Xavier F., *Veronese's Allegories: Virtue, Love, and Exploration in Renaissance Venice,* exh. cat. (New York: Frick Collection, 2006).

———, *Veronese* (London: National Gallery/ Yale University Press, 2014).

Sansovino, Francesco, *Venetia città nobilissima et singolare* (Venice: Sansovino, 1581; reprinted with additions by Giustiniano Martinioni, Venice: Curti, 1663; facsimile ed. with introduction by Jennifer M. Fletcher, Farnborough: Gregg, 1968).

———, *Delle cose notabili della città di Venetia* (Venice: Valgrisio, 1587; 1st ed. 1556, under the pseudonym Anselmo Guisconi).

Sanudo, Marino, *I diarii,* ed. Rinaldo Fulin, Federico Stefani, Nicolò Barozzi, Guglielmo Berchet, and Marco Allegri, 58 vols. (Venice: Visentini, 1879–1903).

———, *Venice, città excelentissima: Selections from the Renaissance Diaries of Marin Sanudo,* ed. Patricia H. Labalme and Laura Sanguineti White, trans. Linda L. Carroll (Baltimore: Johns Hopkins University Press, 2008).

Sapienza, V., "Miti, metafore e profezia: Le *Storie di Maria* di Jacopo Tintoretto nella sala terrena della Scuola Grande di San Rocco," *Venezia Cinquecento* 17, no. 33 (2007), 48–139.

Savoy, Daniel, "Le iscrizioni sulla facciata di San Michele in Isola," *Arte Veneta* 65 (2008), 132–37.

———, *Venice from the Water: Architecture and Myth in an Early Modern City* (New Haven: Yale University Press, 2012).

Schmitter, Monika, "'Virtuous Riches': The Bricolage of *Cittadini* Identities in Early-Sixteenth-Century Venice," *Renaissance Quarterly* 57, no. 3 (Autumn 2004), 908–69.

Schroeder, H.J., trans., *The Canons and Decrees of the Council of Trent* (Rockford, IL: Tan Books, 1978).

Schulz, Anne Markham, *Niccolò di Giovanni Fiorentino and Venetian Sculpture of the Early Renaissance* (New York: New York University Press, 1978).

———, *The Sculpture of Giovanni and Bartolomeo Bon and Their Workshop,* Transactions of the American Philosophical Society 68, pt. 3 (Philadelphia: American Philosophical Society, 1978).

———, *Antonio Rizzo: Sculptor and Architect* (Princeton: Princeton University Press, 1983).

———, *Antonio Rizzo: Scala dei Giganti* (Venice: Arsenale, 1985).

———, *The Sculpture of Tullio Lombardo* (Turnhout: Harvey Miller, 2014).

Schulz, Juergen, *Venetian Painted Ceilings of the Renaissance* (Berkeley: University of California Press, 1968).

———, "Jacopo de' Barbari's View of Venice: Map Making, City Views, and Moralized Geography before the Year 1500," *Art Bulletin* 60 (1978), 423–74.

———, *The New Palaces of Medieval Venice* (University Park: Penn State University Press, 2004).

Scirè, Giovanna Nepi, ed., *Carpaccio: Pittore di Storie,* exh. cat. (Venice: Marsilio, 2004).

——— and Sandra Rossi, eds., *Giorgione: "Le maraviglie dell'arte,"* exh. cat. (Venice: Marsilio, 2003).

Serlio, Sebastiano, *Regole generali di architettura sopra le cinque maniere de gli edifice* (Venice: Marcolini, 1537).

———, *Le antiquità di Roma* (Venice: Marcolino, 1540).

———, *Architecturae liber septimus* (Frankfurt am Main: Wechell, 1575).

———, *Tutte l'opere d'architettura, et prospetiva* (Ridgewood, NJ: Gregg, 1946).

———, *Sebastiano Serlio on Architecture,* trans. Vaughan Hart and Peter Hicks (New Haven: Yale University Press, 1996).

Settis, Salvatore, *Giorgione's Tempest: Interpreting the Hidden Subject,* trans. Ellen Bianchini (Chicago: Chicago University Press, 1989).

Setton, Kenneth M., *The Papacy and the Levant (1204–1571),* 4 vols. (Philadelphia: American Philosophical Society, 1976–84).

Sgarbi, Vittorio, *Tintoretto,* exh. cat. (Milan: Skira, 2012).

———, *I volti e l'anima: Tiziano Ritratti* (Savigliano: L'Artistica, 2013).

——— and Lionello Puppi, *Ca' Dario: Mito e storia di Giovanni Dario e del suo palazzo tra Oriente e Venezia* (Milan: Ricci, 1984).

Sheard, Wendy Stedman, "The Tomb of Doge Andrea Vendramin in Venice by Tullio Lombardo" (PhD diss., Yale, 1971; Ann Arbor: UMI, 1985).

———, "The Birth of Monumental Classicizing Relief in Venice on the Façade of the Scuola di San Marco," *Interpretazioni veneziane: Studi di storia dell'arte in onore di Michelangelo Muraro,* ed. David Rosand, 149–74 (Venice: Arsenale, 1984).

Shephard, Tim, *Echoing Helicon: Music, Art and Identity in the Este Studioli, 1440–1530* (Oxford: Oxford University Press, 2014).

Sherman, A., "Murder and Martyrdom: Titian's Gesuiti *Martyrdom of St. Lawrence* as a Family Peace Offering," *Artibus et historiae* 67 (2013), 39–54.

Sinding-Larsen, Staale, *Christ in the Council Hall: Studies in the Religious Iconography of the Venetian Republic,* Acta ad archaeologiam et atrium historiam pertinentia 5 (Rome: Institutum Romanum Norvegiae, 1974).

Sohm, Philip L., "The Staircase of the Venetian Scuole Grandi and Mauro Codussi," *Architectura* 8, no. 2 (1978), 125–49.

———, "The Scuola Grande di San Marco, 1437–1550: The Architecture of a Venetian Lay Confraternity" (PhD diss., Johns Hopkins, 1978; New York: Garland, 1982).

———, *The Artist Grows Old: The Aging of Art and Artists in Italy, 1500–1800* (New Haven: Yale University Press, 2007).

Stefaniak, Regina, "Of Founding Fathers and the Necessity of the Place: Giorgione's *Tempesta,*" *Artibus et historiae* 29, no. 58 (2008), 121–55.

Syndikus, Candida, and Sabine Rogge, eds., *Caterina Cornaro: Last Queen of Cyprus and Daughter of Venice—Ultima regina di Cipro e figlia di Venezia* (Münster: Waxmann, 2013).

Tafuri, Manfredo, *Jacopo Sansovino e l'architettura del '500 a Venezia* (Padua: Marsilio, 1972).

———, *Venice and the Renaissance,* trans. Jessica Levine (Cambridge: MIT Press, 1989).

———, ed., *"Renovatio Urbis": Venezia nell'età di Andrea Gritti (1523–1538)* (Rome: Officina, 1984).

Tanner, Marie, "Chance and Coincidence in Titian's *Diana and Actaeon," Art Bulletin* 56 (1974), 535–50.

Terribile, Claudia, *Del piacere della virtù: Alessandro Magno e il patriziato veneziano* (Venice: Marsilio, 2009).

Thornton, Peter, *The Italian Renaissance Interior, 1400–1600* (New York: Abrams, 1991).

Timofiewitsch, Wladimir, *The Chiesa del Redentore* (University Park: Penn State University Press, 1971).

Titian: Prince of Painters, exh. cat. (Venice: Marsilio, 1990).

Tolnay, Charles de, "L'interpretazione dei cicli pittorici del Tintoretto nella Scuola di San Rocco," *Critica d'Arte* 7 (1960), 341–76.

Toscano, Gennaro, and Francesco Valcanover, eds., *Da Bellini a Veronese: Temi di arte veneta* (Venice: Istituto veneto di scienze, lettere et arti, 2004).

Turner, Jane, ed., *Encyclopedia of Italian Renaissance and Mannerist Art,* 2 vols. (New York: Grove's Dictionaries, 2000).

Valcanover, Franacesco, *Jacopo Tintoretto and the Scuola Grande di San Rocco* (Venice: Storti, 1983).

Vasari, Giorgio, *Le opera di Giorgio Vasari* (includes *Vite de' più eccellenti architetti, pittori et scultori italiani*), 9 vols., ed. Gaetano Milanesi (Florence: Sansoni, 1878–85).

———, *Lives of the Painters, Sculptors and Architects,* 10 vols., trans. Gaston du C. de Vere (London: Macmillan, 1912–15; reprinted in 2 vols., New York: Knopf, 1996).

———, *The Lives of the Artists,* trans. Julia Conaway Bondanella and Peter Bondanella (Oxford: Oxford University Press, 1991).

Vazzoler, Chiara, *The Scuola Grande di San Giovanni Evangelista* (Venice: Marsilio, 2005).

Vecellio, Cesare, *The Clothing of the Renaissance World: Europe, Asia, Africa, the Americas,* trans. Margaret F. Rosenthal and Ann Rosalind Jones (London: Thames and Hudson, 2008).

———, *Habiti antichi et moderni: La moda nel Rinascimento: Europa, Asia, Africa, Americhe,* ed. Margaret F. Rosenthal and Ann Rosalind Jones (Rome: Istituto poligrafico e Zecca dello Stato, 2010).

Venezia: Palazzo Ca' Corner della Ca' Grande (Milan: Orbicolare, 2013).

Veronese: Gods, Heroes and Allegories, exh. cat. (Milan: Skira, 2004).

Villa, Giovanni Carlo Federico, ed., *Tintoretto* (Milan: Silvana, 2013).

———, *Titian,* exh. cat. (Milan: Silvana, 2013).

Vio, Gastone, *Le scuole piccole nella Venezia dei dogi: Note d'archivio per la storia delle confraternite veneziane* (Costabissara: Colla, 2004).

Vitruvius, *Ten Books on Architecture,* trans. Ingrid D. Rowland (Cambridge: Cambridge University Press, 1999).

Voragine, Jacobus de, *The Golden Legend: Readings on the Saints,* trans. William Granger Ryan, 2 vols. (Princeton: Princeton University Press, 1993).

Waddington, Raymond B., *Pietro Aretino: Subverting the System in Renaissance Italy* (Burlington, VT: Ashgate Variorium, 2014).

Wethey, Harold E., *The Paintings of Titian,* 3 vols. (London: Phaidon, 1969–75).

White, John, *The Birth and Rebirth of Pictorial Space* (Boston: Boston Book and Art Shop, 1967).

Wilinski, Stanislaw, "La Serlina," *Bolletino del Centro Internazionale di Studi di Archittetura Andrea Palladio* 11 (1969), 399–429.

Wilk, Sarah Blake, "The Sculpture of Tullio Lombardo: Studies in Sources and Meaning" (PhD diss., New York University, 1977; New York: Garland, 1978).

Wilson, Carolyn, ed., *Giovanni Bellini: An Art "More Human and More Divine"* (Turnhout: Brepols, 2014).

Wittkower, Rudolf, *Architectural Principles in the Age of Humanism* (New York: Norton, 1971).

Wolters, Wolfgang, *La scultura Veneziana gotica, 1300–1460* (Venice: Alfieri, 1976).

———, *Storia e politica nei dipinti di Palazzo Ducale: Aspetti dell'autocelebrazione della Repubblica di Venezia nel Cinquecento,* trans. Denedetta Heinemann Campana (Venice: Arsenale, 1987).

———, *Architektur und Ornament: Venezianischer Bauschmuck der Renaissance* (Munich: Beck, 2000).

Woods-Marsden, Joanna, *Renaissance Self-Portraiture* (New Haven: Yale University Press, 1998).

———, ed., *Titian: Materiality, Likeness, Istoria* (Turnhout: Brepols, 2007).

Worthen, Thomas, "Tintoretto's Paintings for the Banca del Sacramento in S. Margherita," *Art Bulletin* 78 (1996), 707–32.

Zamperini, Alessandra, *Paolo Veronese* (Venice: Arsenale, 2014).

Zapperi, Roberto, "Alessandro Farnese, Giovanni della Casa and Titian's *Danaë* of Naples," *Journal of the Warburg and Courtauld Institutes* 54 (1991), 159–71.

Zenkert, Astrid, *Tintoretto in der Scuola di San Rocco: Ensemble und Wirkung* (Tübingen: Wasmuth, 2003).

Zorzi, Marino, *La Libreria di San Marco: Libri, lettori, società nella Venezia dei dogi* (Milan: Mondadori, 1987).

Zorzi, Renzi, ed., *Le metamorfosi del ritratto* (Florence: Olschki, 2002).

ILLUSTRATIONS

N.B.: Unless otherwise noted, all works of art are in Venice.

INDEX

PICTURE CREDITS

Mocenigo, 32–33, *33;* Villa Giustiniani, 271–272, *272*

Longinus, 172

Loredan family, 58, 294

Loredan, Andrea (1450–1513), noble patron of Palazzo Loredan, 185

Loredan, Antonio (1420–82), military commander, 58

Loredan, Leonardo (r. 1501–21), doge, 13, 90–92, *92,* 98–99, 119, 185; Bellini's portrait of, 90–92, *92,* 231–232

Lotis, 208, *208,* 209, 210

Louis XII (r. 1498–1515), king of France, 98, 99

Loyola, Ignatius (1491–1556), founder of the Jesuit order, *Spiritual Exercises,* 161, 178

Luther, Martin (1483–1546), German monk, 101–102

Lysippus (4th century BC), sculptor, *Cupid Stringing His Bow,* 214–215

Macrobius (5th century AD), Roman writer, *Saturnalia,* 208

Madonna del Orto, 178

Maggior Consiglio. See Great Council

Magistrato alle Acque, 293

magnificence, theory of, 105, 184

Magnus (7th century), bishop, 26, 122

Malchiostro, Broccardi, canon of Treviso cathedral, 140

Malgrate, Ventura da (15th century), poet, *Visione Barbariga* (Barbarigo vision), 14

Malipiero, Pasquale (r. 1457–62), doge, *18,* 31–32, *32*

Manin, Ludovico (r. 1789–1797), doge, 261

Mansueti, Giovanni (active 1485–1526/27), painter, 52

Mantegna, Andrea (c. 1431–1506), painter, 245; *Assumption,* 138; *Portrait of Cardinal Ludovico Trevisan,* 88

Manuzio, Paolo (1512–74), publisher, 200

Marcello, Girolamo, noble patron of Giorgione, 203, 205

Marcello, Jacopo (1530–1603), nobleman, 262, 294

Maria d'Aragona (b. after 1503–1568), wife of Alfonso d'Avalos, 244, *244*

Mark Antony (83–30 BC), Roman commander, 242

marriage and dowries, 55–56, 104, 105, 204, 206–207

Mars, *13,* 119–121, *120–121,* 201–202, 244, 253, 280, 281, 287

Marsyas, 223–226, *223*

Martini, Simone (1284–1344), painter, 240

Masaccio (1401–28), painter, 42; *Trinity* fresco, 46

Massari, Giorgio (1687–1766), architect, 110; Clock Tower, *14*

Massolo, Lorenzo (d. 1557), patron of Titian, 143

Maurus, king of Brittany, 55–56

Maximilian I (1459–1519), Archduke of Austria and Holy Roman Emperor (r. 1493–1519), 98, 99

Medici, Cosimo de' (1389–1464), Florentine banker, 75, 112

Medici, Cosimo I de' (1519–74), duke of Florence, 233

Medici court, 273

Medici, Lorenzo the Magnificent de' (1449–92), humanist, 272

Medici Palace, 75

mediocritas, 295

Meditations on the Life of Christ, 178

Medusa, 37

Mehmed II (r. 1444–46 and 1451–81), Turkish sultan, 4, 58, 76; Gentile Bellini's *Sultan Mehmed II, 89–90, 91*

Memling, Hans (c. 1430–1494), painter, 45, 90

Memmo, Tribuno (r. 979–91), doge, 127, *131*

Merceria, *xviii,* xix, 15

Merchants' Portico, *xvii,* 63, 116

Mercury, xvi, 74, 111–112, *111,* 203, *208,* 209, 234, 265, 278

methodology, xiii–xiv

Mézières, Philippe de (c. 1327–1405), Grand Chancellor of Cyprus, 59

Michelangelo (1475–1564), sculptor, painter, architect, 143, 149, 213; *David,* 120, 229; honored as *divino,* 148; *Jeremiah,* 225; *Leah,* 154; *Moses,* 148, 232; *Night,* 214; *Pietà* (Florence), 147; *Pietà* (S. Peter), 147; *Rachel,* 154; *Risen Christ,* 148; *Sacrifice of Noah,* 144; and Sansovino's architecture, 187; *Separation of Waters from Firmament,* 171; and Titian, 214–215

Michiel, Giovanni Giacomo, commissioned Giovanni Bellini's *St. Francis in the Desert,* 82

Michiel, Marcantonio (1484–1552), author of *Notes on Works of Art,* 82, 88, 195, 200, 201, 203

Midas, king of Phrygia, 224–225

Minerva (Pallas Athena), 37, 111, 114, 161, 223, 273, 280

Minos, king of Crete, 204

Mint, *xviii,* 109, 197

Mocenigo, Alvise (r. 1570–77), doge, 253

Mocenigo, Pietro (r. 1474–76), doge, *18,* 119

Mocenigo, Tommaso (r. 1414–23), doge, *18,* 28–29, *29*

Modest Venus (Venus pudica), 38, 205–206, 247

Monte Cassino, Benedictine abbey, 127

Moro, Cristoforo (r. 1462–71), doge, 48, 88, *89,* 231–232

Moscus, Demetrius, translator of Philostratus, 210

Moses, 82, 84, 85, 146, 267; Aspetti's *Moses, 126;* Michelangelo's *Moses,* 148, 232; Tintoretto's *Moses Strikes Water from the Rock, 174, 176, 176*

Mount Alverna, 84

music, Veronese and, 159, 161–162

musical ratios (harmonic ratios), 124–125, 279–280, 290

Mustafa Pasha, Lala (c. 1500–80), Turkish commander, 226

Myth of Venice, xii, xiii, 6–7, 48, 74, 103, 107, 118, 122, 202, 253, 258

Napoleon Bonaparte (1769–1821), 10, 261

Neoplatonism, 205, 207, 214, 223

Neptune, xvi, *13,* 74, 119–120, *120,* 121, 253, 280, 281, 287

Nereids, 141, 278

Nessus, 37

Niccolò da Correggio, tailor, 245

Niccolò di Giovanni Fiorentino (1418–1506), sculptor: Arco Foscari, 12–13, *12;* tomb of Francesco Foscari, 29–31, *30*

Nicodemus, 45, 152, 153

Noah, 267

nobles, 4, 93–94, 101, 104, 105; patronage and, 294; rental income from palaces, 185

Novello, Paolo, 264

Octavia (69–11 BC), wife of Mark Antony, 242

Olympus, satyr, 225

one-point linear perspective, 42–43, *42–43*

Opus imperfectum in Mattheum, 195

Or San Michele (Florence), 29

Order of the Golden Spur, 236

Order of St. John in Jerusalem (Knights of Malta, Knights of Rhodes), 65, 66, 68, 99, 136

Ospedale degli Incurabili, 103

Ospedale dei Derelitti, 103

Ospedale dei Mendicanti, 104

Otto (1167/71–1200), son of Frederick Barbarossa, xix, 7, 257, 258, *259*

Ovid (43 BC–17 AD), poet: *Fasti,* 208, 209, 223, 284; *Metamorphoses,* 37, 112, 148, 214, 215, 223–224, 234, 240, 247, 280, 284

Padua, University of, 102

Paffendorp, Anthony, German trader and banker in Venice, xv, xxiii

Pala d'Oro, 257

DESIGNER Claudia Smelser

TEXT 9.75/12 Garamond Premier Pro

DISPLAY Garamond Premier Pro

COMPOSITOR Nicole Hayward

PREPRESS Embassy Graphics

INDEXER Victoria Baker

CARTOGRAPHER AND ILLUSTRATOR Richard Depolo, Berkeley

PRINTER AND BINDER QuaLibre

DATE DUE